The Byzantine empire began with the transformation of the Roman empire initiated by the official acceptance of Christianity and the establishment of Constantinople as the capital city. It ended with the fall of that city to the Ottoman Turks in 1453. The art and architecture of the empire reflects its changing fortunes, the development of Christianity, and the cultural influences that affected it.

This book offers a systematic introduction to the material culture of the Byzantine empire, from the fourth to the fourteenth centuries. It provides for the student or any other interested reader a compendium of material which is generally difficult of access: much of the writing on Byzantine art and architecture is not in English, and is published as articles in scholarly journals. The book sets out the subject in an accessible manner, describing and discussing by period the surviving material – and that which can be reconstructed from documentary sources – and exploring its social/historical context. The text is copiously illustrated by well over 300 halftones, plans and maps.

Byzantine art and architecture
An introduction

Byzantine art and architecture

An introduction

LYN RODLEY

CAMBRIDGE
UNIVERSITY PRESS

Published by the Press Syndicate of the University of Cambridge
The Pitt Building, Trumpington Street, Cambridge CB2 IRP
40 West 20th Street, New York, NY 10011-4211, USA
10 Stamford Road, Oakleigh, Melbourne 3166, Australia

© Cambridge University Press 1994

First published 1994

Printed in Great Britain at the University Press, Cambridge

A catalogue record for this book is available from the British Library

Library of Congress cataloguing in publication data

Rodley, Lyn, 1944–
Byzantine art and architecture/Lyn Rodley
 p. cm.
Includes index
ISBN 0 521 35440 4 (hardback) – ISBN 0 521 35724 1 (paperback)
1. Art, Byzantine. 2. Architecture, Byzantine. I. Title.
N6250.R59 1993
709'.02 14–dc20 92-33797CIP

ISBN 0 521 35440 4 hardback
ISBN 0 521 35724 1 paperback

TAG

CONTENTS

VIII PREFACE

IX ACKNOWLEDGEMENTS

X LIST OF ABBREVIATIONS

2 Introduction

8 1 The early Christian period

58 2 The sixth century

115 3 The dark age and Iconoclasm

132 4 The Macedonian dynasty

195 5 The Comnene dynasty

263 6 The Latin occupation of Constantinople

276 7 The Palaiologan period

342 8 Approaches to the study of Byzantine art and architecture

APPENDICES

347 1 Armenian art and architecture

348 2 The Copts

349 3 Byzantine ceramics

350 4 Byzantine coins and seals

352 5 Byzantine emperors

355 GLOSSARY

361 SELECT BIBLIOGRAPHY

364 SOURCES OF PLANS

368 SOURCES OF PHOTOGRAPHS

370 INDEX

PREFACE

This book is directed towards university students of either art history or Byzantine studies, and others whose interest in Byzantine art and architecture demands more than a popular treatment. It stemmed from the difficulty I have had, when compiling bibliographies for students, in finding anything to recommend as a starting point. Many very good reference books cover too much ground to be useful as introductory texts, and earlier general surveys have been overtaken to various degrees by research published since they were written. Many of the monographs and articles that provide the basic descriptions and discussion of Byzantine material are accessible in only a few academic libraries, and they are often not in English.

My object, then, has been to offer a brief survey of selected examples of Byzantine art and architecture, discussion of the particular difficulties presented by some of this material, and assessment of the issues, controversies and approaches that it has generated. I hope thus to equip the student with a critical framework with which to approach the more specialized scholarly literature. My footnotes refer to works that will supply much fuller bibliography and detailed treatment of particular topics. I have followed the chronological arrangement traditional to the subject, both so that my text may be used easily in conjunction with standard reference books, and because a thematic arrangement might detract from clarity. For the same reasons I have subdivided each chapter, as far as is appropriate, into sections on historical background (necessarily very brief, and concerned chiefly with those aspects of general history relevant to material culture), architecture, sculpture, monumental art, minor arts, and illuminated manuscripts; a summary of general issues ends each chapter. For those looking for information on topics that cross these divisions I have included thematic headings in the index.

ACKNOWLEDGEMENTS

I am most grateful to the Hellenic Foundation for making a handsome grant towards the cost of illustrating this book. My warm thanks are also offered to Mary Hawkins, Margaret Mullett, Nigel Rodley, Elizabeth Thornton and Helen Walker, who all gave generously of their time to read and comment upon drafts at various stages. I was fortunate to have the excellent services of Alison Gilderdale as copy-editor and Jonathan Newdick as designer, and to have assistance in obtaining photographs in Istanbul from Ann and Şeref Haznedar and Maggie Pınar. The helpfulness of staff at the Warburg Institute, the British Library and Cambridge University Library was always much appreciated, and special thanks go to St. Deiniol's Residential Library, Hawarden, which provided the perfect environment for revision of the final draft.

LYN RODLEY AUGUST 1993

ABBREVIATIONS

AB	*Art Bulletin*
ABSA	*Annual of the British School at Athens*
Age of Spirituality	K. Weitzmann, *The Age of Spirituality. Late Antique and Early Christian Art. Third to Seventh Centuries* (New York 1979) (Catalogue of the exhibition at the Metropolitan Museum of Art, New York 1977–8)
AIRN	*Acta ad archaeologiam et artium historiam pertinentia. Institutum Romanum Norvegiae*
AJA	*American Journal of Archaeology*
Anatolian Civilisations	Catalogue of the exhibition *The Anatolian Civilisations* Istanbul 1983, II Greek/Roman/Byzantine (Istanbul 1983)
AnatSt	*Anatolian Studies*
Atlas	*Atlas of the Early Christian World*, F. van der Meer and C. Mohrmann (London/Edinburgh 1966)
BAEA	Catalogue of the exhibition *Byzantine Art, an European Art* (Athens 1964)
Beckwith, *ECBA*	J. Beckwith, *Early Christian and Byzantine Art* (Harmondsworth 1970) (Pelican History of Art)
BM	*Burlington Magazine*
BZ	*Byzantinische Zeitschrift*
CAH	*Cambridge Ancient History* (Cambridge 1939–)
CahArch	*Cahiers Archéologiques*
CSHB	*Corpus Scriptorum Historiae Byzantinae*
CFHB	*Corpus Fontium Historiae Byzantinae*
Cutler, *Psalters*	A. Cutler, *The Aristocratic Psalters in Byzantium* (Paris 1984)
Deichmann, *Ravenna*	F.W. Deichmann, *Ravenna. Haupstadt des spätantiken Abendlandes*, I–III (Wiesbaden/Baden-Baden 1958–89)

Diehl *et al.*, *Salonique* C. Diehl, M. Le Tourneau & H. Saladin, *Les Monuments chrétiens de Salonique* (Paris 1918)

Dodd, *Silver Stamps* E.C. Dodd, *Byzantine Silver Stamps* (Washington DC 1961)

DOP *Dumbarton Oaks Papers*

EB *Etudes Byzantines* (cont. as *Revue des Etudes Byzantines*)

Fıratlı, *Sculpture* N. Fıratlı, *La Sculpture byzantine figurée au Musée Archéologique d'Istanbul* (Paris 1990)

GBA *Gazette des Beaux-Arts*

Grabar, *Sculptures* A. Grabar, *Sculptures byzantines de Constantinople IVe-Xe siècle* (Paris 1963)

Grabar, *Sculptures/Moyen Age* A. Grabar, *Sculptures byzantines du Moyen Age XIe-XIVe siècle* (Paris 1976)

G/W BE A. Goldschmidt, & K. Weitzmann, *Die byzantinischen Elfenbeinskulpturen*, I-II (Berlin 1930–4)

IstMitt *Istanbuler Mitteilungen*

Janin, *Géographie* R. Janin, *La Géographie ecclésiastique de l'empire byzantin. III Les Eglises et les Monastères*, 2nd edn. (Paris 1969)

Janin, *Grands centres* R. Janin, *Les Eglises et les monastères des grandes centres byzantins* (Paris 1975)

JBAA *Journal of the British Archaeological Association*

JBL *Journal of Biblical Literature*

JÖB *Jahrbuch der Österreichischen Byzantinistik*

JRS *Journal of Roman Studies*

Krautheimer, *Architecture* R. Krautheimer, *Early Christian and Byzantine Architecture*, 2nd edn. (Harmondsworth 1975) (Pelican History of Architecture)

Macridy *et al.*, 'Monastery of Lips' T. Macridy, A.H.S. Megaw, C. Mango, 'The Monastery of Lips (Fenari Isa Camii) at Istanbul', *Dumbarton Oaks Papers* 18 (1964) 249–315

Mainstone, *Hagia Sophia* R. Mainstone, *Hagia Sophia* (London 1988)

Mango, *Architecture*	C. Mango, *Byzantine Architecture* (New York 1976)
Mango, *Sources*	C. Mango, *The Art of the Byzantine Empire 312–1453. Sources and Documents in the History of Art* (New Jersey 1972)
Mathews, *Istanbul*	T. Mathews, *The Byzantine Churches of Istanbul. A Photographic Survey* (University Park PA 1976)
MünchJb	*Münchner Jahrbuch der bildenden Kunst*
Oakeshott, *Rome*	W. Oakeshott, *The Mosaics of Rome from the Third to the Fourteenth Centuries* (London 1967)
Obolensky, *Byzantine Commonwealth*	D. Obolensky, *The Byzantine Commonwealth. Eastern Europe 500–1453* (London 1974)
OCP	*Orientalia Christiana Periodica*
Orlandos, *Archeion*	A. Orlandos, *Archeion ton Byzantinon Mnemeion tes Hellados* (Athens 1935–)
Ostrogorsky, *Byzantine State*	G. Ostrogorsky, *History of the Byzantine State* (Oxford 1968)
PG	J. Migne, *Patriologia Graeca*, I-CLXI (Paris 1857–1966)
REB	*Revue des Etudes Byzantines* (continuation of *Etudes Byzantines*)
Restle, *Asia Minor*	M. Restle, *Die Byzantinische Wandmalerei in Kleinasien*, I-III (Recklinghausen 1967), trans. *Byzantine Wall Painting in Asia Minor* (Shannon 1967)
Rodley, *Cave Monasteries*	L. Rodley, *Cave Monasteries of Byzantine Cappadocia* (Cambridge 1986)
SLNPF	H.P. Wace & P. Schaff, *Select Library of the Nicene and Post-Nicene Fathers of the Church* (Oxford/New York 1890–)
Spatharakis, *Corpus*	I. Spatharakis, *Corpus of Dated Illuminated Greek Manuscripts to the Year 1453* (Leiden 1981)
Spatharakis, *Portrait*	I. Spatharakis, *The Portrait in Byzantine Illuminated Manuscripts* (Leiden 1976)
Splendeur de Byzance	Catalogue of the exhibition *Splendeur de Byzance*, Museés royaux d'Art et d'Histoire (Brussels, October–December 1962)

Striker & Kuban, C.L. Striker & Y.D. Kuban, 'Work at Kalenderhane Camii in Istanbul' Preliminary
'Kalenderhane' Reports in *Dumbarton Oaks Papers* 21 (1967) 267–71; 22 (1968) 185–94; 25 (1971)
 251–8; 29 (1975) 306–18

Treasury of San Marco *The Treasury of San Marco, Venice* (Milan 1984) (Exhibition Catalogue)

Vasiliev, *Byzantine Empire* A.A. Vasiliev, *History of the Byzantine Empire* (Madison WI 1958–)

Volbach, *Elfenbeinarbeiten* W.F. Volbach, *Elfenbeinarbeiten der Spätantike und des frühen Mittelalters* (Mainz 1952)

Weitzmann, *LAECBI* K. Weitzmann, *Late Antique and Early Christian Book Illumination* (London 1977)

Weitzmann, *Sinai* K. Weitzmann, *The Monastery of St. Catherine at Mount Sinai. The Icons* (Princeton NJ
 1976)

ZVI *Zbornik Radova Vizantoloskog Instituta, Srpska Akademija Nauka*

ABBREVIATIONS USED IN MANUSCRIPT PRESSMARKS

BL	British Library (London)
BN	Bibliothèque Nationale/Biblioteca Nacional
Öst. NB	Österreichische Nationalbibliothek
Moscow, HM	Historical Museum (Moscow)
Sinai	Monastery of St Catherine, Mount Sinai
Bodl.	Bodleian Library (Oxford)

Personification of 'Truth' on
an enamelled panel from an
eleventh-century crown
(Budapest, Magyar Nemzeti
Múzeum)

Introduction

The Byzantine empire existed for over a millennium, during which it saw great changes of fortune which affected its geography, language, political relationships and social structure. Impoverishment or enrichment of art and architecture do not always match precisely the stages of decline or recovery, but they are closely linked, and an awareness of the changing circumstances of the empire is necessary to interpretation of the changes in its material culture. To this end, there follows a brief survey of the chronological divisions usually applied to the art and architecture of the Byzantine empire, and the reasons for them.

The Byzantine empire emerged from the Roman empire as a result of two moves by the emperor Constantine the Great: the toleration of Christianity in 313 AD (soon followed by positive endorsement) and, in 324, the decision to make his capital in Byzantium, on the strait which joins the Black Sea with the Sea of Marmara. The city was renamed Constantinopolis and in time replaced Rome as the administrative centre of the empire. Thus, during the *early Christian* period (fourth–fifth centuries), the Byzantine empire was almost co-extensive with the Roman empire and, against a background of cultural continuity, the materials and vocabulary of late Roman art and architecture were adapted to Christian purposes. The period may be roughly subdivided into its two centuries, with the fourth century seeing the emergence of new forms, and the fifth their maturity. The period is generally treated as a whole, however, since there is no obvious point at which to separate the two stages. In addition, since most of the material remains are fifth-century, the earlier stage must to a large extent be reconstructed by analysis of the monuments of the later one.

The *sixth century* was the last in which the empire still had the administrative structure and much of the territory of its Roman progenitor. Art historians treat it separately from the fourth and fifth centuries because in it there appear changes that begin a separation from the traditions of the Roman past that will become more pronounced in later centuries. Many of these are associated with the reign of Justinian (527–65) but the term 'the age of Justinian' is often used in order to acknowledge that some of them pre-date his reign.

Next comes the Byzantine *dark age* (seventh–eighth centuries), a period of great disruption, during which extensive Arab occupation of the

east Mediterranean and Anatolia (modern Turkey) overturned the old Roman order. There are few material remains of this time, which ended with the century of *Iconoclasm* (726–843, with a break 780–813). This term refers to the destruction of religious images, the use of which had been a running controversy in the early church, and which now became the subject of an imperial ban. In due course, the iconoclasts were defeated and the use of images re-established as the orthodox position.

The ninth–twelfth centuries form the *middle-Byzantine* period, which is often treated as a whole, but is here subdivided into dynastic sections. The *Macedonian* dynasty was founded by the usurper Basil I and runs from the mid-ninth to the mid-eleventh century, with some interruptions from other usurpers. It began in hope, with the recovery of much of Anatolia from the Arabs in the ninth century, and was a time of cultural revival. The *Comnene* dynasty, founded by another usurper, Alexios I Komnenos, lasted from the mid-eleventh to the late twelfth century. During this period much of Anatolia was once again lost, this time to the Turks, but there was prosperity in the Greek provinces and the increasing presence in Constantinople of Italians and Franks brought Western influences to the capital.

Rather more than influences arrived in 1204, when crusaders on their way to the Holy Land looted Constantinople and settled in for fifty-seven years of the *Latin occupation*, dispersing the Byzantine aristocracy to exile in the provinces, at Nicaea, Arta, Trebizond and Thessalonike. In 1261 Constantinople was recovered, and what was left of the empire entered its last phase under the the *Palaiologan* dynasty, which ruled until the fall of Constantinople to the Ottoman Sultan Mehmet the Conqueror in 1453.

Territorial gains and losses, population movements and the final eclipse by a non-Christian power have reduced the material remains of the Byzantine empire to a very small fraction of what was actually produced. Moreover, that fraction is not a representative cross-section. Most of what remains is ecclesiastical, partly because the church was a major patron of the arts and also because it proved better able to guard its treasures than the court or private patron. As is the case in most cultures, buildings that were the commissions of emperors or aristocrats have a better survival rate than others and luxury items were preserved with more tenacity than the commonplace. Ivories, which cannot be melted down and do not decay, survive more easily than metalwork, woodwork and textiles. In general, a higher proportion of Byzantine monuments survives in Greece and Italy, which remained Christian in post-Byzantine times, than in Anatolia, that did not. On the other hand, the remains in Christian lands have been modified by centuries of alteration and repair, while those in non-Christian areas often reveal their original condition more easily. A related point is that there has been more study of monuments in Christian lands than in non-Christian, resulting in an uneven coverage of the subject – and also the construction of some 'general' theories

that are in fact based on examples representing only part of the empire.

Byzantine material remains themselves present many problems of interpretation. The first task of any art-historical investigation is to establish fact as accurately as possible: to find out what was produced, when, where, for whom and for what purpose. The usual approach is to study in detail the monuments of a particular area, or the objects of a particular category, and to explore their relationships – by comparing the products of different localities, for instance, or the features of one type of artefact with those of another. It may then be possible to draw wider conclusions about sequences of development, about the influence of one region on another – the relationship between the art of the capital and that of the provinces, for example – and about the functions of art and architecture in society. The difficulty of such investigations clearly increases with the scarcity of material available for study, and recognition that the record is very incomplete must be part of any attempt at interpretation. It will never be possible to reconstruct the art and architecture of the Byzantine empire in detail. What can be attempted, though, is accurate definition of the status of what does remain – the extent to which a particular survival is likely to be typical of its class, for example. Art history, a discipline which grew out of connoisseurship, is much concerned with the appearance of things, and sometimes neglects other factors. Most early churches in the West, for example, have endured because something special about them prompted efforts to preserve, rather than replace them, such as association with particularly venerated sites. In central Anatolia, on the other hand, many churches survived because they were built in areas that became isolated by depopulation and they were abandoned. What endures in Rome, therefore, tends to be the very special, while what survives in central Anatolia may more nearly approach the elusive 'ordinary'. In this instance and others, efforts to reconstruct the types and development of Byzantine architecture must take into account that one is not always comparing like with like – differences of function may dictate differences of form.

Appearances may also be misleading. Restoration of buildings may distort their original forms, leaving phases of change that are difficult to sort out. From at least the ninth century, it became customary for Byzantine builders to re-use old materials (*spolia*), so that a fourteenth-century church may have sixth-century columns and twelfth-century capitals. Even an inscription cut in stone need not be contemporary with the building it adorns, but may have been transferred from an earlier one. In monumental art, the resetting of mosaic cubes may modify the style of a decoration, and may render even the relative chronology of different phases unclear. There may be more than one phase even in a portable object, such as a reliquary, crown or book-cover, since metalwork is easily remodelled to accommodate changes of taste. Further, such alterations may incorporate not only new embellishments but also material taken from much earlier pieces, such as enamel or ivory plaques.

Even without such complications, attaching firm dates to Byzantine

remains is often problematic. A few objects and monuments have dated or datable inscriptions but difficulty may be caused by abbreviations, obscure or ambiguous terms, or losses – it seems almost to be a principle that when an inscription is fragmentary, the date was in the area of loss. In any case, inscriptions are the exception rather than the rule, and much Byzantine art and architecture must be dated by attribution. This means estimating the date of a work on the basis of its similarity (stylistic, iconographic or technical) with dated or datable material. Similarity does not always indicate contemporaneity, however, as is illustrated by a number of ivories, once thought to be early Christian but now understood to be copies made in the West around 800. Further, attribution is clearly most reliable when a large quantity of dated material forms a corpus against which to measure undated examples, and it becomes much less so when the dated material is scant and scattered. The number of attributions that offer date brackets of a century or more shows what a blunt instrument attribution often is in the Byzantine context. Nevertheless, attribution must be used if study of undated material is to proceed. The point, of course, is to be aware that it is a potential weakness in some chains of art-historical argument, particularly those in which one attributed date is based on another. Provenance can also be a problem in the case of portable objects, many of which are now in the West, in cathedral treasuries, museums and private collections. Most were brought to such locations by people who left little or no record of their places of origin – looting Crusaders, Byzantine exiles fleeing the advancing Turks, European travellers and scholars, and antique dealers whose interests are often best served by obscuring the routes by which pieces reach them. Conversely, even when the find-site is certain, it does not necessarily fix the place of production: hoards of treasure buried in Germany may contain pieces made in Antioch.

Information about the patronage of works of art or architecture may, like their dates, be supplied by inscriptions. These appear in a variety of contexts: above doorways, on cornices, in the borders of wall-paintings or mosaics, on liturgical objects, or in the scribal notes on the last pages of manuscripts (colophons). If the patron was an important public figure, then documentary sources will often supply biographical details and perhaps also the circumstances of the commission. If no such record exists, then all that can be known of the patron is that he or she had the wish and means to commission the work. Even when inscriptions are lacking, a building or object can still sometimes be matched with a documentary record: the patronage of several churches in Constantinople, for example, is known because their locations in the city are mentioned by one or more sources.

The immediate function of a work of art or architecture is generally obvious, but what may be termed its social purpose is less so. Inscriptions seldom say more about the reason for a commission other than that (in the case of the religious works that form the bulk of Byzantine survivals)

the patron hoped to gain divine benevolence by it. Colophons in illuminated books sometimes add a little more – that the book was to be a gift from the patron to a monastery, for example – but this is the exception rather than the rule. Finer detail of most commissions is usually lacking unless written records supply it – by indicating, for example, that a church was part of a monastery that housed a hospital, or a family mausoleum, circumstances that are rarely evident from the material remains.

The documentary record is also of great value for the information it offers about works of art and architecture that have perished, particularly when they belong to a category of which no example survives at all. Much secular art, for example, is known only by this means. Documentary evidence also brings its own set of limitations and problems of interpretation, however. Some writers mention works of art and architecture without describing them, so that one may know what was produced (and perhaps why), but not what it looked like. Others, writing to praise the largesse of the patron, may be suspected of hyperbole. In fact, very little was written for the purpose of giving detailed and accurate description. This applies even to the *ekphrasis*, a literary form which offers formal praise of a work of art or architecture, but in which the use of elaborate metaphor and other literary devices often renders description ambiguous or obscure. Literary conventions used in the *ekphrasis* may even override fact: standard phrases used for the dimensions, materials and even the structure of buildings, for example, make it evident that many writers relied as much on literary formulae as upon their eyes.

Neither inscriptions *in situ*, nor documentary records say much about the means of production. A few artists and architects are known by name, ranging from those who built St Sophia in Constantinople to some who carved or painted humble rock-cut chapels in Cappadocia (central Anatolia), but it was evidently not a general custom for craftsmen to sign their work. The scribes who identify themselves in manuscript colophons only very rarely name the painters of the miniatures that embellish their work. Scraps of evidence, and the analogy of the better-documented traditions of the mediaeval West, suggest that the workshop was the usual unit of production, probably headed by one or more master-craftsmen supported by assistants and apprentices. There is some evidence of the guilds that regulated some crafts and the rules they set, but virtually none of the details of workshop organization or the working lives of craftsmen. Some workshops may have been monastic, some were perhaps attached to the court in Constantinople or the palaces of aristocrats, and others were doubtless independent secular businesses. Some craftsmen travelled outside the empire, to work in Sicily and Russia for example, but whether they did this on imperial orders or as a result of commercial transactions, is unknown. This lack of information does not necessarily imply the low social standing of the artist/architect, as has sometimes been supposed, since other aspects of Byzantine society are similarly undocumented. It may be guessed that respect for the craftsman was linked to his level of ability, as it still is.

On the historiographical front, the study of Byzantine art and architecture is a relatively recent endeavour. The respect for Graeco-Roman classical art that fashioned European taste from the sixteenth century onwards produced either indifference to, or distaste for the formal, often highly stylized qualities of Byzantine art. There were, therefore, few collections of Byzantine material in the West, and the objects that were collected tended to be those valued for their precious materials. Moreover, when serious scholarly examination of the remains of Byzantine material culture began in the mid-nineteenth century, efforts were made to apply a methodology developed to deal primarily with Renaissance art and architecture, which is (relatively speaking) both abundant and well documented. These led to the formulation of localized traditions of style and iconography, such as the 'Alexandrian', 'Constantinopolitan' and 'Cappadocian' schools, or the 'monastic' and 'aristocratic' approaches to manuscript illumination, which increasing research has eroded or demolished. The recent trend has been to avoid rigidity in the derivation of general principles or patterns of development from evidence that is fragmentary and episodic. 'Continuity and change' nevertheless remains the focus of many art-historical investigations, and properly so, since elucidation of the status of individual works, the sources of new ideas, and the relationships of models and copies will gradually refine our state of knowledge. Most Byzantinists today would also want to take the investigation a step further, and ask why the changes happen when they do, in the manner they do, viewing Byzantine art and architecture as primary sources of information about the concerns and development of Byzantine society.

1 *The early Christian period*

'Metamorphosis' is the term often used for the process by which the pagan Roman empire became the Christian Byzantine empire – an appropriate term because the change came about through the modification of existing traditions to new purposes. The emergent Byzantine empire was a clearly differentiated new entity, but one bearing clear signs of its genesis. The new direction of the Roman empire was settled towards the end of the first quarter of the fourth century, when Constantine the Great began the transfer of the capital from Rome to Byzantium and gave preference to Christianity as its religion. These two moves were made in a world in which changes were already under way (fig. 1). During the preceding forty years, administration of the vast territories of the Roman empire had been by tetrarchy, Diocletian's device for dividing among four the power and responsibility of government. There were two emperors (Augusti), one to govern the west, the other the east; each had a junior partner (Caesar) who might eventually succeed him. The tetrarchs were often on the move, for military or administrative reasons, and they established bases throughout the empire: at Antioch, Nicomedia (modern Izmit, Turkey), Sardica (modern Sofia, Bulgaria), Sirmium (near Belgrade), Trier, Milan, Thessalonike, and Spalato (Split, former Yugoslavia). The leaders ranged widely therefore, and some tetrarchs were themselves of provincial origin – Constantius, Constantine's father, and Galerius both came from the Danube region. This cosmopolitanism of the tetrarchy had a bearing on material culture, since the four leaders took metropolitan art and architecture as well as government to distant provinces, and conversely, took up provincial traditions which were then absorbed into the mainstream. The tetrarch residences were palaces-cum-administrative complexes rather than temporary camps, built with the considerable resources of wealth, materials and labour available to the rulers of a vast empire. Most are no longer standing, but there are substantial remains of the palace complexes of Galerius at Thessalonike, of Constantius and Constantine at Trier and of Diocletian at Spalato. Many features of the latter are derived from the architecture of Syria, where Diocletian had an earlier palace at Antioch. Similarly, Galerius' complex in Thessalonike, while using Roman formulae, was constructed using a technique of rubble-core faced with

1 Map showing principal sites
mentioned in this book.

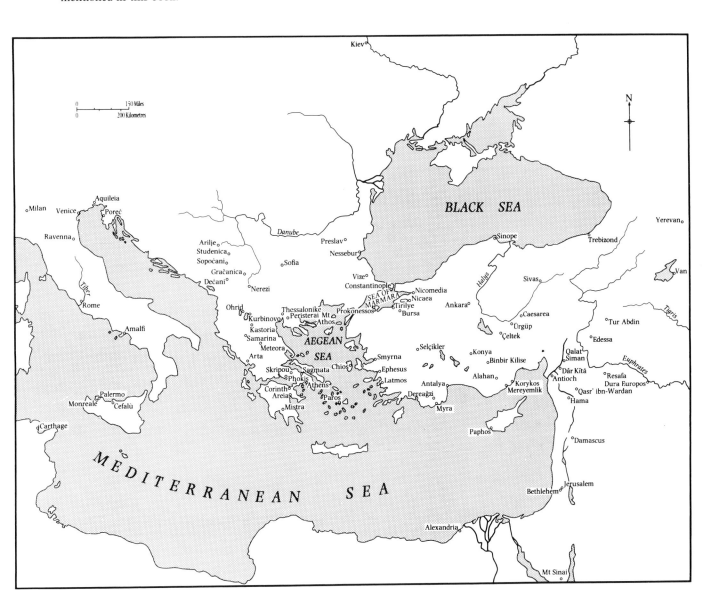

brick and occasional stone courses traditional to the Aegean coastlands.[1]

The tetrarchy may be said, therefore, to have broadened the cultural scope of an already cosmopolitan Roman empire. By the early fourth century, the cultural foundations upon which the Byzantine empire was to build were not only the traditions of Rome but also elements drawn from the indigenous art and architecture of various regions of the empire, some already grafted onto the Roman stock.

Given the competitive nature of the powerful, the tetrarchy was doomed: individual tetrarchs sought sole rule, as did a number of usurpers. The tournament ended with the emergence of Constantine I as sole emperor, after defeating Maxentius, one of the usurpers, at the Battle of the Milvian Bridge in 312, and the Caesar Licinius at Chrysopolis in 324. The inauguration of Byzantium/Constantinople as capital came soon afterwards, in 330. The move shifted the seat of government eastwards, with several cultural implications. In the long term it caused Greek to replace Latin as the language of administration (it was already the lingua franca of the lands bordering the Mediterranean) and it probably also facilitated the secession of western provinces and the division of the church into eastern and western orthodoxies. All this, however, lies ahead. In the area of material culture, the most immediate divergence of Byzantine art and architecture from its late Roman background is associated with Constantine's other decision, the new status of Christianity, to which imperial backing must have given considerable impetus. Christian art and architecture did not begin with Constantine, but entered a new and important stage of development. Christianity had been gaining ground for three centuries and although opinions differ as to the number of Christians in the third and early fourth centuries, it was evidently large enough to cause several emperors to attempt suppression of the sect by persecution (Decius, in 250–1, Valerian, 257–9, and Diocletian, 305–11). (Large enough, too, it is often argued, to make Constantine take the opposite actions, of toleration and then endorsement.) The cult that began in first-century Palestine had spread around the Mediterranean. It had the beginnings of an administrative system, with communities headed by bishops; it also had its rituals, not yet fixed as universal liturgy, and a growing literature.

Throughout the fourth century, Christianity gained in extent and in complexity. An ecclesiastical hierarchy emerged, headed by the Patriarchs of Rome, Alexandria, Antioch, Jerusalem and Constantinople. Theological differences gave rise to many factions, some of them engendering considerable dissent within the Church. A series of ecumenical Councils that sought to define the tenets of orthodox faith began with the Council of Nicaea in 325. This condemned Arianism, the teachings of Arius, an Alexandrian priest who argued that God the Father and Jesus Christ were

1 *CAH* XII chs. 19, 20; T.D. Barnes, *The New Empire of Diocletian and Constantine* (Cambridge MA 1982); J.Ward Perkins, *Roman Imperial Architecture*, Pelican History of Art (Harmondsworth 1981), ch. 15, 441–66.

separate beings and that therefore, within a monotheist concept, Christ could not be divine. The resulting Nicene Creed held God and Christ to be one, the latter having a dual nature, both human and divine. The second Council (Constantinople, 381) refined this concept with the introduction of the Trinity – Father, Son and Holy Spirit – three aspects of a single divinity.

Another fourth-century development, which was to have great importance for the entire Byzantine period was the rise of monasticism. In third-century Egypt some Christians had chosen to pursue their faith removed from the world, either as hermits in semi-desert areas, or in communities of the faithful (*coenobia*). By the fourth century both forms of monastic life were widespread. Syria became famous for its solitary ascetics, some of them taking mortification of the flesh to the extent of self-injury, others adopting eccentric habits, like Symeon the Stylite, who spent many years living at the top of a column. In Anatolia, Basil of Caesarea rejected such excesses and favoured the coenobitic system, incorporating into it such charitable functions as care of the sick and elderly and the provision of hospices for travellers. He thus laid the foundations for a communal monasticism that was, in some respects, to become the public welfare system of the Byzantine empire.

By the end of the fourth century paganism was in abeyance, in spite of the attempt by one emperor, Julian the Apostate (361–3) to revive it. Theodosius the Great (379–95) actively suppressed paganism, prohibiting sacrifices, closing temples and ordering the destruction of cult statues. The secular learning of the ancient world was retained, however – St Basil, like many academically gifted contemporaries, received his higher education in Athens, which remained an intellectual centre until the early sixth century. In the fifth century, theological conflict continued; the third ecumenical Council (Ephesus, 431) denounced as heretical the attempt by Nestorius of Antioch to explain the dual nature of Christ by supposing that he was fully human at birth, becoming divine during his ministry. This interpretation affected assessment of the nature of the Virgin Mary, making her simply the mother of Christ, rather than the mother of God (*theotokos*), which the Council now established as the orthodox position. Nestorianism was defeated by Cyril of Alexandria, who offered the monophysite argument, that Christ had a single, divine nature, a position itself held to be heretical at the fourth Council (Chalcedon, 451) where it was decided that the single nature of Christ embraced both the human and the divine, indivisibly but without confusion.

While their finer points may have been relevant only to an ecclesiastical minority of philosophical bent, these theological debates had political significance, since their exponents sometimes had large followings. The Councils gradually refined the orthodox position, but they did not eliminate the factions: much of the east clung to Monophysitism at least until the seventh century, and Arianism had similar longevity, growing in strength after its adoption by the Goths who became Christian in the fifth

century. The factions posed obvious problems to imperial control of the empire which, once Christianity had become the majority faith, depended upon a close relationship between Church and State. Several emperors began with policies of religious tolerance, but most ended by attempting to banish heresies and establish a single, orthodox faith.[2]

The third-century background

So much can be gathered from the documentary record. It is more difficult to discover the material culture of very early Christianity – its buildings, objects and imagery. It is usually (and probably correctly) assumed that in the first and second centuries there were few physical manifestations of the new religion. Like the adherents of most new minority sects, the faithful probably gathered at first in private houses or out of doors, and since they eschewed idolatry, they produced none of the statuary which is usually so helpful to the archaeologist in the identification of cults. But after two centuries of gathering strength, brief documentary references and fragmentary material remains show the beginnings of ecclesiastical art and architecture by the fourth century. The teacher and writer Lactantius, for example, writing about Diocletian's persecution of Christians in Nicomedia in 305, describes the sacking of a church in the centre of town. It was searched for religious images, books and liturgical utensils, which were destroyed when found, but the building itself was spared, lest burning it should fire the whole neighbourhood. No details are given of the building, other than that it had gates, but the account clearly establishes the existence of a Christian church in a public place, equipped with the accoutrements of worship. Here and elsewhere there is room for argument that 'church' means simply 'meeting place', perhaps in a private house, and there is no surviving example of a pre-Constantinian purpose-built church from which to argue otherwise. Nevertheless, it is entirely plausible that Christian art and architecture were fairly well established by the end of the third century. Persecution of Christians was episodic and often localized, and there were long periods of tolerance, one of them covering most of the second half of the third century. During such periods secrecy, or even circumspection, were unnecessary, and there was no impediment to the development of the 'public' architecture, liturgical equipment and Christian texts which best fit Lactantius' account. Eusebius, Constantine's biographer and the author of the first *Ecclesiastical History*, speaking of the

2 H. Chadwick, *The Early Church*, Pelican History of the Church (Harmondsworth 1967). Copious illustration of early Christian buildings and artefacts, and a useful series of maps are to be found in F.G.L. van der Meer and C. Mohrmann, *Atlas of the Early Christian World* (London/Edinburgh 1958, 1966). For general history of the Byzantine empire, the standard works remain: *Byzantium. An Introduction to East Roman Civilization*, ed. N.H. Baynes and H.St.L.B. Moss (Oxford 1949); A.A. Vasiliev, *History of the Byzantine Empire* (Madison WI 1952); G. Ostrogorsky, *History of the Byzantine State* (Oxford 1968).

period before the persecution of Diocletian, describes a tolerant world, where Christians sometimes held high public office, and had become so numerous and so public that they 'raised from the foundations in all the cities churches spacious in plan'. Later, speaking of the period following the victory of Constantine, he notes Constantine's order that the churches of the empire damaged in the persecutions should be repaired. These references certainly seem to refer to public buildings, rather than private houses. Likewise, the *Didascalia Apostolorum* [Teaching of the Apostles], probably written at the beginning of the fourth century, gives instructions for the conduct and placing of worshippers in a church: priests and bishop at the east, the latter enthroned; a deacon at the door, and another by the altar; separate places for men, young women, old women and widows, children. While this could refer to houses used for religious meetings, the size of a congregation requiring such marshalling suggests instead a purpose-built structure.[3]

Material remains are very few indeed, and these too are not without problems of interpretation. In Rome, archaeology has uncovered the remains of houses modified for use as churches (*tituli*), embedded in churches built after the fourth century, but the very fact that they now form part of the fabric of later buildings makes them difficult to study in detail. Much more impressive remains came to light at the small garrison town of Dura Europos on the Euphrates, part of which was buried in the first half of the third century in the course of adjustment to its fortifications. The preserved fragment contains buildings catering to the faithful of several different religions: a synagogue, temples of Bel, Zeus and Mithras, and a simple house-church. The latter seems to have been built as an ordinary house early in the third century and later (possibly *c.* 233) modified to make a house-church with a hall and baptistry (fig. 2). The baptistry was decorated with wall-paintings of Christian subjects: Christ as the Good Shepherd, Christ healing, the Women at the Tomb, Adam and Eve. It is of interest that the arrangement and style of this decoration has much in common with that of the synagogue and the temples of Dura. It seems therefore that in this town Christianity co-existed with other faiths, and shared with them a common formula for the interior decoration of places of worship. It is difficult, however, to know what to make of this fossilized town-fragment. Was Dura typical? Did most small towns have such a variety of religious establishments? Were they generally so uniform, or were they an aspect of Dura's function as a garrison town, catering to transients coming from several parts of the empire, by provision of a local genus of 'religious meeting hall', furnished to suit each faith?[4]

3 *CAH* XII, ch. 19; Lactantius, *De Mortibus Persecutorum*, XII, trans. W. Fletcher, *The Works of Lactantius* (Edinburgh 1871), II, 174; Eusebius, *Ecclesiastical History*, VIII.ii, *Life of Constantine*, I.xlii, xlvi, trans. SLNPNF I, 324, 494, 511; *Didaskalia Apostolorum* XII,

trans. R.H. Connolly, *Didascalia Apostolorum* (Oxford 1929) 119–21.

4 Krautheimer, *Architecture*, 23–38; A. Perkins, *The Art of Dura Europos* (Oxford 1973).

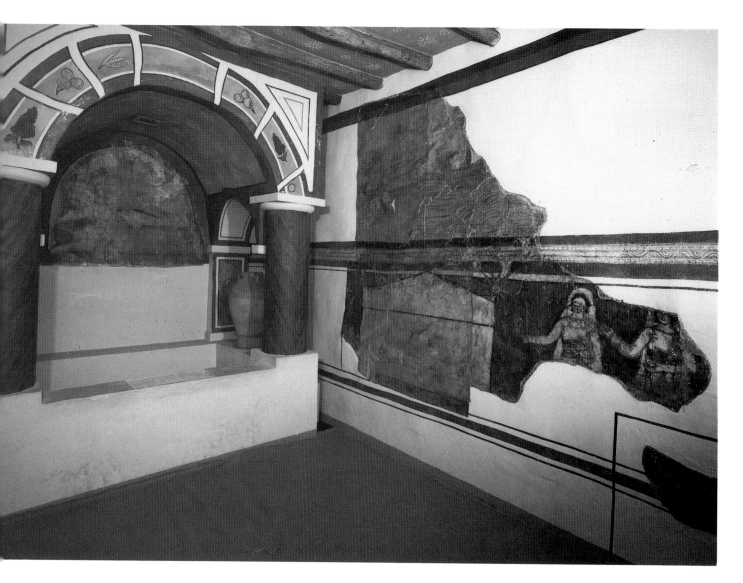

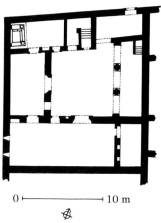

Another pocket of third- and fourth-century material is provided by the catacombs, which are underground labyrinths of corridors and chambers with burial cavities cut into their walls. Some cavities are closed with stone slabs which sometimes bear datable inscriptions. Catacombs are found in several locations where rock suitable for such tunnelling is found, but the best known, and the richest in early Christian remains, are in Rome (fig. 3). Like most burial sites, some catacombs seem to have been private, owned by families or religious groups, others were public. Most are undecorated, but in some the walls of chambers and galleries were plastered after the insertion of burials and decorated with paintings. The subjects depicted indicate the burial of Christians, pagans and Jews, sometimes in close proximity. Early Christian burial clearly followed a tradition common to other faiths, a circumstance which echoes the multi-religious aspect of Dura – but Rome was also cosmopolitan and its

0 ├────────┤ 10 m

2 The Christian house-church at Dura Europos: reconstruction of the baptistry (Yale University Art Gallery); plan, after Kraeling, showing the baptistry in the northwest corner.

3 Via Latina catacomb, Rome, begun in the fourth century: chamber with wall painting; plan, after Ferrua.

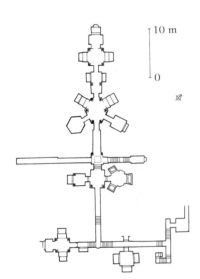

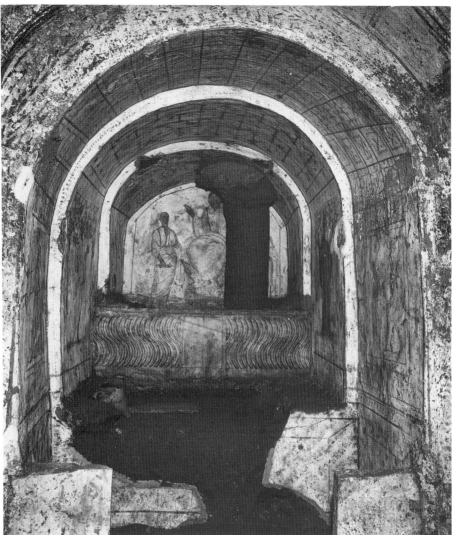

arrangements may not be typical of the empire as a whole. More will be said below about the Christian paintings of the catacombs, which supply a much wider vocabulary of third-century images than is available from Dura. For the moment, it remains to note that the catacombs tell us nothing about early Christian architecture. The notion that they were used as churches is long discredited. They may have been used for ceremonies associated with the burial of the dead, but were not ordinary places of worship.[5]

This indistinct view is virtually all that can be made out of the state of church building and decoration in the third century: chance material

5 E.R. Goodenough, 'Catacomb Art' *JBL* 81 (1962)
 113–42; A. Heidenreich, *The Catacombs*, 2nd edn.
 (London 1962), 14–18.

remains confirm the notion that the house-church was the first stage of ecclesiastical architecture, and a few documents hint at the subsequent development of a widespread public architecture, at least by the early fourth century. This, then, was the state of things in 324, when power returned to a single emperor in the person of Constantine. Imperial endorsement of Christianity then inaugurated the early Christian phase of Byzantine history, during which the evolution of Christian art and architecture accelerates and becomes much more visible in terms of material remains.

Constantinople

With so much territory lying east of Rome, and the continued erosion of the western provinces by barbarians, relocation of the seat of government to the east was an understandable move. Byzantium is a strategically well-placed city, on a water route that links the Black Sea with the Mediterranean. It occupies an easily defensible site, a hilly promontory at the junction of the Sea of Marmara and the Bosphoros strait, with a further stretch of water, the Golden Horn, on its third side. Tradition has it that the city was founded in the seventh century BC by the Greek King Byzas. It eventually became part of the Roman empire and the occasional residence of emperors, notably Septimius Severus, who damaged it considerably in 196 AD and then rebuilt it when he realized its strategic importance. Diocletian and Constantine had both visited the city several times during the period of the tetrarchy, and Constantine returned in 324, after defeating Licinius, his last rival, at Chrysopolis on the other side of the Bosphorus. The pre-Constantinian defences of the city appear to have included a land wall cutting off the tip of the promontory (in modern terms, from Galata Bridge to Küçük Ayasofya Camii) and probably also sea walls, but this point is difficult to prove (fig. 4). A range of public buildings common to most late Roman cities was already present: fora, baths, a hippodrome, an amphitheatre and temples on the acropolis at the tip of the promontory. Since the city has no significant internal supply of fresh water, Hadrian (117–38) had built an aqueduct to service cisterns. (Parts of this remain, many times repaired, and known as the Aqueduct of Valens.) Constantine extended the city by building a new land wall some three kilometres to the west of the old one, thus quadrupling the size of the city. Nothing remains of Constantine's wall, but its approximate line (from Atatürk Bridge to the Istanbul Hospital) can be plotted from documentary references. Virtually nothing remains of Constantine's city since, as with most urban sites, the early fabric has been demolished or modified beyond recognition by later building. Nor do documentary sources offer much help: brief, and not always lucid, references in contemporary writings are supplemented by later sources whose accuracy is difficult to determine. At the tip of the promontory, the city probably changed relatively little from

CISTERNS
Aetios
Aspar
Mokios
Yerebatan

○ PALACES (destroyed)
Blachernae
Hormisdas
Imperial
Mangana

● COLUMNS
a of Arcadius
b of Constantine
g of the goths
m of Marcian

H₁ Hippodome
T Tekfur Sarayı

OTTOMAN FEATURES
YK Yedikule
TS wall of Topkapı Sarayı

CHURCHES
✚ (extant)
⊙ (* destroyed: site known from archaeological or documentary evidence)
1 * Theotokos of Blachernae
2 Christ in Chora (Kariye Camiii)
3 Theotokos Pammakaristos (Fetiye Camii)
4 Theotokos Panagiotissa (of the Mongols)
5 St John in Trullo
6 Gül Camii
7 Christ Pantepoptes
8 * Holy Apostles
9 Churches of the Pantocrator Monastery
10 Churches of the Monastery of Lips
11 Vefa Kilise Camii
12 St Polyeuktos
13 Kalenderhane Camii
14 * Beyazit Churches
15 Myrelaion
16 * St George of the Mangana
17 St Eirene
18 St Sophia
19 * Theotokos Hodegetria
20 St Euphemia
21 Sts Sergius & Bacchus
22 St Andrew in Krisei
23 St John the Baptist
24 * Theotokos of the Pêge

its ancient form, since an area of public buildings was already laid out, but one might guess at a good deal of embellishment of existing structures: Constantine seems to have extended the hippodrome and built a palace alongside it.

The most conspicuous innovation must have been the provision of churches for the new capital. Some must already have been present, but it may be assumed that imperial support of Christianity encouraged commissions for more. Eusebius says that Constantine himself built his mausoleum-church of Holy Apostles, but is vague about the emperor's other churches in the capital, saying only that they were many and splendid – an imprecision that hints at exaggeration. The fourth-century church historian Socrates confirms the building of Holy Apostles and also mentions a church of St Eirene, which was an enlargement or rebuilding of an existing church and for a time served as the cathedral of the city. This church must have been a forerunner of the St Eirene which now stands next to the sixth-century church of St Sophia. The latter was the chief church of the empire and Justinian's sixth-century building was the third on the site. Middle-Byzantine sources credit Constantine with the building of the first of these, but Socrates is clear that this was the commission of Constantius,

4 Map of Constantinople, showing Byzantine sites and the main streets of the modern city.

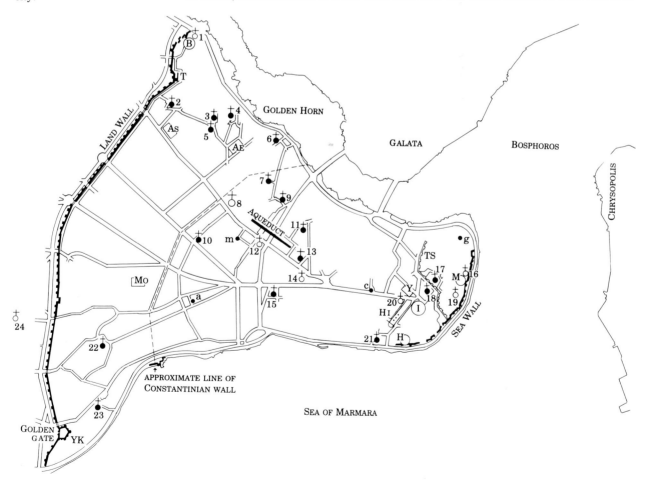

Constantine's son, begun *c.* 350 and dedicated in 360. A little later, towards the end of the fourth century, two large shrine churches were built outside the land wall, dedicated to St Mokios and St Akakios, both martyred in Constantinople during the persecution of Diocletian.

Among other additions and alterations to the city made by Constantine's sucessors, the most notable were those of Theodosius II, who in 413 began to extend the sea walls and build a new land wall some 1.3 kilometres beyond that of Constantine, thus almost doubling the area within the defences. Much of the Theodosian wall is still standing, albeit with considerable later repair, rebuilding and accretions (fig. 5). The struc-

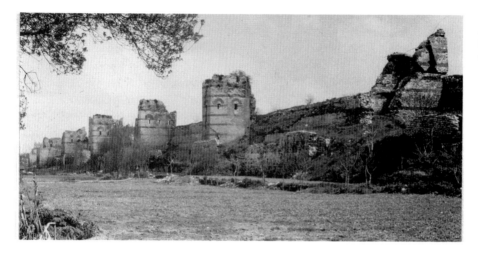

5 Land Wall of Theodosius II, Constantinople (started 413), viewed from outside the city.

ture is massive, with inner and outer walls, each originally studded with ninety-six towers, and a wide outer ditch. The construction uses wide bands of brick alternating with stone-faced concrete, a formula used extensively in Byzantine building. Adherence to the technique over centuries may possibly be attributed to its suitability for building in earthquake zones, since the brick courses probably act as shock-absorbers. The wall is pierced at intervals by gates, the southernmost of them the Golden Gate, which incorporates the triumphal arch of Theodosius. This became the traditional entry point for imperial triumphs throughout the Byzantine period and is now embedded in the Ottoman stronghold of Yedikule (the Seven Towers). The wall resisted all assailants for a thousand years, but was breached eventually in 1453, by Mehmet II, the Conqueror, using a Hungarian cannon. Traditional thinking has been that the expansion of the city by the building of the new wall was to provide more residential space for the growing population of the city, but recent opinion holds that the function of the new wall was to enclose not new urban development, but the new cisterns and aqueducts needed to supply the growing city with water. Constantine's wall still stood (some parts of it until the nineteenth century), and the area between it and the Theodosian wall remained a semi-rural one, containing, in addition to the water-works, a

large cemetery in the vicinity of the church of St Mokios. To the north of this area, in the Blachernae district between the land wall and the Golden Horn, a church of the Virgin was built by Theodosius' successor Marcian and his wife Pulcheria. The church was probably completed by the next emperor, Leo I, who in 474 added a chapel to house one of the city's most important relics, the veil of the Virgin. Probably in the mid-fifth century, the senator John Stoudios founded a monastery that was also to have continuing importance. Nothing remains of the Theotokos of the Blachernae, but the ruins of the Stoudios church still stand, the only substantial remnant of an early Christian church left in Constantinople (fig. 6).[6]

6 St John of Stoudios, Constantinople (mid-fifth century): plan, after Van Millingen; interior to the northeast.

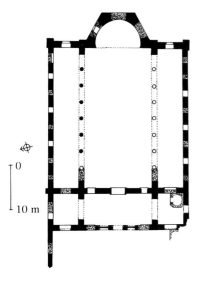

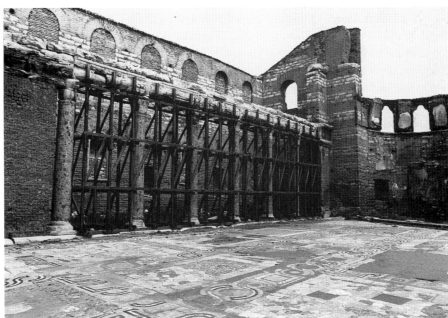

Architecture

The Roman-Byzantine metamorphosis is unlikely to have produced significant changes in secular architecture. As noted above, even the refurbishment of Constantinople appears to have taken place within existing traditions. It is in the relatively new field of ecclesiastical architecture that we should expect to find innovation and expansion. According to Eusebius, Constantine was responsible for much church building well beyond the

6 C. Mango, *Le Développement urbain de Constantinople IVe-VIIe siècles* (Paris 1985); R. Janin, *Constantinople byzantin*, 2nd edn. (Paris 1964); Socrates, *Ecclesiastical History*, I.xvi, II.vi, xvi, xliii, trans. in *SLNPNF*, 11, 20–1, 38, 43, 73; for discussion of sources for the first St Sophia, Mainstone, *Hagia Sophia*, 129–43. For the walls, see A. Van Millingen, *Byzantine Constantinople: the walls of the city and adjoining historical sites* (London 1899), 40–94.

walls of Constantinople: he built new churches at Trier, Rome and
Nicomedia, and at the Holy Places of Palestine. The great hall church of
Trier still stands; the Constantinian basilica (Lateran) in Rome is known
from excavations, likewise the Church of the Holy Sepulchre in Jerusalem
and the Church of the Nativity in Bethlehem; others have perished
entirely. Constantine is also said to have ordered the repair, enlargement
and rebuilding throughout the empire of churches that had been damaged
or destroyed during the persecutions. This claim is perhaps too sweeping
to inspire confidence that there really was widespread church building by
imperial decree, but there can be little doubt that imperial sanction of
Christianity, and the imperial example of construction at several impor-
tant sites, was very good for church architecture.[7]

Most of the new churches were probably basilicas, a form which was
to become standard for the early Christian period, and has remained so in
the West, virtually until the present day. In Roman times, the term
described function rather than form and was applied to large halls of vari-
ous types. In the Byzantine context it is used for buildings of rectangular
plan in which the interior is divided longitudinally into nave and aisles by
rows of columns or piers (uprights of square or rectangular section). In
early Christian basilicas the nave and aisles are usually roofed, with the
aisle roofs at a lower level than that of the nave, so that the building may
be lit by windows in the upper parts of the nave walls (clerestory); occa-
sionally the covering is a brick or stone vault. The nave may be flanked by
two aisles (= three-aisled basilica) or by four (= five-aisled), thus having
two or four rows of supports respectively. Some basilicas have galleries
(upper floors) over the aisles and a few have transepts (lateral extensions
towards the east end which give the plan the form of a Latin cross). At the
east end the nave wall curves into a hemispherical apse, which forms the
sanctuary, housing the altar and sometimes lined by a *synthronon* (con-
centric seating for clergy). This main apse may be flanked by side apses or
small rooms terminating the aisles (pastophories). Most basilicas have an
ante-room (narthex) at the west end, running across the nave and aisles,
and, in front of this, an open courtyard (atrium), lined with roofed pas-
sages fronted by colonnades. (The atrium seldom survives, but is revealed
by excavation.) The basilica had been used in Roman architecture for a
variety of public buildings that required uncluttered space for large assem-
blies. It was relatively simple to construct and easily modified to accommo-
date specific functions. It was, too, a 'neutral' form, since it had no partic-
ular religious associations. It is unsurprising, therefore, that this was the
form adopted when the church found that it needed more than the early
meeting rooms supplied by domestic architecture. It is uncertain just
when the basilical church was developed. The earliest surviving examples
are of the fourth century, but it is not impossible that they continued a

7 Eusebius, *Life of Constantine*, (see n.3), I.xliii, II.xlvi, III,
 IV.

tradition already used for the churches of the third century mentioned in the sources cited above.

Constantine's Lateran basilica, built as the cathedral of Rome (seat of the bishop) was of the five-aisled type, as may be reconstructed from the archaeological record. This form was also used for most of the great shrine churches, such as St Peter's in Rome and the Churches of the Holy Sepulchre and the Nativity in Palestine, all of the fourth century. It is also found as late as the mid-fifth century in St Demetrios in Thessalonike. In the Church of the Nativity in Bethlehem, the five-aisled basilica was used in combination with an octagonal building which sheltered the cave of the Nativity and was placed at the east end of the basilica (fig. 7). Access to the shrine was probably from the eastern ends of the aisles of the basilica, permitting members of the congregation to visit the shrine by leaving from one aisle and returning by the other. At other sites, different solutions were found to accommodate the shrine site. The Holy Sepulchre, for example, was sheltered by a canopy to the west of a basilica. There was no single 'shrine church' formula, therefore, but flexible use of architectural elements to suit particular circumstances. The shrine churches were, of course, buildings of particular importance, serving large congregations of pilgrims, and they are not likely to have been typical of the church building of their time. Most churches serving ordinary communities of Christians were probably of the simpler, three-aisled type.

The three-aisled form is found in most fifth-century basilicas, large or small, of which examples survive at many sites spread throughout the

7 Church of the Nativity, Bethlehem: reconstructed plan of the Constantinian church (fourth century), after Ovadiah; reconstruction, after Krautheimer.

0 ⊢————⊣ 10 m

10 m

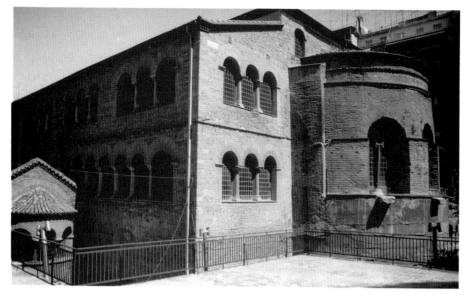

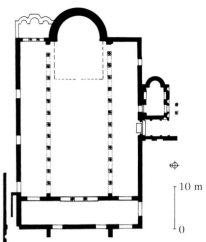

early Christian world. This relative wealth of material reveals many varia-tions on the basic scheme, some forming localized traditions. In Constantinople the basilica had a squat rectangular plan, making the nave almost square. The single surviving example is the mid-fifth century monastery church of St John of Stoudios, mentioned above, but there is archaeological evidence that the fifth-century St Sophia (predecessor to Justinian's church) had similar proportions. In the Stoudios church the division into nave and aisles is made by two rows of seven thick green marble columns with white marble capitals carrying massive entablatures (horizontal bands of masonry), both decorated with carving. The building is now a roofless shell, retaining only parts of the narthex and atrium (fig. 6). There were galleries over the aisles and narthex, lit by round-arched windows. The same heavy entablature above the nave colonnade is found in the church of Sta Maria Maggiore in Rome, built for Pope (Patriarch) Sixtus III (432–40). The building differs in other respects, however, being based on a long rectangular plan and having no galleries. In the Acheiropoietos Church in Thessalonike (after 431), the colonnades sup-port arches rather than entablatures, and the aisles do have galleries (fig. 8). Arcades are also used in Ravenna, north Italy, at St John the Evangelist, for example, built for Galla Placidia, the daughter of Theodosius I, between 424–34. The plan is a long rectangle, there are no galleries and the columns are slender, a combination which produces a light and elegant interior with pronounced longitudinal axiality, charac-teristic of basilicas in Ravenna and its region. On the west coast of Anatolia, the emphasis on the long axis could be even more pronounced. The now-ruined church of the Virgin at Ephesus (c. 400) had nave colon-nades of twenty columns each.[8]

8 Acheiropoietos Church, Thessalonike (after 431): view from the southeast; plan, after Pelekanidis.

8 Mango, *Architecture*, 58–96.

Brick, or brick alternating with stone-faced concrete, is the material used for all these churches. Further east, the material is usually cut stone (ashlar). This is the case in a region of central Anatolia known as Binbir Kilise (the 1001 Churches, but there are not so many). Here basilicas have arcades of horseshoe-shaped arches, often supported on piers instead of columns, and stone barrel-vaults cover the nave and aisles; there are no galleries (fig. 9). These churches are generally quite small (typically about

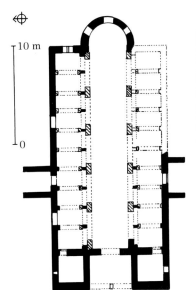

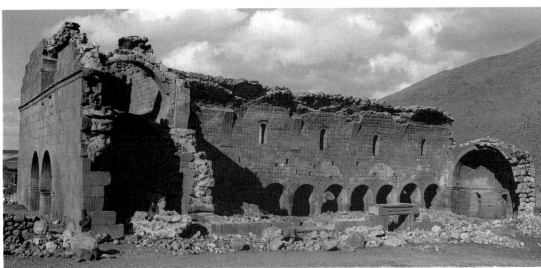

9 Binbir Kilise church no. 1, central Anatolia, fifth century: plan, after Bell; view from the southwest.

10 Dâr Kîtā, Syria (418), after Butler.

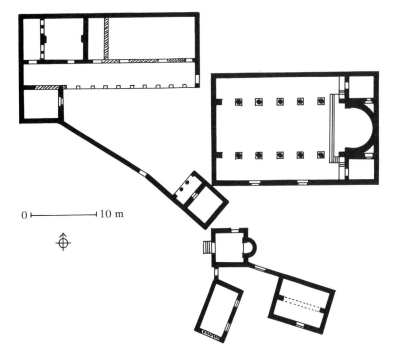

fifteen metres in length or less) and they lack carved ornament. Virtually nothing is known of their patronage or history and none has clear indication of date, but they are generally placed in the fifth century since they have features in common with churches in Syria, several of which have fifth-century inscriptions. The Syrian basilicas are also of stone, but are more ornate, having carved capitals, lintels and doorframes. They are timber roofed, generally without galleries, and have round-arched arcades. The apse does not project, but is flanked by small rooms which terminate the aisles, their east walls extended behind the curve of the apse to produce a straight line at the east end. An example is the church of Paul and Moses at Dâr Kîtâ, dated 418 by inscription (fig. 10).

At Binbir Kilise and at several of the Syrian sites, many churches are surrounded by the ruins of building complexes the precise functions of which are seldom certain. Some may have been monasteries, while others may have been associated with ecclesiastical or secular administration – they probably included offices, baths, treasuries, baptistries and mausolea. Such auxilliary structures were probably the rule rather than the exception and it is likely that many churches throughout the empire which survive as solitary buildings were not always so.[9]

Although the most prevalent, the basilica was not the only form used by the early Christian builder. Roman architecture also offered many building types of 'centralized' form (having no long axis), with plans based on the circle, polygon or cross. Constantine's mausoleum-church of Holy Apostles in Constantinople was apparently cruciform, described by Eusebius as having Constantine's sarcophagus at its centre, flanked or encircled by cenotaphs of the apostles. The shrine of St Babylas, near Antioch, built in the late fourth century (fig. 11), was also cruciform and that of St Lawrence in Milan, of c. 370, a quatrefoil (fig. 12); instructions for a shrine church given by Gregory of Nyssa (c.380) describe an octagon extended by cross-arms and niches. Since many examples of the centralized form are found at shrine sites, it has been argued that this form was the preferred one for such sites, known as martyria since they were often the burial-places of martyrs, or repositories of their relics.[10] The martyrium may then be seen as a development of the Roman mausoleum tradition, in which centralized plans are conspicuous. The mausoleum of the Tetrarch Galerius, in Thessalonike, for example, is a great rotunda (now the church of St George), and in Rome, the mausoleum of Constantine's daughter Constanza is circular, with a domed centre encircled by a colonnaded passage (ambulatory) (fig. 22). The argument should not be extended to the conclusion that the centralized form was a prescribed one for martyria, however, and certainly not that it was restricted to it. It is unsound to identify every centralized ruin as a martyrium, when it could as well be part of a bath-house. Indeed, it is probably unsound in general

9 W.M. Ramsay & G.L. Bell, *The Thousand and One Churches* (London 1909); H.C. Butler, *Early Churches in Syria*

(Princeton NJ 1929).

10 A. Grabar, *Martyrium* (Paris 1943/6).

11 St Babylas, near Antioch, late fourth century, after Lassus.

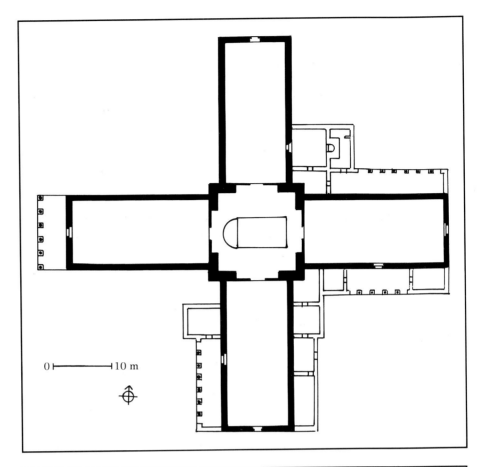

12 San Lorenzo, Milan (c. 370), after Calderini *et al.*

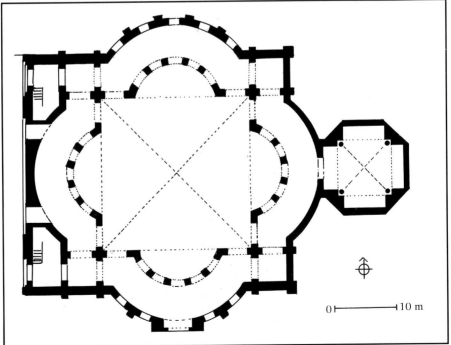

to link building type and function too rigidly, especially in a period which must have been one of experiment. Designers of the early Christian period could draw upon a range of building types from the rich vocabulary of Roman architecture, choosing and modifying traditional forms according to requirements of function, the limitations of the site, the expected size of congregation, the availability of materials and, not least, the wishes of their patrons.

Sculpture

The importance of sculpture to the Roman world is well known. Many buildings were embellished with carved capitals, cornices and mouldings, and friezes or panels of relief-carving were widely used, especially on triumphal arches, columns, temples and altars. There were also statues, in stone or metal (usually bronze), representing single figures, groups, or busts, some of them secular portraits, others cult figures of the gods ('idols'). They were set up in the public squares and buildings of every Roman town, and in the more prosperous private houses. Also for the prosperous, a stone sarcophagus might well have been the last stop. All these traditions continued into the early Christian period, but some fared better than others – the days of the free-standing statue, in particular, were numbered.

Quite a lot of early Christian architectural sculpture has survived, frequently outliving the buildings for which it was made. Carved stone was often re-used to decorate middle-Byzantine or later buildings as the empire declined and fine stone became harder to get. More prosaically, columns, capitals, entablatures, even entire sarcophagi, are found contributing to the fabric of houses and walls in many old cities. The capital is usually the most conspicuous element in the carved ornament of buildings, and the one most likely to reflect changes in taste and the quality of workmanship. Most early Christian capitals are of the Corinthian form, of Roman tradition, which has volutes (scrolls) projecting at the upper corners and encircling acanthus leaves below them, in two or three bands. Capitals of this and related forms are found in many of the basilicas mentioned above, and acanthus and other motifs of Graeco-Roman tradition are found also on entablatures, cornices and lintels (fig. 13 a,b). The chief change from the Roman models is a loss of naturalism, seen most clearly in the treatment of the acanthus leaves, which in the early Christian examples become symmetrical and schematized.[11]

Variety in the form and style of capitals and other decorative elements can sometimes be attached to regions, but with much less certainty than was the case with architecture. The marble used for much architectural sculpture came from coastal quarries, from which it could be easily

11 R. Kautzsch, *Kapitellstudien* (Berlin/Leipzig 1936).

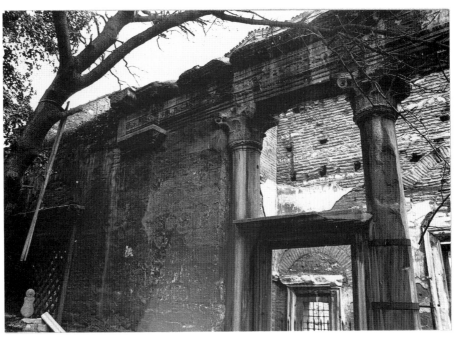

13 Fifth-century architectural sculpture in Constantinople: (a) large capital, possibly from a monumental column, now in the grounds of Topkapı Sarayı; (b) capitals and entablature of the narthex entrance at St John of Stoudios.

transported by sea – moving heavy loads by water was always easier than taking them overland. Fine white marble from the quarries of Prokonessos and Perinthos on the Sea of Marmara (hence its name) was particularly prized, for example. Carved stones weigh less than the blocks from which they are cut, and there is evidence that capitals and other pieces were carved in or near the quarries, and then shipped to their various destinations in finished or near-finished form. Pieces of similar style may therefore be found in widely separated locations.[12]

Liturgical furniture was also often made of carved stone. The sanctuary screens, pulpits and altars that the rituals of Christian worship required must have kept third- and fourth-century sculptors busy as the number of churches increased. Remains are very scarce, however. Churches in areas later overtaken by Islam had their furniture removed when they were remodelled for other functions, and in churches that remained in Christian use, most of the furniture of the early centuries was replaced as it deteriorated, or when liturgical practice evolved. The early Christian sanctuary, consisting of the apse and a slightly raised apron projecting from it, seems to have been fronted by a colonnade partly closed by a low parapet made of carved slabs placed between the columns, leaving one or more spaces open for entrances (fig. 14 a–c). This much can be deduced from the excavated foundations of early Christian churches, and from the many parapet slabs decorated with simple geometric or foliage patterns which are found re-used in later buildings. The ambo (pulpit),

12 N. Asgari, 'Roman and Early Byzantine Marble Quarries of Proconessus', *Proceedings of the Tenth International* *Congress of Classical Archaeology 1973* (Ankara 1978), 467–80.

usually placed in the nave, was a raised platform reached by one or two flights of steps; both platform and steps were edged with parapets much like those of screens. Within the apse, the *cathedra* (bishop's throne) might also be made of stone, again with simple carved decoration on its sides.[13]

Figure carving in relief may have decorated many monuments and buildings of the fourth and fifth centuries, but again few examples remain,

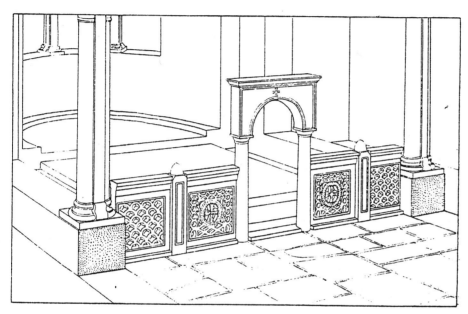

14 Reconstructions of the sanctuary barriers of fifth-century basilicas in Greece, by A.K. Orlandos: (a) Olympia (b) Lesbos (c) Thasos.

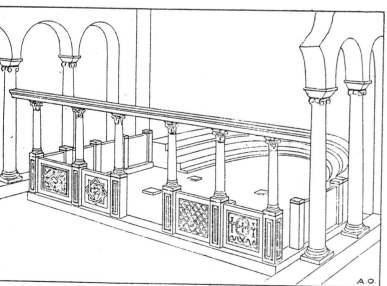

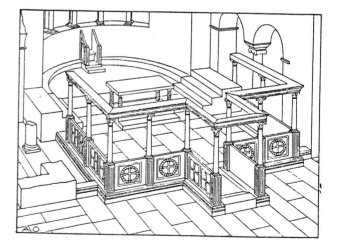

13 T.F. Mathews, *The Early Churches of Constantinople. Architecture and Liturgy* (University Park P A /London 1971), 162–73; *Atlas*, pls. 430–50.

and very few are *in situ*. The rare survivals show the same tendency towards stylization as do the capitals and cornices. In Rome, the Arch of Constantine, completed in 315, combines panels from earlier monuments with newly made ones, thus forming something of a compendium of styles in figure relief-carving over a two-century period (fig. 15). The naturalistic treatment of the re-used Hadrianic (second century) sculpture contrasts sharply with the squat, simplified figures of a frieze showing

15 Arch of Constantine, Rome (315) bearing friezes of fourth-century work combined with sculpture from earlier monuments:
general view of the south side, with friezes of battle scenes;
detail of the north side with a frieze of the emperor in state, below Hadrianic roundels.

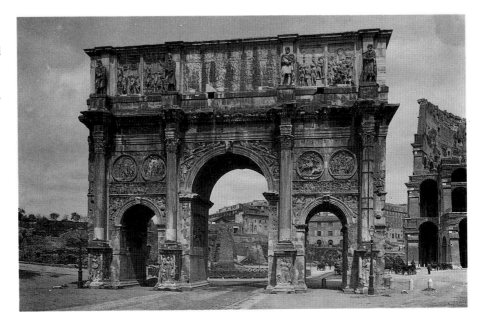

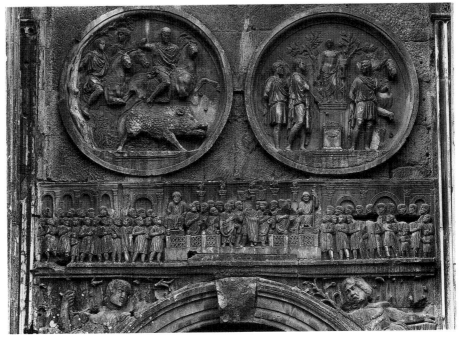

Constantine enthroned between two rows of attendants, made expressly
for the monument. The trend is confirmed by the carvings on the base
made for an Egyptian obelisk set up in the hippodrome of Constantinople
by the emperor Theodosius I in 390 (fig. 16). The panels here show the
emperor presiding at the games in the hippodrome from his imperial box,
flanked by spectators in two tiers. Naturalistic proportion is lost as figures
vary in size according to the space of field available, and postures are uni-
formly 'wooden'.[14]

The ancient tradition of placing the dead in stone containers (at least,
the illustrious dead) continued into the fourth and fifth centuries, and in
some areas into the sixth. Sarcophagi are usually grouped according to
their shapes and type of decoration. Many are plain but for foliage swags

16 Base made for an obelisk
set up in the hippodrome of
Constantinople by Theodosius I
(390), showing the emperor
and attendants at the
hippodrome.

or geometric ornament. A few, made of porphyry, a red/purple stone from
Egypt, were made for emperors, since purple was the imperial colour (per-
sons born into the ruling family would later use the epithet *porphyrogen-
netos*, 'born in the purple'). Sarcophagi with figure reliefs are of particular
interest for the development of Christian imagery since they generally con-
tinue pagan traditions which were modified by substituting Christian sub-
jects for pagan ones. One type is found in many examples from the Roman

14 E. Kitzinger, *Byzantine Art in the Making* (London 1977),
 7–21, 32–3.

catacombs and cemeteries, a context which dates most of them to the third or fourth centuries. These sarcophagi were either embedded in the wall, or placed against it, and therefore have from one to three decorated sides. The decoration consists of densely packed figures, often in two friezes, sometimes with a third, narrower one on the lid (fig. 17). The friezes are sometimes interrupted by roundels housing busts of the occupant (or occupants, often a husband and wife). In pagan sarcophagi of this type the friezes depict scenes from mythology, religious rites, sometimes scenes of the hunt, subjects that are replaced in Christian examples by biblical episodes. These are usually Old Testament 'deliverance' subjects, such as Jonah and the Whale, Daniel and the Lions and the Three Hebrews in the Furnace, chosen because they epitomize the Christian concept of res-

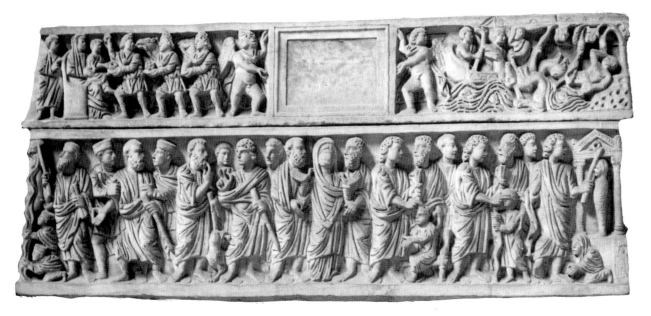

17 Fourth-century sarcophagus, Museo della Therme, Rome. On the lid: the Adoration of the Magi, Jonah and the Whale; below: Moses Striking the Rock, Arrest of Peter, Jesus Predicting Peter's Denial, a woman (the occupant of the tomb?) between Peter and Paul, two miracles of healing, the Raising of Lazarus.

urrection. Occasional New Testament subjects have similar meaning: the Baptism, for example, may be read as a symbolic resurrection. Some pagan images, such as the Good Shepherd or the Philosopher and Disciples are also present. These were taken up in Christian art to represent Christ and Christ Teaching the Apostles respectively. The Christian or pagan faith of the sarcophagus occupant is sometimes established only when other subjects on the same piece are less ambiguous. Another sarcophagus type, in use since the fourth century BC, particularly in Anatolia, has figures placed in an architectural framework of columns, arches and gables. Again, in pagan examples the figures are of gods or heroes and in Christian ones they represent subjects from the Old and New Testaments (fig. 18).

Some variations in sarcophagus form and decoration are regional – the frieze-type, for example, is particularly associated with Rome – but like architectural sculpture, some sarcophagi were made in coastal quarries and shipped to several destinations. There is also some evidence for the

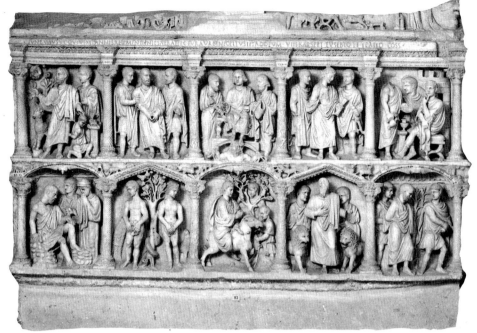

18 Sarcophagus of Junius Bassus (*c.* 359), Rome, Grotte Vaticane. Upper tier: Sacrifice of Isaac, Arrest of Peter, Christ with Peter and Paul, Arrest of Jesus, Pilate; lower tier: Job and his Wife, Adam and Eve, Entry into Jerusalem, Daniel and the Lions, Paul led to Martyrdom.

19 Early statuary of Constantinople: (a) the Column of Marcian (450–7); (b) figure in military dress; (c) pieces now assembled in the garden of Istanbul Archaeological Museum.

movement of craftsmen: a number of sarcophagi found in France are thought to have been made locally, but by sculptors from Italy, or perhaps from Asia Minor.[15]

Free-standing statuary, which was very much a part of the Roman tradition, seems to have retained its importance in the fourth and fifth centuries, although there is clear evidence for its decline later. Several sources mention statues in Constantinople, the most useful being the eighth-century *Parastaseis syntomoi chronikai* (Brief Historical Notes [on Constantinople]), which is a description of the monuments of the city probably compiled by several authors. From this account it is clear that by the eighth century, statues were ill-understood remnants of the past, suspicious objects believed to be capable of mysterious malevolence. This attitude confirms that large-scale figure sculpture had not been produced for some time, but the large number of figures still available to be described implies that the early Christian city was rich in statuary. Most of the figures were portrait statues of emperors and their families, ranging as late as Justinian II in the seventh century, but predominantly of fourth- and fifth-century rulers, particularly Constantine I and his family. Virtually nothing remains of this public statuary but a few fragments gathered in the Archaeological Museum in Istanbul or the gardens of St Sophia and a few heavily weathered monumental columns or bases, lacking the figures they once supported (fig. 19, a–c). A smaller number of statues represented pagan deities. Some of these may have been made in the fourth century –

15 *Atlas*, pls. 167–77, 527–31. M. Lawrence, 'City Gate Sarcophagi', *AB* 10 (1927–8) 1–45; J. Wilpert, 'Early Christian Sculpture: Its Restoration and its Modern Manufacture', *AB* 10 (1927–8) 89–141; A. Katzenellenbogen, 'The Sarcophagus in San Ambrogio and St. Ambrose', *AB* 29 (1947) 249–59.

paganism did not cease abruptly – but many were probably pre-Constantinian. (Indeed, some of the statuary that was brought to Constantinople in the fourth century to embellish the new capital was ancient. There still stands in the hippodrome a mutilated bronze of the fifth century BC, representing three serpents entwined to form a column, made for the Sanctuary of Apollo at Delphi.) There were also statues of animals, probably including the four bronze horses which now stand on the west facade of San Marco in Venice, looted by Crusaders in the thirteenth century. Also of bronze was a monumental weather vane, commissioned by Theodosius I, decorated with reliefs showing vine-scrolls inhabited by *putti* (cherubs), and figures representing the four winds.

There is very little evidence of statues of Christian subjects. The *Parastaseis* notes figures of Adam and Eve on top of columns in Constantinople, and also mentions a group depicting Christ and the Woman with the Issue of Blood, set up in Caesarea Philippi in Palestine, where the healing took place. This curious inclusion in a description of Constantinople was probably lifted from Eusebius, who also describes the

group, treating it as an oddity and explaining it as a vestige of pagan practice. It would seem, therefore, that while secular figures continued to be made for a time, the close association of the free-standing religious figure with pagan idolatry discouraged the production of Christian statuary.[16]

Monumental art

Roman interiors were treated in a variety of ways. Some of the grandest had their walls clad in marble panels, some of the less grand had them painted to look like marble panels. Sometimes the marble (or its painted imitation) might cover just the lower part of the wall, leaving room for painting on the upper part – such schemes are found in the houses of Pompeii and Herculaneum that were buried by the eruption of Vesuvius in 79 AD, and also in the temples, synagogue and baptistry at Dura Europos, mentioned above. The Roman interior also used mosaic, a medium in which small cubes of stone or glass (tesserae) are set into a mortar bed. Stone mosaic was much used for surfaces that needed to be hard wearing, such as floors, fountain niches, water channels and drains. Mosaic with a mixture of stone and glass tesserae was also used for wall panels with figure subjects, some examples of which survive *in situ* at Herculaneum.[17] These, then, were also the materials of Byzantine monumental art. Painting probably continued to be the commonest means of decoration, but it is poorly represented in surviving early Christian monuments because of its perishability (nor, indeed, is there much left from any pretenth century site). Mosaic fares better because it does not fade and is resistant to damp; little short of an earthquake will dislodge it.

 Most of what follows will concern the decoration of walls and vaults, but we may first glance at the floor. Mosaic floors were laid in many early Christian churches, and other buildings, but they survive in greatest numbers in Syria, Palestine and north Africa. Here the churches above the floors have often perished, but low population levels have meant that the sites were not built over, whereas further west early floors were destroyed or buried by later phases of building on the same site. Some in the west have nevertheless been uncovered by excavation, notably the floor of the cathedral at Aquileia in north Italy, which is dated by an inscription naming Theodorus, Bishop of Aquileia 314–20 (fig. 20). In most floors geometric and foliage motifs of many types fill much of the space, often in 'carpet' formations, with borders surrounding panels of figure subjects. The latter include animals and birds, personifications of the seasons, and hunting or fishing scenes. There is some evidence from early Christian writers that

16 A. Cameron & J. Herrin, *Constantinople in the Early Eighth Century. The Parastaseis Syntomoi Chronikai* (Leiden 1984), 45–53; Eusebius, *Ecclesiastical History* VII.xviii (see n.3); Constantius Rhodius v.178ff, trans.

Mango, *Sources* 44–5.

17 H. Joyce, *The Decoration of Walls, Ceilings and Floors in Italy in the Second and Third Centuries A.D.* (Rome 1981).

20 Mosaic floor of the Cathedral of Aquileia, north Italy (314–20).

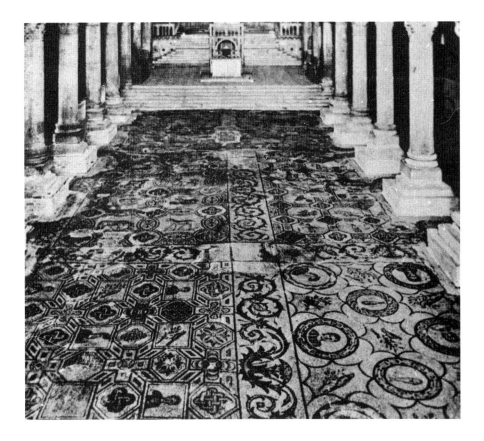

such 'natural world' imagery was used with Christian significance to illustrate the wonders of Creation, but specifically Christian motifs or images are few. Aquileia has the Good Shepherd and Jonah and the Whale, the latter forming part of a large 'fishing' panel with *putti* in small boats surrounded by a great variety of sea creatures. There may therefore have been a reluctance to place religious imagery on the floor, where it would be trodden on. Such was evidently the view that prompted an edict of Theodosius II in 427 that prohibited the representation of the cross on floors. Limitations thus placed on the mosaic floor as a vehicle for Christian imagery may have led to its eventual abandonment. There are few examples after the end of the sixth century, and by the middle-Byzantine period mosaic had been replaced by *opus sectile*, a flooring made of small slabs of marble or other stone in various shapes and colours, forming geometric patterns.[18]

For the earliest substantial evidence of early Christian monumental art it is necessary to sink below floor level and return to the third- and fourth-century catacombs mentioned above. Many tomb chambers were plastered and then painted, using the formulae of Roman domestic interiors. The walls are divided into horizontal registers or panels by painted

18 H. Maguire, *Earth and Ocean. The Terrestrial World in Early Byzantine Art* (University Park PA/London 1987).

lines, and the panels filled with figure subjects or decorative motifs. Sometimes a painted marble dado forms the lowest register. The range of figure subjects is much like that of the sarcophagi, consisting of biblical scenes chosen for their 'resurrection' symbolism, such as Jonah and the Whale, the Three Hebrews in the Furnace, Christ raising Lazarus and other miracles of healing. The paintings are executed in a fairly naturalistic style, with figures usually placed against a light ground, with little

21 Painting in the Via Latina catacomb, Rome, mid-fourth century, The Crossing of the Red Sea.

background detail (fig. 21). In general, the quality of these paintings is not high and they are unlikely to represent the best that the early Christian artists could offer. The catacombs also supply one example of mosaic decoration which may be as early as the fourth century, in a tomb chamber in the complex beneath St Peter's in Rome. Mosaic images of Jonah and the Whale and the Good Shepherd decorate the walls, and in the vault there is a nimbed figure in a chariot, thought to be a representation of Christ, based on the pagan iconography of Helios, the sun-god.[19]

Part of another fourth-century mosaic decoration in Rome remains in the mausoleum of Constantine's daughter Constantia who died in 353 (now known as the church of Sta Constanza). As noted above, this is a circular building with a central dome surrounded by a vaulted ambulatory

19 E. Kirschbaum, *The Tombs of St. Peter and St. Paul* (London 1959), 34–5.

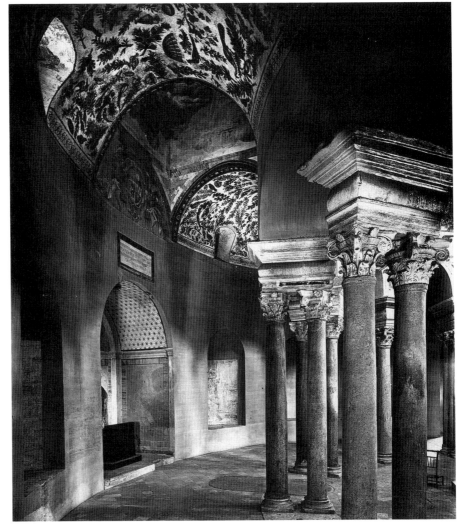

22 Santa Constanza, Rome, originally the mausoleum of Constantia, daughter of Constantine I (d. 353): plan, after Deichmann; view of ambulatory with mosaic.

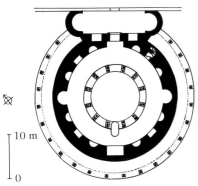

10 m

0

(fig. 22). Mosaic survives only in the ambulatory vault, consisting of twelve panels with motifs familiar from pagan art, including geometric patterns, peacocks, dolphins and *putti* tending vines. There are more peacocks and vines on the great porphyry sarcophagus that once stood at the centre of the building. The meaning of this imagery is ambiguous: it may have Christian reference, since both the vine and the peacock acquired Christian significance as symbols of eternal life, but it has been suggested that it reflects instead the paganism of Constantia's second husband. The dome mosaic, recorded before its destruction in the seventeenth century, seems to have had Christian subjects – biblical scenes framed by foliage scrolls – but it is not certain that this was contemporary with the work in the ambulatory.[20]

20 H. Stern, 'Les Mosaïques de l'église de Sainte-Constance à Rome', *DOP* 12 (1958) 157–218.

Glimpses of a much wider vocabulary of Christian imagery come from a few documentary sources, although it is sometimes unclear whether they refer to panels or to monumental art. Gregory of Nyssa (335–95), however, seems to be describing a wall decoration when he refers to a series of pictures of the life and martyrdom of St Theodore at the saint's shrine in Euchaita, near Amaseia in northeast Turkey. From this it would appear that by the end of the fourth century the narrative cycle was in use as well as the symbolic, single-subject images of the catacombs, and that hagiographical subjects had taken their place alongside biblical ones and images created by the modification of pagan iconography. It would seem that fourth-century Christian art above ground had far more to offer than Jonah and the Whale and its ilk.[21]

The view of church decoration in the fifth century becomes a little clearer, with remains of mosaic decorations in Rome, Ravenna and Thessalonike, which show considerable diversity in their imagery. In Rome, the heavily restored apse mosaic of the Church of Sta Pudenziana, installed during the period of office of Pope Innocent (401–17), depicts

23 Santa Pudenziana, Rome (401–17), mosaic of the apse: Christ enthroned between apostles.

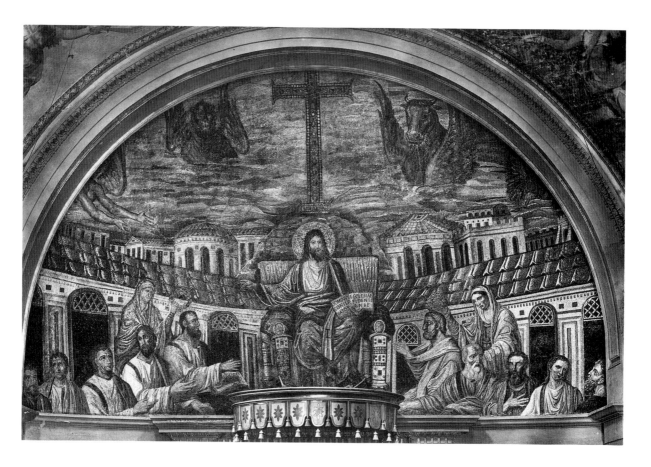

21 Gregory of Nyssa, *Laudatio S. Theodori*, PG X L V I, 737, trans. Mango, *Sources*, 36–7.

Christ enthroned between groups of apostles against an architectural background (fig. 23). Female figures holding laurel wreaths above the heads of Saints Peter and Paul are thought to be personifications of the Church of the Circumcised and the Church of the Gentiles (representing the areas of ministry of the two apostles). In the background, a large jewelled cross is placed above Christ, and flanking it are the four winged creatures that appeared to the prophet Ezekiel and were interpreted as a prophecy of the four evangelists: the man (Matthew), the lion (Mark), the ox (Luke) and the eagle (John), (Ezekiel 1.10).[22]

Also in Rome, the basilica of Sta Maria Maggiore, built by Pope Sixtus III (432–40), has lost its original apse decoration, but retains mosaic in two other areas (fig. 24). A series of panels in the nave show Old Testament episodes from the lives of Abraham, Moses and Joshua, and on the wall above the entrance to the apse (the 'triumphal arch') there is a short New Testament cycle, from the Annunciation to the Magi with Herod. The cycle lacks the Nativity, which may have been in the apse. Aspects of the iconography of the cycle show the augmentation of the narrative account with symbolic references to the decision of the Council of Ephesus in 431 that the Virgin was *theotokos* (mother of God – i.e. that the divinity of Jesus was present at birth, not acquired during his lifetime). Recognition of the raised status of the Virgin, for example, is indicated by depicting her wearing imperial dress, and the Flight into Egypt shows the Governor of Egypt, who is said to have recognized the divinity of Christ when the holy family arrived in his province.[23]

24 Santa Maria Maggiore, Rome (432–40). View of the nave, to the east. Fifth-century mosaic is seen in panels above the entablatures and on the east wall, above the apse.

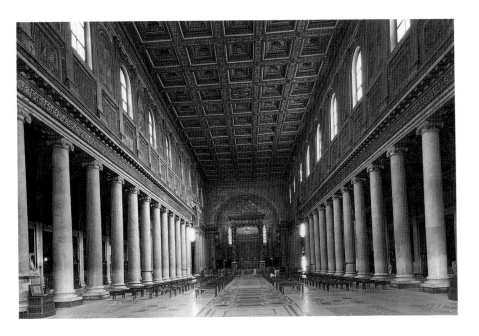

22 Oakeshott, *Rome*, 65–7; Beckwith, *ECBA*, 167 n.12.
23 Oakeshott, *Rome*, 73–89; Beckwith, *ECBA*, 168 n.15.

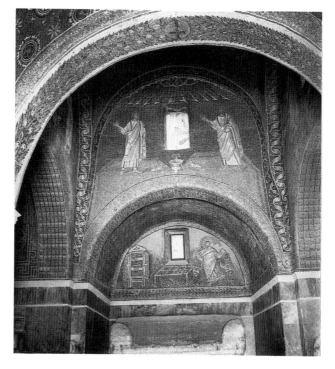

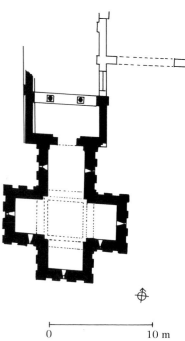

In Ravenna, which became the western seat of Byzantine administration in 402, there are three fifth-century mosaic decorations. One is found in a small cruciform building that was once alongside a basilica built for the daughter of Theodosius I, Galla Placidia, who died in 450. Here the walls are lined with marble, and the vaults and lunettes (half-circle fields where a barrel vault meets a wall) have a mosaic decoration which includes figures of eight apostles, the symbols of the evangelists, Christ as the Good Shepherd and a figure of St Lawrence, standing next to the gridiron on which he met martyrdom (fig. 25). This last image is thought by some to identify the building as a martyrium for relics of St Lawrence, but it was probably intended to be the mausoleum of Galla Placidia, for whom St Lawrence perhaps had some special significance. The lady was probably buried elsewhere, since she died in Rome, but the building is still generally styled with her name.[24]

The other Ravenna mosaics are in two baptistries. The earlier of the two is the Orthodox Baptistry, once an adjunct of the lost Basilica Ursiana, the cathedral of Ravenna, built by Bishop Ursianus at the beginning of the century. Although its interior has undergone several phases of restoration, the octagonal baptistry preserves much of the form, if not always the fabric, of its mid-fifth century decoration by Ursianus' successor, Bishop Neon. Marble panelling and mosaic (nineteenth-century restoration) forms

25 Mausoleum of Galla Placidia (d. 450), Ravenna: interior view to south, showing two apostles (above) and (below) St Lawrence, the gridiron upon which he was martyred and an open book-cupboard; plan, after Deichmann.

24 Deichmann, *Ravenna*, II.I, 61–90, III, 1–31; Beckwith, *ECBA* 167 n.14; O.G. von Simpson, *Sacred Fortress. Byzantine Art and Statecraft in Ravenna* (Chicago 1948); A. Paolucci, *Ravenna* (London 1978); Deichmann, *Ravenna*, II.I, 61–90; III, 1–31.

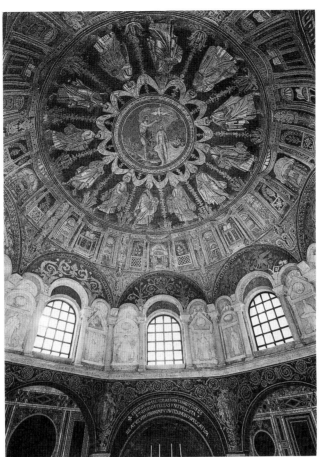

26 Baptistry of Ravenna
Cathedral (Orthodox Baptistry)
(mid-fifth century): plan, after
Deichmann; view into the
dome.

the first zone, above which are stucco figure reliefs (probably representing
prophets) and above them the mosaic of the dome (fig. 26). This has an
image of the Baptism at its summit, with the apostles circling below, hold-
ing crowns; below them is a circle of alternating garden motifs and empty
thrones, interpreted as paradise, with the thrones of heaven awaiting the
righteous. The Arian Baptistry (so called because it was built while
Ravenna was under the control of an Arian, Theodoric the Goth) was dec-
orated towards the end of the fifth century. Its dome contains a similar
programme of Baptism and apostles, below which all decoration is lost.
The ninth-century writer Agnellus gives a little more information about
decorations in Ravenna. As well as decorating the baptistry, Bishop Neon
added buildings to the Ursiana site, including a refectory whose painted
decoration included images of the Flood, the Feeding of the Multitude, the
story of St Peter and an illustration of Psalm 148, its details unspecified.[25]

In Thessalonike the great circular mausoleum of the tetrarch
Galerius was made into the church of St George in the mid-fifth century

25 S.K. Kostoff, *The Orthodox Baptistry of Ravenna* (New
 Haven CT 1965); Beckwith, *ECBA*, 168 n.16.

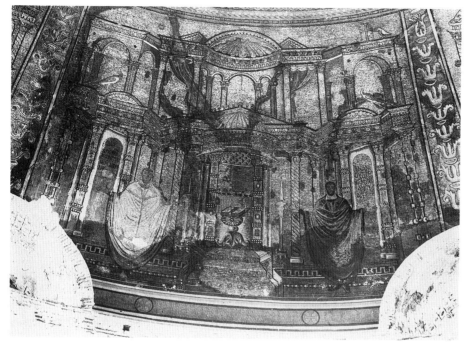

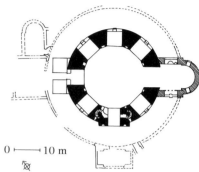

and had its huge dome decorated with a mosaic programme (fig. 27). At the summit there was a striding figure of Christ carrying a cross, encircled by a frieze of figures, variously read as elders of the apocalypse or angels. (All this is now lost, but is apparent from the under-drawing used to guide the mosaicist.) The preserved area below forms a wide band at the base of the dome, in which figures of saints stand in an elaborate architectural framework. This kind of setting is found in some Roman wall-painting and is thought to imitate the architecture of the built stage-back (*scaenae frons*) of the Roman theatre. The saints, identified by inscriptions, include soldiers, clerics and martyrs, but the reason for their selection is unclear; efforts to link them to the liturgical calendar (i.e. the dates which they are particularly venerated) have been unsuccessful.

Also in Thessalonike, the small domed church of Hosios David, the early history of which is unknown, has an apse mosaic attributed to the mid-fifth century on stylistic grounds (fig. 28). It shows Christ enthroned, with symbols of the evangelists and two bearded figures, probably the prophets Ezekiel and Habbakuk, whose visions are interpreted as foretelling the coming of Christ. The Acheiropoeitos Church, of *c.* 470, also once had a mosaic decoration, of which there remain only fragments of ornament in the arcade soffits (undersides of the arches).[26]

Nothing remains of early Christian monumental art in Constantinople except perhaps the scattered tesserae still to be picked up in the ruins of the Stoudios church, the only surviving fifth-century building

27 Rotunda of St George, Thessalonike (originally the mausoleum of the Tetrarch Galerius): detail of fifth-century mosaic in the dome; plan, after Hébrard.

26 Beckwith *ECBA*, 167 n.11, 176 n.2; Diehl, *et al.*,
 Salonique, 19–31, 35–58.

28 Hosios David, Thessalonike (mid-fifth century), mosaic of the apse, showing Christ enthroned, flanked by prophets and symbols of the evangelists.

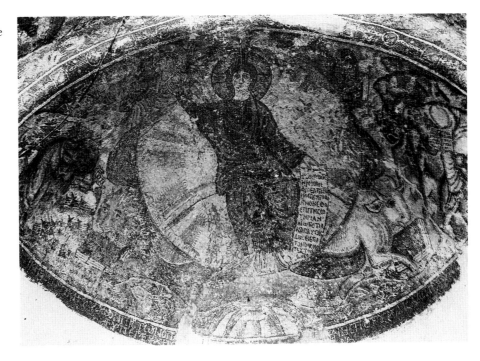

of the capital, and even these may have belonged to a later redecoration. Documentary references to monumental art in the capital are also scarce. An image of gold and precious stones, which may have been a mosaic, was set up by Leo I (457–74) above the reliquary containing the veil of the Virgin at the Blachernae church. It depicted the Virgin enthroned, receiving the supplications of the emperor and his family, an iconography much used in later Byzantine art. There is also the intriguing account by Theodore Lector, writer of a sixth-century ecclesiastical history, of an image ordered by the emperor Anastasius (491–518) to be painted in a Constantinopolitan bath-house to commemorate a recent miracle. (An angel had appeared there and, in decidedly un-Christian manner, had poured boiling water over a bathing heretic.)[27]

The variety evident in the fifth-century decorations is sometimes seen as evidence that the time was still one of innovation and experiment, in which standard formulae for monumental decoration had not yet developed. On the other hand, we should perhaps expect no less than variety: the buildings decorated served different functions, are scattered over the century and are found in widely separated locations. The only two strictly comparable buildings are the baptistries in Ravenna, the similar programmes of which do in fact establish a formula for baptistry decoration, even if it was one confined to Ravenna. Even amid the diversity of other programmes, there are some shared features. The symbols of the evangelists appear in Thessalonike, Rome and Ravenna, for example, and both

27 Theodore Lector, *Ecclesiastical History* 498, in Mango, *Sources* 35–6; for Blachernae, *ibid.*, 34–5.

the apse decorations (Hosios David and Sta Pudenziana) show Christ enthroned, flanked by other figures. The infant Christ is also enthroned in the triumphal arch mosaic of Sta Maria Maggiore, to receive the gifts offered by the Magi. All these 'enthronements' depend ultimately upon the traditional iconography of the imperial audience, with enthroned emperor surrounded by courtiers and supplicants, and are early examples of a formula which will become standard for Byzantine imagery. To them might even be added the Good Shepherd of the Mausoleum of Galla Placidia, who wears the imperial purple as he sits among his flock. Other common threads of this sort might be visible had complete programmes of decoration survived, but in most of the above examples only parts remain. At least it is possible to see the two categories of image that are to form the basis of Byzantine religious art – the narrative cycle of sequential episodes, and the non-narrative 'formal' image like the apse enthronements or the processing Apostles in the baptistries. Also evident is the possibility of overlap between the two, shown by the adaptation of narrative images for symbolic purposes in Sta Maria Maggiore. It is probably as well to compromise, therefore, with a view that, by the end of the fifth century at least, certain conventions in Byzantine monumental art were emerging, but that a rich repertory of images was available, and they were used with flexibility, modification and invention to suit particular circumstances. Were examples available of the monumental art of churches in central and eastern Anatolia, Syria, Palestine and North Africa, the diversity might prove greater still.

Style in monumental art seems to follow the general trend away from naturalism already seen in sculpture. Painting of the pre-Christian era used an illusionistic style which attempted to reproduce the three-dimensional spaces, colours and shadows of the real world. According to Pliny, writing in the first century A D, painting of this kind could be so lifelike that birds would peck at fruit painted on a wall. Pliny may have underestimated even the limited intelligence of birds, but good examples of very lifelike painting survive on the walls of houses at Herculaneum and Pompeii. Catacomb painting, which is mostly of mediocre quality, is already at some remove from this standard, but it, and most of the fifth-century mosaics, show their derivation from the naturalistic approach in their use of a large range of colours and avoidance of harsh lines. The later mosaics (in the Arian Baptistry, for example) show a further movement away from naturalism. Three-dimensional modelling is reduced as figures and other forms are defined by solid lines; details of anatomy and drapery harden into schematic patterns which recall, rather than reproduce, natural appearances. By the nature of the technique, mosaic does not lend itself to naturalism and its greater suitability for simplified forms may have fuelled the movement towards stylization. Finally, it should be noted that the charting of lines of stylistic development in the mosaics described should proceed with caution, since many of them, especially those in Italy, may have picked up some aspects of their style from the hands of the many restorers who have worked on them.

Minor arts

29 Gold-leaf medallions from glass bowls found in Roman catacombs: (a) Sts Peter and Paul, (b) several saints, (c) bowl with medallions of Old Testament subjects (London, British Museum).

'Minor arts' is a general term covering most portable objects that are considered to be works of art, but also serve some other purpose, from the trinket box to the liturgical chalice. Many surviving Byzantine objects of this class, such as silver dishes or carved ivory diptychs, were made to be luxury gifts. Some were given to celebrate an occasion, or achievement of the recipient, others were distributed by holders of high office – the diplomatic, or 'business' gift. Objects with religious purposes form another important group, although they are not well represented among early Christian survivals. The minor arts are usually sub-divided by art-historians according to material – metalwork, ivory, textile, and so on, even though grouping according to the functions just noted would more easily set them in a social context. The conventional taxonomy does not merely reflect the convenience of museum curators and salerooms, however. To a considerable extent, material influences the form of an object, the circumstances of its production (and even circumstances of its preservation), so that much may be learned by study of objects in 'material' groups. Further, the formulation of 'functional' groups is not without problems. There is overlap, for example, between the 'commemorative gift' and 'liturgical object' division just made above, since liturgical objects might also be commemorative gifts. In addition, very broad categories are bound to contain objects so diverse that they will require subdivision, while very specific ones will often cause a false separation of objects that have much in common (ivory boxes, for example, were made for both secular and religious purposes). In this text, therefore, the conventional 'material' categories will be retained and considerations of function discussed within them.

The survey of early Christian minor arts takes us back to the catacombs once again, where some glass bowls have survived because they were set into the plastered walls of tomb chambers. The bowls have gold leaf decoration, usually consisting of figures in a medallion or square frame, applied to the bottom of the bowl and sealed with a layer of glass fused on to it – the design is seen by looking into the bowl. Usually the decorated base is all that survives, the sides of the bowl having been broken away (fig. 29 a–c). The subject matter of the gold decorations reflects the multi-faith nature of catacomb burial, for it includes figures from pagan mythology, portrait busts (sometimes of family groups), victorious charioteers, hunters, biblical subjects (Jonah and the Whale again, Saints Peter and Paul, New Testament healing scenes) and Jewish subjects such as *torah* scrolls or the *menorah* (branched candlestick). Quality varies considerably. The portrait busts on some bowls are finely executed and very lifelike, while figures on other bowls are simplified and clumsy. Inscriptions exhorting the owner to 'drink!' or 'live!' are manifestly inappropriate to the funerary context and identify the bowls as drinking vessels. As such they continue an ancient tradition, since similar vessels,

chiefly of pottery, are known at least since the time of the ancient Greeks. The glass bowls were probably gifts to celebrate a range of events – marriage, attainment of public office, victory in the games, or simply to offer the recipient praise or wishes for success and longevity. They were evidently placed in the catacombs on the demise of their owners, to identify or embellish the tomb. Some bowls remain in the catacombs, but collectors have been removing them since the sixteenth century and many are now in collections. While they may therefore be attributed to the third or fourth centuries by the catacomb context, greater precision is seldom possible. Those with very naturalistic decoration are generally attributed to the third century, and the others to the fourth, an approach consistent with the general stylistic trend mentioned above, although it should perhaps be noted that stylization can be the mediocre artist's attempt at naturalism.[28]

Metalwork of the early Christian period has been preserved chiefly in hoards deliberately concealed for security (usually buried). (Many single pieces now in collections probably also came from hoards – buried treasure is not always handed over to the proper authorities.) Hoards may contain a variety of objects, but silver plate, sometimes with gilding, is most common. A treasure now in Munich, for example, the find-site of which is unknown, contains high-quality silver dishes and bowls, two of which are decorated with portrait-busts of the Tetrarch Licinius I and his son Licinius II respectively. Each bears the same inscription, which names the imperial pair and explains that the dishes were made to celebrate five years in office of Licinius II, thus dating them to 322. Mint stamps identify Nicomedia as the place of production, and it is likely that several such pieces were made, commissioned by the Tetrarch and his son, to be given to their supporters. Other pieces in the hoard bear the stamps of Antioch and Naissus (Niš, former Yugoslavia), a circumstance that illustrates the hazards of defining regional styles and iconography on the basis of the find-sites of portable objects.

Some hoards contain both Christian and pagan pieces. A treasure from Carthage is made up of bowls, plates and spoons, some of them decorated with pagan subjects and others bearing the chi-rho monogram (the first two letters of 'Christ', in Greek). One dish with this device also bears a family name (Cresconi) on the basis of which the hoard is attributed to *c.* 400. Closer mingling of Christian and pagan is seen in the Proiecta casket, an object from the Esquiline Treasure, of about the mid-fourth century, found in Rome and now in the British Museum (fig. 30). The casket, probably a wedding gift, is a large silver-gilt box decorated with embossed subjects from pagan mythology but also bearing an inscription with a Christian message for the couple.

28 C.R. Morey, *The Gold-Glass Collection of the Vatican Library* (Vatican 1959). Many examples illustrated in *Age of Spirituality.*

30 Silver-gilt 'Proiecta' casket, with subjects from pagan mythology (mid-fourth century) from the Esquiline Treasure (London, British Museum).

31 Part of a hoard of church plate found at Water Newton, Huntingdonshire, buried in the mid-fourth century (London, British Museum). Votive plaques; vessels.

Although Water Newton, in Huntingdonshire, was never within the boundaries of the Byzantine empire, what is possibly the earliest surviving set of church plate was found there in 1974 (fig. 31). The hoard, thought to have been buried in the fourth century in the Roman town of Durobrivae on this site, contains about thirty pieces, some bearing chi-rho monograms and simple Latin inscriptions which imply that the pieces were donated to a church. A shallow dish and a cup with two handles may have been the utensils of the eucharist. Small triangular leaves of silver, embossed with the chi-rho monogram, were votive plaques not unlike those still hung on icons and sanctuary screens today. (Pagan worshippers used similar tokens as offerings to their gods, so the Water Newton leaves form yet another example of pagan custom absorbed by Christianity.)

Other pieces, such as a jug decorated with embossed foliage and a set of spoons incised with the chi-rho monogram, have no obvious liturgical purpose and may simply have been gifts made to the church treasury. Further study may elucidate the place (or places) of production of the pieces and their dates – they are at present attributed to the fourth century on stylistic grounds.[29]

There are no certainly fourth- or fifth-century examples of the censers, crosses and lamps that are found from the sixth century onwards. It is likely that the earliest liturgical utensils were, like the Water Newton cup and dish, indistinguishable except by their context from vessels made for domestic use, and that distinctive forms emerged later. This probably happened well before the sixth century, however, and the lack of earlier examples simply reflects a gap in the material record, for very little fifth-century metalwork of any kind has survived.

It is likely, too, that the reliquary made an early appearance, since the cult of relics was well established by the fourth century. Constantine's mother, Helena, travelled to the Holy Land to find the True Cross, and less august pilgrims would have collected oil, earth, or other material associated with the various shrines, including bits of the earthly remains of saints. A small silver box in Thessalonike, which may have been a reliquary, is generally attributed to the late fourth century on the basis of its style and iconography (fig. 32). It is decorated with embossed figures of Daniel and the Lions, the Three Hebrews, and Christ with Peter and Paul.[30]

Objects made of ivory are also much better represented in later centuries, but there are a few early Christian pieces. The ivory diptych is a form that originated as a pair of writing tablets, made of two panels recessed to take blocks of hard wax which could be inscribed with a stylus. The panels were hinged together so that they could be closed like a book to protect the wax surfaces. Diptychs for daily use were probably made of wood, or possibly leather – the ivory model was a luxury item, its outer surfaces decorated with carving and its writing-tablet function eventually lost. An important group of diptychs consists of those made for distribution as gifts by consuls when they took office. Two consuls were appointed annually, one in Constantinople and one in Rome, and their chief function was to finance public games in the hippodrome or circus (an expensive honour). The diptychs usually bear the consul's name, and thus form an important series of over thirty datable objects, spanning a period from the early fifth century to the mid-sixth, although most are sixth-century and will be met in the next chapter. The few fifth-century examples are decorated with full-length portraits of the consul, who may hold the sceptre of his office and the *mappa*, a cloth waved to start the games. This is so in the

32 Silver box, possibly a reliquary (late fourth century?) showing the chi-rho monogram (lid), Daniel and the Lions, Christ between Peter and Paul (Thessalonike, Archaeological Museum).

29 K.S. Painter & J.P.C. Kent, *The Wealth of the Roman World* (London 1977), 20f, 44f, 5of. K.S. Painter, *The Water Newton Early Christian Silver* (London 1977);

D. Watts, *Christians and Pagans in Roman Britain* (London/New York 1991), 186.

30 *Splendeur de Byzance*, 131.

33 Ivory diptych of Boethius, Consul of Rome in 487, showing the consul standing and enthroned, with symbols of office (Brescia, Museo Civico Cristiano).

diptych of Boethius, consul of Rome in 487, for example, (fig. 33) which shows him enthroned on one panel, standing on the other, framed in each case by a gabled canopy.[31]

Secular ivory diptychs were also made for other commemorative purposes. A famous example which now has one leaf in Paris and the other in London was apparently made to celebrate a marriage between members of

31 R.H. Randall, *Masterpieces of Ivory from the Walters Art Gallery* (Baltimore MD 1985), 13–39; Volbach, *Elfenbeinarbeiten* nos. 1–44a; see also A. Cameron and D. Schauer, 'The Last Consul: Basilius and his Diptych', *JRS* 72 (1982) 126–45.

the pagan Symmachi and Nicomachi families of Rome (fig. 34). On each leaf a priestess performs rituals at an open-air altar beneath a tree. The diptych is undated, but attributed to *c.* 400 on the grounds both of its pagan nature and the naturalism of its style.

Liturgical diptychs were used by the fifth century to list the names of persons to be prayed for, the living inscribed on one wax tablet, the dead on the other. A panel in Milan which must have been one leaf of such a diptych shows the Holy Sepulchre on the morning of the Resurrection, with, in the lower field, the women meeting the angel at the door of the empty tomb and, in the upper field, the guards who slept through the miracle (fig. 35). It may be noted that the sepulchre is shown not as the rock-

34 One leaf of an ivory diptych of *c.* 400 (Symmachi panel, London, Victoria and Albert Museum). Ritual performed at a pagan altar.

35 Ivory panel, probably one leaf of a diptych, showing the women at the Holy Sepulchre on the morning of the Resurrection of Christ (late fourth/early fifth century) (Milan, Castello Sforzesca).

hewn cavity of the gospel accounts, but as a domed building, probably reflecting the appearance of the building erected on the site by Constantine. The winged bull and winged man in the upper corners of the panel are symbols of the evangelists Luke and Matthew respectively, and the other leaf probably had the eagle (John) and the winged lion (Mark) to complete the group. The narrative subject of the lost panel may have been the Ascension, which appears in combination with the Holy Sepulchre scene on another ivory panel, now in Munich. In both cases attribution to the late fourth or early fifth century rests upon the naturalistic style of the pieces.

By the nature of their origin, ivory panels could not be very large,

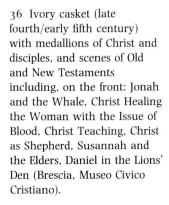

36 Ivory casket (late fourth/early fifth century) with medallions of Christ and disciples, and scenes of Old and New Testaments including, on the front: Jonah and the Whale, Christ Healing the Woman with the Issue of Blood, Christ Teaching, Christ as Shepherd, Susannah and the Elders, Daniel in the Lions' Den (Brescia, Museo Civico Cristiano).

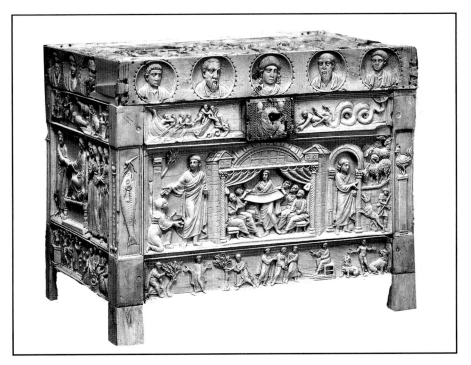

but a number of panels could be mounted on a wooden base to make a larger piece. A fine casket in Brescia is made in this way, its panels decorated with Old and New Testament subjects carved in a naturalistic style that is again the basis for attribution to the late fourth or early fifth century (fig. 36).[32]

There are no surviving dated examples of the illuminated manuscript earlier than the sixth century, but a few are attributed to the fifth century, and something of their place in the early Christian world can be arrived at by inference. An important change in the manner of book production took place in the second and third centuries, when the book of bound pages

32 Volbach, *Elfenbeinarbeiten* nos. 55, 111, 110, 107.

(codex) began to replace the traditional papyrus scroll. The codex proved the superior form in several respects. Long texts, which required many scrolls, might be written in just one or two codex volumes, and the animal skin used for codex leaves (parchment or vellum) was more durable than papyrus; also, as users of the microfilm roll will know, a codex is much easier to use. The early Christian centuries must have seen much copying of texts from scroll to codex form, as well as an increase in production of books for Christian use, such as gospels, collections of sermons and letters, and books of liturgical instruction.

Scrolls had been illustrated – Pliny and others say so – and there remain fragments of second- and third-century illustrated papyri, of both literary and scientific texts. The codex, with its flat pages, was a better vehicle for illustration and it is likely that the new format led to an increase in the range of illustrative techniques. A few pages of a Bible, known as the Quedlinburg Itala fragment and attributed to the early fifth century on stylistic and palaeographical grounds, show illustrations to the book of Kings in the form of narrative episodes framed in the manner still used for cartoon strips (fig. 37). The scenes are painted in the late-Roman illusionistic manner, described above, with indications of background, light and shade and three dimensions. A text of Virgil's *Aeneid*, now in the Vatican Library, has illustrations in similar style. Some attempt to reconstruct the range of fourth- and fifth-century illuminated manuscripts may be made by working backwards from later works which must have used earlier models. For example, many of the manuscripts made by the scholars and artists assembled at the court of Charlemagne around 800 seem to have copied late Roman and early Christian books. These Carolingian manuscripts include works on astronomy and natural sciences which have unframed illustrations placed within blocks of text to elucidate their content, Gospel books with full-page 'author' portraits of the evangelists, and Bibles with narrative illustration arranged in framed registers across the page. It is evident, therefore, that the early Christian models supplied examples of a variety of illustrative techniques.[33]

It remains to mention the icon, which is attested in early Christian documentary sources but has no surviving example earlier than the sixth century – and even then only by attribution. In the Byzantine context, 'icon' can apply to any image – it is simply Greek for 'picture' – but it has come to be applied chiefly to religious images depicting either divine figures or, less often, narrative episodes, painted on portable panels. ('Chiefly' because there are middle-Byzantine and later examples in metalwork, ivory and mosaic, and some icons are fixed in permanent positions on walls or church furniture.) Exactly when icons began to be used in worship is unclear, but Lactantius says that during the sack of the church at Nicomedia in 305 search was made for an image of the divinity – presum-

33 C. de Hamel, *A History of Illuminated Manuscripts* (Oxford 1986); Berlin, Deutsche Staatsbibliothek Cod. theol. lat. fol. 485: Weitzmann, *LAECBI*, 25; F. Mütherich & J.E. Gaehde, *Carolingian Painting* (London 1977).

37 Quedlinburg Itala fragment, a page from a fifth-century illuminated Bible (Berlin Staatsbibliothek Cod. theol. lat. fol. 485). Folio 2r, the meeting of Saul and Samuel (I. Samuel.15, 13–33).

ably an icon, since not much searching would have been required to locate monumental art. The use of icons is also attested in a negative manner by those who opposed them: a letter from Eusebius to Constantine's sister responds to her request for a picture of Christ with condemnation of the making of such images. Epiphanius of Salamis (d. 403) likewise objects vigorously to the images of Christ, the prophets and apostles that he sees in both churches and houses. Such dissention reflects a debate about the validity of the use of images in religion that much concerned the early Church and was to place the icon at the eye of theological storms in later centuries.[34]

34 Eusebius, *Letter to Constantia*, *PG* xx, 1545f, trans. Mango, *Sources* 16–18; for Lactantius, see n.3; Epiphanius of Salamis, *Letter to Theodosius I*, trans. Mango, *Sources*, 41–2.

General issues

Study of early Christian art and architecture has naturally been much concerned with the 'metamorphosis' mentioned at the start of this chapter – the stages by which a material culture to meet the needs of Christianity was developed from the various ingredients supplied by the late Roman world. In the field of architecture, attempts to trace the development of ecclesiastical buildings have examined the range of building types, their functions, regional variations and the transmission of ideas from one place to another. Such analysis encounters many of the problems of interpretation outlined in the introduction. Information about fourth-century and earlier churches comes largely from documentary sources, which may supply details of the dedication, function and patronage of a church, but seldom give clear descriptions of the fabric. Conversely, while a relatively large number of fifth-century churches survive, documentary record is lacking for many of them, so their social contexts may be unclear. The result is that general trends may be apparent but the plotting of specific stages problematic. By the mid-fifth century the basilica had certainly become the chief early Christian church type, but its pre-Constantinian status is uncertain. Were the great shrine churches of the Holy Land grand versions of an established form, a splinter group from an otherwise continuous development, which becomes visible only with the material remains of the fifth century? Or, was it the shrine churches that caused the basilical form to emerge as a standard type, by supplying models which were taken up in the fifth century with changes of scale and regional modifications?

The regional variety of the fifth-century buildings also raises the question of the geography of early Christian architectural development. This was probably complex, given the size of the empire and its network of both ecclesiastical and administrative links. When Constantine and his successors built in provinces distant from the capital, they may have sent plans and/or architects from Rome or Constantinople, thus transplanting metropolitan ideas. Or, they may have sent plans alone, to be interpreted by local architects using local building methods and resulting in architectural hybrids. Or, they may have used local architects, who worked largely within local traditions (and, if the results met with approval, the traditions of the regions might then find their way back to influence the capital and other major cities). There is some evidence for all these permutations, and parts of the web of contacts and influences are reasonably clear, but we shall probably never have a complete picture of regional traditions and their interrelationships.

The development of Christian imagery is another topic much affected by problems of fragmentary and non-uniform survivals. The third- and fourth-century evidence comes largely from the paintings of the catacombs, and from the decoration of the early sarcophagi. It must be asked, therefore, whether the imagery used is particular to the funerary context, or representative of early Christian art in general. Most of the images function as

symbols of resurrection, a theme certainly appropriate to Christian funerary art, and therefore suggesting the former. Against this, however, there is the evidence of the gold-glass bowls, with their clearly non-funerary inscriptions, implying that 'resurrection' symbolism had wider reference. It may have been applied to the notion of rebirth implicit in the baptism that initiates new Christians, so the images may be associated with conversion as much as with death – such was evidently the case in the baptistry at Dura.

The symbolic nature of this early imagery has also generated discussion about stages of development of Christian art. By the fifth century, Byzantine art uses both the narrative image, the purpose of which is to tell a story (typically in sequences of consecutive episodes illustrating Old and New Testaments, or the lives of the saints) and the symbolic one (this may be an episode from a narrative, but it is isolated from this context in order to represent a concept, such as resurrection, for example). The chronology of the surviving material suggests that symbolic imagery, seen in the catacombs and on sarcophagi, was the first type of Christian art to emerge, while the narrative cycle, which appears in the fifth-century mosaics and is attested in late fourth-century documentary sources, came later. It would be incautious, however, to conclude that the art of third- and fourth-century funerary monuments (whether exclusive to that context or not) represents the totality of early Christian imagery. There may have been a much wider range of subjects and treatments, including narrative cycles, from which the catacomb and sarcophagus subjects were drawn.

More might be understood of the development of Christian imagery if the state of monumental art in churches of the fourth century were known, but as noted above, the buildings have not survived. The information available from documentary sources is scant and largely negative: Eusebius says nothing about figural decoration in Constantine's churches, nor does the pilgrim Egeria who visited some of them. Even this is susceptible of two interpretations: it could mean that there were no figural decorations in the shrine churches, or that such decoration was so familiar in the fourth century that it went unremarked. Similarly, the diversity of the surviving decorations of the fifth century may be evidence that the period was one of experiment, the first in which extensive figural decoration was used in churches, or that by the fifth century, monumental art had a well-developed repertory of images serving a variety of different purposes. In addition, even our view of fifth-century monumental art is only partial, since most examples are in Rome, Ravenna and Thessalonike. Almost nothing is known of Anatolia and the east Mediterranean, nor even of Constantinople, perhaps the most important lacuna, since one might reasonably expect the capital to be an important centre of innovation.

The relationship of early Christian imagery and pagan imagery is another topic that has received much attention, coloured somewhat by the concerns of the investigators. Those who approach from an interest in the classical tradition have looked at the continuing role of that tradition in the newly Christian world; those primarily concerned with Christian history

and culture tend to focus upon the modifications and innovations brought to the pagan model by Christianity. The two approaches may lead to the same destinations, but their courses are not always identical and their emphases may vary. Once again, the broad generalization that the sources of Christian imagery were largely Roman is relatively straightforward: the new faith drew on existing Roman imagery for its own purposes. Less clear is the extent to which conscious choice operated, and the manner in which it operated. At one end of the spectrum of possibilities, a pagan image might be taken up for its form alone: the pagan 'philosopher and pupils' is easily modified to become Christ and disciples; the Good Shepherd becomes a visual, as well as literary, metaphor for Christ. At the other end, the significance of the model may be part of the reason for its use. Images of Christ enthroned depend upon images of the emperor in state, and this is unlikely to be merely because the imperial image provided a suitable figure group – its reference to a figure of universal power was doubtless significant. In other cases, the extent to which the meaning, rather than the form of pagan imagery was relevant is unclear: when Helios formed the basis for an image of Christ, was this just a matter of iconographical borrowing, or was the point being made that Christ replaced the old deities?

A fairly obvious point, which may nevertheless be worth making, is that the fact that pagan images were the starting point for so much Christian iconography shows that there was no reluctance to use such models. Although several early sources speak against the use of images in Christian art *at all*, antipathy to the pagan origins of the images does not seem to form part of the argument, at least as far as two-dimensional representation is concerned. There is a sixth-century account of a painter whose hands withered because he painted an icon of Christ in the likeness of Zeus, suggesting that such an aversion did appear later, but the evidence of the fourth century argues for tolerance. The mixture of pagan and Christian pieces in some silver hoards, for example, may have come about simply because hoarders gathered objects from several sources, but it may also denote the coexistence of paganism and Christianity within a family or household. The pagan imagery and Christian inscription of the Proiecta casket further suggest that some Christians found pagan subject-matter acceptable as decoration for objects of secular use, and the evidence of later metalwork is that this remained so.

There evidently was, however, rejection of the pagan custom of cult statuary. Several early Christian writers mention the destruction of pagan statues, and the near-absence of statues representing Christian subjects, even though secular figures were still made, indicates close identification of the statue with pagan idolatry. The concern would appear to have been with function, rather than form, however, since sculpted Christian figures, including images of Christ, were used on sarcophagi, as we have seen. (It is unlikely that a distinction was made between relief sculpture, which only represents its subjects, and free-standing figures, which might be thought to reproduce them, since on many sarcophagi the figures are cut

in such high relief as to be almost in-the-round.) It was, therefore, the context that made the distinction: the sarcophagus was a traditional funerary monument, the function of which did not change according to the faith of its occupant; the tradition could continue with only an adjustment to its iconography. But statues of the pagan gods were made to be worshipped, a function that could not be sustained with the change to Christianity, so there could be no such continuity.

Finally, the issue of style in early Christian art has been a concern of much art historical writing, and one in which the limitations of the incomplete record are too often underestimated. Sequences of stylistic development have been constructed using material of differing (or unknown) provenance, differing functions and uncertain dates. There is certainly enough evidence to support a generalization that the most conspicuous stylistic trend of the early Christian centuries is away from the naturalism of the classical tradition, as seen in Roman art, and towards various degrees of stylization. The problem, as in the case of architecture, is to define the stages, and perhaps the geography, of the process. The difficulty of doing this may be illustrated by a survey of the hypotheses that have been offered to account for some of the undated, unprovenanced, portable works of art that cling to classical naturalism. Such pieces may be attributed to very early dates, before the shift to stylization set in, or to places where the classical heritage might have been strongest, such as Rome or Constantinople. Alternatively, they may be seen as evidence that the naturalistic style was retained in some media (such as ivory carving) while it was lost in others (such as mosaic decoration). A third view is that they represent the conservative tastes of the well-educated (still schooled in the antique heritage, still collecting pagan statuary for the villa garden, perhaps), or conscious revivals of the classical manner, by the same class. All these hypotheses are plausible (with, perhaps, the reservation that if all the classical revivals that have been posited were laid end to end, there would hardly have been time for the classical tradition to have been lost). Choice among the alternatives is inhibited, however, not only by the incompleteness of the record, but also by awareness of the complex nature of early Christian society, in which it is most unlikely that there was any single line of development.

Hypotheses have also been advanced to explain the causes of the movement away from naturalism, whatever the details of its structure. It has been suggested, for example, that the mystical nature of Christianity made mimesis an unsuitable vehicle for visual expression of the new faith. The development of mosaic as an important medium of monumental decoration is sometimes related to this, since it is a technique suited to the production of stylized images that remove religious art from the appearances of the real world. Most commentators, however, note that the change begins at least as early as the Tetrarchy, when much of the world was still pagan. It is better, perhaps, to see Christianity as an accelerator of a change already under way for reasons unconnected with spirituality, such as increasing contact with the stylized arts of the east.

2 The sixth century

The period from the late fifth century to the early seventh may be seen both as the time in which developments of the early Christian centuries reached maturity, and as the final stage of the old order before massive loss of territory and other calamities forced sweeping and permanent change to Byzantine society. Constantinople was by now the unequivocal centre of an empire that retained much of the Roman administrative structure. The eastward shift implicit in the change of capital became more pronounced as the hold on western territories was weakened by barbarian incursions. Rome itself had been sacked in 410 and by the end of the century Theodoric the Goth had control of Italy, with Ravenna as his capital and the reluctant recognition of the Byzantine court. Christianity had displaced pagan religion to an all but negligible degree, but pagan culture endured, in the sense that the literature and learning of classical antiquity was to remain the basis of education and intellectual life. Divisions within Christianity continued, the chief factions now being those of orthodoxy and monophysitism, the latter finding its main support in the eastern provinces.

The eastern component of the empire was much felt in Constantinople during the reign of Zeno (474–91), who came from Isauria, a province in southeast Anatolia. Zeno had married Ariadne, the daughter of Leo I, and on Leo's death succeeded him, appointing fellow Isaurians to senior positions in Constantinople. He was an unpopular ruler, but he managed to reduce the barbarian threat by supporting one group of Goths against another, and made an attempt (unsuccessful) to reconcile the theological factions with the *Henotikon*, or act of union. When Zeno died in 491, Ariadne married a court official, Anastasius, who then became the next emperor. Anastasius expelled many of Zeno's Isaurians, and instituted taxation and currency reforms that were generally popular and much improved the condition of the state treasury. He was responsible for public works in various parts of the empire, including the building of the Long Wall across Thrace, about forty miles west of Constantinople, as a defence against barbarian raids. The reign was nevertheless a turbulent one, witnessing violent clashes of political and religious factions.

On the death of Anastasius in 518, a prominent soldier was elected to succeed him, as Justin I. This emperor relied considerably upon his able

nephew Justinian for the administration of the empire, and thus intro-
duced to power a ruler whose fame was to equal that of Constantine.
Justinian I followed his uncle as emperor in 527 and undertook military
campaigns at both extremes of the empire, aiming to recover the west
from the Goths and defend the east from the Persians. He was largely suc-
cessful: by the end of his long reign (565) the boundaries had been
restored almost to their second-century condition, enclosing Italy, south-
ern Spain and north Africa. The Persian threat had been halted by treaty,
for which the Byzantines paid annual tribute. The campaigns are
described by the historian Procopius, who also records aspects of the wide-
ranging attempts made to unite the empire with an efficient centralized
administration. Justinian instigated legal reforms, consolidating earlier
codes and pruning them of obsolete and contradictory matter. A series of
new edicts (novels) attempted to curb corruption, limit the powers of large
landowners and revise the taxation system to meet the costs of expansion
and reorganization. Like most emperors since Constantine, Justinian saw
himself as head of the Church and concerned himself both with its doc-
trine and with its social and political role. Some of the new edicts sought
to regulate the foundation and patronage of monasteries; senior clerical
appointments were made by the emperor; orthodox clergy were favoured
and heretical groups were suppressed in an effort to achieve religious
unity.

Not all Justinian's policies were popular, and early in his reign he
was almost toppled by the 'Nika' riots of Constantinople (532) which were
put down with extraordinary violence, including the massacre of thou-
sands of people in the hippodrome. In the long term, too, there was a neg-
ative side to Justinian's achievements, particularly his costly campaigns
for territorial recovery. At his death in 565 he left a huge empire which
lacked the financial resources to sustain its size and administrative net-
works. His successors in the late sixth and early seventh centuries could
not hold back the attacks that came from several fronts: the Persians
moved into Syria and Palestine, much of Italy was once again lost, to the
Lombards this time; Slavs and Avars encroached from the north. There
was a brief recovery under Heraclius (610–41), whose campaigns against
the Persians were ultimately successful, but by now the weakened empire
was open to the sweeping territorial gains of the Arabs in the seventh cen-
tury.[1]

1 Ostrogorsky, *Byzantine State*, 68–86; A.H.M. Jones, *The
 Later Roman Empire* (Oxford 1964), 1.viii-x.

Architecture

Like Constantine I, emperors of the late fifth and sixth centuries were sig-
nificant patrons of architecture. In this they were following ancient tradi-
tion by combining practical needs with political expediency, since build-
ings serve well as demonstrations of authority. Zeno, Anastasius and
Justinian are all known from documentary sources to have been responsi-
ble for extensive building, although it is difficult to link surviving buildings
securely to the patronage of the first two. Zeno (474–91) was particularly
concerned with building in the eastern provinces, and is probably to be
credited with Qalat Siman, the great shrine church in north Syria which
was built to commemorate the fifth-century ascetic, St Symeon Stylites,
who lived on top of a column, delivering advice to the faithful gathered
below. There are substantial remains of the church, made of four basilical
halls in a cross formation around the column, and of the large complex of
buildings that surround it (fig. 38). The buildings are of cut stone, the
traditional material of Syrian architecture, and decorated with heavy
mouldings which frame arches and windows and extend into string
courses (horizontal bands) across the facades. Also usually associated with
Zeno is a group of churches in his native Cilicia (southeast Anatolia)
which depart from the standard basilical form by having towers over the
large, easternmost bays of their naves. Churches of this form at
Mereyemlik, Korykos, Dağ Pazarı and Alahan are not certainly of imperial
patronage, but the expansion of building in the region promoted by Zeno

38 Church of St Symeon
Stylites (Qalat Siman) north
Syria (late fifth century): view
from the northeast; plan, after
Krencker.

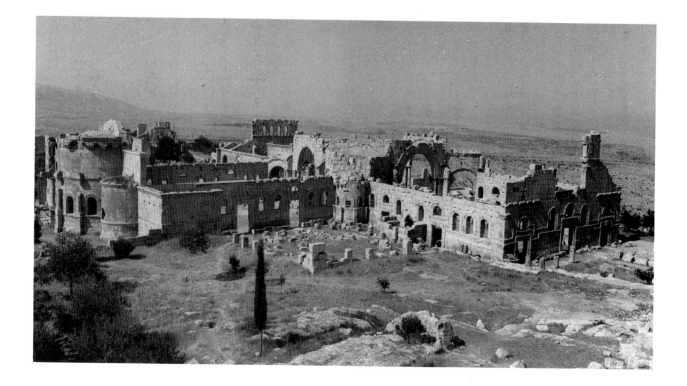

is likely to be their context. All the churches are in ruins and controversy continues as to whether or not the towers were domed, a point that may have relevance for developments in sixth-century architecture to be discussed below. In the best preserved, the East Church at Alahan, the upper corners of the tower are spanned by small arches rising from corbels, turning the square into an octagon (fig. 39). This arrangement provides the surfaces needed to support a circular vault above a square structure, and

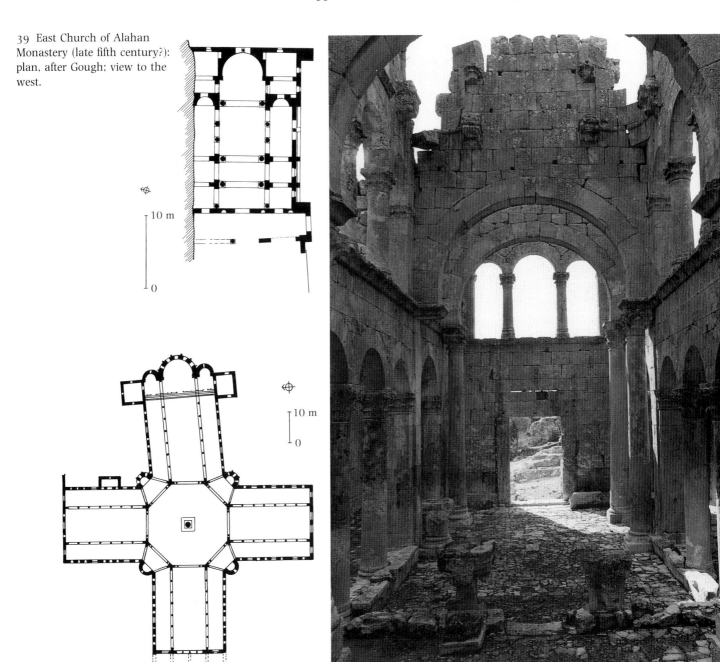

39 East Church of Alahan Monastery (late fifth century?): plan, after Gough; view to the west.

10 m

0

10 m

0

suggests that the tower was domed. On the other hand, the stonework appears too slight to support a dome and most opinion favours timber roofing.[2]

Very little detail of Anastasius' architectural patronage is available, but that of Justinian is well served both by the documentary record and surviving monuments. Architecture had an important role in Justinian's consolidation of the empire. Procopius wrote a book about this aspect of the reign alone, recording the construction of churches, palaces, fortifications, aqueducts and various other public amenities in both the capital and the provinces. *Buildings* is an uneven work, giving details of a few buildings, chiefly in Constantinople, but only vague or cursory description of most, and many are simply listed. (It is possible that the work is unfinished, since it does not cover Italy, and the lists may represent a draft stage.) Where description is given, its vehicle is usually the *ekphrasis*, the literary form whose main purpose is to praise the patron by extolling the excellence of the work, rather than to record its appearance. Such descriptions are rarely lucid, therefore, but rely much upon literary convention (the most irritating of which is that a building or its features are so splendid that they defy description in words). Procopius must also have drawn upon archives when he had no first-hand knowledge and (whether through guile or error) sometimes credits Justinian with work probably done by Anastasius. *Buildings* is therefore not wholly reliable even as a catalogue of Justinian's buildings, and does not offer a comprehensive view of sixth-century architecture. It is nevertheless a valuable guide to the magnitude and range (both geographical and architectural) of Justinian's building programme and to a few of the more important monuments in detail.[3]

Procopius mentions a great deal of secular architecture, especially fortifications in frontier areas. The ruins of some of these remain, in the remoter parts of Anatolia, and a bridge across the Sangarius river, in western Anatolia, still stands. Nothing remains of the palaces, baths and public buildings with which Justinian embellished Constantinople, but some of the cisterns that supplied them survive. Yerebatan Sarayı (also known as the Basilica cistern) which served the imperial palace, is a huge subterranean hall of 297 bays covered by brick vaulting carried on massive columns with an assortment of decorated capitals (fig. 40).[4]

The ecclesiastical architecture of Justinian's reign is best known by its least typical example, St Sophia (Holy Wisdom) in Constantinople, the church of the Patriarch. This astonishing building tends to deflect atten-

2 For Qalat Siman: Mango, *Architecture*, 79–87; for the tower churches: Krautheimer, *Architecture*, 258–61; M. Gough, ed., *Alahan. An Early Christian Monastery in Southern Turkey* (Toronto 1985). C. Mango, 'Isaurian Builders', *Polychronion. Festschrift F. Dölger* (Heidelberg 1966), 358–65; M. Gough, 'The Emperor Zeno and some Cilician Churches', *AnatSt* 22 (1972) 199–212.

3 Procopius, VII *Buildings*, with trans. H.B. Dewing, *Loeb Classical Library* (London 1971); A. Cameron, *Procopius and the Sixth Century* (London 1985), 84–112.

4 Mango, *Architecture*, 123–9; C. Foss and D. Winfield, *Byzantine Fortifications* (Pretoria 1986), ch. 2.

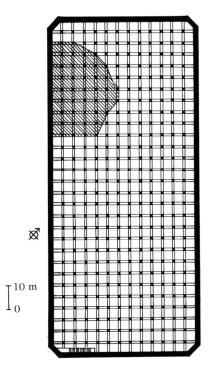

40 Sixth-century cistern near the hippodrome in Constantinople (Yerebatan Sarayı): plan, after Müller-Wiener; view of interior.

tion from the more prosaic business of determining general trends in sixth-century architecture, but it is this background that will here be dealt with first, both for itself and in pursuit of the context from which St Sophia departs.

The timber-roofed basilica seems to have held its position well into Justinian's reign. In Constantinople Procopius mentions Justinian's basilical church of Sts Peter and Paul, built before he became emperor, and there are material remains of a basilica known as 'Beyazit A', fragments of which were uncovered near to the mosque of Beyazit (dated by the distinctive style of its carved ornament, for which see below). Beyond the capital, sixth-century basilical churches are found right across the empire, from Ravenna in the west (San Apollinare in Classe, consecrated in 549) to Syria in the east (the Holy Cross Church at Resafa, dated 559 by a

41 Monastery of St Catherine at Mount Sinai, Egypt (548–65): view from the east, with the church (in the eastern corner) and parts of the fortified wall; plan, after Forsythe.

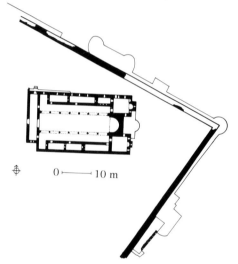

recently found inscription), and at the fortified monastery on Mount Sinai, commissioned by Justinian and his wife Theodora and built between 548 and 565 by an architect from Palestine (fig. 41).[5]

Alongside this conservatism, there are signs of change, particularly in the use of the square, domed bay in a variety of plans. This unit could be used in conjunction with the basilical plan, as seems to have been the case in Justinian's Holy Apostles in Constantinople, a replacement for

5 Sts Peter and Paul was built by Justinian before he became emperor; Sts Sergius and Bacchus was later built alongside it and the two churches shared a narthex (Procopius, *Buildings*, (see n.3) I .iv; for Beyazit: Mathews, *Istanbul*, 28–33; for San Apollinare,

Deichmann, *Ravenna*, II, 233–80; Th. Ulbert, *Resafa II* (Mainz am Rhein 1986); G.H. Forsythe & K. Weitzmann, *The Monastery of St. Catherine at Mount Sinai. The Church and Fortress of Justinian* (Ann Arbor MI 1973).

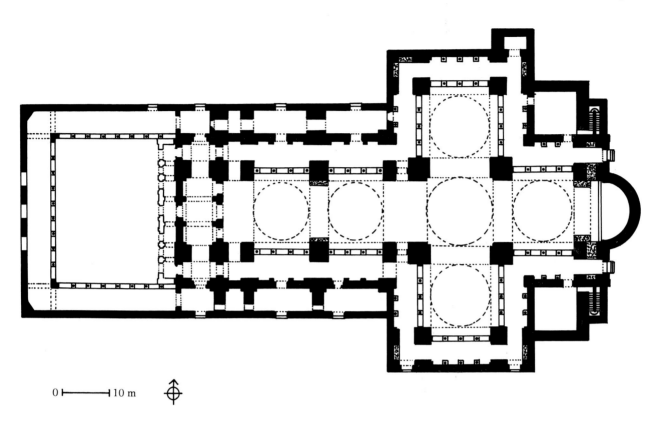

0 ⊢————⊣ 10 m

42 Church of St John at Ephesus (second quarter of the sixth century), plan after Keil.

Constantine's mausoleum church. The building is lost – Fatih Camii now occupies the site – but Procopius' description suggests that this was a transept basilica with six domes forming a latin cross over the nave and transepts. The church of St John at Ephesus, which survives in ruins, had a similar scheme (fig. 42). A single domed unit incorporated into a basilical plan was probably used for Justinian's St Eirene, again a replacement for Constantine's church, which was damaged in the Nika riots, like much else in the palace district of the capital. (The evidence for this is archaeological, for although St Eirene still stands, its sixth-century form has been obscured by a major rebuilding of 740, to be discussed below.) Modification of the basilica is also likely in St Polyeuktos, another important metropolitan church, near the aqueduct of Valens, built by the aristocrat Anicia Juliana, probably between 524–7. Nothing survives above ground, but the substructures are consistent with a squat basilica, in the Constantinopolitan manner, and large sections of carved marble decoration found on excavation make it possible to reconstruct a strongly emphasized main bay in the nave, probably domed. This is tentatively confirmed by a verse inscription carved in the marble decoration of the church interior, fragments of which were discovered on the site. The full text of the inscription is preserved in the *Greek Anthology*, a tenth-century collection of epigrams which includes inscriptions copied from buildings. In the the provinces a few mid-sixth century domed churches are found in widely dispersed locations: the Katapoliane Church on Paros, for example,

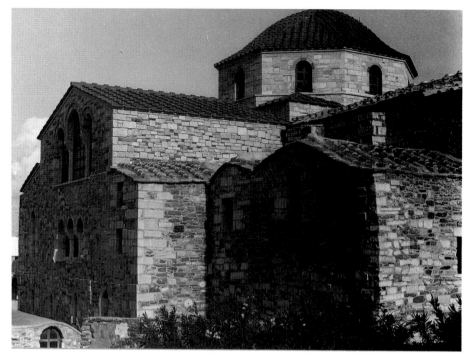

43 Church at Katapoliane, Paros (mid-sixth century): view from the southwest; plan, after Hasluck and Jewell.

which is a domed transept basilica (fig. 43), and at the other end of the empire, the church of a palace complex at Qasr' ibn Wardan in Syria, a domed simple basilica dated 561–4 by inscription (fig. 44).[6]

The buildings just mentioned are by no means uniform, but in all of them the use of the domed nave bay in a rectangular (or latin cross) plan reduces the longitudinal emphasis that had been the hallmark of the roofed basilica. The origins of this 'centralizing' trend are obscure, and the subject of debate. It appears in the capital, as we have seen, by the start of Justinian's reign, but the tower churches of Cilicia noted above, whether domed or not, may be an indication that the 'centralizing' trend was of provincial origin. It may have been a development of the extensive building commissioned by Zeno and Anastasius in the eastern provinces, not reaching Constantinople until the early sixth century. Alternatively, Alahan and its ilk may be provincial reflections of ideas that appeared in the capital earlier than the material remains suggest, and were taken to Cilicia by imperial commission. At the risk of repetition, however, it must be said that the few surviving monuments of the fifth and sixth centuries do not necessarily fit together to form simple sequences.

By far the most impressive of Justinian's buildings, St Sophia in

44 Plan of the Church at Qasr' ibn Wardan, Syria (mid-sixth century) after Butler.

0 10 m

6 For Holy Apostles: Procopius, *Buildings* (see n.3) I.iv; for Ephesus: Krautheimer, *Architecture*, 112–14; for St Eirene: Mathews, *Istanbul* 102–22; U. Peschlow, 'Die Irenenkirchen in Istanbul'. *IstMitt* 18 (1977) Tübingen; for St Polyeuktos: R.M. Harrison, *A Temple for Byzantium* (Austin, TX/London 1989) and *The Greek Anthology*, with trans. W.R. Paton, *Loeb Classical Library* (London 1953), I.10; for Katapoliane, Qasr' ibn-Wardan: Mango, *Architecture*, 146–51, 159–60.

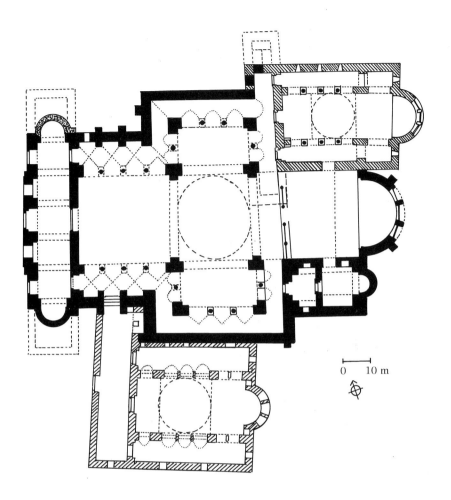

0 10 m

Constantinople, may now be viewed against this background. The Nika riots of 532 caused the destruction of a substantial part of the city in the area of the hippodrome and the imperial palace. One of the casualties was the church of St Sophia built by Theodosius II after the destruction in 404 of the still earlier church of the same dedication, noted above, built by Constantius and dedicated in 360. Justinian's church was begun a few weeks after the riots and dedicated five years later in 537. Procopius describes the practical stages of construction (not always clearly), and names the architects: Anthemius of Tralles and Isidore of Miletus. These two are often described as 'engineers', since the Byzantine world had no architects in the modern sense and the construction of buildings was only one aspect of their work. They had theoretical knowledge of mathematics and physics and wide practical experience of civil engineering – Procopius mentions their work on a flood barrier at Dara, on the Persian border, for example.

The church they built is a squat rectangle in plan, fronted at the west end by a narthex and exonarthex, the latter originally part of an atrium

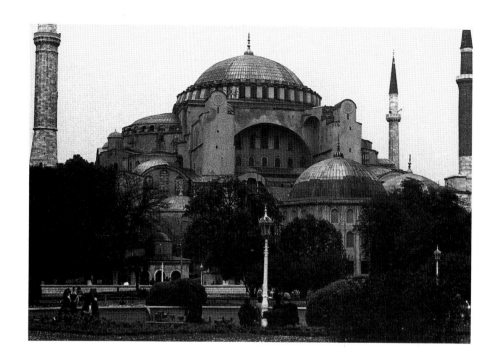

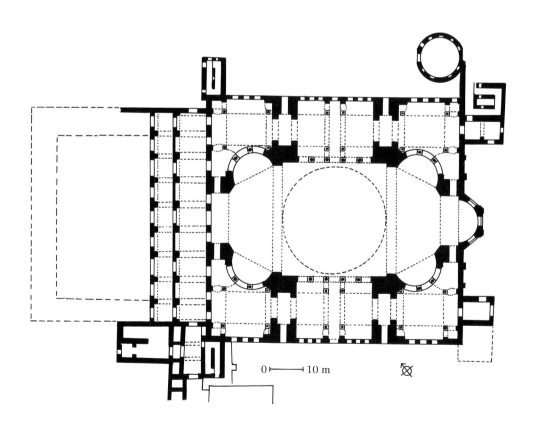

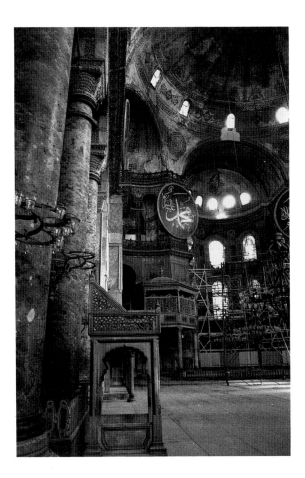

45 St Sophia, Constantinople (537): view from the southwest; plan, after van Nice; northeast exedra and eastern half-dome.

(fig. 45). The interior has the divisions of the three-aisled basilica, with the nave separated from the aisles by columnar arcades; there is a single apse opening off the nave at the east end. The aisles and narthex have galleries, so the nave is enclosed on three sides by a two-storey structure; access to the galleries is by means of ramps at each corner, only three of which remain. A radical departure from the basilical form is made by the vaulting of the nave, which consists of a dome flanked by half-domes, which together cover the rectangular nave space. Four massive piers support the dome – replacing parts of the arcades – and the extremities of the arcades curve to form exedrae (niches) to support the half-domes.[7]

The notion of doming the basilica, whether it reached Constantinople in the early sixth century or before, is clearly a component in the genesis of St Sophia. The 'billowing' combination of dome, half domes and exedrae is much more elaborate, however, than the domed square bay seen in the examples noted above, and another source must be sought for it. A connection of some kind must be made with the much smaller church of Sts Sergius and Bacchus, about five minutes' walk away, built for Justinian in

7 Mathews, *Istanbul*, 262–312; Mainstone, *Hagia Sophia* (London 1988).

the Hormisdas palace complex, his residence before he became emperor
(fig. 46). This brings us back to the second strand of early Christian archi-
tecture, the centralized building, since Sts Sergius and Bacchus is a dou-
ble-shell church, with a domed octagon at its centre, enclosed on three
sides by an ambulatory with gallery, the whole set within a square plan.
The octagon is formed of piers alternating with paired columns, four of the
pairs placed in exedrae. It has long been observed that, by slicing Sts
Sergius and Bacchus in half, from north to south, pulling the pieces apart

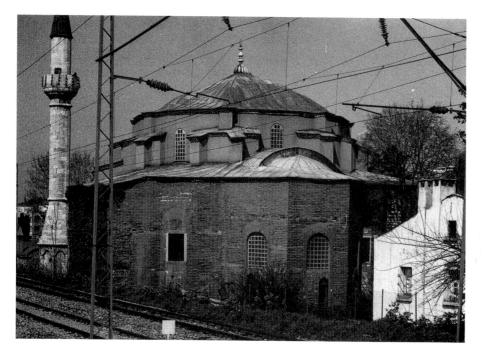

0 ⊢———⊣ 10 m

46 Sts Sergius and Bacchus,
Constantinople (527–36):
exterior from the southwest;
interior view to the west; plan,
after Sanpaolesi.

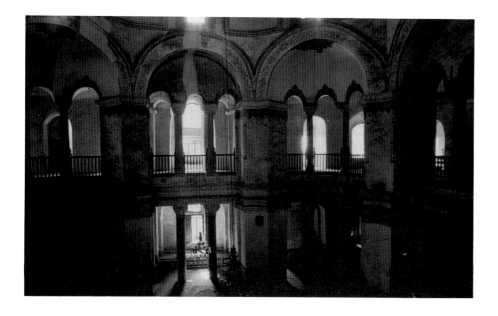

and inserting a dome between them, one can arrive at the scheme of St Sophia. The exact relationship between the two churches is elusive, however, since the date of Sts Sergius and Bacchus is uncertain. It was built some time between 527 and 536, so it may predate St Sophia, and may have been fundamental to the scheme of the latter, or, the churches may have been contemporary experiments.

The double-shell also appears in a slightly different form (with an octagonal exterior) in San Vitale, Ravenna (fig. 58) (which, although not an imperial commission, has portraits of Justinian and Theodora in its sanctuary, of which more below). The date of building is not certain: the church was founded in 526 but not dedicated until 548, so it is possible that work was not started immediately. According to Procopius, the double-shell was also used for St John in Hebdomon (a suburb of Constantinople), probably completed c. 550, which may also have had an octagonal exterior. An ancestry for the sixth-century double-shell has been sought among centralized buildings such as the aisled tetraconch, which has four exedrae opening off a roofed, or possibly domed, central space enclosed by ambulatory. This type is found as early as the fourth century (San Lorenzo in Milan, for example) and has several late fifth- or early sixth-century examples in Syria, including Bosra Cathedral (512/13). Sts Sergius and Bacchus and its relatives may therefore represent sixth-century development of architectural ideas that can be traced to the beginnings of Christian architecture, and the Syrian material has prompted proposals that this was a development originating in the east, rather than in the capital.[8]

St Sophia may therefore be seen as a fusion of two architectural ideas, the double-shell domed church and the domed basilica, which, whatever their origins, appeared in Constantinople by the first quarter of the sixth century. It is likely that the synthesis was spontaneous, rather than part of a gradual development since, for all its wonders, St Sophia has imperfections symptomatic of experiment. Structural weaknesses became apparent even during construction (corrected, Procopius tells us, by the genius of Justinian, who advised the architects) and the dome had to be rebuilt after a collapse in 558, following an earthquake. Anthemius and Isidore cannot have known that the riots would provide them with the most important imperial commission of their age, and the speed of construction suggests that they were pressed for rapid results. They probably coped as with any other emergency in civil engineering, by adapting whatever was to hand. Thus, the basilical form offered a secure starting point (and made practical use of the foundations of the Theodosian church) and the billowing interior of the domed double-shell supplied a novel way of vaulting it, whether derived from Sts Sergius and Bacchus itself or from the tradition to which it belonged. Finally, the independence

8 Mathews, *Istanbul*, 140–2, 242–59; Deichmann, *Ravenna*, II, 47–230; W.E. Kleinbauer, 'The Origins and Functions of the Aisled Tetraconch Churches in Syria and Northern Mesopotamia', *DOP* 27 (1973) 89–114.

of St Sophia is endorsed by its uniqueness – its form is not seen again until Ottoman builders used it for the mosques of fifteenth- and sixteenth-century Sultans.

To summarize, what remains of sixth-century architecture suggests a background of conservatism, with the standard basilica still in use, particularly in the provinces, but also in the capital. Regional traditions probably continued undisturbed in many areas, with even imperial commissions undertaken for the most part by local master-builders, as was the case at Mount Sinai. Against this background at least two strands of architectural development were taking place. One was experiment with the domed and niched interior in relatively small buildings like Sts Sergius and Bacchus, and the other the use of domed vaulting in the basilica, of which St Polyeuktos and St Eirene are probably examples; St Sophia seems to combine elements of both trends. The origins of these developments are obscure, and may well be provincial rather than metropolitan.

Although the entirety of sixth-century architecture is surely more complicated than this, the evidence permits the generalization that, by the mid-sixth century, important buildings exhibit a shift towards centralization, domed vaulting and complexity of interior spaces. These are all features that will become more pronounced in middle-Byzantine churches, so the sixth-century developments constitute the beginning of a radical change in the direction of Byzantine ecclesiastical architecture.

Sculpture

Developments in architectural sculpture in the sixth century to some extent parallel those in architecture. Carved ornament in many of the late fifth-century buildings noted above, such as Qalat Siman and the East Church at Alahan, is in the tradition of the early fifth century, with Corinthian capitals and stylized acanthus motifs predominant. In the sixth century, however, a new style, showing an even greater retreat from naturalism is found in some of the innovative buildings just described, especially those of the capital. The earliest appearance there of the new style seems to be at Anicia Juliana's church of St Polyeuktos, which may well have started a new fashion. As noted above, it was its carved decoration that led to the identification of this church when sections of ornate entablature containing fragments of a dedicatory inscription were found during road-building near the Aqueduct of Valens (fig. 47). Many more fragments found on further excavation, and some now in Venice, taken there by Crusaders, show that St Polyeuktos had elaborate carved decoration, in a distinctive style. The nave entablature was covered in carved vines, with leaves, stems and fruit deeply undercut to produce a 'lacework' effect in two planes, surface and background. A few pieces also remain of thirty stylized peacocks carved in high relief that were set in and around niches in the nave, their opulence enhanced by inlaid glass eyes and necklaces.

47 Part of a carved marble niche from the nave of St Polyeuktos, Constantinople (524–7), with peacock, vine ornament and part of the dedicatory inscription (Istanbul Archaeological Museum).

48 Sixth-century capitals from churches in Constantinople:
(a) St Polyeuktos;
(b) Sts Sergius and Bacchus;
(c) St Sophia.

Some capitals are decorated with stylized acanthus leaves and palm-trees, others have geometrical motifs or interlaced straps. These capitals are also of new shapes: the tapering block (impost) which is of square section, wider at the top than the bottom, and the basket capital, which has convex curves to its sides (fig. 48 a).[9]

While the 'lacework' style may be understood partly as a further stage of the fifth-century development of increasingly symmetrical and stylized foliage patterns, motifs such as the date palm and peacock suggest the influence of contemporary Persian art. Increased awareness of, and taste for, such exotic elements may have resulted from the expansion of imperial building in the eastern provinces and perhaps also from the campaigns on the eastern frontiers – in which, incidentally, Anicia Juliana's husband took part. The means by which the style reached the capital is uncertain: ornamental motifs may have been copied from textiles or portable objects, or, more probably, a few artisans from the east were brought in to instruct the large number of metropolitan craftsmen that would have been necessary to complete the work at St Polyeuktos.

The 'lacework' treatment of carved marble is also found in several other churches of the capital. In Sts Sergius and Bacchus it decorates basket and impost capitals and a cornice with a carved inscription circuiting the nave; in St Sophia there are basket capitals with rudimentary volutes, impost capitals and a facing to the spandrels and soffits of the nave arcade (fig. 48 b,c). Capitals in this style have also been found on excavation at St

9 St Polyeuktos was in disrepair by the eleventh century, perhaps earlier; some of its sculpture was re-used in churches in Constantinople, some went to the West during the Latin occupation of 1204–61. R.M. Harrison, 'A Constantinopolitan Capital in Barcelona', *DOP* 27 (1973) 297–300, and *Excavations at Saraçhane in Istanbul* (Princeton NJ 1986) 1, 117–81, 414–18.

John Hebdomon and Beyazit A. The chief motif in the carving of these churches is the stylized acanthus, and although very ornate, the result is less exuberant than at St Polyeuktos – Justinian seems not to have shared Anicia Juliana's taste for glass-eyed peacocks and date palms. It is likely that the army of stone carvers assembled for the work on St Polyeuktos went on to work for Justinian, and perhaps other patrons of the capital, but were required to apply the 'lacework' manner in a more subdued form, with a narrower range of motifs.[10]

The stone used for all this work was the fine white marble from Prokonessos and other quarries bordering the Sea of Marmara which continued to ship their products further afield, as they had done for centuries. By this means the 'lacework' style reached Tirilye in Bithynia (on the south shore of the Marmara), San Vitale in Ravenna, and the Euphrasian basilica in Poreć, former Yugoslavia. Similar carving is also found in Syria, at the monastery of Symeon the Younger (built 541–55), but this may reflect the eastern origins from which the lacework style springs, rather than Constantinopolitan influence in Syria.[11]

While architectural sculpture of the sixth century thus sees innovation and development, figure sculpture is undistinguished and shows signs of decline. St Polyeuktos is again a valuable reference point, since several small panels bearing high-relief busts of Christ, the Virgin and Child and the apostles (possibly parts of a sanctuary screen) were recovered during excavation (fig. 49). The faces of the figures have been damaged, possibly during Iconoclasm (see the next chapter) but even without them it is clear that the figures are simplified and non-naturalistic. Istanbul Archaeological Museum has two other datable pieces with similar characteristics, both plinths that once carried statues (probably bronze, and now lost) of Porphyrios, a famous charioteer of the early sixth century (fig. 50). The two statue-bases differ slightly in their decoration but both have images of Porphyrios and his chariot team, and of spectators in the hippodrome, a formula reminiscent of the obelisk base made for Theodosius I, mentioned in chapter 1.[12] Similar simplification is found on a pair of tomb reliefs from the cemetery of Mokios, between the Constantinian and Theodosian walls (fig. 51). These reliefs resemble the long sides of sarcophagi, complete with lid, but were probably set into a wall with tombs behind them. Their iconography (Christ with the apostles) follows that of many early Christian sarcophagi, but the pieces are attributed to the sixth century on stylistic grounds. There is little evidence that the sarcophagus proper was still in regular production in Constantinople, but this tradition

49 Marble panel with bust of Christ in relief, possibly part of a sanctuary screen, from the Church of St Polyeuktos, Constantinople (524–7).

50 Base that once supported a statue of the charioteer Porphyrios (early sixth century), showing Porphyrios driving a four-horse chariot, flanked by winged victories and, below, spectators in the hippodrome (Istanbul Archaeological Museum).

51 Tomb relief imitating the side of a sarcophagus, from the cemetery of St Mokios, Constantinople (sixth century?). Christ (seated) with apostles in an architectural framework (Istanbul Archaeological Museum).

52 Sarcophagus in the Mausoleum of Galla Placidia, Ravenna (sixth century).

10 Mathews, *Istanbul*, 252, 258–9, 297–8, 142, 31.
11 N. Asgari, 'Roman & Early Byzantine Marble Quarries of Proconessus', *Proceedings of the Tenth International Congress of Classical Archaeology* (1973) (Ankara 1978), 467–80; C. Mango & I. Ševčenko, 'Some Churches and Monasteries on the South Shore of the Sea of Marmara', *DOP* 27 (1973) 235–77, 235–48; W. Djobadze,

Archaeological Investigations in the Region West of Antioch-on-the-Orontes (Stuttgart 1986), 57–115.
12 Harrison, *Saraçhane* (see n.9) I, pls. 197–205; A. Woodward & A.J.B. Wace, 'The Monument of Porphyrios' in W.S. George, *The Church of Saint Eirene at Constantinople* (London 1913), 79–84; Fıratlı, *Sculpture*, nos. 63 & 64.

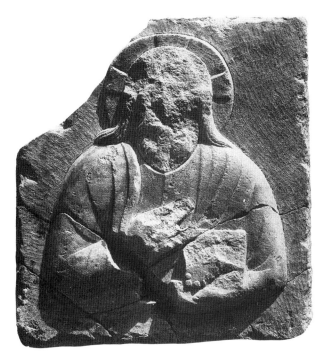

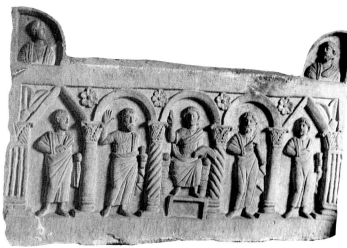

may have endured in Ravenna, where there are several examples attributed to the sixth century, decorated with simple reliefs of crosses, lambs, palm trees and other non-figural subjects (fig. 52). It is possible that sarcophagi of this type were still made as late as the eighth century, but chronology is confused by inscriptions added to some examples when they were re-used, possibly centuries after their manufacture.[13]

13 Fıratlı, *Sculpture*, nos. 96 & 97; N. Fıratlı, 'Deux nouveaux reliefs funéraires d'Istanbul et les reliefs similaires', *CahArch* 11 (1960) 73–92; M. Lawrence, *The Sarcophagi of Ravenna* (New York 1945).

As was the case for earlier centuries, most of our information about sixth-century free-standing statuary comes from documents rather than surviving examples, and it suggests a decline in production. Procopius describes a statue of Theodora and an equestrian figure of Justinian which was on a column in the Augusteion, next to the Senate. With characteristic imprecision, he leaves doubt as to whether Justinian set up both the column and the statue, or the statue alone (as other sources suggest) and modern scholarship has raised the possibility that even the statue was a reworked, or merely renamed, figure of Theodosius I or II. The *Parastaseis* (see chapter 1) mentions statues of sixth-century rulers, including Zeno and Ariadne, Anastasius, Justin I, Justinian and Theodora, and others up to Justinan II (685–95), but in smaller numbers than those of earlier imperial figures. Further, given both the ambiguity surrounding the equestrian statue of Justinian and the possibility of error by the eighth-century writers of the *Parastaseis*, it may be that some of these were earlier pieces re-used or misidentified.[14] Procopius also records that Justinian adorned a waterside courtyard in the palace district with many statues, of bronze and stone, but these may well have been old pieces relocated – the *Parastaseis* notes that the emperor moved 427 statues from the vicinity of St Sophia to other parts of the city (presumably because the neighbourhood had to be cleared for construction work). Procopius says that the statues of the courtyard were so fine that 'one might think them the work of Pheidias, Lysippus or Praxiteles'. These three were Greek sculptors of the fifth and fourth centuries BC and while the comparison may have been relevant to some of the older statues, it was also a literary convention, applied whether or not the work had the naturalism of ancient Greek statuary.[15] The reference therefore says little about the appearance of the statues, but does indicate that statuary was still prized as ornament for the city.

Actual remains are few and none is securely dated. Several marble heads of empresses or aristocrats are attributed to the sixth century partly because they have the simplified style of the relief sculpture mentioned above, and also by means of iconographical parallels with portrait heads in other media – ivories, manuscript illumination and mosaic. One, in Milan, is usually identified as Theodora, and three as Ariadne (two in Rome, one in Paris) (fig. 53 a). A bronze head thought to represent Euphemia, wife of Justin I (518–27), which was found near Niš, in former Yugoslavia, is very similar in style, suggesting that monumental sculpture followed a single stylistic route whatever the medium (fig. 53 b). Stylization much reduces the chances of identifying individuals, however, and the relatively large crop of 'Ariadnes' invites the hypothesis that the heads actually represented different women, all rendered in the same, fashionable

14 Procopius, *Buildings* (see n.3) I .iii; for the *Parastaseis*, see ch. I n. 16; A. Cameron, 'Some Prefects called Julian', *Byzantion* 47 (1977) 42–8; C. Mango, *The Brazen House*

(Copenhagen 1959), app. 2, 174.
15 C. Mango, 'Antique Statuary and the Byzantine Beholder', *DOP* 17 (1963) 53–75.

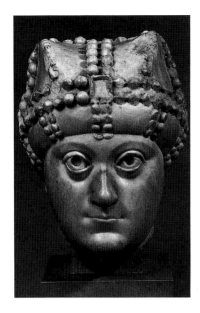

53 Portrait heads of the late fifth/early sixth century: (a) Empress Ariadne? (marble, Paris, Louvre); (b) Empress Euphemia? (bronze, Niš); (c) unknown (marble, New York, Metropolitan Museum).

style. A marble head now in New York (fig. 53 c) has been tentatively identified as Anicia Juliana since it bears some resemblance to a portrait of her in an illuminated manuscript (see below). It is much more naturalistic, and of higher quality than the others, and if the attribution is correct, argues that such work was still available in the first quarter of the sixth century. In the absence of other evidence for this however, most commentators would assign the figure to an earlier date.[16]

In the sixth century, therefore, we find a flourishing of architectural ornament in the important churches of the capital, and in areas most affected by metropolitan influence. At the same time, there are indications that the production and quality of figure sculpture in relief and of freestanding statuary was in decline. The curtailment of production that began in the early Christian period because the pagan cult-figure could not be reworked in Christian terms now seems to extend to the secular portrait statue. Loss of quality, and of naturalism, made the 'portrait' figure increasingly meaningless.

Monumental art

As was the case for the fifth century, surviving sixth-century monumental art consists chiefly of church decorations in mosaic, found in places that remained Christian in post-Byzantine times – Ravenna, in particular, is relatively rich in remains. Once again, lack of information about Constantinople poses considerable problems, not only for an understand-

16 *Age of Spirituality*, nos. 24–7; J. Inan and E. Rosenbaum, *Roman and Early Byzantine Portrait Sculpture in Asia Minor* (London 1966), 38–44; E. Alföldi-Rosenbaum, 'Portrait Bust of a Young Lady of the Time of Justinian', *Metropolitan Museum Journal* 1 (1968) 19–40; Harrison, *Temple* (see n.6) pls. 32, 33.

ing of the art of the capital, but in general, since provincial trends in iconography, programmes and style might be clearer if their relationships with metropolitan art were known. The documentary record is unhelpful. Procopius is silent about the decoration of Holy Apostles, and very brief on Sts Sergius and Bacchus ('adorned throughout with abundant gold' – possibly gold mosaic, but he may have meant sheets of gold used to cover sanctuary screens and other fittings). A few other sources refer to icons in the capital, but there are no descriptions of mosaic or painting in churches. The only surviving figural church mosaic in the capital is a square panel showing the Presentation of Christ, which was found in Kalenderhane Camii, near the Aqueduct of Valens (fig. 54). Now a mosque, this was a middle-Byzantine church, of unknown dedication and history, built on the site of an earlier church for which a mid-sixth century date is indicated by pottery and coin finds. Part of this earlier building was uncovered during restoration work and the mosaic panel was found *in situ* in the apse. It was probably one of a series of images, perhaps in an arrangement like that at Poreč, described below, but nothing remains of

54 Mosaic panel from Kalenderhane Camii, Constantinople, showing the Presentation of Christ in the Temple (mid-sixth century?) (Istanbul Archaeological Museum).

any others. Fragments of figural mosaic also came to light during the excavation of St Polyeuktos, probably from the apse, but none was large enough to reconstruct its subject(s).[17] The inscription from St Polyeuktos, recorded in the *Greek Anthology*, suggests also that there was an image of the Baptism of Constantine on the west facade of the church, above the entrance, and the dome was gilded; both decorations were probably in mosaic.

Fragments of the Justinianic mosaic decoration of St Sophia remain in the soffits of the nave arcades, the vaults of aisles and galleries and on the rim of the apse. The decoration is aniconic (non-figural), consisting of foliage ornament and geometric patterns set against gold backgrounds. The mosaic of the main vaults has been lost, some in earthquake damage, some replaced by redecorations of the ninth century and later. Here, too, the scheme was probably aniconic, since no description of the building mentions a figural programme earlier than that of the ninth century, and an argument from silence seems justified in the case of a church better served than most by the documentary record. Such decoration seems somewhat austere for a building that was supplied with the best of everything, but it may be explained by practical considerations. As noted above, the speed with which the building went up suggests imperial haste to have it completed, and a figural decoration would have taken longer than the aniconic one, which could be finished rapidly by a large crew of artisans. Further, given the great height of the vaults, a figural programme would have been difficult to read (a point confirmed by the poor legibility from the nave of the images installed in the ninth century). One other possibility, generally discounted now, is that Justinian chose an aniconic programme for St Sophia in order to avoid offending those factions hostile to the use of images in religion. The attribution of such a motive meets a serious objection, however, in an *ekphrasis* of Paul the Silentiary, which describes images on the sanctuary screen and altar-cloth of St Sophia that would hardly have been compatible with appeasement of iconophobes. Figures also decorated a room built over the southwest ramp of St Sophia shortly after Justinian's reign, forming part of the patriarchal palace alongside the church. The mosaic here included medallions containing busts, probably of Christ and the apostles, which were destroyed two centuries later during Iconoclasm (see next chapter).[18]

Although reticent about church decoration, Procopius gives a useful glimpse of secular iconography in his description of the Bronze Gate (Chalke) of the Imperial Palace. According to his account, there were mosaics here depicting Justinian's general Belisarius in scenes of conquest, and Justinian, Theodora and the Senate in formal triumph over the Kings

17 Striker & Kuban, 'Kalenderhane', *DOP* 25 (1971) 251–8; Harrison, *Temple* (see n.6) 78–9.

18 H. Kähler & C. Mango, *Hagia Sophia* (London 1967), 47; Mango, *Sources*, 72–102; R.S. Cormack & E.J.W.

Hawkins, 'The Mosaics of St. Sophia at Istanbul: The Rooms Above the Southwest Vestibule and Ramp', *DOP* 31 (1977) 175–251.

55 Detail of a floor mosaic found at the site of the Imperial Palace, Constantinople, (sixth century?).

of the Vandals and the Goths. 'Victory' imagery of this sort is also recorded for later Byzantine periods, and it was probably an important vein of secular art of which there is very little material evidence.

The only secular work to survive in Constantinople comprises substantial remains of a mosaic floor of the Palace, of uncertain date (fig. 55). The floor, which once edged a courtyard fronting a hall, has on it bucolic scenes, hunting scenes and fighting animals against a plain ground, with a border of foliage scrolls inhabited by birds, animals and masks. The naturalistic style of this mosaic has caused its attribution to the early fifth century, but documentary and archaeological considerations suggest that it is sixth-century work.[19]

The view of monumental art in sixth-century Constantinople is, then, decidedly indistinct. Outside the capital the lack of a complete programme in any church, and the non-uniformity of the parts that do survive in each case once again limits the extent to which decorations may be compared. Nevertheless some of the conventions that were emerging in the fifth century become more clearly defined. There are formal images of Christ, or the Virgin and Child, receiving the saint(s) to whom the church is dedicated, and its patrons and clerics. Narrative imagery is also used, sometimes combining symbolic purpose with the illustrative one, according to the particular circumstances of each monument. In style too, while there are variations of the sort to be expected in work by different hands in

19 D. Talbot-Rice, *The Great Palace of the Byzantine Emperors* (Edinburgh 1958), and the review by C. Mango & I. Lavin in *AB* 42 (1960) 67–70; P.J. Nordhagen, 'The Mosaics of the Great Palace of the Byzantine Emperors', *BZ* 56 (1963) 53–68. J. Trilling, 'The Soul of the Empire: Style and Meaning in the Mosaic Pavement of the Byzantine Imperial Palace in Constantinople', *DOP* 43 (1989) 27–72.

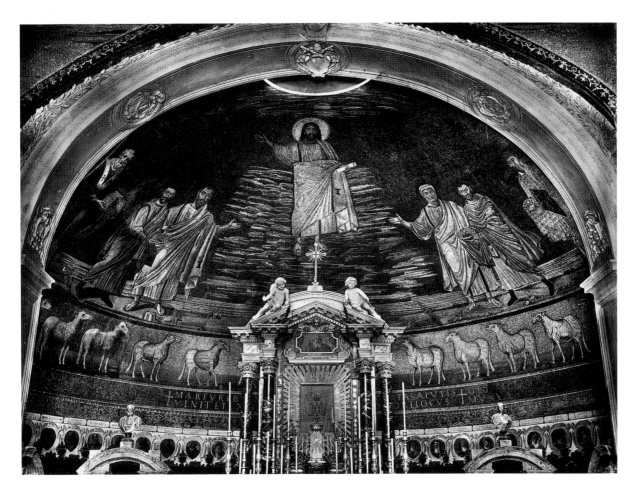

56 Mosaic decoration in the apse of Sts Cosmas and Damian, Rome (526–30): Sts Peter and Paul presenting Sts Cosmas and Damian to Christ, flanked by Pope Felix (restored) and St Theodore.

different locations there is a common thread in that the sixth-century mosaics, like those of the later fifth-century, lack naturalism and instead render details of anatomy, drapery and background schematically.

In Sts Cosmas and Damian in Rome the mosaic in the conch of the apse shows Christ receiving the two saints, who are presented by Peter and Paul; also present are Pope Felix IV (526–30) who commissioned the decoration, and St Theodore (fig. 56). The scheme is relatively straightforward, but the complete programme may have had subtleties that have been lost with the decoration of other parts of the church.[20] A similar scheme does form part of a programme of greater complexity in the basilica of Bishop Euphrasius at Poreč, former Yugoslavia (c. 550) (fig. 57). In the conch, the Virgin and Child flanked by angels receive St Maurus (a local martyr), three other saints, Bishop Euphrasius (offering a model of the church), Archdeacon Claudius and his son (also called Euphrasius). Below this, in five panels set between the apse windows, are the Annunciation, Zacharias (father of John the Baptist), an angel, John the Baptist, and the Visitation. Christ appears with the apostles on the east

20 Oakeshott, *Rome*, 90–4.

wall above the apse, and is also represented as a lamb in a medallion in the crest of the apse arch, among medallions depicting female saints. The scheme thus shows Christ in three aspects, as an infant, as an adult, and as a sacrificial lamb among martyrs. The Annunciation and Visitation may have opened a narrative sequence that once continued in the nave, but, as episodes in the life of the Virgin, they are also pendants to the image of the Virgin and Child in the conch. In conjunction with the fig-ures of Zacharias and John the Baptist, they have a third meaning, form-

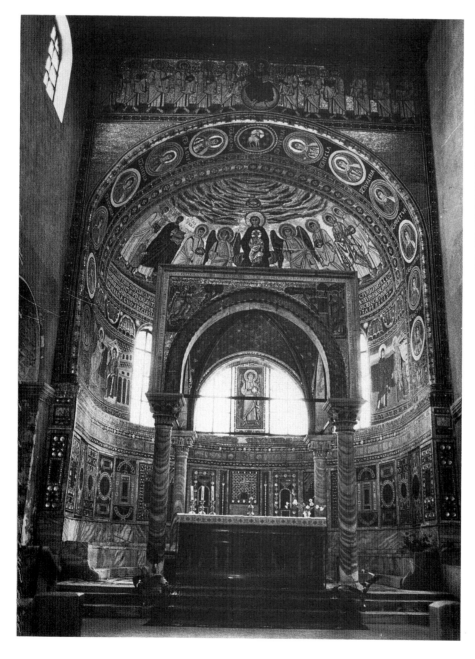

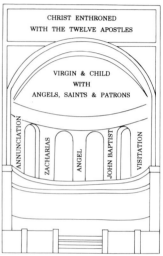

57 East end of the basilica of Bishop Euphrasius, Poreć (*c.* 550).

ing a set of references to the Incarnation, the subject of the Annunciation, which was also divinely revealed to Zacharias, declared by John the Baptist, and foretold by Elizabeth in the Visitation.[21]

A scheme with still more components is found at San Vitale in Ravenna, a church founded in 526, when bishop Ecclesius was in office, dedicated in 548 under his successor Maximian and paid for by the banker Julianus Argentarius (fig. 58). The conch of the apse again refers to the dedication and the initial patronage of the church, with an image of

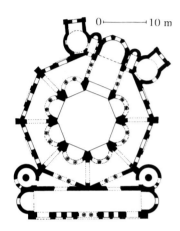

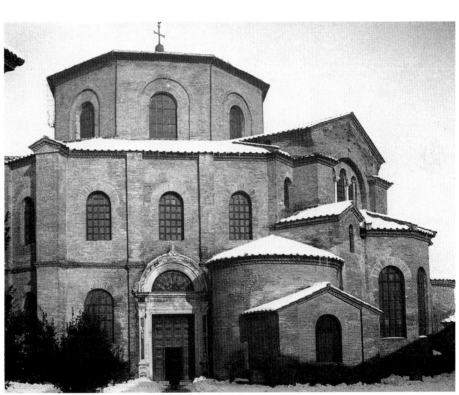

58 San Vitale, Ravenna (526–48): plan, after Deichmann; view from the east; overleaf: mosaic of the sanctuary bay and apse, including a panel showing Justinian and attendants.

Christ enthroned on a globe, flanked by angels, St Vitalis and Bishop Ecclesius, the latter presenting a model of the church. Theological and liturgical themes are expressed in the sanctuary bay, where episodes from Old Testament narratives form part of a complex programme of symbolic references. Abraham's sacrifice of Isaac, for example, prefigures God's sacrifice of his Son, while Moses receiving the Law prefigures Christ, who brought the new law. The priest-king Melchisedek may be included to parallel the role of the Byzantine emperor as God's earthly representative. Two famous panels on the apse wall show, at one side, Justinian with bishop Maximian, an unnamed figure (possibly Julianus), deacons, officials

21 B. Molajoli, *La Basilica Eufrasiana di Parenzo*, 2nd edn. (Padua 1943); J. Maksimović, 'The Iconography and the Programme of Mosaics at Poreć (Parenzo)', *Mélanges Ostrogorsky* (Belgrade 1964), II, 247–62.

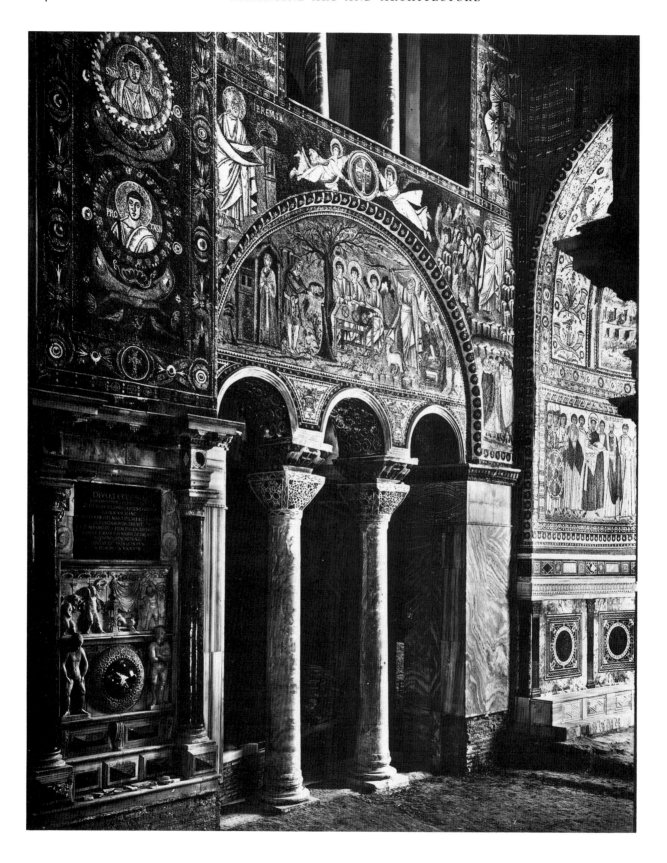

59 Mosaic panel in St
Demetrios, Thessalonike,
showing the saint with donors
(sixth century).

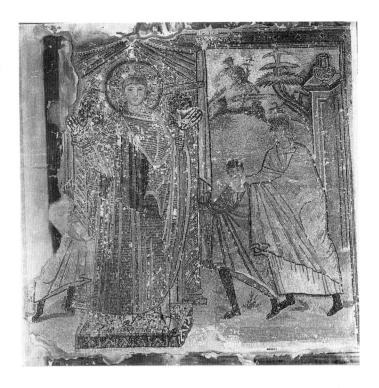

59 Mosaic panel in St Demetrios, Thessalonike, showing the saint with donors (sixth century).

and guards (fig. 58), and at the other, Theodora, with a retinue of women
and two male court dignitaries. Emperor and empress bear a dish and a
chalice respectively, and the panels are thought to represent imperial
participation in the offertory procession that was part of Byzantine church
ritual, linking the imperial couple to the liturgical functions of the sanctu-
ary bay. Justinian and Theodora were not patrons, however, and their
presence is related to the political context: Ravenna was occupied by the
Arian Goths in 493 and did not return to Byzantine control until 540.
Maximian and Julianus were agents of Constantinopolitan orthodoxy, and
one purpose of the panels seems to have been to establish the imperial
'presence' in Ravenna (as indeed does the double-shell church itself, since
the form is an import from Constantinople). Thus, a political message is
added to the theological, liturgical and dedicational messages of the sanc-
tuary.[22]

It is clear from all the above examples that the chief patrons of a
church were usually acknowledged in the decoration of the sanctuary
bay. Rare evidence of the representation of lesser patrons comes from a
mosaic frieze in St Demetrios, Thessalonike, probably installed during the
first quarter of the sixth century, of which records were made before its
destruction by fire in 1917. This frieze, above one of the nave arcades of
the five-aisled basilica, consisted of panels showing St Demetrios and/or
the Virgin, attended by small figures of patrons (fig. 59). As noted in the

22 Deichmann, *Ravenna*, 11.2, 47–230; 111, 280–375;
 Beckwith, *ECBA*, 50–2.

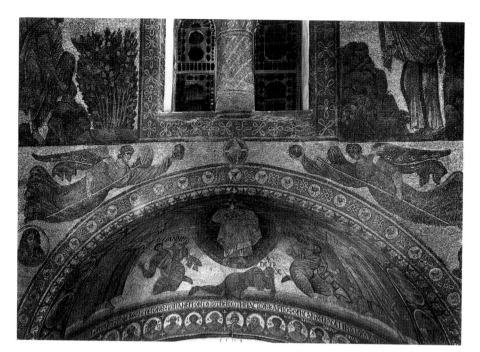

60 Church of the Monastery of St Catherine, Mount Sinai. Mosaic decoration of the apse and east wall (548–65).

last chapter, St Demetrios is a shrine-church, built in the mid-fifth century when the cult of this saint, who was a fourth-century deacon martyred in Sirmium (Serbia) moved to Thessalonike. (His legend changed with the move, and he was remodelled to become a soldier who met martyrdom in Thessalonike.) The founder of the great basilica is likely to have been the Prefect Leontios, who came from Sirmium (and who might have been represented elsewhere in the church, probably in the apse decoration). The sixth-century patrons represented in the mosaic frieze were probably members of the congregation or pilgrims to the shrine, who hoped for divine benevolence in return for donating the cost of the panels. Votive panels of this sort may well have been more common than this isolated example suggests, forming a minor part of the decorative programme in areas outside the sanctuary from which decoration is usually lost.[23]

As has already been seen in San Vitale, narrative imagery could be used for symbolic purpose. In the church of the monastery of St Catherine at Mount Sinai (548–65), the conch houses a Transfiguration (the divinity of Christ revealed on Mount Tabor, when three apostles saw Christ shining with light and flanked by the prophets Moses and Elijah) (fig. 60). This subject was probably chosen because it demonstrates the dual nature of Christ, both human and divine, thus declaring the orthodox position in an issue central to the theological debates of the sixth century. Other functions of the apse programme are supplied by scenes which refer to the site (Moses and the Burning Bush and Moses Receiving the Tablets of the

23 R.S. Cormack, 'The Mosaic Decoration of St. Demetrios, Thessaloniki', *ABSA* 64 (1969) 17–52.

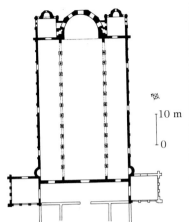

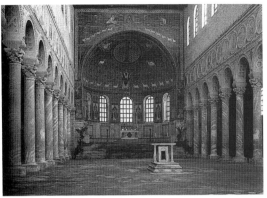

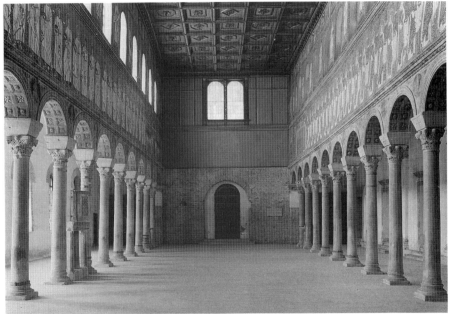

61 San Apollinare in Classe, near Ravenna (549): plan, after Deichmann; interior view to the east.

62 San Apollinare Nuovo, Ravenna, early sixth century with alterations to the mosaic decoration after 655. View of the nave towards the west, showing three registers of mosaic decoration: above, between and below the windows.

Law), and by medallions framing the apse, containing busts of apostles, and of Longinus the *hegoumenos* of the monastery and John, a deacon. The narrative element of the scene is reduced – all background detail of Mount Tabor is eliminated and the figures are placed against a gold ground, in a symmetrical arrangement about the central figure of Christ. An even more 'symbolic' treatment of the Transfiguration is found in the apse at San Apollinare in Classe (dedicated 549), where the three apostles are represented as sheep, and Christ as a great cross with a tiny bust-medallion at its centre (fig. 61). Below, a figure of St Apollinarius signals the dedication of the church.[24]

The only church to preserve a sixth-century narrative sequence is that of San Apollinare Nuovo in Ravenna (fig. 62). Here, the upper regis-

24 Forsythe & Weitzmann, *Sinai* (see n.5) pls CIII–CXXIX; Deichmann, Ravenna, II.2, 233–80; III, 376–413.

ter of the nave decoration has on one side thirteen scenes of a Ministry
cycle (from the Wedding at Cana to the Healing of the Paralytic) and on
the other thirteen scenes of a Passion cycle (from the Last Supper to the
Doubting of Thomas). Attempts to find liturgical reasons for the choice of
episodes are unconvincing and the images are best understood as straight-
forward narrative cycles. They form part of an extensive mosaic decora-
tion, which also has symbolic elements, installed when the church was
built by the Arian Goth Theodoric in the early sixth century and altered
when re-dedicated in 556 after Ravenna returned to orthodoxy.[25] The
placing of the narrative cycles recalls the arrangement at Sta Maria
Maggiore, and suggests that the nave was the usual site for this compo-
nent, not seen in the other churches because only their apse or sanctuary
decorations remain. More evidence for this comes from an account by
Choricius of Gaza, who describes the church of St Sergius at Gaza (built
before 536, now lost). The main apse contained a 'holy court' image, with
the Virgin and Child receiving St Sergius and Stephen, the governor of
Palestine, the latter probably presenting a model of the church. The side
apses had aniconic decorations, of chalices, vine-scrolls and birds, and the
nave (probably painted) had a New Testament narrative cycle of over
twenty episodes (from the Annunciation to the Women at the Tomb, plus
the Ascension in the dome). The large number of scenes, in consecutive
order, suggests that narrative was their chief, and perhaps only purpose;
Choricius describes the episodes in detail, but makes no suggestion of sym-
bolic meaning.[26]

A decoration of a different sort is found in the monastery of Sts
Samuel, Symeon and Gabriel at Kartmin, in the Tur Abdin region of
Mesopotamia. The mosaic of the apse and sanctuary bay of the church of
Mar (saint) Gabriel, consists of vine-scrolls, crosses and altars beneath
ciboria (ornate canopies). Unlike that of St Sophia, this aniconic pro-
gramme probably does reflect the opposition to the use of figures in reli-
gious art that was strong among the monophysites of the east. The work
is attributed to 512 by documentary sources and may have been the com-
mission of Anastasius.[27]

The mosaics at Kartmin and Mount Sinai and the account of
Choricius make up almost all that is known of sixth-century monumental
art in the eastern provinces. Moreover, some would dissociate the mosaic
of Mount Sinai from its eastern context, on the grounds that its high qual-
ity and imperial patronage make it likely that the mosaicists were sent
from Constantinople. This may be so, but not all high-quality workman-

25 Archbishop Agnellus (successor to Maximian in 556)
re-dedicated the Arian churches of Ravenna and the
cathedral became the church of St Martin (a
conspicuous anti-Arian). A later re-dedication, to St
Apollinarius, came in the ninth or tenth century.
Deichmann, *Ravenna*, II.I, 125–89, III, 97–213.

26 Choricius, *Laudatio Marciani* I, 17f, trans. Mango,
Sources, 60–8.

27 E.J.W. Hawkins & M. Mundell, 'The Mosaics of the
Monastery of Mar Samuel, Mar Simeon and Mar Gabriel
near Kartmin', *DOP* 27 (1973) 280–96.

ship must be attributed to Constantinople, and since Justinian used an architect from Palestine to build the monastery, he may also have sent no further for the mosaicists. Although evidence of wall-mosaic in sixth-century Syria and Palestine is scarce, tesserae have been found at several sites, including Qasr' ibn-Wardan, the Holy Cross at Resafa and St Symeon the Younger, near Antioch. Given also that there are remains of floor mosaic at many sites, it is evident that the east was well supplied with artisans skilled in mosaic technique.[28] They may also have produced wall-mosaic, of which the remains are few because in so many cases the upper parts of buildings do not survive.

As the above survey shows, it is possible to identify common functions in the design of church programmes at opposite ends of the empire. The most conspicuous is that of the sanctuary decoration, which was to identify the theological and hagiological concerns of the church, and to acknowledge its patronage. Although the evidence for both narrative cycles and votive panels is scant, these too may have been frequent components of church decoration, either in combination with complex sanctuary programmes or, it may be guessed, as the principal embellishment of the many churches not distinguished by important patrons or by clerics with enthusiasm for theological symbolism.

Minor arts

The starting point for the study of sixth-century minor arts must again be the dated or datable commemorative gift, which in both secular and ecclesiastical contexts provides chronological anchorage for groups of objects with common stylistic and iconographic features. The most important fixed points for ivory carving are the consular diptychs, introduced in the last chapter, of which one or both panels remain of over twenty-five examples made between 506 and 541, after which no more consuls were appointed. Even fixed points waver, however, and a diptych of Basil, until recently identified as the consul of Rome in 480, has now been assigned to a later Basil, consul in Constantinople in 541, although the piece may have been made in Rome. Recent scholarship has also recognized that a diptych of Orestes (Rome 530) is a reworked piece originally made for Clementius (Constantinople 513).

The surviving sixth-century diptychs represent only ten consuls, since there is sometimes more than one for a single consul – there are seven made for Areobindus (506), for example, and four for Anastasius (517). This uneven survival rate suggests either that some consuls distributed far more diptychs than others, or that some kept 'stocks' of their diptychs that were preserved intact for some time. Whatever the explanation,

28 Djobadze, *Antioch* (see n.12) 77; M. Bonfioli, 'Syriac-Palestinian Mosaics in connection with the Decoration of the Mosques at Jerusalem and Damascus', *East and West* n.s. 10 (1959) 57–76.

the groups show that a consul might have more than one kind of diptych. Areobindus had three (fig. 63 a–c). The most elaborate shows him enthroned, holding the sceptre and *mappa* of his office, presiding at the circus in the bottom part of the panel, below a crescent of spectators. The second type has a central medallion containing a bust of the consul, with monograms above and below it, all enclosed by a lozenge of stylized foliage. The third and simplest type, with no portrait, has entwined cornucopiae, a basket of fruit, a monogram and an inscribed tablet. All sixth-century consular diptychs are of one of these three types, with only minor variations (the circus scene of the first type may be replaced by the hippodrome, or a scene of tribute, with small figures emptying sacks of coins or goods at the consul's feet). They were probably made for presentation to recipients of differing ranks, with the elaborate 'circus' diptych reserved for the most esteemed. Most of the consuls are shown as round-faced young men, with staring eyes and pudding-basin hairstyles – evidently a generalized type since the difference between individuals is no greater than that between some images of the same consul. Philoxenus (525) alone presents a more individual appearance – he is square-jawed and jowly – but so is the female figure personifying Constantinople who

63 Ivory diptychs of Areobindus, Consul of Constantinople in 506: (a) whole diptych with cornucopiae and monograms (Lucca, Duomo); (b) leaf with the Consul presiding at the circus (Paris, Musée de Cluny); (c) leaf with a bust of the Consul in a medallion (Paris, Louvre).

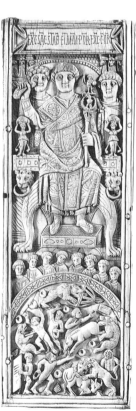

64 Ivory diptych of Philoxenus, Consul of Constantinople in 525, panels set in later metal mounts (Paris, Bibliothèque Nationale).

shares his diptych, so the physiognomy of both must be linked to the style of the artist rather than to the appearance of the subject (fig. 64). The inscriptions giving the name and titles of the consul are usually in Latin, but Clementius (513), presiding over a tribute scene, is named in both Latin and Greek, and two diptychs of Philoxenos give his name and titles in Latin and a salutation to the recipient in Greek. It is not clear why these diptychs alone were bilingual, but they reflect a cultural context in which Greek had already replaced Latin as the lingua franca of the empire, and was increasingly that of administration also.

With the exception of the diptych of Orestes (Rome 530), the sixth-century diptychs represent consuls of Constantinople. It has been proposed that this imbalance indicates a shortage of ivory or ivory carvers in Rome, a circumstance that might also explain why the Orestes example was made by re-cutting an earlier piece, as noted above. The proposition finds other support in the poor quality of the recently reallocated Basil (541) panel, which seems also to have been made in Rome. (And thus invites explanation as to why Basil would order his diptych(s) from a second-rate Roman carver, when he had access to high quality work in the capital – but idiosyncracy may always defeat scholarship.)[29]

29 R. Delbrueck, *Die Consular-Diptychen und verwandte Denkmäler* (Berlin 1929), nos. 9–19, 29–31, 16; A. Cameron & D. Schauer, 'The Last Consul: Basilius and his Diptych', *JRS* 72 (1982) 126–45; N. Netzer. 'Redating the Consular Ivory of Orestes', *BM* 125 (1983) 265–71.

A few ivories with imperial images are attributed to the sixth century, the best known being a five-part panel in Paris (Louvre) (fig. 65). In the centre an emperor rides a horse which rears above a personification of Earth; a Nike (victory) hovers to the right and a subject barbarian is nearly hidden behind the horse; to the left, a soldier offers a Nike statue (as probably did another at the right, where the piece is lost); at the top a pair of flying angels display a bust of Christ, and at the bottom Asian and African tribute-bearers offer goods. The style and iconography of the panel links it to the consular diptychs and there are vestiges of hinge marks on one edge, so the piece is thought to be one half of an imperial diptych,

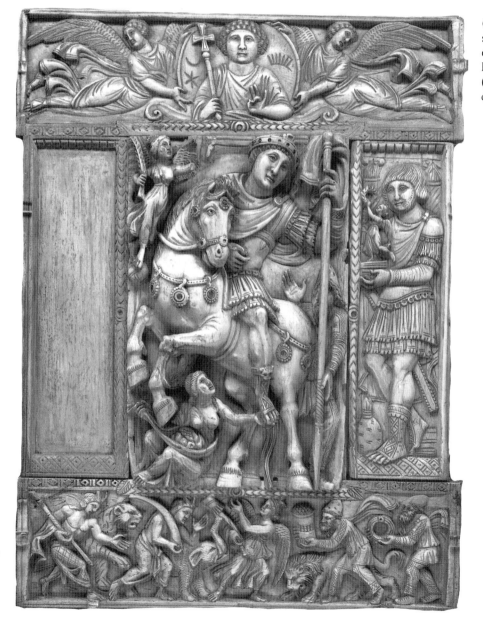

65 Ivory panel in five sections, showing an equestrian emperor; possibly half of an imperial diptych (Paris, Louvre, fifth or sixth century).

66 Ivory panel showing an archangel, one leaf of a diptych (sixth century?) (London, British Musuem).

67 Ivory diptych of the sixth century: on the left panel, Christ between Sts Peter and Paul, on the right, the Virgin and Child between angels. (Berlin, Staatliche Museen, Frühchristlich-Byzantinische Sammlung).

made for presentation to senior dignitaries by the emperor on his accession. Opinions as to which emperor is represented have ranged from Zeno (474–91) to Justinian (527–65), a matter which cannot be settled by reference to imperial images in other media, given the lack of true portraiture mentioned above. Similarly, an empress who appears in two separate panels (in Vienna and Florence) is usually identified as Ariadne (d. 518), the wife first of Zeno and then Anastasius, but the panels bear no inscriptions and may even represent different empresses, as was proposed for the monumental heads mentioned above. The empress panels lack frames, and so may have been the centre-pieces of five-part pieces like the Louvre ivory, either representing the empress alone, or perhaps forming parts of diptychs made for imperial couples, with the emperor on the other leaf, of which, however, no example survives. A panel in London, showing an archangel beneath an arch, may also have been one leaf of an imperial diptych, since the angel apears to offer the globe (symbolizing imperial rule) to whoever was represented on the lost second panel (fig. 66). The meaning of the inscription overhead is unclear, but it would appear to be

68 Ivory diptych (sixth century?) made of two five-panelled leaves (Paris, Bibliothèque Nationale) left: the Virgin and Child between angels, flanked by the Annunciation, Visitation, Test by Water, Journey to Bethlehem, with the Entry into Jerusalem below; right: Christ between Sts Peter and Paul, flanked by miracles of healing, with the Samaritan Woman and the Raising of Lazarus below.

a prayer to the angel for benevolence. Although they cannot be dated precisely, general stylistic affinities with the consular diptychs place all these panels in the first half of the sixth century, and their imperial nature makes Constantinople the most likely place of production.[30]

Several liturgical ivories are also assigned to the sixth century on grounds of stylistic and iconographical links with the consular diptychs. A diptych in Berlin, for example, showing Christ enthroned between Peter and Paul on one panel and the Virgin and Child enthroned between angels on the other, echoes the formula of the 'circus' consular diptychs, and reproduces aspects of their style, particularly in the round faces of Virgin, Child and angels (fig. 67). Both panels have been trimmed: a sigma

30 Volbach, *Elfenbeinarbeiten*, nos. 48, 51–2; *Age of Spirituality*, no. 481.

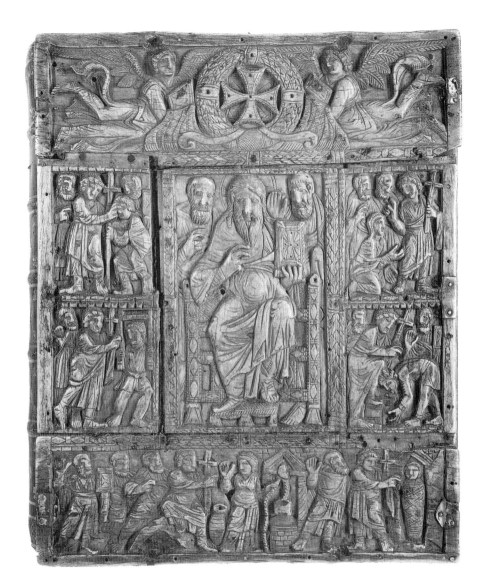

in the lower border of each must have been part of a monogram in a lower field which probably identified the donor(s) of the panels. The panels are usually attributed to Constantinople on the basis of their high quality and the stylistic features they have in common with the archangel panel.[31]

Five-part ivories like the Louvre equestrian emperor also have ecclesiastical parallels. A pair in Paris show, on one panel, Christ between Peter and Paul at the centre, flying angels holding a cross above, and miracles of healing from the Ministry of Christ at the sides and below (fig. 68). The other panel is similar, but with the Virgin and Child between angels at the centre, scenes of the Infancy of Christ at the sides and the Entry into Jerusalem at the bottom. The same formula is found in a pair of panels now in Yerevan, Armenia, a single panel in Ravenna (formerly in

31 *Age of Spirituality*, no. 474.

Murano) and in a third which has its sections dispersed (Manchester, Berlin and St Petersburg).[32] Differences of style, quality and iconographical detail make it unlikely that these five-part panels were closely related. They may have been made in several locations, using a widespread formula whose variations reflect the particular customs or concerns of patrons or communities. The original purpose of the panels is not certain. The Paris and Yerevan pairs have been used as book covers at least since the tenth century, but they may have been made as liturgical diptychs or portable icons.

69 Chair of Maximian (546–56), Ravenna.

The ivory panels on the chair (*cathedra*) of Maximian, in Ravenna, retain their original context – albeit with more than one rebuilding of the chair (fig. 69). Panels of three types are attached to a wooden base: five across the front bear figures of John the Baptist and the four evangelists, each framed by an arch; panels on the back and sides form narrative cycles – the Infancy and Ministry of Christ and the Life of Joseph – and an enclosing framework of strips is decorated with luxuriant vines issuing from chalices and housing a variety of birds and beasts. The prominence given to John the Baptist is thought to reflect the role of the bishop as witness to the rite of baptism, and the narrative cycles juxtapose Jesus and Joseph as ideal rulers, models for the priesthood. On the front of the chair, interrupting the vine-scroll, is the monogram of Maximian, the sixth-century bishop of Ravenna who appears with Justinian in the mosaic panel in San Vitale, noted above.[33] The chair must have been made during Maximian's term of office (546–56), but not necessarily in Ravenna. The figure panels of the front have the flowing draperies and deeply-cut details of hair and beards seen in the Berlin diptych and the London archangel, both generally attributed to Constantinople, so it is argued that the chair may have been the gift of Justinian, made in the capital and sent to Ravenna to mark the dedication of San Vitale in 548. The narrative panels are of notably poorer quality than the figure panels, however, so possibly the latter alone were an imperial gift, used by a Ravenna workshop in combination with its own narrative panels. Alternatively, differences in quality may be accounted for by supposing that the chair was made by a single workshop (in either location), by several craftsmen of differing abilities.

70 Ivory pyxis showing Daniel among the lions, protected by an angel. (Washington DC, Dumbarton Oaks Collection no. 36.22.)

Other ivory panels, decorated with figures or narrative episodes and attributed to the sixth century on stylistic or iconographical grounds, probably formed parts of larger objects – boxes, diptychs or furniture. There are also some forty cylindrical boxes made of sections of elephant tusk (pyxides) decorated with a range of Old and New Testament subjects, typically symbolizing deliverance or resurrection, such as Daniel and the Lions and miracles of healing (fig. 70). They may have served liturgical

32 Volbach, *Elfenbeinarbeiten*, nos. 125, 142, 145; *Age of Spirituality*, nos. 457–61.

33 Volbach, *Elfenbeinarbeiten*, no. 140; Beckwith *ECBA*, 52;

M. Schapiro, 'The Joseph Scenes on the Maximianus Throne in Ravenna', *GBA* 40 (1952) 27–38.

purposes, as containers for incense, for example, but their decoration might simply reflect the faith of their owners. The pyxides are of various styles and qualities and probably originated in several different parts of the empire in the fifth and sixth centuries. Less cautious attributions of date and provenance may be found in handbooks and catalogues, but they should not be accepted uncritically.[34]

Chronological anchorage for sixth-century metalwork is given by pieces with mint stamps and/or datable inscriptions. Hoards of silver are again important sources of these pieces, but while most of the earlier hoards were found in the west, and secular objects predominated, the sixth-century hoards contain mostly church plate and come from the Middle East and Anatolia. Until recently, the literature dealt with several sixth-century Syrian hoards, but it is now argued that some of these (known as the Stuma, Riha, Hama and Antioch treasures) were once a single hoard, found at Stuma and then dispersed in several batches (fig. 71). This single hoard, now called the Kaper Koraon treasure, after the vil-

71 The Hama Treasure, part of the Kaper Koraon Hoard, as it was found in 1910 (Walters Art Gallery, Baltimore).

lage named in inscriptions on some of the pieces, contains objects dated between 540 and 640 by their stamps; two more hoards, the Phela and Beth Misona treasures, may also be part of the same large cache, making a total of sixty-six objects. Smaller hoards, of just a few objects each, are associated with other middle-eastern locations and a second large hoard, the Sion treasure, with over sixty pieces, was found at Kumluca, near Antalya in central Turkey.[35]

34 Volbach, *Elfenbeinarbeiten*, nos. 89–106, 161–201.
35 M. Mundell-Mango, 'The Origins of the Syrian Ecclesiastical Silver Treasures of the Sixth-Seventh

Centuries' in *Argenterie Romaine et Byzantine*, ed. F. Baratte (Paris 1988), 163–86.

72 The Riha Paten (565–78) embossed silver, showing the Divine Liturgy. (Washington DC, Dumbarton Oaks Collection no. 24.5)

The Kaper Koraon hoard, which was probably the church treasure of several villages, assembled and concealed in time of strife, demonstrates the range and quality of the church plate that might be possessed by small communities in the eastern provinces. It includes chalices, patens, candlesticks, crosses, hanging lamps, ewers, spoons, fans, plaques (possibly bookcovers, or revetment panels) and a few secular pieces probably given to the church for their monetary value. Many pieces have inscriptions invoking divine benevolence for the donors, most of whom are without titles – the four exceptions are a bishop and three civil servants, ranging from high to modest levels. Many pieces are plain except for inscriptions, crosses and chi-rho monograms but some are decorated with figure subjects: a chalice has embossed figures of four apostles and two crosses in an arcade; a narrow flask has orant figures of Christ, the Virgin and two saints; two liturgical fans, the earliest surviving examples of such objects, are decorated with peacock feathers, seraphim and cherubim. Two patens with stamps of Justin II (565–78) (known as the Riha and Stuma Patens), have embossed images of the Divine Liturgy, a symbolic image in which Christ, shown twice, administers the bread and wine of the eucharist to two flanking groups of six apostles (fig. 72). This is the earliest securely dated example of this iconography, which becomes an important component of middle-Byzantine monumental art. Lamps from the hoard are of two types, hanging and standing (one of the standing lamps is a very fine piece, decorated with vine-scrolls inhabited by birds and figures, often catalogued as the 'Antioch chalice'). Small crosses drilled with holes may have been worn, or were perhaps mounted on larger objects, such as reliquaries or other containers. Larger crosses with spikes (tangs) at their bases may have been carried on poles or set in fixed stands. Both types are splayed-arm Latin crosses, without decoration except for their dedicatory inscriptions. The 'plaques' are so called because their function is uncertain: four panels with embossed figures form two pairs, one with Peter and Paul, the other with paired figures (probably evangelists) holding large crosses between them. These subjects are appropriate to book covers (of

73 Silver paten of bishop Paternus (*c.* 518), with chi-rho monogram, dedictory inscription and inhabited vii border. (St Petersburg, Hermitage.)

epistles and gospels respectively), but the panels would also make suitable decoration for screens or other items of church furniture.[36]

The Sion hoard, found at Kumluca near Antalya, in central Anatolia, consists of over sixty objects, some commissioned by a bishop, Eutychianos, with inscriptions invoking 'Holy Sion'. The hoard is probably to be associated with a sixth-century monastery in the region, founded by Nicholas of Sion. The range of objects – chalices, patens, plaques and lamps – is similar to that of the Kaper Koraon treasure, and most comparable pieces in the two hoards have general similarities of form but differences of detail. This suggests that the objects were of local manufacture in each case, using standard forms but treating them according to local traditions. The point is relevant to the significance to be attached to the imperial stamps found on several items of each treasure. Although these are usually taken to indicate Constantinopolitan manufacture, it is unlikely that patrons in Syria and central Anatolia would have sent so far for church plate and it may be that imperial stamps were applied to the products of state silver factories in several parts of the empire (the Kaper Koraon pieces could have come from Antioch, for example). The purpose of stamping, then as now, was to indicate standard qualities and weights, and it may be supposed that the large number of silver pieces without such stamps were the products of other, private, manufactories.[37]

In 1912, a few Byzantine objects were found in Malaja Perescepina, south Russia, in a hoard made up of pieces of various provenances and dates. They include a ewer, an amphora, a trulla (dish with one handle) and a paten, which are all high-quality pieces with embossed decoration and gilding. The paten, of *c.* 518, is of particular interest because its Latin inscription claims that it was 'renovated' (*ex antiquis renovatum*) by Bishop

36 M. Mundell-Mango, *Silver from Early Byzantium* (Baltimore MD 1986).

37 S. Boyd, 'A Bishop's Gift: Openwork Lamps from the Sion Treasure' in Barette, ed., *Argenterie* (see n.35), 191–209;

E. Kitzinger, 'A pair of bookcovers in the Sion Treasure' in *Gatherings in Honor of Dorothy E. Miner* (Baltimore MD 1974) 3–17; Dodd, *Silver Stamps*, 23–34; Mango, *Silver from Early Byzantium* (see n.37) 13–15.

Paternus (probably of Tomi, on the Black Sea) (fig. 73). The paten has a chi-rho monogram at its centre, surrounded by the inscription, and an elaborate rim decoration of inhabited vine-scroll with settings for eight jewels. The piece is said to be all of one phase of manufacture, so the meaning of the inscription is not obvious – possibly the metal used came from an earlier object. Reworking of precious metal is not uncommon, but its declaration in an inscription implies veneration of whatever was re-used or reworked – a liturgical object from the Holy Land, perhaps.[38]

Most hoard objects are high-quality pieces made of precious metals and therefore worth concealing. Another kind of value led to the preservation of some three dozen small flasks (ampullae) in the treasuries of Monza and Bobbio cathedrals in Italy (fig. 74). Of modest craftsmanship, and made of tin/lead alloy, these were reliquary-souvenirs made to contain sacred oil from the Holy Land (and probably representative of such objects made for the pilgrim traffic at many shrine sites). The attribution of the ampullae to the sixth century rests upon the tradition that they were given to the Lombard queen Theodelinda by Pope Gregory, whose term of office was 590–603. They may already have been old when he donated them, but dates somewhere in the sixth century seem plausible. Most of the ampullae have embossed images of the Crucifixion and Resurrection, and some also show Virgin and Child, the Annunciation, Visitation, Baptism and Ascension – all scenes referring to the chief shrine sites of Palestine. It has been suggested that the scenes take their iconography from the apse decorations of the shrine-churches, but this view is contested by the lack of iconographical uniformity of individual scenes. The Crucifixion, in particular has several variants. It may be shown in narrative manner, with Christ on the cross, wearing a long tunic (*collobium*) between thieves, or symbolically, with Christ shown either as an enthroned figure, or in a bust-medallion, above a cross, which may be flanked by angels, kneeling figures, or the sponge-bearer and lance-bearer. While not useful in reconstructing the lost monumental art of the shrine sites, therefore, the ampullae are of interest because they demonstrate a range of iconographic variants in objects of common provenance, a point to be resumed at the end of this chapter.[39]

74 Ampulla made to hold oil from the Holy Land, sixth century (Monza, Cathedral Treasury). Embossed decoration shows the Crucifixion (partly symbolic) above, with the Women at the Tomb below.

Several secular items of sixth-century metalwork are embellished with bucolic or mythological pagan subjects. A dish in St Petersburg, for example, decorated with a shepherd, goats and a dog, and the fragment of another in Washington with Silenus and a satyr, both have stamps of the period of Justinian (fig. 75). The embossed decoration is in a style rooted in naturalism, and the pieces may well have been attributed to the previous century but for their stamps. They suggest, therefore, that conservative taste governed the production of at least some secular metalwork in the

38 A. Bank, *et al, Spätantike und frühbyzantinische Silbergefässe aus der staatlichen Ermitage Leningrad* (Berlin 1978), 107, 138, 164.

39 A. Grabar, *Ampoules de Terre Sainte. Monza-Bobbio* (Paris 1958); G. Vikan, *Byzantine Pilgrimage Art* (Washington DC 1982), 20–7.

75 Silver dish with embossed shepherd and flock and date stamps of the Justinianic period. (St Petersburg, Hermitage.)

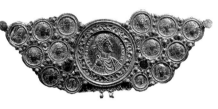

76 Pectoral ornament made of coins (sixth century). (New York, Metropolitan Museum of Art 17.190.1664; gift of J. Pierpont Morgan 1917.)

sixth century (and beyond, for similar pieces are found with seventh-century stamps).[40]

A few pieces of sixth-century jewellery are datable because they are made of coins and specially struck medallions. A pectoral (an ornament worn on the chest) found in Egypt and now in New York is made of coins of various dates from the fourth to the sixth centuries, and a medallion showing the head of an emperor surrounded by an inscription in garbled Greek (fig. 76). Medallions of this sort were probably struck in Constantinople as commemorative issues, and distributed to persons of rank throughout the empire, but the illiterate inscription of this one suggests that there was also a traffic in provincial imitations. A medallion found in Cyprus is of similar type, but has an image of the Baptism on one side, and the Virgin and Child, Nativity and Adoration of the Magi on the other. This piece was once thought to have been made in Syria or Palestine for the pilgrim trade, as a souvenir of the sites of the Nativity and Baptism, like the Monza/Bobbio ampullae. Recent opinion, however, attributes it to Constantinople, and to the occasion of the baptism of the son of Maurice Tiberius in 584, on the Feast of the Epiphany, a context which would also account for the subject matter.[41]

By the mid-sixth century the portable (or, at least, moveable) icon had become an important adjunct to Byzantine worship. From the literary evidence it is clear that icons were used both in public – in churches and martyria – and in private, for individual devotions. Some were credited with miraculous powers, to cure the sick, grant the desires of the devout, or protect the traveller. Some were thought to have been miraculously created, 'made without hands' (*acheiropoietos*).[42] The Monastery of St Catherine at Mount Sinai, mentioned above as part of Justinian's empire-wide building programme, houses a large number of icons, over 150 of them Byzantine. Most of these are middle-Byzantine or later, but six are attributed to the sixth century, and a dozen more to the sixth/seventh centuries, on grounds of iconographic or stylistic similarity to datable material elsewhere, especially monumental art. There are also technical grounds, in that the icons are painted in encaustic, a method in which the pigments are mixed with wax. This technique seems to have been little used after the sixth century, when it was superseded by tempera, for which the medium is egg-yolk.

Most of the early Sinai icons are portrait busts or standing figures of Christ, the Virgin and Child, saints, prophets and archangels. This type probably developed from the pagan Roman custom of placing portraits in funerary contexts, an ancestry evident in an icon of St Peter, painted in

40 Dodd, *Silver Stamps*, nos. 9 & 10.
41 *Age of Spirituality*, nos. 287, 295; W. Dennison, *A Gold Treasure of the Late Roman Period* (London 1918); M. Ross, 'A Byzantine Gold Medallion at Dumbarton Oaks', *DOP* 11 (1957) 247–61; P. Grierson, 'The Date of the Dumbarton Oaks Epiphany Medallion', *DOP* 15 (1961) 221–4.

42 J. Herrin, 'Women and the Faith in Icons in Early Christianity' in R. Samuel & G.S. Jones, eds., *Culture, Ideology and Politics* (History Workshop Series 1982), 56–83.

77 Encaustic icon of St Peter (sixth century?) (Monastery of St Catherine, Mount Sinai).

78 Encaustic icon of the Virgin and Child with saints and angels (sixth century?) (Monastery of St Catherine, Mount Sinai).

the naturalistic manner and three-quarter-face attitude seen in the portraits that have been preserved in Egyptian burials of Roman colonists (fig. 77). The saint is placed against a niched wall, below three bust-medallions, the central one of Christ and the others probably John the Evangelist and the Virgin, who stood either side of Christ at the Crucifixion. A similar niched setting is present in an icon of the Virgin and Child enthroned between two saints (possibly Theodore and George) with a pair of angels behind them (fig. 78). This formula, seen also on the Berlin ivory diptych mentioned above, is derived from imperial iconography. It indicates a second antecedent of the Christian icon in the Roman portraits used to represent an emperor or other dignitary not physically present at an event (the custom is with us still in the portraits of heads of state displayed in embassies). A third encaustic icon, the style of which has been distorted by repainting, depicts Christ as Pantocrator (ruler of all), a half-figure with long hair and beard, holding a book in the left hand and blessing with the right. These three are larger than most of the early Sinai icons (St Peter, at ninety-two centimetres in height is the largest) and they were probably made for display in church. Others are smaller, averaging thirty centimetres in height, and are likely to have been for private use. Some were originally the wings of triptychs, a convenient form for the portable icon since it could be closed for transportation.[43]

Portability is relevant to the question of the provenance of the early Sinai icons and, indeed of many later ones. While it is not impossible for

43 Weitzmann, *Sinai*, B5, B3, B1, B18–20, B22–5, B33–5.

an isolated desert monastery to be a centre of artistic production, the wide range of style and iconography seen in the icons of the collection suggests that many of them were not made on the spot. They were probably brought to the monastery over the centuries by pilgrim visitors, possibly from many different points of origin. The St Peter, Virgin and Child with Saints, and Christ Pantocrator icons have been attributed to Constantinople because of their high quality, and because the monastery, as an imperial foundation, may well have received gifts sent from the capital. A Syro-Palestinian origin has been proposed for a second Pantocrator icon which shows Christ with short hair, because this iconography is found in the illustration of the sixth-century Syriac Rabbula Gospels (see below). (The type also appears on coins issued in Constantinople, however, so the case is not proven.) Syria or Palestine is also the suggested provenance of the only icon of sixth century attribution not in the portrait category, an Ascension, with Christ in a mandorla occupying the upper field and the Virgin and apostles in the lower, an iconography that also appears in the Rabbula Gospels. Some icons in the 'sixth/seventh-century' group are attributed to Egypt because they caption the Virgin H ΑΓΙΑ ΜΑΡΙΑ (Holy Maria), used in Coptic monumental art, whereas M(ητη)Ρ θ(∈ο)Υ (Mother of God) is the more familiar Byzantine form. In all cases the arguments offer plausibility rather than certainty, but geographical proximity certainly suggests that Egypt, Syria and Palestine should be well represented in the Sinai icon collection.[44]

Like the icon, the high-quality Byzantine textile has a history reaching back well before the sixth century, but it is at this time that it begins to be 'visible'. In the early Christian period, raw silk was imported from the Far East, to be made up into cloth in Byzantine workshops that were governed by a well-developed system of guilds. It is said (by Procopius) that a pair of monks smuggled the first silkworm eggs into the empire in the sixth century, thus making supplies more secure, although both raw silk and made-up cloth continued to be imported. There is no securely dated example of sixth-century Byzantine silk, but representations of fine cloth appear in the consular diptychs, the early Sinai icons and, above all, the mosaics of Ravenna. In the 'Theodora' panel in San Vitale, for example, the ladies wear cloth with what appear to be woven patterns of circles, birds and foliage. Also present are borders and 'patches' which may have been either woven or embroidered. The earliest datable remains are fragments of silk found in the reliquary of St Madeberte, in Liège, which have a pattern of foliage sprigs enclosed by linked ovals, circles and monograms of Heraclius (610–40), in yellow on a red ground. The find-site of this textile is typical. Byzantine silk was an ideal diplomatic gift – precious and easily portable – and so was sent with embassies to the West, where some of it was used to wrap the relics or bodies of saints, clerics and kings.[45]

44 Weitzmann, *Sinai*, B6, B10, 6–7.
45 *Splendeur de Byzance*, 205–7; R. Sabatino-Lopez, 'Silk

Industry in the Byzantine Empire', *Speculum* 20 (1945) 1–42.

Illuminated manuscripts

The illuminated manuscript has only two securely datable sixth-century examples, a Greek secular text known as the Vienna Dioscurides, and the Rabbula Gospels mentioned briefly above. The Vienna Dioscurides was made for Anicia Juliana, the aristocrat who has already been encountered as the patron of St Polyeuktos in Constantinople. It contains several medical works, of which a first-century text on herbal medicine by Dioscurides of Anazarbos is the longest. Miniatures (the conventional term for paintings in manuscripts, whatever their size) are found on most of the verso (left-hand) pages, as follows:

1v a peacock
2v the centaur Chiron, with pupils
3v Galen, with pupils
4v Dioscurides discovering the Mandrake plant
5v Dioscurides studying the Mandrake plant
6v portrait of Anicia Juliana (dedication page)
7v contents page
8v to 484v plants, birds etc.

The significance of the unframed peacock at the start of the book is uncertain, but the bird may have had special meaning for Anicia Juliana, given the proliferation of carved peacocks in St Polyeuktos. The next four miniatures, all framed, (2v–5v) refer to the history of pharmacology and Dioscurides' role in it. The centaur Chiron had healing skills, and Galen was a second-century medical writer (his pupil group includes Dioscurides, who in fact preceded him by at least a century). Dioscurides discovering the Mandrake on 4v is attended by a figure personifying 'Discovery', and on 5v he studies the plant aided by 'Thought', while an artist paints it (fig. 79 a). Folio 6v, the dedication page, has a portrait of Anicia Juliana enthroned between figures personifying Magnanimity and Prudence; another, labelled 'Thanksgiving of the Arts', kneels at her feet and a *putto* holding a book represents 'Yearning of the Lovers of Building' (fig. 79 b). The group is set within an eight-pointed star-and-circle frame whose spaces are filled by *putti* engaged in various building activities – altogether the image is a less than subtle celebration of Anicia Juliana's patronage of architecture. Personifications are a familiar aspect of Roman art, and their use here may be a somewhat self-conscious reference to Anicia Juliana's familiarity with classical learning. An acrostic in the framework offers her the praises of the people of Honoratae, near Constantinople, for whom she built a church sometime before 512, so the book was probably their gift to her. Dioscurides' herbal, and other medical texts, follow the contents page (7v) and are profusely illustrated, with unframed miniatures (mostly of plants) on each verso, facing the text on the rectos (fig. 79 c).[46]

The Rabbula Gospels, a Syriac manuscript now in Florence, was

79 Vienna Dioscurides
(Vienna, Öst. NB Med. gr. 1),
a copy of the herbal of
Dioscurides made for Anicia
Juliana *c.* 512. (a) Folio 5v,
Dioscurides studying the
Mandrake plant; (b) folio 6v,
Anicia Juliana with
personifications; (c) folio 333v,
the Chervil plant (Scandix).

completed in 586 by the scribe Rabbula in the monastery of Zagba in
Mesopotamia – he tells us as much at the end of the manuscript.[47] In addi-
tion to the four gospels, the book contains a set of Canon tables, which set
out the concordances of the four gospels, indicating where and how the
evangelists overlap in their accounts. These tables, prefaced by a letter
concerning their use written by Eusebius, who drew them up, are a stan-
dard part of mediaeval gospel books in both east and west.[48] The decora-
tion of the book is confined to fourteen folios at the beginning:

1r Matthias Joining the Apostles (to return their number to twelve
after the defection of Judas)
1v Virgin and Child framed by an arch
2r Eusebius and Ammonius
2v and 3r Eusebius' letter
3v to 12v Canon tables (with evangelists on 9v and 10r)
13r Crucifixion and Resurrection
13v Ascension
14r Christ enthroned with four monks
14v Pentecost

Each set of Canons is placed in an ornate arched framework, flanked by
illustrations of gospel episodes related to the Canons, and by figures of the
Old Testament prophets who anticipated the events depicted (fig. 80 a).
Two pages lack this narrative element and show instead the evangelists, in
two pairs: John and Matthew seated (9v) and Luke and Mark standing

46 Vienna, Öst. NB Med. gr. 1: Weitzmann, *LAECBI* 61–71;
H. Gerstinger, *Dioscurides, Codex Vindobonensis med. gr. 1,*
(facs.) (Graz 1970).
47 Florence, Laur. Plut. I. 56: Weitzmann, *LAECBI,*

97–105; J. Leroy, *Les Manuscrits syriaques à peintures*
(Paris 1964), 139ff.
48 C. Nordenfalk, 'The Apostolic Canon Tables', *GBA* 62
(1963) 17–34.

(10r). The full-page framed miniatures of 13r, 13v and 14v continue and conclude the New Testament narrative begun on the Canon table pages, showing the final episodes of the Passion cycle followed by the Pentecost. In the Crucifixion (fig. 80b), Christ wears the long tunic (*collobium*) seen on some of the Monza/Bobbio ampullae and thought to be an iconographical type originating in the east. The intervening miniature on 14r is a dedication page, showing Christ enthroned between four monks, two of them holding books and being presented to Christ by the other two, in the man-

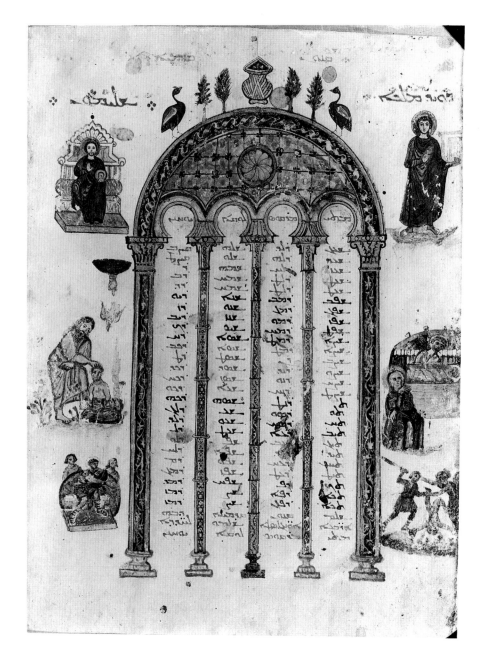

80 Rabbula Gospels of 586
(Florence, Biblioteca
Laurenziana cod. Plut. I. 56).
(a) folio 4v, Canon table;
(b) Folio 13r, the Crucifixion
and Resurrection.

ner of monumental donor images. The figures are not identified, but the two with books may be the scribe Rabbula and the patron, presumably the superior of the Monastery of Zagba, presented by a pair of monk saints. In this image Christ is shown with short hair and beard, whereas in the narrative miniatures both are long, recalling the different iconographies found for Christ Pantocrator in the Sinai icons (and also establishing that the two forms may appear in the same vehicle, a point to be resumed at the end of this chapter).

It has been observed that if Matthias Joining the Apostles (1r) and Christ with the monks (14r) were exchanged, a more coherent order would result, placing the donor page at the beginning of the sequence and Matthias Joining the Apostles in correct narrative order towards the end. The two miniatures are both on rectos which have others, in correct sequence, on their versos, so the misordering was not introduced by

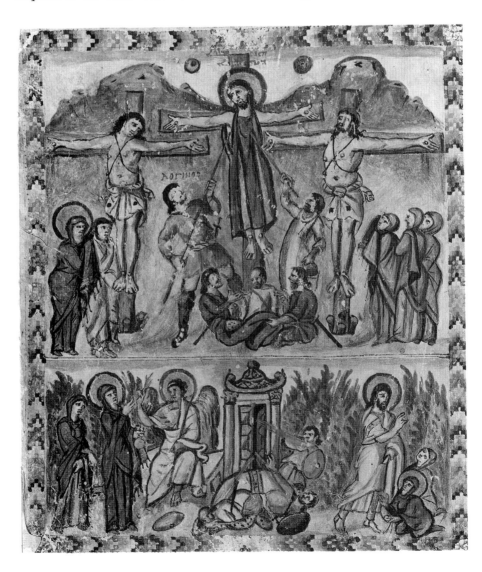

rebinding. The manuscript painter must have misordered the miniatures while at work, an indication that confirms the common-sense hypothesis that most manuscript illumination was done on loose folios before the book was bound. (Such practice would also account for the tendency to group illumination at the front of a book, which simplifies the task of combining text and picture pages when the finished book is assembled.)

These, then, are the two datable illuminated manuscripts of the sixth century. Although they are some seventy years apart, produced at opposite ends of the empire in different languages and of quite different content, they have several features in common. In each one, framed and unframed miniatures are used, and a frontispiece is formed of several illuminated pages. Some of these refer to the authors of the texts, and to those responsible for copying them, in either the practical sense, as scribes, or as patrons. In style, too, although different, the paintings of both manuscripts declare inheritance of the classical tradition in their naturalistic approach. Figures are modelled and many are set in three-dimensional space, against landscape or architectural backgrounds, both features seen in the early Sinai icons. This comparability of quite unrelated illuminated manuscripts argues that basic traditions in book illumination must have developed early in the history of the codex and were widely established by the sixth century. There is no reason to suppose that these books represent the beginning of their traditions.

Several other illuminated manuscripts are attributed to the sixth century on stylistic or palaeographic grounds (analysis of the writing). Of these, the closest in style of illumination to the Rabbula Gospels is a Syriac Bible in Paris, which once had complete texts of Old and New Testaments, but is now fragmentary. Each book has a framed miniature at its head, and others at intervals in the text (fig. 81). A few illustrate narrative episodes (Pharaoh with Moses and Aaron, to illustrate Exodus, for example) and others are author portraits (mostly of prophets).[49]

Three more manuscripts attributed to the sixth century are written in a fine uncial script (capital letters) on purple-stained vellum. These three, often known as the 'purple codices' are the Rossano Gospels (Rossano Cathedral), the Sinope Gospels (Paris) and the Vienna Genesis (Vienna). None is complete, and all lack the opening and closing sections that might have identified the patron, and perhaps the scribe.

Of the Rossano Gospels there remain the Gospel of Matthew, parts of Mark and Eusebius' letter on the Canons, 188 folios in all. Some folios have been misordered on rebinding, but the manuscript appears to have had most of its illumination grouped at the front, in an original sequence that may be reconstructed as follows: ten pages each with a gospel scene at the top of the page and busts of four prophets below, holding texts prophetic of the gospel scene (fig. 82); full-page miniatures which con-

49 Paris BN Syr. 341: Weitzmann, *LAECBI*, 106–11; Leroy,
 Les Manuscrits syriaques (see n.47) 208–19.

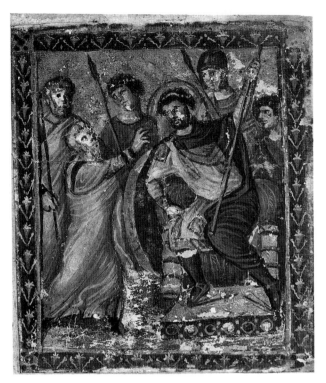

81 Mid-sixth century Syriac
Bible (Paris, BN Syr. 341).
Folio 8r, Moses and Aaron
before Pharaoh.

82 Rossano Gospels (Rossano
Duomo), on purple vellum,
sixth century. Folio 2v, the
Wise and Foolish Virgins, with
the four Evangelists below.

tinue the gospel narrative (two of these remain, showing episodes of the
Passion concerning Pilate); the title page of the gospels, with busts of the
four evangelists in a circular motif; Eusebius' letter, framed, (and presum-
ably once followed by the Canon Tables). After this pictorial sequence
came the texts of the four gospels, each prefaced by a full-page author por-
trait, of which only that of Mark remains.

The miniatures of the Rossano Gospels are all unframed. There is lit-
tle background detail and most of the figures are set against the purple
ground of the vellum. A similar formula was used for the Sinope Gospels,
of which forty-four separate leaves remain, forming a fragmentary gospel
of Matthew. Five pages, doubtless once part of another illuminated fron-
tispiece, each have a Gospel episode painted at the bottom of the page,
while to right and left Old Testament prophets clutch texts of their prophe-
cies and point to the scene, a slight variant of the formula used in the
Rossano Gospels. The arrangement also recalls the juxtaposition of Old
Testament prophets and the gospel events they anticipate in the Canon
tables of the Rabbula Gospels, another instance of comparability that
implies the existence of well-established traditions of gospel illumination.

The third purple manuscript, the Vienna Genesis, has twenty-four
folios (forty-eight pages) each with a miniature occupying the lower third
(or sometimes half) of the page, and a much abbreviated text above (fig.
83). This was, therefore, a picture book with extracts of text, rather than
an illustrated text. The miniatures begin with Adam and Eve and end
with the Death of Jacob, thus spanning the entire book of Genesis, but there

83 Vienna Genesis (Vienna, Öst. NB cod. theol. gr. 31), part of an illuminated bible of the sixth century. Folio 35, Pharoah's Dream.

are many lacunae and the complete book was probably twice as long.[50]

Although written and painted by several hands, the three purple manuscripts are closely related by their palaeography and style of illumination, as well as by format, a circumstance that suggests closer ties than just dependence on a common illustrative formula. They were therefore probably made in the same place at roughly the same time. The fact that three such rare objects survives suggests that they were preserved as a group for centuries after their production, probably as part of the treasure of a church or monastery. Two factors suggest that this was in Constantinople: first, the purple vellum of the manuscripts, which may indicate an imperial patron, and second the fact that the Vienna Genesis

50 A. Muñoz, *Il Codice Purpureo di Rossano* (facs.) (Rome 1907); Paris BN Supp. gr. 1286: A. Grabar, *Les Peintures de l'évangiliare de Sinope, Bibliothèque Nationale Suppl. gr.* 1286 (facs.) (Paris 1948); Vienna Öst. NB gr. 31: Weitzmann, *LAECBI*, 76–96; H. Gerstinger, *Die Wiener Genesis* (facs.) (Vienna 1931).

was in Venice in the fourteenth century and the Rossano Gospels were already 'an old treasure' of Rossano Cathedral in 1845. These Italian locations make it likely that the manuscripts were among the treasures looted from Constantinople by the Crusaders who sacked the capital in 1204. There is no apparent link with the capital for the Sinope Gospels, which were bought by a collector in Sinope, on the Black Sea, at the end of the nineteenth century, but this need not have been their place of production. The purple codices may, therefore, offer a second glimpse of sixth-century manuscript illumination in the capital, to complement that provided by the Vienna Dioscurides.

General issues

It is usual to regard the sixth century, and the reign of Justinian in particular, as the period during which the formal and stylistic developments of the early Christian centuries matured, producing a Byzantine art and architecture that acknowledged, but was now largely independent of, its Roman origins. As generalizations go, this is good enough, but subject to qualification and refinement in places. The emergence of a distinctive 'Byzantine' manner is perhaps clearest in the church architecture of Constantinople, where St Sophia, Sts Sergius and Bacchus and St Polyeuktos anticipate the ornate domed buildings with complex interior spaces that are to become characteristic of later Byzantine ecclesiastical architecture. No clear reason for the change to centralization is available. Some speculate that it was the result of changes in liturgical practice, but there is no firm evidence for this. Possibly it was simply the long association of the dome with shrine sites that encouraged its wider use in church architecture. In any case, these buildings signal a new stage in church design, and one in which the classical past is little more than vestigial. Weakening of links with that past is also apparent in the continued decline of free-standing statuary, and the (probably related) retreat from portraiture and from naturalism in general. In its place there is an often elegant stylization of the human form and its draperies, seen particularly in ivory carving and mosaics.

The classical tradition is not entirely lost, however, and a different angle of view reveals several examples of its tenacity, albeit in attenuated forms. They include the silver plates with pastoral or mythological subjects and the miniatures of the Vienna Dioscurides, both securely dated, and, if correctly attributed, the floor mosaic of the Imperial Palace in Constantinople and some of the early Sinai icons. (It may be that more material should be added to this list, since the tendency to use degrees of naturalism as a scale upon which to base chronological attributions may have caused some sixth-century art of naturalistic style to be assigned to the fifth century.)

As noted in the last chapter, the emergence of Christian art from its

pagan antecedents was the context for the coexistence of stylization and classical naturalism in the early Christian period. The persistence of this coexistence in the sixth century has prompted other interpretations. One possibility offered is that a stylistic dichotomy came about, with the classical tradition retained for works of secular art, while religious art took a different direction – possibly in subliminal quest of forms that would set Christian imagery apart from the real world, and at the same time dissociate it from the art of the pagan past. This approach would see the Palace floor, the Dioscurides' illumination and the silver plates as sixth-century examples of a conservative secular art that had changed little since pagan times. It might also explain the considerable difference between the Dioscurides, with its personifications and naturalistic plant pictures and the more stylized approach of the purple codices (always assuming the latter to be approximate contemporaries of the Dioscurides and products of Constantinople, neither point secure). But it does not account for the Sinai icons of the St Peter group that are obviously not secular and yet are only a short step away from late Roman funerary portraiture.

A second theory, already noted in discussion of early Christian developments, sees a separation of metropolitan and provincial custom, with Constantinople staying close to its classical roots, while stylization matures elsewhere. This too would account for the Palace floor and the Dioscurides (and assists the attribution of the St Peter icon and its relatives to the capital). It would also see the Ravenna mosaics not as a reflection of metropolitan tradition, as is often claimed, but as examples of a north Italian one that was far more schematic than that of the capital. This hypothesis stumbles over some of the ivories that have been attributed to Constantinople (Maximian's chair, the Berlin diptych, the London Archangel) that seem more in keeping with the Ravenna mosaics than with the Palace floor or the St Peter icon. The flaw may be removed, of course, by inverting the argument that attributes these ivories to the capital and supposing that a tradition of high-quality ivory carving was centred in Ravenna, whence pieces were ordered even by metropolitan patrons – Maximian's chair might still have been Justinian's gift, but commissioned from a workshop in Ravenna.[51]

Any analysis that depends upon a simple separation of metropolitan and provincial traditions is questionable, however. In the sixth century military campaigns and civil and ecclesiastical administration still gave a mobility to the patron class that might cause icons and architects alike to travel widely. Regional traditions must have existed, but transference of artistic forms, styles and iconography, sometimes between geographically remote areas, must also have taken place. The carved marble of St Polyeuktos shows that imported ideas could become fashionable in the

51 T. Mathews, *The Early Churches of Constantinople:*
 Architecture and Liturgy (University Park PA/London
 1971), 105–87.

capital, just as medallions struck in Constantinople were imitated in Egypt, and even the brick technique of metropolitan building found its way to Qasr' ibn-Wardan in Syria. Such mobility not only makes the attribution of provenance as problematic as ever, but also explains the appearance of common features in works of art that were certainly produced in different parts of the empire, such as the Rabbula and Rossano Gospels. It is unsound also to see the capital as the sole fountainhead of innovation, or repository of excellence. The centralizing trend in architecture may have been a metropolitan development of the early sixth century that spread to the provinces with Justinian's building programme, or it may have been generated in the late fifth century by Zeno's work in the eastern provinces.

Less tidy, but probably more likely than either the secular/religious or Constantinopolitan/provincial dichotomies, therefore, is that artistic production in the still-huge empire of the sixth century was multi-faceted, with craftsmanship of high quality available in several important centres as well as the capital, offering a range of different styles to suit patrons with various tastes. Procopius' claim that some of the statues of Constantinople were worthy of the sculptors of ancient Greece is probably just a literary convention, but one that may betray a taste – even a fashion – for the classical among the well educated (and those who wished to emulate them). The personifications crowding Anicia Juliana in the Vienna Dioscurides may have the same implication. There may even have been an element of antiquarianism here, seen also perhaps in the 'renovation' of the Paternus paten. Alongside this there is also evidence of lack of concern with the old, however. Procopius so often mentions the demolition of churches, in order to rebuild entirely (rather than repair or extend) that it is clear that while sites were venerated, ancient buildings on them were not. Greater reverence was shown by providing a wholly new structure than by preserving the old. (Justinian's enthusiasm in this respect doubtless accounts in part for the near-absence of pre-sixth century remains in Constantinople.) Even a single patron might have a variety of tastes – Anicia Juliana presumably appreciated the classical allusions in the imagery of her manuscript, but at the same time shows a predilection for oriental ornateness in the glass-eyed peacocks of St Polyeuktos. The patronage of Justinian seems to have been governed by pragmatism as well as preference: modest conservatism was adequate for the remote desert monastery in Sinai, which got a timber-roofed basilica, but bold experiment and the latest in 'lacework' carving was required for the churches of his capital.

Similar considerations of innovation, conservatism and individual choice also affect the study of Christian iconography and the manner in which images were used. There is evidence for a framework of widespread 'standard' formulae in both monumental and minor arts, even though the surviving examples are so fragmentary. The 'enthronement' images of Christ with saints, for example, or the Virgin with Archangels, appear in church apses, on ivories, icons and in manuscript illumination.

Iconographically similar narrative subjects appear in contexts as diverse as the Rabbula Gospels and the Ravenna mosaics. Generically similar relationships between image and text appear in the Rabbula Gospels and the Rossano and Sinope Gospels. If the evidence were fuller, it would probably show in detail how the basic vocabulary of images was modified by regional traditions and used in conjunction with non-standard types generated by specific factors as various as theological affiliation and the idiosyncracies of patrons. (The creativity of artists, often overlooked because virtually impossible to demonstrate, must also have had a role.) As it is, attempts to define the precise meanings of iconographical variants call up a familiar range of problems. For example, the apses of St Catherine on Mount Sinai and San Apollinare in Classe offer two very different treatments of the Transfiguration. Do these represent different regional iconographical traditions, or different theological concerns, or are they simply different solutions to the problem of modifying a narrative episode for use as a formal apse image? Sometimes iconographical variants are found in objects of similar provenance and function, as is the case in representations of the Crucifixion on the Monza/Bobbio ampullae. Was the symbolic image with the tree-like cross the standard iconography of the shrine site, while the narrative type, in which Christ wears the long tunic (*collobium*), seen also in the Syriac Rabbula Gospels, a variant produced for pilgrims from Syria? Even today the souvenir trade of the Holy Places still caters for visitors of differing religious persuasions. The Rabbula Gospels offers proof that different iconographies might appear within the same object: Christ is shown with long hair and beard in the images of Gospel narrative, but with short hair and beard in the formal image of the dedication page. Are the images different because the artist used different models for the narrative sequence and the formal image? Or do the two iconographies have different meanings and their combination some intentional significance? Discussion of these examples and many others has been too lengthy for summary here, where they serve simply to demonstrate the complexity of sixth-century Byzantine religious imagery and some of the approaches taken to it.[52]

For all the 'unknowns' of this period, however, it is possible to see in it coherent features that separate it from the obviously derivative material culture of the early Christian centuries, at least in the most conspicuous works of art and architecture produced for major patrons. The elegance of domed architecture is complemented by the ornate carved marble of the 'lacework' style and the sumptuous appearance of mosaic – particularly gold mosaic – applied to its vaults. All of this looks forward to the taste for luxury and visual sophistication that characterizes the arts of the middle-Byzantine centuries.

52 A. Grabar, *Christian Iconography. A Study of its Origins*
 (New York 1968); L. Reau, *Iconographie de l'art chrétien*
 (Paris 1955–9).

3 *The dark age and Iconoclasm*

The cost of Justinian's ambitions for territorial recovery was ruinous in human as well as financial terms, since many died in the wars. A severe outbreak of bubonic plague in 542 had also killed thousands a day in Constantinople alone, so many that the burial grounds were exhausted and the fortified towers of Galata were used as makeshift mass graves. Much weakened by depopulation, over-extension and over-spending, the empire after Justinian entered a long period of territorial losses and administrative disintegration.

In the late sixth century the Lombard invasion of Italy severely undermined the gains made by Justinian in his attempt to recover the western empire. Ravenna and its region were retained for a further century and a half, as an 'Exarchate' under a Byzantine military governor (Exarch), but this too was lost to the Lombards in 751. Byzantine authority also survived in Rome which, however, looked increasingly to the West for support. By the end of the eighth century the greatest strength in Europe was that of the Franks, who overtook the Lombards and made alliance with the Pope. The Frankish king Charlemagne was crowned emperor in Rome in 800, and his power reluctantly acknowledged by Constantinople.

Also in the late sixth century, Slavs and Avars attacked from the north, occupying parts of Greece, and in the early seventh century the Persians took Syria, Palestine and Egypt. Some of the damage was stemmed by Heraclius (610–41), whose defeat of the Persians in 628 removed one enemy, but from the 630s to the early eighth century the Arabs moved northwards and westwards, taking north Africa and much of Anatolia. They reached as far as the walls of Constantinople, and although driven back, their incursions all but demolished Byzantine civil administration of the eastern provinces. In its place there evolved a military administration whose basic unit, the theme, was a region under military control. The place of the civil provincial governor was therefore taken by a military commander (*strategos*), whose troops were settled and given land. The theme system entailed significant changes in social structure, since it introduced a new class of soldier-landowners whose holdings must often have come from redistribution of the devastated estates of the traditional aristocracy. The latter class, although not obliterated by the invasions, was much diminished, having lost both its

land-based wealth and its power in a civil administration now largely
defunct.[1]

The *strategos* of a theme, with a home-based army behind him, might
have enormous power. The new order therefore facilitated the emergence
of usurper-emperors, sometimes bringing to power men from outside the
hereditary aristocracy. One such was Leo III, born in Syria, who as *strate-gos* of the Anatolikon theme of central Anatolia took the throne in 717
and held it until his death in 741. Leo appears to have attributed the mis-
fortunes of the Byzantine empire to divine wrath, called up particularly by
the use of figural images in religious art. As has already been noted, the
acceptability or otherwise of icons (in this context the term covers all fig-
ural religious art) had been debated since early Christian times. Opponents
saw the use of images in worship as idolatrous, and therefore alien to
Christian tradition, while supporters maintained that images were an aid
to worship, not its object. When in 726 Leo ordered the removal of an
icon of Christ from the Chalke Gate of the Imperial Palace in
Constantinople and issued an edict banning the figural image from reli-
gious art, he therefore brought an old dispute to the fore, where it
remained for over a century, until the death of the last iconoclast emperor,
Theophilos, in 843.

Iconoclasm continued and intensified under Leo's son Constantine
(741–75), who convened the Council of 754 in Constantinople which
condemned the use of icons. The ban was of course controversial and
many opposed it – Iconoclasm had its martyrs and exiles. Hundreds of
monks 'languished in prison', according to the *Life of Stephen the Younger*,
who was an ascetic of the Monastery of St Auxentios, near Chalcedon,
and one whose self-imposed austerities must have been almost as painful
as the tortures he endured as an iconodule martyr. A more tolerant stance
was taken by Constantine's son Leo IV (775–80), and his widow Eirene,
who supported the use of icons, revoked the iconoclast decrees in 787.
Iconoclasm was only suspended, however, for it was reinstated in 814, in
circumstances that echoed its beginnings. Another usurper, Leo V (the
Armenian), also a *strategos* of the Anatolikon theme, ordered the removal
from the Chalke Gate of the icon of Christ restored there by Eirene. Leo V
was murdered in 820 and although his successors (Michael II 820–9 and
Theophilos 829–42) allowed Iconoclasm to continue, it succumbed to
popular opposition and was finally rescinded by Theodora, the iconodule
widow of Theophilos. A procession to St Sophia before Easter of 843 pub-
licly marked the return of orthodoxy.[2]

1 Ostrogorsky, *Byzantine State*, ch. 2; C. Mango, 'Heraclius,
 the Threat from the East and Iconoclasm – A.D.
 610–843', in P. Whitting ed., *Byzantium. An Introduction*
 (Oxford 1961), 41–59.

2 Ostrogorsky, *Byzantine State*, ch. 3; A. Bryer and J.
 Herrin eds., *Iconoclasm. Papers given at the Ninth Spring
 Symposium of Byzantine Studies* (Birmingham 1977).

3 Mango, *Architecture*, ch. 6.

Architecture

The 'dark age' from the late sixth to the mid-ninth centuries was an infertile one for art and architecture. Territorial losses, precarious control of many areas still held and the great social upheaval that this entailed must have led to a reduction in commissions for new building. Builders and other artisans must have diminished in number and in ability as their work in most cases was reduced to the maintenance and repair of existing buildings. Important dark age churches are smaller and less well constructed than comparable sixth-century buildings, and very few of them remain. For the history of architecture the scarcity of either documentary or material record of this period is frustrating, since this was also a time of change. The standard basilica of the fourth to sixth centuries gave way, probably by the mid-ninth century, to the much smaller, domed, fully centralized middle-Byzantine church which will be discussed in the next chapter. We have seen the beginnings of this change in the late fifth-century 'tower' churches of Anatolia, and its stronger assertion in Justinian's domed buildings in the capital and elsewhere, but the stages of the process cannot be reconstructed in any detail.[3]

The remaining pieces of the puzzle are as follows: St Eirene in Constantinople, although a Justinianic commission (built, like St Sophia, to replace an earlier church destroyed in the Nika riots) was largely rebuilt after 740, when an earthquake caused serious damage. The eighth-century church is a cross-domed basilica, with nave and aisles separated by four-column arcades linking the piers which carry the vaulting (fig. 84). A dome over the main nave bay is carried on four great arches. The west and east arches, plus a western sail-vault, complete the covering of

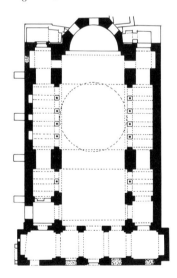

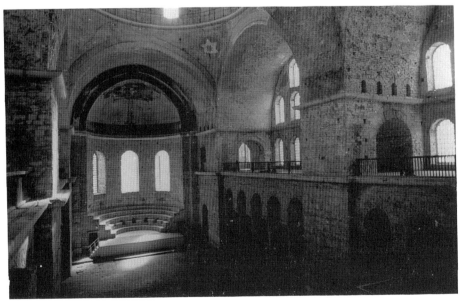

84 St Eirene, Constantinople (rebuilt after 740 on sixth-century remains): plan, after George; interior view to the southeast.

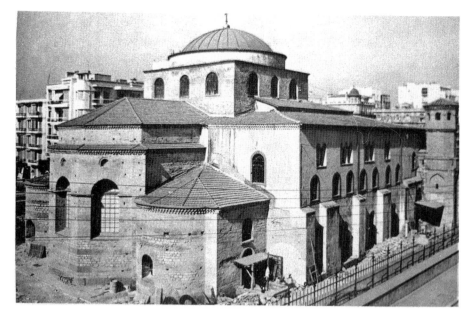

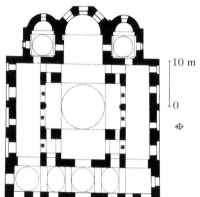

the rectangular nave, while the north and south arches cover the aisles and the open galleries. The second datable church of the period is St Sophia in Thessalonike, which has an inscription in its sanctuary mosaic referring to Constantine VI and Eirene (780–97) and was probably commissioned to celebrate victory over the Slavs in Greece in the 780s. This also has vestiges of the basilical plan, with nave and aisles separated by arcades of alternating piers and columns and a U-shaped gallery surmounting the aisles and narthex (fig. 85). Here, too, the nave is vaulted by a dome set on four large arches, those to west and east completing the cover of the rectangular nave. St Sophia differs from St Eirene, however, in that the north and south arches do not cover the aisles, but are set within the arcades, making the nave cruciform; this type will here be described as cross-domed.[4]

Before proceeding further, it should be noted that dark age architecture has had its obscurity deepened by problems of nomenclature. In the early literature, 'domed basilica' is used for churches of both the above types. Later authors call some of them 'cross-domed', but differ in their criteria for the application of the term. My division depends on the relationship of the lateral arches to the outer walls: in the cross-domed basilica, the lateral arches extend to the outer walls, thus covering aisles (as in St Eirene) and in the cross-domed church the lateral arches end at the line of the arcade, with the aisles extending beyond the cross-domed unit (as in St Sophia, Thessalonike).[5]

85 (above), St Sophia, Thessalonike (780s): view of east end; plan, after Theoharidou.

86 (opposite, top left), eighth-century church at Dereağzı, Lycia, plan after Morganstern.

87 (opposite, top right), St Nicholas, Myra (Demre) (eighth century); plan after Demirez.

88 (opposite), St Sophia, Vize, Thrace (eighth century); plan after Dirimtekin.

4 For St Eirene: Mathews, *Istanbul*, 103; W.S. George, *The Church of Saint Eirene at Constantinople* (London 1913); U. Peschlow, 'Die Irenenkirchen in Istanbul', *IstMitt* 18 (1977). For St Sophia, Thessalonike: Mango, *Architecture*

161–5; Diehl, *et al.*, *Salonique*, 117–49.

5 Krautheimer, *Architecture* 514 n.302; H. Buchwald, *The Church of the Archangels in Sige, near Mudania* (Vienna/Cologne/Graz 1969), 43, 47 n.213.

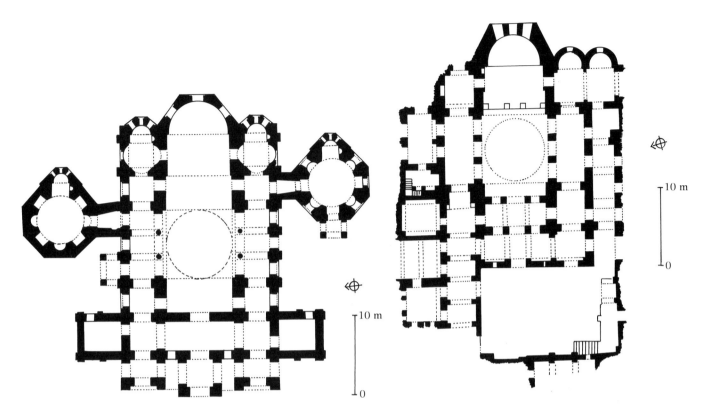

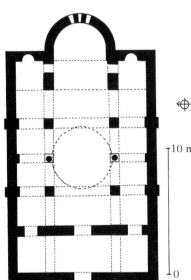

Both forms are found in several other churches for which dating evidence is uncertain or entirely lacking. With St Eirene may be placed three more cross-domed basilicas. One is a church of unknown history at Dereağzı in Lycia (southwest Turkey), which lacks the western sail vault of St Eirene and has nave arcades of only two columns on each side (fig. 86). St Sophia in Vize (Thrace), also of obscure history, is similar, but with nave arcades supported on two piers and a central column (possibly once three columns, the outer ones later encased to form piers) (fig. 87). St Nicholas in Myra (modern Demre) has a shorter nave, since the west and east arches are narrow; three-arched lateral arcades are set on piers and complemented by a further arcade at the west end of the nave (fig. 88). Radiocarbon dating of a beam in the narthex at Dereağzı suggests a building date no earlier than *c.* 750, but the church may be as late as the end of the ninth or beginning of the tenth century; there is no dating evidence for the other two churches.[6]

With the cross-domed church of St Sophia Thessalonike may be

6 J. Morganstern, 'The Byzantine Church at Dereağzı and its Decoration', *IstMitt* 29 (1983) (bibliog. 81 nn. 240, 241); C. Mango, 'The Byzantine Church at Vize (Bizye) Thrace and St. Mary the Younger', *ZVI* 11 (1968) bibliog. 9 n.1; for St Nicholas at Myra: H. Rott,

Kleinasiatische Denkmäler aus Pisidien, Pamphylien, Kappadokien und Lykien (Leipzig 1908), 32f.; F. Darsy, 'Il sepolcro di S. Nicola a Mira' *Mélanges Eugène Tisserant* (Vatican City 1964) 11, 29–40.

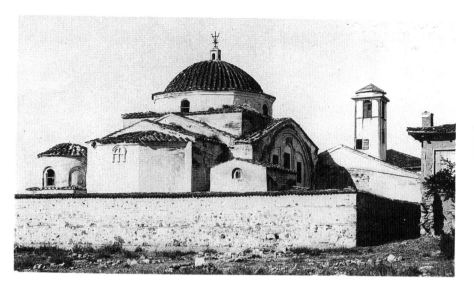

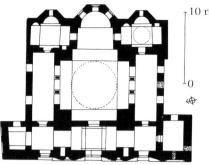

grouped the Church of the Koimesis (Dormition of the Virgin) at Nicaea, which was destroyed in 1922, but is known from photographs and descriptions (fig. 89). This must have been built before Iconoclasm, because its figural mosaic decoration was removed and replaced with a cross (see below). The Koimesis Church differed from St Sophia in Thessalonike in having uniform arches below the dome, making the nave an equal-armed cross, (whereas that of St Sophia is longer than it is wide). The lateral arcades at the Koimesis Church were of three arches, on piers. A third church, St Clement in Ankara, destroyed in the 1920s and undated, was similar to the Koimesis Church, but has a three-arched arcade on piers to the west, as well as to north and south, like St Nicholas at Myra (fig. 90).[7]

The problems surrounding these two groups of churches will be evident even from this brief outline. Their chronology is imprecise in most cases: St Sophia in Thessalonike alone is dated; the Koimesis Church at Nicaea pre-dates Iconoclasm, but it is not known by how much. St Eirene was largely rebuilt after 740, but the extent to which its form was dictated by that of the sixth-century building is uncertain. The other churches are attributed to the dark age period largely on typological grounds, an approach that demands caution since the cross-domed scheme is also found much later, in the eleventh- or twelfth-century Constantinopolitan church now known as Gül Camii, for example, and in the fourteenth-century Aphendikon Church at Mistra.

When looking for the origins of the cross-domed basilica and cross-domed church, it should be noted that there is variety within each group – in the number and type of arcade supports, in the treatment of the west side of the nave, and in the shape of the nave. Further, the two types are not far apart, since both have the dome on four arches as their main

89 Church of the Koimesis (Dormition), Nicaea (before 742), destroyed in 1922: view from the northeast; plan after Schmit.

7 Th. Schmit, *Die Koimesis-Kirche von Nikaia* (Berlin/Leipzig 1927); G. de Jerphanion, 'L'Eglise de Saint-Clément à Angora', *Mélanges de l'Université Saint-Joseph* 13 (1928) 113–43.

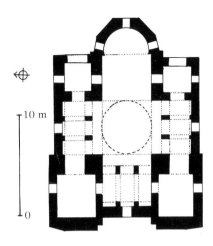

90 St Clement, Ankara
(eighth century?) destroyed;
plan after de Jerphanion.

vaulting element, combined in most cases with vestiges of the basilical plan. Both types may therefore be derived from the sixth-century architectural ideas seen in the churches of St John at Ephesus, Katapoliane and Gortyn, which also have the dome on four arches as their chief vaulting unit. The probability, therefore, is that the dark age churches do not represent points on a single line of development, but are the descendents of several sixth-century schemes. There is no direct connection with the more complex form of St Sophia in Constantinople, a point consistent with the view expressed in the last chapter, that the Great Church was a unique combination of the architectural ideas of its day, rather than part of a gradual evolution. St Sophia must, however, have had considerable conceptual impact, confirming the domed form as a canon of ecclesiastical architecture, and promoting an interest in spatially complex interiors.

The cross-domed church and the domed basilica may therefore be seen as the rather impoverished descendents of sixth-century architectural grandeur, calling not upon its most ambitious experiments but on the simpler forms that were part of the background to St Sophia. The buildings are poorer in materials, scale, and engineering than their sixth-century progenitors, a decline that points the way to the adoption of the smaller, structurally simpler domed churches of the middle-Byzantine period. This general view is all that the remaining evidence permits. Brave attempts have been made to place all the cross-domed and domed-basilica churches at stages in a process of evolution linking sixth-century buildings with tenth-century ones, but the incomplete record and the uncertainties of chronology and relationships noted above requires them to be treated with caution.[8]

Of secular achitecture in the dark age still less is known until the end of the period, when there are signs of recovery – or at least of imperial profligacy – in the capital. According to a tenth-century source, Theophanes Continuatus, the last iconoclast emperor Theophilos was responsible for considerable repairs to the city walls and for much work on the Imperial Palace. He built, or in some instances perhaps restored, a whole series of rooms and halls, courtyards, gardens and terraces. The account is imprecise, saying little of the structure of the buildings other than that some were domed and some had columns – these were presumably aisled halls. As well as reception halls, there were winter and summer bedrooms for the emperor, chapels dedicated to the Virgin and the Archangel Michael, and accommodation for the eunuchs who served the ladies of the Palace. The description dwells upon the costly decoration of the new buildings, especially the marble columns, revetments and floors, the gold mosaics and bronze and gold doors. Theophilos apparently enjoyed luxury, presiding from a gold throne over entertainments at

8 Morganstern, 'Dereağzı' (see n.6) 81–93; Krautheimer,
 Architecture, 299–315; Mango, *Architecture* 174;
 Buchwald, *Sige* (see n.5) 43–62.

which fountains in the form of bronze lions spouted wine. He also built an entirely new palace on the Asian side of the Sea of Marmara, at Bryas, near modern Bostancı. This was designed by John the *synkellos*, following the scheme of Arab palaces that he had seen on an ambassadorial visit to Baghdad in 830, and apparently differing from its models only in having a triconch church. The foundations of a large rectangular hall of twenty-one bays, made by three rows of six columns each, have been found at Küçükyalı, near Bostancı, and may be remains of this palace, although there is no trace of the church. The hall abuts a square structure that may have been domed, and there are traces of a wall enclosing a courtyard on three sides of the building (fig. 91). These prosaic remains of what was probably another very luxurious establishment do indeed have details in common with Abbasid palaces of the east.[9]

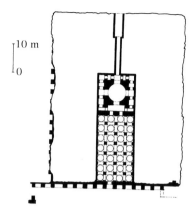

91 Palace at Küçükyalı, near Bostancı, possibly the Palace of Bryas, built for Theophilos (829–42) after Eyice.

The arts before Iconoclasm

The monumental art of Constantinople in the seventh and early eighth centuries is virtually unknown, since there are neither surviving examples nor written accounts from which the losses may be reconstructed. In Nicaea, to the south of the capital, it may be deduced from analysis of later changes to the mosaic decoration of the Koimesis Church that in the seventh century it had in its apse a lone standing figure of the Virgin against a gold ground, framed by pairs of archangels on either side of the wide arch fronting the apse.[10] Given the proximity of Nicaea to Constantinople, it may be guessed that schemes of this sort were also to be found in metropolitan churches.

The chief source of material remains, however, is Rome, where several buildings received mosaic decorations which follow familiar lines, usually showing saints and donors in formal compositions. In Sta Agnese, for example, a central figure of the standing saint is flanked by Pope Honorius (625–38) who commissioned the decoration and Pope Symmachus, a sixth-century patron of the church (fig. 92). In San Stefano Rotonda a jewelled cross, with a bust of Christ at its top, is set between Sts Primus and Felicianus, and was probably installed when the relics of these saints were brought to the church by Pope Theodore (642–9). The apse decoration of the Chapel of St Venatius in the baptistry of St John Lateran was probably the commission of Pope John IV (640–2) and shows the Virgin with Sts Peter, Paul, John the Evangelist and John the Baptist, below a bust of Christ with angels. A combination of narrative and formal imagery was used in the mosaics commissioned by Pope John VII (705–7)

9 Theophanes Continuatus, *CSHB* 139–47, trans. Mango, *Sources*, 160–5; S. Eyice, 'Istanbul'da Abbâsi Saraylarının Benzeri olarak yapilan bir Bizans Sarayı: Bryas Sarayı', *Belleten* 89–92 (1959) 79–99 (French summary 101–4).

10 P.A. Underwood, 'The Evidence of Restorations in the Sanctuary Mosaics of the Church of the Dormition at Nicaea', *DOP* 13 (1959) 235–44.

for his oratory in old St Peter's. This decoration is now fragmented and dispersed to several locations, but a seventeenth-century drawing by J. Grimaldi shows that it originally consisted of a large panel showing the Virgin in imperial dress (Maria Regina) surrounded by smaller panels which make up a narrative cycle of the Life of Christ (fig. 93); the

92 Mosaic in the apse of Sta Agnese, Rome, commissioned by Pope Honorius (625–38). St Agnes flanked by the Pope, who holds a model of his church, and Pope Symmachus, an earlier patron of the church.

93 Seventeenth-century drawing by J. Grimaldi of mosaic decorating the oratory of Pope John VII (705–7) in St Peter's, Rome.

programme also included a cycle of the lives of Sts Peter and Paul. Rome also has fragments of wall-painting in several layers of different periods in Sta Maria Antiqua. The uppermost layers (v, and v i) are associated with Pope Martin I (649–55) and Pope John VII (705–7) respectively, and both appear to have combined narrative imagery (Life of Christ cycles) with formal images of saints. The John VII programme includes a donor image (as may also the Martin I programme, which survives only in very small fragments).

It is debatable, of course, whether this seventh/early eighth-century Roman material should be regarded as Byzantine art, when Rome had been isolated from the empire by Lombard control of Italy since the late sixth century, and the Papacy had assumed an increasingly westward-looking stance. Its inclusion here is justified on the grounds that Roman church art can be seen to continue the early Christian traditions that were probably common to both old and new capitals, and may therefore have some value in estimating the state of monumental art in properly Byzantine contexts. The point is strengthened by arguments, on both iconographic and technical grounds, that some Roman work, particularly that commissioned by Pope John VII, was influenced by the contemporary art of Constantinople, possibly even executed by Byzantine craftsmen.[11]

So few dated or datable examples of the minor arts remain from the dark age that here too no survey is possible. What there is does, however, suggest conservatism rather than innovation. Silver dishes dated by their stamps to the reigns of Heraclius (610–41) and Constans II (641–51) have embossed decoration in a sub-classical style similar to that of the fifth- and sixth-century examples noted in earlier chapters. Some, like the Meleager plate and the Maenad plate, both now in St Petersburg, have subjects from Greek mythology. Christian subjects appear on others, like the fine set of dishes from a hoard found near Lambousa in Cyprus which are decorated with episodes from the life of David (fig. 94). There may be more here than just continuity of tradition. It has been argued that the decoration of some of these dishes resembles that of classical models more closely than do the sixth-century examples of the genre, and that this is evidence of a classical revival at the time of Heraclius. Alternatively, however, it may be their high quality that gives some of the seventh-century dishes their apparent proximity to classical models, whereas chance may have preserved only lesser-quality examples from the sixth century. In either case, the dishes are evidence of a continuing taste for very traditional forms in at least one area of the minor arts.[12]

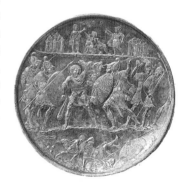

94 Silver dish with stamp of Heraclius (610–41), found in Karavas, near Kyrenia, Cyprus: David and Goliath. (Metropolitan Museum, New York, 17.190.396, gift of J. Pierpont Morgan 1917.)

11 Oakeshott, *Rome*, 148–59; P.J. Nordhagen, 'The Earliest Decorations in Santa Maria Antiqua and their Date', *AIRN* 1 (1962) 53–72, and 'The Mosaics of John v i i', *AIRN* 2 (1965) 121–66.

12 Dodd, *Silver Stamps*, nos. 57, 70, 58–66; D.H. Wright, 'The Shape of the Seventh Century in Byzantine Art',

First Annual Byzantine Studies Conference, Cleveland 1975. Abstracts of Papers, 9–28; E. Kitzinger, 'Art in the period between Justinian and Iconoclasm', *Berichte zum XI. internationalen Byzantinisten-Kongress, München 1958* (Munich 1958) i v.i, 1–50.

Both before and during Iconoclasm conservatism seems also to be the case in textile design, as far as can be judged from a few pieces found in the West and attributed to the seventh–ninth centuries according to the dates of the tombs or reliquaries in which they were found. These include a silk now in Cluny, from the tomb of Charlemagne (d. 814), which has a pattern of interlinked circles with flower borders, each enclosing a four-horse chariot (*quadriga*) with its charioteer, a motif of Roman tradition. A very similar silk in Brussels, from the reliquary of St Landrade (680–90) and St Amour (ninth century), has the same pattern, with the *quadriga* motif, and another in which a two-horse chariot is driven by a Sassanian (Persian) king, identified by his winged crown (fig. 95). This iconography

95 Byzantine silk (seventh/eighth century), Brussels, Musées Royaux d'Art et d'Histoire.

is seen in Persian artefacts of the sixth century, which is probably when it found its way into Byzantine textile production. This and other oriental motifs must have been easily assimilated by a craft so closely linked with eastern trade, joining a repertory of textile patterns that changed little with the centuries.[13]

The arts during Iconoclasm

The main issue concerning art in the eighth and early ninth centuries must clearly be that of the impact of Iconoclasm. Prohibition of figural imagery in religious art, lasting over a century, must have affected both existing religious art and new artistic production. The nature and extent of its impact varied, however, and it would be wrong to assume that religious figural art simply disappeared. Although lengthy, the ban was not uniform in its imposition across the 116-year span, and throughout the period it met with resistance. There is little evidence for the destruction or removal of religious images in the early years of the ban, other than that

13 *Splendeur de Byzance*, 211–14.

of the removal of the icon of Christ from the Chalke Gate in Constantinople in 726. There may have been other such incidents, but Iconoclasm does not seem to have been rigorously imposed at first. Later, during the reign of Constantine V (741–57), iconodules were persecuted, and we hear in the *Life of Stephen the Younger* of the defacement of monumental images and destruction of liturgical objects 'in every town and village'. This source also describes the obliteration of a monumental cycle of the Life of Christ in the Theotokos Church in the Blachernae district, and the removal from the Milion (a monumental arch in the vicinity of the Imperial Palace) of representations of the Church Councils, which were replaced by hippodrome scenes.[14]

There are also a few physical traces of the destruction of monumental images. The room of the patriarchate mentioned in the last chapter, built over the southwest ramp of St Sophia in Constantinople, had a pre-iconoclast mosaic decoration which included busts of Christ and saints in medallions. In 768/9 the busts were replaced by crosses, and the dark tesserae of inscriptions which named the figures were picked out and replaced by cubes of the background colour (fig. 96). (Parts of the inscriptions are still legible, since the replacement cubes differed in tone from the background. It is by this means that the original subjects of the decoration are known.) In Nicaea, at an unknown date, the mosaic figures of the Virgin and Archangels in the sanctuary of the Koimesis Church were removed, leaving the tesserae of their backgrounds intact. The jewelled podium upon which the figure of the Virgin stood was also left, and a cross made of new mosaic set upon it. This in turn was removed after Iconoclasm, and the figure restored, but seam-lines have left a ghost of the cross on the gold background.[15]

The removal of monumental images is certainly attested by both documentary and material evidence, therefore, but it may not have been extensive. The few accounts of specific acts of destruction concern buildings with which the iconoclast emperors had close connections, such as the Palace and the Theotokos of Blachernae. Otherwise, the damage is described in suspiciously general terms, without naming the churches affected. The evidence of image-destruction given to the iconodule Council of 787 (during the hiatus in Iconoclasm) is decidedly thin – it tells of the burning of books in St Sophia and in a town near Smyrna, but offers nothing to support the assertion of wholesale destruction found in the *Life of Stephen the Younger*. It may be noted, too, that the changes to the Patriarchal room in St Sophia did not occur until forty-two years after the begining of Iconoclasm, at the instigation of the iconoclast Patriarch Nicetas. The possibility that many other monumental images remained in place throughout Iconoclasm is suggested by a letter from the iconoclast

96 Mosaic in the room over the southwest ramp of St Sophia, Constantinople, in which busts of saints were replaced by crosses during Iconoclasm.

14 Mango, *Sources*, 151–6.
15 R.S. Cormack & E.J.W. Hawkins 'The Mosaics of St. Sophia at Istanbul: The Rooms above the Southwest Vestibule and Ramp', *DOP* 31 (1977) 175–251; for Nicaea see n.10.

emperors Michael II and Theophilos to Louis the Pious in 824. This says that while images at ground level had been removed, those high up on church walls or in vaults might be retained for didactic purposes. The statement sounds very like an iconoclast apology for the widespread preservation of monumental figural imagery. It may also indicate that, in practice if not in stated policy, a distinction was made between monumental images and the more intimate portable ones, such as icons, reliquaries and illuminated books, which must have been more susceptible to veneration than the distant imagery of church vaults.

Geography may also have played a part. Most evidence of destruction concerns Constantinople and its immediate vicinity and the ban may have been less regarded (and less enforceable) away from the court of the iconoclast emperors. Another passage in the invaluable *Life of Stephen the Younger* describes the distant provinces – Cyprus, Italy, southern Asia Minor – as the only safe refuges for iconodules after the iconoclast Council of 754. While this may be an exaggeration, it at least indicates that the ban was not universally applied or obeyed.

Finally, opposition to iconoclasm is manifested not only by the crop of martyrs that it made, but also by evidence of concealment even of monumental images. In Thessalonike, the fifth-century mosaic still present in the apse of Hosios David (mentioned in the last chapter) was covered with hide and then bricked over, an act of pious conservation rather than compliance with the ban, and probably not the only one of its kind. It is probable, then, that even when pressed most vigorously, by Constantine V, Iconoclasm did not cause anything like the obliteration of existing monumental art.[16]

The next point to consider is the effect of Iconoclasm on the production of new monumental art. While it is possible that new figural church programmes continued to be installed in areas remote from the control of the capital, flouting the ban in the major centres would have been imprudent on the part of artists and patrons alike. Workshops would of course have continued to produce secular figural images, which were not subject to the ban, such as scenes of the hunt, hippodrome and theatre mentioned with scorn in the *Life of Stephen the Younger*. The skills of figural art were not lost, therefore, and were certainly available during the hiatus in Iconoclasm (780–814) when Eirene ordered portraits of herself and her son for the Pêge Church in Constantinople, and later still, when Theophilos (829–42) included scenes of fruit-pickers in an orchard among the new mosaics in the Imperial Palace. Nevertheless, without commissions for figural church art, a traditionally important element of the work of painter and mosaicist must have been curtailed, and this may have diminished the number of workshops.[17]

16 S. Gero, *Byzantine Iconoclasm During the Reign of Constantine V* (Louvain 1977), 111–22, 126–7; Mango, *Sources*, 153–8.

17 For Pêge: *Acta Sanctorum. Novembris III* (Brussels 1910), 880, trans. Mango, *Sources*, 156–7; for Theophilos: Theophanes Continuatus (see n.9), 163.

The aniconic programmes needed to replace figural ones, and to decorate newly built churches, may be reconstructed only to a very limited extent. The cross appears to have been given prominence, taking the place of formal figural images. As noted above, a large cross replaced the standing figure of the Virgin in the apse of the Koimesis Church in Nicaea. Another was installed in St Sophia in Thessalonike (780–97), as the first decoration of the church. It was removed after Iconoclasm, when figures of the enthroned Virgin and Child (still present) replaced it, but as at Nicaea the cross-arms are visible as 'ghosts'. Wide bands of ornament using a cross motif were also placed (and remain) on the springing of the bema arch fronting the apse. A complete example of the apse-cross survives in St Eirene in Constantinople, where it was installed after the rebuilding of 740 (fig. 97). More elaborate programmes were also produced. The *Life of Stephen the Younger* says that trees and flowers, birds and beasts replaced the figural mosaics of the Theotokos of Blachernae, but is unfortunately silent on their arrangement or location(s) within the church. Some idea of what an extensive non-figural programme may have looked like is perhaps to be gathered from two early Islamic monuments, said to have had their mosaic decorations executed by Byzantine craftsmen. The Dome of the Rock, in Jerusalem, completed in 691/2, has below its dome two friezes of acanthus scroll issuing from ornate chalices. At the Great Mosque in Damascus, completed by 715, the courtyard walls have a frieze of trees, flowers and fanciful architecture (fig. 98). None of this makes a convincing case for the emergence of a developed 'iconoclast' art. The cross had been an important element of Christian art for centuries and the motifs used to decorate the Islamic monuments also have long pre-iconoclast pedigrees. The invention of new imagery was unnecessary therefore, since non-figural programmes could be created simply by a change of emphasis which lifted traditional aniconic elements to new prominence.[18]

The fate of the minor arts was probably similar to that of the monumental. As noted above, there is documentary record of the taking down of icons and destruction of illuminated books and liturgical vessels bearing figures. Portable objects may be hidden, however, and many iconodules doubtless considered it their sacred duty to save what they could from the depredations of the iconoclasts. The eleventh-century chronicler Skylitzes records that in 1031 an icon was discovered hidden beneath the silver revetment of the Church of the Virgin at Blachernae, presumably concealed there when the church was being stripped of its figural decoration in the eighth century. There is also evidence for continued production in the tale (in Theophanes Continuatus) of the painter Lazarus, famous for his work, who went on painting icons after repeated warnings to desist,

97 Cross in mosaic in the apse of St Eirene, Constantinople (eighth century).

18 Diehl *et al.*, *Salonique*, 117–49; Underwood, 'Nicaea' (see n.10) 238; George, *Saint Eirene* (see n.4) 47–56; A. Grabar, *L'Iconoclasme byzantin* (Paris 1957), 153–5; K.A.C. Creswell & M. van Berchem, *Early Muslim Architecture* (Oxford 1969), I.1, 213–322.

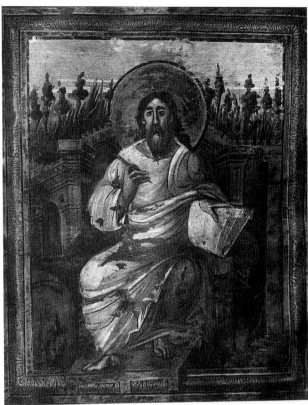

98 Mosaic decoration on the façade of the courtyard arcade, Great Mosque of Damascus (715).

99 Coronation Gospels, made c. 800 at the court of Charlemagne (Vienna, Weltlische Schatzkammer Ms. XIII/18). Folio 178r, the evangelist John.

and eventually had his hands burned on the order of Theophilus (829–42). A miracle allowed him to paint in spite of his injuries, and it was he who restored the icon of Christ to the Chalke Gate at the end of Iconoclasm. The tale shows signs of literary tailoring and some of it may be legendary, but it still lends support to the notion that icon painting continued and painters could be well known for it. The makers of figured reliquaries, crosses and ivories probably also continued their trades, albeit circumspectly.[19]

Relative ease of concealment – especially within monastery walls – also makes it a near certainty that illuminated religious books were not only preserved throughout Iconoclasm, but that new ones were made, even though no certain examples survive. Reconstruction of eighth- and early ninth-century book illumination is largely a matter of guesswork, however, since the pre-iconoclast state of the art is itself very indistinct. Some illumination may have resembled that of the Coronation Gospels, painted around 800 at the court of Charlemagne and thought to have been the work of Byzantine artists who joined the eclectic Carolingian court (fig. 99). This book has full-page evangelist portraits painted in a fairly naturalistic style, on purple vellum. These features, plus the fact that

19 For the icon: John Skylitzes, *Synopsis historiarum, CFHB,* 384 (trans. from the transcription by George Cedrenus in Mango, *Sources,* 154–5); for Lazarus: *ibid.,* 159 (Theophanes Continuatus, *CSHB,* 102).

100 The Chludov psalter (ninth century) (Moscow, State History Museum Cod. grec. 129). Folio 67, the Crucifixion juxtaposed with iconoclasts defacing an icon.

the illumination is unlike anything else being made in the West at the beginning of the eighth century, are the main grounds for Byzantine attribution. (Another is the technical point that the paintings have flaked rather badly, a familiar deficiency of Byzantine miniatures.)

A different illustrative formula, reminiscent of that seen in the sixth-century Rabbula Gospels, is seen in two ninth-century psalters, the Pantocrator Psalter and the Chludov Psalter, both of which have many unframed illustrations in their margins. These psalters are of particular interest because they demonstrate that Iconoclasm generated an 'anti-iconoclast' imagery. On folio 67 of the Chludov Psalter, for example, an image of two iconoclasts defacing an icon is placed next to a Crucifixion, with which it forms an iconographical parallel (fig. 100). The dates of these manuscripts are uncertain – they may have been made shortly before, or shortly after the end of Iconoclasm – but their polemical imagery may have been developed earlier, when the dispute was at its height.

101 Astronomical Tables of
Ptolemy (Vatican gr. 1291)
828–35. Folio 9r, circular
table representing the sun, the
months and the zodiac.

Continued production of illuminated secular manuscripts is indicated
by the single illustrated book of the dark age period which is datable. This
is the Vatican Ptolemy, an astrological text whose tables give a date
bracket of 828–35 (fig. 101). The book is decorated with personifications
of the zodiac, sun and moon, executed in a sub-classical style, and belongs
to the same stable as the sixth-century Vienna Dioscurides.[20]

In summary, therefore, the impact of Iconoclasm on the arts was
probably less profound than a century-long ban on religious figures might
lead one to suppose. It is likely to have been a period of stagnation rather
than obliteration. Some monumental art remained visible, illuminated
manuscripts and objects of the minor arts were probably preserved, and
new ones discreetly made. There is no reason to suppose loss of either
artistic traditions or skills, although reduced resources and the need for
caution probably brought about a reduction in the number of artisans. It
can hardly have been a time of innovation, except in the devising of anti-
iconoclast imagery.

20 Vatican gr. 1291: F. Mütherich & J.E. Gaehde,
 Carolingian Painting (London 1977), 51; for psalters,
 see ch.4 n.57; Spatharakis, *Corpus*, no. 3.

4 *The Macedonian dynasty*

The period between the end of Iconoclasm and the Latin occupation of Constantinople in 1204 is generally known as the 'middle-Byzantine' and its first 180 years, which formed a period of recovery in several senses, has been termed the 'golden age' of the Byzantine empire. During the reign of the first post-iconoclast emperor, Michael III (843–67), there began a gradual recovery of the eastern territories from the Arabs and the successful defence of the empire against Russian and Bulgar advances from the north.

Michael made a favourite of a palace groom, possibly of Armenian parentage, but later styled Basil 'the Macedonian' after the theme in which he was born. In 867 Basil murdered his imperial patron and usurped the throne. As Basil I, he continued the Byzantine advance east, kept the Bulgars at bay and and consolidated Byzantine power in south Italy. (The rest of Italy remained in the hands of the Frankish successors of Charlemagne.) Although not unchecked, Byzantine territorial recovery, backed by legal and administrative reforms, proceeded steadily for the next century, under the dynasty founded by Basil which, albeit with interruptions by usurpers, governed the empire for over a century and a half.

When not of a military disposition themselves, the Macedonian emperors put the campaigns in the hands of a series of able military commanders, usually drawn from the powerful provincial aristocracy. Two of these usurped the throne for brief, consecutive reigns: Nikephoros Phokas (963–9) and John Tzimisces (969–76). Between them they took the Byzantine eastern advance as far as Palestine and Mesopotamia, recovered Crete and, for a while, Cyprus. After the death of Tzimisces in 976, Macedonian rule returned with Basil II, who ended a long period of threat from the north by his decisive defeat of the Bulgars in 1014, for which he earned the epithet 'Bulgar-slayer'. He also annexed part of Armenia and strengthened the Byzantine presence in south Italy. On his death in 1025 the empire was once again large, wealthy and well administered.[1]

It was, however, an empire with a social and administrative structure much different from that of the earlier ages of prosperity. As Byzantine lands were recovered, the theme system of military governorship matured and in the provinces the civil administration of Roman

1 Ostrogorsky, *Byzantine State*, 210–315.

inheritance all but disappeared. Power lay increasingly with the new landowning aristocracy which raised the armies and supplied their commanders. Imperial legislation in the tenth century, which sought to limit the absorption by 'the powerful' of the small land-holdings of peasants and soldiers, is an indicator of metropolitan disquiet at a formula that, while it secured the empire, facilitated usurpation.

On the religious front, the half-century after the defeat of Iconoclasm was one of expansion for eastern Christendom. In 864 the conversion of Boris I brought Bulgaria into the Christian fold, albeit a Bulgaria reluctant to accept Byzantine ecclesiastical dominance. The evangelization of Russia probably began at about the same time, although it was a further century before the Russian princes were baptized. Conversely, relations with the church in the West were strained. The Pope in Rome was still nominally the senior of the five patriarchs, but with most of Italy no longer in Byzantine hands and Rome allied to the Franks, real authority in the orthodox church resided with the patriarch of Constantinople. A schism that was eventually to separate the orthodox east from the catholic west began in the 860s with a protracted dispute between Pope Nicholas I and Patriarch Photios. It was spurred by the appointment of Photios without papal sanction, and it took in theological differences over the concept of the Trinity (the *filoque* issue), but at base it was a battle for authority. It ended in 867 when Basil took the throne, conceded supremacy to Rome and exiled Photios, but the underlying issue remained, to return in later centuries. (Photios, one of the outstanding intellectuals of his day and a shrewd diplomat, returned much sooner, recalled to the capital by Basil a few years later and reinstated as patriarch.)[2]

The renewed prosperity of the ninth century brought with it a proliferation of monasteries that continued throughout the middle-Byzantine period – so much so that in the tenth century a series of imperial decrees sought to reduce the amount of land that might be given to existing monasteries, and to limit the number of new foundations. The novels had little impact, for the Byzantine monastery was part of the social fabric and not easily dislodged. It took various forms. Many monasteries were small, sheltering just a few monks (or nuns) and created mainly to provide retirement accommodation and final resting places for their founders. Others were large, especially the urban monasteries which often had charitable functions such as the care of the sick and the elderly. There were monastic 'centres', where, somewhat paradoxically, clusters of monasteries formed in locations that had been attractive to their eremitical founders for their remoteness and isolation. The monastic centre of Mount Athos, on a peninsula to the east of Thessalonike, founded in the tenth century by St Athanasius under the patronage of Nikephoros Phokas, is functioning still.[3]

2 D. Obolensky, *The Byzantine Commonwealth* (London 1974), 116ff, 188ff; R. Jenkins, *Byzantium: The Imperial Centuries* (London 1966), 168–82.

3 P. Charanis, 'The Monk as an Element of Byzantine Society', *DOP* 25 (1971) 61–84.

The 'golden age' is so called also because of its cultural revival, the beginnings of which are seen in the reign of Michael III (843–67). Michael's uncle Bardas is credited with reorganizing the provision for higher education and scholarship in the capital, central to which was renewed study of the classical texts fundamental to the liberal arts curriculum. Some notion of the range of literature available to the ninth-century scholars is given by the *Bibliotheca* of Photios, which contains synopses of 280 books read by him and his circle. Of the texts summarized, 122 are secular, and they include works of history, medicine, geography, mythology, philosophy, romance and mathematics. Intellectual life in the capital also had the support of some of the Macedonian emperors. Basil I is said to have been respectful of education, even though illiterate himself, and his son Leo VI 'the Wise', who was tutored by Photios, was responsible for many liturgical poems, sermons and other orations of religious content. Leo's son Constantine VII Porphyrogennetos (913–59), was himself a scholar, with interests in the fine arts and music as well as literature, and gave much encouragement to the intellectual circle gathered at his court. The three soldier-emperors who ended the period, Nikephoros Phokas, John Tzimisces and Basil II, were not much given to intellectual pursuits, however, and after the death of Constantine VII in 959 the scholarly circle appears to have declined.[4]

Architecture

The material recovery of the empire is marked by an imperial building programme in the ninth century. According to the *Life of Basil I*, written during the reign of his grandson, Constantine VII, this first Macedonian emperor was responsible for work on many churches in Constantinople and its vicinity. The building campaign may be seen as an aspect of the usurper's attempt to shed his humble origins and establish himself as a patron of the arts. It is also evidence of substantial deterioration of the fabric of the city, where a good deal of earthquake damage and the dilapidations of time had probably gone unrepaired during the seventh and eighth centuries. Even the most important buildings required attention: St Sophia needed a new western arch, and Holy Apostles had to be buttressed and restored; many other churches needed extensive repair and others still were razed and entirely rebuilt.[5]

As is usually the case in such accounts, little is said in the *Life of Basil* about the forms of the new buildings. The description of his most important commission, the Nea Ekklesia, built in the Imperial Palace precinct and consecrated in 880, goes into detail about the opulence of the interior

4 L.D. Reynolds & N.G. Wilson, *Scribes and Scholars* (Oxford 1968), 51–8; D.S. White, *Patriarch Photius of Constantinople* (Brookline MA 1981), 48ff; G.L. Huxley,

'The Scholarship of Constantine Porphyrogenitus', *Proceedings of the Royal Irish Academy*, 80 (1980) 29–40.

5 *Vita Basilii*, 78–94, trans. Mango, *Sources*, 192–9.

decoration but is vague about the structure. It does however mention that the church had five domes, which suggests that it was an inscribed-cross, a type that was to dominate Byzantine ecclesiastical architecture for the remaining five centuries of the empire, and persists in post-Byzantine building. The form is so called because the main vaults of the naos (the core of the building) make an equal-armed (Greek) cross which is set within a square outer wall. In plan, therefore, this unit has nine bays, the central one domed (the five domes of the Nea were probably the central one plus four over the corner bays).

The inscribed-cross scheme is found in two tenth-century churches that are the earliest dated post-iconoclast monuments of the capital, the North church of the Monastery of Constantine Lips and the Myrelaion. The latter retains its original form best, and will therefore be described first. The church was built in 920–2 for the usurper emperor Romanos I, an admiral who became regent for the infant Constantine VI Porphyrogennetos and then, in 920, his co-emperor (emperor, in effect, since Constantine was still only fourteen years old). Romanos had a palace in the Myrelaion district (about halfway between the Aqueduct of Valens and the Sea of Marmara) which he turned into a convent when his seizure of power provided him with other quarters. It was probably intended to serve as a family mausoleum, although Romanos was not in fact buried there. The church was built on a massive substructure constructed to provide a level site next to the palace. It is small (barely eighteen metres from entrance to apse wall) and built of thin, tile-like bricks separated by thick mortar beds (fig. 102). The central dome, of 'pumpkin' type (with eight concave segments) was originally carried on four columns (later replaced

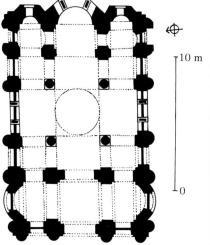

102 Myrelaion Church, Constantinople (920–2): plan (part reconstruction) after Striker; view from the northwest.

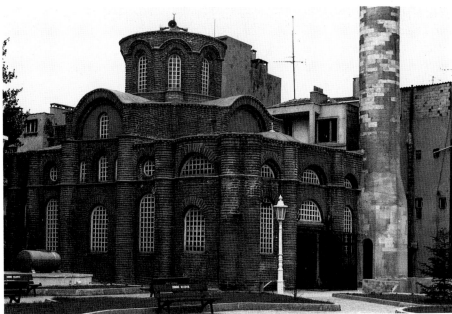

by Ottoman piers), and flanked by four cross-groined vaults. The square is completed by four small corner bays, also with cross-groined vaults, at a lower level than those of the cross-arms. To the east a large main apse and two small lateral apses are separated from the core by three further bays (intercalary bays). To the west, there is a three-bay narthex, with a domical vault over the central bay, the other two cross-vaulted. The structure of the church is articulated on the exterior: a tall drum encloses the central dome, the high vaults of the cross-arms rise above the lower roofs of the corner bays, and each division of the interior is marked by half-round brick buttresses which, with the brick fabric itself, create a heavily textured surface.[6]

The Monastery of Lips, also south of the aqueduct, but to the northwest of the Myrelaion, was built for the aristocrat Constantine Lips and its north church dedicated in 907 (a south church was added in the thirteenth century) (fig. 103). Alterations have obscured many details of the

103 North church of the Monastery of Constantine Lips, Constantinople (907): view from the northwest, showing also the dome of the south church added in the fourteenth century; plan, after Megaw.

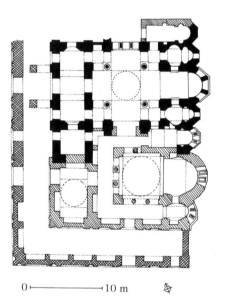

0 ⊢————————⊣ 10 m

church, but excavation has established the original nine-bay inscribed-cross naos, with three apses opening off intercalary bays, and a three-bay narthex. Thus far, the church resembles the Myrelaion, with which it also shares details such as niching of the north and south intercalary bays, and of the north and south walls of the narthex; it is also similar in size. At the Lips church, however, the basic formula was elaborated. To north and south, chapels flanked the east end, projecting from the body of the church and provided with independent western entrances as well as open-

6　Mathews, *Istanbul*, 209–19; C.L. Striker, *The Myrelaion (Bodrum Camii) in Istanbul* (Princeton NJ 1981).

ings to the corner bays of the naos. There was a porch at the west entrance to the narthex, and a stair-tower to its south, which led up to a narthex gallery. The lateral bays of the gallery open to a pair of small chapels above the western corner bays. Two more roof chapels, above the eastern corner bays and intercalary bays, were reached by open exterior galleries supported on corbels; they were entered from the north and south extremities of the narthex gallery. The roof chapels were domed, making five domes in all (and compatible with a rather more complex structure for the five-domed Nea Ekklesia than the scheme proposed above). The Lips church, like the Myrelaion, declares its form on its exterior, with the lines of its main sections and their vaulting clearly visible. The exterior is again highly textured, with alternating bands of brick and stone to the springing level, brick alone above this, and each door and window covered by a brick arch.[7]

Although these two are the earliest surviving inscribed-cross churches in the capital, they cannot be placed at the beginning of the development of the type. The Nea Ekklesia probably places the form in the capital at least by 880, and churches of essentially inscribed-cross form have been attributed to dates earlier still. A church at Side on the south coast of Anatolia was probably built in the early ninth century, since the town was abandoned in the mid-ninth century following devastation by Arab raids. Earlier still may be two churches at Tirilye, Bithynia (Fatih Camii and St John of Pelekete), which could belong to the mid-eighth century if they are the first on their sites.[8] Further, neither of the tenth-century buildings in Constantinople has the uncertainties of design usually associated with experimental structures. On the contrary, they appear to be confident variants on a well-established formula. The provision of many chapels at the Monastery of Lips may have been to accommodate relics, or to serve a multiple dedication of the church (the Nea had such a dedication, to Christ, the Virgin, the Archangel Gabriel, Elijah the Prophet and St Nicholas). The probability, therefore, is that the inscribed-cross church was developed during the dark age, and the surviving ninth- and early tenth-century examples show it in mature form, exhibiting variations to meet individual requirements.

Beyond this, the origins of the type remain obscure, in spite of much conjecture. Some authors, noting similarities with the sixth- or seventh-century domed churches of Armenia, have suggested an eastern origin, others have attempted to place the inscribed-cross at the end of a chain of development from the domed basilica, via the cross-domed churches. Given the lack of material remains from the dark age period, neither case can be substantiated, and it may be fruitless to search the surviving mon-

7 Mathews, *Istanbul*, 322–45; Macridy *et al.*, 'Monastery of Lips', 249–315.

8 S. Eyice, 'L'Eglise cruciforme byzantine de Side en Pamphylie', *Anatolia* 3 (1958) 35–42; C. Mango &

I. Ševčenko, 'Some Churches and Monasteries on the South Shore of the Sea of Marmara', *DOP* 27 (1973) 235–77, 236, 242.

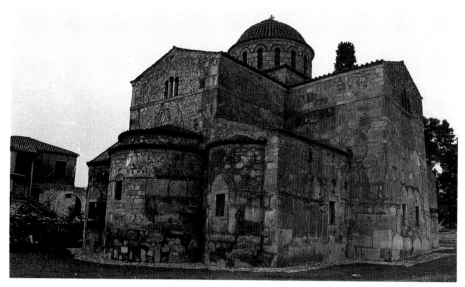

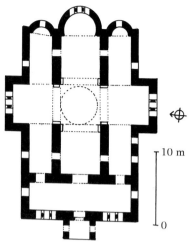

uments for an evolutionary sequence behind the inscribed-cross, except in the most general terms. The importance of the domed-basilica and cross-domed developments is that they established the domed, centralized church as the preferred form. Once this step had been taken, the requirements of engineering would encourage the adoption of bilateral symmetry. The inscribed-cross was probably one of several responses to the need for simple and secure domed forms to be used for the smaller churches that must have existed alongside the large domed-basilicas and cross-domes.[9]

Such a framework accommodates the few churches datable to the ninth century more easily than any attempt to link them in a typological sequence. Thus, the Church of the Dormition at Skripou, Boeotia, built by an imperial official, Leo the *protospatharios*, in 873/4, has a dome at the centre of a Greek cross made of four barrel vaults, and barrel-vaulted aisles less wide than the lateral cross-arms leave the latter projecting from north and south walls (fig. 104). Although the central element (of barrel-vaulted Greek cross with domed centre) is shared with the inscribed-cross church, the Skripou building has little else in common with it and must be regarded as, at best, a relative of uncertain connection. Two other ninth-century churches make use of the inscribed-cross element proper, in different ways. The church at Side, mentioned above, has cross-arms extending beyond very small corner bays (but not projecting on the exterior because of the uneven thickness of the walls) (fig. 105). There is only one apse, and the bema is flanked by large square bays. This may be seen as a fore-runner of the much more regular inscribed-cross church, as it appears in the tenth century, but could as well be simply a variant. At Peristerai,

104 Church of the Dormition, Skripou, Boeotia (873–4): view from the northeast; plan after Megaw.

105 Church of Side, south Anatolia (early ninth century?) plan after Eyice.

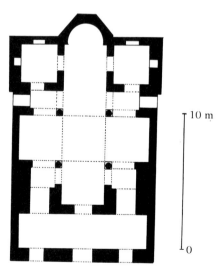

9 Krautheimer, *Architecture*, 360–1; H. Buchwald, *The Church of the Archangels in Sige, near Mudania*, (Vienna/Cologne/Graz 1969), 44–5.

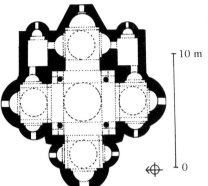

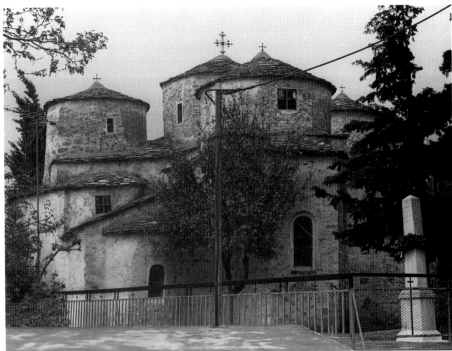

106 Church of the Theotokos, Peristerai, Thrace (879–71): plan, after Orlandos; view from the southeast.

near Mount Athos, the Theotokos church built by Abbot Euthymios in 879/71 has a condensed inscribed-cross core with very short cross-arms, which are extended on all four sides into domed and niched square bays (fig. 106). The church may therefore be seen either as an elaboration of the inscribed-cross scheme, or as an unrelated type except in its use of the four-arch four-column unit as its core.[10] The relationship between these ninth-century churches and the inscribed-cross churches of the tenth century is clearly ambiguous. In all probability, several different centralized domed types were used during the eighth and ninth centuries, some of them making use of the inscribed-cross unit, others not.

From this background, the inscribed-cross church with its relatively simple engineering and consequent ease of construction emerged as a standard type. It will be obvious from the above that it is not possible to say whether it first appeared in the provinces or in the capital, but it may be supposed that it was metropolitan use of the form that caused it to become widespread by the tenth century. The earlier of two churches at the Monastery of Hosios Loukas in Greece (near Delphi) was built between 946–55 by the *strategos* Krinites, who occasionally visited the holy hermit Loukas to hear his advice. The small church, now known as the Theotokos Church, but originally dedicated to St Barbara, shows the inscribed-cross at its simplest, with barrel-vaulted cross-arms, cross-vaulted corner bays, three apses opening off intercalary bays and a

10 Krautheimer, *Architecture*, 329, 394; Mango, *Architecture*, 208.

narthex (fig. 107). It also has a highly decorative exterior, using stones encased in brick, a technique which borrows the term 'cloisonné' from enamelwork, and which becomes characteristic of Greek middle-Byzantine churches.[11] The inscribed-cross was taken as far as Russia in 996, when Byzantine builders were sent to construct the Tithe Church in Kiev for Vladimir, after his conversion to Christianity and marriage to Anna, sister of Basil II. The church was destroyed in the thirteenth century, but its form has been determined by excavation of its foundations.[12] No central Anatolian inscribed-cross church is firmly dated, but the type appears in Kılıçlar Kilise, a Cappadocian cave church attributed to the early tenth century by the style of its painting (fig. 108). Built examples in the same area, such as Çanlı Kilise, near Çeltek and Karagedik Kilise in Ihlara, probably predate the mid-eleventh century Turkish occupation (fig. 109). (In passing, it may be noted that the hundreds of rock-cut churches and chapels of Cappadocia have preserved many forms other than the inscribed-cross: single-naved, twin-naved, transverse-barrel vaulted, triconch, and free-cross. This suggests that much greater variety was available in middle-Byzantine church types than is apparent from the surviving built examples. It is a reminder, too, that the greatest area of loss is

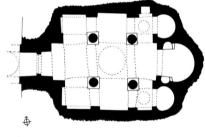

0 10 m

108 Kılıçlar Kilise, an early tenth-century cave church in Cappadocia (plan after Restle).

11 R.W. Schultz & S.H. Barnsley, *The Monastery of St. Luke of Stiris, in Phocis* (London 1901); Mango, *Architecture,* 212–15; P.M. Mylonas 'Nouvelles remarques sur le

complexe de Saint-Luc en Phocide' *CahArch* 40 (1992) 115–22. esp. p. 119 n.45 for bibliography.

12 Mango, *Architecture,* 324.

107 Monastery of Hosios
Loukas, Phokis (first church
946-55, second early eleventh
century): exterior from the
east; plan after Stikas.

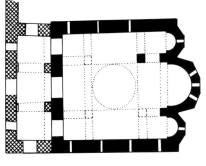

109 Çanlı Kilise, near Çeltek,
central Anatolia (tenth/
eleventh century) plan after
Restle.

that of the commonplace – the buildings which were not products of impe-
rial or aristocratic patronage.[13]

With so few datable churches, identification of regional traditions in
ninth- and tenth-century Byzantine architecture can seldom be secure. An
exception is provided by Mount Athos, where the churches of twenty
monasteries are built on the inscribed-cross plan, modified by the addition
of apses to the ends of the north and south cross-arms. With the main
apse, these create a triconch naos, in which the lateral apses provide space
for choirs. Most of the Athonite churches are post-Byzantine, and none
has been studied in detail, but the fabric of two is said to be tenth-century:
the Theotokos Church of the Vatopedi Monastery (972), and the Koimesis
Church of the Iviron Monastery (976) (fig. 110). Imperial patronage may
have brought the inscribed-cross to Athos, but by the second half of the
tenth century the form was probably available closer to hand, in
Thessalonike, even though no examples of that date survive there. The tri-
conch variant may have been inspired by St Athanasius' own church, the
Great Laura, which is a true triconch with apses on three sides of a square
centre bay – if this was indeed built in 963, as tradition has it.[14]

13 Rodley, *Cave Monasteries*, 153–65, 230–1, 224ff.
14 P.M. Mylonas, 'L'Architecture du Mont Athos' in *Le
 Millénaire du Mont Athos* (Chevetogne 1963), II 229–46
 (fuller version in Greek, with plans, in *Nea Hestia* 74

(1963) 189–207). P.M. Mylonas 'Le plan initial du
catholicon de la Grande-Lavra au Mont Athos et la
genèse du type du catholicon athonite' *CahArch* 32
(1984) 89–112.

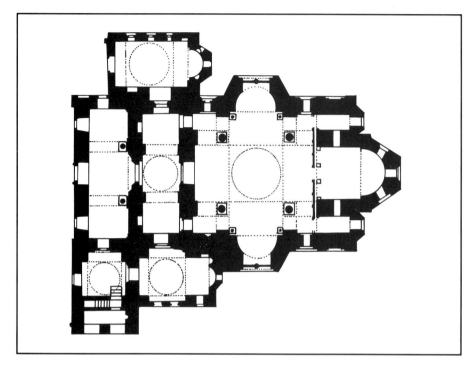

110 Church of the Iviron Monastery, Mount Athos (976) plan after Millet.

The sweep of the inscribed-cross church was not complete, however, for it seems not to have penetrated the Pontus region, on the south shore of the Black Sea until the eleventh or twelfth century. In Trebizond (Trabzon), its chief city, the church of St Anne, rebuilt by the *proto-spatharios* Alexios in 884/5, is a small basilica (twelve metres long), with a nave arcade of just two arches (fig. 111). The form is found in other

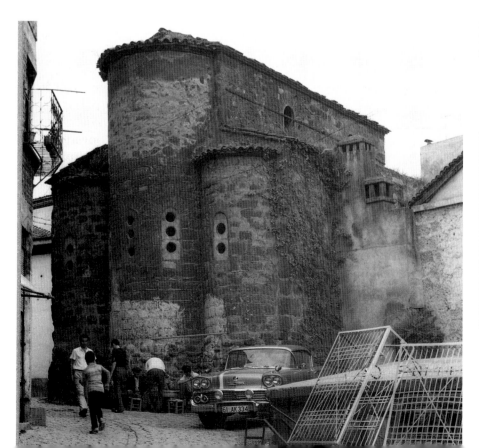

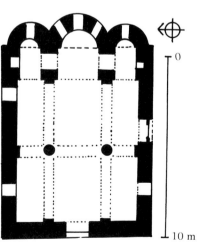

111 St Anne, Trebizond (884/5): view from the northeast; plan after Ballance.

undated but probably later buildings of the Pontus and seems to be a local type. Domed forms of any sort do not make their appearance until much later, and when they do they form somewhat awkward hybrids with the local tradition.[15]

More important than the origins of the inscribed-cross, or the relationships between its variants, is the change of concept in ecclesiastical architecture that it, and most other middle-Byzantine church types, represent. They are for the most part small buildings, with complex interior spaces and highly textured exteriors, quite unlike the spacious, simply-finished forms of earlier Byzantine architecture. Several factors have been adduced to account for this radical change in architectural direction, some practical, some social. Reduction of scale must first be associated with the impoverishment and instability of the empire during the dark age. Even though these conditions were no longer present in the ninth century, the custom of building large churches (and perhaps also the taste for them) would have diminished after two centuries of curtailment. Similarly, the technical skills necessary for building on a large scale, although preserved to the extent that extensive repair work could be done on buildings as large as St Sophia, must have declined from lack of practice. By the mid-ninth century there could have been no craftsman alive who had participated in the construction of buildings even as large as the eighth-century cross-domes. Further, although the empire had recovered much of its wealth, its resources in practical terms had changed somewhat. The fine marble needed to furnish columns and revetments in Constantinople was no longer brought from distant quarries, but was salvaged from derelict buildings. This was the case, according to Leo Grammatikos, even for the Nea Ekklesia, Basil I's showpiece. Such a source of materials is convenient, but it has its limits, and must favour small buildings.

These practical considerations cannot, however, have been the only force for change in church size, and were probably not even the main ones. Had large buildings been wanted, one feels that the confident aristocracy of the ninth and tenth centuries would have found the means to build them, even if not quite of Justinianic proportions. The deciding factor must have been social changes that affected habits of worship. It is argued that the early Christian church was built large for reasons both of utility and propaganda – to accommodate large congregations of converts and to declare the strength of the faith. Although such requirements may have been redundant by the end of the fifth century, with the converts safely gathered in and the supremacy of Christianity not seriously at risk, important churches continued to be built large as a matter of custom until lack of resources interfered. Once the tradition was broken, however, it was never resumed because there was no need for it.[16]

Further, it may be noted that nearly all the churches mentioned

15 S. Ballance, 'The Byzantine Churches of Trebizond', *AnatSt* 10 (1960) 141–75, 154f.

16 Krautheimer, *Architecture*, 362; Mango, *Architecture*, 198.

above were monastic, commissioned by members of the aristocracy or gentry. The same is true of a great many middle-Byzantine churches and points to a change in the nature of provision for worship. The 'personal' monastery, founded by an individual or family, was an important aspect of middle-Byzantine culture – so much so that, as noted above, Nikephoros Phokas sought to curb the number of such institutions by imperial decree, and encouraged patrons to assist already existing monasteries rather than found new ones. His efforts had little impact, for the monastery could supply many needs in addition to the spiritual. It could be a library or treasury, a place for the care of sick, elderly or embarrassing members of the family, a place of retirement (for reasons of old age or political expediency) and, finally, a burial place with a community of monks or nuns on hand to say prayers for the departed.[17] Many large parochial churches built in earlier times doubtless remained in use, especially at important shrine sites, but commissions for new churches intended for public worship must have declined as those with the means turned increasingly to the personal or family foundation. This change of habit favours the small church, which could offer its small congregation an intimate, intricate interior, made opulently mystical by the application of lamplight to gold and silver revetments and jewel-encrusted fittings.

The change in size and form of the church is accompanied by a change in the form of the sanctuary screen, which is preserved in several of the above churches. At Skripou, screens covered all three openings to the eastern bays, each section with columns carrying an entablature (two in the lateral sections, four in the central one). The intercolumniations were half closed by parapet slabs, leaving a single entrance at the centre (fig. 112 a). Hosios Loukas has a simpler, two-column screen, across the opening to the bema only. The barrier of columns and entablature rendered the

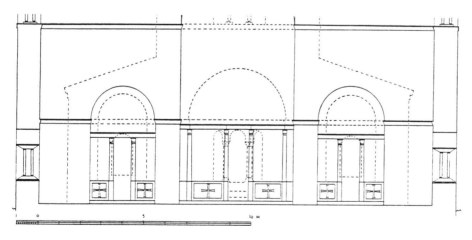

112 (a) Sanctuary screen of the Church of the Dormition at Skripou (873/4): reconstruction, A.H.S. Megaw.

17 For Byzantine monasticism, see D. Nicol, *Meteora* (London 1963), ch. 2.

sanctuary less visible to the congregation than had the low parapets of the fifth and sixth centuries, and visibility may have been reduced still further by curtains hung from the entablature. The change thus forms a step on the way to the complete opacity of the post-Byzantine *iconostasis*, which is a tall, solid screen hung with icons. This closes off the sanctuary completely, except when its central doors are opened at prescribed stages of the liturgy. It is unclear when the columnar middle-Byzantine screen made its first appearance. Skripou has the earliest surviving dated example, but it was probably not the first of its kind and the development was probably closely associated with that of the small middle-Byzantine church itself.[18]

The evidence for secular architecture of the Macedonian period is entirely documentary. The *Life of Basil* falls back on a tiresome literary convention: Basil's work on the Imperial Palace was so fine that it defeated the writer's powers of expression. In fact, given the extensive rebuilding of the palace by Theophilos less than forty years previously, it is likely that Basil's work was mostly refurbishment. The writer of the *Life* did manage to describe one new structure, the Kainourgion, a hall with an eastern dome (or apse,) and sixteen columns. Eight of these were of green marble and eight onyx-like, probably indicating the re-use of material from two different earlier buildings. Theophanes Continuatus records that Constantine VII was also responsible for some work on the Imperial Palace, but this too seems to have been repair, redecoration and minor modification – he turned one of the rooms built for Theophilos into a library. He is also said to have built palaces for his son Romanos II, but where they were and what they looked like is not recorded. The anonymous author of *Digenes Akrites*, a long poem concerning the exploits of a hero of the eastern frontier, is a little better at description. He tells us that Digenes' palace on the Euphrates was a large square building, on at least three floors, with an interior courtyard large enough to accommodate a church. This is imaginary, of course, and is likely to be based on a Constantinopolitan model, rather than a Mesopotamian one, but it does suggest that a middle-Byzantine palace could be a single large building, rather than the collection of pavilions that made up the Imperial Palace. Such would seem to be the case of the palace built by Basil I in the Mangana district of Constantinople, near the sea wall on the Marmara coast. A brief aside in the twelfth-century biography of Alexios I, by his daughter Anna Komnena, tells us that the dying emperor was moved to the fifth floor of the Mangana Palace, to enjoy the sea breezes. The Myrelaion Palace of Romanos I must also have been a compact structure, given the limitations of its site and the size of remaining substructures.[19]

18 A.W. Epstein, 'The Middle-Byzantine Sanctuary Barrier: Templon or Iconostasis?', *JBAA* 134 (1981) 1–28, 27.

19 *Vita Basilii* 89–90, trans. Mango, *Sources*, 196–9; *ibid.*, 207–8 (Theophanes Continuatus 15–24); J.

Mavrogordato, *Digenis Akrites* (Oxford 1956), 219–23; *Vita Basilii*, 91 (Theophanes Continuatus, *CSHB* 337); Striker, *Myrelaion*, see n.6 13–16.

Finally, mention must be made of what is perhaps the most timeless document produced in the tenth century. The *Book of the Eparch* is a compilation of regulations applied to the craft guilds of Constantinople. Artisans, it tells us, may not leave work unfinished on one site to start on another; they must make good, at their own expense, faulty domes that collapse in less than ten years other than by act of God; they must not charge more than their estimates, unless authorized to do so by the Eparch, who will be advised by expert opinion. All this on pain of flogging, tonsure or banishment. Conflict between client and builder appears to be changeless in its nature.[20]

Sculpture

The buildings of the Macedonian period vary in their use of carved decoration – some have it, others do not; some ornament is re-used from earlier buildings, some newly made. This may be illustrated by a review of the churches already mentioned, and consideration of a few more. The church at Peristerai (870/1) has virtually no carved ornament, but that at Skripou (873/4) has cornices, string courses and the sanctuary screen noted above, all decorated with geometric patterns and highly stylized foliage, some of it harbouring birds and animals (fig. 112 b). Similar carv-

112 (b) Detail of sculpture from the sanctuary screen of the Church of the Dormition, Skripou (873/4).

ing was found on marble blocks and panels excavated at the sites of the church of St John Mangouti in Athens and the chapel of St Gregory in Thebes, both dated by inscriptions, to 871 and 872 respectively. Several more sites in central Greece have preserved *ex situ* pieces which are attributed to similar dates on stylistic grounds.[21] At Selçikler, on the outskirts of Sebaste in Anatolia, parts of a sanctuary screen with two columns, entablature and two parapets have been found in the ruins of what appears to

20 I. Dujcev, *The Book of the Eparch* (London 1970), 268–70.

21 A.H.S. Megaw, 'The Skripou Screen', ABSA 61 (1966), 1–32.

113 Sanctuary screen of a church at Selçikler, near Sebaste (tenth century?): reconstruction, Ü. Izmirligil; detail of sculpture.

be a tenth-century church built on the remains of an earlier basilica. An inscription on the entablature credits a Bishop Eustathios with the rebuilding, but gives no date. The decoration of the sanctuary screen includes, in addition to geometric, foliage and animal motifs, bust-medallions in a row on the entablature, representing the Deesis (Christ between the Virgin and John the Baptist), flanked by four archangels and the apostles (fig. 113). The medallions, and other parts of the decoration, had coloured glass inlay, some fragments of which remain in place. Similar work has been found at other sites in the region, but the technique is unlikely to be local – it recalls the sixth-century glass-inlay work at St Polyeuktos in Constantinople. Also found at Selçikler were two arched facings decorated with bust-medallions like those of the screen, possibly the fronts of tomb-niches.[22]

22 N. Fıratlı, 'Découverte d'une église byzantine à Sébaste de Phrygie', *CahArch*, 19 (1969) 151–66.

The sources say nothing about sculpture at the Nea Ekklesia in Constantinople, but the *Life of Basil* mentions columns with inhabited vine ornament in the Kainourgion at the Imperial Palace – possibly old ones re-used, or perhaps new work like that at Skripou. In the north church at the Monastery of Lips (907) old materials and new were combined: four fifth-century impost capitals with stylized acanthus decoration were halved to make eight pilaster-capitals for the walls of the naos, but new carving was made for cornices, window mullions and corbels. This uses sharply cut, very stylized, regular leaf patterns with drilled centres to curled elements. There is a particularly fine cornice of this type below the dome, with birds flanking a cross (fig. 114). In contrast, the Myrelaion Church (920–2) is almost without carved ornament. Fifth-century capitals were used in the

114 Marble cornice below the dome of the North Church of the Monastery of Constantine Lips, Constantinople (907).

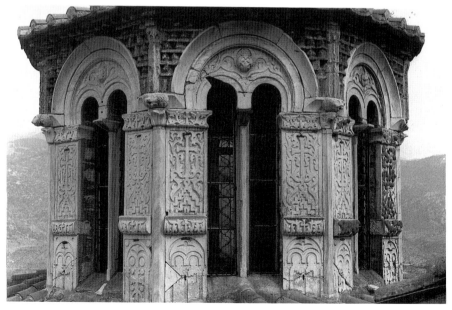

115 Church of St Barbara (now Theotokos) at the Monastery of Hosios Loukas, Phokis (946–55):
(a) sculpture on the drum of the dome; (b) (opposite), brick ornament imitating kufic script.

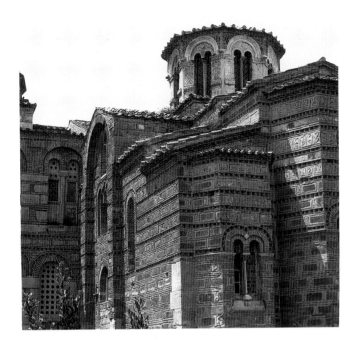

substructure, and four more may have been used for the columns of the naos (now replaced by post-Byzantine piers).

The first church of the Monastery of Hosios Loukas (946–55) is very rich in ornament. Its dome is encased by an octagonal drum, on each face of which there are four revetment panels with ornate crosses in relief, flanking two-light windows with paired horse-shoe arches, set below a round arch. The panels are surmounted by sections of cornice decorated with stylized leaf patterns, and lion-head gutter spouts are placed at the angles of the octagon (fig. 115 a). A string course on the exterior of the east end has 'kufic' ornament, patterns based upon an ornate style of Arabic script often used in Islamic art, both minor and monumental (fig. 115 b). Opinions differ as to whether the 'script' ever formed real words, or simply imitated their shapes. Inside the church, the two columns of the narthex have re-used Corinthian capitals but the capitals of the naos were newly made. These reproduce the Corinthian form, translating it into dense, regular patterns of stylized leaves and volutes, with angels and tetramorphs (the four symbols of the evangelists conflated); similar carving is used for the sanctuary screen.[23]

All the carving cited is similar in style and technique, but there are few instances of exact correspondence of motifs in the sculpture of different sites. This suggests that the surviving examples represent a widespread tradition involving many workshops. (It reached as far as Preslav, in

23 Macridy et al., 'Monastery of Lips', 259–62. An archivolt with figure sculpture found during excavation of the north church and then thought to be contemporaneous with it, belongs to the fourteenth-century development of the monastery (see ch. 7 below). L. Bouras, *O Glyptos Diakosmos tou Naou tes Panagias sto Monasteri tou Osiou Louka* (Athens, 1980) (English summary 123–34).

Bulgaria, where sections of decorated cornice and panels have been recovered during excavation of the Round Church, destroyed during the sack of the town in 972.) In such circumstances, the absence of carving in some churches deserves comment. At Peristerai it may have been a matter of limited resources in a rustic context (St Euthymios is said to have built the church himself, with assistance from fellow monks), but this was not the case with the Myrelaion Church, which was an imperial commission in the capital. It has therefore been suggested that the taste for architectural sculpture declined in the tenth century, a theory consistent with its rather limited use in the churches of the capital in the eleventh century and later. If so, the change of taste was a rapid one, since only about thirteen years separate the rich ornament of the Monastery of Lips and the austerity of the Myrelaion Church.[24]

In style, the ninth- and tenth-century sculpture, with its sharply cut regular patterns, recalls the 'lacework' carving of the sixth century. Many motifs are quite different, however, and their range is wider – the acanthus is rare, but there are birds and animals, including, at Selçikler, exotic species such as the dragon-like *senmurv* of Persian art. The closest parallels for some of these motifs are found in the carved ornament of Islamic monuments of approximately the same period, such as the Great Mosque at Kairouan, Tunisia and the Palace of Madinat al-Zahrah in Spain. It would be fanciful, however to propose direct links with such far-flung monuments. Much of the similarity may be more easily explained as parallel development, since both Byzantine and Islamic craftsmen were using a vocabulary of ornament that had already absorbed oriental motifs by the sixth century and probably continued to do so. At Hosios Loukas, however, the the ornament which imitates kufic script does suggest some direct imitation of Islamic models, if only the Arab and Persian pottery and textiles that found their way to the Byzantine empire through Mediterranean trade.[25]

By the Macedonian period, free-standing figure sculpture would appear to be quite literally a thing of the past. It is recorded in Theophanes Continuatus that Constantine VII put statues in the Bucoleon, part of the palace precinct, but the pieces were old ones and the collection possibly an aspect of the scholar-emperor's antiquarian interests. Production had probably ceased long before, since the eighth-century writers of the *Parastaseis syntomoi chronikai*, (see chapter 1), described the old statuary of Constantinople in terms that make it clear that they were recording monuments of a past age. There is evidence of statuary of a sort in accounts of mechanical figures made of metal, or wood encased in metal, that embellished the court of Constantinople. Liudprand of Cremona, an Italian ambassador who made several visits to the capital in the tenth century,

24 Grabar, *Sculptures*, 100ff, pls. LXII-LXIII.
25 D. Hill, *Islamic Architecture in North Africa* (London 1976), 91–3; B.P. Maldonado, *Memoria de la Excavación de la Mezquita de Medinat Al-Zahra* (Madrid 1966), pls. LXXX-LXXXIV.

116 Mosaic decoration in St Sophia, Constantinople. (a) The Virgin and Child in the apse (967).

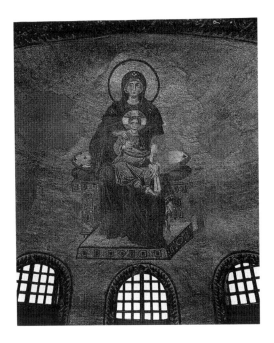

records an audience with Constantine VII in 949 at which he saw a gilded bronze tree full of singing birds, and lions whose tails and jaws moved as they roared. These pieces were probably antiques by the mid-tenth century, since very similar equipment is described at the court of Theophilos (829–42) (as well as a jewel-encrusted throne and a fountain that spouted wine on festive occasions). All this seems more to the taste of the flamboyant Theophilos than that of the scholarly Constantine – although the latter was not averse to using a mechanical throne that lifted him high above the ground while the lions and birds performed – but whether a frequent feature of aristocratic audience rooms or not, these automata belong to the genre of fairground devices rather than that of monumental sculpture.[26]

Monumental art

In 867 the Patriarch Photios delivered a homily on the mosaic image of the Virgin and Child that is still present in the apse of St Sophia in Constantinople. The elegant figures are set against a plain gold ground, and accompanied by an inscription: 'The images which the imposters had cast down here pious emperors have again set up' (the pious emperors were Michael III and Basil I) (fig. 116 a). The language of the homily sug-

26 Theophanes Continuatus, *CSHB*, 447f, trans. Mango, *Sources*, 207; for the *Parastaseis* and the later compilation known as the *Patria Constantinopoleos*, see Cameron & Herrin (see ch.1 n.16), 3–8; Liudprand of Cremona, *Antapodosis* VI, 5, 8, trans. Mango, *Sources*, 209–10; for Theophilos: Leo Grammaticus, *CSHB* 215, trans. Mango, *Sources* 160–1.

gests that the mosaic was recently completed, and that other work was in progress in the Great Church. Angels in imperial dress, one each side of the bema arch, belong to the same phase and were probably already in place. A similarly worded inscription in the *Chrysotriklinos*, the main audience hall of the Imperial Palace, is known from the *Greek Anthology*, and its terms imply a date between 856–66. It records that an image of Christ was placed in the apse above the throne, the Virgin was on the wall above the entrance, and figures of the emperor (Michael III), the patriarch (Photios), angels, apostles, martyrs and priests were 'all round the building'.[27]

It may be noted, however, that these decorations were installed well after the end of Iconoclasm, so that as expressions of iconodule triumph they are somewhat lame. Some suggest that the iconodules chose to proceed cautiously, lest they provoke an iconoclast revival, others that it took time for the skills of monumental art to be recovered – but neither argument convinces. What seems to be a delay in restoring images is equally consistent with the suggestion of the last chapter that many churches had not, in fact, had their monumental images removed, and wholesale restoration was simply not necessary. Just as the sources are either vague or very limited in their accounts of iconoclast destruction, they are near silent on the replacement of losses due to this cause. The *Life of Basil*, for example, does not give iconoclast damage as a reason for work on any of the dozens of buildings it lists, whereas deterioration resulting from natural causes, such as earthquake damage, is often cited. When church decoration was undertaken, therefore, it may well have been as part of the general refurbishment attendant on renewed prosperity. Within this context, the mosaics and inscriptions placed in St Sophia and the Imperial Palace clearly were self-conscious assertions of orthodoxy (and, it may be guessed, representative of others in those buildings that actually had been defaced by iconoclasts). But they seem to have been the exception rather than the rule. No demonstration of iconodule victory was felt necessary even in the small room over the ramp in St Sophia, for the iconoclast crosses that replaced figures are there still.[28]

The programmes of several ninth-century church decorations are known from both material remains and documentary sources. There is far less evidence for the tenth century, but many features of ninth-century monumental art reappear in eleventh-century decorations, so a high degree of continuity may be supposed. The ninth-century programmes show a certain uniformity in that their images have a hierarchical relationship to the vaulting system of the domed church. Thus, Christ appears in the dome, sometimes with angels or prophets, the Virgin is placed in the

27 C. Mango & E.J.W. Hawkins, 'The Apse Mosaics of St. Sophia at Istanbul', *DOP* 19 (1965) 115–51; Photios, *Homily XVII*, trans. Mango, *Sources*, 187ff; for Chrysotriklinos: *Greek Anthology* (see ch.2 n.6) 1, 106.

28 For a summary of post-iconoclastic art: R.C. Cormack, 'Painting after Iconoclasm' in *Iconoclasm. Papers given at the Ninth Spring Symposium of Byzantine Studies* (Birmingham 1977), 147–63.

apse, and, in the minor vaults there are episodes from the Life of Christ and figures of saints. The narrative element consists not of full cycles, but of episodes pertinent to major feasts of the Church and known therefore as 'festival icons'.[29]

Descriptions of church decorations in Constantinople that are now lost provide the chief evidence for this scheme. Thus, at the Theotokos of the Pharos, a church in the Imperial Palace, near the *Chrysotriklinos*, a figure of Christ was placed in the dome, with angels in its ribbed segments; the Virgin (probably an orant figure) was in the apse, and apostles, martyrs, prophets and patriarchs 'filled the whole church'. All this is described in another homily of Photios, written between 864 and 866, probably to mark the redecoration of the church. A similar programme in the church of the Theotokos of the Pêge, restored by Basil I and his sons Constantine and Leo, is known from inscriptions recorded in the *Greek Anthology*, which allude to an Ascension in the dome and several festival icons in unspecified locations (the Crucifixion, Transfiguration, Presentation and the Women at the Tomb). Thanks to a miracle, we know that there was also a mosaic image of the Pentecost, for while it was being put up, the Virgin appeared to support collapsing scaffolding and save the craftsmen. Basil's restoration of Justinian's Holy Apostles, the church of the imperial mausoleum, probably included the decoration described in a tenth-century *ekphrasis* by Constantine Rhodios. It had Christ, the Virgin and apostles in the dome (probably in an Ascension) and festival icons in the minor vaults (Annunciation, Nativity, Magi, Presentation, Baptism, Transfiguration, Raising of the Widow's Son, Raising of Lazarus, Entry into Jerusalem, Betrayal and Crucifixion). Two more examples are known from sermons written by Basil's successor Leo VI. In a church built by Stylianos Zaoutzas, Leo's father-in-law, and consecrated between 886–93, the dome had Christ Pantocrator at its summit and seraphim and prophets below. (The Pantocrator image shows Christ as a half-figure in a medallion, holding a book in the left hand.) Festival icons included the Annunciation, Nativity, Magi, Presentation, Baptism, Transfiguration, Raising of Lazarus, Crucifixion, Entombment, Anastasis and Ascension. Another sermon by Leo records that the church of the Monastery of Anthony II Kauleus (Patriarch of Constantinople 893–901) had an image of Christ in the dome, with 'God's own servants' (angels?) both in the dome and on the arches below it; also the Virgin and Child, probably in the apse.[30]

The Virgin and Child with Archangels in the sanctuary of St Sophia were almost certainly the first-completed elements of a programme with features in common with those noted above (fig. 116 b). An image of Christ in the dome, destroyed in 1346, is known from several accounts,

29 O. Demus, *Byzantine Mosaic Decoration* (London 1948).
30 Pharos: Photios, *Homily X*: C. Mango & R.J.H. Jenkins, 'The Date and Significance of the Tenth Homily of Photius' *DOP* 9/10 (1955/6) 125–40; Pêge: *Greek Anthology* (see ch.2 n.6) 1, 109–14, *Acta Sanctorum Novembris III*, 882; Constantine Rhodios, *Description of the Church of Holy Apostles*; Leo VI, *Sermons*, 28, 34. All in trans. Mango, *Sources*, 185–6; 201–2; 199–201; 202–5.

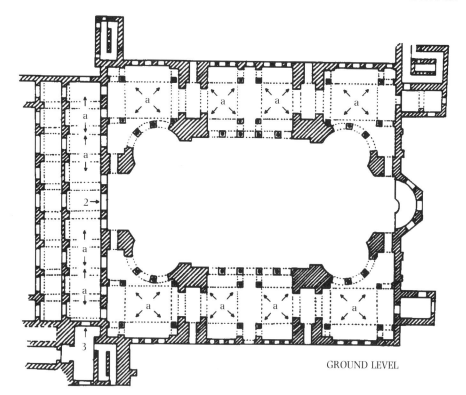

GROUND LEVEL

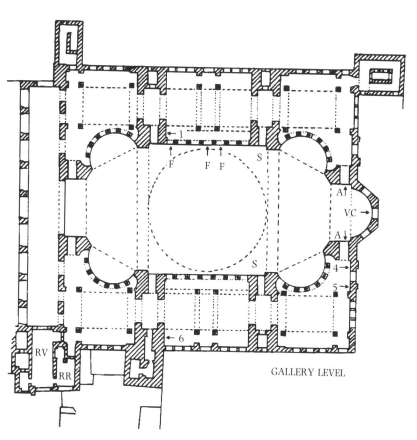

GALLERY LEVEL

116 (b) scheme showing the location of surviving mosaic from the sixth to thirteenth centuries.

Surviving mosaic decoration in St Sophia, Constantinople:

SIXTH CENTURY

a Aniconic mosaic (vaults of ground floor) [fragments also in soffits of the gallery arcades]

RR Room over the Ramp [probably Small Secreton of the Patriarchate] Late 6th Ct. mosaic including figure medallions replaced by crosses during Iconoclasm

NINTH CENTURY

VC Virgin and Child

A Archangel

S Seraph

F Church Father

RV Room over the Vestibule [probably Large Secreton of the Patriarchate] *Deesis*, Saints

TENTH CENTURY ONWARDS

1 Alexander (912/13)

2 An emperor (?Leo VI) kneeling before Christ (?920)

3 Virgin and Child with Justinian and Constantine (?end 10th Ct.)

4 Constantine IX and Zoe (after 1028)

5 John II, Eirene and Alexios (1118–22)

6 *Deesis* (late 13th Ct.)

none of which details its iconography. Seraphim on the pendentives below the dome survive in parts, although heavily restored in post-Byzantine paint and with their faces obscured. The *Life of Basil* records an image of the Virgin flanked by Sts Peter and Paul on the new western arch that was part of the emperor's repair work. Other images were found between 1847–9, when Swiss architects named Fossati were engaged by Sultan Abdül Mecit to restore St Sophia, then in use as a mosque. When removing plaster from the walls, they discovered several mosaics of which they made records before they were obliged to conceal them once more. Wanting though they are in completeness and accuracy, the Fossati drawings are important since much of what was found perished later in the century. Among the losses were figures of prophets and saints on the great north and south tympana, and two festival icons, the Pentecost and Baptism, in the gallery vaults. Also in a gallery vault was an image of Christ Pantocrator, encircled by cherubim, seraphim and tetramorphs. In shallow niches at the base of each tympanum there was a series of standing figures of Church Fathers, some of which survive (fig. 116 c).[31] None

116 (c) Sts John Chrysostom and Ignatios in panels of the north tympanum (late ninth century).

of these mosaics is dated, but in conjunction with the sanctuary figures they make a coherent programme likely to have been conceived as a whole.

For once, evidence of monumental art in the provinces is scarcer than that for the capital. In the Koimesis Church in Nicaea, a sanctuary programme in mosaic much like that of St Sophia is known from photographs taken before the destruction of the church in 1922. They show a standing figure of the Virgin and Child in the conch of the apse, and two pairs of angels on opposite sides of the bema arch. As noted in the last

31 C. Mango & E.J.W. Hawkins, 'The Mosaics of St. Sophia at Istanbul. The Church Fathers in the North Tympanum', *DOP* 26 (1972) 1–41; C. Mango, *Materials for the Study of the Mosaics of St. Sophia at Istanbul*, *Dumbarton Oaks Studies* 8 (Washington DC 1962); Mainstone, *Hagia Sophia*, 280–1.

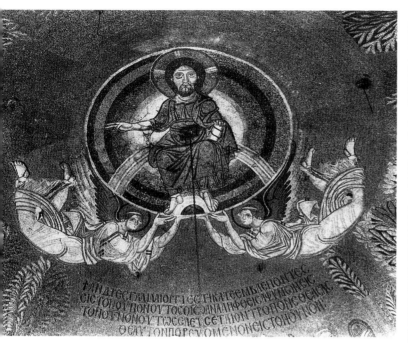

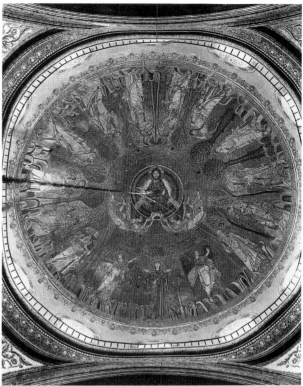

chapter, the archaeological indications are that these figures replaced an iconoclast cross. The date of the restoration, by one Naukratios, is unknown, but it was surely during the second half of the ninth century. As in St Sophia, the figures are simple and dramatic, set against a plain gold ground.

An Ascension in a strikingly schematic style survives in the dome of St Sophia, Thessalonike, installed, according to its inscription, by an Archbishop Paul, probably in 885. The mosaic shows Christ enthroned at the summit of the dome, in a mandorla held by flying angels. Below, the Virgin, two angels and the twelve apostles ring the dome, gesturing towards the summit. Highly schematized trees separate the figures and once again all elements are set against a gold ground. It is unlikely that this was the whole of the ninth-century decoration of the church, but the rest is lost (fig. 117).[32]

The programmes described above evidently vary in some details. Christ in the dome may be represented in an Ascension or as a Pantocrator medallion (and possibly in other forms, since the iconography is unspecified in some cases). The Virgin of the apse may be a standing figure, as at Nicaea, or enthroned, as in St Sophia in Constantinople. The

117 St Sophia, Thessalonike, mosaic of the Ascension in the dome, *c.* 885: detail of Christ carried by Angels; general view.

32 P.A. Underwood, 'The evidence of restorations in the sanctuary mosaics of the Church of the Dormition at Nicaea', *DOP* 13 (1959) 235–44, 240; J.M. Spieser, 'Les Inscriptions de Thessalonike', *Travaux et Mémoires* 5 (1973) 145–80, 160.

number and selection of festival icons appears to vary, although the extent of differences cannot be known, since it is not certain whether the sources describe the complete programme in each case. Nevertheless, in their placing of components, all these programmes are consistent with the 'hierarchical' formula outlined above.

There has been some debate as to whether this formula was a post-iconoclastic creation, or the continuation of an earlier tradition. The sanctuary decoration of the Koimesis Church in Nicaea argues the latter, since, as noted above, it appears to have duplicated the pre-iconoclastic scheme. Reason, too, suggests that the development of the formula is to be associated with the rise of the domed church as a standard type. With the change in church architecture, both the formal and narrative images of traditional monumental art had to be deployed in a small, domed building with complex vaulting. The assignment of the main spaces to the chief figures of the holy hierarchy would be an obvious starting point, and the need to abbreviate narrative to fit the limited spaces would naturally prompt selection of the most important scenes to create a festival icon cycle. The chronology of such a development obviously depends upon that of the architectural changes, which is itself unclear, but would seem to begin well before the mid-ninth century.

Whatever its origins, the 'hierarchical' formula does not represent the totality of church decoration in the Macedonian period. Indeed, it may represent only the programmes of the naos and sanctuary vaults of churches like those described. That a wider repertory of images was used in other areas is suggested by a note in the *Life of Basil* of scenes of the sufferings and miracles of martyrs in the Nea Ekklesia, which were in the vault of a portico reached from the north door of the church.[33] The other churches may also have had more extensive imagery than their descriptions record.

Greater variety in ninth- and tenth-century church decoration is also attested by the painted decoration of the small cave churches and chapels of Cappadocia, mentioned above for their architecture. In particular, they provide evidence that the detailed narrative cycle was not superseded by the abbreviated festival icon sequence. It is found, for example, in Ayvalı Kilise, in Güllü Dere, a church with twin barrel-vaulted naves which is dated by inscription to the reign of Constantine VII (fig. 118). In the south nave an Ascension occupies half of the vault, while in the other half, and on parts of the walls, there is a Life of Christ cycle of twenty-two episodes in densely packed registers; below this there are figures of saints. In the north nave, Christ of the Second Coming is painted in the barrel vault, Christ enthroned in the apse, and more saints on the walls. An even longer narratave cycle is present in the approximately contemporary Tokalı Old Church in Göreme, painted by the same workshop, where thirty episodes running from the Annunciation to the Anastasis fill the

33 *Vita Basilii* 83–6, trans. Mango, *Sources*, 194–5.

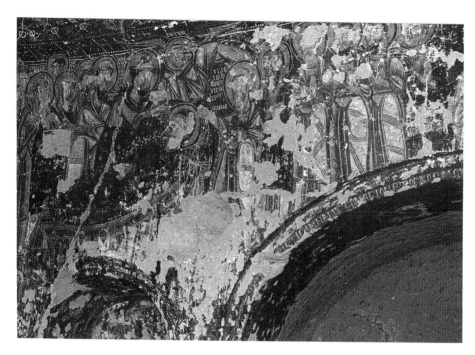

118 Ayvalı Kilise, Cappadocia
(913–20): detail of the
Dormition of the Virgin on the
north wall of the north nave;
scheme of painted decoration.

single barrel vault. The dense cycle also appears in several other barrel-vaulted churches, but is not exclusive to this architectural form. It is found also in Kılıçlar Kilise in Göreme, an inscribed-cross church attributed to the early tenth century on the style of its painting (fig. 119). It has the Ascension in its dome, Christ in majesty in the main apse, the Virgin in

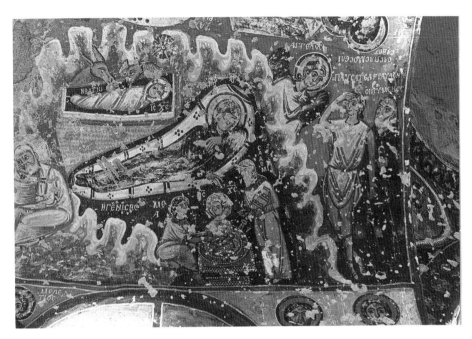

119 Kılıçlar Kilise, Cappadocia (early tenth century): detail of the Nativity in the south barrel-vault; scheme of painted decoration.

the north apse and a cycle of thirty-two episodes in the minor vaults and on the upper parts of walls.[34]

When first studied in the early years of this century the cave churches with long narrative cycles were termed 'archaic', and interpreted as 'fossils' of early Christian narrative art which had been preserved in a remote provincial area. More recent study has shown similarities between Cappadocian painting and the art of major centres. The style of Ayvalı Kilise, for example, much resembles that of the Ascension dome at St Sophia in Thessalonike. A direct link is unlikely, but this and similar examples show that the painting of the cave churches was not isolated from developments in monumental art elsewhere. Pilgrims who visited the pious hermits settled in the volcanic valleys may have come from far afield and brought artistic traditions (even artists) with them. The narrative cycles may therefore be elements of ninth- and tenth-century church decoration that were widely used, but seen only where the unusual context of rock-cut architecture has preserved them. While perhaps not present in churches decorated with mosaic, where marble revetment would usually cover the walls, the narrative cycle may have been most used in painted churches where such revetment was lacking and there was more space for it.

A final aspect of monumental art of the Macedonian period to be considered is the imperial image, of which several examples are known. There was a portrait of Basil I in the Nea Ekklesia, known from the *Book of Ceremonies* of Constantine VII, which describes the lighting of candles before it on prescribed ceremonial occasions, but does not give its precise location or iconography. In contrast, the *Life of Basil* gives considerable detail of the huge work of self-congratulation with which this emperor decorated the Kainourgion, his new hall in the Imperial Palace. Basil was represented three times: enthroned and flanked by generals offering him the towns they had captured (probably in an apsidal niche); in scenes of his victories (in the vault); and with his empress and their children (on the walls). In this last image, the daughters as well as the sons carried books to demonstrate that the offspring of the erstwhile stable hand were well-educated.[35]

St Sophia in Constantinople has three surviving tenth-century panels depicting emperors, all serving different functions (see fig. 116 b for locations). A lunette over the central door of the narthex shows an emperor prostrate before Christ enthroned and medallions of the Virgin and an Archangel (fig. 120 a). There is no inscription to identify the emperor, an unusual omission in a panel of this sort and one that makes it unlikely that the mosaic commemorates an act of patronage. It is thought instead that the subject is Leo VI, shown kneeling before Christ in penitence for

34 Rodley, *Cave Monasteries*, 207ff, 213ff, 39ff.
35 Constantine Porphyrogennetos, *Ceremonies* 1.19, 3, 1.20, 2 (French translation by A. Vogt, *Le Livre des Cérémonies* (Paris 1935–9); for the Kainourgion: *Vita Basilii* 89, trans. Mango, *Sources*, 196–7.

120 Mosaic panels in St Sophia, Constantinople: (a) an emperor (possibly Leo VI) kneeling before Christ enthroned (920?) (over the Imperial door); (b) the emperor Alexander (913) (north gallery).

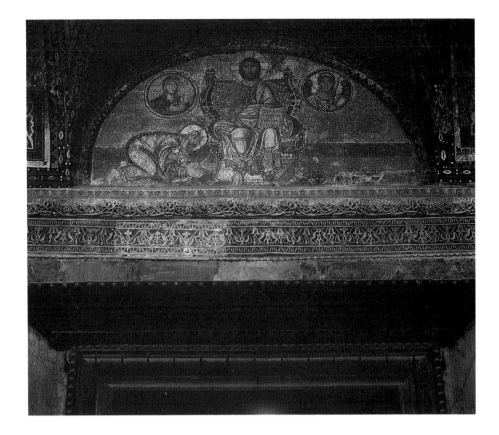

the fourth marriage that he contracted in 906 (prohibited by church law, but needed because the demise of three earlier wives left Leo without an heir). Leo is said to have repented of this action on his deathbed in 912, and the panel may have been installed in 920 when a Council reaffirmed the rule that fourth marriages were forbidden on pain of excommunication. The angel in the mosaic may then be the 'avenging angel' traditional to penitence scenes, and the presence of the Virgin denotes her role as intercessor on behalf of the penitent.

In a narrow field behind the arcade of the north gallery, a mosaic of fine quality depicts the emperor Alexander, who was the dissolute brother of Leo VI and his immediate successor (Constantine VII, the product of Leo's fourth marriage, was recognized as his heir, but was still a minor when Leo died). Alexander reigned very briefly in 912/13, to which period the panel must be dated. He wears ceremonial dress and juggles monograms giving his name and invoking divine benevolence (fig. 120 b). The panel seems to have been part of a refurbishment of the north gallery, which may account for its curious position, high on the northwest pier and barely visible. Alternatively, Alexander may have placed his image thus for some personal reason, such as the proximity of a particular icon or relic. A different sort of image again is found in the lunette over the door to the narthex from the southwest vestibule, where the Virgin and Child enthroned receive Constantine I, who presents a model of the city,

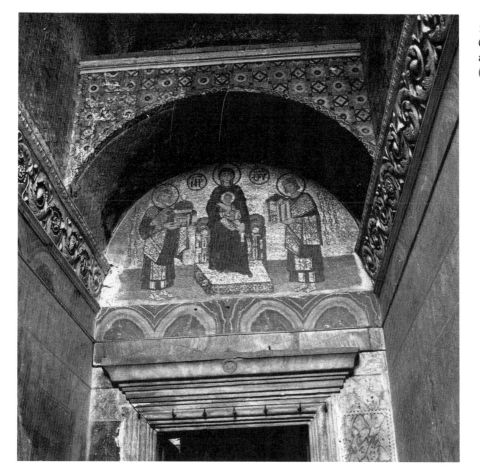

120 (c) Justinian I and Constantine I with the Virgin and Child (late tenth centry?) (southwest vestibule).

and Justinian, who presents a model of the church (fig. 120 c). The panel is undated, but was probably installed during repairs to the Patriarchate at the end of the tenth century. It is a rare example of Byzantine imagery in which former emperors, rather than the current one, are lauded. Its function was clearly to commemorate the founder of the capital and the builder of the church and to honour the Virgin as patroness of the city.[36]

A Cappadocian cave church provides a rare example of the imperial image in a much humbler context than any of these. The usurper Nikephoros Phokas (963–9), is represented in the north apse of the Pigeon House Church at Çavuşin, standing at the centre of a family group consisting of his wife Theophano, father Bardas, brother Leo and one other (probably Leo's wife). Shown on horseback on the adjacent north wall are two of Nikephoros' generals, Melias and (probably) John Tzimisces (shortly to usurp the throne himself, after murdering Nikephoros in conspiracy with

36 N. Oikonomedes, 'Leo VI and the Narthex Mosaic of Saint Sophia', *DOP* 30 (1976) 151–72; P.A. Underwood and E.J.W. Hawkins, 'The Mosaics of Hagia Sophia at Istanbul. The Portrait of the Emperor Alexander', *DOP* 5 (1961) 189–215; T. Whittemore, *The Mosaics of St. Sophia at Istanbul. Second Preliminary Report. The Mosaics of the Southern Vestibule* (Paris 1936).

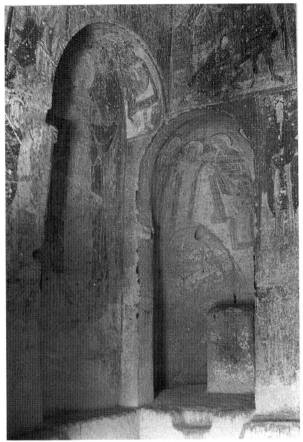

121 The Pigeon House Church, Çavuşin, Cappadocia (963–9). Painting in the northeast corner: (A) patrons kneeling before an archangel; (B) the emperor Nikephoros Phokas and his family; (C) two of Nikephoros' generals.

Theophano) (fig. 121). Between the two groups is a niche containing a large archangel, at whose feet are the tiny kneeling figures of the couple who were the patrons of the church. This unique image therefore demonstrates that the imperial image need not be an imperial commission. The patrons are anonymous because their inscriptions are all but lost, but they were presumably persons with reason to honour their emperor and his generals. They may have been related to the emperor, since the Phokas family belonged to the land-owning aristocracy of Cappadocia.[37]

Minor arts

The Macedonian period has left very few portable icons, even though the end of Iconoclasm and renewed prosperity must have benefitted this field of religious art as much as any other. There are no dated examples, but several icons in the Mount Sinai collection are attributed to the ninth or

37 L. Rodley 'The Pigeon House Church, Çavuşin', *JÖB* 33 (1983) 301–39, 309–14.

122 Icon of Sts Zosimos and Nicholas (tenth century?). (Monastery of St Catherine, Mount Sinai.)

tenth centuries, largely on the grounds of stylistic similarity with dated or datable manuscript illumination (for which see below). Thus, the style of an icon, which has the Baptism and Anastasis on one side and St Damian on the other, resembles that of the mid-ninth-century Pantocrator and Chludov Psalters. The icon was probably one wing of a triptych which probably had St Cosmas, Damian's companion saint, and other festival scenes, on its lost wing and centre panel. In a group of three icons that were perhaps by the same painter, the style is very close to that of the Paris Gregory, made for Basil I in the last quarter of the ninth century. These all have formal images of saints (Zosimos and Nicholas on one (fig. 122), the Virgin and Child with John the Baptist and Nicholas on another, and the Virgin and Child with Hermolaos and Panteleimon on the third). Each is of the 'integral frame' form, in which the painting is done on a recess cut into the wooden panel, leaving the original thickness of the wood as a border around it. The figures, identified by inscriptions in red, are painted against a plain gold ground, recalling the treatment of mosaic images like those of St Sophia in Constantinople. Both the gold ground and the integral frame remain in use for icons for the rest of the Byzantine period.

Perhaps the most interesting of the Sinai icons attributed to the Macedonian period is the 'King Abgar' icon, which consists of two panels, now fixed together in a frame but originally wings of a triptych (fig. 123).

123 Icon of King Abgar and the Mandylion (tenth century?). (Monastery of St Catherine, Mount Sinai.)

The icon refers to one of the holiest Christian relics, the Mandylion, a cloth with which Veronica wiped the face of Christ on the way to the Crucifixion, and which was miraculously imprinted with an image of his face. In the sixth century another miracle allowed this relic to be found in Edessa (Syria), where it remained until 944, when it was brought to Constantinople by Romanos I. Each of the surviving wings is divided horizontally into two fields. In the upper left there is a seated figure of Thaddeus, the apostle who baptized the Essenes, and in the upper right, Abgar, their king, who was given the Mandylion when he asked for a portrait of Christ. The lower fields have images of two saints each (Paul of Thebes and Anthony to the left, Basil and Ephraim to the right). The lost centre panel probably bore an image of the Mandylion with more saints below it. Few though they are, these examples demonstrate something of the range of subject matter used in icon painting of the Macedonian period, which evidently included the formal image of saint or saints, the festival icon and imagery developed for particular circumstances, in this case the translation of a relic.[38]

Objects of middle-Byzantine metalwork are far more numerous

38 Weitzmann, *Sinai*, nos. B.52–61; K. Weitzmann, 'The Mandylion and Constantine Porphyrogennetos', *CahArch* 11 (1960) 163–84.

thanks to the sack of Constantinople by the Fourth Crusade in 1204, an unedifying episode of later Christian history. Precious objects that were looted from the capital found their way into the treasuries of the West, particularly that of San Marco in Venice, where they now form the chief material evidence of middle-Byzantine minor arts. The range of objects is traditional, including reliquaries, chalices, patens, crosses and book-covers (which may or may not have started out as icon-diptychs). They are distinguished by their opulence, often combining precious metals, gemstones, pearls and brilliant enamelwork. Some also bear inscriptions that supply information about middle-Byzantine patronage of the luxury arts.

One such object in the San Marco Treasury is a votive crown (made not to wear but to hang in a church sanctuary as an imperial gift) (fig. 124). By the ingenuity of a western craftsman this now forms the base of

124 Votive crown of Leo VI (866–912) (Venice, Treasury of San Marco no. 116). Used since the fourteenth century as the base for a statue of the Virgin housed in an antique rock-crystal.

a piece known as the Grotto of the Virgin, in which a thirteenth-century figure of the Virgin is housed in a rock-crystal 'building' probably of Roman origin. The crown is a silver-gilt band rimmed by gold beading, originally decorated with fourteen enamelled medallions, seven of which remain, containing busts of six apostles and an emperor Leo. (The seven lost medallions probably contained the rest of the apostles and Christ.) The emperor is almost certainly Leo VI (866–912), since the other emperors named Leo were either iconoclasts or lived in the fifth century. The medallions alternate with pairs of triangular cabochons (polished gems or glass) and each medallion is (or was) encircled by pearls strung on wire fastened

down at four points. Beneath each medallion is a ring for the suspension of jewels, all now lost. Three peacocks with rings on their backs, placed on struts which join the upper rim, may be the original means of suspending the crown, or may have been added when the 'grotto' was put together. The enamelled medallions are made in the cloisonné technique, in which thin metal walls (cloisons) separate areas of colour made with melted glass. The cloisons in this case are widely spaced, so that the glass areas are broad. The colours are bright and varied, with emerald green as background, in which cloisons are used to make inscriptions.[39]

The crown provides useful chronological anchorage for other objects of similar style and technique, such as a pair of panels which now bind a book in the Marciana Library in Venice (fig. 125). These are also decorated with gold beading, strung pearls and enamels with emerald grounds.

125 Book cover, with jewels and enamel (tenth century?) (Venice, Biblioteca Marciana Ms. Lat. Cl. I, 101). Virgin orant (left), Christ crucified (right).

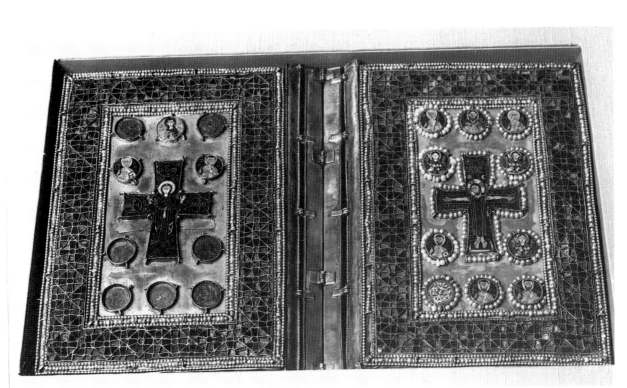

On one side Christ on the cross, wearing the collobium, occupies a cruciform central enamel, surrounded by medallions with busts of apostles, saints and angels. As in the crown of Leo, the enamels are rimmed with strung pearls. The arrangement on the other side is similar, but with an orant Virgin in the central cruciform field. This and other pairs of book-covers with Christ on one side and the Virgin on the other may have been made as icon-diptychs and only later used to bind books,

39 *Treasury of San Marco*, 120–2.

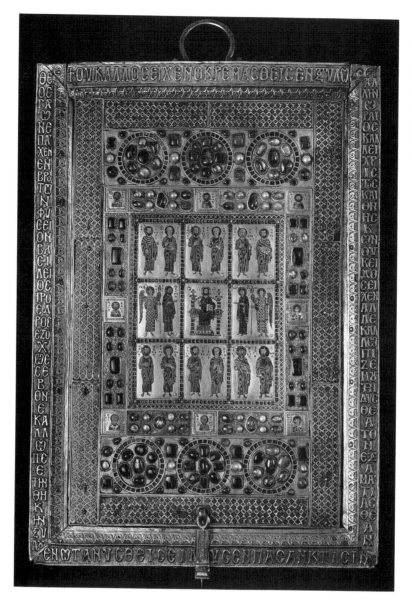

126 Limburg Reliquary
(Limburg, Cathedral Treasury).
(A) container for a relic of the
True Cross (948–59) which
fits a cavity in (B) a box
reliquary (963–85) with
compartments for other relics;
the outer lid is seen closed in
the photograph.

a function to which their encrusted surfaces would seem to be ill-fitted.[40]

A great reliquary of the True Cross, also looted in 1204, found its way further west, to the Cathedral Treasury of Limburg (fig. 126). The piece is a flat rectangular box with inner and outer casings. On the lid a central block of nine enamelled panels shows the *Deesis* (Christ enthroned between the Virgin and John the Baptist) and angels in a horizontal band, with the twelve apostles above and below. Bands set with cabochons, enamelled busts of saints and strips of patterned enamel form a frame. The lid lifts to reveal an inner case with a cross-shaped cavity to take the relic of the True Cross. Compartments around the cavity, covered by enamelled

40 *Treasury of San Marco*, 124–8.

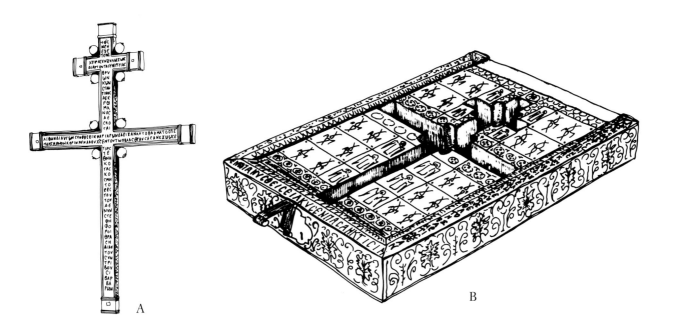

lids decorated with seraphim and angels, contain other relics of the Crucifixion, such as fragments of the crown of thorns. The fragment of the True Cross has its own metal casing, on the back of which an embossed inscription records that the emperors Constantine and Romanos provided the relic with 'a setting of translucent gems and pearls', a description which fits the decoration of the casing. On the frame of the outer case a second embossed inscription credits Basil the *proedros* with embellishing the reliquary. There were thus two stages of patronage, the first not without problems of interpretation, since during his minority Constantine VII reigned from 920–44 with the regent-usurper, Romanos I, and as an adult from 948–59 with his son Romanos II. The inscription probably refers to the second period, however, when Constantine was adult. Basil was an illegitimate son of Romanos I, who held until 985 the title *proedros*, which was created for him by Nikephoros Phokas in 963, in return for his support of Nikephoros' usurpation. Basil had already been a powerful figure under Constantine VII, and managed to remain so after the murder of Nikephoros, by timely transference of his allegiance to John Tzimisces. The San Marco Treasury has a chalice and paten also made for him. Since the workmanship of the inner and outer cases of the reliquary appears uniform, it seems that Constantine and his son commissioned only the cruciform casing of the relic itself. Basil the *proedros* later provided the whole of the elaborate case, which may therefore be dated to Basil's term of office 963–85.[41]

Several chalices of the Macedonian period in the Treasury of San

41 J.M. Wilm, ed. 'Die Limburger Staurothek', *Das Münster*
8 (1955) 201–40.

Marco are grouped around two that are named, somewhat prosaically, the Chalice of Romanos (with handles) and the Chalice of Romanos (without handles) (fig. 127). In both, sardonyx bowls are encased by silver-gilt rims and stems, decorated with beaded borders, strung pearls and panels with enamelled busts of Christ, the Virgin, apostles, saints and angels. Both are inscribed: 'Lord help Romanos, the orthodox emperor', usually identified as Romanos II (959–63) on the grounds that the enamels are similar to those of the Limburg reliquary. The sardonyx bowls of these chalices, and of several more in the San Marco Treasury, are late Roman pieces the blood-like colouring of which doubtless suggested their re-use as liturgical chalices.[42]

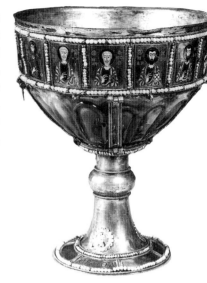

127 Chalice of Romanos (959–63) (Venice, Treasury of San Marco no. 65), incorporating a third/fourth-century sardonyx bowl.

The enamels of the chalices and the Limburg Reliquary differ from those of the votive crown of Leo and the Marciana book-cover in that the cloisonné enamel figures are set in gold grounds, rather than in green enamel. Their inscriptions, too, are different, made in red enamel, instead of in cloisons. There may be a sequential implication here, that the emerald ground technique of the ninth century was superseded by the gold ground of the tenth, but given the longevity of techniques in most crafts, it is equally possible that both types were in use for long periods and the chronological pattern of survivals is fortuitous. There is uncertainty, too, concerning the origins of the enamel technique. The pieces just considered are the earliest datable Byzantine examples. A few others have been attributed to periods as early as the sixth century, but on grounds that are far from secure. The apparently sudden appearance of enamel work causes some to suggest that the technique was brought from the mediaeval West, where datable examples place it slightly earlier. Others argue the reverse, that the Western tradition started from pieces sent as Byzantine diplomatic gifts, and earlier Byzantine pieces simply do not survive. Cloisonné work using solid glass inlay (rather than melted glass) is technically not distant from enamelwork, and is known from ancient times both in Europe and the Mediterranean, so either origin is plausible.[43]

In contrast to the apparent novelty of enamelwork, continuity of tradition is evident in tenth-century crosses. A silver processional cross in Geneva, for example, is of Latin form, with flared arms finished by discs, much like the crosses of the sixth-century hoards (fig. 128). The Geneva cross is no earlier than 959, since it bears an inscription identifying its owner as Leo, *domestikos* of the West, an office introduced by Romanos II in that year. The small pectoral cross (worn on the chest) is also still in use. An example in Washington, made of silver, has inscriptions invoking divine benevolence for Romanos II and his son Basil II, who were styled co-emperors between 960–3, even though Basil was still an infant. This is a fairly humble object of mediocre workmanship. It is unlikely therefore to have been a possession of the emperors, but was probably

128 Silver cross of Leo, *domestikos*, (after 959) (Geneva, Musée d'art et d'histoire).

42 *Treasury of San Marco*, 129–40, 159–67.
43 K. Wessel, *Byzantine Enamels* (Shannon 1969);

P. Hetherington, 'Enamels in the Byzantine World. Ownership and Distribution', *BZ* 81 (1988) 29–38.

129 Ivory sceptre-finial,
representing Leo VI
(886–912) (Berlin, Staatliche
Museen, Frühchristlich-
Byzantinische Sammlung).

130 Ivory panel showing
Christ crowning an emperor
Constantine (probably
Constantine VII, 944–59)
(Moscow Museum of Fine Art).

one of many such objects made for distribution as imperial largesse.[44]

A few ivories may be attributed to the ninth and tenth centuries by their inscriptions, although some of these are less than straightforward. An ivory in Berlin, which may have been part of a sceptre, has inscriptions referring to an emperor Leo, identified as Leo VI (886–912) for the same reasons as given in the case of the votive crown (fig. 129). On one face it has half-figures of the emperor, an archangel and the Virgin, who places a crown on the head of the emperor. The figures are set below an arch which encloses the three apses of the east end of a church. Christ flanked by Sts Peter and Paul occupy a similar panel on the other side, and Sts Cosmas and Damian are on the two short sides.[45]

Like the sceptre, a few other 'coronation' ivories of the middle-Byzantine period stressed the divine appointment of the emperor. A panel in Moscow shows Christ crowning the standing figure of an emperor Constantine, usually identified as Constantine VII, on the basis of comparison with coin portraits of this emperor (fig. 130). If the attribution is correct, then the piece was probably made during Constantine's period of sole rule, 944–59. A panel in Paris, showing Christ crowning an emperor Romanos and empress Eudokia is thought by some to represent Romanos II and his empress, and its style has been made the basis of tenth-century attribution for several pieces known as the 'Romanos group' of ivories. The emperor is more probably Romanos IV (1068–71), however, and the piece is dealt with in the next chapter (fig. 186). It may nevertheless be noted here that the 'coronation' iconography of the panel, showing an imperial couple, was certainly established by the mid-tenth century, since it was copied in a panel made in the West for Otto II of Germany. In 972 Otto married Theophano, a Byzantine princess, and their 'coronation' panel must depend on a Byzantine model.[46]

The style of the Moscow Constantine panel is distinctive, having slender figures with thin, angular faces and sharply cut drapery with closely placed folds. This style is found in three other pieces also bearing inscriptions referring to a Constantine. A triptych in Rome (fig. 131) has an inscription invoking divine benevolence on behalf of 'Constantine', and two panels, in Venice and Vienna, have inscriptions asking that the 'emperor Constantine' be preserved from harm, and absolved of sin, respectively. The probability is that in all cases the emperor is the same one, and Constantine VII is a likely candidate, since it is known from Theophanes Continuatus that he was a connoisseur of the arts and presented many luxurious gifts to St Sophia. If not among them, these ivories may have been gifts to other churches, or perhaps to individuals. The

44 A. Bank, B. Bouvier, I. Djuric and L. Bouras, 'Etudes sur les croix byzantines du Musée d'art et d'histoire de Genève', *Genova* n.s. 28 (1980) 97–124, 105–6; *Handbook of the Byzantine Collection* (Dumbarton Oaks, Washington DC 1967), no. 77.

45 G/W *BE* II, no. 88, *Splendeur de Byzance*, 97.
46 G/W *BE* II, nos. 35, 34; I. Kalavrezou-Maxeiner, 'Eudokia Makrembolitissa and the Romanos Ivory', *DOP* 31 (1977) 307–25.

Rome triptych has its centre panel divided horizontally into two fields, with five apostles in the lower one and a *Deesis* above. Both wings, again divided, have two saints in each compartment, front and back, making sixteen in all. They include military saints, patriarchs and martyrs in a selection that also appears on other triptychs, so they may be drawn from a liturgical source. The back of the centre panel is decorated with a low-relief cross and foliate medallions. The triptych probably served as an icon for private prayer, centred upon the notion of intercession provided by the *Deesis*. On each of the Venice and Vienna panels there is a pair of standing apostles – John and Paul (Venice) and Andrew and Peter (Vienna). The panels are so similar that they must belong together, but they lack hinge attachments and so were not diptych or triptych wings. They may have been part of a set of six panels, showing all twelve apostles, probably made

131 Tenth-century ivory triptych with inscription asking divine benevolence for 'Constantine': *Deesis* (centre panel, upper field) and saints (lower field and wings). (Rome, Palazzo Venezia.)

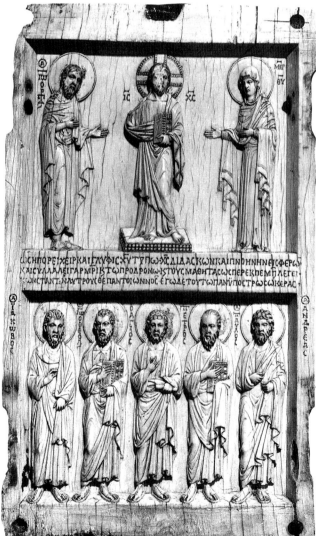
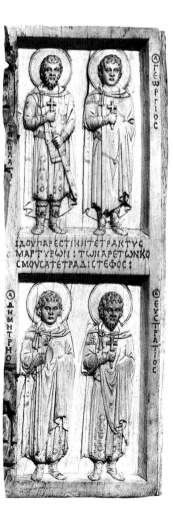

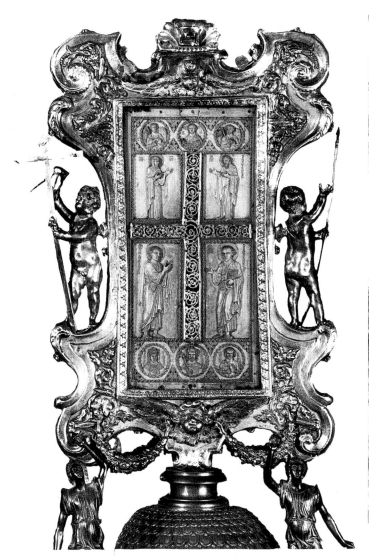

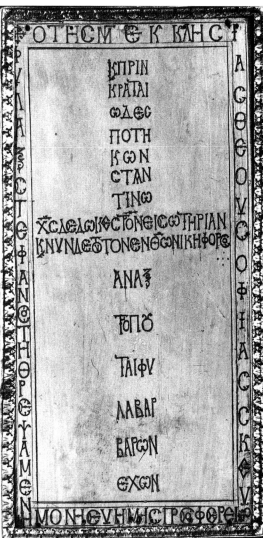

132 Cross-reliquary containing an ivory panel of 963–9 in a later mount: front, and detail of the back of the ivory with inscription. (San Francesco, Cortona.)

for an item of liturgical furniture, such as an altar frontal or sanctuary screen.[47]

A reliquary of the True Cross now in the Cortona Cathedral Treasury is made of an ivory panel in which a cross-shaped recess is cut to hold the relic (now secured by a later filigree cage) (fig. 132). At the top of the panel, busts of Christ and two angels in medallions form part of a *Deesis* completed below by standing figures of the Virgin and John the Baptist. In the lower half of the panel there are standing figures of Sts Stephen and John the Theologian, and at the bottom, Helena, Constantine and Longinus (the lance-bearer at the Crucifixion). The figures are somewhat ill proportioned, clad in finely detailed draperies with closely cut folds. An inscription on the back of the panel records that the cross, once given to

47 G/W *BE* II, nos. 31, 43, 44; *Splendeur de Byzance*, 105.

Constantine (the Great) is now in the possession of Nikephoros, who has conquered the barbarians (referring to Nikephoros Phokas, whose military exploits brought him the throne). Another inscription, framing the first, says that Stephen, the *skeuophylax* (keeper of the treasury) of St Sophia, offers the relic to the monastery where he was raised. The second inscription is unlikely to be a later addition, since it is cut in similar lettering to the first, and the inclusion of St Stephen in the imagery of the panel is surely a reference to the *skeuophylax*. Stephen, rather than Nikephoros, would seem to be the patron here, donating the relic and its luxury casing to his monastery. The first inscription may refer not just to the relic, but to the concept that the emperor Nikephoros is now the symbolic custodian of the cross, as once was the first Christian emperor. If the relic came from the treasury of St Sophia, the emperor may have authorized the *skeuophylax* to make the donation.[48]

A number of small ivory panels (about fourteen to eighteen centimetres high) display narrative subjects framed by elaborate 'filigree' canopies cut in high relief. None is dated, but one, showing the Dormition of the Virgin, was used to decorate the cover of a gospel book made in the West

133 Ivory panel showing the Dormition of the Virgin (tenth century), used to decorate the cover of the Gospels of Otto III (983–1002). (Bayerische Staatsbibliothek, Munich, cod. Lat. 4453 Cim. 58.)

134 Ivory panel showing the Entry into Jerusalem (tenth century?) (Berlin, Staatliche Museen, Frühchristlich-Byzantinische Sammlung).

48 G/W *BE* 11, no. 77.

for the son of Otto II and Theophano (fig. 133). The ivory probably reached the West in Theophano's wedding-chest, and so was made before 972. Beneath the canopy in this panel the Virgin lies on a bier, with the apostles grouped at her head and feet, while Christ lifts her soul to a pair of angels hovering above. There are several more 'canopy' panels with other festival icon subjects: the Entry into Jerusalem (Berlin) (fig. 134), Nativity, (Paris), Crucifixion (New York) and Descent from the Cross (Washington). The figures in all of them have linear, closely folded drapery and a rather globular treatment of hair, facial features and musculature – this is particularly noticeable in the figures of children in the Entry into Jerusalem. The panels vary in size, however, and their stylistic proximity is not great enough to suppose that they come from a single object, or even the same workshop. Their link is probably that of a conventional

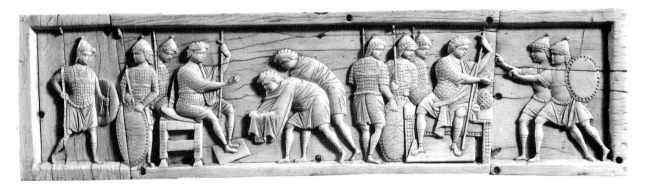

135 Ivory panel from a casket (tenth century?) showing Joshua receiving ambassadors (London, Victoria and Albert Museum).

formula. At least one panel, the Paris Nativity, was the centre of a small triptych, with the Entry into Jerusalem, Anastasis and Ascension on the wings. Most are not hinged, however, but have their frames drilled for attachment to some kind of base, so they probably decorated boxes or furniture.[49]

Long rectangular ivory boxes (caskets) on which panels with figure subjects are framed by borders of rosettes or other repeated motifs seem to have been produced throughout the middle-Byzantine period, and perhaps beyond. Some of them have been attributed to the tenth century on stylistic grounds, like a very fragmentary example in New York, of which three panels with their borders are all that remain. The panels depict episodes from the story of Joshua, and are very similar in style and iconography to the paintings of the Joshua Roll, an illuminated manuscript discussed below and attributed to the tenth century. Another 'Joshua' panel in London, which shows Joshua receiving ambassadors, although carved by a different hand, also corresponds closely to the miniatures of the Joshua Roll (fig. 135). It has been suggested therefore that the manuscript was used as a model by the ivory carvers. Alternatively, both the manuscript

49 G/W *BE* II, nos. 1–6; *Splendeur de Byzance*, 109;
Handbook, Dumbarton Oaks (see n.44), no. 280.

illuminator and the ivory carvers were using a single workshop model-book.[50]

A complete example of the 'rosette' casket in London, known as the Veroli Casket, is a secular piece which has scenes from Greek mythology and the drama of Euripides in seven panels on its sides and lid, among them the Rape of Europa and the Sacrifice of Iphigeneia (fig. 136). On the sides of the casket the panels are enclosed by strips of rosettes within circles, and on the lid, rosettes alternate with profile heads, recalling Roman cameos. The small figures of the narrative subjects, with their bulging musculature, round faces and childlike proportions resemble those of the 'canopy' panels, and are the basis of attribution to the second half of the tenth century. The classical subject matter of the casket has caused it to be associated with the revival of learning centred on the court of Constantinople in the ninth and tenth centuries. This context, of which more will be said below, is no doubt loosely appropriate, but the casket can hardly have been made for a discerning patron. Its clumsy construc-

136 Veroli casket, ivory (tenth century?) showing scenes from Greek mythology or drama (London, Victoria and Albert Museum).

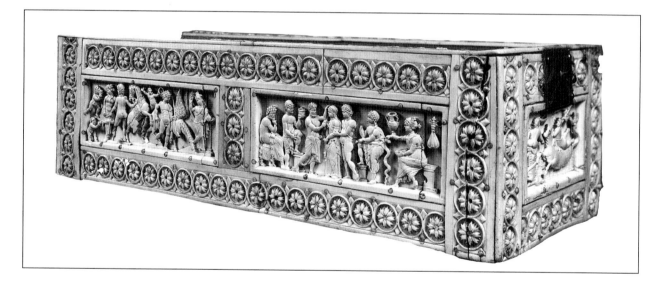

tion, with joins cutting the rosettes of the borders, suggests that it was just one of a run of many such objects, put together by a workshop whose apprentices turned out the ornamental strips by the foot.[51]

Also associated with the 'canopy' group are four curious panels in Darmstadt which were probably the two long and two short sides of another secular casket (fig. 137). Each panel has three canopies, sheltering subjects that include the labours of Hercules, St George, an emperor in triumph, another ascending to heaven in a chariot pulled by gryphons, and, in iconographical parallel, a naked lute-player – perhaps a prince,

50 G/W BE 1, nos. 1–4; *Splendeur de Byzance*, 113.
51 J. Beckwith, *The Veroli Casket* (London 1962).

137 Ivory panel from one side of a casket (tenth century?): lute-player on a lion-throne. (Hessiches Landesmuseum, Darmstadt, Kg. 54 215.)

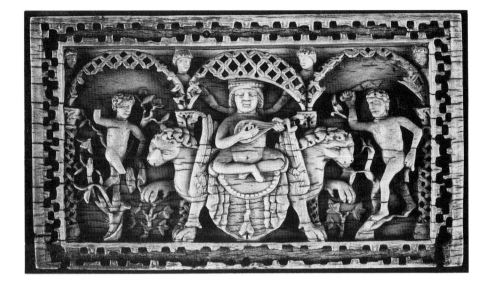

since he wears a crown – seated cross-legged on a throne in the form of two lions. The meaning of all this is elusive. Conceivably the mythological element reflects the fashion for such subjects that produced the Veroli casket, and perhaps the 'programme' depends upon some lost literary work that provided a connection between the seemingly disparate components. The tenth-century attribution rests on figure style and the imperial dress of the emperors depicted, as well as the use of the canopy formula.[52]

The Treasury of San Marco contains a rather more elegant 'classicizing' object which must have been brought from Constantinople by a looter with a delicate touch. This is a glass bowl decorated with gilding and painting, with silver-gilt collar, foot and handles (fig. 138). Its repertoire of motifs is much like that of the ivory casket. Circular fields contain subjects from classical mythology, painted in white on the dark glass ground to resemble cameos. These are rimmed by rosettes in circles done with gilding and paint, and the remaining spaces are filled by more 'cameo' heads and gilded scrollwork. On base and rim, there are patterns imitating kufic script, of the sort seen also in the brickwork of the Theotokos Church at the Monastery of Hosios Loukas, probably borrowed from imported Islamic pottery. This, too, was probably made for a patron in fashionable society.[53]

Finally, a few pieces of Byzantine silk found in the West are datable to the Macedonian period because inscriptions naming emperors are woven into them. The inscriptions form part of repeating patterns of very stylized pairs of confronted lions. The best preserved is in Cologne, found in the reliquary of St Heribert (d. 1002). It names 'Basil and Constantine', probably Basil II and Constantine VIII, who were co-emperors 976–1025 (fig. 139). An earlier silk of this kind, once in Auxerre, is known from a description made before its wartime destruction. It names 'Leo', thought to

52 G/W BE I, no. 125; *Splendeur de Byzance*, 118–19.
53 *Treasury of San Marco*, 181–3.

be Leo VI, (886–912). Also destroyed was a 'lion' silk of Romanos I and Christopher (his son, and co-emperor 921–31), at Siegburg. These silks, and a few more like them are (or were) heavy cloths of high quality, made to be used as hangings, rather than to be worn. The significance of the inscriptions may be that the silks were products of imperial workshops, and/or that they were made to be imperial gifts. Other silks attributed to the Macedonian period on the basis of style and technique have the inter-linked circle pattern seen in the last chapter, enclosing confronted ele-phants in a silk in Liège, and Persian *senmurvs* in an example in Brussels. Another design, of repeating rows of very stylized eagles and rosettes, is seen on a silk of lighter weight made into a chasuble for St Albuin (975–1006); another very like it is in Auxerre. All these silks have markedly 'oriental' features, in their motifs and the highly ornamental treatment of them. No less is perhaps to be expected of an applied art rooted in eastern traditions and still open to patterns introduced by the trader's caravans (the lions of the Cologne silk look distinctly Chinese). The textiles do, however, signify a vein of ninth- and tenth-century Byzantine taste that is in contrast to the 'classicizing' trend seen in some of the minor arts noted above.[54]

138 Glass bowl (tenth century?), with fired-on painting and gilding, showing mythological subjects in roundels, 'cameos', and kufic ornament inside the rim (Venice, Treasury of San Marco no. 109).

139 Byzantine silk (976–1025) found in the twelfth-century shrine of St Héribert, Cologne. Lions, with inscriptions naming Basil and Constantine. (Erzbischöfliches Diözesan-Museum, Köln, Inv. p. 392.)

54 *Splendeur de Byzance*, 215–17. A. Muthesius, 'A Practical Approach to the History of Byzantine Silk Weaving', *JÖB* 34 (1984) 325–54.

Illuminated manuscripts

The Macedonian period, especially the tenth century, is relatively rich in illuminated manuscripts and there does seem to have been increased production of books generally. Associated with this was a change from uncial script (capitals) to minuscule, which increases both the speed of copying and the amount of text that may be fitted on the page. The change probably began in the early ninth century and both scripts are found in the tenth century, but after this uncial becomes rare. Over thirty illuminated manuscripts of the period are securely dated by colophons (short entries at the end of the text, giving such details as the name of the scribe, the place of production and often the day, month and year in which the work was finished). A dozen more may be dated by their patronage or other means, and as many again may be attributed to the period on palaeographical grounds, or on the style of their illumination. Most of the illuminated texts are religious ones. Of the dated group, nearly half are New Testament texts – gospels, gospel lectionaries (extracts of the gospels), and Acts of the Apostles. Homilies, particularly those of the fourth-century Church Fathers Gregory of Nazianzos and John Chrysostom account for most of the rest, and the remaining few are menologia (brief accounts of saints' lives arranged in calendrical order), psalters and other books of the Bible. In most cases the illumination is very simple, consisting of ornamental headings to sections of the text and/or decorated initials. This embellishment was probably supplied by the scribe. A few books have more elaborate decoration which was in most cases probably done by artists who were not responsible for the text, although the possibility of an occasional artist-scribe is not to be discounted.[55]

Of the manuscripts with extensive illumination, three psalters with marginal illustrations are probably the earliest survivors of the Macedonian period, although none is firmly dated. They are the Pantocrator and Chludov Psalters (mentioned above for their anti-iconoclast imagery) and another in Paris. In each of the three psalters the text, in uncial script, occupies only part of the page, leaving a wide margin to the right on recto pages and to the left on versos, which contains images relating to the text. The images are unframed and sometimes extend into the lower margin of the page. The arrangement parallels that of books in which written commentary on a text (*catena*) is placed in the margins, and the images of the marginal psalters do in fact form a pictorial commentary on the psalms. Thus, Old Testament subjects complement psalms that refer to them. In the Pantocrator Psalter, for example, Psalm 105, which deals with the Exodus from Egypt, is illustrated by the Column of Fire, the Manna from Heaven, Moses Striking the Rock and the Sacrifice of Isaac. The images extend the text, rather than simply illustrate it,

55 Reynolds & Wilson, *Scribes and Scholars* (see n.4), 51–2;
Spatharakis, *Corpus*, nos. 4–47.

since while the psalm refers to the first three subjects specifically, it does not mention the Sacrifice of Isaac. New Testament subjects are necessarily 'extensions' of this sort, used to show how some psalms were prophetic of the Gospel story. In the Pantocrator Psalter, for example, Psalm 22, which opens with David's words 'My God, my God, why hast thou forsaken me?' is illustrated by an image of the Crucifixion. Hagiographical subjects also function in this way, as, for example, the image of the Conversion of St Eustace which accompanies Psalm 97 (fig. 140). The Roman solider Eustace became a Christian when he saw a cross of light between the horns of a stag he was hunting, and in the psalm images of light are used to describe the revelation of God to the people of the earth.[56]

140 Pantocrator Psalter (Mount Athos, Pantocrator Monastery Ms. 61) (tenth century?). Folio 138r, the Conversion of St Eustace, illustrating Psalm 97.

Although not by the same hand, the miniatures of the three psalters are very similar in style, with small, stocky figures, many in 'shrugging' attitudes, as if they lacked necks. The three also have many images in common, which in turn bear common relationships with the text. The manuscripts are likely, therefore, to be of similar date, and this date is thought to lie in the years immediately following the end of Iconoclasm. The reason for this is that, as noted above, the Pantocrator and Chludov psalters contain images which refer directly to the controversy and the iconodule victory. In the Pantocrator Psalter, Psalm 26 ('I have not sat with vain persons, neither will I go in with dissemblers') is accompanied by pictures of the Iconoclast Council of 815, and the iconodule Patriarch Nikephoros, holding an icon, with prostrate figures of the vanquished iconoclasts Theodotos and John the Grammarian at his feet. On the same page there is a short poem added after the manuscript was completed, describing the iconodule victory in terms implying that John the Grammarian was still living. The manuscript may therefore be dated before his death which was around 850. It has also been argued that these three psalters were not the first of their kind, but follow a prototype produced during, or even before, Iconoclasm. The suggestion is certainly plausible, since the formula of marginal illumination is an old one, seen in the sixth-century Rabbula Gospels described in chapter 2.

A similarly sophisticated relationship between text and illustrations is found in the Paris Gregory, a *Homilies of Gregory of Nazianzos* made for Basil I, probably between 879 and 883 (fig. 141). The book is large (41.8 × 30.5 cm) with 468 folios bearing forty-six full pages of painting and a text in uncial script. It begins with a five-page pictorial preface, now misordered but originally as follows: Basil, crowned by an angel and flanked by the prophet Elias; his empress Eudokia and their sons Leo and Alexander; Christ enthroned; a cross; another cross. The remaining forty-

56 Pantocrator Monastery Ms. 61, Moscow Cod. Grec. 129, Paris BN grec. 20: S. Dufrenne, *L'Illustration des psautiers grecs du moyen âge* (Paris 1966); M.B. Scepkina, *Miniatjury Chludovskoj Psaltyri* (facs.) (Moscow 1977) (English summary 315–18); I. Ševčenko, 'The anti-iconoclastic poem in the Pantocrator Psalter', *CahArch* 15 (1965) 39–60.

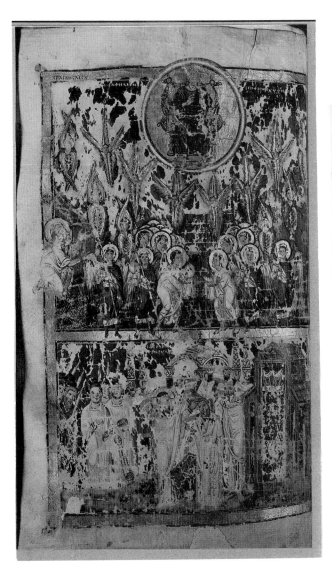

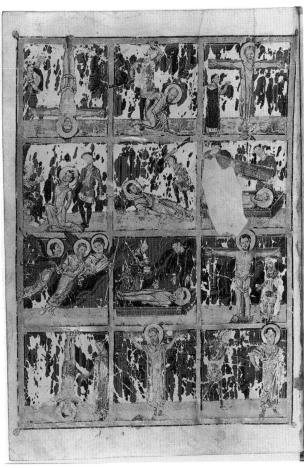

141 Homilies of Gregory of Nazianzos made 879–83 for Basil I (Paris, BN gr. 510). Folio 67v, the Vision of Isaiah (top) and the Consecration of Gregory (bottom); folio 32v, twelve scenes of martyrdom.

one picture pages are dispersed throughout the book, as prefaces to the homilies – there were probably fifty-two originally, one for each homily. As in the 'marginal' psalters, the link between image and text is sometimes direct, sometimes subtle. The homily on Easter, for example, is straightforwardly illustrated by images of the Crucifixion, Deposition and Resurrection, on a page divided into three registers. The Oration for the Festival of Baptism, however, is prefaced by Moses and the Burning Bush, Paul on the Road to Damascus, Elias Ascending to Heaven and the Crossing of the Red Sea behind the pillar of fire, subjects whose connection with Baptism is not at first obvious. In fact, all these events are held to prefigure Baptism, and are also concerned with fire or light, which is a theme of the Oration. The images prefacing some homilies depend on more than one source. The Oration on Gregory's consecration as bishop, for example, is illustrated by the Consecration of Gregory (presumably an invented

image) coupled with the Vision of Isaiah from the Old Testament. The combination draws a parallel between Gregory's reluctance to accept the bishopric and Isaiah's fear of responsibility when chosen by God.[57]

The subjects illustrated are thus drawn from several sources. Most are biblical, some are hagiographical, illustrating episodes from saints' lives (including Gregory's own), some historical (an invective against Julian the Apostate is illustrated with episodes from the history of this last pagan emperor). The pictorial formula also varies, so that some pages contain a single image, while others have from two to five registers, and others still are divided into four, nine or twelve square compartments. The most likely explanation for this variety is that the artist, probably working to a plan supplied by the designer of the book, drew upon a number of models with differing layouts for their images. He might have used gospel books and lectionaries for the New Testament subjects, Bibles, or parts thereof, for the Old Testament, chronicles for history, saints' lives or

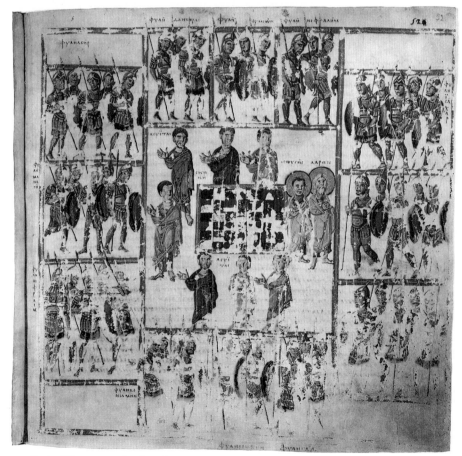

142 Late ninth-century copy of the Christian Topography of Cosmas Indicopleustes (Vatican gr. 699). Folio 52, the leaders and forces of the Israelites.

57 Paris, BN gr. 510: Spatharakis, *Corpus* no. 4; H. Omont, *Les Miniatures des plus anciens manuscrits grecs de la bibliothèque nationale du VIe au XIVe siècle* (Paris 1929); S. Der Nersessian, 'The Illustrations of the Homilies of Gregory of Nazianzus, Paris gr. 510', *DOP* 16 (1962) 195–228. For the imperial images of the preface folios, I. Kalavrezou-Maxeiner, 'The Portraits of Basil I in Paris gr. 510', *JÖB* 27 (1978) 19–24.

menologia for hagiographical subjects. If this is so, it follows that there was in the ninth century a much wider range of illuminated texts than there are surviving examples, and the Paris Gregory can to some extent be used to chart the losses. It would seem, for example, that there must have been gospels or gospel lectionaries with extensive narrative illustration to supply the Paris Gregory with its many New Testament scenes. It may also be implied that there was no extensively illustrated Gregory to copy from, but on the other hand, the intricacy and subtlety of the illumination of the Paris Gregory suggests that it was the unique product of a learned designer who might have eschewed traditional formulae.

A much simpler form of illumination is found in the Vatican Cosmas, a copy of the *Christian Topography* of Cosmas Indicopleustes, which is undated but attributed to the period of the Paris Gregory because its painting style is so similar (fig. 142). Cosmas was a sixth-century merchant who probably became a monk later in life and wrote an account of the world based on his own wide travels. He deals with rain, earthquakes, the Flood, the migration of Noah, the silk routes, sources of the Nile, unicorns (although he admits to not having seen one), measurement of the earth, the destruction of old empires and the primacy of the Roman one, the life of Christ and, to his great credit, the equality of men and women. His main purpose, however, was to prove that the earth had the form of the Holy Tabernacle. In the Vatican Cosmas, the uncial text is illustrated with maps, diagrams, portraits of prophets and apostles, and narrative subjects drawn from both Old and New Testaments. Some are framed, some not, some are set within the text, like pictures in a modern newspaper, others occupy whole pages. Cosmas' intricate arguments about the shape of the world demand illustration with the maps and diagrams, and these were doubtless present in the sixth-century original and its descendents, following the ancient tradition of illustrating scientific books with images placed at intervals in the text. The portraits and biblical subjects however, which are rendered in a much more painterly style, may have been added to the scheme of illumination by the ninth-century copyist. Like the Paris Gregory, therefore, this may be a 'luxury edition' associated with the ninth-century revival of learning.[58]

The earliest dated illuminated manuscript surviving from the tenth century is the Marciana Job, in Venice, a book of Job in 246 folios, dated by its colophon to 905 (fig. 143). Framed images on twenty-seven pages of the first fifty-four folios illustrate the story of Job in a literal manner. They are often several to a page, leaving only a small space for the minuscule text. The bulk of the text is unillustrated, but one more miniature (Job, his wife, sons and daughters) appears on the last page.[59]

143 Book of Job (Venice, Biblioteca Marciana gr. 538). Folio 246v, Job and his wife, and their seven sons and three daughters (c. 905).

58 Vatican, gr. 699: C. Stornajolo, *Le Miniature della Topografia Cristiana di Cosma Indicopleuste; codice Vaticano greco 699* (facs.) (Milan 1908); for the text in translation, J.W. McCrindle, *The Christian Topography of Cosmas, an Egyptian Monk* (London 1897).

59 Venice, Bibl. Marciana gr. 538: Spatharakis, *Corpus*, no. 5.

144 Bible of Leo the *sakellarios* (Vatican gr. 1) (mid-tenth century). Folio 46v, illustrating Exodus: Moses and the Burning Bush, Moses and Aaron before Pharaoh, Leading the Israelites out of Egypt, Crossing the Red Sea.

A group of illuminated manuscripts attributed to the tenth century are evidence of a classical bent to the revival of learning, and have brought into use the term 'Macedonian Renaissance'. The core of the group is formed by the Bible of Leo, the Paris Psalter and the Joshua Roll, three manuscripts with illuminations closely similar in style and, where comparable, iconography. None is securely dated, but one, the Bible of Leo (in the Vatican) may be attributed to the mid-tenth century if its patron, Leo the *sakellarios*, is the one referred to in other documents of that date. The Leo Bible existed originally in two volumes, of which only the first survives (it has a contents page covering both volumes) (fig. 144). The surviving volume has 565 folios (410 × 27cm), with minuscule text in two columns, written by four hands, with coloured initials and uncial titles. Six full-page framed miniatures form a pictorial preface which includes an image of Leo the *sakellarios* offering his book to the Virgin, and another in which Makarios, a monk, and Constantine the *protospatharios*, brother of Leo, kneel before St Nicholas. Inscriptions in the miniatures indicate that Leo had the Bible made as a gift for a monastery of St Nicholas founded by his deceased brother Constantine, of which Makarios was the Abbot. Twelve more full-page miniatures are dispersed within the text, each illustrating one or more episodes from the book of the Bible to which it is attached. The 'commentary' function of the image seen in the Paris Gregory and the 'marginal' psalters is also present here, since texts

145 Paris Psalter, (Paris, BN gr. 139) folio 1v, David playing the Harp, with personifications of Melody, Echo and Mount Bethlehem (mid-tenth century?).

in the frames of the pictures explain their relevance. Leviticus, for example, is prefaced by an image of Moses and Aaron leading a procession carrying the ark of the covenant, and the frame inscription draws a Christological parallel – just as the ark delivered the tablets of the old law, so the Virgin delivered Christ.[60]

The Paris Psalter is a large book (36 × 26cm) of 449 folios with a minuscule text of the Psalms and Canticles (songs or prayers from various parts of the Old Testament) (fig. 145). Rebinding has misordered some folios, but in the original arrangement eight miniatures illustrating the life of David probably formed a pictorial 'author' preface at the front (one of these is now folio 136v). Each miniature is square, with an ornamental frame. Six more picture pages, with Old Testament subjects, are interspersed with the text. Four of them show prophets at prayer (placed before the appropriate Canticles), while the other two (the Crossing of the Red Sea and Moses on Mount Sinai) preface the odes of Moses drawn from Exodus and Deuteronomy. Three miniatures have subjects in common with the Leo Bible (Crossing the Red Sea, Moses on Sinai, the Anointing of David) and are closely similar in style and iconography. Detailed compari-

60 Vatican, gr. 1: T. Mathews, 'The Epigrams of Leo Sacellarios and an Exegetical Approach to the Miniatures of Vat. Reg. Gr. 1', *OCP* 43 (1977) 94–133;

C. Mango, 'The date of Cod. Vat. Reg. Gr. 1 and the "Macedonian Renaissance"', *AIRN* 4 (1969) 121–6.

son shows that neither was the model for the other, but that the two sets of illustrations probably had a common model, suggesting approximate contemporaneity and shared provenance.[61]

Also grouped with these two on stylistic grounds is the Joshua Roll in the Vatican, a very unusual manuscript in that it is a roll, not a codex (or was, until some time after 1902, when it was sliced into fifteen sheets). The text of the book of Joshua, in minuscule, is placed in page-sized blocks along the bottom of the roll, with a narrative frieze above, illustrating Joshua's conquest of Canaan (fig. 146). The text is deficient, with spaces

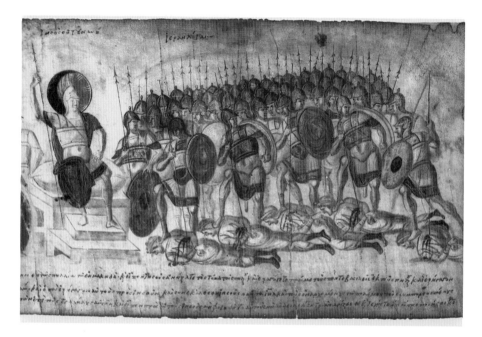

146 Joshua Roll (Vatican gr. 431) (mid-tenth century), sheet xiv, Joshua's soldiers with the captured Amorite kings (Joshua X.24).

left for omitted words and phrases. The scribe was evidently copying a flawed model, possibly a much earlier one in poor condition. His intention must have been to add the illegible words and phrases from another source, but this was never done. This, plus the fact that the text is an abbreviated one, makes it clear that the pictures were of greater importance than the text, much as was the case with the Vienna Genesis in the sixth century (see chapter 2). The Joshua Roll is thought to have been made as a gift for a military emperor, the most likely contender being Nikephoros Phokas, whose exploits provoked comparison with Joshua in other contexts. In the Pigeon House Church at Çavuşin mentioned above, for example, the scene of Joshua and the Angel is placed above the imperial group.[62]

All three manuscripts are painted in a sub-classical style that gives

61 Paris, BN gr. 139: Cutler, *Psalters*, 63–71.
62 Vatican, gr. 431: U. Hoepli, *Il Rotulo di Giosuè* (Milan 1905); M. Schapiro, 'The Place of the Joshua Roll in Byzantine History', *GBA* 35 (1949) 161–76; K. Weitzmann, *The Joshua Roll. A Work of the Macedonian Renaissance* (Princeton NJ 1948).

147 Menologion of Basil II (976–1025) (Vatican gr. 1613), folio 2, St Symeon Stylites.

an approximate rendering of three dimensions to figures and detailed backgrounds. In their postures and draperies, many individual figures are easily paralleled in classical art – the wall paintings of Pompeii are often cited. Further, a particularly classicizing feature in all three manuscripts is the use of personifications, for both natural features and concepts. Thus, in the Paris Psalter, the isolation of David Playing the Harp as he tends his flock is diminished by figures of Melody, Echo and the Hill of Bethlehem. In the Leo Bible a naked man labelled 'Mount Sinai' watches Moses Receiving the Law, and in the Joshua Roll the rivers, hills and cities of Canaan are all represented by figures.[63]

A few secular manuscripts attributed to the tenth century also have illustrations in classicizing style, often including personifications. In a copy of the *Theriaca* of Nicander in Paris, which is a second-century BC treatise on the treatment of snakebite, figures resembling those of the Paris Psalter and Joshua Roll are found alongside pictures of snakes and the plants that provide antidotes to their venom. Similarly, a medical treatise *On Bones* by Apollonius is illustrated with classicizing figures demonstrating remedies for skeletal disorders. The illustration of such texts continues a tradition of classical antiquity (seen before in the sixth-century Vienna Dioscurides). It is surely to be associated with the revival of learning in the Macedonian period, to which the renewed study of ancient texts was fundamental.

A menologion made for Basil II is among the most lavishly illuminated of all Byzantine books, 36.5 × 28.5cm in size, with 430 miniatures, each occupying half a page, with minuscule text either above or below it (fig. 147). The text gives brief accounts of the saints whose feasts fall

63 K. Weitzmann, *Studies in Classical and Byzantine Manuscript Illumination* (Chicago/London 1971), 141–50, 192–8.

between September and February, the first half of the ecclesiastical year, and there is one miniature for each saint. There may have been a second volume to complete the calendar. As in the Joshua Roll, the illustration takes precedence over the text, which is an abbreviated one and was left out altogether on several pages. The manuscript is of particular interest because the names of its eight painters are inscribed in the margins, next to the miniatures. These are in the scribal hand, and are therefore not signatures, but they provide unique evidence of the manner of production of a large illuminated book. It seems that bifolios (sheets folded to make four pages) were distributed among the painters, since in most cases the name of a single painter appears on all four miniatures of a bifolio. Of the 413 miniatures, some 250 show the martyrdom of the saint and about 100 use formal images of the saint standing against either an architectural background or in a landscape. The others are narrative images, including scenes of the life, funeral, miracles or translation of relics of the saint; a few subjects are drawn from the New Testament. Repetitive iconography is the order of the day, for a relatively small number of iconographic types is used (one may speak, for example, of a 'standard decapitation' used with only slight modification for the last moments of many different saints). This suggests that models were available for only a few of the miniatures and that the others were created, using a few standard martyrdom scenes or formal portraits as models. Once again, this is evidence of elaboration of illumination in the period. Although it has occasional classicizing motifs in the architectural settings of some saint portraits, the Menologion of Basil II is without the personifications and overtly classicizing figures of the Paris Psalter group, an indication perhaps that the fashion for such things was fairly shortlived.[64]

Other illuminated manuscripts of the tenth century lack both the self-consciously classicizing element and the elaborate schemes of illumination described above, and were probably much more typical of Macedonian book production than the 'special editions'. Several tenth-century gospel books, for example, contain evangelist portraits of the type seen as early as the sixth century in the Rossano Gospels (see chapter 2), showing the evangelist seated and writing; others show him standing (fig. 148). These author portraits are framed, occupying either a full page opposite the start of the appropriate gospel, or part of the page, with text placed around them. The figures are often set against gold grounds and are painted with strong highlights and formulaic drapery, although the overall effect is fairly naturalistic. Two Prophet Books (major and minor prophets) attributed to the tenth century on palaeographical and stylistic grounds also have simple decorative systems, with images of the prophets, either as full figures or busts, placed before their texts. A psalter in Oxford has a single

148 Gospels dated 964 (Paris, BN gr. 70) folio 4v, standing figure of the evangelist Matthew.

64 Vatican, gr. 1613: Spatharakis *Corpus* no. 35; I. Ševčenko, 'The Illuminators of the Menologium of Basil II', *DOP* 16 (1962) 245–76.

149 Psalter of Basil II
(976–1025) (Venice,
Biblioteca Marciana gr. 17),
folio 3r, Basil with angels and
military saints, above the
conquered Bulgars.

author portrait (a standing figure of David) rather than a preface of several pictures as in the Paris Psalter.[65] Relative simplicity of illumination is present even in a large psalter (38.8 × 30.5cm) made for Basil II (976–1025). At the start of this manuscript there is a miniature that probably reflects some of the lost 'victory' images of monumental art, consisting of a portrait of Basil in military dress, flanked by busts of military saints, with flying angels hovering above him (fig. 149). The Archangel Michael gives the emperor a lance, while Gabriel crowns him. Above, a half-figure of Christ suspends another crown above his head, while at his feet are eight prostrate figures of vanquished enemies. The book has one more picture page, divided into six compartments occupied by episodes from the life of David.[66]

The Macedonian period was, therefore, a very fertile one for book production in general, and for the illuminated book in particular. Simple systems of illumination were doubtless the most common, and many of those that survive follow the ancient tradition of the author portrait. A few, like the Marciana Job, provide evidence of narrative illustration also, and the evidence of the Paris Gregory is that this type of illumination was used for a range of texts of which no examples have survived. Against this background, the period saw the production of a number of 'luxury editions' which built on traditional forms. The author portrait was extended into an 'author preface' in the Paris Psalter, for example, and in the Menologion of Basil II the calendar of saints was turned into an enormous

65 Spatharakis, *Corpus* nos. 8, 9, 17, 33, 34, 40 (gospels) 11 (Psalter); J. Lowden, *Illuminated Prophet Books*

(University Park PA 1988).
66 Venice, Marciana gr. 17: Spatharakis, *Corpus*, no. 43.

picture-book. Other books, like the psalters with marginal illumination and the Paris Gregory, were not only extensively illuminated, but often had subtle relationships between text and picture, developments that attest the activity of creative and erudite designers associated with the ninth-century revival of learning. This intricacy of text and image has given rise to the suggestion that the psalters with marginal illumination were made for monastic use, whereas those with simpler and more luxurious illumination, like the Paris Psalter, were made for aristocratic patrons. There is no evidence to support such a division, however, and in general no clear-cut association between particular types of illumination and particular classes of patrons or recipients.

Nor can much information be gathered about the circumstances of production of illuminated manuscripts of this period. Many colophons identify the scribes as monks or priests, and the monastery may well have been the most common place of production. Literacy was not confined to these groups, however, particularly in Constantinople. The scholarly revival was as much a secular concern as a religious one and there may well have been professional scribes outside the religious houses. Similarly, while illuminators may in many cases have been artist-monks, the eight named painters of the Menologion of Basil II are not identified as such and were probably secular artists. Since artists are usually in shorter supply than scribes, it is quite possible that commercial workshops were at times engaged to provide paintings for manuscripts copied in monastic scriptoria.

General issues

As the above survey shows, the Macedonian period saw a resurgence of art and architecture concomitant with territorial and economic recovery. Much of what was produced, at least in Constantinople and other major centres, is markedly different in nature from the art and architecture of the sixth century, the last period from which there is enough material to make such a general assessment. Churches are small, domed, and decorated with images following the 'hierarchical' scheme with its festival icons. A taste for the sumptuous is seen in the jewelled and enamelled metalwork of liturgical objects and in the setting of figures against gold grounds in both mosaic decoration and the portable icon. This opulence must have been enhanced by the small scale of most churches, which set the worshipper in close contact with the precious materials of their embellishment. The Roman past, with its art based on the appearances of the real world, and its buildings symbols of authority as much as of faith, now appears very distant, except in some manuscript illumination and products of the minor arts which refer to it self-consciously.

Although the revival is likely to have encouraged innovation, it is improbable that all the features just listed were developments of the post-iconoclast period. It is argued above that while Iconoclasm and the social

upheavals of the seventh and eighth centuries doubtless diminished artistic production, they could not have ended it. Further, post-iconoclastic ninth-century art is confident and sophisticated, with none of the hesitancy of experiment. As is the case at most times, the working methods of its designers must have been part conservative, part experimental. Just what is new and what traditional is ill-defined, however, given the obscurity of the two centuries preceding Iconoclasm. Thus, while the 'hierarchical' scheme has not been seen before, it is likely to have at least begun its development much earlier, in harness with the emergence of the inscribed-cross and other small, domed church forms. This is the implication of the evidence from the Koimesis Church in Nicaea, where the post-iconoclast programme seems to have duplicated the pre-iconoclast one. Some stylistic ingredients, such as the plain gold ground and the reduction of narrative detail, may be seen in the sixth-century mosaic of Mount Sinai, and so may have been conventional well before Iconoclasm. Even greater continuity of tradition, as well as an available alternative to the 'hierarchical' formula, is demonstrated by the long narrative cycles of Cappadocian cave churches, which may represent a programme element used in the decoration of many painted churches.

In the minor arts, most forms are traditional, as is usually the case with functional objects. The ivory triptych has no certain pre-Iconoclast examples, but this may simply indicate that none has survived, since the triptych is just one species of a genus that is represented in earlier periods. The absence of pre-iconoclast examples of metalwork ornamented with enamel and strung pearls does, however, suggest that these techniques were more recently developed. Whether before, after or during Iconoclasm, is impossible to say, but Iconoclasm may well have fuelled the taste for splendour by enhancing among the iconodule majority the sense of preciousness of the images and objects of religion.

The illustrative formulae used in Macedonian books, with miniatures either full-page, marginal, or interspersed with text, are all of at least sixth-century pedigree, and the searching out of old books that was a practical aspect of the revival of learning may well have brought to light examples of earlier illumination to swell the repertory of images. More than any other form of art, the illuminated book had a good chance of riding out both the dark age and Iconoclasm and it is likely that the range of models available to mid-ninth-century illuminators was fairly wide. The increase in book production must have generated invention, or at least new interpretations of old models, but as in other fields, there is difficulty in identifying them. Some, like the Paris Gregory and other 'special editions', are obvious products of the artistic and scholarly revival, but these were the exception rather than the rule. Debate continues as to whether the 'marginal' psalters were a pre-or post-iconoclast development.[67]

67 A. Cutler, 'The Byzantine Psalter: Before and After
 Iconoclasm', in Bryer & Herrin eds., *Iconoclasm* (see
 n.28), 93–102.

The great social changes of the seventh to ninth centuries brought with them a change in the nature of imperial and aristocratic patronage of architecture. While the building programme of Basil I recalls that of Justinian, albeit on a much smaller scale, it took place in the special circumstances of a dilapidated capital city. More typical are the commissions for private buildings, such as the monasteries built for Constantine Lips and Romanos I in Constantinople, and for the *strategos* Krinites at Hosios Loukas in Greece. It was no novelty to build monasteries, of course, but the patronage of a personal or family monastery now begins to take the place of the commission for public buildings seen in the past. Even Basil's own chief work, the Nea Ekklesia was a palace church, unlike, for example, Anicia Juliana's St Polyeuktos.

In their patronage of the minor arts, emperors and aristocrats display the traditional motives of invoking divine benevolence and demonstrating their status. The (relatively) large number of objects and manuscripts of known patronage of this period also permits the discernment of aspects of patronage that may not be new, but are now more visible. It is likely, for example, that patrons had various degrees of engagement with their commissions. Constantine VII may have supplied the inscriptions of the Rome triptych and the Venice/Vienna panels – we are told that he took an active role in the supervision of craftsmen working for him. In contrast, the uneducated Basil I can hardly have been involved in the design of the Paris Gregory, one of the most elaborate and sophisticated of all Byzantine illuminated manuscripts. This example raises the question of the meaning of 'donor images' in the Byzantine minor arts. Did Basil I commission the Paris Gregory himself, or was it the gift of someone anxious to gain his favour? (The Patriarch Photios, for example, had both this motive and the intellect necessary to produce the design.) In either case, the book supports Basil's interest in separating himself from his humble origins, an aim seen also in the decoration of the Kainourgion, with his children carrying books. Basil II also seems to have had little personal interest in the arts, and yet we have two finely illuminated books made for him. Here again, the psalter, with its image of Basil victorious over the Bulgars, may have been the emperor's own choice, or that of a courtier looking for preference. The lavish (and enormous) menologion is more likely to be an imperial commission than a gift received, intended to impress those who saw it – it is as near as a book can come to being a public monument. Objects like the Limburg reliquary suggest that a patron might wish to signal not only his own piety and high rank, but also his status in relation to other figures of power. In its inscriptions, Basil the *proedros* not only acknowledges the earlier patronage of Romanos II and Constantine VII, but in so doing declares his own close connection with them. A similar motive may explain the reference to Nikephoros Phokas on the Cortona reliquary made for Stephen the *skeuophylax*.

Imperial imagery sees a development that may be identified as post-iconoclastic with some security. Although portraits of the iconoclast

emperors may have been made, they would surely not have shown imperial persons in the company of Christ or the Virgin, as is the case in the 'coronation' ivories, the sceptre of Leo, the Paris Gregory, the Psalter of Basil II, the Kainourgion of the palace and the two lunette mosaics of St Sophia in Constantinople. Such intimacy of divine and imperial figures also appears to be absent from pre-iconoclast imperial imagery. It is to be associated with the concept, well attested in middle-Byzantine literary sources, of divine endorsement of the emperor – even of the usurper (who, it would be argued, could have reached the throne only with divine assistance).[68]

The term 'Macedonian Renaissance', has been used sparingly here, in order not to prejudice judgement, since it is a controversial one that appears very frequently in the literature on Byzantine art. None would disagree that there was a Macedonian revival of the arts, but the term 'renaissance' implies that this revival embraced a return to the style, iconography and aesthetic values of classical art, and it is this that causes disagreement. Such a phenomenon would certainly be consistent with the circumstances of the Macedonian period, which are not unlike those obtaining in other 'renaissances', most conspicuously that of fourteenth- to fifteenth-century Italy. The revival of learning was very much based on the renewed study of classical literature, and may have caused the scholars engaged in it to look with new eyes on the art of the Roman world still available to them. This included the statues of Constantinople and probably the silverware still being made in classical manner at least as late as the seventh century. They may also have seen late Roman painting in some of the old manuscripts that were being gathered for study. Evidence that something like this did happen is offered by the fairly naturalistic figure style of ninth-century manuscript painting like that of the Paris Gregory or the Vatican Cosmas. It is also attested by the group of manuscripts attributed to the tenth century which have unquestionably classical components, such as the Paris Psalter, Leo Bible and Joshua Roll, with their personifications and other figures with conspicuously classicizing postures and gestures, and by objects like the Veroli and Darmstadt caskets, and the San Marco glass bowl, with their subjects drawn from classical mythology and drama. Constantine VII's statue collection, and the mounting of antique bowls as liturgical chalices (that of Romanos II, for example) may also indicate antiquarian tastes on the part of some patrons.

On the other hand, when a wider view is taken, these developments appear limited in their extent. There was evidently no classical revival in architecture, and classicizing figures and personifications do not appear in monumental art, nor (as far as one can tell) in icons, nor in ivory carving, with the exception of the Joshua panels, which apparently copy the Roll. The jewel- and enamel-encrusted metalwork recalls the splendour of bar-

68 A. Grabar, *L'Empereur dans l'art byzantin* (Paris 1936), and Variorum Reprint (London 1971).

barian art rather than the restraint of the classical. Nor was there renewed production of free-standing sculpture, which must have been the most conspicuous relic of the classical, still available in the streets of Constantinople. Further, the classicizing art of the Macedonian period is superficial in its approach. It uses classical subjects and iconography, and an approximation of naturalistic style, but does not reproduce the heroic idealism of the model. The Macedonian version of classical art offers the visual equivalent of the literary convention in which the achievements of Byzantine artists were implausibly likened to those of the painters and sculptors of ancient Greece.

The classical element, therefore, is perhaps to be seen as a fashion, rather than a fundamental influence in the Macedonian period. It may have been stimulated by the scholars of the capital, but it probably found its greatest expression when it reached the less scholarly but more fashionable members of their aristocratic circle. The classical subjects of the Darmstadt casket and the Venice bowl appear to have no meaning beyond ornament, and one wonders whether a serious student of Euripides, in any age, could have responded to the chubby figures of the Veroli casket with anything but recoil. By the mid-tenth century therefore, classicism may simply have entered the stream of fashion, much as eighteenth-century archaeology supplied motifs for French drawing-room furniture. On the evidence of the Menologion of Basil II, where it is vestigial, it was already outmoded by the early eleventh century.

The term 'Macedonian Renaissance' is therefore an unfortunate one, because it implies a phenomenon much more widespread and profound than the evidence allows. While a classical revival of sorts is beyond dispute, it is probably best understood as something closely associated with the court of Constantinople, and largely confined to it.[69]

69 K. Weitzmann, 'The Character and Intellectual Origins of the Macedonian Renaissance', *Studies* (see n.63) 176–223, and 'The Classical Mode in the Period of the Macedonian Emperors: Continuity or Revival?', in *Classical Heritage in Byzantine and Near Eastern Art*, Variorum Reprint (London 1981).

5 *The Comnene dynasty*

This chapter covers the period from the death of Basil II in 1025 to the Latin Occupation of Constantinople in 1204. It is titled Comnene, after its most important dynasty, but the period actually begins with the sorry decline of the Macedonian dynasty and ends with eighteen years of unkempt government by another aristocratic family, the Angeloi.

After a reign of nearly forty years, Basil II left no heir and the throne went to his elderly brother Constantine VIII (1025–8). Constantine was followed by his daughter Zoe and her three successive husbands, and, very briefly, other members of the Macedonian house. Incompetence and maladministration in these thirty-odd years caused both immediate and long-term damage to the structures of the empire. Weak imperial authority could not check the battle for power between the civilian aristocracy of the capital and the provincial military aristocracy with its vast Anatolian estates. Civil wars drained the economy and the army was undermined as the civil bureaucracy encouraged provincial soldiers to buy their way out of military obligation. Basil II had amassed considerable wealth, partly by harsh taxation that was certain to cause problems for his successors. Their attempts at reform succeeded only in reducing the supply of state funds and the situation was worsened by their disposition to squander the fortune that had been left. By the mid-eleventh century desperate remedies included debasement of the coinage. This state of affairs was checked temporarily when the remains of the Macedonian dynasty were finally pushed aside in 1057 by Isaac Komnenos, a member of one of the powerful military families whose land was in northwestern Anatolia. His reign lasted only two years before opponents in the capital forced his abdication, and the decline continued during the brief reigns of his four immediate successors.

Basil II had also left the empire with its borders reasonably secure and its traditional enemies, notably the Bulgars, subdued. Members of the Bulgarian ruling families had been absorbed into the Byzantine aristocracy by marriage, and the Bulgarian patriarchate of Ohrid reduced to an archbishopric. This was autocephalous – not answerable to the patriarchate of Constantinople – but its incumbent was appointed by the Byzantine emperor. Peace with other neighbours to the north was temporarily disrupted in 1043, when a Russian fleet attacked Constantinople in response to a dispute involving Russian merchants in the capital. The move was

defeated by the forces of Constantine IX, however, and the peace treaty that followed in 1046 was marked by the marriage of this emperor's daughter to the son of Yaroslav of Kiev. Thereafter, relations with Russia never erupted into armed conflict.

Other enemies were gathering, ready to take advantage of the weakened defences of the empire. The Pechenegs, Cumans and Uzes (all Turkic tribes) became a problem to the north, and in the west the Normans began moving into Greece and Albania from their strongholds in south Italy. In the east the Seljuk Turks were making their way across Anatolia. Melitene was sacked in 1058, Caesarea in 1067, and in 1071 there was a debacle at Manzikert (near Lake Van) in which the Byzantine army was virtually wiped out and the emperor (Romanos IV) captured. By about the 1080s the Seljuks had reached as far west as Nicaea. The theme system had broken down, the army was in decay and the empire became increasingly dependent upon mercenaries and temporary alliances that might at any moment turn sour.

In 1081 the Komnenoi secured the throne once more, for Isaac's nephew Alexios I Komnenos, whose thirty-seven-year reign inaugurated over a century of Comnene rule which passed from father to son for five generations. The old problem of conflict of interests between imperial authority and the power of the aristocratic families ended as the distinction itself disappeared. One family had moved into the imperial seat, and part of its success lay in its alliances by marriage with several of the others – the Doukai in particular, also the Angeloi and Palaiologoi. Many of the matches were the work of Alexios' very able mother, Anna Dalassena, to whom he also entrusted civil administration while he was away on campaign. A measure of stability was recovered, and the condition of the state treasury improved – partly by the confiscation of church treasure, an action that the Komnenoi were never allowed to forget. More than ever before, power and wealth were centred upon Constantinople, but there were still prosperous provincial towns, especially in Greece. Trading privileges were granted to Western merchants, particularly the Venetians, Genoese, Pisans, which brought considerable numbers of them to the capital, where they settled in the Galata region and built their warehouses on the Golden Horn.

In the last quarter of the twelfth century a Serbian attempt to throw off Byzantine control, led by the chieftain (Zupan) Stephen Nemanja, was defeated by Manuel I Komnenos, who took Nemanja to Constantinople in triumph in 1172. A later Serbian uprising was also contained, and in 1190 Nemanja's son married a niece of Isaac II Angelos, the first of the short-lived dynasty to follow the Komnenoi. Shortly before, in 1185, there was a new Bulgar revolt, which succeeded in taking control of Northern Bulgaria. Isaac II Angelos, was obliged to acknowledge its leader Asen, who was crowned Tsar in Trnovo, its new capital. A newly-created archbishopric there superseded Ohrid as head of the Bulgarian church.

In spite of its problems, Constantinople in the eleventh and twelfth

centuries had a thriving intellectual life. Higher education, which had declined after the death of the scholar-emperor Constantine VII, enjoyed a revival in the mid-eleventh century which involved such prominent figures as Michael Psellus, a civil servant and historian, whose *Chronographia* covering the period 976–1078 is among the most entertaining as well as informative of Byzantine histories. Support for high standards of education and literary endeavour continued with the Komnenoi, and it encompassed the women of the family as well as the men. Anna Dalassena, Alexios' mother, was given to informed discussion of both secular and religious topics, and her very well-read granddaughter, Anna Komnena, wrote a history of her father's reign, the *Alexiad*, which is a chief source for the period. The tradition of female scholarship continued with Eirene *sebastokratorissa*, sister-in-law of Manuel I, Alexios' grandson, who gathered around her a circle of literati, among them the poet Theodore Prodromos, who wrote on theological, historical and classical subjects. A similar range is found also in the output of Eustathios, archbishop of Thessalonike 1175–91, whose commentaries on Homer, Aristophanes and other classical writers reflect the fact that classical learning was still the foundation of all education.

The Komnenoi had been able to reverse some of the military defeats of the eleventh century, with significant defeats of both the Pechenegs and the Normans, and recovery in Anatolia might have followed, had not the West presented a novel problem in the form of the Crusades. The schism begun in the ninth century with the conflict between Photios and Pope Nicholas had resurfaced in 1054 with another exchange of vituperative letters between Patriarch and Pope – now Michael Keroularios and Pope Leo IX. This time it ended with mutual excommunications that did little more than solemnize a *de facto* separation of long standing. Christendom was divided, therefore, by the time Jerusalem fell to the Turks in 1077, and Western moves to recover that city, spurred by motives ranging from the pious to the territorial, were viewed with suspicion in Constantinople. The First Crusade of 1096–7 brought an uneasy alliance, with Byzantine supplies and assistance on the route east given in exchange for oaths of loyalty from the Frankish knights. When the Crusaders recaptured Nicaea from the Turks in 1097, they restored it to Byzantine control, but when Antioch and Jerusalem were taken in 1098 and 1099, the Crusaders claimed these cities for themselves and the alliance was ruptured. It deteriorated further with the Second and Third Crusades (1147 and 1189/90), and by the Fourth Crusade open hostility culminated in the sack of Constantinople in 1204 and the beginning of the Latin occupation.[1]

1 Ostrogorsky, *Byzantine State*, 316–417; Obolensky, *Byzantine Commonwealth*, 275–302; Vasiliev, *Byzantine Empire* 11, 487–503; M. Angold, *The Byzantine Empire 1025–1204* (London 1984); E.R.A. Sewter trans., *Michael Psellus. Fourteen Byzantine Rulers* (Harmondsworth 1966) and *The Alexiad of Anna Comnena* (Harmondsworth 1969).

Architecture

The evidence for secular building of the eleventh and twelfth centuries is, as usual, almost entirely documentary. Much of it concerns the aristocrats in Constantinople, who continued to build or rebuild their palaces whatever the financial problems of the empire. The Blachernae district, between the Land Wall and the Golden Horn, began to be a fashionable area. Since the fifth century, the Church of the Theotokos of Blachernae, which housed the veil of the Virgin, seems to have had alongside it apartments to facilitate imperial visits to the shrine. At least by the mid-eleventh century these must have grown into, or been displaced by, an imperial palace, since Zoe and Constantine IX, the third of her husbands, are said to have made an appearance on its balcony. Positioned on the Land Wall, the site had the advantage of being easily fortified, and Anna Komnena tells us that the Blachernae Palace was used as a stronghold by the Komnenoi at the start of the usurpation that put Alexios on the throne in 1081. Under the Komnenoi, this palace became the chief imperial residence and Alexios probably added a great hall to it shortly before 1092, when a synod was held there. The form of the palace is otherwise unknown, but massive substructures embedded in the wall are probably remains of it.

The old Imperial Palace, at the other end of the city, retained its importance as an administrative and ceremonial centre. Niketas Choniates records that Manuel I Komnenos (1143–80, Alexios' grandson) added new halls to both Imperial and Blachernae Palaces, and also built summer mansions on the Bosphoros. The same source credits Isaac II Angelos with similar commissions later in the century. Nikolaos Mesarites mentions another addition to the Imperial Palace, known as the Mouchroutas, built next to the *Chrysotriklinos*, probably in the mid-twelfth century. This large building had tiled surfaces and 'stalactite' embellishment of its vaults, both features of Seljuk architecture and proof of the enduring Byzantine capacity to absorb extraneous traditions.[2]

Alexios I Komnenos seems not to have been much of a builder. He may, indeed, have chosen to demonstrate imperial sobriety in this respect after the extravagance of some of his Macedonian predecessors. Apart from the hall at the Blachernae Palace, his only recorded major architectural undertaking was a philanthropic one. This was the Orphanage, which occupied a site on the acropolis near to the fourth-century church of St Paul, which he repaired. The Orphanage appears to have been a large complex of buildings, probably two-storeyed and arranged in concentric circles. It functioned as a refuge for the poor, elderly and infirm, including the wounded of military campaigns.[3]

Church building appears to change little during the eleventh and

2 Mango, *Sources*, 224, 226, 228–9, 236; R. Janin,
 Constantinople byzantin (Paris 1950), 123–8.
3 *Alexiad* (see n.1) x v .vii.

twelfth centuries. The inscribed-cross remains the most frequent and wide-spread type, and while other forms are found, particularly in Greece (of which more below), they differ in detail rather than in concept. The distribution of surviving churches reflects both contemporary and subsequent developments. There are very few in Anatolia, where the middle-Byzantine empire was losing its hold and where post-Byzantine Islamic supremacy resulted in abandonment and decay. Conversely, there is a relatively large number in Greece, where economic prosperity encouraged patronage and post-Byzantine Christianity preserved its products.

In the capital, imperial and aristocratic patronage followed the trend noted in the last chapter, with the founding of personal or family monasteries that would usually serve also as mausolea. In the case of imperial commissions, this represents a final break with the tradition that emperors and their families would be laid to rest in the mausolea of the Church of the Holy Apostles (unless they died in exile, disgrace or in distant provinces). The last emperor to be thus accommodated was Michael V (1041–2), an adopted son of Zoe, and the custom had already been breached in the tenth century by Romanos I, with the Myrelaion.[4]

A fifteenth-century account describes the Monastery of the Theotokos Peribleptos, built by Romanos III (1028–34, the first of Zoe's husbands) as having an inscribed-cross church with a marble tomb for the emperor set in its north wall, and a refectory with a long marble table and benches. The second husband, Constantine IX (1059–67) built the Monastery of St George in the Mangana district, and was accused of wanton extravagance by contemporaries for changing the form of the building twice during construction to make it ever more lavish. The only remains of his achievement are substructures abutting the Sea Wall. By 1081, Maria Doukaina, mother-in-law of Alexios I, had restored the Monastery of Christ in Chora in the Blachernae district, which had been founded in the sixth or seventh century. She built an inscribed-cross church which constitutes archaeological phase III on the site, and survives only as fragments embedded in the later reconstructions of the building (now Kariye Camii).[5]

The first surviving church of this group of aristocratic commissions is that of Christ Pantepoptes, part of a monastery built by Anna Dalassena, Alexios' mother, who retired to it shortly before her death in 1087 (fig. 150). The church is a small inscribed-cross, originally with a single three-bay narthex with niches in north and south walls. (The outer narthex is a Palaiologan addition, probably of the fourteenth century.) A U-shaped gallery above the western corner bays and narthex may have been for Anna Dalassena's own use. The dome, rising above the four

4 P. Grierson, 'Tombs and Obits of the Byzantine Emperors
 337–1042', DOP 16 (1962) 1–63.

5 Peribleptos: Ruy González de Clavijo, trans. in Mango,
 Sources, 217–18; Janin, Géographie 227ff. Mangana:
 Psellus, Chronographia VI, 185–8, trans. Sewter, Psellus

(see n.1), 250–2; Mathews, Istanbul 200–5. Chora: R.G.
Ousterhout, The Architecture of the Kariye Camii in
Istanbul. Dumbarton Oaks Studies 25 (Washington DC
1987), 15–20.

150 Christ Pantepoptes,
Constantinople (before 1087):
view from the southeast; plan
after Van Millingen.

barrel vaults of the cross-arms, is divided into twelve segments by flat ribs. At the east end, the three apses open off intercalary bays, the north and south ones niched. In this and other features the church resembles the Myrelaion of Romanos I, built over a century and a half earlier. On the exterior, arched recesses frame the windows, brick pilasters mark the main divisions of the interior and arched niches decorate the upper wall of the apse. Surface texture is further developed by the use of the 'recessed brick' technique, in which alternate layers of brick are inset and then covered with mortar, giving a coarsely striped finish to the wall. In places, bricks are arranged in meander and other patterns, but it is possible that these belong to the Palaiologan alteration.[6]

Alexios I himself seems to have eschewed ostentation, and was buried in his wife's monastery of Christ Philanthropos, but his successors had their family mausoleum in the Pantocrator Monastery (fig. 151). This large establishment, on a hill near the Aqueduct of Valens, was the commission of John II, Alexios' son, although some sources credit his wife, Eirene, with initiating it. The project was a further demonstration of Comnene philanthropy, for the monastery *typikon* (foundation charter) provides for a hospital of some sophistication, with a total of fifty beds in five separate wards for different sorts of ailment, and a specialist medical staff. The churches of the monastery, which are all that remain, form a three-part complex. First built was the southernmost, dedicated to Christ Pantocrator, which is an inscribed-cross church with a single narthex. This was followed by a second inscribed-cross, dedicated to the Virgin, to

6 Mathews, *Istanbul*, 59–70.

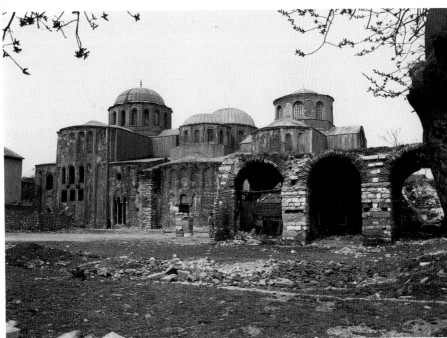

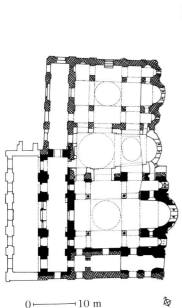

0 ⊢————⊣ 10 m

151 Churches of the
Pantocrator Monastery,
Constantinople (1118–36):
plan after Van Millingen and
Megaw; view from the
northeast.

the north. Finally the two-domed chapel of St Michael, housing the imperial sarcophagi, was built in the irregular rectangle between these two, and an outer narthex was added to the south church. Like the Pantepoptes, the churches are built in recessed brick and have blind niches in the apse walls and recesses over arched windows. The three-church complex seems to have been built between John's accession in 1118 and 1136, the date of the *typikon*, possibly by a single architect, Nikephoros, who is mentioned in an *ekphrasis*.[7]

Several other middle-Byzantine churches of unknown date and patronage survive in the capital. St John in Trullo is a small inscribed-cross church, as is the core of Vefa Kilise Camii (beneath Palaiologan alterations that will be described in due course). Older plans are also represented. Kalenderhane Camii is a domed Greek cross, dated by pottery finds to the late twelfth century. A similar form was used for a second Comnene rebuilding of the Chora Monastery church (Kariye Camii, phase IV) replacing the inscribed-cross of Maria Doukaina, noted above. Phase IV was probably the work of Maria's grandson Isaac Komnenos, around 1120, only about 40 years after Maria's work and presumably necessitated by some structural damage to her church. Gül Camii, sometimes called St Theodosia, was once assigned to the ninth century because of its cross-domed plan, but is now thought to be no earlier than the eleventh century since it uses the recessed-brick technique described above. It is impossible

7 Mathews, *Istanbul*, 71–101; P. Gautier, 'Le typikon du
 Christ Sauveur Pantocrator', *REB* 32 (1974) 1–131;
 A.H.S. Megaw, 'Notes on Recent Work of the Byzantine
 Institute at Istanbul', *DOP* 17 (1963) 333–71, 342
 n.24.

to say whether these examples of old church types indicate their continuous use over a long period, or their middle-Byzantine revival.

The 'ambulatory' plan, which is to become important in the Palaiologan period, is found in the Theotokos Pammakaristos (now Fetiye Camii) (fig. 233). The form resembles that of the cross-dome, but has rather different proportions. The domed nave is smaller and the spaces around it wider and more uniform, making an embracing ambulatory around the domed core. According to an inscription on the bema cornice, now lost but recorded in an eighteenth-century manuscript, the church was built by John Komnenos and his wife Anna Doukaina, who were evidently members of the imperial family, but whose precise identity is unknown. The recessed brickwork of both the church and the cistern beneath it argue for a late twelfth-century attribution. The monastery was refounded in the Palaiologan period, and for over a century after the fall of Constantinople it was the seat of the Patriarch.[8]

None of these buildings marks the capital of the eleventh and twelfth centuries as a place of architectural innovation. Their patrons, where known, were of the highest rank and presumably able to command the best the city could offer, and yet most churches use the inscribed-cross plan, by now standard for at least two centuries, and others depend on still older traditions. The piecemeal construction of the Pantocrator churches, with its associated asymmetries and awkwardnesses is of a sort usually associated with structures built in phases separated by long intervals, and yet the whole appears to have been completed in eighteen years, and may have been built by a single architect. (Perhaps his imperial patrons kept changing their requirements, but one nevertheless feels that a more able designer would have managed a more coherent result.)

Conservatism was probably also the case in Anatolia, where only a few churches remain, and in most cases even the attribution to the 'tenth to twelfth centuries' cannot be refined. A distinction of regional tradition is sometimes made between the use of piers in the Anatolian inscribed-cross churches and of columns in Constantinople, but the columns in the capital were generally re-used, and the distinction may have been largely a matter of the availability of *spolia* from earlier buildings. Columns are found in some of the cave churches of Cappadocia, where they were cut out of the rock, so the tradition was not unknown there.[9]

For variety and sophistication in church design in the eleventh and twelfth centuries one has to turn to Greece. The inscribed-cross is still the most frequently used type, with widespread examples, although few have firm dates. Among them is the only middle-Byzantine church remaining in Thessalonike, the Panagia Chalkeon, which was probably a monastery church, the commission of the *protospatharios* Christopher and his wife Maria in 1028, according to an inscription over its entrance. The church

8 Mathews, *Istanbul*, 159–67, 386–401, 128–39,
 171–85; Striker & Kuban, 'Kalenderhane'; Ousterhout,

Kariye Camii (see n.5), 20–32.
9 Rodley, *Cave Monasteries*, 230–5.

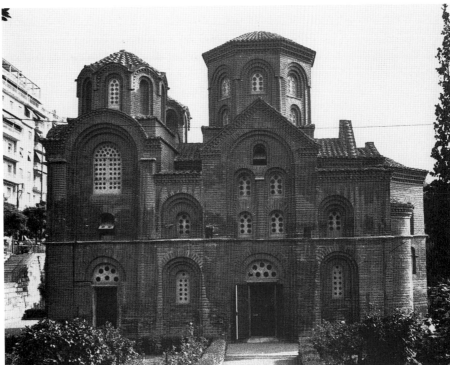

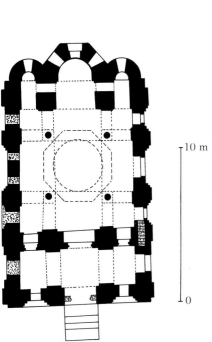

152 Panagia Chalkeon, Thessalonike (1149): view from the south; plan after Diehl, le Tourneau & Saladin.

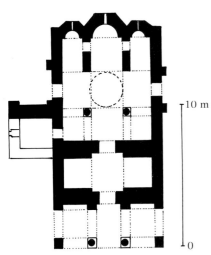

153 Church at Samarina, Messenia (twelfth century) plan after Millet.

has four columns, intercalary bays and a three-bay gallery above the narthex, with domes over the lateral bays (fig. 152). It is built of brick and has a highly textured exterior with arched recesses over the windows, brick pilasters and arched niches in the apse wall. All these features are found in buildings of the capital, and the Panagia Chalkeon would seem to be a provincial representative of the metropolitan style.[10] More typical of building practice in Greece is the church of the Nea Mone at Areia, near Nauplion, built, according to documents and an *in situ* inscription, by Leo the bishop of Argos, in 1149. The inscribed-cross church is faced in stone, with thin bricks bordering each block (the method termed 'cloisonné') and string courses of brick meander and dog-tooth patterns forming bands across the exterior walls.[11] There are many more such churches, often without precise dates but attributed to the eleventh/twelfth centuries on the basis of their plans and manner of construction. Some features of the inscribed-cross church in Greece appear to be local, such as the combination of columns and piers below the dome, with the columns to the west, and the piers extending eastwards to join projections from the east wall that flank the apse. This arrangement is seen at the twelfth-century church Samarina, Messenia (fig. 153). Conversely, some aspects of Constantinopolitan churches are rare in Greece: the intercalary bays found in all metropolitan examples of the inscribed-cross church are

10 Mango, *Architecture*, 205–7.
11 G.A. Choras, *H Hagia Mone Areias* (Athens 1975).

usually absent, so that the apses open directly off the three easternmost bays of the core. The exceptions are usually churches which have metropolitan connections of some kind. The functional significance of the presence or absence of intercalary bays is not yet explained.[12]

It is in Greece that we find the most subtle of middle-Byzantine church designs, the Greek-cross-octagon, of which the *katholikon* of Hosios Loukas in Phokis is an example. This church was built in the first half of the eleventh century, alongside the tenth-century Theotokos Church mentioned in the last chapter, and is traditionally credited to Constantine IX Monomachos. Some authors regard this claim as legendary and suggest instead that the church was built by the monks of the monastery, which had become an important pilgrimage site (presumably attracting pious donations from visitors). This view may be supported by a painting in the crypt below the church, which shows a monk presenting a model of the church to Hosios Loukas. Alternatively, this monk may be an aristocratic patron who adopted the monastic habit in retirement, a procedure well known in the middle Byzantine context. Whatever the circumstances of its commission, the building is a fine one. It has a dome set on an octagon formed by squinches (small niches) spanning the corners of the square central bay. Four bays form a Greek cross around the domed core: the easternmost, in front of the apse, is domed, the others are cross-vaulted (for plan, fig. 107). The near-square naos is completed by L-shaped corner groups of three small cross-vaulted bays, which link the cross-arms. Galleries form a U-shape above the north, south and west sides of the domed core and the plan is completed by a three-bay narthex. A rather simpler form of Greek-cross-octagon, lacking the galleries, is found in the monastery church at Daphni, near Athens, and attributed to the late eleventh century. Both churches figure large in the literature on middle-Byzantine art because they are the only ones on the Greek mainland to have preserved extensive mosaic decoration. A more securely dated example of the Greek-cross-octagon is found in the Panagia Lykodemou, in Athens, much altered in the mid-ninteenth century. This was built before 1044, the date of the obituary inscription of its founder, Stephen, which is in the south wall. All three churches are constructed using the cloisonné brick and stone technique, and all have the 'kufic' ornament noted in the last chapter.[13] The Greek-cross-octagon is found chiefly in southern and central mainland Greece, but is usually assumed to be of metropolitan origin, given the sophistication of the form and the traditional association of one example with imperial patronage. The recent discovery that vaulting resembling that of the Greek-cross-octagon survives in the small church of Panagia Kamariotissa on Heybeliada, one of the islands in the Sea of Marmara, near Constantinople, has for some supplied a further link with

12 G. Millet, *L'Ecole grecque dans l'architecture byzantine* (Paris 1916), 55–8.

13 C.L. Connor, *Art and Miracles in Medieval Byzantium* (Princeton NJ 1991), 122; Mango, *Architecture*, 222; Krautheimer, *Architecture*, 356–8, 408–14. For Hosios Loukas, see also ch. 4, n.11.

the capital. The relationship seems tenuous, however, since this church is (or rather was – it is much mutilated) a triconch. Further, there seems no reason to deny the possibility that the most elegant of Comnene church designs was a creation of the Greek provinces, where prosperous towns could well have supported master-builders of quality.[14]

More convincing metropolitan origin is indicated for the so-called octagon-domed church, even though it is found only on the island of Chios. The chief example is the *katholikon* of the Nea Mone, a foundation of *c.* 1042, whose imperial patrons were Zoe and Constantine IX, and Zoe's sister Theodora. Constantine is said to have sent both the architect and mosaicist from Constantinople to work on the church, which may have been modelled on the mausoleum of Constantine at the Church of the Holy Apostles, although the relationship is likely to be one of general form, not detail. The church is without aisles and its square naos is turned to an octagon below the drum of the dome by four squinches at the corners of the square, and four niches over the four walls (fig. 154). At the east end

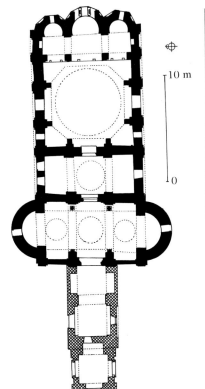

154 Nea Mone, Chios (*c.* 1042): view from the northeast; plan of the church, after Bouras.

two piers separate the naos from a three-bay bema with three apses. There is an inner narthex of three bays, the central one domed, and an exonarthex, also with three bays, all domed, and with apsed ends. This church too has a mosaic decoration, recently conserved. Several other churches on the island copy Nea Mone, but the form is unknown elsewhere.[15]

Alongside these middle-Byzantine types, the basilica remains in limited use. In Kastoria in northern Greece there are several examples, such as the church of the Anargyroi, a small building with its exterior richly ornamented with patterns of cloisonné brick and stone (fig. 155). Here and elsewhere most middle-Byzantine basilicas are small, often with nave

14 T.F. Mathews, 'Observations on the Church of Panagia Kamariotissa on Heybeliada (Chalke) Istanbul', *DOP* 27 (1973) 117–32.

15 C. Bouras, *Nea Moni on Chios. History and Architecture* (Athens 1982), 139–45; A.K. Orlandos, *Monuments byzantins de Chios* (Athens 1930).

155 Church of the Anargyroi,
Kastoria (twelfth century).

arcades of just two or three piers or columns, and bearing only a generic relationship to the great churches of the fifth century of which they are descendents. An exception is the basilica of St Sophia at Nicaea, probably built after the severe earthquake of 1065, to replace a fifth- or sixth-century church of similar proportions (fig. 156). The old form was probably retained because the church was the cathedral of Nicaea and a large structure was needed for it.[16]

 In its layout, the monastery is perhaps the most stable element of Byzantine architecture. The form seen in the sixth-century Monastery of St Catherine at Mount Sinai is found in many middle-Byzantine (and, indeed, post-Byzantine) monasteries. A high perimeter wall, often with just one entrance, encloses a courtyard with the *katholikon* at its centre. Refectory, bakehouse, laundry, workshops, sanatoria and other rooms line the perimeter wall, as do blocks of cells, sometimes on two or more storeys; the twelfth-century Sagmata Monastery in Boeotia, will serve as an example (fig. 157). Although there is little evidence for it outside Greece, this basic formula was probably used throughout the empire. In central Anatolia it is reproduced to some extent in Cappadocian cave monasteries, where rooms are grouped around a courtyard cut into the

16 Millet, *L'Ecole greque* (see n.12) 15ff; Krautheimer,
 Architecture, 354.

156 St Sophia, Nicaea (after
1065): plan after Schneider;
view from the southeast.

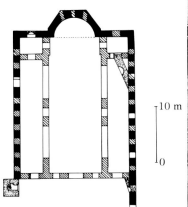

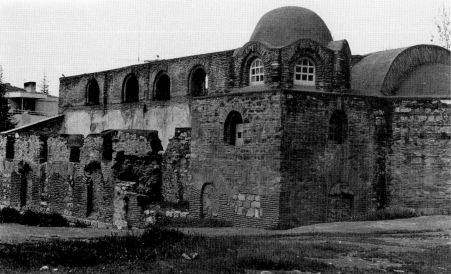

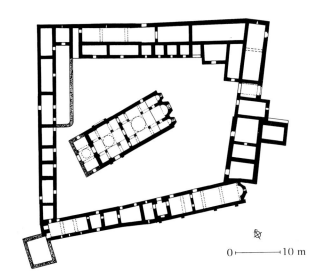

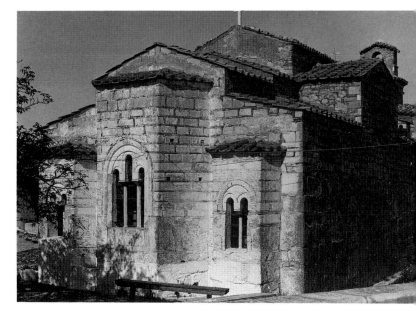

157 Sagmata Monastery,
Boeotia (twelfth century):
plan after Orlandos; view of
the church from the
northeast.

rock. Here, however, the church is at one side of the courtyard, rather than free-standing, since it too is rock-cut (fig. 158).[17]

Finally, it may be noted that in the eleventh and twelfth centuries there are several instances of the spread of Byzantine architecture beyond the borders of the empire. The *Russian Primary Chronicle* records that in 1037 Yaroslav the Wise, whose father Vladimir had formally brought Russia into Christendom, began extensive building in Kiev. Several fea-

17 A.K. Orlandos, *Monasteriake Architektonike* (Athens
1958); for Sagmata: Orlandos, *Archeion*, 7 (1951)
72–110. Rodley, *Cave Monasteries*, 11–120.

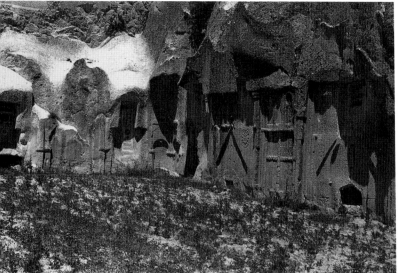

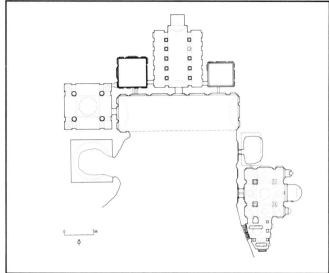

tures of this work suggest that Yaroslav had Constantinople in mind as a model for his own capital, among them a church dedicated to St Sophia, built and decorated by Byzantine craftsmen. In plan the church appears to depart from Byzantine tradition, since it consists of a large grid of domed or barrel-vaulted bays (fig. 159). This form is created, however, from essentially Byzantine components, comprising an inscribed-cross core embraced by two sets of aisles which form a U-shape around it, the outer set having galleries. The core has cruciform piers rather than columns (probably because *spolia* columns were not available in Kiev and it was too difficult to transport them from Constantinople). This stage was complete by the 1040s, and later in the century a U-shaped ambulatory was added. The augmentation of the basic inscribed cross makes the structure much larger than most middle-Byzantine churches, a requirement of function, since St Sophia was the cathedral of the Metropolitan of Kiev, head of the Russian church.

In the West, increased contacts with Venice are reflected in the rebuilding of San Marco, started *c.* 1063, which used the church of Holy Apostles in Constantinople as its model. The large cruciform building has five domes, covering the crossing and the four arms, and a U-shaped narthex enclosing the west arm (fig. 160). Less thorough reference to Byzantine types is seen seventy years later in Sicily, which had been taken by the Normans, along with much of south Italy. That the Norman kings looked towards Byzantium for material expression of their status is clearest from the mosaic decoration of their churches, discussed below, but their architecture draws on both eastern and western traditions. Roger II's first church, at Cefalù, was a western-style basilica, built by 1143. His approximately contemporary palace chapel in Palermo was a hybrid, however, with a domed east end attached to a basilical nave (fig. 161). The same formula was adopted for the great abbey church of Monreale, just outside Palermo, built by 1183 for William III, the third Norman king. Here, how-

158 Hallaç Monastery, Cappadocia (mid-eleventh century): view of the northeast corner of the courtyard; plan.

159 St Sophia, Kiev (second quarter of the eleventh century) plan after Aseyev, Volkov & Kresalny.

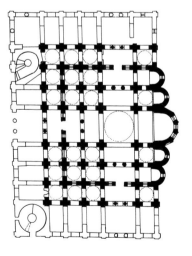

0 ⊢———⊣ 10 m

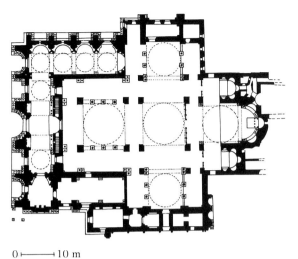

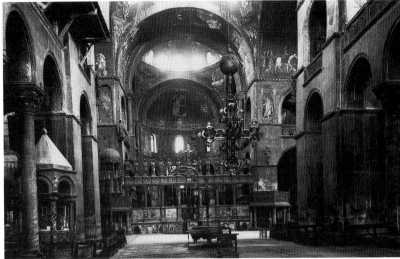

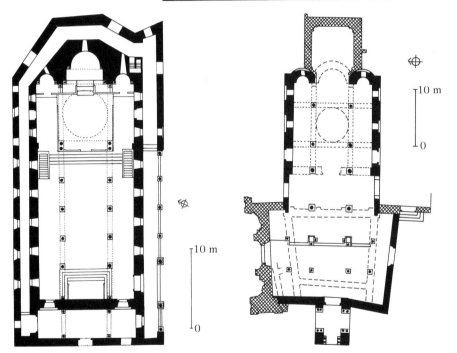

160 San Marco, Venice (started *c.* 1063): plan after Demus; view towards the east end.

161 Palace Chapel, Palermo (by 1143) plan after di Stephano.

162 Martorana Church, Palermo (by 1148) plan after di Stephano.

ever, the sanctuary was roofed rather than domed because of the size of the building. The only fully Byzantine church of Norman Sicily is the Martorana church in Palermo, built by 1143 for Roger's admiral George of Antioch. This is an inscribed-cross although its form has been obscured by a nave added later to its west end to bring it closer to the basilical form of the Western church (fig. 162).[18]

18 O. Demus, *The Church of San Marco in Venice* (Washington DC 1960); for St Sophia, Kiev: Mango, *Architecture*, 324–8; for Sicily: J.A. Hamilton, *Byzantine Architecture and Decoration* (London 1933), 137–45.

Sculpture

Production of new carved ornament for the churches of Constantinople during the eleventh and twelfth centuries appears to have been modest, with much use instead made of material recovered from earlier buildings. In St John in Trullo, for example, the only middle-Byzantine church that has not had its columns and capitals replaced by Ottoman piers, these elements are *spolia*, probably of the late fifth century. New carving was done only for small tapering-block window capitals, decorated in relief with very simple foliage ornament or crosses. Similarly, in the south church of the Pantocrator Monastery, the cornices and window capitals are contemporary with the building but the sanctuary screen was made from sixth-century panels originating in St Polyeuktos. Such combinations of old stones for major elements and new for minor ones was probably general. The Comnene ornament consists of very regular, stylized foliage patterns, cut in low relief and usually of mediocre quality. An exception is the work in the north church of the Pantocrator Monastery, where accomplished hands decorated cornices with an elaborate schematized vine ornament, inhabited by birds of several types (fig. 163); window capitals have foliage ornament of similar style.

163 Part of the upper cornice in the north church of the Pantocrator Monastery, Constantinople (1118–36).

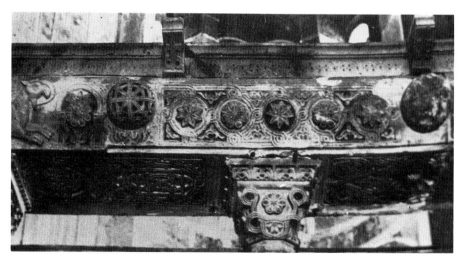

164 Sculpture on the iconostasis of the *katholikon* of Hosios Loukas, Phokis (first half of eleventh century).

High quality carving is found in greater quantity and variety in the churches of the Greek provinces: at Areia, Daphni, St Meletios near Megara and the *katholikon* of Hosios Loukas, for example, where capitals, cornices and in some cases sanctuary screens are decorated with very stylized foliage, sometimes housing animals and birds (fig. 164). Relief panels decorated with stylized birds and beasts are occasionally set into exterior walls, as at Hosios Loukas, for example, and the Panagia Gorgoepikoos in Athens (fig. 165). At the latter, such panels are combined with many others, of various dates, to make friezes all around the building, but this is the exception rather than the rule.[19]

165 Panagia Gorgoepikoos (Little Metropolis) Athens, (twelfth century) west side, showing re-used carved panels.

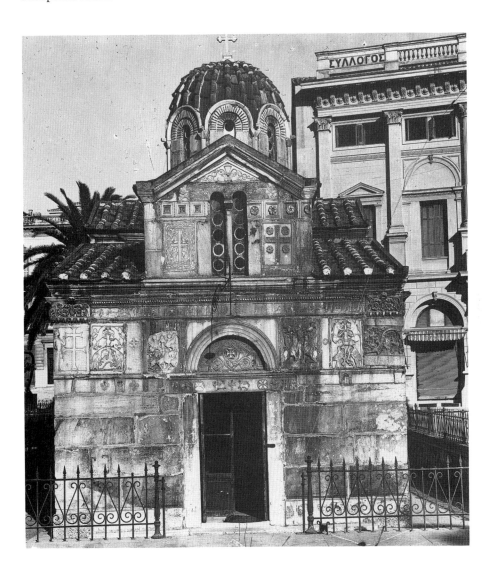

19 Mathews, *Istanbul*, 163–5, 84, 185, 70; Striker & Kuban, 'Kalenderhane', *DOP* 21 (1967) 267–71. For Pantocrator: R.M. Harrison, *Excavation at Saraçhane in Istanbul* (Princeton NJ 1986), 146; A.H.S. Megaw, 'Notes on Recent Work of the Byzantine Institute in Istanbul', *DOP* 17 (1963) 333–71, 345–6.

None of this architectural ornament departs significantly from the traditions of the Macedonian period, which also had decorated cornices, lintels, screens and capitals. Novelty does however appear in another area of the sculptors' art, namely the large-scale figure relief. Marble panels bearing single figures cut in high relief have been found in various locations, including Thessalonike, Athens, south Italy and Constantinople; several in Venice were probably brought from the capital after the sack of 1204. Most of these panels are tall rectangles, one to two metres high, with integral frames and plain grounds. Archangels and saints are sometimes depicted, but the Virgin is the most frequent subject. Some, like a panel of the Virgin and Child, found near Sts Sergius and Bacchus in Constantinople, must have been monumental icons (fig. 166). A panel in Washington, on which a standing figure of the Virgin is inclined to the right, was probably one of a pair of icons placed either side of an apse, the

166 Marble icon of the Virgin and Child, Constantinople eleventh or twelfth century (Istanbul Archaeological Museum).

167 Marble icon or fountain front showing the Virgin orant, found in the Mangana district, Constantinople (late eleventh century?) (Istanbul Archaeological Museum.)

other showing Christ, facing left. Other panels, like one found during excavation of St George of the Mangana, depict the Virgin orant (hands raised, palms outward) and may have been fountain-fronts, emitting water through holes drilled in one or both hands (fig. 167). The figures on these marble reliefs are generally of stocky proportions, with simplified draperies into which are drilled clusters of holes, which probably served to secure ornaments of precious metal. Attribution of the panels to the eleventh or twelfth centuries rests upon their close stylistic similarity to a steatite medallion of the Virgin, in London (Victoria and Albert Museum) which bears an inscription referring to the emperor Nikephoros Botaneiotes (1078–81) who was the last emperor before the usurpation of Alexios.

168 Marble relief of an emperor, Constantinople (eleventh century?) (Istanbul Archaeological Museum).

The large-scale relief was also used for imperial portraits. A relief in the Istanbul Archaeological Museum with a figure (now headless) of an emperor in ceremonial dress was perhaps part of a larger panel showing the emperor crowned by Christ, as in the Moscow ivory of Constantine (fig. 168). Another iconography is found in a marble roundel in Washington, upon which a standing emperor holds an orb and sceptre. This, and a very similar piece in Venice, may have been made in Italy, but they presumably copied a Byzantine model. Neither has an identifying inscription, but they are attributed to the late twelfth century on grounds of iconographical similarity with coins of Isaac II Angelos (1185–95) and his successor Alexios III (1195–1203).

The figure panels bear little resemblance to the figural relief sculpture of the sixth century that represented the tail end of a Roman tradition. Their appearance is likely to be a matter of innovation, therefore, rather than revival. This may well have occurred in the capital, prompted by the increasing numbers of Western merchants there, who are likely to have brought with them a European taste for figure sculpture. They may have brought sculptors too, who could have introduced the skill of figure-carving. The panels look much like ivory carvings writ large, and these may well have been the models that initiated the new tradition. The production of figure panels may have begun as early as the mid-tenth century, since fountains with figures of the Virgin are mentioned in the *Book of Ceremonies* of Constantine VII – but from the number of surviving examples, it seems probable that the form had its greatest development during the Comnene period.[20]

If correctly attributed to the twelfth century, four capitals re-used in the exonarthex of the Palaiologan church of Christ in Chora (Kariye Camii) are evidence that figure reliefs were also sometimes used in other contexts than on panels. The four are tapering-block capitals with half-figure angels on two adjacent faces and bosses of foliage and crosses on

20 R. Lange, *Die byzantinische Reliefikone* (Recklinghausen 1964); Grabar, *Sculptures/Moyen Age*, nos. 37, 35, 20; Fıratlı, *Sculpture*, nos. 131, 365, 77; S. Der Nersessian, 'Two Images of the Virgin in the Dumbarton Oaks Collection', *DOP* 14 (1960) 71–86; H. Pierce and R. Tyler, 'A Byzantine Emperor Roundel', *DOP* 2 (1940) 1–10; *Anatolian Civilisations* 11, nos. C.68, C.97, C.104.

169 Twelfth-century capitals re-used in the fourteenth-century rebuilding of the church of the Chora Monastery, Constantinople.

170 Marble floor (*opus sectile*) in the south church of the Pantocrator Monastery, Constantinople (1118–36).

the other two (fig. 169). (This suggests that they were made for the crossing of a small church, the angels facing inwards, the bosses outwards.) The faces of the angels have been damaged, but as far as it is possible to tell their style resembles that of the large figure panels, and the drapery has similar drilled holes. The capitals may come from one of the Comnene phases of the church, mentioned above, or perhaps from another church altogether.[21]

Some middle-Byzantine floors have ornamental stonework of another kind, known as *opus sectile*. This is inlay-work, using tiles of coloured marble and other stone cut into a variety of shapes. There is a fine example in the south church of the Pantocrator Monastery, in which large square and circular motifs are linked by interlacing borders and surrounded by scrolls of stylized foliage inhabited by human and animal figures (fig. 170). A similar floor is found in the church of the Stoudios Monastery, presumably the result of a middle-Byzantine refurbishment of the fifth-century church. The technique is not new, for it is found in Roman and early Christian contexts, but by the middle-Byzantine period it seems to have overtaken mosaic as a luxurious treatment of floors. The latter technique seems not to have survived the dark age.[22]

Monumental art

With the eleventh and twelfth centuries, middle-Byzantine monumental church art becomes more visible, in the sense that a number of near-complete programmes of decoration survive. There are examples in Greece, Cyprus, Cappadocia and the Balkans, and outside the empire in Sicily and Russia, where work was done, or at least supervised, by Byzantine craftsmen. None of them, however, is in Constantinople, a circumstance that once again raises the problem of reconstructing the monumental art of the capital from scant documentary records and by extrapolation from material in the provinces or beyond.

Much study of the middle-Byzantine church programme has centred upon the only mosaic decorations surviving within the empire, in Hosios Loukas, Nea Mone and Daphni, the three Greek monastery churches mentioned above. Although not precisely dated, these are attributable to the first half, middle and end of the eleventh century respectively. Nea Mone had imperial patrons, Hosios Loukas may have had, and the work in all three is of high quality, likely to represent the best craftsmanship of the day. The decorations of these churches have therefore come to be regarded as examples, or at least close reflections of, an 'ideal' or 'standard' middle-Byzantine church programme created in the capital and subsequently followed throughout the empire. This assessment should not

21 Ø. Hjort, 'The Sculpture of Kariye Camii', *DOP* 33 (1979) 201–89, 237–46.

22 Megaw, 'Notes...Istanbul' (see n.19) 335–40; Mathews, *Istanbul*, 88–9, 154–5.

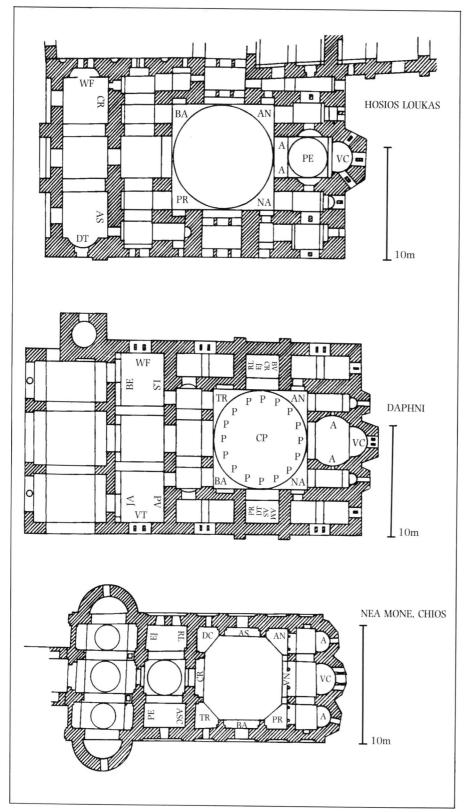

171 Schemes of decoration in middle-Byzantine Greek monastery churches (Hosios Loukas, Daphni, Nea Mone, Chios).

Subjects represented in mosaic

AN	Annunciation
NA	Nativity
AM	Adoration of the Magi
PR	Presentation of Christ in the Temple
BA	Baptism
TR	Transfiguration
RL	Raising of Lazarus
EJ	Entry into Jerusalem
BE	Betrayal
WF	Washing of Feet
LS	Last Supper
CR	Crucifixion
DC	Descent from the Cross
AS	Anastasis (Resurrection)
DT	Doubting of Thomas
PE	Pentecost
ASC	Ascension
CP	Christ Pantocrator
VC	Virgin and Child
A	Archangel
P	Prophet
JA	Joachim and Anna (parents of the Virgin)
BV	Birth of the Virgin
PV	Presentation of the Virgin in the Temple
VT	The Virgin in the Temple
DV	Dormition of the Virgin

In each case, the programme is completed by figures of saints.

172 The Monastery of Hosios Loukas, Phokis (first half of eleventh century): centre bay of the *katholikon* narthex: Christ, the Virgin and angels in mosaic.

stand without qualification, however, for reasons that will emerge below.[23]

In all three Greek monastery churches, mosaic decoration is placed in the vaulting, above walls revetted in marble. The programmes follow the 'hierarchical' scheme seen in the last chapter, which combines formal images of the divine hierarchy (Christ, The Virgin, Prophets, Angels and Saints) with a small number of narrative subjects representing the most important feasts of the church ('festival icons') (fig. 171). Thus, at Hosios Loukas, the programme (some of which has been lost and replaced with painting) consists of Christ Pantocrator and prophets (dome); Virgin (conch of the apse); Pentecost (bema dome); Annunciation, Nativity, Presentation, Baptism (squinches); Christ Washing the Feet of the Disciples, Crucifixion, Anastasis, Doubting of Thomas (narthex lunettes); and saints (minor vaults and arches in both naos and narthex). The entrance bay of the narthex has its own 'hierarchichal' programme, with Christ Pantocrator above the door to the naos, and the Virgin, John the Baptist and Archangels in the vault above (fig. 172). In the crypt below the church, where the saint was buried, painting contemporary with the mosaics includes a Passion cycle that duplicates some of the scenes of the narthex, and was evidently part of a separate funerary programme.[24]

At Nea Mone the arrangement is similar, with Christ Pantocrator and Angels in the dome, apostles below the rim of the dome, eight festival icons in the squinches and niches, and seven scenes of the Passion cycle in the narthex (fig. 173). The central bay of the narthex is again distin-

173 *Katholikon* of Nea Mone, Chios, (*c.* 1042); naos, south side.

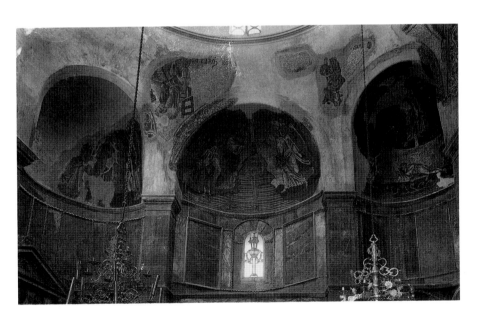

23 O. Demus, *Byzantine Mosaic Decoration* (London 1948) is an important pioneering work in this field, but does not deal with the whole range of middle-Byzantine church decoration.

24 E. Diez, & O. Demus, *Byzantine Mosaics in Greece* (Cambridge MA 1931), 92–3; K.M. Skawran, *The Development of Middle Byzantine Fresco Painting in Greece* (Pretoria 1982), 155.

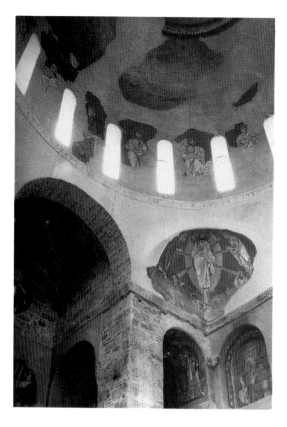

174 *Katholikon* of the Monastery of Daphni, near Athens, interior view to the northwest.

guished, this time by having a figure of the Virgin in its cupola.[25] Below the Pantocrator in the dome at Daphni are sixteen prophets, set between the windows, and thirteen festival icons in the squinches and on areas of wall below the vaults of the cross-arms, two from the Life of the Virgin, the rest from the Life and Passion of Christ (fig. 174). Three more scenes of the Passion cycle are in the north bay of the narthex and three more of the Virgin cycle in the south bay.[26]

The organizational principles of these three programmes are clear enough, and were seen in outline in decorations of the Macedonian period. Formal images of the divine hierarchy occupy vaulting spaces according to rank, with the dome reserved for Christ, angels and prophets. The Virgin is in the conch of the apse, and saints occupy the minor vaults. Festival icons are found in both naos and narthex, in squinches, niches and lunettes. Although some have suggested symbolic reasons for the selection and placing of these narrative images, the basic principles are clearly prosaic ones. The number of festival icons depends upon the available space, and they are placed in narrative order in each section of the church. In the naos they are to be read starting at the east and moving

25 D. Mouriki, *The Mosaics of Nea Moni on Chios* (Athens 1985) 1, 38–9.

26 G. Millet, *Le Monastère de Daphni* (Paris 1899); M. & G. Herbert, *Daphni. A Guide to the Mosaics and their Inscriptions* (Chichester 1978).

clockwise. Narthex images are read either in a complete circuit of the narthex, starting at the north end (Hosios Loukas, Nea Mone) or in separate circuits in the lateral bays, starting on the west wall (Daphni). There was, therefore, a 'middle-Byzantine formula' for church decoration, but its application should not be interpreted as rigid adherence to prescriptive rules governing the choice and placing of images. (Nor should variants of the formula be diagnosed as 'provincial misunderstandings'.) It will be evident from the church decorations surveyed below that the formula was flexible, capable of adjustment to suit the size, architecture and function of each church and the concerns of patrons. Even the three Greek churches are not uniform – Daphni and Nea Mone have more fields available for festival icons than Hosios Loukas and consequently have longer cycles, and Daphni alone has episodes from the Life of the Virgin.

Nor are they uniform in their iconography. For example, the Anastasis at Hosios Loukas has Christ between Solomon and David at the left, and Adam and Eve at the right, emerging from their sarcophagi. At Nea Mone, the two flanking groups are supplemented by other figures in the background, and at Daphni, Adam and Eve join the two Kings at the left, while a group to the right incudes John the Baptist (fig. 175 a–c). At Hosios Loukas there are even iconographical differences in the treatment of subjects that appear both in the mosaics of the church and the paintings of the crypt, which are contemporary and very similar in style. In both Crucifixions, for example, the chief figures are very similar, but in the painting they stand against a background of hills and vegetation, while in the mosaic there is a plain gold ground. Possibly narrative detail was reduced in this (and other) mosaics in order to enhance the gold background and make the image an icon rather than an episode, but the approach was not uniformly adopted. A more fundamental difference is seen in the Doubting of Thomas, where in the mosaic Christ raises his right hand to display his wound, while in the painting of the same scene he grips Thomas' arm to guide him to the wound. The meaning of these variations is still uncertain after much discussion, which may be pursued elsewhere. Suffice it to note here that their existence indicates a flexibility of iconography as well as programme in the decoration of the middle-Byzantine church.[27]

A wider view of the middle-Byzantine church programme than that given by the Greek mosaics may be obtained by taking painted decoration into account. Painting may be combined with mosaic, as it is in Hosios Loukas, but more often appears alone. Where painting is the only medium, programmes tend to be fuller, since painted churches generally lack marble revetments and the painting covers at least the upper parts of the walls. Thus, a group of very small inscribed-cross Cappadocian cave churches which are attributed to the mid-eleventh century (Elmalı Kilise,

27 *Dumbarton Oaks Bibliographies I. Literature on Byzantine Art 1892–1967*, II. 327–429.

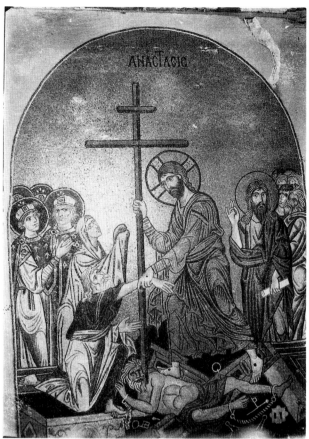

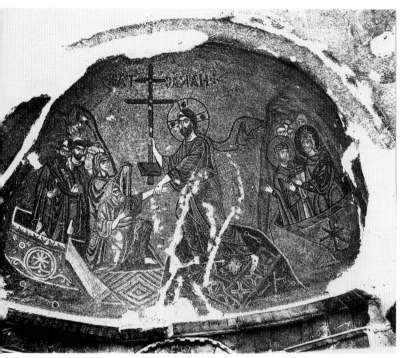

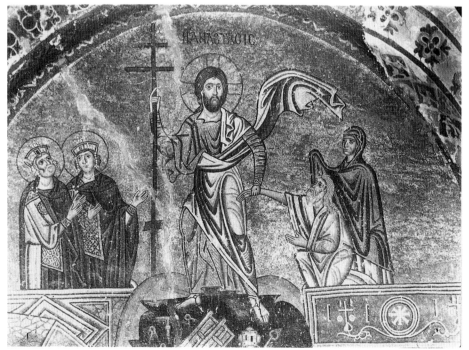

175 Mosaic images of the
Anastasis in eleventh-century
Greek monastery churches:
(a) Nea Mone, Chios;
(b) Daphni, near Athens;
(c) Hosios Loukas, Phokis.

176 (opposite), Elmalı Kilise,
an eleventh-century
Cappadocian cave church:
plan, after Restle; view into
northeast corner; scheme of
painted decoration.

ENTRY INTO JERUSALEM NATIVITY WOMEN AT THE TOMB ← Upper register NORTH WALL

HOSPITALTY OF ABRAHAM ← Lower register

RAISING OF LAZARUS

ARCHANGEL

ADORATION OF THE MAGI

ARCHANGEL

ADORATION OF THE MAGI

ARCHANGEL

ENTOMBMENT *

VIRGIN AND CHILD

LUKE JOHN

ASCENSION

CHRIST PANTOCRATOR

ARCHANGEL

MARK MATTHEW

BAPTISM

ARCHANGEL

WAY OF THE CROSS

ANGELS

BETRAYAL

ARCHANGEL

LAST SUPPER *

ARCHANGEL MICHAEL

DORMITION OF THE VIRGIN ← Lower register SOUTH WALL

ANASTASIS ← Upper register

TRANSFIGURATION CRUCIFIXION

↑ *

East wall

Çarıklı Kilise and Karanlık Kilise) have from twelve to fifteen festival icons each, placed in the cross-arm barrel vaults and upper wall registers (fig. 176 for Elmalı Kilise). The siting of formal images in these churches differs from that in the Greek monastery churches in that Christ enthroned occupies the main apse, instead of the Virgin, who apears in a side apse. This placing of Christ may be a local tradition, since it occurs in many of the Cappadocian cave churches. Other departures from the Greek schemes are seen in the painting of the Panagia Chalkeon in Thessalonike (1028), which has ten festival icons in the cross-arm barrel vaults, but an Ascension in the dome, rather than the Pantocrator. The Virgin and Archangels occupy the conch of the apse, and on the walls below there is also a Divine Liturgy in which two figures of Christ dispense the bread and wine of the eucharist to groups of apostles. This subject, although not present in the Greek mosaic programmes, is a traditional one in Byzantine iconography (seen in the sixth-century Riha and Stuma patens, for example), and it appears to have been widely used in middle-Byzantine monumental art. It is found, for example, in Karabaş Kilise (1060/1), a single-naved chapel in Cappadocia, where it is set below a Deesis in the conch of the apse; a festival icon sequence is placed in the barrel vault of the nave.[28]

The range of middle-Byzantine imagery is broadened further by the mosaic and painting of St Sophia in Kiev, which is likely to be very close to Byzantine models, since Russia had adopted Christianity only in the tenth century and was without a substantial tradition of Christian monumental art of its own. As noted above, the church was built for Yaroslav the Wise, starting *c.* 1037, and the work of decorating it may still have been in progress as the Russian fleet set out to attack Constantinople in 1043. The central naos is decorated in mosaic, with Christ Pantocrator and angels in the dome, evangelists in the pendentives, the orant Virgin in the apse with the Divine Liturgy below (fig. 177). The Annunciation is split, occupying the eastern faces of the northeast and southeast piers, with the angel to the left and the Virgin to the right. The rest of the programme is painted, and includes festival icons in the barrel vaults of the cross-arms, extended into a Passion cycle on the north and south walls. Side apses contain cycles of the Life of the Virgin, St George, St Peter, and the Archangel Michael.

On the walls of the western cross-arm of St Sophia there is a family donor image, showing Christ enthroned between Yaroslav and his sons on one side, and Yaroslav's wife and their daughters on the other (fig. 177). The painting clearly borrows the iconography of Byzantine imperial imagery (recalling, for example, the ninth-century portrait of Basil I and his family in the Imperial Palace) and signals Yaroslav's wish to emulate

28 Restle, *Asia Minor*, nos. XVIII, XXI, XXII, XLVIII;
 Rodley, *Cave Monasteries*, 52–5, 164–7, 196–200;
 Skawran, *Fresco Painting*, (see n.24), 158.

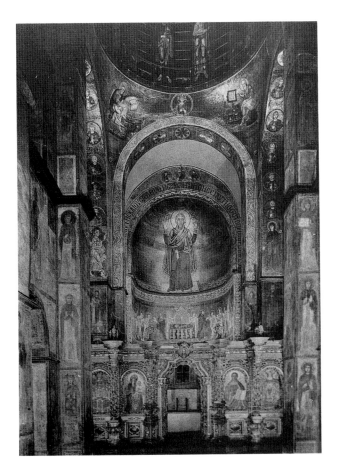

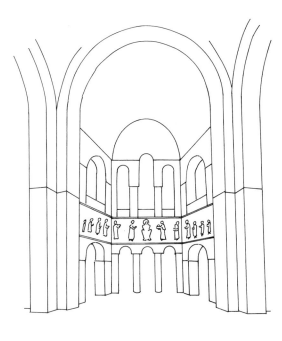

177 St Sophia, Kiev (second quarter of the eleventh century): the apse, with mosaic of the Divine Liturgy; schematic drawing of the donor portrait of Yaroslav and his family on the west wall of the naos (after Lazarev).

the emperor in Constantinople. Similar intent lies behind painting in the two stairwells that give access to the galleries, which consists of scenes of the hippodrome, including one of an emperor watching the games from his box, as well as hunting scenes, musicians and other entertainers. All of these paintings must have been based on Byzantine models, and provide examples of Byzantine imagery otherwise known only from documentary sources.[29]

The painting of the church of St Sophia in Ohrid is also likely to be very close to the Byzantine tradition, since it was probably done in the time of Archbishop Leo (1037–56), the first Byzantine appointee to this post following its establishment as head of the Bulgarian church. (The church itself is a domed basilica of uncertain date – opinions differ as to whether it was built in the late ninth or late tenth century, or, indeed, in the mid-eleventh century, replacing an earlier building.) What is left of the eleventh-century programme follows the 'hierarchical' formula, placing the Virgin in the apse, with the Divine Liturgy below on the apse wall, and

29 V. Lazarev, *Old Russian Murals and Mosaics* (London 1966), 236; A. Grabar, 'Les Fresques des escaliers à Sainte-Sophie de Kiev et l'iconographie impériale byzantine', *Seminarium Kondakov* 7 (1935) 103–17; for another family donor portrait, in Selime Monastery, Cappadocia: Rodley, *Cave Monasteries*, 71–2.

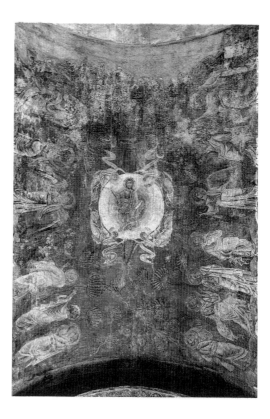

178 Painting of the Ascension in the bema vault, St Sophia, Ohrid (mid-eleventh century).

an Ascension in the barrel vault in front of the apse (fig. 178). Below this are Old Testament subjects, including the Sacrifice of Isaac, Jacob's Ladder and the Three Hebrews in the Furnace. A John the Baptist cycle and scenes of the martyrdoms of apostles in the east end of the south aisle are likely to belong to the eleventh-century programme, as is an image of the Forty Martyrs of Sebaste in the east end of the north aisle.[30]

The eleventh-century mosaics and paintings noted above vary in style – in some cases, such as St Sophia in Kiev, more than one style is present, indicating that more than one artist was at work, as is likely to be the case in a large building. A general stylistic range is nevertheless definable, from the restrained lines and compact figures of Hosios Loukas, Nea Mone and St Sophia in Kiev, to a more flowing line and 'expressive' treatment of facial features in Daphni, the Panagia Chalkeon and St Sophia in Ohrid. This 'expressive' style gains ground in the twelfth century, where it is seen in church paintings in Cyprus and the Balkans, and in the mosaics of Norman Sicily.[31]

Cyprus had close links with Constantinople in the twelfth century, when the Komnenoi found it a convenient staging post from which to involve themselves in Crusader operations in the Holy Land. Painting of

30 B.M. Schellewald, *Die Architektur der Sophienkirche in Ohrid* (Bonn 1986).

31 D. Mouriki, 'Stylistic Trends in Monumental Painting of Greece During the Eleventh and Twelfth Centuries', *DOP* 34/5 (1980/1) 77–124.

high quality, found in small churches of very modest construction, suggests that the painters were 'imported' by some of the Byzantine generals and others based on the island. The 'expressive' style is evident in the church of the Panagia Phobiotissa in Asinou, which is a single-naved barrel-vaulted church with an inscription recording that it was built and decorated for the *Magistros* Nikephoros, and finished in 1105/6. In a panel in the nave above the side entrance, the Virgin presents Nikephoros, who carries a model of the church, to Christ enthroned. Behind Nikephoros is a small figure of his first wife, who had died a few years earlier (he later married a daughter of Alexios I). Part of the programme has been obscured by sixteenth-century repainting, but it seems to have consisted of the Virgin and Archangels in the apse, with the Divine Liturgy below, a festival icon sequence that included episodes from the Life of the Virgin, and a Passion cycle. The 'expressive' style is much more developed at the small domed hall church of the Panagia of Arakos, in Lagoudera, which was painted in 1192 for an aristocratic patron named Leo. Here, elongated figures with dramatic expressions are clad in draperies that coil and bunch in serpentine forms, a style sometimes described as 'mannerist' (fig. 179). The style is also present in some of the paintings of the Hermitage of

179 Painting of the angel Gabriel from the Annunciation, northeast pendentive of the Panagia Church, Lagoudera, Cyprus (1192).

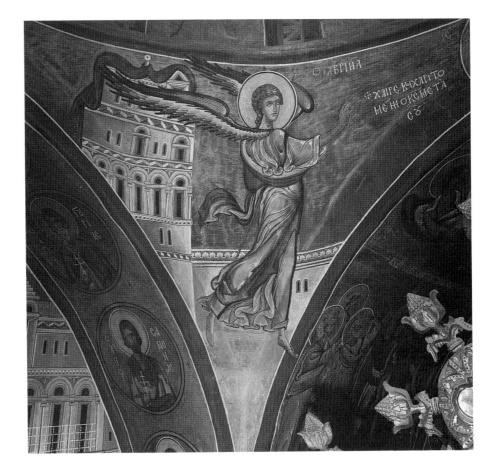

St Neophytos, a rather tiresome, attention-seeking ascetic who carved a chapel and cell for himself in a cliff face near Paphos. The decoration was done by several painters, the best of them signed by one Theodore Apseudes and dated to 1182/3. The programme omits most of the festival icons, but has an extensive Passion cycle of eleven episodes, plus the Ascension, to which is appended a highly idiosyncratic image of Neophytos himself lifted heavenwards by angels (fig. 180). The choice of

180 Painting of the ascent to heaven of the hermit Neophytos, assisted by angels, in the Hermitage of St Neophytos, Paphos, Cyprus (1182/3).

subjects here depends partly on the dedication of the chapel to the Holy Cross, of which Neophytos had obtained a relic, and partly on the hermit's sense of his own importance.[32]

Paintings in churches in the Balkans show a parallel development of the 'expressive' style. The small inscribed-cross church of St Panteleimon at Nerezi was commissioned by a Byzantine aristocrat Alexios, son of Constantine Angelos and his wife Theodora, who was a daughter of Alexios I Komnenos. An inscription over the door gives a date of 1164. Here the programme includes about twenty narrative subjects (there are areas of loss), at least half of them forming a Passion cycle, the rest festival

32 A.H.S. Megaw, 'Twelfth-century Frescoes in Cyprus', *Actes du XIIe Congrès International des Etudes Byzantines. Ohrid 1961* (Belgrade 1964), 257–66; C. Mango and E.J.W. Hawkins, 'The Hermitage of St. Neophytos and its Wall Paintings', *DOP* 20 (1966) 119–206; C. Galatariotou, *The Making of a Saint. The Life, Times and Sanctification of Neophytos the Recluse* (Cambridge 1991).

181 Painting in the Church of St Panteleimon, Nerezi, former Yugoslavia (1164). The Lamentation.

icons, including the Ascension and the Birth and Death of the Virgin (fig. 181). The narthex contains a fragmentary St Panteleimon cycle. The 'mannerist' development of the style, seen in Lagoudera, is closely paralleled in the paintings of St George, Kurbinovo, south of Ohrid, which is attributed to the late twelfth century for this reason.[33]

Several programmes of twelfth-century mosaic decoration are found in Sicily, where a Norman kingdom had been established in the first quarter of the twelfth century under Roger II. The circumstances that brought Byzantine craftsmen to the island are unknown, but commercial contracts are perhaps the most likely. Roger II used Sicily as a base from which to attack Byzantine territory in Greece, so was not likely to have been sent his mosaicists as a diplomatic courtesy. In Sicily the position was rather different from that obtaining in Russia, since Christianity had long been established in the West. Although there was some assimilation of Byzantine church form, as noted above, it was Western architecture that predominated. Byzantine mosaicists therefore had to adapt their schemes to decorate buildings of unaccustomed form – only the inscribed-cross Martorana, in Palermo, built for the admiral George of Antioch, would have been wholly familiar. Unsurprisingly, therefore, its programme, probably complete by 1148, follows the Byzantine formula, with Christ, Angels and prophets in the dome, four evangelists in the pendentives, and four festival icons in the arches around the dome (the original decoration of the apse is lost).[34] There are also two donor images in the Byzantine manner. One shows George of Antioch prostrate before the Virgin, the other Roger

33 R. Hamman-MacLean & H. Hallensleben, *Die Monumentalmalerei in Serbien und Makedonien* (Giessen 1963–76), I, 7–19, pls. 29–45.

34 O. Demus, *The Mosaics of Norman Sicily* (London 1949), 78–82; E. Kitzinger, *The Mosaics of St. Mary's of the Admiral in Palermo* (Washington DC 1990).

182 Mosaic image of Christ with Roger II, in the Martorana church, Palermo, Sicily (by 1148).

II, in the ceremonial costume of a Byzantine emperor, crowned by Christ – an iconography of which Constantinople would hardly have approved (fig. 182).

The Palace Chapel of Roger II, also in Palermo, built by 1143, combines an inscribed-cross east end with a basilical west end (fig. 161). Much of the decoration of the east end conforms to the familiar pattern, with Pantocrator and Angels in the dome and evangelists, prophets and festival icons below, on arches, vaults and the end walls of the transept. The mosaic extends into three registers on the transept walls, providing space for some expansion of the festival icon cycle. The Pantocrator reappears in the conch of the apse, with the Virgin below (now replaced in paint) (fig. 183). This apse programme, seen also at Norman churches in Cefalù (1143) and Monreale (1183), has been seen as a corruption of the Byzantine standard, since its Pantocrator duplicates the image in the dome. More probably, it responds to the large size of the Sicilian apses, which permitted depiction of a complete holy hierarchy rather than just one figure. Repetition of iconography was in any case not avoided even in the Greek churches – at Hosios Loukas the Pantocrator appears over the naos entrance as well as in the dome.

The style of the Palermo mosaics is thoroughly within Byzantine tradition, having similarities with the mosaics of Daphni and the paintings of

183 Mosaic decoration of the Palace Chapel, Palermo, Sicily (c. 1143) (heavily restored), view towards the sanctuary.

St Sophia in Ohrid. Close dependence upon Byzantine tradition is also indicated by the Greek inscriptions which identify all the images of the Martorana, and of the Palace Chapel east end, where they are supplemented by a Latin gloss. In the basilical west end of the Palace Chapel, however, which was probably not completed until the 1160s, long narrative cycles are inscribed in Latin alone, and may have depended on Western models. The cycles illustrate the Lives of St Peter and St Paul (in north and south aisles respectively) and the Old Testament, from the Creation to the story of Jacob. A western origin is particularly likely for the latter, since while single Old Testament episodes occasionally appear in Byzantine monumental art, there is no evidence for long cycles.[35]

The church at Monreale, founded in 1174 and probably complete by about 1183, was the commission of William II, the third of the Norman kings. Its programme was probably based on that of the Palace Chapel, consisting of New and Old Testament cycles and the Lives of Sts Peter and Paul. The building lacks vaulting, however, so the festival icons are absorbed into the New Testament narrative of the south aisle of the east

35 Demus, *Sicily* (see n.34) 37–46; E. Kitzinger, 'The Mosaics of the Capella Palatina in Palermo', *AB* 31 (1949) 269–92.

end. Monreale is much larger than the Palace Chapel and the mosaic
decoration covers the walls, like opulent wallpaper (fig. 184). The cycles
had to be stretched to fill the space – a single episode of 'Rebecca's
Journey' at the Palace Chapel becomes two at Monreale, with 'Rebecca at
the Well' in one panel and 'Rebecca's Journey' in the next.[36]

Since there is no documentary record of the installation of the
Sicilian mosaics, the practical aspect of the work must be a matter of spec-
ulation. Work probably began around 1140 and continued episodically for
at least forty-five years. Although requiring many hands, most could have
been semi-skilled and it is possible that just a few Byzantine masters were
involved. They may have arrived at the start of each major phase of work,
gathering about them local craftsmen, some of whom would acquire their

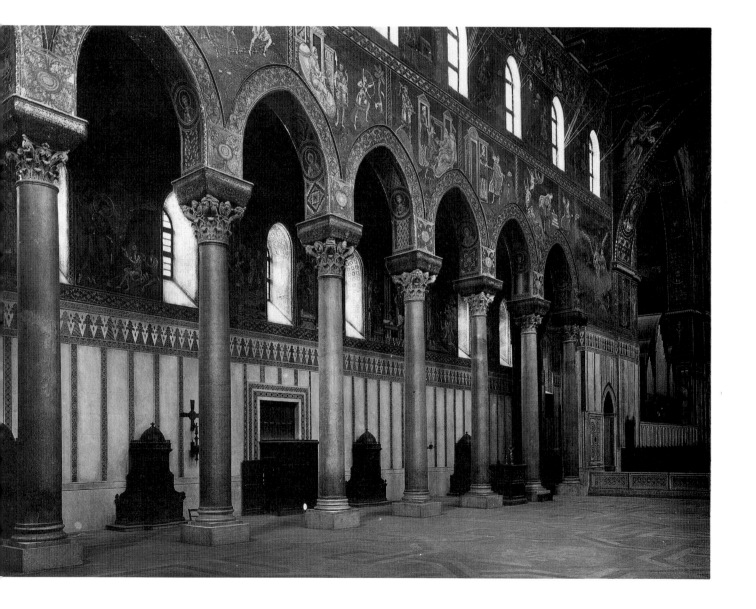

expertise. The last mosaic programme, at Monreale, has only a few Greek inscriptions, in the sanctuary, which may imply that by this time most of the work was in the hands of local workshops. Even at this stage, however, there appears to have been some direction from Byzantine masters, since the style of the Monreale mosaics is paralleled in the 'mannerist' paintings of churches of similar date in the Balkans and Cyprus.

The work of twelfth-century Byzantine craftsmen is also found in north Italy, in the Cathedral of Torcello and in San Marco in Venice, much restored in each case. In the main apse at Torcello a standing figure of Virgin and Child is set against a plain gold ground, following the tradition seen in the Dormition Church in Nicaea and St Sophia in Kiev. The mosaic is attributed to the late twelfth century, and a row of apostles below, on the apse wall, may belong to an earlier twelfth-century phase. The surviving mosaic at San Marco is much more extensive, covering the five domes of the church (fig. 160), the upper parts of the walls and the narthex. It is the result of work done in several phases from the early twelfth century onwards, including that of restorers active from the mid-fifteenth century to the present. In such circumstances definition of the original programme is difficult, but it seems to have followed Byzantine tradition, combining images of the 'holy hierarchy' with narrative subjects. As in the Sicilian churches, the latter are expanded to cover the many fields available in so large a church. Cycles of the Ministry of Christ, and the Life of the Virgin, were probably added in the thirteenth century.[37]

What little is known from documentary records of the monumental art of Constantinople is in general accord with the conventions which emerge from the material evidence of the provinces and areas receiving Byzantine 'exports' surveyed above. A Spanish ambassador's fifteenth-century account of St George of the Mangana (the mid-eleventh century church for which Constantine IX was accused of extravagance) notes a Christ Pantocrator in the dome and the Pentecost above the entrance. These were presumably part of a larger programme, since Michael Psellus, a contemporary of Constantine IX, says the church had extensive mosaic decoration. A twelfth-century *ekphrasis* by Nikolaos Mesarites on the church of the Holy Apostles describes much narrative imagery, but probably refers largely to the decoration described two centuries earlier by Constantine Rhodios. Some features are new, however: the Ascension of the dome had been replaced by an image of Christ Pantocrator, and narrative subjects not mentioned by Rhodios are included, such as the Women at the Tomb, the Disciples on Lake Galilee and several scenes of the ministry of the Apostles. While some of these may belong to earlier work simply not mentioned by Rhodios, some were certainly done in Mesarites' own time. The Women at the Tomb contained a portrait of the artist, one

184 Mosaic decoration in the Abbey Church at Monreale, Sicily (by 1183); view of the nave towards the northeast.

36 E. Kitzinger, *The Mosaics of Monreale* (Palermo 1960).
37 Beckwith, *ECBA*, 132–3; O. Demus, *The Mosaics of San Marco in Venice*, I–IV (Chicago 1984).

Eulalios, who is described in terms suggesting that he was Mesarites' contemporary. Many other churches in the capital must also have had composite programmes, resulting from the episodic refurbishment of important monuments.[38]

The only surviving eleventh and twelfth-century mosaics in the capital are two panels in the south gallery of St Sophia, a part of the church

185 Mosaic panels in the south gallery of St Sophia, Constantinople.
(a) Christ flanked by the empress Zoe and Constantine IX Monomachos (after 1028 with later adjustments).

set aside for the use of the imperial family (see fig. 116 b for locations). (According to Anthony of Novgorod, who visited the church in 1200, this area once contained many images of imperial persons and patriarchs, most of which would have been portable panel-paintings and are therefore lost.) The mosaic panels are applied to the east wall and form a pair, even though they are some ninety years apart in date. The earlier of the two, to the left, shows Christ enthroned, with Constantine IX Monomachos, who presents a money-bag, and the Empress Zoe, the last of the Macedonian line, who presents a scroll (fig. 185 a). The image probably represents an annual ceremony at which the reigning imperial couple gave money and land to the church. The head and name-inscription of the emperor have

38 Psellus, *Chronographia*, VI, 185f. trans. Sewter (see n.1) 250–2; G. Downey, 'Nikolaos Mesarites: Description of the Church of the Holy Apostles at Constantinople', *Transactions of the American Philosophical Society* n.s. XLVII/6 (1957) 857–924, extract in Mango, *Sources*, 232–3.

been changed at least once, and perhaps twice, to cope with Zoe's changes of husband, so the panel was probably made shortly after Zoe's accession in 1028. The heads of Zoe and Christ have also been changed, a curiosity for which there is as yet no adequate explanation. The second panel, to the right, shows John II Komnenos and his empress Eirene, also presenting a money-bag and scroll, this time to the Virgin (fig. 185 b). Their son

185 (b) Virgin and Child flanked by John II Komnenos, and empress Eirene; their son Alexios is to the right.

Alexios II is placed at right-angles to his mother, on the north face of a pier jutting from the wall.[39] This Comnene panel, made between 1118–22, was evidently intended to complement the first, in order to show the Komnenoi as proper successors to the Macedonian dynasty, of which Zoe was the last representative. (The awkward placing of Alexios must have come about because to serve this purpose the panel had to be sited next to the earlier one, and have figures of approximately the same proportions. This left no room for Alexios in the main field, which is limited by the projecting pier.)

Many other Comnene imperial images are known from documentary accounts of mosaics and paintings in several churches and monasteries, in

39 T. Whittemore, *The Mosaics of Hagia Sophia at Istanbul. Third Preliminary Report. The Imperial Portraits of the South Gallery* (Boston MA 1942).

both the Imperial and Blachernae Palaces, in private houses and other, unspecified, locations. These images showed the Komnenoi in a variety of contexts, singly or in groups. In one of the palaces – it is not clear which – one image depicted Alexios I observing, or perhaps as part of, a Last Judgement. Another showed him victorious over the Normans, Pechenegs and Turks, while a third showed the dead emperor mourned by his son John II. Manuel I, the next in line, is said to have been represented many times – in triumph, securing captives, founding cities. A picture of Manuel crowned by the Virgin was set up on the gate of the house of the Sebastos Andronikos, so that this aristocrat might praise the emperor. These and other imperial images evidently continue the tradition seen in the Macedonian period. It is uncertain whether there were more of them during the Comnene period, or whether there are simply more surviving records of them (many of the above examples are known from a single collection of inscriptions referring to Manuel I). It certainly seems, however, that the Komnenoi were eager to stress the validity of their position. In the Monastery of Mokios, which was restored by Manuel I, successive patrons represented included not only the Komnenoi Alexios I, John II and Manuel, but also Basil II, of the Macedonian dynasty. This imagery, like the placing of the John panel in St Sophia, insists upon the rightness of Comnene succession.[40]

Minor arts

The conservative nature of the minor arts continues to be evident in Byzantine objects of the eleventh and twelfth centuries, many of which differ little in their forms, techniques and even style from those of the Macedonian period. This observation may be justified by consideration of an ivory panel in Paris, upon which Christ crowns an emperor Romanos and an empress Eudokia (fig. 186). The emperor was initially identified as Romanos IV (1068–71), the only Romanos married to a Eudokia during his reign. The closest available parallels for the panel seemed however to be the tenth-century objects with imperial imagery seen in the last chapter: the sceptre of Leo, the Moscow Constantine panel and the Paris Otto and Theophano panel. The Romanos panel was therefore reassigned to Romanos II, who in 945, at the age of six and already betrothed to a four-year-old Eudokia, became co-emperor with his father Constantine VII. This Eudokia died when she was eight, so the panel was dated 945–9 and it was inferred both that 'coronation' imagery was used for co-emperors (Romanos did not become sole emperor until 959) and that in imperial

186 Ivory panel showing Romanos IV and Eudokia (1068–71) (Paris, Bibliothèque Nationale).

40 P. Magdalino & R. Nelson, 'The Emperor in Byzantine Art of the Twelfth Century', *Byzantinische Forschungen* 8 (1982) 123–83; for the collection of epigrams praising Manuel Komnenos: S. Lambros 'O Markianos Kodix 524', *Neos Helenomnemon* 8 (1911) 3–59, 113–192 (some translated in Mango, *Sources*, 226–9); for Eulalios, *ibid.*, 229–33.

images adult figures might be used to represent children. Although not implausible, this analysis clearly requires special pleading, a fact which, together with further study of the inscription on the Romanos panel, has caused opinion to shift back to Romanos IV as the more likely subject. This brings with it the implication that mid-tenth-century forms were still in use over a century later. The move affects not only the Romanos panel itself, but all those ivories grouped with it stylistically. Tenth-century attribution of these had given the impression that the tenth century was a period of high productivity of ivories, followed by a decline, since so few pieces were placed in the eleventh and twelfth centuries. The later dating of the 'Romanos group' now spreads ivory production more evenly across the middle-Byzantine period – and has caused properly cautious compilers of catalogues to list many pieces as 'tenth–twelfth century'.[41]

Conservatism was not confined to imperial panels. The group of ivories very similar in style to the Romanos panel includes several which have forms familiar from tenth-century work. The Harbaville triptych in Paris, for example (fig. 187), has much the same form as the triptych in

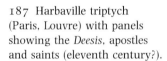

187 Harbaville triptych (Paris, Louvre) with panels showing the *Deesis*, apostles and saints (eleventh century?).

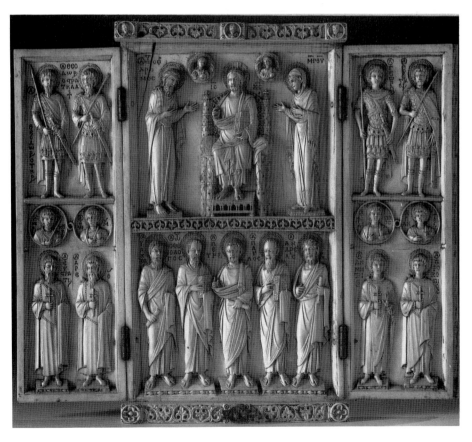

41 I. Kalavrezou-Maxeiner, 'Eudokia Makrembolitissa and the Romanos Ivory', *DOP* 31 (1977) 307–25.

Rome (considered in the last chapter) which is attributed to the tenth century because its inscription probably refers to Constantine VII. Like it, the Harbaville has a centre panel of two registers with a Deesis above and five apostles below. On the wings there are pairs of military saints in the upper registers and martyrs below. The two triptychs are different in style, however, since the Rome triptych has stocky, rounded figures while those of the Harbaville are tall and thin, with a linear, almost pleated treatment of draperies. (When both pieces were thought to be tenth-century work, this difference of style was explained by assuming that contemporary workshops had different styles, a plausible analysis, even if not applicable here.)

The diptych with narrative subjects, of even longer tradition, is also represented in the Romanos group, by a piece now split between Hannover and Dresden. One panel has the Crucifixion and Deposition, the other Christ appearing to the Women at the Tomb and the Anastasis (fig. 188). 'Rosette' caskets seem also to have continued in production: an example in Florence has rosette borders virtually indistinguishable from those of the tenth-century Veroli Casket and its ilk, but its panels containing busts of Christ and the Virgin, saints and apostles, are carved in the linear style of the Romanos group (fig. 189).

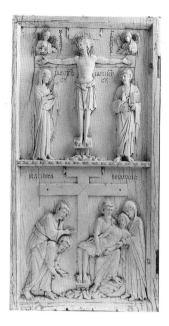

188 One leaf of an ivory diptych (eleventh century?): the Crucifixion and Deposition (Hannover, Kestner Museum).

189 Ivory panels from a casket (eleventh century?) with figures of Christ, the Virgin and saints (Florence, Museo Nationale del Bargello).

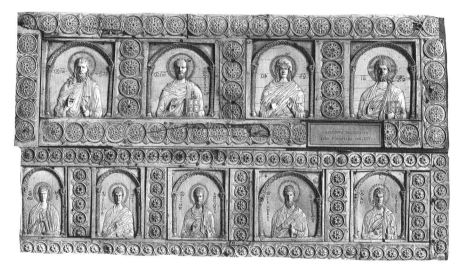

The Romanos group also includes two triptychs of the Crucifixion, one in Paris and the other in London, which demonstrate the same flexible treatment of standard formulae as is found in monumental art. Each has the Crucifixion in its central panel and saints on the wings, but the selection of saints is different, and they appear as bust-medallions in the Paris triptych and as standing figures in the London one (fig. 190). The two images of the Crucifixion are very similar in most respects, but the Paris triptych has small figures of Constantine and Helena flanking the cross and inscriptions above and below, details lacking in the London piece. It would seem that, as in the case of church decorations, modification of

191 Ivory panel showing the Virgin Hodegetria (eleventh century?) (Utrecht, Rijksmuseum het Catharijneconvent).

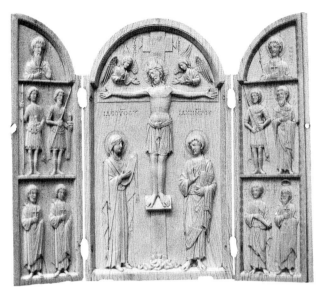
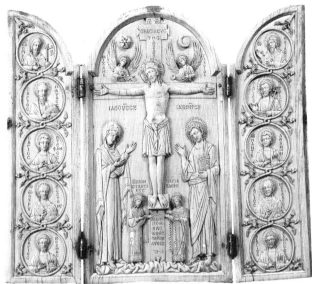

190 Ivory triptychs with the Crucifixion and saints (eleventh century?).
Left: London, British Museum; right: Paris, Bibliothèque Nationale, Cabinet de Medailles.

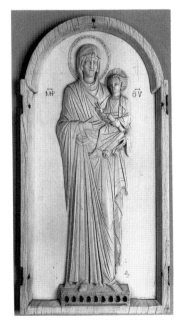

basic types was introduced by the requirements of individual patrons.

Several ivory panels bearing standing figures of the Virgin and Child against a plain ground are assigned to the eleventh/twelfth centuries. Two of them (in Utrecht and Liège) are in the Romanos style, and all of them resemble, on a smaller scale, the monumental marble icons discussed above, even reproducing the decorative clusters of drilled holes on the draperies (fig. 191). The backgrounds of some ivory panels of this sort have been cut away to leave the figures free-standing, presumably to meet the taste of post-Byzantine collectors for figurines rather than panels. One exceptionally large free-standing figure of the Virgin (32.5cm high, in London) does seem to have been made in the round, however (fig. 192). In the absence of an earlier tradition of free-standing religious sculpture in Byzantine art, this rare example may indicate some assimilation of Western forms, such as was suggested above for the monumental icons. Indeed, it has been suggested that the piece is Italian, but its proximity to the other figures of Virgin and Child discussed here makes it more likely that it was the commission of a Western patron resident in Constantinople. The unusual nature of the piece is confirmed by the fact that the craftsman, lacking a background in which to carve the customary identifying inscriptions, has cut them rather awkwardly into the draperies of the figures.[42]

Imperial imagery like that of the Romanos and Eudokia ivory is found also in metalwork of the eleventh century, for which there is firmer chronological anchorage. A crown now in Budapest, known as the Crown of Constantine IX Monomachos, survives as a group of seven shield-

42 G/W BE, I, no. 99, II, nos. 33, 38–41; *Splendeur de Byzance*, 99–103, 120. M.H. Longhurst, *Victoria and Albert Museum: Catalogue of Carvings in Ivory* (London 1927), 41.

shaped enamelled panels without their mounting (fig. 193). (A pair of circular medallions decorated with busts of Saints Peter and Paul which are sometimes associated with the crown, are of a different technique and probably come from another object.) The seven panels are of four sizes, and bear one figure each: of Constantine IX (the largest panel), empresses Zoe and Theodora, two dancing girls and female personifications of Truth and Humility. The imperial figures and dancing girls are set against bird-inhabited scroll-foliage, a feature which, with the dress and posture of the dancing girls, finds its closest parallels in Islamic art. The crown further indicates, therefore, the Byzantine assimilation of Islamic motifs and forms seen already in the use of 'kufic' ornament and the building of the Mouchroutas at the Imperial Palace. The imperial figures provide a date between 1042–50, when all three reigned, but the crown was probably not that of Constantine IX himself, since the panels cannot be reconstructed as a crown of the sort that he wears in the 'Zoe' panel in the south gallery of St Sophia. The panels are most easily reassembled as a band, with Constantine at the centre and an empress, dancing girl and personification at each side – two examples of this form survive intact in Kiev, though not with imperial figures. The dancers and female personifications suggest association with one of the empresses, but again, the single band of panels is not the form of Zoe's crown in the St Sophia panel. The empresses may, of course, have had crowns of different forms for different occasions, but a plausible alternative explanation is that the crown was an imperial gift to a political ally. Indeed, tradition has it that it was sent to King Andrew of Hungary (1046–61), and although generally discredited, something similar may have been the case. Some such transaction probably accounts also for the enamelled plaque showing Christ crowning Michael VII Doukas (1071–8) and his empress Maria, which is set into the Georgian Khakhouli triptych in Tbilisi. This is mostly of twelfth-century Georgian work, but incorporates some Byzantine enamels of the tenth–twelfth centuries (fig. 194). Maria was a Georgian princess, and the panel probably originated in an object that was part of the customary exchange of luxury goods that took place when marriages cemented political alliances.[43]

A second crown in Budapest (the Holy Crown of Hungary) seems also to have been an imperial gift from Michael VII, to Geza I of Hungary (1074–7) (fig. 195). There is again no documentary record of the gift, but historical circumstances and the iconography of the crown make it very likely. In its present state the crown consists of a Byzantine diadem surmounted by curved bands which may have originated as part of a Western book-cover. The diadem is a band of uniform width, rimmed with

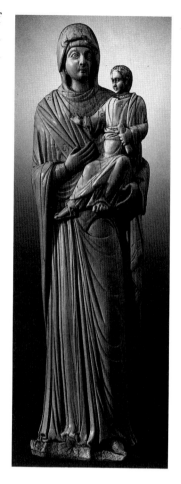

192 Ivory statuette of the Virgin Hodegetria (twelfth century?) (London, Victoria and Albert Museum).

195 (opposite), 'Holy Crown of Hungary', incorporating material of various dates, including Byzantine enamels of Michael VII (1072–8) and Geza I of Hungary (1074–7) (Budapest, Magyar Nemzeti Múzeum): detail of front, with enamel of Christ Pantocrator; drawing: front and back.

43 M. Barany-Oberschall, *The Crown of the Emperor Constantine Monomachos* (Budapest 1937); A. Grabar, 'Le Succès des arts orientaux à la cour byzantine sous les Macédoniens', *MünchJb* 2 (1951) 32–60, 45. For the Khakhouli triptych: A. Javakhishvili & C. Abramishvili, *Jewellery and Metalwork in the Museums of Georgia* (Leningrad 1986), 165–75.

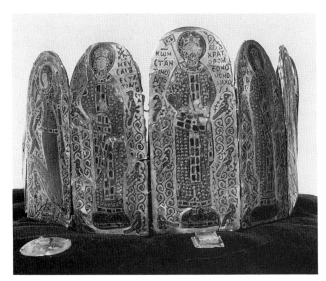
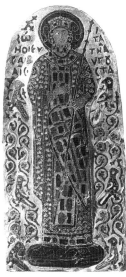
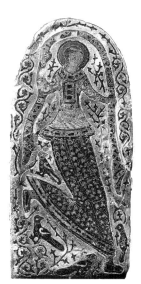

193 Enamelled panels from a crown, showing Constantine IX (1042–54), Theodora and Zoe (Budapest, Magyar Nemzeti Múzeum): the panels assembled as a diadem; Zoe; dancing girl.

194 The Khakhouli Triptych (Tbilisi, Georgia): part of the central panel; detail of enamelled plaque showing Michael VII Doukas (1071–8) and Maria.

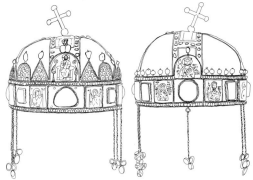

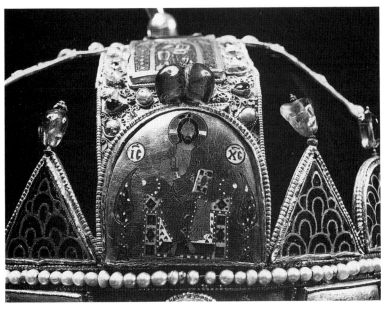

strung pearls and ornamented with alternating polished gemstones (cabo-chons) and square enamelled panels, thus differing little in form from the votive crown of Leo VI (886–912). Two shield-shaped enamels project from the upper rim, one of them bearing a figure of Michael VII; flanking plaques on the band below show Geza I and Michael's son Constantine. Christ Pantocrator occupies the second projecting plaque and other enam-els on the band have busts of saints and archangels. Transparent enamel 'fish-scale' projections on the upper rim of the diadem, and jewels hanging from the lower rim, are additions of uncertain date. The enamels are brightly coloured and make much use of 'arrow-head' shapes to decorate draperies, a feature found also on the enamels of the Monomachos crown and the Khakhouli triptych.[44]

Imperial imagery appears also on a unique Byzantine silk in Bamberg, preserved in the tomb of bishop Gunther (fig. 196). This is a wall-hanging showing a triumphant emperor, on horseback and holding a standard, flanked by female figures who present a crown and a crested

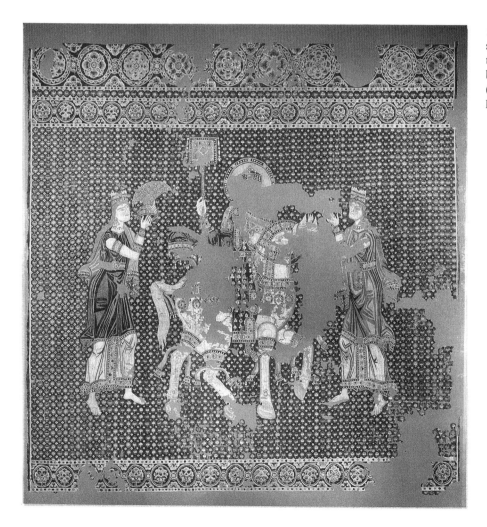

196 Silk wall-hanging showing an emperor in triumph, found in the tomb of bishop Gunther of Bamberg (d. 1065) (Diözesan Museum, Bamberg).

helmet. There is no inscription to identify the emperor, whose face is lost in an area of damage. Bishop Gunther died in 1065, on his way back from Constantinople, where he presumably acquired the cloth, and at which time the throne was occupied by Constantine X Doukas. Constantine was not a military emperor, however, and is unlikely to be the subject. The silk may represent one of the heroized soldier emperors of the past, like Justinian, or simply the concept of imperial triumph. More familiar Byzantine textiles were also still making their way to the West. A silk in Liège, added to the shrine of St Lambert in 1142, has the traditional pattern of interlaced circles, this time enclosing paired animals so schematic that their species is uncertain (horses, perhaps) (fig. 197).[45]

Several examples of the silver cross with splayed arms, of long tradition, are usually assigned to the eleventh century. The crosses have on their faces embossed medallions of Christ, the Virgin, saints and angels, and on the reverse nielloed figures or narrative subjects. The chronological 'anchor' claimed for this group is a fragmentary example in Washington

197 Byzantine silk found in the shrine of St Lambert (Liège, Musée d'Art Religieux et d'Art Mosan).

in which the nielloed images show the Archangel Michael saving the church at Chonae from a flood, Constantine the Great bowing before icons of Sts Peter and Paul held by Pope Sylvester, and the Archangel Michael appearing to Joshua before Jericho (fig. 198). It has been proposed that the cross was made for the Patriarch Michael Keroularios, and that this unusual group of subjects refers to political and theological events in which he took part, notably the schism of 1054 and the usurpation of

44 P.J. Kelleher, *The Holy Crown of Hungary* (Rome 1951).
45 A. Grabar, 'La Soie byzantine de l'éveque Gunther à la Cathédrale de Bamberg', *MünchJb* 7 (1954) 7–25.

198 Fragments of a silver cross with nielloed images: the Archangel Michael saving the church at Chonae, Constantine I venerating icons, the Archangel appearing to Joshua, eleventh century (Washington DC, Dumbarton Oaks Collection no. 79).

199 Silver-gilt cross with nielloed images: the Crucifixion, Annunciation, Virgin and Child, Presentation of the Virgin, Virgin in the Temple Fed by Angels, the donor Kosmas (eleventh or twelfth century) (Paris, Musée de Cluny).

Isaac Komnenos in 1057. The attribution has been questioned, however, and a simpler explanation offered for the iconography. Crosses of this type were probably gifts to churches or monasteries, the selection of subjects in each case determined by the affiliations of the institution concerned and/or of the donor. A complete example now in Paris, with nielloed images of the Crucifixion, Annunciation, Virgin and Child, Presentation of the Virgin and the Virgin in the Temple Fed by an Angel, was probably made for a monastery dedicated to the Virgin, and was commissioned by a monk, Kosmas, who is shown kneeling at the foot of the cross (fig. 199). Removal of the 'Keroularios' association leaves only the style of the figures as evidence of production in the eleventh or twelfth centuries.[46]

Traditional form is also followed by two cross-reliquaries made for Comnene ladies in the first quarter of the twelfth century. Both are wooden Latin crosses with sliver-gilt backing and arm-ends, one, in Venice, was made for Eirene Doukas, the wife of Alexios I, the other, in Audenarde, for Eirene's daughter Maria, younger sister of Anna Komnena the historian. Both pieces resemble the chief relic of the tenth-century Limburg Reliquary, which may well have been the model, and like it, they too were probably once housed in the cross-shaped cavities of elaborate outer casings. Surviving box-reliquaries of this type include one at Esztergom in Hungary, which has enamels depicting the Way of the Cross and the Deposition, two angels and Constantine and Helena (fig. 200). The reliquary is attributed by a seventeenth-century source to 1190,

46 R.J.H. Jenkins, & E. Kitzinger, 'A Cross of the Patriarch
 Michael Cerularius', *DOP* 21 (1967) 235–49.

200 Reliquary of the True Cross, silver and enamel (1190) (Keresztény Múzeum, Esztergom).

201 Silver-gilt reliquary for the hand of St Marina (Venice, Civico Museo Correr). (Back view; the embossed medallion of the saint and its inscription are to be read from the other side.)

when Bela III of Hungary and Manuel I Komnenos were allies. The draperies of Constantine and Helena have the arrow-head patterns noted on the two crowns and the Khakhouli triptych panel, so the feature is perhaps diagnostic of eleventh and twelfth century enamelwork.[47]

A reliquary of less familiar form, in Venice, is an approximately fist-shaped silver-gilt container for the hand of St Marina (fig. 201). On the base of the container, which must once have had a glass or crystal cover to display the relic, an embossed bust of Marina is executed in a style recalling that of the monumental icons of the Virgin in Constantinople. The cult of St Marina was popular in the mediaeval West, where also reliquaries representing parts of the body are less unusual, so the piece is possibly another that is to be linked to the Western presence in Constantinople in the eleventh/twelfth centuries.[48]

Many icons are attributed to the eleventh and twelfth centuries on stylistic grounds, by comparison with monumental art or manuscript illuminations. Once again, the Sinai collection furnishes examples, including several long wooden panels of a size consistent with placing on or above the architraves of sanctuary screens. The panels are painted with rows of

47 *Splendeur de Byzance*, 152; E. Voordeckers & L. Milis, 'La croix byzantine d'Eine', *Byzantion* 39 (1969) 456–88. A. Frolow, *La Relique de la vraie Croix* (Paris 1961), no. 308, illustrated in A. Frolow, *Les Reliquaires de la vraie Croix* (Paris 1965), fig. 69.

48 *Splendeur de Byzance*, 155; M.C. Ross, & G. Downey, 'A Reliquary of St. Marina', *Byzantinoslavica* 23 (1962) 41–4. Frolow, *La Relique*, no. 340, illustrated in A. Frolow, *Reliquaires*, fig. 41 (see n. 47).

festival icons, usually combined with the Deesis (fig. 202). There is documentary evidence that in some instances festival icons were hung in this position, rather than painted on a continuous panel, so that they could be removed one at a time on the appropriate feast day and taken to the lectern. A large icon of the Annunciation, also in the Sinai collection, may be an example of this type (fig. 203). It is attributed to the late twelfth century because of stylistic similarity with the paintings of St George, Kurbinovo (1191) and, less securely, to Constantinople on the basis of its high quality. Among 'portrait' icons, an approximately dated example now in Moscow is known as Our Lady of Vladimir. According to Russian chronicles, this was brought from Constantinople to Kiev in about 1131 and moved to the principality of Vladimir some twenty years later. The icon is a wooden panel, with integral frame, bearing a head-and-shoulders image of Virgin and Child, against a gold ground, following the formula seen in icons of the tenth century.[49]

A series of church doors in Italy provides evidence of the export of Byzantine bronzework in the eleventh century. This was a tradition of long standing, known as early as 800, when Byzantine craftsmen worked on Charlemagne's Palace Chapel at Aachen. Between 1062–87, members of a family of merchants from Amalfi, who had commercial ties with Constantinople, commissioned several sets of panelled bronze doors for churches in Italy. In some the panels are decorated with a combination of applied crosses and figure subjects in metal inlay, in others there are figure panels only. This is the case in a pair of doors given to St Paul outside the Walls in Rome, which has a programme made up of twelve festival icons, figures of the twelve apostles, images of their martyrdoms or funerals, and figures of twelve prophets (fig. 204). A donor panel shows Pantaleon of Amalfi at the feet of Christ and St Paul, and an inscription names the

202 Iconostasis beam with painted icons (twelfth century?) (Monastery of St Catherine at Mount Sinai).

49 K. Weitzmann *et al.*, *The Icon* (London 1982), 18, 58, 63; V. Lasareff, 'Trois fragments d'epistyles peintes et le templon byzantin', *Deltion* 4 (1964–5) 117–43;

C. Walter, 'The Origins of the Iconostasis', in *Studies in Byzantine Iconography*, Variorum Reprints (London 1971).

203 Icon of the Annunciation (twelfth century?) (Monastery of St Catherine at Mount Sinai).

204 Detail of bronze doors in St Paul outside the Walls, Rome.

bronze-caster as one Staurakios. The significance of another inscription, giving the same information in Syriac, is still imperfectly understood. It may indicate the presence of Syriac-speaking bronzeworkers either in the Constantinopolitan workshop that made the panels, or in Rome, where they were presumably assembled.[50]

Finally, a famous object in Italy illustrates a whole range of Byzantine contacts with the West. The Pala D'Oro in San Marco, Venice, is an altar frontal which owes its present form to thirteenth- and fourteenth-century remodellings but incorporates Byzantine enamels of several

50 M.E. Frazer, 'Church Doors and the Gates of Paradise: Byzantine Bronze Doors in Italy', *DOP* 27 (1973) 145–62; A.L. Frothingham, 'A Syrian Artist Author of the Bronze Doors of St Paul's, Rome', *AJA* 18 (1914) 484–91.

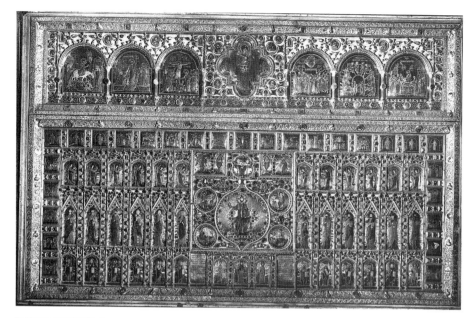

205 The Pala d'oro, an altar frontal made of Byzantine enamels of several periods (San Marco, Venice).

TOP
Ent. Entry into Jerusalem
Ana. Anastasis
Crû. Crucifixion
Asc. Ascension
Pen. Pentecost
Dor. Dormition of the Virgin
AM Archangel Michael

BELOW
S saint
A Annunciation
N Nativity
P Presentation
B Baptism
L Last Supper
C Crucifixion
A Anastasis
W Women at the Tomb
D Doubting of Thomas
A Ascension
P Pentecost

CENTRE PANEL
A angel
s seraph
Het. hetoimasia
Ev. evangelist
Chr. Christ

I inscription
D Doge Ordelafo Falier
V Virgin
E Empress Eirene

M Life of St Mark
A angel
Ap apostle
P prophet

periods (fig. 205). Some come from an altar panel that was made in Constantinople for Doge Pietro Oreolo in 976–8, others from a panel made in Venice by Byzantine craftsmen in 1105 for Doge Ordelafo Falier, and still others from pieces of Byzantine metalwork looted during the sack of Constantinople in 1204. The Pala has two sets of festival icons, a life of St Mark in ten episodes and many panels and medallions with figures of saints, angels and prophets. It is likely that the square panels of the St Mark cycle belonged to the frontal made in 1105 in Venice, given the dedication of the church. This was probably also the origin of one of the groups of festival icons, the panels of which are also square, and of the

same size and style. Other efforts to establish the chronology of the Pala have centred upon a panel showing an empress Eirene, who could be one of several, since the empresses of Alexios I, John II and Manuel I all had this name. Whichever she is, the empress and the panels of the St Mark group would appear to extend the range of datable Byzantine enamels to the twelfth century. The Pala also gives some notion, gothic additions set aside, of the large pieces of enamelwork that must also have been made for Byzantine churches.[51]

Illuminated manuscripts

Over 100 illuminated manuscripts of the eleventh and twelfth centuries are firmly dated, either by their colophons or by other secure internal evidence, and as many more can be attributed to the period on stylistic or palaeographic grounds. With this volume of material, it is possible to map out some general areas of the wood, in addition to studying individual specimen trees. Thus, the most frequently illustrated texts are, as the material of the Macedonian period suggested they might be, the gospels, gospel lectionaries, psalters, and the homilies of Church Fathers, particularly John Chrysostomos and Gregory of Nazianzos. Menologia form a smaller group, and illuminated secular texts are rare.[52]

The illustrative formulae used are for the most part familiar, following those seen in the Macedonian period or even earlier. Thus, many illuminated gospel books have ornamented Canon tables and, at the start of each gospel, an evangelist portrait and decorated headpiece. The elaborate headpiece is a feature of many 'luxury editions' of this period, such as a gospels in Oxford, in which the headpieces incorporate figural miniatures (fig. 206). The Flight into Egypt, for example, is found in the headpiece to the gospel of Matthew. Such decoration is often applied also to the preface material customary in gospel books. In the Oxford Gospels, the headpiece for Eusebius' letter introducing the Canons contains portraits of Eusebius and Karpanius, and the one for the prologue introducing the four gospels has Christ Pantocrator, with evangelist symbols and evangelist portraits. It is unlikely that the ornamentation of preface texts began in the eleventh-to twelfth-century period, but most extant examples are of this period or later. Full-page evangelist portraits in the Oxford Gospels occupy the versos preceding each text, and show the evangelist seated at a writing desk before an architectural background. This iconography is frequently found in eleventh- and twelfth-century gospels, although with many variations of detail and style.

A different formula is found in a gospel book in Paris which has, in addition to its four evangelist portraits, an elaborate narrative cycle of

51 S. Bettini, in *Treasury of San Marco*, 35–64.
52 Spatharakis, *Corpus*, nos. 48–172.

over 350 minatures placed between blocks of text (fig. 207). The manu-
script is undated, but is very similar in style and iconographical detail to a
psalter made in 1066 by the presbyter Theodore of the Stoudios
Monastery in Constantinople (now in London). It is therefore likely to be
an approximately contemporary product of the same workshop, probably
that of the Stoudios Monastery itself. Similar decorative treatment, using
about 300 miniatures, is found in a gospels in Florence, which may be of
the same provenance.[53]

Extensive narrative illumination is also seen in illuminated
Octateuchs (the first eight books of the Bible), of which four examples are
attributed to the eleventh or twelfth centuries. One of them, in Topkapı
Palace in Istanbul, contains a reference to Isaac Komnenos, a son of
Alexios I, and therefore belongs to the first half of the twelfth century. It
has over 350 framed miniatures, placed either within blocks of text or at
top or bottom of the page (fig. 208). Their painterly style and use of back-
ground detail is reminiscent of the illumination of the tenth-century Paris
Psalter, and the Octateuch cycle is likely to have originated during that

206 Late eleventh-century
gospel book (Oxford, Bodleian
Ms. Clarke 10, folios 10v and
11r). The start of the gospel of
Matthew, with the evangelist
opposite an ornamental
headpiece showing the Dream
of Joseph and the Flight into
Egypt.

53 Oxford, Bodl. Clarke 10: I. Hutter, *Corpus der
byzantinischen Miniaturenhandschriften. I. Oxford Bodleian
Library* (Stuttgart 1977) 1, no. 38, 56–9. Paris, BN gr.
74: S. Dufrenne, 'Deux chefs d'oeuvre de la miniature du
XIe siècle', *CahArch* 17 (1967) 177–91. Florence, Laur.
VI. 23: T. Velmans, *Le Tétraévangile de la Laurentienne*
(Paris 1971); R.S. Nelson, *The Iconography of Preface and
Miniature in the Byzantine Gospel Book* (New York 1980).

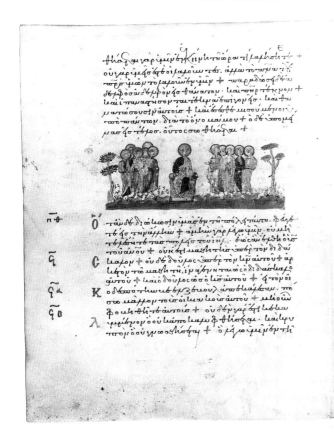

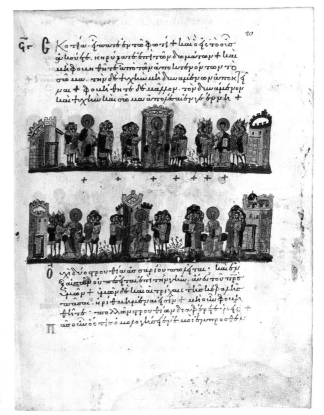

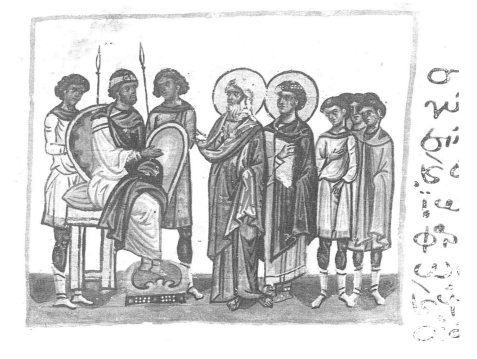

207 Gospels, eleventh century
(Paris, BN gr. 74). On folio
19r Christ bids his disciples to
preach in all nations; on 20v
six of them are seen doing so
(the rest follow on subsequent
folios).

208 Twelfth-century
Octateuch (Topkapı Sarayı Ms.
G. I. 8) Folio 139r, detail of
Joseph and Pharaoh.

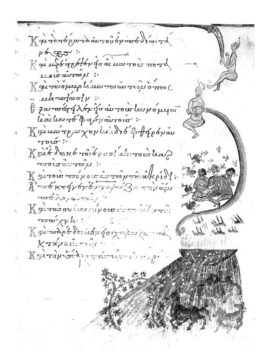

209 'Theodore Psalter' of 1066 (London, BL Add. 19.352), folio 104r, the plagues of Egypt, illustrating Psalm 77.

period, although some have argued for an early Christian model, from which the middle-Byzantine copies were made.[54]

The Theodore Psalter of 1066, mentioned above, belongs to the tradition of the ninth-century 'marginal' psalters, the 430-odd images in its margins having the same variety of relationships to the text as those of the earlier examples (fig. 209). The choice of scenes shows the Theodore Psalter to be a descendant of the Chludov Psalter, but it is not simply a copy. Some images have been replaced or adjusted, no doubt to reflect the theological concerns of the patron, Michael Synkellos, *hegoumenos* (superior) of the Stoudios Monastery. The anti-iconoclast images created for the ninth-century psalters, for example, have been modified to give greater prominence to the role of Theodore the Stoudite as a champion of orthodoxy during the dispute. Two more 'marginal' psalters, the Bristol Psalter, in London, and another in Baltimore, are attributed to the eleventh or early twelfth centuries on palaeographical and stylistic grounds.[55]

So-called 'aristocratic' psalters with pictorial prefaces, like the tenth-century Paris Psalter, also continue in production. An example in the Dumbarton Oaks Collection in Washington, dated by its Paschal tables to

54 Istanbul, Topkapı Sarayı Ms. 8: Spatharakis *Corpus* no. 325; T. Ouspensky, *L'Octateuque de la bibliothèque du Sérail à Constantinople* (Sofia 1907) (in Russian).

55 London, *BM* Add. 19352: Spatharakis, *Corpus* no. 80; S. Dufrenne, *L'Illustration des psautiers grecs du moyen âge* (Paris 1966). London, *BM* Add. 40733: S. Dufrenne, 'Le

Psautier Bristol et les autres psautiers byzantins', *CahArch* 14 (1964) 159–82. Baltimore, Walters Art Gallery 733: D.E. Miner, 'The "Monastic" Psalter of the Walters Art Gallery' in *Late Classical and Medieval Studies in Honor of A.M. Friend Jr.* (Princeton NJ 1955), 232–53.

210 Menologion of 1056
(Vienna, Öst. NB Hist. gr. 6);
folio 3v, saints for the month
of October.

c. 1084, has a David cycle of fifteen full- or three-quarter-page framed miniatures. There is also a series of 'prayer' images to illustrate the canticles, supplemented by marginal figures of the prophets from whose texts the canticles are taken. Not all the episodes of the David cycle in the Dumbarton Oaks Psalter match those of the Paris Psalter, and those that do have iconographical differences. Such is also the case with other eleventh- and twelfth-century psalters of this form, which have therefore a generic relationship to the Paris Psalter and represent (as do the 'marginal' psalters and the gospels) continuing evolution of established forms rather than direct copying. (The point is made here because actual copies of the Paris Psalter do appear later, in the fourteenth century, and will be looked at in due course.)[56]

There are no surviving menologia with illumination on the scale of the book made for Basil II, but there are more modest examples of similar type. A menologion of 1063 now in Moscow, covering the feast days from May to October, has twelve ornamental headpieces with figural images above or within them. Subjects include portraits of the saints, their miracles or martyrdoms, or the translation of relics. A colophon on the last

56 Washington, Dumbarton Oaks Ms. 3 (formerly
Pantocrator Monastery Ms. 49): Spatharakis, *Corpus* no.
101; Cutler, *Psalters*, no. 51; S. Der Nersessian, 'A

Psalter and New Testament Manuscript at Dumbarton
Oaks', *DOP* 19 (1965) 153–83.

page marks the end of the volume, and there was probably another for the remaining six months of the year. A different approach to menologion illumination is seen in several manuscripts which were once part of a set, now held in Oxford (September), Vienna (October) (fig. 210), Paris (November) and Mount Sinai (part of January). The date of the menologion, 1056, may be deduced from a colophon in the Paris volume, referring to the sole reign of Theodora and the patriarchate of Michael Keroularios. Each month opens with a single full-page miniature divided into either three or four registers, with standing figures of the saints for the month in uniform rows. This scheme may have been derived from calendar icons, which also have figures in several registers, representing the saints of from one to three months on a single panel, and therefore made in sets of twelve or four. A set attributed to the eleventh century on stylistic grounds is one of several in the icon collection at Mount Sinai.[57]

In parallel with the treatment of menologia, illumination of Homilies and other theological works in the eleventh and twelfth centuries nowhere rivals the scale and complexity of imagery in the ninth-century Paris Gregory, but there are many examples of simpler illustrative treatments. The developed headpiece seen in the Oxford Gospels is used in a luxurious copy of the *Homilies of Gregory of Nazianzos*, now in the Monastery of St Catherine at Mount Sinai. This manuscript was commissioned by the *kathegoumenos* (abbot) of the Pantocrator Monastery in Constantinople, around 1149, for presentation to a monastery on the island of Hagia Glykeria off the coast of Bithynia. A figural image enclosed in a very ornate frame is placed at the start of each Homily, supplemented in most cases by marginal figures and initials with figures. At the start of the manuscript, an author portrait shows Gregory seated at a writing desk and lectern, in an architectural frame representing a church (fig. 211). The disorderly domes and roofs of this building are reminiscent of those of the Pantocrator Monastery itself and it is possible that this was the artist's intention. Some twenty other illuminated *Homilies of Gregory*, most of them of lesser quality than the Sinai Gregory, have similar combinations of author portrait and headpieces with a uniform series of figure subjects for each homily (the Anastasis, for example, always accompanying the first Homily).[58]

Stylistic and iconographic proximity indicate that the workshop, and probably the hand, responsible for the Sinai Gregory also decorated two copies of the *Homilies on the Virgin* by James, a monk of the Kokkinobaphos Monastery in Bithynia, one now in Paris, the other in the Vatican. In these volumes, each of the six Homilies opens with a full-page

57 Moscow, HM gr. 382: Spatharakis, *Corpus* no. 78. Oxford, Bodl. Barocci 230, Vienna, Öst NB Hist. gr. 6, Paris, BN gr. 580 and 1499, Sinai gr. 512: Spatharakis, *Corpus* nos. 63–7. K. Weitzmann *et al., The Icon* (London 1982), 50. S. Der Nersessian, 'The Illustrations of the

Metaphrastian Menologion' in *Etudes Byzantines et Arméniennes* (Louvain 1973) I, 129–38.

58 Sinai gr. 339: Spatharakis, *Corpus* no. 146. G. Galavaris, *The Illustrations of the Liturgical Homilies of Gregory of Nazianzos* (Princeton NJ 1969).

211 Homilies of Gregory of Nazianzos (Sinai gr. 339), (c. 1149). Folio 4v, Gregory writing, in an architectural setting.

212 Homilies on the Virgin by James of Kokkinobaphos (Paris, BN gr. 1208); mid-twelfth century. Folio 3v, the Ascension in an architectural setting.

verso miniature and an ornate headpiece on the adjacent recto; seventy-odd other framed miniatures then follow paragraphs of text. The Homilies draw upon the Life of the Virgin from the *Protevangelion of St James*, and the images likewise come largely from cycles based on this source, supplemented by inventions. The Ascension introduces the first Homily, and is set within a 'church' frame like that of the Sinai Gregory author portrait, but of more regular, five-domed type and thought to represent the church of Holy Apostles in Constantinople (fig. 212). If so, then representing the churches of Constantinople in author portraits may have been a feature of this artist's work. The Paris manuscript opens with a miniature showing a monk (presumably James of Kokkinobaphos) prostrate before his sources of inspiration, St James and St Gregory of Nazianzos. A similar miniature was probably present in the Vatican copy but is now lost. The Paris manuscript is a close copy of the Vatican one, but neither has a colophon or dedication miniature that might explain why, or for whom, they were made.[59]

As before, many of the scribes mentioned in eleventh- and twelfth-

59 Paris, BN gr. 1208: H. Omont, 'Miniatures des Homélies sur la Vierge du moine Jacques', *Bulletin de la Société française de reproduction de manuscrits à peintures* 11 (1927) 5–24. Vatican, gr. 1162: C. Stornajolo, *Miniature delle omilie di Giacomo Monaco (Cod. Vat. gr. 1162)* (Rome 1910).

213 Gospel book of *c.* 1100 (National Gallery of Victoria, Melbourne, cod. 710/5, Felton Bequest 1959). Folio IV, Theophanes, the donor, scribe and painter, presenting his book to the Virgin.

century colophons are described as presbyter or monk, but painters are seldom acknowledged, and the details of production of illuminated texts are no clearer. However, rare confirmation that the entire work might be that of a single hand comes from a gospel book in Melbourne attributed to *c.* 1100, which has on its first folio a figure of a monk Theophanes, standing next to the Virgin and Child in a two-arched frame (fig. 213). Theophanes presents his book to the Virgin and Child, and an inscription identifies him as donor, scribe and painter. Possibly he was prompted to give these details because they were untypical.[60]

Illuminated manuscripts of the eleventh and twelfth centuries are relatively rich in 'donor' images, which demonstrate the pious motives of the patron in a variety of ways. Thus, some images, like that of Theophanes in the Melbourne Gospels, show the donor in *proskynesis* before Christ or the Virgin, usually inscribed with a prayer for forgiveness of sins. A lectionary of 1061 (in Jerusalem) has a miniature of the standing Virgin with a donor named Basil kneeling before her; he wears a plain robe and may be a monk. Another lectionary of the twelfth century, in the Great Laura of Mount Athos, has a richly clad figure, presumably a man in public life, prostrate before the Virgin. The iconography resembles that of the mosaic panel of George of Antioch and the Virgin, in the Martorana in Sicily.

60 Melbourne, National Gallery of Victoria, Cod. 710/5:
Spatharakis, *Portrait*, 76–8.

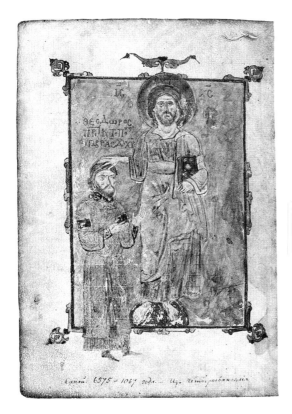
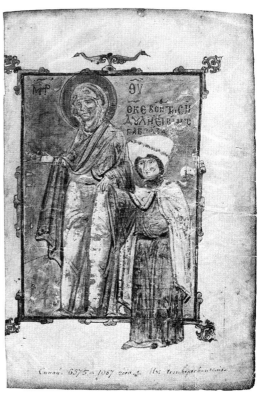

214 Gospel book of 1067 (St Petersburg Public Library gr. 291); folios 2v–3r, Theodore Gabras with Christ, and his wife with the Virgin.

Husband and wife are represented in a gospels of 1067, now divided between the Sinai Monastery and St Petersburg. On a verso page, Theodore Gabras, a provincial governor, stands next to Christ, whose hand touches his head, while on the facing recto, the Virgin leads Theodore's wife Eirene by the hand, in effect presenting her to Christ on the opposite page (fig. 214). Some donors are shown offering their books. In a lectionary in Princeton, John the *proedros*, in rich costume, stands next to a large cross and holds a scroll inscribed with a statement that, for remission of his sins, he is offering 'ten books' on the lives of saints. (Not, evidently, the lectionary to which the miniature is now attached, but probably a menologion from which it was removed.) In a variant on this theme, a lectionary in the Kutlumusiu Monastery on Mount Athos, made before 1169, shows a donor Basil, standing next to Christ and proffering a book, while his wife kneels at Christ's feet. A combination of author portrait and donor image appears in a Homilies of Gregory of Nazianzos in the Dionysiou Monastery on Mount Athos. Here a young nobleman holds the book and St Gregory touches it with one hand, making a gesture of blessing with the other (fig. 215). No inscription identifies the young man, who was perhaps named in a lost preface.[61]

61 Jerusalem, Greek Patriarchate, Megale Panagia, 1: Spatharakis, *Corpus*, no. 72, and *Portrait*, 57–60. Athos, Laura A 103: *ibid.*, 78–9. Sinai, gr. 172 & St Petersburg Public Library gr. 291: *Corpus*, nos. 81, 82. Princeton, Speer Library 11.21.1900, Athos, Kutlumusiou 60 and Athos, Dionysiou 61: *Portrait*, 74–6, 83–4, 118–21.

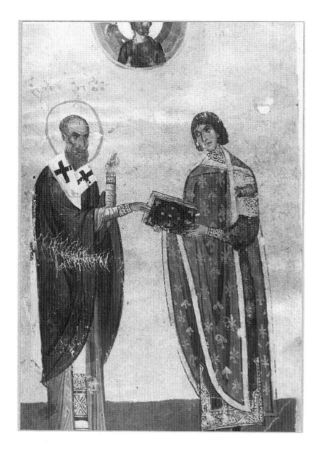

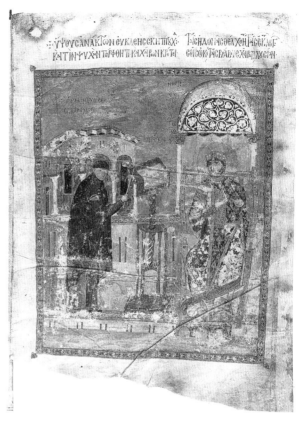

Several illuminated manuscripts contain imperial images, some of them of the 'coronation' type seen in ivories and metalwork. Thus, an ornamented headpiece in a Sacra Parallela in Paris encloses an image of the Virgin crowning Constantine X and Eudokia, while angels do the same for their sons Michael and Constantine. A Homilies of John Chrysostom in the Sinai Monastery has Constantine IX Monomachos, Zoe and Theodora standing below Christ enthroned flanked by angels. Three crowns, two held by the angels and another at the feet of Christ, are suspended above the imperial heads. Elsewhere, more than one imperial image is present, as in a Homilies of John Chrysostom in Paris, which has four (fig. 216). In their original order these showed first, an emperor enthroned, flanked by small personifications of Mercy and Justice, with courtiers in attendance, then an emperor standing between John Chrysostom and the archangel Michael. The emperor holds the book while the saint touches it, and a tiny figure (the painter, perhaps) kneels at the emperor's feet. Next, a monk Sabas, possibly the scribe, stands before the emperor, pointing to the book on a lectern and finally, a hovering figure of Christ touches the crowns of an imperial couple. Inscriptions above each miniature praise the emperor. The first also asks him to reward his servants generously, while the next two ask his benevolence for the scribe (perhaps indicating a certain freedom on the part of the scribe to add his own pleas to those commanded by the patron). The

215 Homilies of Gregory of Nazianzos (Mount Athos, Dionysiou Monastery Ms. 61), folio 1v, a nobleman presenting the book to St Gregory.

216 Homilies of John Chrysostom (c. 1078) (Paris, BN Coislin 79). Folio 1(2bis)r, the monk Sabas presenting the book to the emperor.

217 *Panoplia Dogmatica* by
Euthymios Zygabenus
(Vatican gr. 666). Folio 2v,
Alexios I Komnenos
(1081–118) presenting the
book to Christ.

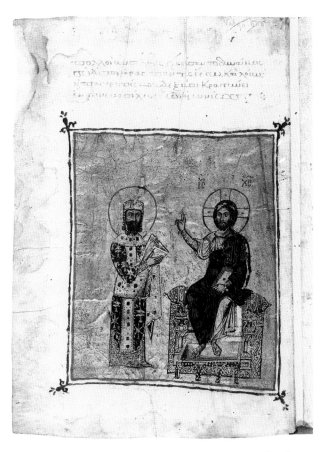

emperor is identified by inscription as Nikephoros III (1078–81), but the
miniatures appear to have been cut from an earlier manuscript and may
originally have represented his predecessor Michael VII (1071–8), ousted by
Nikephoros. Whatever the case, the sequence shows that donor images
might embody several ideas about the patron and the circumstances of
patronage – not all of them clearly understandable in this case.[62]

Another sequence of images is found in a copy of the *Panoplia
Dogmatica* in the Vatican. The text is a treatise against heresy commis-
sioned by Alexios I from Euthymios Zygabenus, a monk of Constantinople
(fig. 217). On the first verso an assembly of Church Fathers, the guardians
of orthodoxy, offer scrolls representing their writings to a figure of Alexios
on the facing recto, where the emperor also receives the blessing of a small
figure of Christ. In a third miniature (on the next verso), Alexios offers the
book to Christ enthroned. Inscriptions accompanying the miniatures
praise Alexios as emperor and as patron of the *Panoplia*. Since Alexios
commissioned the text, it is possible that the Vatican copy was a presenta-
tion volume made expressly for him. Another copy, however, (in Moscow,

62 Paris, BN gr. 922, Sinai, gr. 364 and Paris, BN Coislin
79: Spatharakis, *Corpus*, nos. 71, 53, 94; Spatharakis,
Portrait, 102–6, 99–102, 107–19.

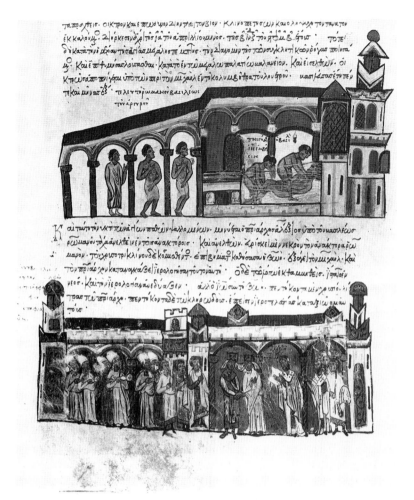

218 Chronicle of John Skylitzes (Madrid, BN Vitr. 26–2), probably mid-twelfth century. Folio 206v, the murder of Romanos III in his bath (1034) and (below) the wedding later the same day of his widow Zoe to her lover, who thus became Michael IV.

and of uncertain date), has the same set of miniatures, indicating that the images are also to be understood as illustrating the commissioning of the work itself, and not necessarily the particular copy they embellish. Similarly, a miniature of Manuel I and his wife Maria of Antioch is present in a copy of the Acts of the 1166 Council of Constantinople (in the Vatican), which contains signatures of Council participants and may therefore be the original record of the event. The imperial miniature may have been included because the document was presented to Manuel, or it could be there simply to honour the rulers at the time of the Council.[63]

Connections with the West noted above also appear in the manuscript evidence. A psalter in Vienna, dated to *c.* 1077 by its Paschal tables, was apparently made for the church of St Gereon in Cologne. The psalter is in Greek, and is of the 'preface' type, with miniatures of the Virgin and

63 Vatican, gr. 666 and Vatican, gr. 1176: Spatharakis, *Corpus*, nos. 126, 155; Spatharakis, *Portrait*, 122–9, 208–10. Moscow, HM Synodal 397: Spatharakis, *Portrait*, 128–9.

Child, Crucifixion, David, and three ornamental headpieces decorating the Psalms. It opens, however, with a portrait of St Gereon, inscribed in Greek like the other miniatures, but with the saint's name given in Latin as well, possibly by the scribal hand. The book may have been a diplomatic gift, or perhaps the commission of a Western patron visiting Constantinople or resident there. Greater fusion of Western and Byzantine traditions is seen in Greek manuscripts made in Sicily, where there were Byzantine monasteries, as well as the Norman monarchy with its Byzantinizing tastes. A Greek gospel book in Paris, made in 1167, has a colophon naming Manuel I and William II of Sicily as current rulers, and highly ornamented initials of a type traditional for several centuries in Western manuscripts. Also probably of Sicilian origin is a very fully illustrated copy of the Chronicle of John Skylitzes (now in Madrid), which has 574 miniatures, two or three to a page, separated by text (fig. 218). One of several scribal hands is matched in another manuscript, made in Sicily and datable to the mid-twelfth century. Skylitzes was writing in the late eleventh century, and one school of thought has it that the Madrid manuscript is a Sicilian copy of a book produced in Constantinople, commissioned by the author himself, for presentation to the emperor Alexios I. There is no evidence for this, however, and some features of the illumination argue against it. The miniatures seem to depend on several different sources, and a good deal of invention. Moreover, the representation of St Sophia and Holy Apostles in Constantinople as Western-style basilicas suggests that no Byzantine model was to hand. A plausible explanation for this unique manuscript is, therefore, that it was a 'special edition' produced for Roger II who, raised in polyglot Sicily as well as ruling it, would probably have been able to cope with the Greek text. The book would thus take its place alongside the Norman commissions for Byzantine mosaic decoration in Sicilian churches.[64]

General issues

Continuity of form and formulae is the keynote for the material culture of the eleventh and twelfth centuries. Where innovation appears it is generally a matter of modification or change of emphasis. The Pantocrator Monastery in Constantinople, among the most important imperial commissions of the twelfth century, had its churches built on the inscribed-cross plan used two centuries earlier at the monastery of Constantine Lips, and not new even then. Even new types like the Greek-cross-octagon, and the octagon-domed church are simply sophisticated developments of architectural ideas that are by now standard. Similarly, monumental art con-

64 Vienna, Öst. NB Theol. gr. 336 and Paris, BN gr. 83: Spatharakis, *Corpus*, nos. 97, 158. Madrid, BN Cod. Matritensis gr. Vitr. 26–2: A. Grabar & M. Manoussacas, *L'Illustration du manuscrit de Skylitzès de la Bibliothèque Nationale de Madrid* (Venice 1979); N.G. Wilson, 'The Madrid Skylitzes', *Scrittura e Civiltà* 2 (1978) 209–19.

tinues to use the 'hierarchical' arrangement and festival icon scheme developed in the ninth century, if not before. The range of imagery evident in decorative programmes is certainly greater than that attested for the ninth and tenth centuries, particularly in the field of narrative subjects, but how far this range had been available in the ninth or tenth centuries is uncertain. There may have been development and refinement in the selection and placing of images, but nothing suggests that there were significant innovations. The Comnene period is often seen as one of stagnation or decline for manuscript illumination, since it produced few elaborate 'special editions' like those of the ninth century, nor the self-conscious classicisms of the 'Macedonian Renaissance' which appear to have formed an isolated pocket of tenth-century specialization. Instead, the elaboration of decorative headpieces and initials suggests elegant refinement of illustrative formulae that developed during the post-iconoclast increase of book production.

Other trends of the earlier part of the middle-Byzantine period are also in evidence. A few more artists are known by name, so that the eight painters of the Menologion of Basil II are joined by Nikephoros Bezaleel, architect of the Pantocrator Monastery, Theophanes of the Melbourne Gospels, Eulalios, who put a self-portrait in his painting at Holy Apostles, and Theodore Apseudes who decorated the Hermitage of St Neophytos. For some this denotes the improved status of the craftsman, but the proposition is to be doubted. It is not clear why some painters signed their work, and some records name artists or architects, but the examples are still so few that such identification would seem to be incidental, rather than symptomatic of a changed relationship between patron and craftsman. More convincing is the view that the patron becomes more visible in middle-Byzantine art than was the case in earlier times, as the number and variety of donor images in eleventh- and twelfth-century manuscript illumination, monumental art and minor arts confirms a trend seen in the ninth century. The importance of the imperial image in particular is evident not only in its Byzantine examples but also in the manner in which Byzantine imperial iconography was adopted by the rulers of Sicily and Russia. Further, a broadening of the range of imperial imagery is implied by the large number, and apparent variety, of images of Manuel I known from documentary sources. These, and the panel set up in St Sophia by Manuel's father John II, suggest that the Komnenoi sought not just to celebrate the divinely ordained status of the emperor, but also to show him as rightful successor to eminent predecessors, whether of the same blood-line or not.

The continuity just outlined leads most handbooks to treat the whole period from the end of Iconoclasm in 943 to the Latin occupation of 1204 as a single 'middle-Byzantine' block. It is also responsible for the view that middle-Byzantine religious art and architecture was subject to rigid formulae imposed by some kind of ecclesiastical control and implemented by slavish adherence to workshop rules. There is no real evidence for such imposed inflexibility, however, and it is more likely that the basic forms of art and architecture that were developed by the mid-ninth century contin-

ued in use because the functions they served changed little during the middle-Byzantine period. The marked differences between early Byzantine and middle-Byzantine art and architecture resulted from great changes in the structure of the empire and its social customs, which are without middle-Byzantine parallel. Adherence to convention does not in any case imply that Byzantine art and architecture was static for three centuries, rather that changes were subtle, not fundamental.

The most visible change is one of style rather than form, seen best in monumental art but reflected in various degrees in the minor arts. The mosaics and paintings of early to mid-eleventh century mosaic and painting, such as those of Hosios Loukas and St Sophia in Kiev, have stocky figures, clad in draperies rendered in compact patterns. By the mid-eleventh century there is the 'expressive' style, seen in Asinou, Nerezi, and the Palermo mosaics, in which draperies are treated in a fluid, 'springing' manner and facial features become strongly articulated, producing a range of vigorous, dramatic expressions. (The attribution of the mosaics of Daphni to *c.* 1100 depends largely upon the fact that they appear to represent an intermediate stage, combining aspects of both styles.) There is no sharp chronological division of styles, however, and the 'expressive' style is seen as early as St Sophia in Ohrid in the mid-eleventh century. A still more dramatic 'mannerist' style is seen towards the end of the twelfth century in the paintings of Lagoudera and Kurbinovo, and the mosaics of Monreale.

This general trend in stylistic development is reasonably clear, but, as has been the case elsewhere, there is much uncertainty about the places within it occupied by the individual works upon which it is based, and about their relationships. At the heart of this uncertainty is the absence of survivals from Constantinople, which obscures the nature of artistic connections between the capital and the provinces. It is likely that many stylistic changes had their origin in metropolitan workshops, since a common point of origin is the most plausible explanation for shared stylistic features in the art of monuments that are widely separated geographically and unlikely to have direct connections with one another. Constantinopolitan origin would explain, for example, the similarity between the mosaics of St Sophia in Kiev and Hosios Loukas in Greece. The precise manner in which these, or any other particular works are related to metropolitan models is often difficult to define, however, given the lack of such models for comparison. It may be supposed that in both programme content and style, the work at St Sophia in Kiev is a close reflection of the art of the capital, done by artists from Constantinople and unlikely to have been subject to any other influence. It is less certain that stylistic proximity identifies the work at Hosios Loukas as the product of another Constantinopolitan workshop, as is often supposed. The style may have originated in the capital, but may have spread to Greece before its appearance at Hosios Loukas. Similarly, in the twelfth century, the appearance of the 'mannerist' style at Lagoudera in Cyprus and Kurbinovo in the Balkans again indicates a com-

mon point of origin in the capital, but the relationship of Constantinople and Sicily may be less straightforward. It is probable that the first mosaics made for Norman patrons reflect the traditions of the capital closely (assuming that this was where the mosaicists came from, which, although likely, remains unproven in the absence of documentation). Changes in style between the mosaics of the 1140s and those of the 1180s, which have signs of the 'mannerist' style, are likely to have been the result of successive 'injections' of Byzantine style, brought by itinerant masters arriving for each phase of work. It is not impossible, however, that the work of these craftsmen, exposed to new challenges and, perhaps, Western models, underwent stylistic development that they then took back to the capital. Such an hypothesis cannot be tested, but is offered to illustrate the point that the relationship between Constantinople, the provinces and beyond may have greater complexity than a simple series of waves of metropolitan influence radiating outwards.

The evidence of architecture also implies that the capital may not have been the sole source of innovation. While it is likely that the octagon-domed churches characteristic of Chios derive from a Constantinopolitan model introduced for Nea Mone, such instances do not justify the reconstruction of lost metropolitan archetypes for all provincial monuments of quality and refinement. Thus, although all extant examples of the Greek-cross-octagon church are in Greece, it is often supposed that the form depends upon metropolitan models of which none remains, and the loosely similar Panagia Kamariotissa on Heybeliada has been offered as the 'missing link'. The Greek-cross-octagon does not appear among the imperial commissions of the Comnene capital, however, and as noted already, the prosperous market towns of Greece may have provided conditions just as good as those of the capital for architectural development. The possibility that the design originated in Greece and a modest reflection of it reached Heybeliada in the Sea of Marmara, much frequented by Greek traders, should therefore not be discounted. The evidence of architectural sculpture likewise suggests that the provinces could offer as much, if not more, than the capital.

Thus, the sound general principle that Constantinople, with its resources of wealth and patronage, is likely to be chief generator of artistic influences, should not obscure the possibility that it could also be a recipient. Both roles are likely in the context of the increasing numbers of Western residents and traders in the capital of the eleventh and twelfth centuries. The bronze doors sent to Italy and the altar frontal made for San Marco in Venice attest the export of Byzantine craftsmanship, but the current might occasionally be reversed. After centuries in which Byzantine carved stone ornament was largely confined to aniconic cornices and capitals, the appearance of marble panels with large figures cut in relief constitutes a novelty likely to have been introduced by the tastes of patrons familiar with the much more developed sculptural traditions of the mediaeval West.

6 *The Latin occupation of Constantinople*

Since the late eleventh century Crusaders from the West had been passing through Byzantine territory on their way to the Holy Land. They had been aware of the usefulness of Constantinople as a staging post and, no doubt, of the suspicion and distaste displayed by their reluctant Byzantine hosts. At the same time, Western mercantile groups resident in Constantinople were keen to shed the trading restrictions inherent in their position as tenants of the empire, and in 1182 relations were soured still futher by a city riot in which many Latins were massacred. These factors led eventually to an episode of violent destruction and pillage in 1204, when the Fourth Crusade, in alliance with the Venetians, sacked Constantinople. The Latin Empire of Constantinople was proclaimed, with Baldwin I of Flanders as its emperor, and a quarter of all Byzantine territory as its share. The Venetians took part of Constantinople itelf, and half the rest of the empire, including the territory of most interest to a trading power, the coasts and islands between Constantinople and the Mediterranean. What remained went in smaller packages to the Western knights of the Crusade. The neighbours to the north recognized the changed circumstances with a transfer of allegiance. Kaloyan of Bulgaria was crowned in 1204 by a Roman cardinal, and Stephen Prvovenčani ('first-crowned'), the son of Stephen Nemanja, divorced his Byzantine wife and married the daughter of Enrico Dandolo, Doge of Venice; in 1217 he was crowned Tsar by a papal legate. Culturally, however, the Bulgars and Serbs retained close links with Byzantium, both through intermarriage with its aristocracy and through religion. The tie with Byzantine orthodoxy was strong, and although Western clerics might perform coronation ceremonies, it was the Patriarch of Constantinople who was approached in order to negotiate the independence of the Bulgarian and Serbian churches.

Communities of exiled Byzantine aristocracy were established in Nicaea, on the coast of Asia Minor, under Theodore I Laskaris (1204–22), the son-in-law of Alexios III (1195–1203), and in Epiros, on the west coast of Greece, by Michael Angelos Komnenos Doukas, a cousin of Alexios. At the same time, two grandsons of Andronikos I Komnenos (1183–85), who had been raised at the Georgian court in eastern Asia Minor, established the Byzantine Kingdom of Trebizond, on the southeast coast of the Black Sea, styling themselves the Grand Komnenoi. Battles for territory and power during the ensuing half-century involved the Latin

Empire, all three factions of Byzantine exiles, the Bulgars and Serbs, the Seljuk Sultanate of Konya and the Mongols. Of the three Byzantine groups, Trebizond was too remote from the capital to play any part in its recovery, and soon became a vassal state first of the Sultanate of Konya and then of the Mongols. Epiros made gains on the Latin Empire and took Thessalonike in 1224, but lost to the Bulgars. Nicaea, however, gained steadily in power, growing wealthy on its trade with the Turks and re-establishing traditional administrative and ecclesiastical structures to become the Byzantine empire in exile. Much of the credit for this goes to John III Doukas Vatatzes (1222–54), the son-in-law and successor of Theodore I Laskaris, whose reign is also marked by philanthropic endeavour and cultural revival, to the extent that his court was compared to that of Constantine VII. Meanwhile, the Latin Empire continued to lose territory to both Byzantine and other opponents, and by the mid-century had only a fragile hold on Constantinople. In July 1261, during the temporary absence of the Venetian fleet that was its main defence, the Byzantine recovery of the city was effected against little resistance. The Byzantine emperor who entered in triumph two weeks later was Michael VIII Palaiologos, who had taken a familiar path of usurpation, becoming regent for the young grandson of John III Vatatzes, whom he then had blinded.[1]

Constantinople retains little trace of the Latin occupation. It is unlikely that the Franks and Venetians made significant alterations to the fabric of the city in their relatively brief, and never very secure, fifty-seven-year tenure, and many signs of their presence must have been erased when the city returned to Byzantine control in 1261. There was, in any case, no need for new building since the incomers simply appropriated what they needed. The Blachernae Palace became the residence of Baldwin I and his successors, and Western clergy and administration took over many of the most important churches and monasteries. Baldwin and his brother Henry, wearing Byzantine dress, were crowned in Hagia Sophia, and Doge Enrico Dandalo was buried there in 1205. The Pantocrator Monastery was given to the Venetians, who removed to it one of the most precious icons of Constantinople, the Virgin Hodegetria, reputedly painted by St Luke and regarded as protector of the city.[2] Other churches and monasteries annexed included the Theotokos of Blachernae, the Nea Ekklesia, Christ Pantepoptes, the Theotokos Chalkoprateia, Holy Apostles, (where several eminent Latins were buried), St John of Stoudios and St George of the Mangana. Over thirty appropriations are known from the documentary record and there were probably more.[3]

1 Ostrogorsky, *Byzantine State*, 418–50; D.M. Nicol, *The Despotate of Epiros* (Oxford 1957); M. Angold, *A Byzantine Government in Exile. Government and Society under the Laskarids of Nicaea 1204–1261* (Oxford 1975); A.A. Vasiliev, 'The Foundation of the Empire of Trebizond 1204–1222', *Speculum* 11 (1936) 3–37;

Obolensky, *Byzantine Commonwealth*, 309–16.

2 R.L. Wolff, 'Footnote to an Incident of the Latin Occupation of Constantinople: The Church and the Icon of the Hodegetria', *Traditio* 6 (1948) 319–28.

3 R. Janin, 'Les Sanctuaires de Byzance sous la domination latine', *EB* 1 (1944) 134–84.

219 Painting in
Kalenderhane Camii,
Constantinople (1204–61):
fragment of a cycle of the life
of St Francis of Assisi.

Most of the surviving buildings of Constantinople are without obvious sign of alteration during the Latin occupation, but there are a few exceptions. At Kalenderhane Camii, a twelfth-century church the Byzantine identity of which is still unknown, recent excavation has uncovered in a side chapel a fresco cycle of the life of St Francis of Assisi (fig. 219). This very fragmentary decoration is of particular interest because it must be among the earliest examples of its kind, painted between the death of St Francis in 1228 and the return of the Byzantine aristocracy to Constantinople in 1261. At the Pantocrator Monastery fragments of coloured and painted glass found in the south church are the remains of glazing in the three windows of its apse. Although this has been seen as evidence for a Byzantine tradition of stained-glass manufacture, there is no convincing background for such a tradition, and it is more likely to have been a Latin introduction. A belfry at St Sophia, visible in the seventeenth-century engravings of G. Grelot, was probably another such introduction. Constantinople thus underwent relatively minor adjustment to Latin requirements, and there is, unremarkably, no evidence of substantial Western imports such as appear in the Crusader settlements of the Holy Land, where figured capitals cut by French stonemasons embellish Gothic architecture.[4]

Indeed, in Constantinople Latin effort went into removal rather than addition. During the sack of the city and afterwards, much portable wealth was removed to the West, where it is now represented by the precious objects in cathedral treasuries and collections mentioned in previous chapters. Even some monumental pieces were shipped out, such as the four bronze horses from the hippodrome that now stand above the entrance to San Marco in Venice, and the marble reliefs noted in the last chapter, also now in Venice. Much more perished, especially monumental metalwork. The historian Niketas Choniates describes the removal of the great silver and gold ciborium of St Sophia (possibly replaced by a marble structure made of columns removed from the Anastasis Church), and the melting down of bronze statues, many of them taken from columns and pedestals in the public areas of the city. His account is of particular interest since it indicates the range of monumental sculpture still in place over half a millennium after the manufacture of such things ceased. The pieces include a great weather-vane with many figures of animals and birds, an equestrian emperor from the Forum of Taurus, a Heracles and several bronze animals from the hippodrome, including an elephant and a hyena. Some figures were apparently of enormous size, like a figure of Hera that required four pairs of oxen to drag the head alone.[5]

The removal from Constantinople of many of the aristocratic families

4 Striker & Kuban, 'Kalenderhane', *DOP* 22 (1968) 185–93; A.H.S. Megaw, 'Notes on Recent Work of the Byzantine Institute in Istanbul' *DOP* 17 (1963) 333–71, 349–64; J. Folda, *Crusader Art in the Twelfth Century*

(Oxford 1982).

5 Niketas Choniates, *Annals*, CFHB, 643, trans H.J. Magoulias, *O City of Byzantium, Annals of Niketas Choniates* (Detroit 1984), 353ff.

must have affected the artists and craftsmen who served them. Some probably also left, following their patrons into exile; others may have been kept in work by commissions from the new Latin rulers, who cannot all have been as uncouth as the Byzantine sources would have us believe. It has been argued, indeed, that a group of high quality gospel books, some of which have Latin as well as Greek inscriptions or even parallel Greek and Latin texts, were made in Constantinople for Latin patrons. As noted above, however, the greatest development of Crusader art is likely to have taken place in settlements outside Constantinople, where greater security and cultural isolation encouraged a hybridization of Byzantine, Frankish and Italian art to produce a new style. A group of Crusader icons has been identified in the collection at Mount Sinai (fig. 220), as has a Crusader 'school' of manuscript painting in the Latin Kingdom of Jerusalem.[6]

While Byzantine patronage of art and architecture declined in the capital, it increased in those areas to which the aristocratic refugees fled.

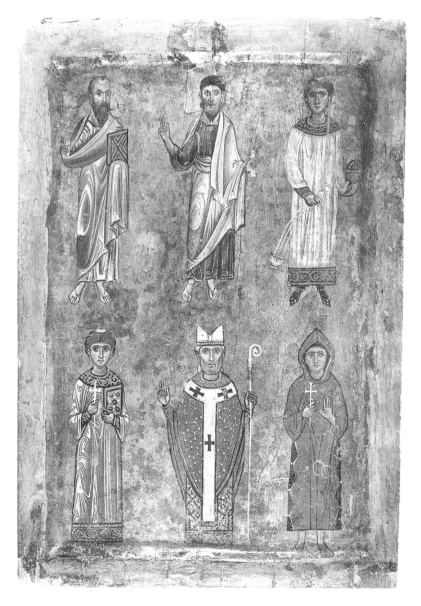

220 'Crusader' icon, probably made in Jerusalem, showing Western saints Martin of Tours and Leo of Limoges (twelfth or thirteenth century) (Monastery of St Catherine at Mount Sinai).

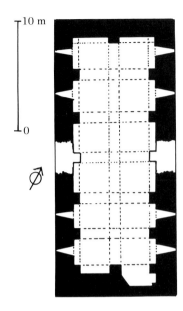

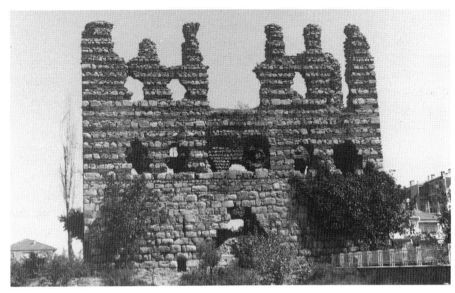

221 Palace at Nymphaion (Kemalpaşa, near Izmir) thirteenth century: plan after Eyice; exterior.

Nicaea, the seat of the most prosperous and ultimately most powerful Byzantine exile community, must have seen a good deal of restoration and new building, although very little remains of it. The large basilica of St Sophia, rebuilt after 1065, and the cross-domed Church of the Dormition, both mentioned in earlier chapters, would still have been in use. In addition, it is known from documentary sources that John III Vatatzes (1222–54) founded a Monastery of St Anthony within the city walls, and another at Sosandra, near Smyrna, where he and his son Theodore II Laskaris were buried. There is no trace of these, but an inscribed-cross church in Nicaea, whose lower courses were unearthed in 1949, has been tentatively identified as the church of St Tryphon, part of a monastery restored by Theodore. The ruins of another church, found about twenty years ago and still unidentified, show it to have been built on the ambulatory plan, in which a domed naos is flanked by aisles to north and south and a narthex to the west. This plan, which has affinities with the early cross-domed church, has an example in Gül Camii, a large church in Constantinople of unknown dedication and history, dated eleventh–twelfth century because recessed brick is used in its construction. The ambulatory plan becomes common in Palaiologan building and the Nicaea church, which is a mature example of the form, is therefore likely to be of the Laskarid period. Indeed, it probably has as much claim to identification as St Tryphon as the inscribed-cross church just noted.

In Nymphaion, near Smyrna, there are the remains of the imperial palace of the Nicaean emperors, used chiefly by John III Vatatzes (fig. 221).

6 For example: Athens, NL 118 and Paris, BN gr. 54: K. Weitzmann, 'Constantinopolitan Book Illumination in the period of the Latin Conquest', *GBA* 86 (1944) 193–214; also Weitzmann, 'Thirteenth-Century Crusader Icons on Mount Sinai', *AB* 45 (1963) 179–203; H. Buchthal, *Miniature Painting in the Latin Kingdom of Jerusalem* (Oxford 1957); G. Kühnel, *Wallpainting in the Latin Kingdom of Jerusalem* (Berlin 1988).

The building is a tower-like rectangular block of four storeys, built of stone at ground level and alternating bands of brick and stone above, resembling Tekfur Sarayı in Constantinople (for which see below). The ground floor, which was probably vaulted, is lit by slit windows and the three upper floors, which formed the residential part of the palace, have larged arched windows.[7]

There is rather more left of the monuments of the Grand Komnenoi of Trebizond. There had been a fortified city on this site at least since Roman times, but as the seat of claimants to the Byzantine throne it gained importance and underwent a phase of rebuilding and renovation, including some extension of the walls. A church of the Theotokos Chrysokephalos on the citadel was rebuilt as a galleried basilica, probably between 1214–35. This form, by now archaic, was probably used to meet the need for a 'great church' for coronations and imperial ceremony (fig. 222). The building survives as Fatih Camii, in somewhat different

222 Chrysokephalos Church, Trebizond (1214–35): view from the northeast; plan after Ballance.

form, since fourteenth century modification added a dome. More typical middle-Byzantine architecture is found at the monastery church of St Sophia, just outside the walls of the city, which was probably founded by Grand Komnenos Manuel I (1238–63) and became his burial place. A portrait of Manuel, identified by inscription, was seen in the church by a nineteenth-century visitor, but has since been lost. The church is an

7 R. Janin, 'Nicée. Etude historique et topographique', *Echos d'Orient* 24 (1925) 482–90; S. Eyice, 'Iznik'de bir Bizans Kilisesi', *Belleten* 13 (1949) 37–51; Janin, *Grandes centres*, 105–25; S. Eyice, 'Le Palais byzantin de Nymphaion près d'Izmir', *Akten des XI. internationalen Byzantinistenkongresses, München 1958* (Munich 1960), 150–3.

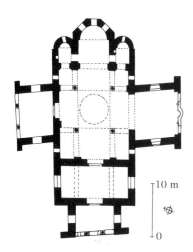

inscribed-cross with three apses and a galleried narthex (fig. 223). It also has some unusual features, gathered from the local traditions of the eastern Black Sea area, such as projecting porches in front of north, south and west entrances are probably derived from Georgian architecture. Relief-carved panels on the south porch, depicting episodes of the story of Adam and Eve, may also be related to a Georgian and Armenian background, (see appendix I). Other carved decoration on the porches includes fifth- and sixth-century capitals and Seljuk 'stalactite' ornament, all *spolia* from earlier buildings. Surviving areas of painted decoration include the Pantocrator in the dome, ringed by a host of flying angels, and prophets and apostles in the drum. The pendentives have an unusual combination of evangelist portraits and festival icons (Nativity, Crucifixion, Baptism and Anastasis). The rest of the programme consists of narrative cycles of the Life and Ministry of Christ, the Passion of Christ and the Life of the Virgin (in the body of the church and the narthex), Old Testament scenes

223 St Sophia, Trebizond (f. 1238–63): plan after Ballance; interior, showing painting: Christ Pantocrator in the dome, angels in the drum, the Nativity, Baptism, Crucifixion and Anastasis in the pendentives; view from the northwest.

(north porch), and a Last Judgement (west porch). In style, the frescoes have features in common with the paintings of Nerezi and also traces of the mannerisms of Kurbinovo. The painters were probably not Trapezuntine, therefore, but came from the western part of the empire – whether or not Constantinople, as is sometimes claimed, cannot be determined.[8]

The third group of exiles, in Epiros, took Arta as their capital. No

8 A. Bryer & D. Winfield, *The Byzantine Monuments and Topography of the Pontos* (Washington DC 1985), 178ff.

238–43; D. Talbot Rice, *The Church of Hagia Sophia at Trebizond* (Edinburgh 1968).

surviving building is attributable to the first Despot, Michael I Angelos Komnenos Doukas, who was murdered in 1215, nor to his half-brother Theodore, who succeeded him, but soon made Thessalonike his base. Michael's illegitimate son, Michael II (1231–71) was responsible for much building and restoration, however, with the encouragment of his pious and long-suffering wife Theodora, who was later rewarded with canonization. The chronology of surviving thirteenth-century churches in Arta has still to be clarified, since most exhibit one or more phases of alteration, but it seems that the chief local church type was the small basilica, with three aisles divided by nave arcades of just two or three columns each. This form is also found at Kastoria and elsewhere in northern Greece and the

224 St Theodora, Arta (founded as the church of St George, mid-thirteenth century): view from the northwest; plan after Orlandos.

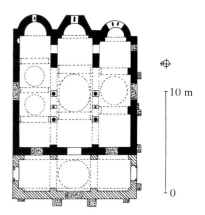

225 *Katholikon* of the Blachernae Monastery, Arta (mid-thirteenth century) plan after Orlandos.

Balkans, and was probably a common provincial type. It was used for the church of the monastery of St George founded by Theodora, where two-column arcades separate the nave and aisles in an interior which is almost square (fig. 224). Theodora retired to the monastery after her husband's death and was eventually buried in the narthex. After her canonization the church was rededicated and is now St Theodora. Modifications to the squat basilical form in Arta consist largely of attempts to bring it closer to standard middle-Byzantine centralized form, a taste which may have been introducd by the refugee aristocrats. Thus, the church of the Monastery of Blachernae, where Michael II and two of his sons were buried, was built as a basilica, but domes were later constructed over the nave and aisles (fig. 225). Similarly, at the church of the Monastery of Kato Panagia, also Michael's commission, a transverse barrel vault crosses that of the nave, producing an interior visually similar to that of an

inscribed-cross church (fig. 226). Another basilica, St Demetrios at Katsouri, outside the city of Arta, was fully reworked as an inscribed-cross, probably in the second quarter of the thirteenth century.

The churches of Arta are built of brick and stone, making use of the 'cloisonné' technique and also of decorative brick patterns, especially above and flanking the windows, producing highly ornate exteriors. Here as elsewhere, capitals, cornices and other carved ornament of much earlier periods are re-used, but there is also a good deal of contemporary sculpture. Newly carved ornament decorates the sanctuary screen of the Blachernae monastery with regular patterns of interlaced circles, stylized foliage and occasional figures (fig. 227). The same style, executed by a less accomplished hand, is found on a panel now forming one side of Theodora's tomb, showing two imperial figures – probably Theodora and her son Nikephoros – between large half-figure angels. All of this carving is robust, taking its ornamental motifs from fifth- and sixth-century *spolia* models. It is sometimes attributed to Constantinopolitan craftsmen exiled with their patrons, but is just as likely to belong to the vigorous tradition of sculptural decoration seen in Greece since at least the eleventh century. The figural element, however, may be a result of Western influence, particularly in the case of the capitals of St George, which are fifth-century pieces partly re-cut to produce relief figures, in the manner of Western figured capitals. Large relief panels, like that of Theodora and her son, and another of the Archangel Michael on the south wall of the Blachernae church, appear to continue the taste for such pieces seen developing in twelfth-century Constantinople (fig. 228).[9]

The fate of art and architecture in Thessalonike during this period is virtually unknown. The city had its own Latin occupation, but a briefer one than that of the capital, lasting only until 1224. It then became the seat of Theodore, the brother of Michael I of Epiros, who set himself up as yet another claimant to the Byzantine throne. Patronage of the arts cannot have been favoured by the turbulence of the period, but nor is it likely to have ceased altogether. Whatever was produced, however, has been lost or obscured by later changes, for there is virtually no trace of the thirteenth-century monuments of the city.

The material culture of central Asia minor in this period is almost as obscure. It may be guessed that twelfth-century traditions continued relatively undisturbed in regions remote from the upheaval caused by the Latin presence (and accustomed, for centuries, to dealing with their more traditional enemies). Such is suggested by two Cappadocian cave churches dated by inscription – Karşı Kilise on the Nevşehir-Gülşehir road (1212) and the Church of the Forty Martyrs in Şahinefendi (1216/17). Both churches are painted, the first with episodes of the Passion cycle, a Last

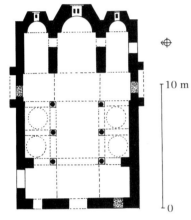

226 Kato Panagia Church, Arta (mid-thirteenth century) plan after Orlandos.

10 m

0

227 Marble sculpture from the sanctuary screen of the church of the Blachernae Monastery, Arta (thirteenth century).

9 A. Foss, *Epirus* (London 1978); G. Millet, *L'Ecole grecque dans l'architecture byzantine* (Paris 1916) (Variorum reprint 1974) 15–16, 22–30; A.K. Orlandos, *Archeion 2*

(1936); D.M. Nicol, *The Despotate of Epiros* (Oxford 1959), 196–203.

Judgement and figures of saints, the second with festival icons and a large barrel-vault image of the Forty Martyrs of Sebaste (fig. 229). Both monuments owe their preservation to their rock-cut nature rather than to their importance, and are of modest quality. They therefore represent the routine artistic production of regions largely unaffected by the tournament being played out by the imperial factions. The Cappadocians were not unaware of the issues, however, since the inscription at Karşı Kilise declares the allegiance of its patron by naming Theodore Laskaris as emperor in its inscription.[10]

In the Balkans, late twelfth- and thirteenth-century ecclesiastical architecture is a hybrid of eastern and western traditions. At Studenica, a monastery founded by the Serbian ruler Stephen Nemanja in 1192, the main church, dedicated to the Virgin, incorporates a domed square flanked by barrel vaults to east and west which form the bema and narthex; an exonarthex lengthens the church still further. The domed bay is extended to north and south by porches. While the domed core is clearly of Byzantine tradition, the longitudinal emphasis of the church, and its exterior decoration of blind arcading, are much more in keeping with the Romanesque (fig. 230). Nemanja retired to Studenica in 1196, abdicating in favour of his son, Stephen Prvovenčani. In 1219 a younger son, Rastko, who became a monk (Sava) of Mount Athos, obtained the approval of the exiled Patriarch in Nicaea for the establishment of an independent Serbian church, and returned to Serbia as its first archbishop. He died in Bulgaria in 1235, but two years later his body was moved to the Monastery of the Ascension in Mileševo, founded in about 1230 by

228 Marble relief showing Theodora of Arta and her son, in the thirteenth-century church of the Blachernae Monastery, Arta.

229 Cave church of the Forty Martyrs of Sebaste, Şahinefendi, Cappadocia, 1216/17: in the barrel vault the Forty Martyrs die of exposure in the lake of Sebaste, while on the lunette one of their number succumbs to temptation and enters the bath-house on the shore.

10 Restle, *Asia Minor*, nos. LI and XLV.

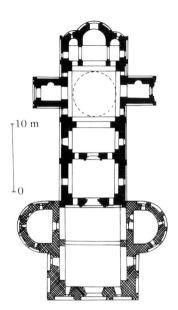

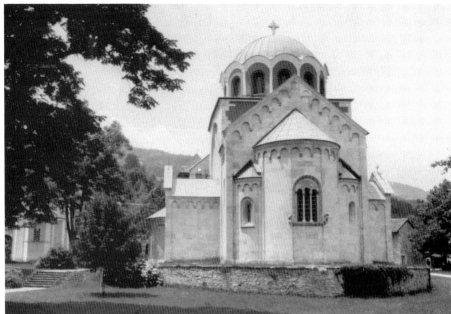

230 Church of the Virgin, Studenica (founded 1192): view from the east; plan, after Radojčić.

Vladislav I, the son of Stephen Prvovenčani. The Church of the Ascension is of essentially the same hybrid form as that at Studenica, but in its painted decoration the cultural dependence of the Balkans on the Byzantine empire is more evident. The programme survives only in fragments, but it appears to have had the usual Byzantine scheme of formal images, festival icons and Passion cycle. It also has two groups of donor images in the Byzantine manner. On the south wall of the narthex, Vladislav, holding a model of the church, is presented by the Virgin to Christ enthroned. In the northeast corner of the exonarthex, a dynastic group shows Vladislav (again with a model of the church), his brother and predecessor Radoslav, and their father Stephen Prvovenčani bowing to Sava (Stephen's brother) and Stephen Nemanja (as the monk Symeon), founder of the dynasty. The group recalls the dynastic imagery favoured by the Komnenoi in the twelfth century.

There are fewer Bulgarian examples of assimilation of Byzantine style and iconography, but there is a very fine example in St Nicholas in Boyana, near Sofia. This may have been an eleventh-century foundation, which the Sebastocrator Kaloyan, a cousin of the Bulgarian Tsar, partially rebuilt and repainted in 1259. In addition to festival icons and a life cycle of St Nicholas, the programme includes images modelled on some of the famous icons of Constantinople, such as Christ of the Chalke, noted above for its prominent role in the events associated with Iconoclasm. In the narthex there are portraits of Kaloyan and his wife, the former holding a model of the church, and of the Tsar (Constantine Asen) and his wife (a daughter of Theodore II Laskaris), both wearing Byzantine court costume.

Back in Serbia, one more generation on, Uroš I, brother and successor to Vladislav, founded a monastery at Sopoćani in about 1256. Its

church of the Trinity, which was painted between 1263–8, became a family mausoleum (fig. 231 a). Anna Dandolo, Uroš' mother, was buried in the narthex soon after it was completed, the body of his father Stephen Prvovenčani was moved to it and Uroš himself was interred against the south wall in 1276. Here, too, the programme follows the Byzantine formula, of which the Virgin and the Divine Liturgy are preserved in the apse, and festival icons and a Passion cycle in the naos and narthex. In the southeast corner of the exonarthex Uroš I and his wife Helena present their young sons Dragutin and Milutin to the Virgin. The church was probably painted before 1268 when Dragutin married, since no bride is included. On the north wall there is a narrative image of the death of Anna Dandolo, iconographically dependent upon the *Koimesis* (Death of the Virgin) which is on the adjacent west wall (fig. 231 b). Comnene imagery is again recalled, this time the scene of the death of Alexios I Komnenos in the Blachernae Palace.

231 Church of the Trinity, Sopoćani (*c.* 1256): (a) exterior from the south; (b) painting on the north wall of the narthex: the death of Anna Dandolo (lower register).

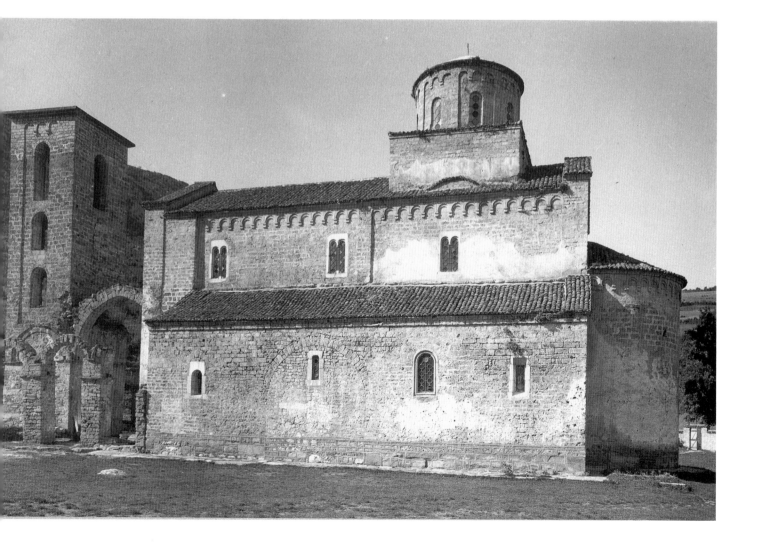

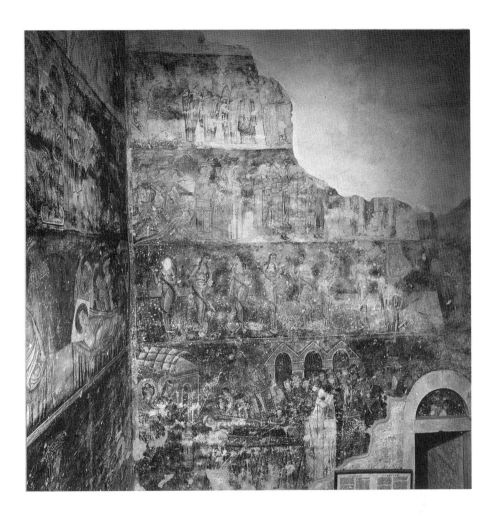

The paintings at Mileševo and Sopoćani fall into two general stylistic groups, sometimes known as the 'court' style, which approximates the 'expressive' style of the twelfth century, and the 'monastic' style, which is rather harder and more restrained. The implied distinction of status of the artists is without foundation, however, and 'Byzantine' and 'Serbian' have been proposed as more plausible labels for the stylistic difference. Some of the paintings at Mileševo are signed with Greek names – George, Demetrios and Theodore – which would perhaps support this, and it is certainly likely that some painters fleeing Constantinople during the Latin Occupation sought work in the Balkans. Their styles may have undergone development as a result, for most of the paintings surveyed here have in common a tendency to increase narrative detail by supplying architectural or other backgrounds and by multiplying the number of bystanders in many scenes. This expansion was conceivably a response to the large amount of wall surface presented by the 'hybrid' Balkan churches.[11]

11 R. Hamman-MacLean & H. Hallensleben, *Die Monumentalmalerei in Serbien und Makedonien* (Giessen 1963–76), 1, 19–23, 25–6, pls. 53–79, 82–98, 115–42. K. Miyatev, *The Boyana Murals* (Sofia 1961).

7 The Palaiologan period

The removal of the Latins from Constantinople and the establishment of Michael VIII Palaiologos as emperor in 1261 gave the Byzantine empire its capital once more, but it also marked the beginning of terminal decline. The ancient problem of neighbours who sought to annexe what was left of Byzantine territory was as pressing as ever, with the Turks growing steadily more powerful in settled bases in western Anatolia, the Serbs encroaching from the north, and the various Western groups looking for an opportunity to move in again. The fragmentation of the Byzantine ruling class into the exile groups of the Latin occupation period presented a serious problem of internal disunity. Constantinople accepted Michael VIII, but his rivals in Epiros and Thessalonike did not, and would soon form alliances with traditional enemies in their attempts to gain power for themselves. They failed, but the conflict between Greek factions was as detrimental to the goal of restoring the strength of the empire as were the depredations of invaders.

In order to allay the threat from the West, Michael VIII offered the bait of church unity, but his diplomatic advances to Rome met with hostility at home. Other diplomatic ventures were more successful. The threat of a new Crusade led from Sicily by Charles of Anjou was removed when Michael's ally Peter of Aragon took power there. In 1282 Peter ousted the Angevin government by means of a Byzantine-aided conspiracy, known as the Sicilian Vespers because it culminated in a bloody rebellion that broke out while the Frankish rulers were at prayer. With the Western threat thus stemmed, Michael's son Andronikos II (1282–1328) was able to defuse the religious crisis by renouncing the plans for unification with the church of Rome, and to turn his attention to the severe economic problems of the empire. The army, consisting largely of expensive mercenaries, was reduced in size. Taxation was increased, but revenue could no longer be gathered from the separatist elements, and the wealth of the Nicaean empire had diminished with the move back to the capital. A conflict between the Genoese and the Venetians, in which Andronikos backed the former, ended in 1302 with the restoration of trading privileges to the Venetians and the establishment of a fortified Genoese settlement in Galata, across the Golden Horn from Constantinople – gains for both groups of Italians, but increased insecurity for the Byzantine empire.

To the north, Bulgar power had declined in the second half of the

thirteenth century, but that of the Serbs grew steadily as they extended their control southwards. Towards the end of the century Milutin, son of Uros I, occupied northern Macedonia. Further encroachment was checked by the desperate, and to many Byzantines unacceptable, expedient of the marriage in 1299 of Andronikos' five-year-old daughter Simonis to Milutin. The match sealed a settlement in which Serbia accepted Byzantine authority in exchange for the right to keep the annexed territory.

Developments in Greece were more promising, with gradual Byzantine recovery of the Frankish principality of the Morea (Peloponnese) which had developed from the apportionment of Byzantine lands in 1204. The fortified town of Mistra, near Sparta, became a stronghold from which the rest of the Peloponnese was gradually recovered. After 1262 the Morea had a Byzantine governor, and it became a Despotate in 1348 when the post was given to Manuel, son of John VI. Thereafter the Despot was always someone close to the Byzantine throne, and Mistra became an important cultural, as well as political centre.

The recovery of Greece could not, in the end, offset the most serious threat of all that was forming to the south. During the thirteenth and early fourteenth centuries several Turkish chieftains and their followers had moved into western Anatolia in order to find territory beyond that held by the Seljuks. One of them, Osman, had ambitions greater than pillage and piracy, and in 1326 settled his tribe in Bursa, to the south of Constantinople, a base from which the disintegration of Byzantine order might easily be exploited.

Disorder came with a civil war between Andronikos and his grandson, Andronikos III (the intervening father, Michael IX, predeceased his son). The eventual victory of Andronikos III in 1328 introduced to power his ally John Kantakouzenos, who became regent when Andronikos died, leaving a nine-year-old son, John V Palaiologos as his successor. Further civil strife ensued as John V grew up, and Byzantine allegiance was split between his faction, supported by Thessalonike, and that of Kantakouzenos, who resorted to potentially dangerous alliances with the Serbians, the Seljuks and finally the Ottomans. By the time John V gained the upper hand, in 1352, the Serbian empire had taken most of Macedonia, including the old Despotate of Epiros, and the Ottoman Turks were poised to move into the Balkans and begin their expansion into Europe, with the Byzantine empire paying them an annual tribute. The last twenty years of his reign saw John V undertaking journeys of extraordinary diversity – to Asia Minor on campaign with Sultan Murat I as part of Byzantine vassallage to the Ottomans, and to Europe in search of Western help to save the east Christian empire. In the course of the latter, John accepted conversion to the church of Rome, a move which had as little appeal for the Byzantine church and people as had the similar overtures of his ancestor Michael VIII.

From the last quarter of the fourteenth century until the fall of

Constantinople in 1453 the web of alliances and treacheries continued to be complex, but the fundamental problem grew simpler as the expanding Ottoman empire reduced the number of Byzantine enemies to one. The Serbian and Bulgarian empires were engulfed by the end of the fourteenth century. For a while Byzantine/Ottoman coexistence was maintained. When Andronikos, the son of John V, rebelled against his father, it was with the assistance of the son of Murat I, and it was Murat who restored order and returned John to his throne. John's successor, Manuel II, spent time in the Ottoman court, now of Sultan Beyazit, but also continued the peripatetic and largely fruitless search for allies in Italy, France and even England. Russia alone sent money, in 1398, to aid the defence of Constantinople. A temporary setback to Ottoman expansion was provided by the Mongol, Timur (Tamburlane), who defeated Beyazit in 1402 near Ankara and thus delayed the attack on Constantinople for a further half-century. There was also a brief period of peace between Manuel and the next Sultan, Mehmet I, but after his death in 1421 the siege of Constantinople began.

A final effort to secure Western help by offering church unity was made at a Council held in Florence in 1438–9, when John VIII, grandson of John V, agreed to an Act of Union the terms of which included Papal supremacy. As a political move this had no effect, since Western aid against the Turks was not given. As an ecclesiastical one it was disastrous, stirring division in Constantinople and alienating the Russian church, which in time took over the guardianship of religious orthodoxy, declaring Moscow to be the 'Third Rome'.

The siege of Constantinople took 31 years, during which the Byzantine border was the city wall, enclosing a dwindling population. It was eventually breached by means of a great cannon built by a Hungarian engineer who, with the traditional morality of arms dealers, had first offered it to Constantine XI. This last Byzantine emperor could not afford to buy expensive artillery and died fighting in the streets of his capital.[1]

Architecture

Building of the Palaiologan period is found in Constantinople and in the Greek provinces, particularly in Thessalonike and Arta, and at Mistra, which became an important centre after Byzantine reocovery of the Peloponnese in the late thirteenth century. Byzantine building continued in Trebizond, but there is little evidence for it elsewhere in Anatolia, not even in Nicaea, which declined once the capital was regained. Conversely, a new spread of Byzantine influence is found to the north, in the architecture of Serbia and Bulgaria, reflecting close, if not always amicable,

1 Ostrogorsky, *Byzantine State*, 450–572; S. Runciman, *The Fall of Constantinople* (Cambridge 1965); D.M. Nicol, *The End of the Byzantine Empire* (London 1979); Obolensky, *Byzantine Commonwealth*, 321–34.

connections between the ruling classes of Byzantium and its neighbours.

The period produced a distinctive final phase of Byzantine architecture that consisted not in the development of new architectural forms, but in new combinations of old ones of several different types. The most characteristic feature of Palaiologan building is in fact superficial rather than structural, consisting of still further development of the Byzantine taste for the ornamental exterior. Traditional decorative features such as niches, recessed arches and alternate coursing of brick and stone are supplemented by bands of brick arranged in rosettes, meanders and herringbone patterns and in some cases by tile-work and relief sculpture. This ornamental exuberance has its roots in middle-Byzantine architecture, particularly that of the Greek provinces, which was probably its source. Indeed, since the Byzantine patron class had been absent from Constantinople for over half a century – or in practical terms, two generations of craftsmen – it is likely that most of the architectural ideas of the Palaiologan period were developed in provincial centres, although they may have used ingredients of ultimately metropolitan origin.

The aristocrats who returned to Constantinople in 1261 found the city squalid and dilapidated, a condition they attributed to Latin uncouthness, but which must also have been a product of natural decay in a city of steadily declining population. Michael VIII made repairs to the Land Walls and had the Blachernae Palace cleaned of the smoke and soot of Baldwin II's coarse *ménage*, but there is no record of new work there and the building does not survive. A palace built in the same district for Theodore Metochites, Grand Logothete under Andronikos II, is known only from a poem written by Metochites which gives no details of its structure, but seems to describe a collection of buildings for himself and his family, with its own chapel. There were other palaces in the area, but the only survival is a substantial ruin on the Land Wall, near to the site of the Blachernae Palace and known as the Palace of the Porphyrogennetos (now Tekfur Sarayı), which may have been built for Michael's son Constantine (fig. 232). This building resembles the Palace of the Nicaean emperors at Nymphaion in that it is a rectangular block of three storeys, the two upper ones with large arched windows. The vaulted ground floor is windowless, but opens through a four-arched portico to a courtyard on the north side. The north facade above it is richly ornamented, with banded voussoirs forming its window arches and decorative tile-work in the spandrels and in a frieze above.[2]

The traditional aristocratic need for personal or family monasteries for retirement and burial was often met by restoring existing structures rather than building new ones. This cannot have been a matter of limited funds, since several sources note the wealth of patrons, garnered during

2 George Pachymeres, *Chronicles*, II.31, CFHB, 219; R. Guilland, 'Le Palais de Théodore Métochite', *Revue des Etudes Grecques* 35 (1922) 82–95; for Tekfur Sarayı: A. Van Millingen, *Byzantine Constantinople: The Walls of the City and Adjoining Historical Sites* (London 1899), 109–14.

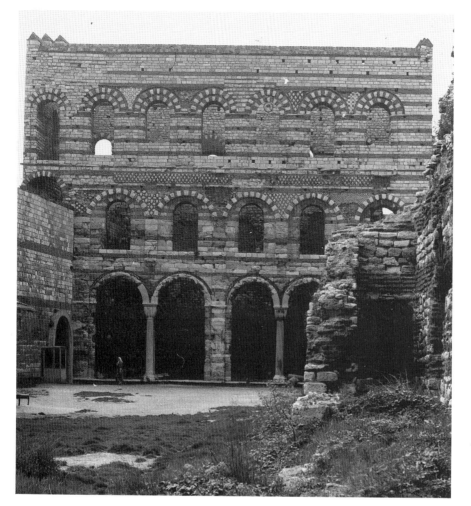

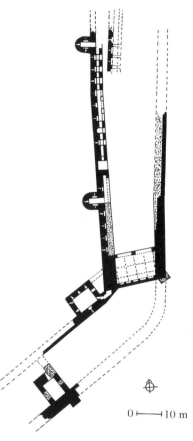

232 Tekfur Sarayı,
Constantinople (late
thirteenth/early fourteenth
century): exterior from the
north; detail; plan after
Meyer-Plath and Schneider.

the prosperous years of exile in Nicaea. It may however indicate limited availability of master builders in the capital, at least at first. These restored monasteries, which may be placed within about seventy years of the recovery of the city, represent the last phase of Byzantine architecture in Constantinople of which there is record and/or remains. It is unlikely, indeed, that much more than running repairs were done in the ensuing century as the end drew closer.

From the documentary record it is known that Michael VIII rebuilt a monastery of St Demetrios founded by his twelfth-century ancestor George Palaiologos, and his sister Maria restored a convent of St Martha. The monastery of statesman and writer Nikephoros Choumnos, dedicated to the Virgin Gorgoepikoos, was probably a rebuilding between 1295 and 1308 of an eleventh-century foundation of Michael IV and Zoe. Nikephoros' daughter Eirene retired in 1308 to her monastery of Christ Philanthropos near the Mangana, of which there remain substructures embedded in the sea wall and a fragment of facade decorated with niches, brick rosettes and meander patterns.[3]

In other instances, entire churches survive. The nature of the work undertaken in each case differed according to the state of the building being renovated, but some common features are evident. Lateral annexes, often with a funerary function, were added to the restored or rebuilt naos, and the additions were usually made in stages rather than in single phases of rebuilding. A final stage consisted of the construction of an exonarthex to link the various elements and present a unified west front. The Theotokos Pammakaristos (now Fetiye Camii) for example, was restored by the General Michael Glabas Tarchaneiotes, possibly as early as the mid-1260s. The starting point was a twelfth-century ambulatory-plan church in which a domed centre bay is separated by paired columns from aisles on all but the east side (see chapter 5). (The plan is a reconstruction: the columns were removed in post-Byzantine alterations.) Michael Glabas must have refurbished the church and may have added the four-bay north annexe with its tomb recesses. Following his death in the first decade of the fourteenth century, his widow Maria (now becoming Martha the nun), added a funerary side-chapel (parekklesion) to the south of the naos (fig. 233). This has the form of a complete inscribed-cross church, with a gallery over its narthex and a large arcosolium for Michael's tomb in the north wall. The inscribed-cross form is unusual for a funerary chapel and was perhaps adopted in order to provide Martha with her own place of worship in a men's monastery. The narthex gallery may have been for her private use. The parekklesion is perhaps the most elegant of the Palaiologan buildings of Constantinople, with slender columns supporting the fluted dome, narrow cornices and shallow capitals of carved marble

3 Janin, *Géographie*, 92–4, 324–6; and 'Les Monastères du
 Christ Philanthrope' *EB* 4 (1946) 135–62, 151–62;
 Mathews, *Istanbul*, 200–4.

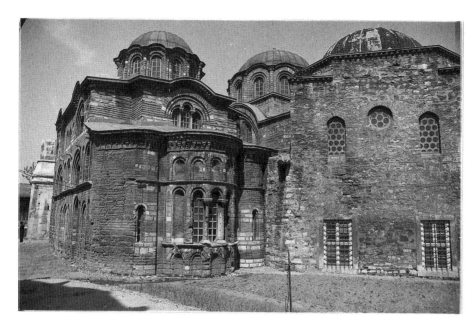

233 Church of the
Theotokos Pammakaristos,
Constantinople. View from the
southeast: Commene church
(right) with Ottoman wall
replacing the apse and
Palaiologan parekklesion (left);
plan after Hallensleben.

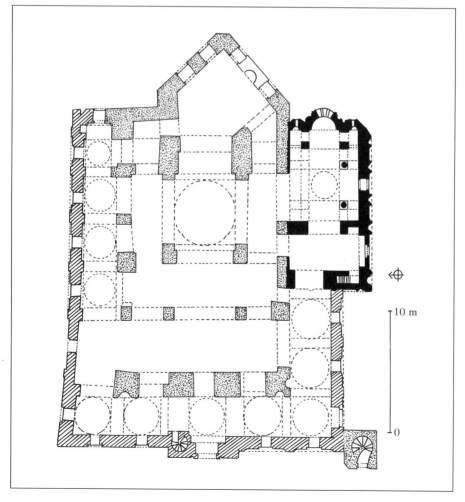

(fig. 255). On the south facade, the three-tier elevation of which recalls Western architecture, shallow niches with recessed borders flank windows and entrances, breaking up the surface and complementing the window-arches of the tall drums of the domes above. On the west facade, banded voussoirs forming blind arches in the upper tier have lunettes with patterned tile-work much like that of Tekfur Sarayı nearby. An inscription composed by Manuel Philes, the Glabas' 'house poet', is set in brick letters in a horizontal band on west and south walls. Sometime after the building of the parekklesion, an exonarthex with easterly projections was built to link the north annexe, naos and parekklesion and unify the exterior. This last stage is undated, but since the new structure abuts the parekklesion, obscuring much of its west facade, it is unlikely to have been added for a decade or more.[4]

The ambulatory church of Glabas' monastery was a matter of inheritance rather than choice, but other patrons appear to have selected the plan, possibly indicating a preference formed during the period of exile in

234 St Andrew in Krisei, Constantinople (after 1284): exterior from the southeast; plan after Van Millingen.

0 |————————————| 10 m

Nicaea, where there is the unnamed example noted in the last chapter. The plan was used for St Andrew in Krisei, the church of a monastery restored by Michael VIII's niece Theodora Raoulina after 1284 (fig. 234). (Only the western pair of columns remains; in north and south bays the columns have been removed, and conches have been added.) The church is now a mosque (Koça Mustafa Paşa Camii) and whatever other structures once existed are now lost or concealed by development of the mosque complex.[5] Michael VIII's widow Theodora also used the ambula-

4 Mathews, *Istanbul*, 346–65; H. Belting, C. Mango, D. Mouriki, *The Mosaics and Frescoes of St. Mary Pammakaristos (Fethiye Camii) at Istanbul* (Washington DC 1978), 3–38; H. Hallensleben, 'Untersuchungen zur Baugeschichte der ehemaligen Pammakaristoskirche der heutige Fethiye Camii in Istanbul', *IstMitt* 13/14, (1963/4) 128–93.

5 Mathews, *Istanbul*, 3–13.

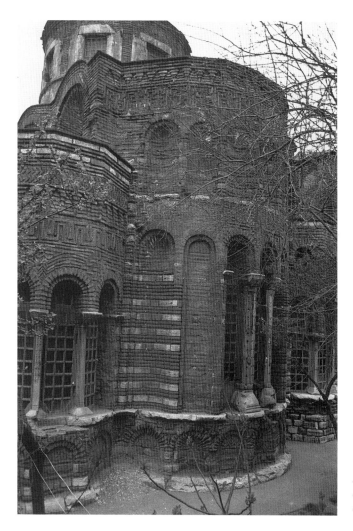

235 East end of the South
church of the Monastery of
Constantine Lips,
Constantinople (*c.* 1282).

tory plan for the church of John the Baptist that she added to the south of
the tenth-century church at the Monastery of Constantine Lips, started in
or before 1282 when Michael VIII died (figs. 235 and 103; the plan is
again a reconstruction). Provision for burials was made in the west and
south aisles of the naos and in the narthex, which is asymmetrical
because it had to accommodate the stair-tower of the old church. On the
exterior of the east end niches with recessed borders again form the chief
ornament, with friezes of ornate brickwork above them. The south and
west facades were obscured by the addition, in a final phase similar to that
at the Pammakaristos, of a south annexe with more tomb spaces, and an
exonarthex running the width of both churches.[6]

 A similar pattern of additions is seen in a church in the Vefa district
near the Aqueduct of Valens, now known as Vefa Kilise Camii, 'the

6 Mathews, *Istanbul*, 322–45; Macridy *et al.*, 'Monastery of
 Lips', 249–315, 3–38.

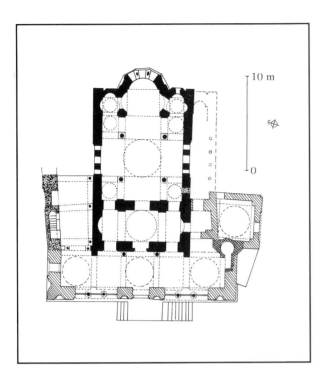

236 Vefa Kilise Camii, Constantinople: eleventh-century? naos with later additions: exterior from the northwest, showing the Palaiologan exonarthex; plan after Van Millingen and Hallensleben.

church-mosque', since its Byzantine identity is unknown (fig. 236). Here, a middle-Byzantine inscribed-cross church, probably of the eleventh century, forms the core, to which were added a rectangular annexe of two bays to the north, and to the south, a belfry and a parekklesion with a south portico (both now lost, but recorded by nineteenth-century observers). All three elements were later linked by an elegant exonarthex of five bays, three of them domed. On the western exterior tall niches flank triple arcades on re-used columns and capitals, partly closed by marble slabs, probably from a fifth-century chancel barrier.[7]

The restoration of the Chora Monastery (Kariye Camii) by Theodore Metochites was started c. 1315 and finished in time for Lenten services in 1321 (fig. 237). The foundation, apse and lower parts of the naos walls of the second Comnene phase (that of Isaac Komnenos) were retained, but all else was new building. The scheme resembles that of the final forms of the other restored churches, with an exonarthex linking a naos and lateral annexes. Thus, the naos is enclosed by an annexe to the north, a four-bay narthex with two domes to the west and a funerary parekklesion to the south. The very thick wall between naos and parekklesion houses two small rooms, one of which, lying behind a tomb thought to be Theodore Metochites' own, may have been his oratory. The exonarthex extends across the entire west end, and, like that of Vefa Kilise Camii, was

7 Mathews, *Istanbul*, 386–401; H. Hallensleben, 'Zu Annexbauten der Kilise Camii in Istanbul', *IstMitt* 15 (1965) 208–17.

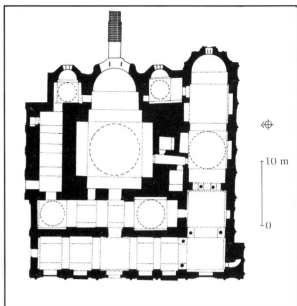

originally a portico partly closed by parapets. The southernmost bay supported a belfry, later remodelled as a minaret. The ornament of the exterior consists of blind arcades on the facades and niches on the east end of the parekklesion; traces of patterned brickwork remain in the spandrels of the north facade.[8]

At the Chora Monastery, Metochites thus achieved in a single programme of building an assemblage of elements arrived at elsewhere by additive stages. At first glance it appears that his builder simply copied the accumulated features of the earlier buildings, but since none of the exonarthexes is dated, and they are in all cases final additions, it is not certain that they were in place by 1315. Instead, the complete scheme of naos, lateral aisles and exonarthex may have been introduced to Constantinople from Thessalonike, where it appears about a decade earlier in the Church of Holy Apostles, dated by monograms and an inscription on the narthex facade to the term of office of Niphon, patriarch of Constantinople 1310–14. Holy Apostles has an inscribed-cross naos fronted by a narthex. This central unit is enclosed by aisles to north and south and an exonarthex to the west (fig. 238). Flanking its central entrance, the exonarthex has triple arcades on pairs of re-used columns and capitals, the openings partly closed by parapets.[9] The arrangement resembles that at Vefa Kilise Camii so closely that both may have been the work of a single master builder, offering both a date in the first quarter of the fourteenth century for the final stage of Vefa Kilise Camii and evidence

237 Chora Monastery Church (Kariye Camii) Constantinople (1321): view from the northwest; plan after Ousterhout.

8 R.G. Ousterhout, *The Architecture of the Kariye Camii in Istanbul, Dumbarton Oaks Studies* 25 (Washington DC 1987), 37–90.

9 N. Nikonanos, *Oi Hagioi Apostoloi Thessalonikes* (Thessalonike 1972); Diehl, *et al.*, *Salonique*, 189–200.

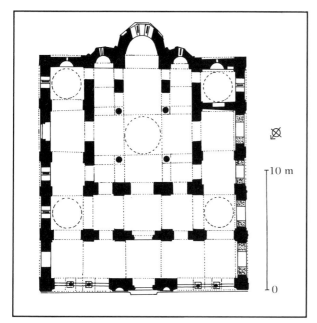

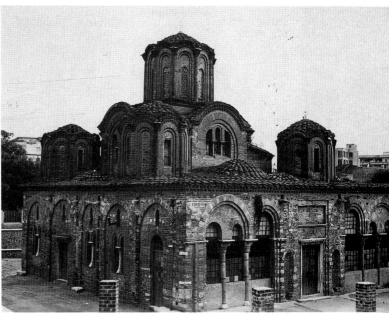

238 Holy Apostles, Thessalonike, 1310–14: plan after Tapoulas/Nikonanos; exterior from the northwest.

239 St Panteleimon, Thessalonike (fourteenth century) plan after Diehl.

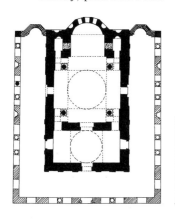

of the movement of architectural ideas, and perhaps of craftsmen, between Constantinople and Thessalonike. Such ties are also evident from the documentary sources which show members of the Palaiologan patron class moving between the two cities. Either Michael VIII or his grandson Michael IX made extensive repairs to St Demetrios, for example, and in the same church an inscription dated 1303 names Michael Glabas and his wife Maria as patrons of the basilical chapel of St Euthymios added to the east end.[10] It may well be, therefore, that the scheme with enclosing aisles and exonarthex seen at Holy Apostles in Thessalonike was introduced to Constantinople either by the Chora Monastery church, or by the final stages of one or more of the other restored monastery churches, prompting other patrons to tidy up their haphazard church fronts in a similarly streamlined manner.

Comparable schemes are found in several other undated Palaiologan churches of Thessalonike. At St Panteleimon the surviving inscribed-cross naos and domed narthex were once enclosed by aisles and narthex with open columnar arcades on all three sides (fig. 239). At St Catherine, a similar form was achieved in two stages when aisles and narthex were added to an inscribed-cross naos. The narthex is open on three sides through arcades on columns, the openings partly closed by parapets, resembling the arrangement at Holy Apostles. Even the small church of Nikolas Orphanos, attributed to the fourteenth century by the style of its painting, has a parallel arrangement, its small roofed naos enclosed by a wide U-shaped aisle (fig. 240).[11]

10 G.A. & M.G. Soteriou, *H Basilike tou Hagiou Demetriou Thessalonikes* (Athens 1952), 224–5.

11 Diehl, *et al., Salonique,* 167–86, 218–19.

It would seem therefore that in the Palaiologan period the 'enclosing aisles' formula (or aisles and exonarthex) evolved to meet some functional requirement – perhaps simply that of extra space around the naos that could be used to house side chapels and tombs. Exactly when and where this development occurred is uncertain, however. For the reasons given above, the location is unlikely to have been Constantinople, since the scheme was not used for the thirteenth-century restorations, but was applied to them in later phases of alteration. Thessalonike is a likely point of origin, in spite of the lack of dated examples before the early fourteenth century, but the scheme does appear earlier, in the grandest church of the Despotate of Epiros, the Theotokos Paregoritissa (fig. 241). This was built after 1283 for Nikephoros, son of the Despot Michael II and his wife Anna, a niece of Michael VIII Palaiologos. The naos here is unique in its ingenious use of *spolia*, for the dome is carried on eight supports made of columns in three stages, standing on brackets made of further columns sunk horizontally into the wall. The result is much like a wedding-cake decoration, so unstable in its appearance that it must have been an act of faith for the congregation to assemble below it. The ornate exterior is constructed of stone and brick in 'cloisonnée' courses, often decorated with patterns made of brick and pieces of carved marble gathered from earlier buildings. The influence of the West is seen in the three-storey exterior elevation, which is windowless at ground level and has rows of regular windows in the upper tiers, not unlike the palace buildings noted above. Direct Western involvement is also evident in carved capitals, corbels and

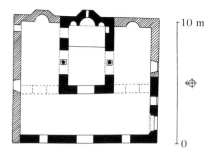

240 St Nicholas Orphanos, Thessalonike (early fourteenth century) plan after Diehl.

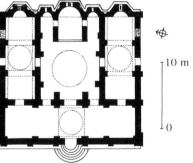

241 Theotokos Paregoretissa, Arta (after 1283): exterior from the northwest; plan after Orlandos.

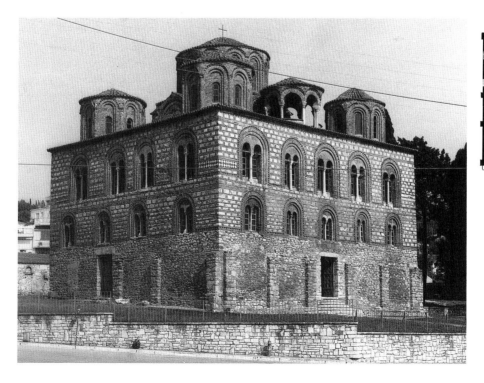

voussoirs decorated with figures, which were probably done by Italian stonemasons.[12]

A variety of influences produced several different building types at Mistra after 1262 when restored Byzantine rule made the settlement an important cultural as well as strategic centre. St Demetrios, known as the Metropolis, was built by 1291/2, the date of an inscription naming Nikephoros, metropolitan of Lacedaemonia. The church was originally a squat basilica of the type seen widely in the Greek provinces, with three-column arcades and barrel vaults (in the fifteenth century it was remodelled by the addition of a domed upper storey) (fig. 242). St Theodore,

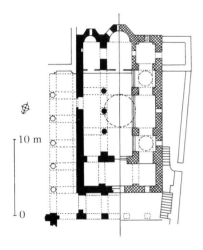

242 St Demetrios, Mistra (late thirteenth century, fifteenth century dome): plan after Orlandos; exterior.

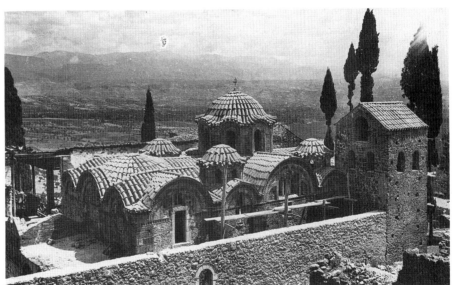

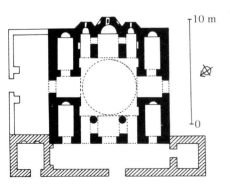

243 St Theodore, Mistra (late thirteenth century) plan after Orlandos.

a church of the Brontocheion Monastery, probably built between 1290–5, is quite different, using the Greek-cross-octagon plan seen in eleventh-century examples such as Hosios Loukas (fig. 243). The Theotokos Hodegetria (Aphendiko), a second church built for the same monastery about twenty years later, is different again, combining a basilical ground floor almost identical to that of St Demetrios, with an inscribed-cross gallery floor, an arrangement that puts a dome above the nave of the basilical ground floor (fig. 244). This scheme was used again in the fifteenth century, for the remodelling of St Demetrios, mentioned above, and for the Pantanassa church founded, according to a lost inscription, by the Protostrator John Phrangopoulos, and dedicated in 1428. The common Greek variant of the inscribed-cross, with two columns and two piers, also appears at Mistra, in St Sophia, built by the first Despot, Manuel Kantakouzenos (1348–50) and was used also for the Peribleptos and

12 Mango, *Architecture*, 259–62; A.K. Orlandos, *H Paregoretissa tes Artes* (Athens 1963).

Evangelistra churches, which are undocumented and undated. Exteriors at Mistra are as ornate as those of Constantinople and Thessalonike, but the effect is achieved by different means, since the fabric is the cloisonné stone and brick traditional to central Greece, with serrate brick courses under the eaves and framing windows.[13]

Mistra also provides more physical evidence of domestic architecture than is available from any other Byzantine site, but not strictly of Byzantine domestic architecture, since Western origins may be cited for many features. The palace complex of Mistra has three phases, the earliest of which probably belongs to the Frankish period (before 1262) and consists of a two-storey block with pointed-arch windows and a kitchen wing, also of two storeys, with cisterns below it (fig. 245). In the second phase, possibly of the Despotate of Manuel (1348–80) a further two-storey block with six rooms on each floor was added, abutting the kitchen wing. At the north side of this building a portico fronts the ground floor, its roof forming a terrace for the upper floor, the openings into which are decorated with ogival mouldings. The third and largest palace building is another rectangular block with a vaulted cellar/substructure carrying a

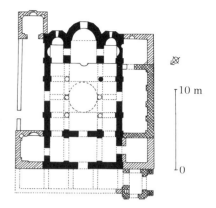

244 Church of the Theotokos Hodegetria, Mistra (early fourteenth century) plan after Orlandos.

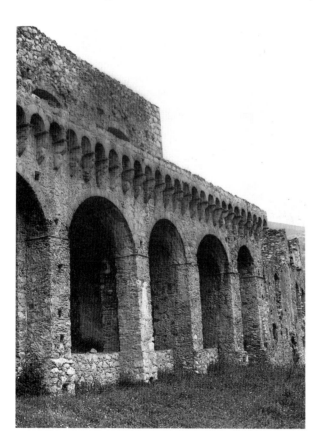

245 Palace complex at Mistra: view of central block, from the east; plan after Orlandos.

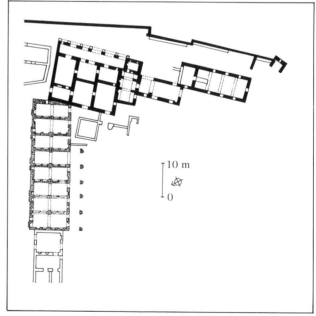

13 M. Chatzidakis, *Mistra* (Athens 1987); M.G. Soteriou, *Mistra* (Athens 1956).

first storey of eight rooms, also vaulted, each opening to the east facade. The entire second floor is an audience hall with two rows of windows on the east side, circular above and rectangular below, capped by ogival mouldings; a throne-niche in the east wall forms the only projection on the exterior. As in the previous building, a porch fronting the lower floors forms a terrace at the audience hall level. This final phase of the palace may belong to the period 1384–1460 when members of the Palaiologos family were appointed to the Despotate, but as with the other phases, no firm evidence of date is available. Also undated, the houses of Mistra range from modest to grand proportions, but all follow much the same principle as the palace structures, with upper residential floors and a lower utility area, often with a terrace on one face at first floor level.[14]

In buildings of the Palaiologan period in Thrace and the Balkans elaborate exterior decoration is particularly conspicuous. In Selymbria (Silivri), in Thrace, a decorative scheme like that at Tekfur Sarayı, with banded voussoirs and tile decoration in the spandrels, was used at the inscribed-cross church of St John the Baptist, built between 1321–8 by Alexios Apokaukos, a member of the court of Andronikos III. In Bulgaria, Mesembria (Nessebur) on the Black Sea coast has several fourteenth-century churches of various forms, also with blind niching and brick-pattern ornament. The inscribed-cross church of St John Aleitourgetos, for example, has niches with banded voussoirs and tile-decorated lunettes that resemble those of the west facade of the parekklesion of the Theotokos Pammakaristos (fig. 246). Further to the west, an exonarthex was added

246 Mesembria (Nessebur), St John Aleitourgetos (fourteenth century), view from the northeast.

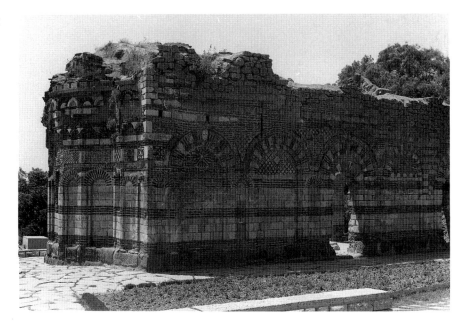

14 A.K. Orlandos, 'Ta Palatia kai ta Spitia tou Mystra', *Archeion* 3 (1937) 3–52.

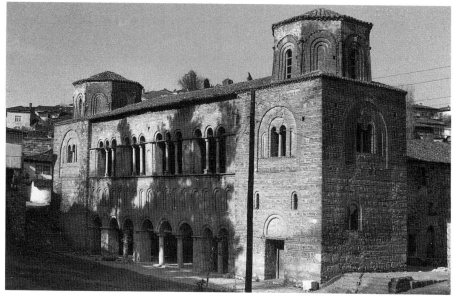

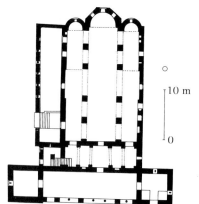

247 St Sophia, Ohrid: view of the Palaiologan exonarthex, plan after Schellewald.

to St Sophia in Ohrid in 1313/14, consisting of lateral towers linked by a two-storey structure with open arcades (fig. 247). On the upper floor these are of three arches each, flanked by niched piers, an arrangement recalling that of the narthexes of Vefa Kilise Camii in Constantinople and Holy Apostles in Thessalonike. A frieze of small blind niches decorated with brick patterns runs above the lower arcade, and an inscription in brick above the upper one.[15]

Architecture in Serbia continues to depend upon both Byzantine and Western traditions in varying proportions. The close ties with Constantinople established by the marriage of Uroš II Milutin to Simonis are reflected in several of his commissions. The Theotokos church at Prizren (1306/7) and St George at Staro Nagoričino (1312/13) both have inscribed-cross plans extended to east and west, an adjustment necessitated by the fact that both were built using the shells of earlier basilicas. Milutin's monastery at Gračanica, which was completed by 1321, is even closer to Byzantine models, although not reproducing any known example exactly (fig. 248). The church uses the 'enclosing aisles' scheme, in which an inscribed cross naos is embraced by aisles which end in side chapels, and a narthex. The structure of the naos is elaborated in a manner that defies brief explanation, but consists essentially of the addition of a gallery level which duplicates the inscribed-cross formula. This is seen most clearly on the exterior, where two sets of cross-arms flank the dome, one above the other, the top set with pointed arches. The domes of corner bays rise above small towers, adding to the 'stilted' effect and giving the upper

15 F. Forlati, C. Brandini, Y. Froidevaux, *Saint Sophia of Ochrida* (Paris 1953); P. Magdalino, 'Byzantine Churches of Selymbria', *DOP* 32 (1978) 309–18.

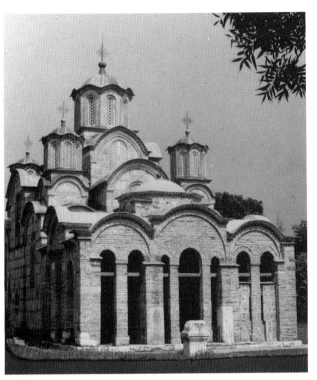

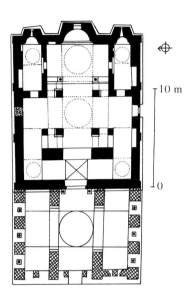

248 Church of Gračanica Monastery, Serbia (built by 1321, exonarthex added later): plan after Ćurčić; view from the northwest.

part of the building an alpine appearance. Opinions differ as to whether this confection is the result of Serbian imagination working on Byzantine forms, or a wholly Byzantine development. More straightforward dependence on Byzantine models is seen in the church built by Milutin in the Chilandar Monastery on Mount Athos, the foundation of his ancestors Stephen Nemanja and Sava, which follows the Athonite triconch scheme.[16]

Milutin's son, Uroš III Dečanski, returned to traditional Serbian form for his monastery at Dečani, built in 1327–35. This has a five-aisled naos with a dome over the centre bay and a large nine-bay narthex to the west. The roofing of each section at two levels, like a basilica, and external details such as blind arcading under the eaves and sculpted portals, give the building a decidedly Romanesque appearance, like that of Sopoćani, built for Uroš I about seventy years earlier. Dečani is the exception rather than the rule, however. The inscribed-cross reappeared in the church of the Monastery of the Archangels, Prizren (now lost), built for Dečanski's successor, Stephen Dušan in the mid-fourteenth century, and later on the Athonite triconch was used for churches at Ravanica (c. 1375) and Kalenić (1413–17). It was the Byzantine tradition, rather than the Romanesque, therefore, that had the greatest impact on Serbian church building.[17]

16 D. Ćurčić, *Gračanica* (University Park PA/London 1979).
17 Mango, *Architecture*, 316–23.

Sculpture

The carved stone ornament of Palaiologan buildings in Constantinople consists, like that of middle-Byzantine ones, of both new material and re-used pieces. The supply of the latter must have been greater than ever in the late thirteenth-century city, as the result of neglect and declining population. The exonarthex of Vefa Kilise Camii has several matched Corinthian capitals, a pair of fluted basket capitals and several parapet slabs, all of the fifth or early sixth-centuries. Sixth-century material at the Chora Monastery church includes a lintel in the naos and a pair of capitals at the entrance to the parekklesion, and there are also the four capitals decorated with high-relief busts of angels, mentioned in chapter 5, which are probably twelfth century. These were used in the southernmost bay of the exonarthex to support arches added shortly after completion of Metochites' rebuilding, to strengthen the bay beneath the belfry.[18]

New carved ornament often reproduces old forms. The decoration of cornices and window fittings in the new south church of the Monastery of Lips is similar in style to that of the tenth-century sculpture of the North Church and probably represents a concern to unify the two interiors. A much earlier style is reproduced in the parekklesion of the Pammakaristos and the naos of St Andrew in Krisei, where impost capitals are decorated with the spiky, stylized acanthus of Justinianic carving. The same motif is also the basis of the most distinctive form of Palaiologan ornament in the capital, which consists of stylized acanthus projecting sharply from the background plane and curling forwards. This is found on two tomb-fronts in the parekklesion of the Chora Monastery church. The tomb-niche thought to be that of Theodore Metochites has a rim of such ornament around its arch, once supported on colonnettes, and a panel above bearing a central bust of Christ flanked by two half-figure angels in the spandrels (fig. 249). Opposite, the tomb of Metochites' contemporary, Michael Tornikes, has a similar frame, but with a panel bearing an inscription at its top. The arched marble frames partly obscure adjacent painting and were probably added when Metochites and Tornikes were buried (Metochites in 1332 and Tornikes at an unknown, but probably proximate date). Similar frames were also used in the naos of the church. A mosaic icon of the Virgin to the right of the apse retains an upper panel in which projecting acanthus frames a lunette enclosing the bust of Christ flanked by angels. The frame was completed by colonnettes, now lost, which stood on corbels, of which one survives. Traces remain of a matching frame enclosing the mosaic icon of Christ to the left of the apse, and it has been proposed that the two once formed the lateral extremities of an elaborate iconostasis. Fragments of similar framing elements, of uncertain provenance and function, are conserved in the Istanbul Archaeological

18 Mathews, *Istanbul*, 388, 394–5; Ø. Hjort, 'The Sculpture of the Kariye Camii', *DOP* 33 (1979) 201–89.

249 Carved marble canopy of the tomb of Theodore Metochites in the parekklesion of the Chora church (Kariye Camii), Constantinople (c. 1332).

250 Marble funerary stele of a Palaiologan lady (Istanbul Archaeological Museum).

Museum and it would seem that they were a fashion of fourteenth-century Constantinople.[19]

Both the stylized acanthus ornament and the overall form of arched framework draw upon early Byzantine models, recalling the sixth-century Consular diptychs and the arched decoration of sarcophagi, a retrospectivity that may demonstrate a conscious attempt to duplicate the splendours of the past. At least it indicates the availability of high-quality craftsmanship in the capital. This is also apparent from the production of the monumental relief figure seen in the twelfth century, for which Western influences were proposed above. A fragmentary funerary monument for a lady of the Palaiologos family, found in the St Sophia district, uses the formula of the twelfth-century monumental icon, setting a female figure against a plain ground bearing an inscription (fig. 250). The figure, the upper part of which is lost, may have depicted the Virgin, or perhaps the deceased lady herself. There was also some production of figured capitals in the

19 Macridy *et al.*, 'Monastery of Lips', 309–10; Matthews, *Istanbul*, 361–4, 10–12; Hjort, 'Sculpture', see n.18, 201–89.

251 Palaiologan figured capital, with busts of military saints (late thirteenth/ fourteenth century) (Istanbul Archaeological Museum).

252 Carved marble archivolt from the south church of the Monastery of Constantine Lips, Constantinople (late thirteenth century).

tradition of the twelfth-century ones that were re-used in the Chora Monastery church. Excavation at the Pammakaristos produced a capital decorated with three high-relief busts of apostles, probably from an iconostasis. A similar piece, now in Paris, has busts of military saints on three faces, as does a third, in the Istanbul Archaeological Museum (fig. 251). The figures of all three capitals are naturalistic, with long faces, bulbous foreheads and heavy-lidded eyes. The style appears also in busts of apostles on an archivolt found beneath the floor of the North Church at the Monastery of Lips (fig. 252). This find-site, and the naturalistic style,

caused the piece to be attributed to the tenth-century 'Macedonian Renaissance' until the Pammakaristos capital appeared. In fact, the archivolt was probably the rim of a tomb-front which embellished one of the imperial arcosolium graves in the new south church. It retains a few fragments of a band of acanthus ornament curling above the busts of apostles, like that of the two tomb-fronts in the Chora Monastery church. Both the style of the figures and their use on an archivolt are to be associated with the sculptural traditions of the mediaeval West. It is possible that some of the Western sculptors who worked at provincial sites, such as Arta, or on the Serbian churches of the Balkans, found their way to the capital as it became once more a centre of important artistic patronage.[20]

Finally, Pachymeres records earthquake damage to a bronze figure group set on a column near the Holy Apostles, showing Michael VIII kneeling to present a model of the city of Constantinople to the Archangel Michael. The bronze must have been made before Michael's death in 1282, and may have been set up earlier, to celebrate the Byzantine recovery of the city. It may have been an isolated example of its kind, possibly the work of an Italian craftsman, for there is neither physical nor documentary evidence that monumental figures were widely produced. It nevertheless offers evidence that the Palaiologan period saw the reintroduction, after a lapse of many centuries, of the monumental free-standing figure, a logical end to the revival of figure sculpture begun in the twelfth century.[21]

Monumental art

The Palaiologan restoration of buildings in Constantinople naturally brought with it a revival of monumental art. It may be guessed that while some workshops had continued to function in the capital during the Latin occupation, others would have come in from the Despotates, on the coattails of their patrons. Probably the earliest surviving example of new work is a panel in the centre bay of the south gallery of St Sophia, a *Deesis*, with standing figures of John the Baptist and the Virgin flanking Christ enthroned (fig. 253). The lower third of the panel, which may have contained a donor image or an inscription, is lost, so the work is undated, but its stylistic similarity to Palaiologan mosaic described below places it in the second half of the thirteenth century. The mosaic differs from middle-Byzantine work in both style and technique, using very small tesserae for faces and hands to achieve fine detail and modelling of figures of slender

20 Grabar, *Sculptures/Moyen Age*, nos. 128, 130, 135; Fıratlı, *Sculptures*, nos. 115, 238, 414; Macridy *et al.*, Monastery of Lips, 252, 262–4; W.H. Buckler, 'The Monument of a Palaiologina' in *Mélanges offerts à M. Gustave Schlumberger* (Paris 1924), 521–6; H. Belting,

'Zur Skulptur aus der Zeit um 1300 in Konstantinopel', *MünchJb* 23 (1972) 63–100.

21 Pachymeres II, 234 (see n.2) trans. Mango, *Sources*, 245–6.

proportions. The location of the Deesis panel, in the part of St Sophia given
to portraits of emperors and patriarchs, makes it likely that it was set up to
commemorate the recovery of Constantinople.[22]

253 Mosaic panel of the
Deesis in the south gallery of
St Sophia, Constantinople
(soon after 1261).

Mosaic decoration also survives in the Chora Monastery church, the
Theotokos Pammakaristos and Vefa Kilise Camii in Constantinople, and
outside the capital there is mosaic or painting at many of the churches
mentioned above, particularly in the Balkans, a relative abundance of
material which permits some generalizations about the programmes of the
period. The middle-Byzantine formula, with its festival icons and formal
images in the main vault spaces of the naos, is still present, and alongside
it there appears to be greater development of the narrative component.
Detailed cycles of the Infancy, Ministry and Passion of Christ, the Life of
the Virgin, and sometimes the lives of saints appear in aisles, narthexes
and on the naos walls in painted churches. Such cycles are not new as ele-
ments of the programme, but the number of episodes and the detailed
treatment of each scene is increased, following the trend seen in the
twelfth-century programmes of Norman Sicily and in the mid-thirteenth
century at St Sophia at Trebizond and the monastery of Uroš I at Sopoćani.

Most of the components noted above are found in the decoration of
Theodore Metochites' church at the Chora Monastery in Constantinople,

22 T. Whittemore, *The Mosaics of Hagia Sophia at Istanbul.
 Fourth Preliminary Report. The Deesis Panel of the South*
 Gallery (Boston MA 1952); H. Kähler and C. Mango,
 Hagia Sophia (London 1967). 58–9.

A: Patron and Christ
B: Patrons in *Deesis*
C: Presentation of the
 Virgin in the Temple
D: Miracle at Cana
 Miracle of Loaves
 and Fishes

254 The decoration of the church of the Chora Monastery (Kariye Camii), Constantinople, complete by 1321. (a) Scheme.

the architecture of which is described above (fig. 254 a). Following the tradition of centuries, the naos and narthexes are panelled in coloured marble and have mosaic in the vaults. Most of the mosaic of the naos is lost, but there are substantial remains in the domes, vaults, arches and wall lunettes of both narthexes. The Life of the Virgin occupies three bays of the inner narthex (fig. 254 b), where the dome of the north bay has a bust of the Virgin at its summit, and ancestors of Christ in its sixteen fluted segments. The narrative cycle starts below, on the northwest pendentive, and makes a circuit of the lunettes and vaults of three bays, ending on the east lunette of the domed bay, next to its starting point. Here and in most

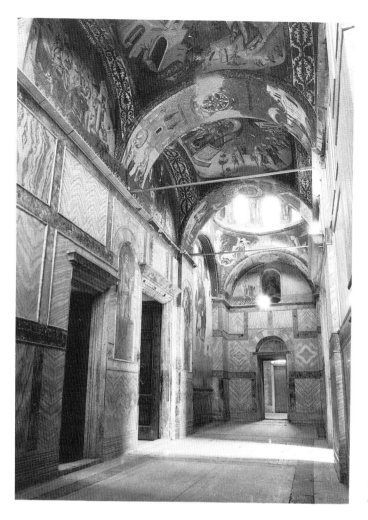

254 (b) inner narthex, view to the south, showing the Life of the Virgin in the vaults and the donor image above the door to the naos (mosaic).

other contexts the cycle is based on the account given in the apocryphal Protevangelion of St James, which tells of the birth of the Virgin to Joachim and Anna, who take her as an infant to the temple. Here she grows up, nurtured by angels and instructed by the priests, until her betrothal to Joseph. Narrative sequence is slightly adjusted in order to place the important episode of the Presentation of the Virgin in the Temple in the vault of the third bay, above the entrance to the naos. The Infancy of Christ, in eighteen episodes, from the Dream of Joseph to Christ taken to Jerusalem for Passover, is placed in the lunettes of the exonarthex and the bay linking it to the parekklesion. This cycle starts on the north wall and moves south along the west wall, finishing back at the north end of the exonarthex. A Ministry cycle then moves south in the vaults and arches of the same L-shaped area, continuing into the last bay of the inner narthex and ending under the south dome. The cycle has about twenty-nine episodes (some are missing), most of them scenes in which Christ miraculously heals the sick or disabled. The south dome, with Christ at its summit, has more ancestors of Christ in its twenty-four flutes, complementing

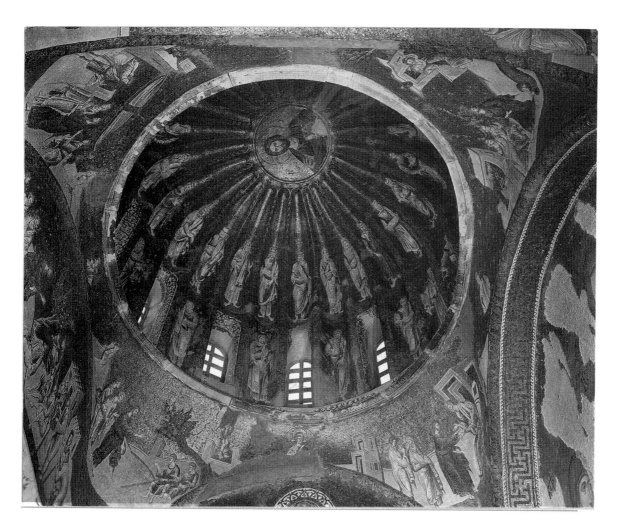

254 (c) south dome of the inner narthex: Christ Pantocrator with prophet-ancestors in the flutes of the dome; miracles of healing in the pendentives (mosaic).

the programme of the north dome (fig. 254 c). There is no structural reason for the larger number of flutes here, which may therefore have been dictated by the spatial requirements of the 'ancestor' programme, planned before the building was complete.

The mosaic of the naos is lost, except for the icons of Christ and the Virgin mentioned above, which flank the apse, and the Dormition on the west wall. It may be deduced that festival icons were once present, since the Christological cycles of the narthexes lack several important episodes, such as the Annunciation, Baptism, Adoration of the Magi, Presentation, and Transfiguration. There are no areas of loss anywhere in the church to account for a Passion cycle, but episodes such as the Entry into Jerusalem and Crucifixion were probably present among the festival icons of the naos. A poem by Theodore Metochites makes it clear that the monastery was dedicated to Christ and the Virgin, and the programme is clearly appropriate to this dedication. This said, it is also the case that cycles pertaining to Christ and the Virgin form a major component of the decoration of most churches of the Palaiologan period, whatever their dedication.

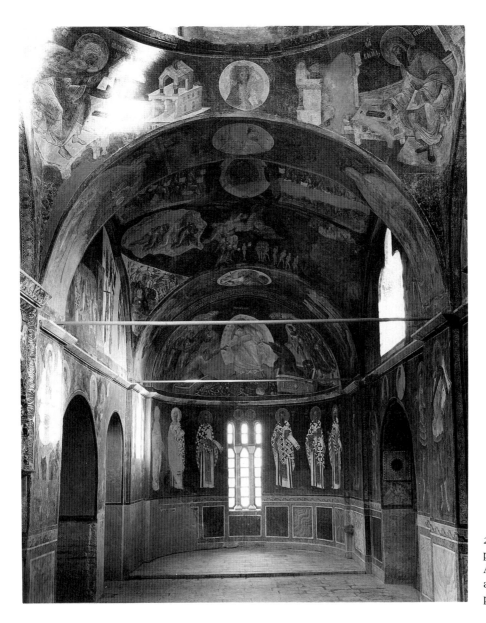

254 (d) the funerary parekklesion, showing the Anastasis in the conch of the apse, Last Judgement in the preceding vault (painting).

The style of the Chora mosaics is related to that of the Deesis panel of St Sophia, Figures are tall, with small heads and wide, 'boneless' bodies, given approximate anatomical form by their draperies. Heavy shadows give anxious or gloomy expressions to faces set above goitred necks, and postures and gestures are mannered. In narrative images the figures are often set against backgrounds of lurching architectural forms that suggest distant, and none too committed, reference to the formulae of perspective drawing.

The same style is found in the painting of the parekklesion, which must have been decorated by the same workshop (fig. 254 d). The change of medium is unlikely to have been motivated by reasons of economy, as is

sometimes suggested, for Theodore Metochites does not seem to have been troubled by lack of funds. The combination of mosaic and painting in the same programme has been seen before – at Hosios Loukas, for example, and at St Sophia in Kiev – and may have been chosen simply to provide variety of embellishment. It also has the advantage of providing more fields for decoration, since it was customary to use the walls as well as vaults for painted schemes. The programme of the Chora parekklesion served two themes, that of the Resurrection, with evident reference to the funerary function of the parekklesion, and that of the exaltation of the Virgin. The first occupies the eastern bay and the apse, where the Anastasis is placed in the conch. This is one of the most famous works of Byzantine art, in which a dynamic figure of Christ strides across the broken gates of Hell and hauls Adam and Eve from their graves in readiness for the Last Judgement. Resurrection miracles (the Raising of the Daughter of Jairus, and of the Widow's Son) are placed on the apse arch, and the Last Judgement itself fills the vault and walls of the eastern bay. In the western bay the second theme begins in the dome, which has a bust of the Virgin at its summit and angels in the ribbed sections below. John of Damascus, Cosmas, Joseph and Theophanes, who all wrote hymns in praise of the Virgin, occupy the pendentives, their iconography and location paralleling that of evangelists in other contexts. Arches and lunettes flanking the western bay have Old Testament subjects which prefigure the Virgin (Jacob's Ladder, for example, which, like the Virgin was a route to Heaven, and the Ark of the Covenant, an earlier Vessel of the Lord).

Other parts of the decoration concern the patronage of the monastery (fig. 254 e). Theodore Metochites is represented in the lunette above the entrance from inner narthex to naos, where he kneels before Christ, presenting a model of his church. To the right of this, on the east wall of the domed south bay of the inner narthex, a much larger panel shows the Virgin interceding with Christ on behalf of small figures of Isaac Komnenos, the twelfth-century patron of the monastery, and Melane the nun, a lady of Metochites' family, who presumably had some role in the patronage of the Palaiologan phase (fig. 254 f). At intervals after completion of the decoration, more painting and some mosaic was added to the tomb-niches of the parekklesion and others made by blocking the open arches of the exonarthex. The best preserved example is that of the tomb of Michael Tornikes, noted above for its carved canopy. Michael and his wife are depicted twice, in secular dress on the back wall of the niche and in the monastic dress of their retirement on the side walls. The decoration of Metochites' tomb is entirely lost.[23]

A second mosaic programme surviving in Constantinople is that of the inscribed-cross parekklesion at the Theotokos Pammakaristos, built by

23 P.A. Underwood, *The Kariye Djami*, I-III (New York 1966); IV (London 1975).

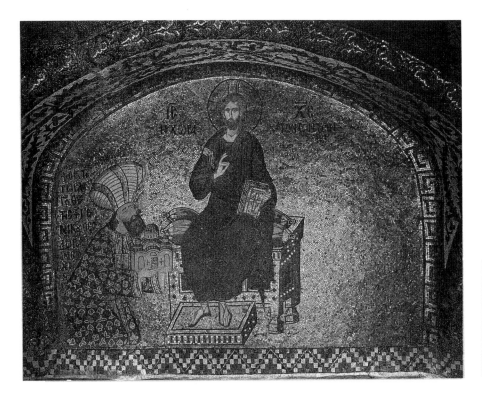

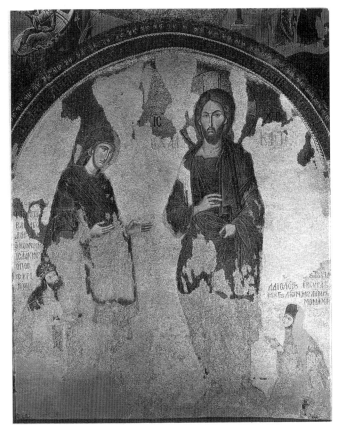

254 (e) panel above the door from narthex to naos showing the patron, Theodore Metochites, kneeling before Christ; (f) *Deesis* with Isaac Komnenos and Melane the nun (both mosaic).

Martha Glabas as a funerary chapel for her husband (fig. 255). The chapel had a festival icon programme, of which only the Baptism remains. Christ enthroned in the conch of the apse and John the Baptist and the Virgin in flanking lunettes creates a Deesis in the sanctuary vault pertinent to the funerary function of the chapel. Nothing remains of the interior decoration of the main church, restored by Michael Glabas, but there are fragments of a painted programme exalting the Virgin on the exterior south wall (now within the added south aisle). This painting on an exterior wall

255 Interior of the funerary parekklesion of the Theotokos Pammakaristos (Fetiye Camii), Constantinople (first decade of fourteenth century), view to the east.

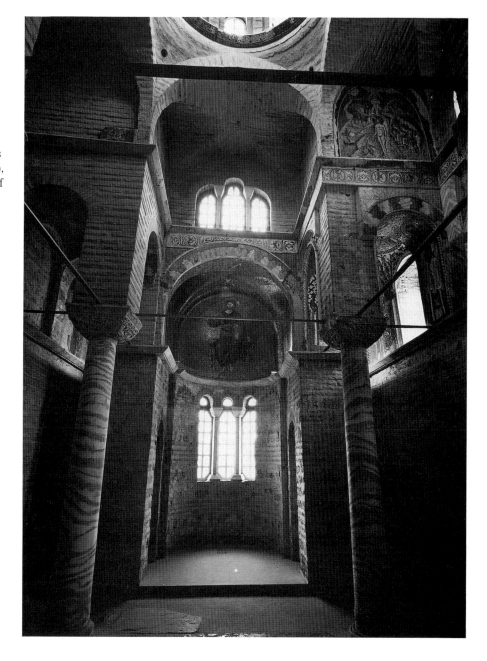

is a lone example of a custom which may have been quite commonplace, since there are many later examples in the churches of the Balkans.[24]

The close link between the capital and Thessalonike is evident from the decoration of Holy Apostles in Thessalonike, which has a programme similar in style content and arrangement to that of the Chora Monastery church. The work, consisting of mosaic in the naos and painting in the narthex and aisles, was commissioned by the 'second founder' Paul, who succeeded Niphon, the builder of the church, after the deposition of the latter in 1315 (fig. 256). The naos has a smooth dome, with Christ

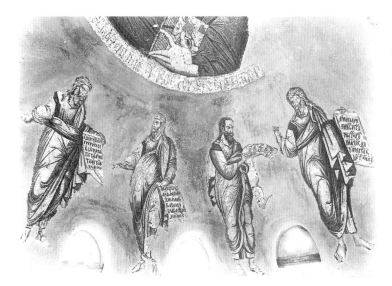

256 Mosaic decoration in the church of Holy Apostles, Thessalonike, after 1315: prophets in the dome, evangelists in the pendentives below.

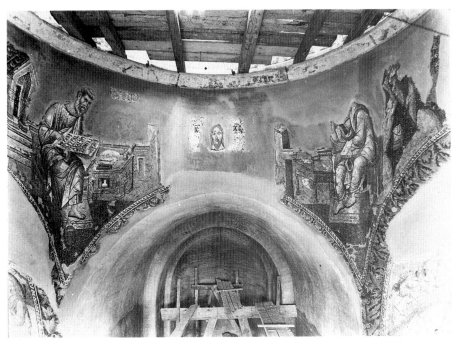

Pantocrator at the summit, prophets below and evangelists on the pendentives. A cycle of festival icons in the surrounding vaulting includes the Nativity, Baptism, Transfiguration, Entry into Jerusalem, Crucifixion and Anastasis; the Dormition of the Virgin is on the west wall, above the entrance. The apse decoration is lost, but probably consisted of Virgin and Child with Divine Liturgy below, following the middle-Byzantine tradition (as seen for example in St Sophia, Kiev and several of the thirteenth-century painted churches of the Balkans mentioned in the last chapter. If the church was dedicated to Holy Apostles at its foundation, then it is likely that there was once a Pentecost in the bema vault, from which the mosaic is lost. It is possible, however, that this dedication is post-Byzantine, replacing an original dedication to the Virgin.

Narrative cycles are found in the areas outside the naos. Eight episodes of a John the Baptist cycle remain in the north aisle, which must have functioned as a chapel of this dedication, and in the inner narthex there remain several scenes of the Life of the Virgin. These include the Presentation of the Virgin in the Temple, which is placed above the entrance from the outer narthex, opposite a donor image showing Paul kneeling at the feet of the enthroned Virgin, an arrangement that parallels that of the equivalent bay at the Chora. Further correspondence is found in the two domes of the inner narthex, which have 'ancestor' programmes, and in the selection of Old Testament prefigurations of the Virgin found in the south aisle. In addition, the decorations of Holy Apostles and the Chora are sufficiently similar in style to suggest the activity of a single workshop, not necessarily using the same combination of hands in each case. If Paul commissioned the decoration of Holy Apostles just after the deposition of Niphon in 1315, then it was started when the rebuilding of the Chora had just begun and may have served as a model for the decoration of the latter. In particular, the use at the Chora of 'ancestor' domes with different numbers of flutes may have been an elaboration of the simpler arrangement at Holy Apostles. Fragments of a mosaic 'ancestor' programme are also found in the three domes of the exonarthex of Vefa Kilise Camii in Constantinople, for which a close link with Holy Apostles was proposed above, based on the similarity of their western facades. In this case, therefore, both the architectural form and the decoration may have been introduced from Thessalonike.[25]

The burgeoning of narrative imagery also includes hagiological cycles in churches or chapels dedicated to saints, where such cycles often supplement the 'standard' elements relating to Christ and the Virgin. At the fourteenth-century church of St Nicholas Orphanos in Thessalonike, for example, the Life of St Nicholas is present in the west aisle. Several

24 H. Belting, C. Mango, D. Mouriki, *The Mosaics and Frescoes of St. Mary Pammakaristos (Fethiye Camii) at Istanbul* (Washington DC 1978).

25 A. Xyngopoulos, 'Les Fresques de l'église des Saints-

Apôtres à Thessalonique', in *Art et Société à Byzance sous les Paléologues* (Venice 1971), 83–89; for Vefa Kilise Camii, see n.7.

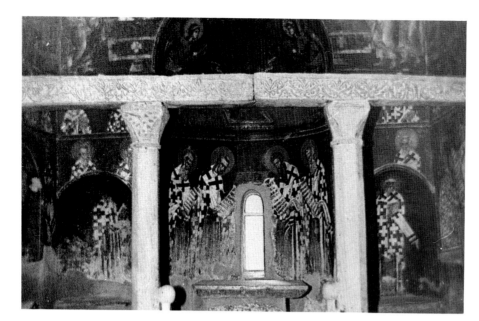

257 Painting in St Nicholas
Orphanos, Thessalonike:
the east wall.

Scheme, after Xyngopoulos

INNER WALLS

M	Mandylion
DL	Divine Liturgy
V	Virgin
D	Dormition of the Virgin

1	Annunciation
2	Nativity
3	Adoration of the Magi
4	Presentation
5	Baptism
6	Raising of Lazarus
7a,b	Entry into Jerusalem
8	Transfiguration
9	Last Supper
10	Washing of Feet

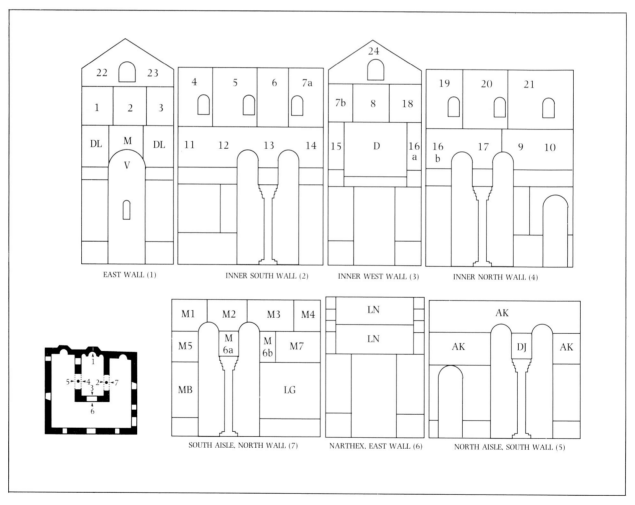

11 Gethsemane
12 Betrayal
13 Christ before Caiaphas
14 Christ before Pilate
15 Denial of Peter
16a,b Mocking of Christ
17 Christ put on the Cross
18 Crucifixion
19 Descent from the Cross
20 Lamentation
21 Anastasis
22 Resurrected Christ
23 Women at the Tomb
24 Ascension

OUTER WALLS
Miracles of Christ
M1 Healing the Crippled
 Woman
M2 Healing the Dropsical Man
M3 Healing the Man Possessed
M4 Healing two Cripples
M5 Healing the Paralytic
M6a,b The Samaritan Woman
M7 The Wedding at Cana

MB Moses and the Burning
 Bush
LG Life of St Gerasimos
LN Life of St Nicholas
AK Akathistos Hymn
DJ Dream of Joseph

episode detail the birth and upbringing of the saint, his ordination and progress through the ecclesiastical hierarchy, his miracles and finally his death. The naos and lateral aisles contain Christological cycles and images exalting the Virgin, including scenes illustrating the *Akathistos* (a hymn in praise of the Virgin) (fig. 257). Similarly, in the basilical Chapel of St Euthymios, added to St Demetrios in Thessalonike by Michael Glabas in 1303, there is a St Euthymios cycle in the north aisle, and festival icons, Ministry and Passion cycles in the nave and south aisle. The cycle of St Euthymios, who was the founder of monasticism, includes the Annunciation to his parents, his presentation to a priestly mentor, Eudoxios, his ordination, miracles of healing, and death. The hagiological cycle is represented in Constantinople by paintings in the old chapel of St Euphemia near the Hippodrome, where fourteen paintings illustrate the story of this early Christian martyr, most of them scenes in which the saint and her fellow Christians were subjected to torture. The cycle was placed in one of five interior niches of the hexagonal building and must have been part of a Palaiologan restoration.[26]

As noted above, the combination of festival icons and detailed narrative cycles is virtually a standard feature of church decoration of the Palaiologan period. Such programmes survive in some of the churches of Mistra, where long naves provided greater space for expansion of the narrative element than was available in the small churches of Constantinople. At St Demetrios, for example, in a programme painted in several phases from the late thirteenth century to the first quarter of the fourteenth, there are over 240 fields of painting, containing festival icons and a Passion cycle in the nave, a Ministry cycle and miracles of Saints Cosmas and Damian in the south aisle, and a Life of St Demetrios in the north aisle. In the narthex the Last Judgement occupies the vault and upper wall registers, and on the lower wall register are represented the Councils of the Church that established orthodox doctrine. Also in Mistra, less complete remains attest programmes of similar extent at St Theodore and the Hodegetria Church.[27]

The greatest repository of painting of the Palaiologan period is in the Serbian churches commissioned by members of the Nemanjid dynasty. The monastery of Arilje (St Achilleios) was founded in 1296 by Dragutin, the great-grandson of Stephen Nemanja, and provided with a church of traditional Serbian form, its square, domed naos extended by lateral projections to north and south, much like the Church of the Virgin at Sopoćani. The painted decoration includes the 'holy hierarchy' of Pantocrator and prophets in the dome, Virgin and Divine Liturgy in the

26 T. Velmans, 'Les Fresques de Saint-Nicolas Orphanos à
 Salonique', *CahArch* 16 (1966) 145–76; R. Naumann &
 H. Belting, *Die Euphemia-Kirche am Hippodrome zu
 Istanbul und ihre Fresken, Istanbuler Forschungen* 25
 (Berlin 1966); T. Gouma-Peterson, 'The Parecclesion of

St. Euthymios in Thessalonica: Art and Monastic Policy
under Andronicos II', *AB* 58 (1976) 168–82.

27 S. Dufrenne, *Les Programmes iconographiques des églises
 byzantines de Mistra* (Paris 1970).

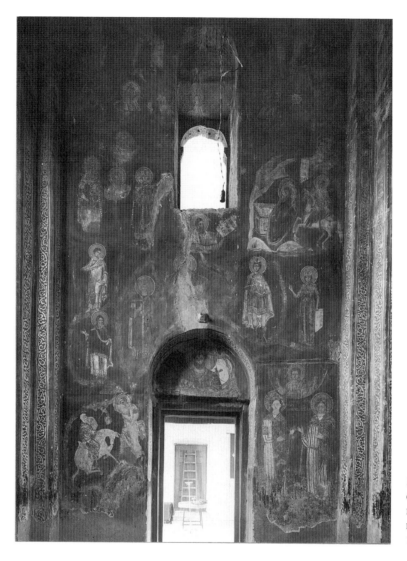

258 Painting of the Jesse Tree on the west wall of the narthex in the church of the monastery at Arilje (founded 1296).

apse, and also festival icons, a Passion cycle and episodes of the Life of the Virgin, with the Dormition on the west wall. On the west wall of the narthex is a Tree of Jesse, a device based on the prophecy of Isaiah (11.1) for illustrating the genealogy of Christ, showing a stem growing from Jesse and branching to accommodate the ancestors of Christ (fig. 258). This convention is found in Western mediaeval art from the late eleventh century and is probably of Western origin, but it appears in the early twelfth century at the Panagia Mauriotissa in Kastoria, and so may have reached Serbia as a Byzantine rather than a Western import. The Councils of the Church are also represented in the narthex and to them is added the Council of Stephen Nemanja, at which Byzantine orthodoxy was embraced by the Serbian church. Donor images in the Byzantine manner in the narthex show Dragutin with a model of the church, his wife Katelina and his brother Milutin. The concern with dynastic imagery seen

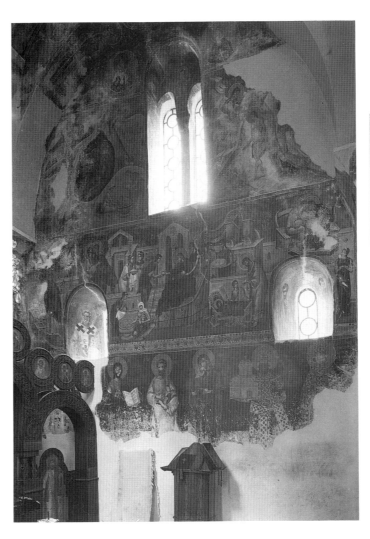

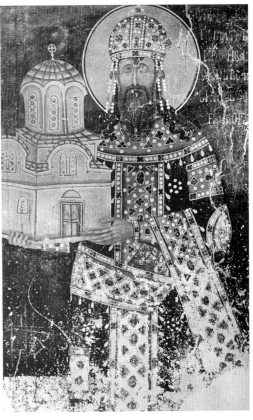

259 Painting in the Chapel of Joachim and Ann (also known as the King's Church) at Studenica Monastery (1313/14): south wall top register: the Nativity and Baptism; middle: Life of the Virgin; bottom: King Milutin and Simonis presenting a model of the church to the Virgin; detail of Milutin.

in earlier Serbian painting is also sustained, with images of Dragutin's parents Uroš I and Helena, and his grandfather Stephen Prvovenčani, all three represented in the monastic dress of their retirement.[28]

Several more painted decorations survive in the churches and chapels commissioned by Uroš II Milutin, Dragutin's brother and successor, whose Byzantine bride Simonis was the daughter of Andronikos II. The Church of the Virgin at Prizren (1306–9) has the holy hierarchy, festival icons, a Passion cycle, fragments of a St Nicholas cycle and, in the exonarthex, a Tree of Jesse. In the narthex Milutin is represented twice, once as patron of the church and again as part of a dynastic group of his ancestors, including Nemanja's son Sava, the first Serbian archbishop. In 1313/14 Milutin built a single-naved domed chapel dedicated to Joachim

28 R. Hamman-MacLean & H. Hallensleben, *Die Monumentalmalerei in Serbien und Makedonien* (Giessen 1963–76), I, 26–8, pls. 143–58.

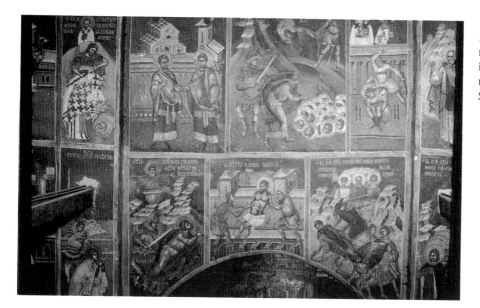

260 Scenes of the lives and martyrdoms of saints painted in the narthex of the monastery church at Dečani, Serbia (by 1335).

and Anna at the Monastery of Studenica, founded at the end of the twelfth century by Stephen Nemanja. The painted decoration of the chapel again includes the holy hierarchy in the dome and sanctuary, and the walls are divided into three main registers, with festival icons in the uppermost and a Life of the Virgin in fourteen episodes below it. The lowest register has standing figures, most of them saints, including Archbishop Sava and Stephen Nemanja as the monk Symeon, his status upon retirement. On the south wall the dedication of the chapel is demonstrated by figures of Christ, Joachim and Anna, the latter holding the infant Virgin, and a donor image of Milutin presenting a model of the chapel, with Simonis at his side (fig. 259). A similar programme, including Ministry and Passion cycles, a St George cycle of eighteen scenes and more portraits of Simonis and Milutin is found at St George, at Staro Nagoričino (1317). The 'standard' programme is again present at the most thoroughly 'Byzantine' of Milutin's buildings, the Church of the Virgin at Gračanica (1318–21) and on the east wall of the narthex the iconographic form of the Tree of Jesse is adopted for the Nemanja family tree, starting with Stephen Nemanja and ending with the children of Milutin. Traditional Byzantine 'coronation' iconography is used on the arch separating narthex and naos, where Milutin and Simonis are crowned by angels flanking a bust of Christ.[29]

Further examples of painted decorations of similar content and extent are found in Serbian churches later in the fourteenth century. At the monastery of Dečani, founded by Milutin's son Uroš III Dečanski in 1328, and completed in 1335, the size of the building permitted the inclusion of extra elements and the programme has illustrations of the Parables and the Acts of the Apostles. In the large nine-bay narthex, the vault decora-

29 ibid., 1, 29–37, pls. 182–212, 245–345.

tion forms a monumental menologion, with scenes from the lives of the saints, arranged in the order of the liturgical calendar (fig. 260). At Peć, to which the Serbian archepiscopate moved from Zica in the mid-thirteenth century, the existing complex of the church of Holy Apostles (c. 1250) and St Demetrios (c. 1320) was expanded by Archbishop Danilo II in the 1330s, with the addition of chapels of the Theotokos Hodegetria and St Nicholas, and an exonarthex. The painted decoration follows the conventions of the programmes outlined above, with Danilo II represented as patron, and a cycle of the life of Arsenije I, the first archbishop of Peć. The Nemanjid dynasty is once again represented in tree-form in the narthex.[30]

There are variations in style and quality in most of these Serbian painted decorations, and in some cases the task of defining phases of work and restoration has still to be done. Nevertheless, much of the best quality work is characterized by the boneless figures, mannered postures and fanciful architectural backgrounds seen in the mosaics and paintings of the Chora Monastery church in Constantinople. The chief difference is that the number of figures and amount of detail in narrative subjects tends to be greater in the Serbian paintings, reflecting the larger fields available for decoration. The Chora church itself could not have initiated the style, since several of the Serbian examples predate it, but there is little doubt that Byzantine artists were at work in the Serbian churches. At Gračanica and Staro Nagoričino, and also at St Niketas, Čučer, (c. 1310) another commission of Milutin, artists named Michael and Eutychios signed some of the work. They also signed work at St Clement in Ohrid (1295) and the painting of the Chapel of Joachim and Anna at Studenica has been attributed to them.[31] The origins of these two are not certain, but they were probably Greeks, perhaps from Thessalonike. It is likely, therefore, that important Serbian patrons used itinerant Byzantine painters to decorate their churches, at times working alongside local workshops.

The range of subjects found in the Serbian churches is greater than that of the programmes of Constantinople or Thessalonike, but as was the case in earlier centuries, it is probable that this is largely because the few surviving monuments of those cities do not demonstrate the full range of Byzantine monumental art. At the same time, it is probable that there was as much, if not more work for Byzantine artists in the Balkans than in the remnants of the empire, and it is not impossible that some of the stylistic and iconographical developments of late Byzantine painting had their origin in the Serbian commissions.

30 ibid., 1, 38, 23–4, pls. 350–1, 99–114.
31 C. Grozanov, La Peinture murale d'Ohrid au XIVe siècle (Belgrade 1980); P. Milković-Pepek, L'Œuvre des peintres Michel et Eutych (Skopje 1967); Beckwith, ECBA, 143–4, 149.

Minor arts

Some changes are evident in the traditionally conservative field of the minor arts in the Palaiologan period. The enamels, ivories and jewel-encrusted metalwork of middle-Byzantine splendour are scarce, but embossed silver is often encountered and there are new forms, such as the miniature mosaic. The icon is the best-represented category of the minor arts, with many examples attributed to the late-thirteenth or fourteenth century on grounds of close stylistic similarity to Palaiologan monumental art. The small-headed, wide-bodied, 'boneless' figure style of the Chora Monastery church and Holy Apostles in Thessalonike is seen, for example, in an icon of St Matthew in Ohrid (fig. 261). The improbable architecture of the narrative cycles of the Chora and other early fourteenth-century churches is also much in evidence, as in an Annunciation from St Clement in Ohrid, for instance (fig. 262). This image is on one side of an icon which has the Virgin and Child on its other face, and forms a pair with another two-sided icon of Christ Pantocrator and the Crucifixion. Such icons were probably carried in processions and, when in church, were set up on stands so that they could be viewed from both sides. The form had

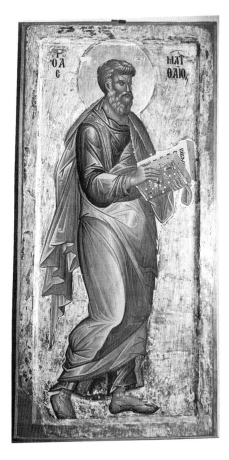

261 Icon of St Mathew (*c.* 1300) (St Clement, Ohrid).

262 The Annunciation, on one side of an early fourteenth-century double icon from St Clement, Ohrid (on the other side, the Virgin and Child) (Skopje).

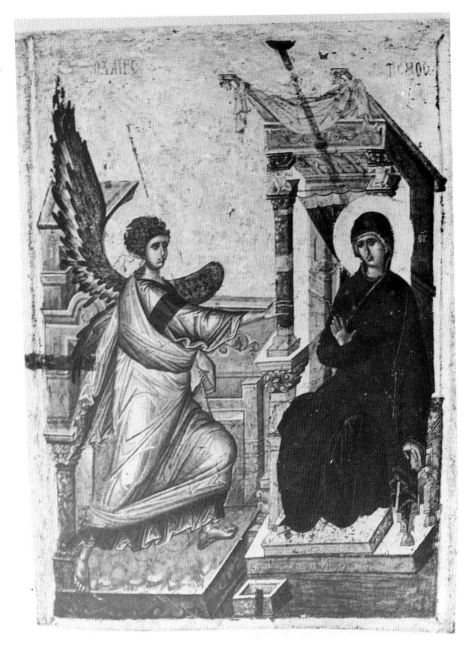

been in use at least since the twelfth century, but judging by the number of surviving examples, was more often produced during the Palaiologan period.[32]

Firmly dated icons are rare, but a group at the Meteora Monastery in Thessaly may be placed in the second half of the fourteenth century by reference to their patrons, Maria Angelina, sister of the second founder of the monastery, and her husband Thomas Preljubovic, Despot. of Ioannina 1367–84. One shows the Virgin and Child with a small kneeling figure of Maria, the whole group framed by busts of fourteen saints in a wide

32 K. Weitzmann et al., Icons (New York 1980), 175, 147/171, 149/178; Grabar, Revêtements (see n.36) 11, 12.

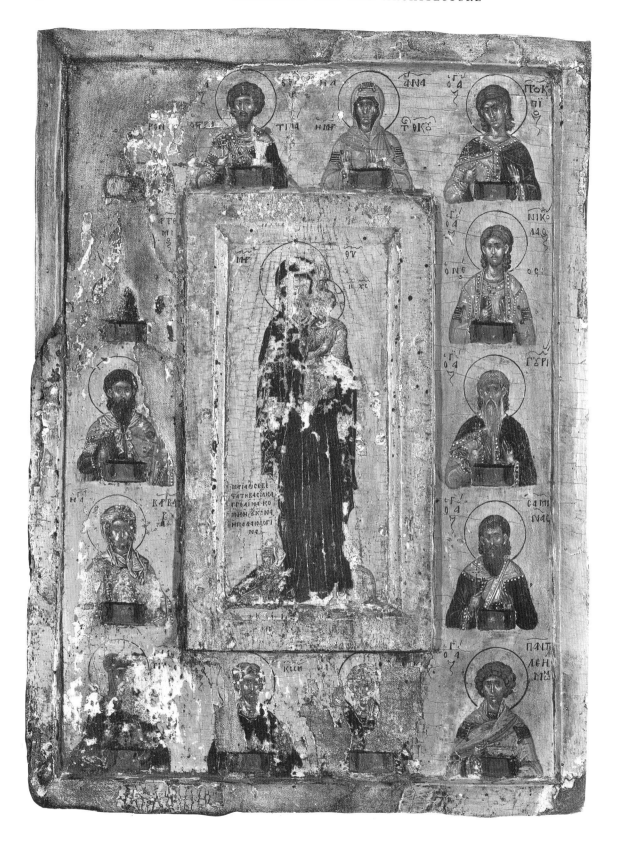

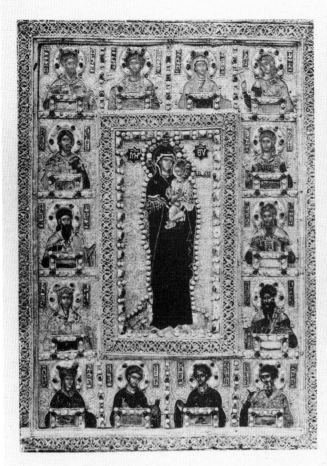

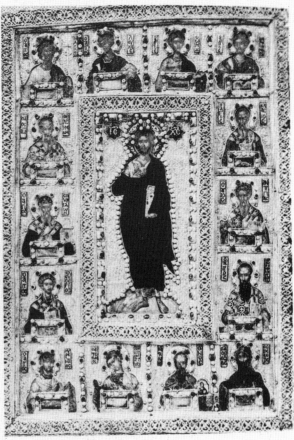

264 Pair of reliquary-icons of the Palaiologan period. Main panels showing the Virgin and Child and Christ are framed by busts of saints, each housing a jewelled recess for relics. (Cuenca, Cathedral Treasury).

263 Icon of the Virgin and Child with saints, each painted over a cavity for relics. The donor, Maria Angelina, kneels at the feet of the Virgin. (Meteora Monastery, second half of the fourteenth century.)

border, each of which has below it a small niche to hold relics (fig. 263). The icon is known to have been one of a pair, the other showing Thomas kneeling at the feet of Christ, since it was the model for a reliquary now in Cuenca Cathedral in Spain, of which both halves survive (fig. 264). This reliquary, studded with pearls and precious stones against embossed silver, is one of the few Palaiologan examples of jewelled metalwork. Another Meteora icon, of the Doubting of Thomas, is of particular interest because it depicts Maria and Thomas as witnesses to the event, among a group to the left of Christ – Maria as a full figure and the head of Thomas peering over the shoulder of the apostle Thomas (fig. 265). Such representation of donors, as participants in a narrative subject, is unusual in Byzantine art, although the lost portrait of the twelfth-century painter Eulalios in Holy Apostles (see chapter 5) is an earlier example.[33]

A two-sided icon now in the Sofia Museum shows the 'Chora' style still current at the end of the fourteenth century. The icon was made for a monastery in Poganovo (former Yugoslavia), founded by the empress Helena, wife of Manuel II (1391–1425) (fig. 266). On one face it has

33 *BAEA*, 211, 212, 193.

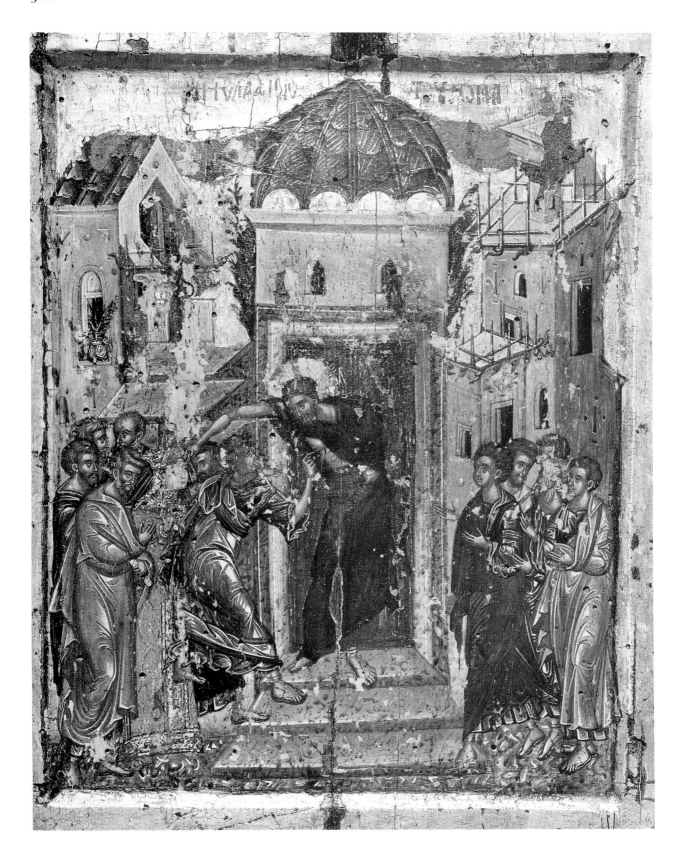

265 (left), Icon of the Doubting of Thomas, with Maria Angelina and Thomas Preljubovic as witnesses, second half of the fourteenth century (Meteora Monastery).

266 (below), Icon of Poganovo, former Yugoslavia (fourteenth century) showing the Prophetic Vision.

267 (right), Palaiologan miniature mosaic icon of St John Chrysostom (Washington DC, Dumbarton Oaks Collection no. 353).

standing figures of the Virgin and John the Theologian, and on the other the Prophetic Vision – Ezekiel and Habbakuk below Christ enthroned in a mandorla framed by evangelist symbols. An inscription indicates that the latter image reproduces that of the fifth-century apse mosaic of Hosios David in Thessalonike, in which the figure of Christ was believed to have appeared miraculously.[34]

Mosaic icons are known from the twelfth century, but a new taste of the Palaiologan period is attested by over twenty portable miniature

34 T. Gerasimov, 'L'Icone bilatérale de Poganovo au Musée Archéologique de Sofia', *CahArch* 10 (1959) 279–88; A. Xyngopoulos, 'Sur l'icone bilatérale de Poganovo', *CahArch* 12 (1962) 341–50; A. Grabar, 'Sur les sources des peintres byzantins des XIIIe et XIVe siècles', *CahArch* 12 (1962) 351–84.

268 (left), Palaiologan
miniature mosaic icon of the
Forty Martyrs of Sebaste
(Washington DC, Dumbarton
Oaks Collection no. 124).

269 (right), Palaiologan
miniature mosaic icon of
St Anne (Mount Athos,
Vatopedi Monastery).

mosaic icons, made with very small tesserae of semi-precious stones, gold
and silver, and enamel paste. Most are less than twenty-five centimetres
high and of the portrait type, showing either half-figures, such as the icon
of John Chrysostom in the Dumbarton Oaks Collection (fig. 267), or full
figures, such as St Anne with the infant Virgin at the Vatopedi Monastery
on Mount Athos (Fig. 269). The range of subjects is small, with several
appearing more than once – there are four icons of St Nicholas, for exam-
ple. Narrative subjects are scarcer, but there is a Crucifixion in the
Vatopedi Monastery and a Transfiguration in the Louvre (larger than
most, at fifty-two centimetres high). A pair of icons in Florence shows the
twelve feasts of the church with six on each panel and an icon in
Washington shows the Forty Martyrs of Sebaste, suffering martyrdom in
the lake (fig. 268). None of the miniature mosaic icons is dated, and
Palaiologan attribution is largely based on style. The case may be sup-
ported on technical grounds however, since the use in Palaiologan monu-
mental mosaics of small cubes to achieve greater detail, especially for
faces, is a likely context for the development of the miniature mosaic icon.
Several of the icons share such details as chequered haloes and chevron-
patterned borders and they may well be the products of just a few work-
shops, perhaps the same ones that made monumental mosaics.[35]

35 O. Demus, 'Two Palaeologan Mosaic Icons in the *BAEA*, 161–71; Grabar, *Revêtements* (see n.36) 22, 23,
 Dumbarton Oaks Collection', *DOP* 14 (1960) 87–119; 26, 31.

Many icons, both mosaic and painted, have their wooden frames covered by embossed sheet silver, typically with figure subjects alternating with panels of ornament. The frame of the Vatopedi St Anne, for example (only partly visible in fig. 269), has busts of two angels and the *hetoimasia* (symbolic throne) in its upper border, Joachim and Joseph as full figures at the sides and apostles at the bottom, alternating with square panels of quatrefoil patterns with bosses. The same formula is used for the frame of the Vatopedi Crucifixion, but here twelve scenes from the festival icon sequence alternate with the ornamental panels. The silver revetment of painted icons often invades the field of the icon subject, making a patterned surround for the exposed painted figure(s). This is the case in an icon of the Virgin and Child in the Tretyakov Gallery, Moscow, where the revetment of the haloes is also raised, forming rolls of silver around the divine heads (fig. 270). In post-Byzantine icons the silver revetment often covers all but the faces of the figures, producing, when the painting darkens with age, the appearance of empty armour.

The chronology of silver-framed icons is problematic since the frame may not always be contemporaneous with the icon, and in several instances there is evidence that frames have been altered. The tradition of silver revetment evidently began before the Palaiologan period, since an inscription on an icon of the Virgin and Child in Freising (sent as an imperial gift to a Duke of Milan and changing hands several times before 1440) names Manuel Disypatos, bishop of Thessalonike between 1235–61. The

270 Icon of the Virgin and Child, with silver revetment showing donors Constantine Akropolites and his wife Maria (first quarter fourteenth century) (Moscow, Tretyakov Gallery).

271 Miniature mosaic icon of St John, much deteriorated with enamelled medallions decorating the frame, thirteenth/fourteenth century (Mount Athos, Laura).

Tretyakov Virgin and Child is also dated, by figures of donors Constantine Akropolites and his wife Maria in the lower corners (fig. 270) – Constantine was a Grand Logothete under Andronikos II and died *c*. 1324. Many other silver-framed icons are attributed to later dates on stylistic grounds, suggesting that the form achieved popularity during the Palaiologan period, even if invented earlier; it continued in use in the post-Byzantine orthodox world for centuries.[36]

In a few cases, enamelled medallions take the place of embossed figure subjects in the silver icon frames. An icon of St John the Theologian in the Great Laura of Mount Athos, for example, has enamelled busts of several saints named John, and Zacharias and Elizabeth, the parents of John the Baptist, who is, however, absent (fig. 271). Similar enamelled medallions are found on the frame of the Freising Virgin and Child, and also on a pair of book-covers in Venice, the form of which imitates that of the framed icons, having central panels of the Crucifixion and Anastasis bordered by alternating pattern and figure subjects. In style and technique all the enamel medallions resemble twelfth-century work such as that of the Pala d'Oro, suggesting either that enamelwork changed little in over a century, or that the medallions were twelfth-century pieces re-used. The absence of John the Baptist from the Laura icon is perhaps to be accounted for by supposing that the chance availability of an incomplete set of twelfth-century enamels recovered from an earlier object prompted a Palaiologan metalsmith to incorporate them in a frame for an icon of John the Theologian.[37]

Ivory, too, is rare in the Palaiologan period, to which only one piece may be securely attributed. This is a pyxis (a cylindrical box made from a section of elephant tusk) in the Dumbarton Oaks Collection, decorated with a frieze of figures (fig. 272). Two imperial groups appear side by side, each consisting of emperor, young son and empress; next come a group of musicians and dancers and a kneeling figure presenting a model of a walled city to the first of the emperors. Inscriptions attached to four of the imperial figures, and plausibility of context, identify the six as John VII Palaiologos, his son Andronikos V and wife Eirene in one group, and Manuel II, his son John VIII and wife Helena in the other. During the period 1399–1408, there were two imperial families, since Manuel II allowed his nephew John VII to reign as emperor of Thessalonike, and the pyxis is thought to celebrate that decision – Thessalonike is thus the city being presented to him. The uniqueness of the piece is enhanced by its very form, since the pyxis virtually disappears from Byzantine minor arts after the sixth century, possibly because the supply of elephant tusk diminished with the loss of the middle-eastern and African territories. Such isolation suggests that the chance availability of the required material

36 A. Grabar, *Les Revêtements en or et en argent des icones byzantines du Moyen Age* (Venice 1975); D.M. Nicol, 'Constantine Akropolites: A Prosopographical Note', *DOP* 19 (1965) 249–56.

37 Grabar, *Revêtements* (see n.36), nos. 33, 16 & 37; *Treasury of San Marco*, 177–8.

273 Gospel book of 1285
(London, BL Burney 20). Folio
90v, portrait of the evangelist
Mark.

272 Ivory pyxis with imperial
figures (1399–1408).
(Washington DC, Dumbarton
Oaks Collection no. 36.24).

prompted deliberate imitation of a form associated with the great days of
the empire.[38]

Although the circumstances of the Dumbarton Oaks pyxis may be
very particular, it nevertheless establishes that the skill of ivory carving
was still available to an imperial patron at the end of the fourteenth cen-
tury. Conceivably it was the skill of a Western craftsman, but the style and
iconography suggest otherwise, since they are rooted in Byzantine tradi-
tion. The imperial groups find parallels in Palaiologan manuscript illumi-
nation and the dancers have a pedigree at least as early as the crown of
Constantine Monomachos. It is probable nevertheless that pieces were not
made in great numbers, since other attributions of Palaiologan date are
unconvincing. Two caskets of eleventh-century type, with 'rosette' borders
(in Krakow and Rome) have been placed in the fourteenth century
because heraldic shields on their lids signal Western contacts, and their
rosette borders are rather simpler and more crudely cut than those of

38 A. Grabar, 'Une pyxide en ivoire à Dumbarton Oaks',
 DOP 14 (1960) 123–46.
39 G/W BE, I, nos. 65, 66.

eleventh-century examples. The caskets could as well be poor-quality eleventh- or twelfth-century pieces, however, made for Western patrons, or Western copies of Byzantine models.[39]

Although the scarcity of ivory and enamel may in part be accounted for by circumstantial factors – the volume of production must have lessened as the empire diminished in size, and the Turks of 1453 did not dispatch part of their loot to Western treasuries as did the Crusaders of 1204 – the relative abundance of icons, silver revetment and miniature mosaic suggests that loss of skills, scarcity of craftsmen and changes of taste also played a significant role.

Illuminated manuscripts

There survive over 100 dated illuminated Palaiologan manuscripts and many others are attributed to the period on palaeographical or stylistic grounds. The number of examples is therefore similar to that for the Comnene period, and the range and frequency of texts illustrated is also similar, with gospels or gospel lectionaries accounting for over half the dated examples. The others consist of less than ten each of psalters and writings of the Church Fathers, and even fewer examples of other theological text, menologia, saints' lives, historical and scientific works. The Palaiologan period is not one of high achievement in the field of manuscript illumination. In nearly half the dated manuscripts illumination is confined to ornamental headpieces and initials, sometimes of high quality, but repeating patterns in use for two centuries or more with little change. Most of the manuscripts with figure subjects are gospel books or lectionaries with evangelist portraits, and the author portrait is also often the only embellishment of theological and other works.[40]

The evangelist portraits of most gospel books follow iconographic traditions of long standing, in which the evangelist is seated at a writing desk, on the verso facing the page upon which his gospel begins below a decorated headpiece. Palaiologan style is evident, however, in the oddly proportioned figures, draperies and swaying architectural backgrounds of the miniatures, which match the features of monumental art of the period. A gospel book of 1285, in the British Library, will serve as an example (fig. 273). Variants include the evangelist (usually Matthew) sharpening his pen, which is possibly a Western import, and the evangelist John glancing over his shoulder to receive the divine revelation, against either an architectural background or the rocks of Patmos where the revelation occurred. Such types have a wide chronological span, from, for example, a gospel book in the Vatopedi Monastery on Mount Athos, made in 1304, to

40 Spatharakis, *Corpus*, nos. 182–295; H. Buchthal, *Das illuminierte Buch in der spätbyzantinischen Gesellschaft* (Heidelberg 1970).

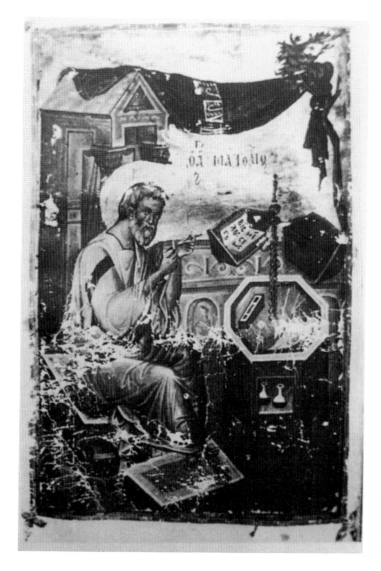

274 Gospel book of 1304
(Mount Athos, Vatopedi 938).
Folio 18v, portrait of the
evangelist Matthew.

another in Athens, of 1418 (figs. 274 and 275). A rare alternative to the
seated figure is found in a gospel book now in the Monastery of St
Catherine on Mount Sinai, made in 1346 for Isaac Asen, grandson of
Michael VIII, in which four miniatures each show the bowing evangelist
offering his book to a standing figure of Christ.[41]

There is evidence that some artists in Constantinople were using
models of the Macedonian period for their miniatures. A few psalters
attributed to the Palaiologan period on stylistic grounds appear to copy
the miniatures of the tenth-century Paris Psalter closely. An example in
the Vatican, for example, has framed miniatures of David Playing the

41 London, BL Burney 20; Athos, Vatopedi Ms. 938;
 Athens, NL 2603; Sinai, gr. 152: Spatharakis, *Corpus*,
 nos. 195, 219, 281, 256.

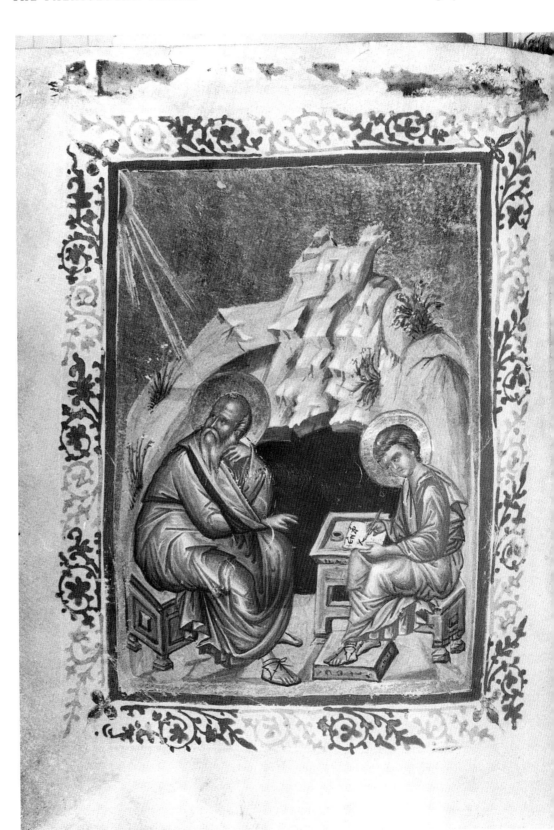

275 Gospel book of 1418
(Athens, National Library
2603). Folio 269v, portrait of
the evangelist John.

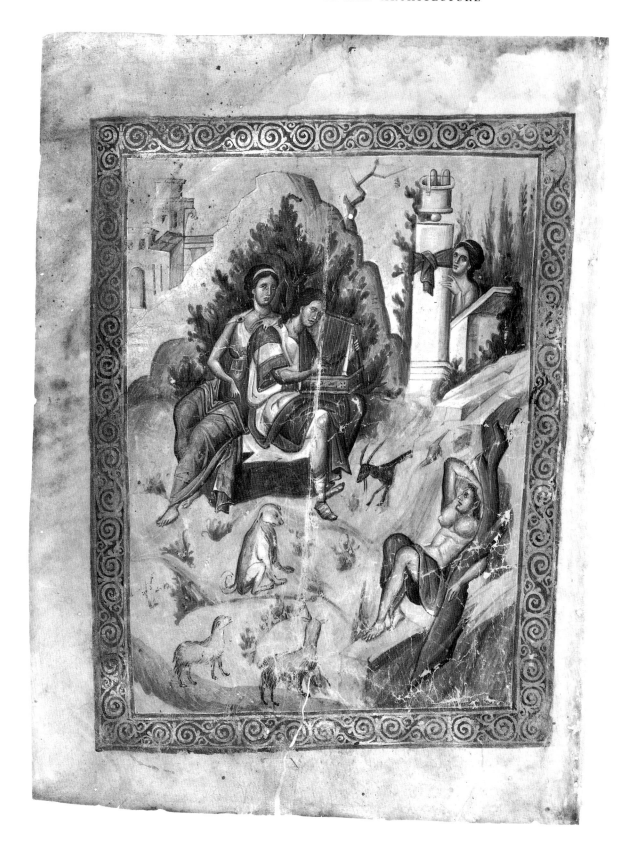

276 Fourteenth-century
Psalter (Vatican Palat. gr.
381). Folio 1v, David Playing
the Harp.

Harp, David with Wisdom and Prophecy, the Crossing of the Red Sea and
Moses Receiving the Law, which reproduce the iconography of the Paris
Psalter images in detail (fig. 276). It has also been proposed that some
gospel books, of which there are two closely related examples in the
Vatican, one dated 1285, depend upon tenth-century models such as
Stauronikita 43. In this case however the copying is less close, since the
architectural backgrounds present in the proposed model are omitted in
the copies. Artists of the thirteenth and fourteenth centuries cannot have

277 Late thirteenth-century
Psalter (Sinai gr. 61); folio 2v,
David writing, playing the
harp and wrestling with a
lion.

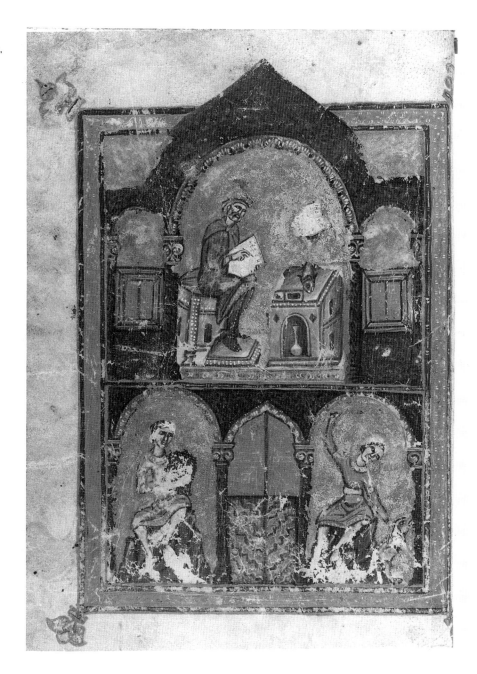

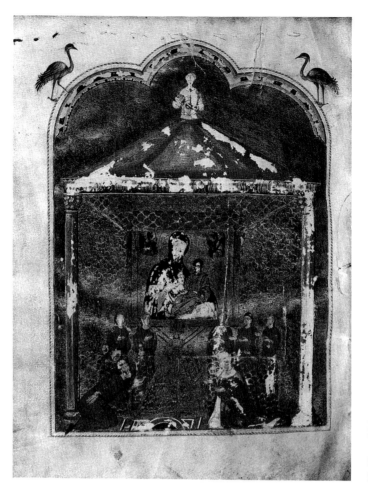

278 Hamilton Psalter (Berlin, Kupferstichkabinett, Ms 78.A.9) folio 39v, the donor family venerating an icon of the Virgin.

been without more recent models, so it would seem that some artists, or perhaps some patrons, were intent upon reproducing masterpieces of the past.[42]

Other psalters dated (or datable by their Easter tables) to the Palaiologan period show continuity with the eleventh- and twelfth-century derivatives of the Paris Psalter type, rather than direct reference to it, using a David cycle preface and placing Old Testament subjects relevant to the Odes and Canticles, at appropriate intervals in the text. An example in the Sinai Monastery (Sinai, gr. 61), which has Easter tables covering 1274–95, has David composing the psalms, playing the harp and grappling with the lion all in one miniature, and on separate pages the Repentence of David, Moses Receiving the Law, the Crossing of the Red Sea and the Dance of Miriam (fig. 277). At the end of the manuscript, a

42 Vatican, Palat. gr. 381: Cutler, *Psalters*, no. 45, see also nos. 27, 46. For the gospels (Vatican, Laura Plut. VI 28, Vatican, gr. 1158): H. Buchthal, 'Illuminations from an Early Palaeologan Scriptorium', *JÖB* 21 (1972) 47–55;

and 'Toward a History of Palaeologan Illumination' in *The Place of Book Illumination in Byzantine Art* (Princeton NJ 1975), 143–77.

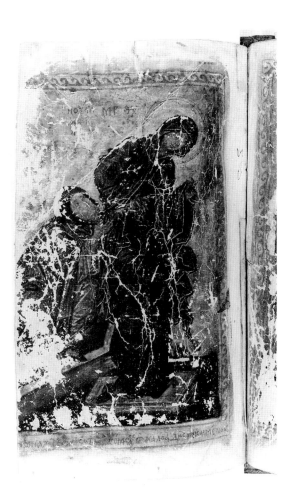

279 Psalter of 1391 (Oxford, Christ Church gr. 61). Folio 102v, the Virgin drawing the monk Kaloeidas from his tomb for presentation to Christ.

donor portrait shows a nun, Theotime, kneeling at the feet of the Virgin; it may be guessed that Theotime was an aristocratic lady who retired to a convent. The Hamilton Psalter in Berlin, which is attributed to the Palaiologan period by the style of its miniatures, combines both the 'preface' and 'marginal' traditions of middle-Byzantine psalter decoration. It begins with eight 'David' scenes, on four pages, and a full-page author portrait of David writing the psalms, but it also has many marginal illuminations spread throughout the text.[43]

Donor portraits constitute one of the most interesting and varied aspects of Palaiologan manuscript illumination. Before the David preface in the Hamilton Psalter there is a miniature in which an icon of the half-figure Virgin and Child, set upon a stand, is venerated by five standing adults and a child, and two more adults kneeling (fig. 278). It has been

43 Sinai, gr. 61: Spatharakis, *Corpus*, no. 184; Cutler, *Psalters*, no. 57. Hamilton Psalter (Berlin, Kupferstichkabinett 78.A.9): P. Wescher, *Beschreibendes Verzeichnis der Miniaturen...des Kupferstichkabinetts der Staatlichen Museen Berlin* (Leipzig 1931); Spatharakis, *Portrait*, 45.

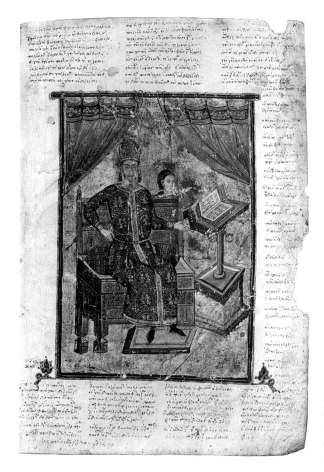

280 Copy of the works of Hippokrates (Paris, BN gr. 2144) folio 11r, the patron, Alexios Apokaukos (after 1331).

suggested that the icon represented is the famous Theotokos Hodegetria of Constantinople, mentioned in the last chapter, which was appropriated by the Venetians during the Latin occupation. After the recovery of the city it was returned to its traditional site, the Hodegon Monastery, near St Sophia. The identity of the family is unknown, since its members lack inscriptions and their plain dress gives no indication of their station. The text is given in both Greek and Latin, implying that the family had Western connections, but this hardly limits the field in the Palaiologan context, since so many aristocratic families acquired members of Western origin by marriage. Another psalter now in Oxford was the work of a scribe named Ioasaph, who completed the task in 1391, apparently for a monk whose family name was Kaloeidas – possibly another aristocrat who retired to monastic life. The psalter has a portrait of David at its start, and is otherwise undecorated except for a unique pair of miniatures which form a diptych at 102v and 103r. On the verso, the Virgin drags the monk from his sarcophagus, leading him towards Christ enthroned on the opposite page (fig. 279). The image clearly borrows the iconography of the Anastasis, and the episode has been shown to refer to the Apocalypse of the Virgin, an apocryphal text of middle-Byzantine origin, in which the Virgin descends into Hell, guided by the Archangel Michael; she is moved

281 Theological writings of
John Kantakouzenos (Paris,
BN gr. 1242) folio 123v, John
as emperor, left, and as a
monk, right (1375).

by pity for the sinners she finds there, and on her return pleads with Christ
on their behalf. The use of this unusual scene in a Palaiologan psalter is
perhaps to be associated with the general increase in the use of imagery
concerned with the Virgin that is seen in the monumental art of the
Palaiologan period.[44] A rare secular book, the medical works of
Hippocrates, written on watermarked paper made in Italy after 1331, con-
tains an author portrait of Hippocrates and a donor portrait of Alexios
Apokaukos, the courtier of Andronikos III who built the church in
Selymbria referred to above (fig. 280). The image uses the iconography of
the evangelist portrait, showing a richly dressed Alexios seated next to a
lectern. A small figure behind his chair is thought to be the personification
of Medicine, a detail possibly introduced by an artist familiar with the per-
sonification-laden tenth-century works of the capital.[45]

Three portraits of the emperor John VI Kantakouzenos are found in a

44 Oxford, Christ Church gr. 61: Spatharakis Corpus, no.
 274; G. Galavaris, 'Mary's Descent into Hell: A Note on
 the Psalter Oxford Christ Church Arch. W. Gr. 61',
 Byzantine Studies 4 (1977) 189–94; P.L. Vokotopoulos,
 'An unnoticed manuscript of the Scribe Joasaph and its

Miniatures: The Psalter Christ Church Arch. W. Gr. 61',
Deltion Christianikes Archaeologikes Hetaireias 8
(1975–76) 79–195 in Greek, English summary 196–8.
45 Paris, BN gr. 2144: Spatharakis, Corpus, no. 252; and
 Portrait, 148f.

282 Theological writings of Dionysios the Areopagite (Paris, Louvre MR 416). Folio 2r, the Virgin and Child blessing Manuel II (1391–1421) and his family.

copy of his own theological writings on topics relevant to Hesychasm, a religious movement concerned with mysticism and asceticism that came to prominence in the Palaiologan period and was a cause espoused by the emperor. The book, dated 1375 and now in Paris, is another work of the scribe Ioasaph and its colophon supplies the extra detail that he was a monk of the Hodegon Monastery in Constantinople, mentioned above. There are four full-page miniatures. One represents the Church Council of 1351, which adopted Hesychasm, using iconography traditional to Council images, showing John VI presiding, surrounded by metropolitans, monks and court officials. In another miniature the emperor appears twice, first in imperial dress and then as a monk, the latter figure holding

a scroll with an inscription from the treatise against Islam which it prefaces (fig. 281). In all instances, the face of John is rendered very naturalistically, although the figures are formulaic, a feature shared by other Palaiologan portraits. The remaining two miniatures, a Transfiguration and a portrait of Gregory of Nazianzos also refer to subjects dealt with in the text.[46]

Imperial portraits of more traditional type appear in a few chrysobulls, the documents (often scrolls) that recorded grants of land or privileges to their recipients. Andronikos II appears in two chrysobulls, one of 1301 addressed to the Metropolitan of Monemvasia, which shows the emperor offering the chrysobull to Christ, and the other of 1307, confirming the possessions of Bishop Kanina of Albania, in which he is shown with the Virgin and Child. A third example, of 1374, shows Alexios III of Trebizond and his wife Theodora blessed by John the Baptist as they hold between them a chrysobull granting annual revenue to the newly founded Monastery of the Grand Komnenoi on Mount Athos.[47]

Similar iconography applied to a family group is seen in a copy of the theological writings of Dionysios the Areopagite now in Paris, which opens with an author portrait of Dionysios, followed by a miniature in which Virgin and Child bless Manuel II (1391–1425), his wife Helena and sons John, Theodore and Andronikos, identified by inscriptions (fig. 282). The manuscript is undated, but must have been painted before the birth of a fourth son, Constantine, in 1405. A note on folio 237v added by Manuel Chrysoloras in 1408 says that the manuscript was given to him to be presented to the Church of St Denis in Paris, doubtless on one of the many diplomatic missions that sought Western assistance for the failing empire.[48] Much fuller demonstration of family relationships is seen in the Lincoln Typikon, now in Oxford, which is the *typikon* of the Convent of True Hope in Constantinople, founded by Theodora Palaiologina, a niece of Michael VIII (fig. 283). This has a pictorial preface of ten miniatures, showing Theodora's parents, herself and husband, her two sons and their wives, her four granddaughters and their husbands; Theodora and a daughter who joined her in the convent then appear as nuns. The sequence ends with the nuns of the convent in a densely packed group, making supplicatory gestures to the Virgin, an image for which Western models have been proposed. Western influence may also have been responsible for the inclusion of small pictures of the twelve labours of the months in another *typikon*, of St Eugenios in Trebizond, written in 1346.[49]

Narrative subjects in Palaiologan manuscript illumination do not have the prominence that they have in the monumental art of the period, but there are some examples. The Oxford Menologion is a small picture-

46 Paris, BN gr. 1242: Spatharakis, *Corpus* no. 269; and *Portrait*, 71ff.

47 Spatharakis, *Portrait*, 184f.

48 Paris, Louvre MR 416: Spatharakis, *Corpus*, no. 278.

49 Lincoln College gr. 35: Spatharakis, *Portrait* 190f.

283 Typikon of the Convent of True Hope, Constantinople (Oxford, Lincoln College Ms. grec. 35), second quarter of the fourteenth century. Folio 11r, the founder of the convent, Theodora Palaiologina, and her daughter Euphrosyne. Theodora presents a model of the convent church, and Euphrosyne a book, to the Virgin who appears on folio 10v.

book, with no text apart from a dedicatory poem, made for Demetrios Palaiologos, Despot of Thessalonike 1322–40. The calendar of church feasts is illustrated by twelve full-page miniatures on the first six folios, followed by ninety-three miniatures, most of them placed four to a page, showing episodes of the lives, miracles or martyrdoms of saints. Most of these are single images, one for each saint, in the middle-Byzantine tradition of the Menologion of Basil II and its followers. The final two pages, however, are decorated with six scenes of the Martyrdom of St Demetrios, and a portrait of this saint (fig. 284). The name of the patron and his office governed the choice of St Demetrios for this special treatment, and the manuscript was probably made in Thessalonike.[50]

The imagery of the Virgin which is so conspicuous in Palaiologan monumental art is found also in a manuscript of the *Akathistos* (hymn in praise of the Virgin) now in Moscow. Small framed miniatures at the head or foot of text columns show sixteen episodes of the Life of the Virgin, and seven more illustrate the doxologies of the Virgin with formal images of the Virgin standing or enthroned. The manuscript has several points of contact with others mentioned above. It has been attributed on palaeographical grounds to the scribe Ioasaph of the Hodegon, and may contain another portrait of John Kantakouzenos as a monk, in a miniature on folio

50 Oxford, Bodl. gr. Th. f.1: Spatharakis, *Corpus*, no. 237.

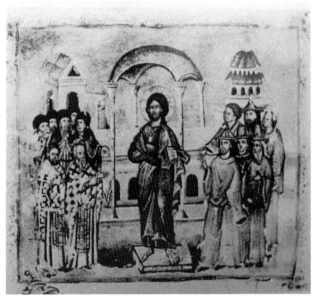

284 Menologion made for
Demetrios Palaiologos, Despot
of Thessalonike 1322–40
(Oxford, Bodleian Library gr.
th. f. 1). Folio 22r, four of
the feasts of December:
St Anastasia, Martyrs of Crete,
St Eugenia, the Nativity.

285 Akathistos hymn
(Moscow Synodal gr. 429),
folio 28: Christ with laymen,
priests and monks, one of
whom may be John
Kantakouzenos (1347–54).

28v, in which Christ is flanked by two groups of prelates, monks and lay-men (fig. 285). A further miniature on folio 33v, shows an icon of the Virgin on a stand, flanked by two groups of clerics and others. While this is appropriate to the context, and possibly depicts the singing of the *Akathistos*, it also recalls the family group venerating an icon in the Hamilton Psalter and may indicate a Palaiologan fashion for such images.[51]

A little of the circumstances of manuscript production in Palaiologan Constantinople may be gleaned from colophons, although the information they supply is not without problems of interpretation. For example, a number of colophons mention the Hodegon Monastery, which was located near to St Sophia and is best known because it housed one of the most famous icons of the capital, as noted above. The scribe Ioasaph of the Hodegon is identified in several manuscripts with ornamental headpieces, as well as in the two with figural miniatures already mentioned, and in others without illumination, making over thirty in all. The manuscripts

51 G.M. Proxoros, 'A Codicological Analysis of the Illuminated Akathistos to the Virgin', *DOP* 26 (1972) 239–52; V.D. Lixačeva, 'The Illumination of the Greek Manuscript of the Akathistos Hymn (Moscow, State History Museum Synodal Gr. 429)', *DOP* 26 (1972) 255–62.

were produced between 1360 and 1405, implying a working life of at
least forty-five years for this scribe, who eventually became *hegoumenos* of
the monastery. Between 1319 and 1336, another scribe of the Hodegon,
named Chariton, copied five manuscripts which were decorated with
ornamental headpieces. Still more scribes of the Hodegon are known from
colophons dating from 1327 to 1456 in manuscripts without illumina-
tion.[52] It would seem, therefore, that the Hodegon Monastery became an
important centre of manuscript production during the last phase of the
empire. It was not necessarily the only such centre, however, since many
scribes do not identify their locations, and this apparent concentration of
work in one monastery may simply indicate that the scribes of the
Hodegon chose to depart from custom because their monastery was asso-
ciated with a famous icon.

 None of the scribes lays claim to being illuminator as well, and in
most cases they would have left space for ornament on some text pages
and handed them to a painter for completion. Many full-page miniatures
are painted on separate leaves, to be added at the binding stage, another
indicator that writing and illumination were separate tasks, possibly car-
ried out in different locations. In the two manuscripts written by Ioasaph
that have figural images (the Oxford Psalter and the Works of
Kantakouzenos), the illuminations differ in style, and the same is true of
most of the ornamental headpieces in these and Ioasaph's other manu-
scripts. Manuscripts written by Chariton, too, appear to have received
their ornament from a different painter in each case. All this would tend to
support the proposition that manuscripts were 'sent out' from scriptoria to
painters' workshops for illumination, rather than that there was routine
collaboration between scribe and painter operating in the same establish-
ment. This said, the works of both scribes span long periods in which sev-
eral shorter phases of painter/scribe collaboration may be masked by the
fact that the surviving examples represent only a small fraction of the
scribes' output. Even in the Palaiologan period, therefore, the evidence is
still too fragmentary to permit confident conclusions about this aspect of
the production of illuminated manuscripts.[53]

52 L. Politis, 'Eine Schreiberschule im Kloster ton Hodegon',
 BZ 51 (1958) 17–36.
53 Spatharakis, *Corpus*, nos. 246, 265, 269, 270, 274,
 276, 345, 346 (Iosaph); 231, 242, 248, 255, 258

(Chariton); 186, 202, 205, 211, 214–16, 220, 226
(Theodore); H. Buchthal, 'Palaeologan Illumination',
(see n.42) 165.

General issues

The century following the Latin occupation is often described as the time of a 'final flowering' of Byzantine art and architecture – a period of revival, even 'renaissance'. Revival was necessarily the case in Constantinople, where there was clearly a phase of rebuilding, restoration and monumental decoration following the Byzantine recovery of the city. Moreover, by the early fourteenth century the repairs were not merely a matter of patching up the fabric of the city. Master builders working within the limitations set by existing structures, and heavily dependent upon *spolia* for their materials, nevertheless produced polished results. The ornate exteriors and delicate proportions of Palaiologan churches are perfectly complemented by the elegant style of high quality mosaic and painted decoration. Subtlety of design is seen in the intricate relationships between architecture and monumental art, as, for example, in the 'ancestor' domes of the Chora and the adjustment of its cycles to fit the vaults of the narthexes. Similarly, although there is little evidence for great variety or innovation in the minor arts, the quality of the miniature mosaic icons, the elaboration of their silver frames and the delicacy of manuscript illumination all identify Palaiologan Constantinople as a centre of artistic excellence, even though the number of craftsmen was probably always smaller than in the middle-Byzantine period. Re-use of models representing the heights of excellence of the past, such as sixth-century sculpture and tenth-century manuscripts, may also indicate that the revival embraced a conscious concern to refer to the accomplishments of the past. The restoration of old monasteries, while rooted in practical expediency, may also have embodied a sense of heritage. Such is the implication of Theodore Metochites' retention of a fragment of the Comnene fabric of the Chora, which could well have been cleared away in so extensive a rebuilding, and in his inclusion of Isaac Komnenos among the donor images.

Outside Constantinople, too, the buildings and monumental art of Mistra, Thessalonike and the Balkans assert the high quality of Palaiologan material culture and, as is so often the case, give a fuller view of it than is supplied by the remains in the capital. Indeed, there is also a change to the traditional role of the capital as a centre of excellence from which the forms and styles of art and architecture were carried to the provinces and beyond. The revival in Constantinople must have depended upon the continued production of Byzantine art and architecture elsewhere during the Latin occupation when, for a period representing two generations of craftsmen, the most important commissions were not metropolitan. It may be supposed therefore that some of the best artists and builders in late thirteenth-century Constantinople came, like their patrons, from the areas of exile. The 'revival' must therefore be seen at least in part as the relocation of traditions that had been sustained, and perhaps developed, in the Empire of Nicaea and the Despotates, particularly in Thessalonike. Many of these traditions must have been of metropolitan

origin, but they are likely to have assimilated, in varying degrees, the customs of their localities. The commissions of Serbian patrons also gave Byzantine builders and artists the opportunity to develop their work in response to new requirements. Developments in Constantinople in the 1260s, therefore, are likely to have drawn on a variety of resources.

In architecture, for example, the initial phase of restoration and addition in the capital may have depended upon the current customs of Nicaea, while the introduction of the 'unifying exonarthex' scheme of the Chora was an early fourteenth-century import, probably from Thessalonike. The related consolidation of the somewhat haphazard buildings resulting from the first phase was part of the same introduction to the capital of the 'enclosing aisle' scheme found in churches in Thessalonike and elsewhere. The most obvious provincial accretions to metropolitan style are the ornate brick and tile patterns of several Constantinopolitan facades, which have their antecedents in twelfth- and thirteenth-century provincial work in Macedonia and Thrace. Other introductions came from the West and included the heraldic motifs which enter the Byzantine decorative repertoire, the belfries and ogival arches, and possibly the 'painterly' development in mosaic and the naturalism of some donor portraits. The precise provenance and chronology of these features is elusive, since significant Western influences were already apparent in the twelfth-century capital and more may have been effected by the Latin occupation itself. Nevertheless, more Western imports must have arrived after 1261, when the Palaiologan world became increasingly open to Western culture, with hardly an aristocratic family not connected by marriage to prominent Italian or Frankish families.

The long narrative cycles of Palaiologan monumental art may also owe some of their development to artistic activity outside the capital. As we have seen, the narrative tradition is of long standing in Byzantine art, but it is not clear just where and when the cycles began to increase in length and detail, and acquire the distinctive Palaiologan style that is seen in the Chora church. The expansion of cycles may have begun in twelfth-century Constantinople, encouraged perhaps by the experience of artists in Sicily, where the need to cover large areas of wall provides a suitable context for the development. The trend is seen in St Sophia in Trebizond in the thirteenth century, and may therefore have also been present in the other regions of exile during the Latin occupation. It must also have been spurred by the thirteenth-century commissions of Serbian patrons at sites such as Studenica and Sopoćani. By the time it reached the Chora, therefore, the extensive narrative cycle was a mature component of monumental art. Indeed, the cycles of the Chora, which are less detailed than those of contemporary Balkan monuments, may be seen as abbreviated versions of schemes developed for buildings with much more space available for decoration.

Even after the initial period of revival, the art of Constantinople remained closely linked to that of the provinces and of the Balkans. The

close stylistic similarity between work in Constantinople, Thessalonike and some of the Serbian churches of the fourteenth century suggests that the best artists were in fairly short supply and moved around the vestiges of the empire and beyond to meet the requirements of their patrons. Specific examples of itineracy include painters Eutychios and Michael, who signed their work in some of the Serbian monastery churches, and also in St Clement, Ohrid. They may also have worked on Mount Athos, where painting at the Great Laura has been attributed to them. Patrons like Michael Glabas, who commissioned work in both Constantinople and Thessalonike, would also have encouraged the movement of artistic ideas and artists.

The freedom from the limitations of local traditions brought by the movements of patrons and craftsmen may account for the eclecticism of Palaiologan architecture, which has no 'typical' church type. A range of plans of several periods is found, among them the inscribed-cross, the ambulatory plan, the triconch, the Greek-cross-octagon and the basilica. Local preferences may be identified – the ambulatory church in Constantinople, for example, the inscribed-cross in Thessalonike, and the combination inscribed-cross basilica in Mistra, but no centre is without variety. The Palaiologan stamp is given by the ornament of the exterior, and by the common feature of aisles embracing the naos, whatever its plan. Exactly what developments of Palaiologan usage or ritual required these peripheral spaces is not certain, but it would appear that functional requirements were the unifying factor, and the particular forms assembled to meet them were selected from a wide range of models.

Given the cosmopolitan nature of the Palaiologan aristocracy, therefore, and the continued importance of the Greek Despotates after the recovery of Constantinople, it is likely that from the early fourteenth century onwards the relationship of capital, provinces and neighbours was to a large extent one of mutual exchange. Thessalonike was probably as important a source of craftsmen as the capital, particularly for the Serbian rulers, who were as important to patronage of the arts as the Byzantine aristocracy. In these circumstances, the customary term 'metropolitan' for the Palaiologan style clearly requires qualification. Like the Tetrarchs with which this survey began, the Palaiologan patrons took a comprehensive view, but of a much smaller world.

8 Approaches to the study of Byzantine art and architecture

There is not room in a text of this length for a critical assessment of scholarship spanning at least a century, but the purpose of this final chapter is to draw together some of the observations about approaches to Byzantine art and architecture that have been touched upon at various points above. As was said at the outset, the study of art and architecture, in common with most other scholarly disciplines, has two basic strands, the first of which may be termed archaeological and encompasses all work with artefacts, whether field-work or study in museums and libraries. The second, interpretation, necessarily follows the first, just as catching the hare is the essential first step in the proverbial instruction to cooks. It is clearly important to determine as much fact as possible about Byzantine artefacts before assigning them places in artistic or cultural development. This said, it is also evident that if certainty were made a condition of any attempt at interpretation, then historians of Byzantine material culture might as well cut their losses and apply themselves to more promising fields. Conjecture must be permitted, therefore, always with the reservation that it is just that, and should be modified if new evidence demands it – in art history, as in most other fields, it is not unknown for a scholar to cling to an hypothesis long after it has been undermined.

To some extent the balance of fact and conjecture contributing to the present understanding of Byzantine art and architecture differs according to the area of study concerned and the approaches traditional to it. Thus, even the earliest investigations of architecture were generally archaeological in nature, with the primary aim of determining the forms, phases and chronology of a site. The same is generally true for monumental art, since study of wall painting and mosaic often takes place alongside conservation work which (at its best, at least) includes observation and recording of different phases and techniques. Great advances in archaeological methodology have improved the accuracy and extent of such investigations, but not changed their essential nature. At the other end of the scale, the study of many portable works of art, such as metalwork, ivories and icons, grew out of connoisseurship and collecting. It was often concerned chiefly with style and iconography, neglecting the systematic analysis of forms and materials. It is in this minor arts area that the 'house of cards' is most often found, wherein the foundation for conjecture is merely earlier conjecture, falsely hardened by long use. Fortunately this is changing and few

modern scholars of (for example) manuscript illumination, will ignore the palaeography or codicology of the books containing their miniatures. There are still areas, however, where archaeological investigation is hindered because much Byzantine art consists of religious objects that are still venerated. Drilling holes in icon panels to obtain samples for dendrochronology is understandably unacceptable to those for whom the icons are an important part of a living religious faith. One can only hope for further development of non-destructive techniques and willingness on the part of custodians to allow properly supervised expert examination of their treasures.

A further consideration is the increasing specialization evident in all academic research this century, which has had a dual effect on our subject. Its positive value is obvious – concentration on a particular discipline, or even on an area within it, is likely to unearth refinements that escape the dilettante. Its negative side, however, is that valuable information available from other disciplines may be overlooked by the specialist working within narrow limits. Thus, while early scholars often drew upon both documentary and archaeological materials, later study has tended to separate them. This development is to some extent inevitable and should not be condemned outright. It is often judicious to stick to a single area of expertise rather than make ill-informed forays into several. There are hazards for the unwary, for example, in Byzantine literature as a source for the art historian. Texts referring to works of art or architecture may rely more on literary formulae than on observation (as in the well-known example of the *ekphrasis*), or may include passages lifted from other authors, possibly distorting fact and context in the process. Such complexities are best sorted out by those with wider knowledge of them than is possible for many art historians. There may also be a risk of over-valuing information from outside one's own discipline, for which perhaps one feels less intellectual responsibility. Documentary proof that the founder of a particular monastery provided for the care of the sick within its walls does not, for example, justify labelling one building on every monastery site as the hospital.

Nevertheless, such potential pitfalls do not justify complete insularity of academic disciplines. There can be no doubt that the attempt to place art and architecture in its social context enlarges understanding of the work of art or architecture itself as well as contributing to the identification and understanding of social trends. In recent decades, therefore, Byzantine art history has turned increasingly to the interdisciplinary approach, calling upon literature, theology and general history – just as many scholars in these areas of Byzantine studies now make more use of art and architecture to elucidate their texts. This wider approach can sometimes release the study of Byzantine art and architecture from the dead ends that are often reached by the purely archaeological approach. It may never be possible, for example, to determine the provenances of the silver-gilt crosses described in chapters above, nor to offer a chronology

beyond 'tenth to twelfth centuries', but against the background of middle-Byzantine custom that can be drawn from documentary sources it may be reasonable to see them as the gifts of founders or other patrons to churches and monasteries, and to associate them with what is known of Byzantine liturgy and other religious ceremony.

The interdisciplinary development is helped by the growth of Byzantine studies generally, since the increasing availability of information and analysis in all fields means that the social context of artefacts is much better understood. It also brings greater opportunities for collaboration between scholars of different disciplines and this, rather than desperate attempts at polymathy, is among the most welcome advances of recent decades.

Interpretation is to some extent directed by the conventions of scholarship, and the growth of Byzantine studies as a whole has also loosened the hold of some traditional lines of thinking and encouraged new ones. The role of the Classics as the foundation of European education and scholarship naturally generated in many scholars of Byzantine art an interest in the fate of Hellenism in the Christian world and in tracing the conservation of Classical elements. This is a justified and important line of enquiry, of course, but it is also one that should not take a disporportionate place. As we have seen, the Classical component in Byzantine art is relatively minor (as distinct, perhaps, from its place in Byzantine literature). Byzantine architecture loses most of its connections with the classical past by the sixth century, and when viewed against the wider background, phenomena such as the much-discussed 'Macedonian Renaissance' are best understood as fashions of relatively short duration and limited extent. Widening of the field of Byzantine studies has prompted, in recent decades, similar and equally valid investigation of other sources and influences, such as those of Persia and other parts of the Islamic east. (As, indeed, the study of some aspects of Byzantine history is now being extended by increasing use of Arabic and other non-Greek sources.)

The artistic relationship between Constantinople and the Byzantine provinces has long been the subject of attention. While scholarly opinion has generally abandoned both the assumption of Constantinopolitan provenance for all work of high quality and the early attempts to define provincial 'schools', replacing these ideas with a subtler understanding of metropolitan diffusion and its interaction with provincial traditions is a sterner task; taking things to pieces is much easier than reassembling them in working order. A chief requirement here is fuller knowledge of provincial monuments and artefacts, a need that is being addressed by the growth of Byzantine studies in Greece and Cyprus, where detailed studies of buildings and artefacts are increasingly available. Less progress of this sort has been made in Anatolia, in spite of the impressive work of a small number of Turkish scholars and the accomplishments of European and American field-work.

The influence of Byzantine art and architecture beyond the borders of the empire is also an area in which refinements have still to be made. 'Byzantium and the West' is a venerable topic, but one that has been mainly concerned with tracing Byzantine influences in Western art. Several points made above however suggest that there is room for reciprocal exploration of influence on Byzantine custom and taste brought by Western settlement in Constantinople, the Latin Occupation and intermarriage between the aristocracies of both camps. Likewise, it has been argued above that in the late Byzantine period the artistic relationship between Constantinople and the Balkan states may have been interactive, rather than simply a matter of metropolitan diffusion. Recent developments beyond the small world of Byzantine studies will, one hopes, lead eventually to an increase in published studies of the early mediaeval art and architecture of eastern Europe, which will doubtless elucidate relationships that are at present indistinct.

A further topic, the question of conservatism in Byzantine art is one that has often provoked a defensive reaction. Study of Byzantine material culture has had to contend with the view that cultural decline from the pinnacle of Roman achievement produced in the Byzantine empire an unchanging art and architecture that was governed by rigid formulae established by the church. This view has been properly dismissed as simplistic (and challenged, one hopes, by the common sense of all who have even a passing acquaintance with the practical aspects of craftsmanship). The case for the defence argues that conservatism of form is common to the arts of most cultures, especially the applied arts, where form is intimately linked to function. It is in style, and to a lesser degree iconography, that one sees change, and this is discernible in Byzantine art, at least to the practised and unprejudiced eye. The swings of attribution that have caused examples of Byzantine art in most categories to gain or lose centuries result not from artistic sterility but from the fact, demonstrated many times above, that a full catalogue of stylistic development simply cannot be compiled from the scarce surviving material.

The charge of 'unchanging' has stronger grounds when applied to middle-Byzantine architecture – although always with the qualification that we are speaking of ecclesiastical architecture and cannot know what flights of fancy might have been expressed in the lost palaces and villas of the empire. In church design, however, conservatism cannot be denied as we see the same few standard plans used from the ninth century until, in the closing phase of the empire, innovation is brought by the cosmopolitanism of the Palaiologan aristocracy. Some qualification to this judgement is perhaps in order, since, as in the minor arts, change may have been in style rather than form and may once have been apparent in the interior and exterior finishing of churches which in most cases has been removed or obscured. Nevertheless, an essential distinction is evident between the rich architectural experiment of the early Byzantine centuries and the middle-Byzantine lack of it, and efforts to deny stagnation may

have deterred investigation of a phenomenon that would be better admitted and examined for what it says about Byzantine custom and taste. It has been argued above that middle-Byzantine conservatism in church architecture was not inevitable. Economic decline may have initiated the reduction in church size and led to the replacement of the experimenting architect by the convention-bound master-builder, but neither development need have been sustained after the ninth-century recovery. Had there been a demand from patrons for grandeur and innovation in church design the requisite technology could probably have been restored in a few generations. That this did not happen may be explained by the change in the nature of patronage, wherein the public commission of the early Byzantine patron gave way to the private, usually monastic foundation. This offered no incentive to increase of church size, since most Byzantine monasteries had small communities, nor would changes in form be encouraged by the essentially constant rituals of monastic worship. Whether this last point is interpreted as stagnation or as stability probably depends upon one's view of the monastic life.

In either case, the identification of one area of conservatism, albeit an important one, does not constitute evidence for rigid adherence to convention or lack of creativity in the artist across the whole spectrum of Byzantine material culture. Even within the monastery, scope for invention may have been provided by adjuncts to the basic formula that met the requirements of individual patrons, such as chapels and mausolea. This is an area of which little is known, but which may one day be elucidated by archaeological investigation of monastery sites. There were also still opportunities for commissions on the grand scale in the form of refurbishment of large buildings of an earlier age, something of which we have tantalizing glimpses in the documentary sources, but little tangible remains.

Finally, neither documentary sources nor cognizance of human nature suggests that the middle-Byzantine patron shunned ostentation, and it may be that constraints on the scale and forms of church architecture encouraged artistic creativity in other channels, such as the production of costly and splendid decoration and furnishings – the gold mosaic, gold and silver panelling, the jewelled reliquaries and liturgical implements. This is not to accuse patrons of the earlier Byzantine centuries of austerity – Anicia Juliana's glass-eyed peacocks should not be forgotten – but it is in the middle-Byzantine period that the taste for the opulent appears to be most developed. The wine fountains and mechanical lions of the imperial palace exhibit similar tastes in secular art, the least-known area of our field. Once again, whether one sees all this as magnificence or decadence depends upon one's point of view. It was a taste that provoked awe in foreign visitors to Constantinople but the scorn of Edward Gibbon, whose *Decline and Fall of the Roman Empire* must bear a good deal of responsibility for the defensive nature of much subsequent assessment, this one included.

APPENDICES

I *Armenian art and architecture*

The kingdom of Armenia, which was established at the end of the third century AD and had its period of greatest prosperity in the tenth and eleventh centuries, occupied an area to the southeast of the Black Sea. The region was once part of the Roman Empire and now straddles northeast Turkey, south Russia and northern Iran. Armenia became Christian in the early fourth century but separated from Byzantine orthodoxy after the sixth-century Council of Chalcedon. There were many points of contact between the Armenians and their Byzantine neighbours, whether as allies or enemies, and Armenian populations were from time to time resettled in various parts of Byzantine Anatolia, particularly in the middle-Byzantine period. Armenians became generals in the Byzantine army and participants in the intellectual and administrative life of the Byzantine court. A few became Byzantine emperors, notably Basil I 'The Armenian'.

Similarities between Armenian and Byzantine art and architecture are the result partly of this interaction throughout the Byzantine period and partly because both Armenian and Byzantine traditions spring from the common source of the Roman background – the ancient Armenian city Artaxata was built by Roman architects sent by Nero in the first century BC. The programmes, styles and iconography of Armenian wall-painting, manuscript illumination and minor arts have much in common with Byzantine tradition. In one area, that of decorative sculpture, the Armenian tradition appears to be stronger than that of Byzantine Anatolia, for elaborate carving is found on Armenian funerary stelae (*katchkars*), and many churches are embellished with figure subjects and ornament cut in high relief, usually on exterior walls. The tenth-century Church of the Holy Cross at Aghtamar, in Lake Van, furnishes a particularly elaborate example.

Points of correspondence between Armenian and Byzantine church architecture are of particular interest, and suggest a parallel development. In fifth-century Armenia the basilica was prevalent, usually on a relatively modest scale, like the basilicas of central Anatolia, and, like them, built of fine ashlar masonry. By the seventh century domed buildings were being built, becoming the dominant type from about the ninth century onwards, still of ashlar construction. The relationship to Byzantine architecture is

not simply that of a provincial cousin, however. Many features of plan and construction show Armenian architecture to be the product of an independent building tradition of high quality. Indeed, it is argued that it was sometimes the source, rather than the reflection, of innovations in Byzantine architecture. While seldom demonstrable with certainty, such hypotheses are plausible, given the contacts noted above. It was an Armenian, Trdat, architect of Gagik I of Armenia, who repaired the dome of St Sophia in Constantinople in 989, and the migrant Armenian populations of the seventh–ninth centuries must have included masons and master-builders.

BIBLIOGRAPHY
S. der Nersessian, *Armenian Art* (London 1978); P. Charanis, *Armenians in the Byzantine Empire* (Lisbon 1963).

2 *The Copts*

Egypt was a significant centre of early Christianity, with a patriarchate at Alexandria and burgeoning monasticism in its deserts – the fourth-century pilgrim, Egeria, found them almost crowded with monks. Several important shrines grew up, such as that of St Menas at Abu Mina in the Western Desert and St Jeremiah at Saqqara. Although much of Egypt was lost to Christendom in the seventh century as the followers of Mohammed moved north and west from Arabia, some communities remained Christian, and survive to the present day as the Copts (the name comes from the Arabic word for Egyptian written in Greek). Until the upheaval of the seventh century, Egypt was an important part of the Byzantine trading network in the Mediterranean. Porphyry, the prized purple stone used to make imperial sarcophagi, was quarried in Egypt and shipped to Constantinople. Conversely, acanthus and basket capitals made in the quarries of Proconnesos (southwest of Constantinople) were sent to Egyptian sites such as Saqqara. After the Arab incursion, however, Coptic material culture had an independent development with little input from the Byzantine empire and increasing dependence on the artistic traditions of Islam.

In common with the rest of the early Christian world, Egypt took the basilica as a standard church type, and examples built in the sixth or seventh century still function in Old Cairo and elsewhere. In Egypt, however, the basilical form was retained, never giving place to the domed types of the Byzantine architectural development from which it had become isolated. Early Coptic sculpture, most of it made to decorate buildings and sarcophagi, displays figure reliefs and ornament in styles dependent upon, but less naturalistic than, the models of the Hellenistic and Roman background. Similarly, Coptic wall painting, from the mid-sixth century (at St

Apollo at Baouit, for example) to the present day, shows a very stylized treatment of figures.

Coptic Egypt is of particular interest as a source of textiles of the fifth century, perhaps earlier, which have been preserved in the peculiarly dry climate. Linen and wool strips or patches have woven decoration using a range of motifs – geometric patterns, schematized plants and animals and sometimes figure subjects, both secular and religious. These strips and patches were sewn onto larger pieces of plain cloth which were used as hangings, or to make tunics or other clothing, a few examples of which have been preserved entire.

BIBLIOGRAPHY
B. Watterson, *Coptic Egypt* (Edinburgh 1988); A.B. Badawy, *Coptic Art and Architecture* (Cambridge M A/London 1978).

3 *Byzantine ceramics*

The traditional role of pottery in archaeology as a guide to the chronology of a site has limitations in the Byzantine field. For pottery to serve this function there must be a corpus of classified material gathered from many systematically excavated and recorded sites, against which new finds can be matched. Little work of this kind was done in Byzantine contexts until the second quarter of this century, leaving Byzantine ceramics a still largely uncharted territory. The position is gradually changing and proper stratigraphical recording of pottery finds is now part of the archaeological work at many Byzantine sites – in recent years at Kalenderhane Camii and the Church of St Polyeuktos in Constantinople, for example. Until this line of research is further advanced, however, understanding of Byzantine ceramic production can be little more than generalization and conjecture.

It would appear that, as might be expected, Byzantine pottery of the fourth to sixth centuries continues the traditions of late Roman production, but that new types emerge by the middle-Byzantine period. These include various white clay wares, some with greenish-yellow glaze, others with a clear glaze over polychrome decoration. There are also red/brown wares, often coated with a thin layer of white clay (slip) and then incised to produce patterns in the exposed red/brown body. Forms are generally simple – bowls, plates and occasional jugs or flasks – and decoration, whether painted or incised, is generally secular, consisting of ornament and/or stylized figures of plants and animals. Byzantine pottery is seldom of high quality and most pieces are probably to be regarded as objects of routine domestic use. There is nothing to match the fine ceramic ware produced from the ninth century onwards in the Islamic world, the import of which may have been partly responsible for the appearance of Islamic motifs in middle-Byzantine art (ornament derived from kufic script, for

example). Conceivably the availability of such imports discouraged development of a Byzantine fine ceramics industry.

Glazed tiles have been found on many Byzantine sites, and were evidently in production at least since the ninth century. They were used in the decoration of architecture, and, in addition to the standard flat square or rectangle, some were made with curved surfaces to cover moulded revetments. The tiles have polychrome painting, usually of ornament but sometimes of religious subjects such as the Virgin and Child. Tile-work icons are attested by a ninth or tenth-century example found at Patleina in Bulgaria, which has an image of St Theodore made up of a number of tiles. It would seem that Byzantine tile-making had declined or ceased by the Palaiologan period, and the conquering Ottoman Turks brought tile-makers from Persia to set up the factories that produced the famous decoration of their mosques.

BIBLIOGRAPHY
D. Talbot Rice, *Byzantine Glazed Pottery* (Oxford 1940); *Splendeur de Byzance* (Exhibition Catalogue) (Brussels 1982), 225–39; C.L. Striker & Y.D. Kuban, 'Work at Kalenderhane Camii in Istanbul: Fifth Preliminary Report', *Dumbarton Oaks Papers* 29 (1975) 306–18; R.M. Harrison, *Excavations at Saraçhane in Istanbul* (Princeton NJ 1986) I; T. Totev, 'L'atelier de céramique peinte du monastère royal de Preslav' *CahArch* 35 (1987) 65–80.

4 *Byzantine coins and seals*

Byzantine coins were minted in gold, silver, copper, bronze and other alloys, and with a range of quality tending to reflect value, so that gold coins are generally made with better dies and more careful finishing than those of base metal. This said, it is also the case that Byzantine coins seldom attained the quality of their Roman antecedents and even gold Byzantine coins often have irregular edges and crudely rendered details. For this reason, perhaps, they have had limited popularity with collectors.

Many coins of all denominations produced throughout the Byzantine period bear an image of the emperor on the obverse. This is usually a bust, but sometimes a standing or enthroned figure, with an inscription giving the emperor's name and titles, often abbreviated. The reverse may have a further inscription referring to the emperor, or identifying the mint, or a cross, often on a stepped base. On other types the emperor may be shown with a co-emperor (usually his son or brother) and occasionally with an empress, particularly if her claim to the throne was direct, rather than as consort. On early Byzantine coins religious figure subjects are rare, but they become common in the middle-Byzantine period. Christ or the Virgin and Child are the most frequently represented figures, with archangels appearing occasionally and saints still less often. Occasional 'coronation'

images, in which Christ (sometimes the Virgin) demonstrates divine approval of the ruler by touching his crown, duplicate the imagery seen also in manuscript illumination, ivory panels and enamelwork.

Style and iconography similar to that of the coinage is found on the seals that were used to authenticate important documents by emperors, other members of imperial families, patriarchs, court officials and commercial functionaries. Most of the surviving examples are of lead, but a few wax seals are also preserved. The name of the person issuing the seal is usually present on the obverse, sometimes as a monogram, but portraits are not found, except on imperial seals. Some seals have religious subjects, often with an invocation for divine benevolence on behalf of the seal-issuer.

The serious numismatist is chiefly concerned with the elucidation of economic history, but the study of coins (and seals) also has something to offer the art historian. Since they are generally dated or datable, coins may be of archaeological importance as indicators of the chronology of a systematically excavated site. Further, although the imperial portraits on Byzantine coins and seals are usually far from naturalistic, some appear to indicate specific physical characteristics of their subjects (a gaunt face as opposed to a plump one, for example, or a long or short beard), distinctions which may assist the identification of imperial images in monumental or minor arts which lack inscriptions. Similarly, coins and seals extend the evidence available for imperial costume and for iconographic types, both of imperial and religious subjects.

BIBLIOGRAPHY
P. Grierson, *Byzantine Coinage* (Washington DC 1982); G. Zacos & A. Veglery, *Byzantine Lead Seals* (Basel 1972).

5 *Byzantine emperors*

DATE	NAME*	MANNER OF ACCESSION**
324–37	Constantine I	
337–61	Constantius	son
361–3	Julian	appointed
363–4	Jovian	appointed
364–78	Valens	appointed
379–95	Theodosius I	son
395–408	Arcadius	son
408–50	Theodosius II	son
450–7	Marcian	married Pulcheria, widow of Theodosius II
457–74	Leo I	appointed (his daughter Ariadne m. Zeno)
474	Leo II	infant son of Ariadne & Zeno
474–5	Zeno	husband of Ariadne
475–6	Basiliscus	brother-in-law of Leo I
476–91	Zeno	(second term)
491–518	Anastasius I	married Ariadne
518–27	Justin I	appointed
527–65	Justinian I	nephew
565–78	Justin II	nephew
578–82	Tiberius I	adopted son
582–602	Maurice	son-in-law
602–10	Phocas	usurper
610–41	Heraclius	usurper
641	Constantine III & Heraclonas	sons, co-emperors
641–68	Constans II	son of Constantine III
668–85	Constantine IV	son
685–95	Justinian II	son
695–8	Leontius	usurper
698–705	Tiberius II	usurper

DATE	NAME*	MANNER OF ACCESSION**
705–11	Justinian II	(second term)
711–13	Philippicus	usurper
713–15	Anastasius II	appointed
715–16	Theodosius III	appointed
716–40	Leo III	usurper
740–75	Constantine V	son
775–80	Leo IV	son
780–97	Constantine VI	son (mother Irene regent)
797–802	Irene	mother
802–11	Nicephorus I	usurper
811	Stauracius	son
811–13	Michael I Rangabe	usurper
813–20	Leo V	usurper
820–9	Michael II	usurper
829–42	Theophilus	son
842–67	Michael III	son
867–86	Basil I	usurper
886–912	Leo VI	son
912–13	Alexander	brother, regent for Leo's son Constantine
913–20	Constantine VII	son of Leo VI, with regent Romanus Lecapenus
920–44	Romanus I & Constantine VII	co-emperors
944–59	Constantine VII	sole emperor after exile of Romanos
959–63	Romanus II	son
963–9	Nicephorus II Phocas	usurper
969–76	John I Tzimisces	usurper
976–1025	Basil II	son of Romanus II
1025–8	Constantine VIII	brother
1028–34	Zoe & Romanus III	daughter and her first husband
1034–41	Zoe & Michael IV	Zoe & second husband
1041–2	Michael V	adopted son of Zoe
1042–54	Zoe & Constantine IX Monomachus	Zoe & third husband
1055–6	Theodora	sister of Zoe
1056–7	Michael VI	appointed
1057–9	Isaac I Comnenus	usurper
1059–67	Constantine X Ducas	appointed
1068–71	Romanus IV Diogenes	married widow of Constantine X
1071–8	Michael VII Ducas	son of Constantine X
1078–81	Nicephorus III Botaneiates	married widow of Michael VII
1081–118	Alexius I Comnenus	usurper

DATE	NAME*	MANNER OF ACCESSION**
1118–43	John II Comnenus	son
1143–80	Manuel I Comnenus	son
1180–3	Alexius II Comnenus	son
1183–5	Andronicus I Comnenus	nephew of John II
1185–95	Isaac II Angelus	usurper
1195–203	Alexius III Angelus	brother
1203–4	Isaac II & Alexius IV	(second term of Isaac, with son as co-emperor)
1204	Alexius V Murtzuphlus	son-in-law of Alexios III
1204–61	Latin occupation of Constantinople	
[NICAEA]		
1204–22	Theodore I Lascaris	son-in-law Alexius III
1222–54	John III Ducas Vatatzes	son-in-law Theodore I
1254–8	Theodore II Lascaris	son (took mother's name)
1258–61	John IV Lascaris	son
[EPIROS]		
1204–15	Michael I	illeg. grandson Alexius I Comnenus
1215–24	Theodore	brother
1231–71	Michael II	illeg. son Michael I
1271–96	Nicephorus I	son
1261–82	Michael VIII Palaeologus	regent-usurper
1282–1328	Andronicus II Palaeologus	son
1328–41	Andronicus III Palaeologus	grandson of Andronicus II
1341–91	John V Palaeologus	son; father-in-law John Cantacuzenus regent
1347–55	John VI Cantacuzenus	
1376–9	Andronicus IV Palaeologus	son of John V
1390	John VII Palaeologus	son
1391–1425	Manuel II Palaeologus	son of John V
1425–48	John VIII Palaeologus	son
1449–53	Constantine XI Palaeologus	brother

*For consistency, Latin forms have been used in the above table for all names, whereas in the text of the book Greek forms are used for middle- and late-Byzantine emperors, following the custom of modern scholarship.

** This column offers a rough indication of the vicissitudes of Byzantine rule; the distinction between appointment and usurpation is often tenuous.

GLOSSARY

acanthus	Herbaceous plant with luxuriant foliage, often reproduced in carved ornament.
acheiropoietos	Lit. 'not made by hands' i.e. produced miraculously; applied to some icons and relics.
akathistos	Lit. 'not seated', referring to a hymn in praise of the Virgin, originally sung by a standing congregation.
ambo	Pulpit, often a stone structure, with one or two small flights of steps leading to a raised platform.
anargyroi	Lit. 'without silver', applied to Sts Cosmas and Damian, doctors who treated the poor without charge.
anastasis	Resurrection: depiction of the Harrowing of Hell, when Christ descended to the underworld, vanquished Hades and began raising the dead for the Last Judgement.
aniconic	Without human figures; usually applied to ornament of geometric and/or foliage motifs.
archivolt	Moulding or band of ornament decorating the rim of an arch.
arcosolium	Arched tomb recess housing a sarcophagus or grave pit.
ashlar	Building stone cut into well-finished square or rectangular blocks.
atrium	Open courtyard in front of a church or other building.
automata	Figures or other devices capable of movement by mechanical means, like the bronze lions at the Imperial Palace in Constantinople.
barrel-vault	Vault with a single axis and semi-circular section, like a half-cylinder.
basket capital	Capital with convex sides, like a basket.
bema	Sanctuary area of a church; hence bema arch which covers or fronts the sanctuary.
cabochon	Polished, but unfaceted, gemstone.
canon tables	Tables giving the concordance of the Gospels as set out by Eusebius of Caesarea.
cathedra	Bishop's throne.
chi-rho	The first two letters of 'Christ' in Greek; in art usually combined as a monogram.

chrysobull	Lit. 'gold seal'; a charter or other formal document bearing an imperial seal.
Church Councils	Meetings convened to decide doctrine; particularly the seven ecumenical councils of the early Church.
Church Fathers	Spiritual leaders of the early Church whose writings form the doctrinal basis of Byzantine orthodoxy.
ciborium	Open-sided canopy; typically, that which houses the altar in a church.
cloisonné	Enamelwork in which fused glass is contained within upright metal 'walls'; also applied to a masonry technique in which thin bricks surround stones.
codex	The familiar book with pages, which replaced the scroll of antiquity by the middle Byzantine period.
coenobium	A community of monks (or nuns); coenobitic monasticism is distinguished from the eremitic, or solitary religious life.
collobium	A long tunic worn by Christ in some images of the Crucifixion.
colophon	Manuscript entry, usually at the end of the work, naming the scribe and circumstances of production of the text; sometimes an addition by a later hand.
consular diptych	Ivory diptych commemorating the year of office of a Consul.
corbel	Projection for the support of upper structures (roof timbers, the springing of an arch).
Corinthian capital	Carved capital decorated with volutes at each corner and acanthus leaves.
cornice	Horizontal moulding or other ornament at the top of a wall.
cornucopia	Horn of plenty; a horn overflowing with fruit and flowers.
diptych	Pair of hinged panels, often of ivory; in the ancient world used to hold wax writing tablets; later paired icons.
Divine Liturgy	Symbolic eucharist, in which two figures of Christ dispense the bread and wine from an altar to the Apostles.
domestikos	Commander; a senior miliary or civil title.
Dormition	Death of the Virgin (*Koimesis*).
ekphrasis	Lit. 'description'; formal praise, usually of a building and its decoration, often written as a tribute to the patron.
encaustic	Painting using a wax medium; found especially in icons on wood panels up to the sixth century.
entablature	Horizontal band of masonry carried on columns or piers; often decorated with mouldings and/or carved ornament.
eparch	Civil governor of Constantinople.

evangelist symbols	Symbolic figures based on the prophetic vision (Ezekiel 1.10): the winged man (Matthew), lion (Mark), bull (Luke) and eagle (John).
exarch	Senior official, secular or ecclesiastical.
exedra	Semicircular or rectangular recess or niche, often with arched opening.
exonarthex	Outer entrance hall of a church, sometimes open-fronted.
festival icons	Icons depicting the major feasts of the church (typically the Annunciation, Nativity, Adoration of the Magi, Presentation, Baptism, Transfiguration, Entry into Jerusalem, Crucifixion, Women at the Tomb, Anastasis, Ascension, Pentecost).
filoque	Lit. 'and from the son' referring to the notion that the Holy Spirit proceeds from the Son as well as the Father, a doctrinal issue that was the stated cause of dispute between the western and eastern churches in the ninth century.
gallery	Upper part of a two-tier structure flanking, and open to, a single-storey main space (typically, the area above an aisle or narthex opening to the naos or nave of a church).
gospel lectionary	Collection of extracts from the gospels for liturgical use.
Great Church	Synonym for St Sophia, Constantinople.
gryphons	Fantastic winged creatures, approximate hybrids of the eagle and lion.
Hesychasm	From the Greek for 'quietness'; a manner of contemplation and prayer, applied to a fourteenth-century movement in Byzantine monasticism.
hegoumenos	Superior of a monastery (sometimes *kathegoumenos*).
hodegetria	Lit. 'showing the way', an epithet for the Virgin, applied to an icon in the Hodegon Monastery in Constantinople and its iconographic type.
house-church	Early Christian private house used as a place of worship.
iconography	Manner of representation of a subject (number, appearance and arrangement of figures and other elements).
iconostasis	High sanctuary screen, bearing icons and having one or more doors.
impost capital	Capital of square section, with four flat faces tapering sharply from top to bottom.
inhabited vine	Ornament made of scrolling foliage, the curves of which house human and/or animal figures.
katholikon	Chief church of a monastery.
koimesis	Lit. 'sleeping' applied to the death of the Virgin; Dormition.
kufic	Decorative arabic script, or ornament that imitates this.
lintel	Horizontal element at the top of an opening (typically, a doorway or window).

magistros	Byzantine dignitary of high rank.
Mandylion	Image of the face of Christ miraculously imprinted on the cloth offered to Christ by St Veronica, on the road to Calvary; a famous *acheiropoietos* relic.
mappa	Originally the cloth used by an emperor or consul to signal the start of events in the hippodrome; later a symbol of imperial office.
martyrium	Church built over the place of burial of a saint or his/her relics
meander	Pattern using square or rectangular elements in scroll-like arrangement.
menologion	Compilation of brief accounts of the lives and miracles of saints, arranged in the order of the liturgical calendar.
Metropolitan	Senior ecclesiastical title.
minuscule	Cursive script, lower case (cf. uncial)
monophysitism	Belief in the single, divine nature of Christ; condemned as heresy by the Council of Chalcedon (451).
naos	Body of a church (often used of centralized churches; cf. nave for basilicas).
narthex	Entrance hall of a church (see also exonarthex).
Nestorianism	Doctrine stressing the human nature of Christ; condemned as heresy by the Council of Ephesus (431).
nike	Winged female figure, personifying Victory.
octateuch	The first eight books of the Old Testament.
ogive	Pointed arch with S-shaped sides.
oratory	Room or recess for private prayer.
parekklesion	Side-chapel, often with a funerary function.
passion cycle	Series of images illustrating the death and resurrection of Jesus.
pastophories	Areas flanking the sanctuary of a church, often lateral apses.
paten	Plate used for the bread or wafers of the eucharist.
Patriarch	Chief ecclesiastical office; the Patriarch of Constantinople became the head of the Byzantine church; the Patriarch of Rome is known as the Pope.
pectoral	Ornament worn across the chest and shoulders, not unlike a mayoral chain of office.
personification	Human figure representing something inanimate, either physical (city or river) or conceptual (Justice, Prophecy).
pier	Free-standing architectural support with square or rectangular section.

pilaster	Architectural support with rectangular section, partly embedded in a wall.
porphyrogennetos	Lit. 'born in the purple'; of imperial birth. Referring both to the imperial colour and the palace birthing-room which was decorated with porphyry (see below).
porphyry	A reddish-purple stone, quarried in Egypt, used in the decoration of imperial buildings and for imperial sarcophagi.
presbyter	Priest
proedros	High ranking civil or ecclesiastical title.
proskynesis	Prostration as a sign of respect, before an emperor, senior cleric, or icon.
protospatharios, protostrator	Dignitaries of the imperial court; sometimes with military command.
putti	Idealized naked figures of small children.
pyxis	Cylindrical ivory box made of a section of elephant tusk (pl. pyxides).
quadriga	Four-horse chariot.
revetment	Decorative panels (e.g. of marble on the walls of a building, or silver on furniture or icon frames).
Sacra Parallela	Theological anthology (*florilegium*).
sail-vault	Square or rectangular vault which curves to an apex from four corners, like a wind-filled sail.
sakellarios	Senior administrator, usually with financial responsibility, in secular or ecclesiastical contexts.
sarcophagus	Above-ground container for human remains, typically a large stone chest with carved decoration.
sardonyx	Semi-precious blood-red translucent stone.
Sassanian	Pertaining to the Persian empire of the third to seventh centuries, ruled by the Sassanid dynasty.
scaenae frons	The permanent 'backdrop' of the Roman theatre, typically an arrangement of columns, entablature and pediments, at the back of the stage.
senmurv	Fantastic beast of Sassanian origin.
silver-gilt	Silver with a thin layer of gold applied to it; typically the silver shows through in raised areas of decoration on such a surface.
skeuophylax	Keeper of the Skeuophylakion, or treasury of a church or monastery.
spolia	Re-used material such as columns, capitals etc., taken from earlier buildings.

squinch	Niche formed below an arch which spans the corner of a square, usually in order to support a dome.
strategos	General; military commander.
stucco	Fine plaster, often used to make mouldings or other relief ornament.
synkellos	Lit 'same cell'; advisor of a patriarch or bishop.
synthronon	Concentric seating (usually stone benches) for clergy in the apse of a church.
tempera	Painting using egg-yolk medium; used for small-scale work, such as icons on wood panels.
tessera	Small cube of stone or glass, used to make mosaic; gold tesserae have gold leaf backing on clear glass.
tetramorph	The four symbols of the evangelists (q.v.) assembled into a single four-part winged form.
tetrarchs	The four leaders of the Roman empire during the late third/early fourth centuries AD (two imperial pairs with the titles Augustus and Caesar).
theotokos	Lit. 'God-bearing', an epithet for the Virgin Mary.
titulus	Properly 'titular church'; early Christian meeting house, in Rome.
triconch	Architectural scheme with three elements of hemispherical plan arranged as a trefoil.
triptych	Hinged set of three panels: a large central panel and smaller flanking wings that can close over it.
trulla	Ladle or small bowl with a handle.
typikon	Document setting down the rules of conduct (administrative or liturgical) of a monastery.
uncial	Majuscule script, roughly equivalent to capital letters.
vellum	Animal skin prepared for writing; parchment.
vine-scroll	Ornament formed of stylized vine leaves and fruit
votive	Pious gift in fulfilment of a vow.
voussoirs	Stones or bricks forming an arch.

SELECT BIBLIOGRAPHY

Most of the titles given below are cited elsewhere in this volume, but are gathered here for convenience. They do not offer comprehensive coverage of the field, but rather a selection of further reading chosen on the basis of accessibility, both in terms of lucidity of text and availability in libraries. Each category lists general works first, followed by others in chronological order of their subject matter. Those pursuing topics in Byzantine art and architecture in greater depth may find it helpful to use the footnotes in this volume, wherein the aim has been to cite references which will in turn supply extensive bibliography on the particular topic.

History

G. Ostrogorsky, *History of the Byzantine State* (Oxford 1968)
A.A. Vasiliev, *History of the Byzantine Empire* (Madison WI 1952)
S. Runciman, *Byzantine Civilization* (London 1933, New York 1962)

A.H.M. Jones, *The Later Roman Empire* (Oxford 1964)
D.J. Chitty, *The Desert a City* (Oxford 1966)
A. Cameron, *Procopius and the Sixth Century* (London 1985)
A.J. Toynbee, *Constantine Porphyrogenitus and his World* (London 1973)
D. Obolensky, *The Byzantine Commonwealth* (London 1974)
D.M. Nicol, *The End of the Byzantine Empire* (London 1979)
S. Runciman, *The Fall of Constantinople* (Cambridge 1965)

Sources in translation

C. Mango, *The Art of the Byzantine Empire, 312-1453* (Englewood Cliffs NJ 1972)

H.B. Dewing, *Procopius VII Buildings* (Cambridge MA/London 1971)
H. Turtledove, *The Chronicle of Theophanes* (Philadelphia PA 1982)
I. Dujcev, *The Book of the Eparch* (London 1970)
E.R.A. Sewter, *Michael Psellus. Fourteen Byzantine Rulers* (Harmondsworth 1966)
 The Alexiad of Anna Comnena (Harmondsworth 1969)
H.J. Magoulias, *O City of Byzantium, Annals of Niketas Choniates* (Detroit MI 1984)
C.M. Brand, *Deeds of John and Manuel Comnenus by John Kinnamos* (New York 1976)

General

A.P. Kazhdan, ed., *The Oxford Dictionary of Byzantium* (Oxford 1991)
K. Wessel & M. Restle, eds., *Reallexikon zur byzantinischen Kunst* (Stuttgart 1963-)
J. Lassus, *The Early Christian and Byzantine World* (London 1967)
J. Beckwith, *Early Christian and Byzantine Art* (Harmondsworth 1970)

F. van der Meer and C. Mohrmann, *Atlas of the Early Christian World* (London 1966)
K. Weitzmann, *Age of Spirituality. Late Antique and Early Christian Art* (New York 1979)
E. Kitzinger, *Byzantine Art in the Making* (London 1977)
J. Beckwith, *The Art of Constantinople. An Introduction to Byzantine Art* (London 1961)
O. Demus, *Byzantine Art and the West* (New York 1970)

Architecture and monumental art

C. Mango, *Byzantine Architecture* (New York 1976)
T. Mathews, *The Byzantine Churches of Istanbul. A Photographic Survey* (University Park PA 1976)
A. Van Millingen, *Byzantine Churches in Constantinople, Their History and Architecture* (London 1912)
W. Oakeshott, *The Mosaics of Rome from the Third to the Fourteenth Centuries* (London 1967)

A. Heidenreich, *The Catacombs*, 2nd edn. (London 1966)
M. Gough, *Alahan* (Toronto 1985)
R.M.A. Harrison, *A Temple for Byzantium* (Austin TX/London 1989)
R. Mainstone, *Hagia Sophia* (London 1988)
G.H. Forsythe & K. Weitzmann, *The Monastery of St. Catherine at Mount Sinai. The Church and Fortress of Justinian* (Ann Arbor MI 1973)
O. von Simpson, *Sacred Fortress* (Chicago 1948)
A. Paolucci, *Ravenna* (Florence/London 1978)
M. Restle, *Byzantine Wall Painting in Asia Minor* (Shannon 1967)
L. Rodley, *Cave Monasteries of Byzantine Cappadocia* (Cambridge 1985)
C. Bouras, *Nea Moni on Chios. History and Architecture* (Athens 1982)
O. Demus, *The Church of San Marco in Venice* (Washington DC 1960)
V. Lazarev, *Old Russian Murals and Mosaics* (London 1966)
E. Kitzinger, *The Mosaics of Monreale* (Palermo 1960)
E. Kitzinger, *The Mosaics of St. Mary's of the Admiral in Palermo* (Washington DC 1990)
H. Belting, C. Mango, D. Mouriki, *The Mosaics and Frescoes of St. Mary Pammakaristos (Fethiye Camii) at Istanbul* (Washington DC 1978)

R.G. Ousterhout, *The Architecture of the Kariye Camii in Istanbul. Dumbarton Oaks Studies* 25 (Washington DC 1987)
P.A. Underwood, *The Kariye Djami* I-III (New York 1966) IV (London 1975)

Minor arts and manuscript illumination

K. Weitzmann, *Icons* (New York 1980)
K. Wessel, *Byzantine Enamels from the Fifth to the Thirteenth Century* (Shannon 1969)
K. Weitzmann, *Late Antique and Early Christian Book Illumination* (London 1977)

A. Grabar, *Les Ampoules de Terre Sainte (Monza, Bobbio)* (Paris 1958)
G. Vikan, *Pilgrimage Art* (Washington DC 1982)
K.S. Painter & J.P.C. Kent, *The Wealth of the Roman World* (London 1977)
M.M. Mango, *Silver from Early Byzantium* (Baltimore 1986)
H. Maguire, *Earth and Ocean: the Terrestrial World in Early Byzantine Art* (University Park PA 1987)
K. Weitzmann, *The Monastery of St. Catherine at Mount Sinai. The Icons* (Princeton NJ 1976)
J. Beckwith, *The Veroli Casket* (London 1962)

SOURCES OF PLANS

Plans have been redrawn from the following sources:

2 Dura Europos: C. Bradford Welles (ed.) *The Excavations at Dura-Europos. Final Report. VIII.II, The Christian Building*, by C.H. Kraeling (New Haven CT 1967), plan v.

3 Via Latina catacomb: A. Ferrua, *Le Pitture della Nuova Catacomba di Via Latina* (Rome 1960), fig. 1.

6 Stoudios Monastery church: A. Van Millingen, *Byzantine Churches in Constantinople, Their History and Architecture* (London 1912), p. 56.

7 Church of the Nativity, Bethlehem: A. Ovadiah, *Corpus of Byzantine Churches in the Holy Land*, Bonn 1970, pl.73 (from *Q.A.D.P.* 6 (1938) p. 6).

8 Acheiropoeitos, Thessalonike: S. Pelekanidis, *Palaiochristianika mnemeia Thessalonikes* (Thessalonike 1949), pl. 1.

9 Binbir Kilise no. 1: W.M. Ramsay & G.L. Bell, *The Thousand and One Churches* (London 1909), fig. 2.

10 Dâr Kîtā: H.C. Butler, *Early Churches in Syria* (Princeton NJ 1929), fig. 13.

11 St Babylas, Antioch: J. Lassus, *Sanctuaires chrétiens de Syrie* (Paris 1947), fig. 51.

12 San Lorenzo, Milan: A. Calderini, G. Chierici, C. Cecchelli, *La Basilica di San Lorenzo Maggiore in Milano* (Milan 1951), fig. 45.

14 Sanctuary barriers: A.K. Orlandos, *H Xylostegos Palaiochristianeke Basilike tes Mesogeiakes Lekanes* (Athens 1952), figs. 491, 492, 493.

22 Sta Constanza, Rome: F.W. Deichmann, *Frühchristliche kirchen in Rom* (Basel 1948), plan 4.

25 Mausoleum of Galla Placidia, Ravenna: Deichmann, *Ravenna*, plan 8.

26 Orthodox Baptistry, Ravenna: Deichmann, *Ravenna*, plan 1.

27 Rotunda, Thessalonike: Diehl, *et al.*, *Salonique*, fig. 8.

38 Qalat Siman, Syria: D. Krencker, *Die Wallfahrtskirche des Simeon Stylites in Kal'at Sim'ân* (Berlin 1939), fig.2.

39 Alahan, central Anatolia: M. Gough, *Alahan* (Toronto 1985), fig. 44.

40 Yerebatan Sarayı, Istanbul: W. Müller-Wiener, *Bildlexikon zur Topographie Istanbuls* (Tübingen 1977), fig. 323.

41 St Catherine, Mount Sinai: G.H. Forsythe & K. Weitzmann, *The Monastery of St Catherine at Mount Sinai. The Church and Fortress of Justinian* (Ann Arbor MI 1973), p. 7.

42 St John, Ephesus: J. Keil, *Forschungen in Ephesos*, IV.3 (Vienna 1951), pl. LXVIII.

43 Katapoliane, Paros: F.W. Hasluck & H.H. Jewell, *The Church of Our Lady of the Hundred Gates in Paros* (London 1920), pl.1.

44 Qasr' ibn-Wardan, Syria: H.C. Butler, *Early Churches in Syria* (Princeton NJ 1929), fig. 194 Q.

45 St Sophia, Istanbul: Mainstone, *Hagia Sophia*, fig. A2, p. 271.

46 Sts Sergius & Bacchus, Istanbul: P. Sanpaolesi, 'La Chiesa dei SS. Sergio e Bacco à Costantinopoli', *Rivista dell' Istituto Nazionale D'archeologia e Storia Dell'arte*, n.s. 10 (1961) 116–80, fig. 1.

58 San Vitale, Ravenna: Deichmann, *Ravenna*, plan 37.

62 San Apollinare Nuovo, Ravenna: Deichmann, *Ravenna*, plan 50.

84 St Eirene, Istanbul: W.S. George, *The Church of Saint Eirene at Constantinople* (London 1913), pl. 1.

85 St Sophia Thessalonike: K. Theoharidou, *The Architecture of Hagia Sophia Thessaloniki*, BAR International Series 399 (Oxford 1988), fig. 1.

86 Dereağzı, central Anatolia: J. Morganstern, 'The Byzantine Church at Dereağzı and its Decoration', *IstMitt*, Beiheft 29 (Tübingen 1983), foldout 2.

87 Myra, southern Anatolia: Y. Demirez, *Türk Arkeoloji Dergisi* 15/1 1966, 13–34.

88 Vize, Thrace: F. Dirimtekin, 'Vize'deki Ayasofya Kilisesi (Süleyman Paşa)', *Ayasofya Müsesi Yılliği* 3 (1961) 18–20.

89 Koimesis Church, Nicaea: Th. Schmit, *Die Koimesis-Kirche von Nikaia* (Berlin/Leipzig 1927), pl. IV.

90 St Clement, Ankara: G. de Jerphanion, 'L'Église de Saint-Clément à Angora', *Mélanges de l'Université de Saint-Joseph* 13 (1928) 113–43, pl. LXVII.

91 Bryas Palace, Bostancı: S. Eyice, 'Istanbul'da Abâsi Saraylarının Benzeri olarak yapılan bir Bizans Sarayı', *Belleten* 1959, 79–92, fig. 3.

102 Myrelaion, Istanbul: C.L. Striker, *The Myrelaion (Bodrum Camii) in Istanbul* (Princeton NJ 1981), fig. 19.

103 Monastery of Lips, Istanbul: Macridy *et al.*, 'Monastery of Lips', *Dumbarton Oaks Papers* 18 (1964) 249–315, fig. A & plate 5 (Mamboury).

105 Side, south Anatolia: S. Eyice, 'L'Église cruciforme byzantine de Side en Pamphylie', *Anatolia* 3 (1958) 35–42, fig. 2.

106 Peristerai, Thrace: A.K. Orlandos, *Archeion ton byzantinon mnemeion tes Hellados*, Athens 7 (1951) fig. 31.

107 Hosios Loukas, Phokis: E.G. Stikas, *To Oikodomikon Chronikon tes Mones Osiou Louka Phokidos* (Athens 1970), fig. 1.

108 Kılıçlar Kilise, Cappadocia: M. Restle, *Byzantine Wall Painting in Asia Minor* (Shannon, 1969), 2, opp. p. 250.

109 Canlı Kilise, central Anatolia: M. Restle, *Studien zur Frühbyzantinischen Architektur Kappadokiens* (Vienna 1979), 2, fig. 49.

110 Iviron Monastery church, Mount Athos: G. Millet, *L'École grecque dans l'architecture byzantine* (Paris 1916, Variorum reprint 1974), fig. 26.

111 St Anne, Trebizond: S. Ballance, 'The Byzantine Churches of Trebizond', *Anatolian Studies* 10 (1960) 141–75, fig. 8.

112 Skripou, Boeotia: A.H.S. Megaw, 'The Skripou Screen', *ABSA* 61 (1966) 1–32, fig. 1.

118 Ayvalı Kilise, Cappadocia: L. Rodley, *Cave Monasteries of Byzantine Cappadocia* (Cambridge 1985), fig. 40 p. 208.

150 Christ Pantepoptes, Istanbul: A. Van Millingen, *Byzantine Churches in Constantinople, their History and Architecture* (London 1912), fig. 73.

151 Pantocrator Monastery, Istanbul: A. Van Millingen, *Byzantine Churches in Constantinople, their History and Architecture* (London 1912), fig. 77, and A.H.S.

Megaw, 'Notes on Recent Work of the Byzantine Institute in Istanbul' *DOP* 17 (1963) 333–64, fig. D.

152 Panagia Chalkeon, Thessalonike: Diehl *et al.*, *Salonique*, pl. L.

153 Samarina, Messenia: G. Millet, *L'École grecque dans l'architecture byzantine* (Paris 1916), fig. 32.

154 Nea Mone, Chios: C. Bouras, *Nea Moni on Chios. History and Architecture* (Athens 1982), fig. 25.

156 St Sophia, Nicaea: A.M. Schneider, 'Die römischen und byzantinischen Denkmäler von Iznik-Nicaea', *Istanbuler Forschungen* 16 (Berlin 1943), pl.5.

157 Sagmata Monastery, Boeotia: A.K. Orlandos, *Monasteriake Architektoneke* (Athens 1958), fig. 3.

158 Hallaç Manastir, Cappadocia: L. Rodley, *Cave Monasteries of Byzantine Cappadocia* (Cambridge 1985), fig. 2.

159 St Sophia, Kiev: H. Logvin, *Kiev's Hagia Sophia* (Kiev 1971), fig. 9.

160 San Marco, Venice: O. Demus, *The Church of San Marco in Venice* (Washington DC 1960), fig. 1.

161 Palatine Chapel, Palermo: G. di Stefano, *Monumenti della Sicilia Normana* (Palermo n.d.), fig. 84.

162 Martorana, Palermo: G. di Stefano, *Monumenti della Sicilia Normana* (Palermo n.d.), fig. 100.

177 St Sophia, Kiev, Donor image: V. Lazarev, *Old Russian Murals and Mosaics* (London 1966), 236, fig. 26.

221 Nymphaion, Kemalpaşa: S. Eyice, 'Le Palais byzantin de Nymphaion près d'Izmir', *Akten des XI. Internationalen Byzantinistenkongresses, München 1958* (Munich 1960), 150–3, fig. 20.

222 Chrysokephalos, Trebizond: S. Ballance, 'The Byzantine Churches of Trebizond', *Anatolian Studies* 10 (1960) 141–75, fig. 4.

223 St Sophia, Trebizond: D. Talbot Rice, *The Church of Hagia Sophia at Trebizond* (Edinburgh 1968), fig. 15.

224 St Theodora, Arta: A.K. Orlandos, *Archeion ton byzantinon mnemeion tes Hellados*, Athens 2 (1936) fig. 3, p. 90.

225 Blachernae Monastery church, Arta: A.K. Orlandos, *Archeion ton byzantinon mnemeion tes Hellados*, Athens 2 (1936) fig. 1, p. 7.

226 Kato Panagia, Arta: A.K. Orlandos, *Archeion ton byzantinon mnemeion tes Hellados*, Athens 2 (1936) fig. 4, p. 73.

230 Studenica, Yugoslavia: S. Radojcić, *Slavische Grundriss* (Berlin 1969), fig. 5b.

232 Tekfur Sarayı, Istanbul: After Meyer-Plath & Schneider, as in *Bildlexikon zur Topographie Istanbuls* (Tübingen 1977), fig. 275.

233 Theotokos Pammakaristos, Istanbul: H. Hallensleben, 'Untersuchungen zur Baugeschichte der ehemaligen Pammakaristoskirche der heutige Fethiye Camii in Istanbul', *IstMitt* 13/14 (1963/4) fig. 1.

234 St Andrew in Krisei, Istanbul: A. Van Millingen, *Byzantine Churches in*

Constantinople, their History and Architecture (London 1912), figs 36 & 37.

236 Vefa Kilise Camii, Istanbul: H. Hallensleben, 'Zu Annexbauten der Kilise Camii in Istanbul', *IstMitt* 15 (1965) 208–17, fig. 2.

237 Chora Monastery church, Istanbul: R.G. Ousterhout, *The Architecture of the Kariye Camii in Istanbul*, DO Studies 25 (Washington DC 1987), fig. 10.

238 Holy Apostles, Thessalonike: A. Tapoulas, in N. Nikonanos, *The Church of Holy Apostles in Thessalonike*, 1986, fig. 1.

239 St Panteleimon, Thessalonike: Diehl *et al.*, *Salonique*, pl. LIV.

240 St Nicholas Orphanos, Thessalonike: A. Xyngopoulos, *Oi toichographies tou Agiou Nikolaou Orphanou Thessalonikes* (Athens 1964), fig. section (no p. nos.)

241 Paragoretissa, Arta: A.K. Orlandos, *H Paregoretissa tes Artes* (Athens 1963), fig. 18.

242 St Demetrios, Mistra: M.G. Soteriou, *Mistra* (Athens 1956), fig. 30.

243 St Theodore, Mistra: M.G. Soteriou, *Mistra* (Athens 1956), fig. 36.

244 Theotokos Hodegetria, Mistra: M.G. Soteriou, *Mistra* (Athens 1956), fig. 37.

245 Mistra palaces: M.G. Soteriou, *Mistra* (Athens 1956), fig. 33 (after Orlandos).

247 Ohrid, former Yugoslavia: B.M. Schellewald, *Die Architektur der Sophienkirche in Ohrid* (Bonn 1986), pl. 11.

248 Gračanica, former Yugoslavia: S. Ćurčić, *Gračanica* (University Park PA/London 1979), figs. 10 & 11.

257 Decoration at St Nicholas Orphanos: A. Xyngopoulos, *Oi toichographies tou Agiou Nikolaou Orphanou Thessalonikes* (Athens 1964), fig. section (no p. nos.)

SOURCES OF PHOTOGRAPHS

The following sources of photographs are gratefully acknowledged:

Institutions

Ann Arbor MI, Michigan–Princeton–Alexandria Expedition to Mount Sinai: 60, 77, 78, 122, 123, 202, 203, 220, 277; *Athens*, Benaki Museum Photographic Archive: 27, 28, 59, 117, 155, 165, 175, 227, 228, 256, 269; *Baltimore MD*, Walters Art Gallery: 71; *Bamberg*, Diözesanmuseum & Ingeborg Limmer: 196; *Berlin*, Deutscher Staatsbibliothek Berlin in der Stiftung Preussischer Kulturbesitz: 37; Staatliche Museen Preussischer Kulturbesitz, Frühchristilich-Byzantinische Sammlung: 67, 129, 134, 278; *Brescia*, Museo Civico Cristiano: 33, 36; *Brussels*, Musées Royaux d'Art et d'Histoire: 95; *Budapest*, Magyar Nemzeti Múzeum: 193, 195; *Cambridge MA*, Visual Collections, Fine Arts Library, Fogg Art Gallery, Harvard University: 89; *Cologne*, Erzbischöfliches Diözesan Museum: 139; *Cortona*, Museo Diocesano: 132; *Darmstadt*, Hessisches Landesmuseum: 137; *Esztergom*, Keresztény Museum: 200; *Florence*, Biblioteca Nazionale: 93; Fratelli Alinari: 15, 22, 23, 56, 58, 92, 182, 183, 184, 189, 205; Biblioteca Medicea Laurenziana: 80; *Geneva*, Musées d'Art et d'Histoire Genève: 128; *Hannover*, Kestner Museum: 188; *Harmondsworth*, Penguin Books Ltd: 7, 85, 265; *Istanbul*, Topkapı Sarayı Müzesi: 208; Istanbul Archaeological Museum: 54, 219, 250; *Kiev*, Mistetstvo Publishers: 177; *Liège*, Musée d'Art Religieux et d'Art Mosan: 197; *Limburg*, Bischöfliches Ordinariat: 126; *London*, British Library: 209, 273; British Museum: 30; British School at Athens: 112; Conway Library, Courtauld Institute of Art: 9, 15, 17, 18, 24, 25, 38, 39, 50, 52, 58, 61, 79, 98, 104, 106, 111, 115, 124, 125, 127, 143, 146, 147, 149, 154, 157, 160, 169, 174, 178, 223, 224, 241, 245, 246, 249, 254b, 266; Pindar Press: 275; Thomas Nelson & Sons, 20; Victoria & Albert Museum: 34, 135, 136, 192; *Lucca*, C. Caretta: 63c; *Madrid*, Biblioteca Nacional: 218; *Marburg*, Bildarchiv Foto Marburg: 173, 231, 247, 258, 259; *Melbourne*, National Gallery of Victoria (Felton Bequest): 213; *Milan*, Castello Sforzesca (Foto Saporetti): 35; *Monza*, Museo del Duomo: 74; *Moscow*, State History Museum: 100, 286; *Mount Sinai, Egypt*, Monastery of St Catherine: 211; *Munich*, Bayerische Staatsbibliothek: 133; Hirmer Fotoarchiv: 252, 263, 265; *Ohrid*, Naroden Musei: 261; *New Haven, CT*, Yale University Art Gallery: 2; *New York*, Metropolitan Museum of Art, Gift of J. Pierpont Morgan: 76, 94; Metropolitan Museum of Art, The Cloisters Collection, Purchase 1966: 53c; *Niš*, Narodni Museum: 53b; *Oxford*, Bodleian Library: 206, 284; Governing Body of Christ Church: 279; Governing Body of Lincoln College: 283; *Paris*, Bibliothèque Nationale: 64, 68, 81, 141, 145, 148, 186, 207, 212, 216, 280, 281; Musée National des Thermes et de l'Hôtel de Cluny 63b, 199; Musée du Louvre: 53a, 65, 187, 190b, 282; A. & J. Picard: 113, 164; *Rome*, Deutsches Archäologisches Institut: 3, 21, 26, 62, 69; Josephine Powell: 231b; Soprintendenza per i Beni Artistici e Storici di Roma, Museo del Palazzo Venezia: 131; Biblioteca Apostolica Vaticana: 101, 142, 144, 217, 279; *Rossano*, Museo Diocesano di Arte Sacra: 82; *St*

Petersburg, Hermitage: 73, 75; *Tblisi*, Museum of Fine Art: 194; *Thessalonike*, Archaeological Museum: 32; John Rekos & Co: 257; Vlatadon Monastery: 140, 215; *Utrecht*, Rijksmuseum het Catharijneconvent: 191; *Venice*, Archivo Fotografico del Museo Correr: 201; Procuratoria di San Marco: 138; *Vienna*, Bildarchiv der Österreichische Nationalbibliothek: 79, 83, 210; Kunsthistorisches Museum: 99; *Washington*, DC, Dumbarton Oaks Byzantine Visual Resources: 40, 49, 57, 70, 72, 96, 114, 116, 120, 152, 163, 166, 170, 179, 180, 185, 198, 254c-f, 255, 267, 268, 272.

Individuals

Professor Ch. Bouras 107; Professor A.A.M. Bryer 221, 238; Dr Zaga Gavrilović 230, 248, 260; Professor R.M. Harrison 48a; Dr Judith Herrin 111, 115, 245; Mrs A. Haznedar 16, 48b,c; Mr G. House 38, 169, 254b; Dr Henry Maguire 17; Dr Robert Ousterhout 152; Dr Anne Terry 57; Mr David Winfield 230.

INDEX

In this index, buildings are listed according to their locations; the same is true for objects and manuscripts, but very well-known examples are also listed alphabetically by their popular names; some entries are grouped by category: Architecture, Artisans, Book decoration, Book type, Building techniques, Church furniture, Iconography, Materials, Object types and Patrons; this last category does not include imperial persons and patriarchs, who are listed alphabetically. Numbers in italics are the page numbers of illustrations.

Aachen 244
Abdül Mecit, Sultan 155
Abgar, King 164, 165, *165*
Abu Mina, St Menas 348
acheiropoietos images 101, 355, 358
Act of Union (*Henotikon*) 58, 278
Africa, north 34, 44, 59, 115
Aghtamar, Holy Cross 347
Agnellus 41
Akathistos hymn 303, 309, 336, 337, 355
Alahan, Monastery 60, 61, *61*, 66, 72
Albania 196, 335
Alexander, emperor 161
Alexandria 10, 12, 348
Alexios I 3, 145, 196, 198–200, 213, 225, 226, 234, 242, 247, 248, 257, 259, 274
Alexios II 233
Alexios III 263, 335
Amalfi 244
Amaseia 38
Anastasius, emperor 43, 58, 60, 62, 66, 76, 88, 89, 93
Andrew, King of Hungary 238
Andronikos I 263
Andronikos II 276, 279, 311, 323, 335
Andronikos III 277, 291, 333
Ankara, St Clement 120, *121*
Anna Komnena 145, 197, 198, 242; *Alexiad* 197
Antalya 97, 99
Anthony of Novgorod 232
Antioch 5, 8, 10, 12, 24, 46, 89, 97–9, 197, 209, 227, 254, 258; Chalice of 98; St Babylas 24, *25*; St Symeon the Younger 74, 89
Apollonius, *On Bones* 187
Aquileia, cathedral 34, 35, *35*
Arabs 2, 3, 59, 115, 122, 132, 137, 150, 348

architect *see* artisans
ARCHITECTURE
BUILDING TYPES amphitheatre 16; aqueduct 18, 62, 65, 72, 78, 135, 136, 200, 284; bath 16, 24, 43, 62; church: – basilica 20–2, 24, 26, 39, 40, 54, 62, 63, 65, 66, 69, 71, 72, 74, 81, 85, 86, 113, 117–21, 137, 138, 142, 147, 205, 206, 208, 223, 259, 267, 268, 270, 271, 289, 292, 293, 341, 347, 348, 358; – cross-domed 118, 120, 121, 137, 138, 201, 267; – cross-domed basilica 117, 118, 120; – domed basilica 71, 117, 118, 120, 121, 137, 223; – domed transept basilica 66; – double-shell 70, 71, 85; – free-cross 140; – Greek-cross-octagon 204, 259, 262, 289, 341; – house-church 13, 15, 16, 357; – inscribed-cross 135–43, 159, 191, 199–203, 208, 209, 219, 226–8, 259, 267, 269, 271, 281, 285–7, 289, 291, 292, 293, 303, 341; – octagon-domed 205, 259; – single-naved 140, 222, 225, 311; – transverse-barrel vaulted 140; – triconch 122, 140, 141, 205, 293, 341, 360; – twin-naved 140;
cistern 16, 18, 62, 63, 202, 290; column, monumental 11, 26, 32, 33, 60, 76, 265, 297; fortification 13, 62; hospital 6, 16, 200, 343; martyrium 24, 40, 101, 358; mausoleum 6, 17, 24, 36, 37, 40, 41, 44, 65, 135, 153, 199, 200, 205, 274, 346; palace 6, 8, 17, 62, 65–7, 70, 76, 79, 80, 111, 112, 116, 121, 122, 126, 127, 132, 134, 135, 145, 148, 150, 152, 153, 160, 192, 193, 198, 208, 222, 228–30, 234, 238, 244, 248, 264, 267, 268, 274, 279, 288, 290, 291, 345, 346, 355, 359; temple 11, 13, 16, 26, 34; triumphal arch 18, 39, 44
COMPONENTS aisle 20–4, 69, 79, 117, 118, 138, 205, 208, 224, 229, 267, 270, 281, 284, 286–8, 292, 298, 305–7, 309, 340, 341, 357; ambulatory 24, 36, 37, 70, 71, 202, 208, 267, 281, 283, 341; apse 20, 24, 27, 28, 38, 39, 42, 44, 69, 78, 79, 81–3, 86–8, 100, 113, 114, 122, 127, 128, 135, 136, 138, 139, 141, 145, 151–3, 155–7, 159,

160, 162, 171, 200, 201, 203–5, 212, 217, 218, 222–5, 227, 228, 231, 265, 269, 274, 285, 294, 301, 303, 305, 307, 310, 319, 358, 360; arcosolium 281, 297, 355; atrium 20, 22, 67, 355; baptistry 13, 24, 34, 40, 41, 43, 44, 55, 122; belfry 265, 285, 286, 294, 340; bema 128, 138, 144, 152, 155, 202, 205, 217, 272, 307, 355; chapel 6, 19, 121, 122, 136, 137, 140, 146, 157, 201, 208, 222, 226, 228–30, 244, 265, 279, 281, 287, 288, 292, 305, 307, 309, 307, 311–13, 346, 358 (see also parekklesion); clerestory 20; crypt 204, 217, 219; exedra 69–71, 357; exonarthex 67, 205, 213, 272–4, 281, 283–8, 291, 294, 300, 303, 307, 311, 313, 340, 357, 358; facade 33, 60, 79, 279, 281, 283, 284, 286, 291, 307, 340; gallery 14, 20, 22–4, 69, 70, 79, 118, 137, 155, 161, 199, 203, 204, 208, 223, 238, 281, 289, 292, 297, 322, 357; gate 12, 18, 303; naos 135–137, 141, 148, 149, 157, 204, 205, 217, 218, 222, 228, 267, 274, 281, 283–8, 292–4, 298–301, 303, 306, 307, 309, 312.; naos 341, 357, 358; narthex 20, 22, 67, 69, 118, 119, 136, 137, 140, 149, 160, 161, 199–201, 203–5, 208, 217–19, 227, 231, 267, 269, 270, 272–4, 281, 284–7, 292, 293, 298, 299, 300, 301, 303, 306, 307, 309–13, 339, 357, 358; nave 20, 22, 23, 28, 39, 60, 65, 66, 69, 72, 73, 79, 82, 85, 88, 117–20, 142, 157, 202, 205, 208, 209, 222, 225, 270, 289, 309, 357, 358; oratory 123, 285, 358; parekklesion 281, 283, 285, 286, 291, 294, 300, 302, 303, 358; pastophory 20, 358; pavilion 145; porch 137, 269, 272, 291; sanctuary 20, 27, 33, 71, 74, 78, 79, 83, 85, 86, 88, 89, 118, 126, 145, 146, 153, 155, 157, 166, 209, 210, 231, 305, 312, 355, 357, 358; tomb 35, 36, 45, 46, 74, 147, 199, 271, 281, 284, 288, 294, 297, 303; tower 18, 60, 61, 62, 66, 115, 117, 137, 268, 284, 292; transept 20, 65, 66, 228
DETAILS archivolt 296, 297, 355; banded voussoir 279, 283, 291; barrel-vault 23, 272, 355;
 capital 4, 22, 24, 26, 27, 29, 62, 72, 73, 148, 149, 210–13, 215, 262, 265, 269, 271, 281, 285, 286, 288, 294–6, 348, 356, 357, 359; – basket 73, 355; – Corinthian 26, 72, 149, 294, 356; – impost 73, 148, 294, 357; – tapering-block 210, 213;
 column 4, 20, 22, 23, 26, 27, 31, 62, 70, 117–19, 121, 122, 135, 139, 143–6, 148, 149, 202, 203, 206, 208, 210, 265, 270, 281, 283, 285–9, 297, 336, 356, 359, 360; corbel 61, 137, 148, 288, 294, 356; cornice 5, 26, 29, 73, 146, 148–50, 202, 210–12, 262, 271, 281, 294, 356; entablature 22, 26, 72, 144–7, 356, 359, 360; gutter spout 149; horseshoe arch 23; intercalary bay 136, 137, 139, 200, 203, 204; lintel 24, 26, 212, 294, 358; moulding 26, 60, 290, 291, 355, 356, 360; pier 20, 23, 69, 70, 117–20, 136, 149, 161, 202, 203, 205, 206, 208, 210, 222, 233, 289, 292, 356, 359; revetment, stone 143, 149, 160, 219, 359; sail-vault 117, 359; squinch 204, 205, 217, 218; string course 60, 146, 203
Areia, Nea Mone 203, 211
Ariadne, empress 58, 76, 77, 93
Arianism 10, 12
Arilje, St Achilleios 309, 310
'aristocratic' psalters 250
aristocrats 3, 6, 65, 76, 104, 115, 116, 132, 133, 136, 143,

144, 163, 190, 192, 194–6, 198, 199, 204, 225, 225, 234, 263, 265, 266, 270, 279, 331, 332, 340, 341, 345
Armenia 95, 132, 137, 347, 348
Arsenije I 313
Arta 3, 269–71, 278, 297; Blachernae 270, 270, 271, 271, 272 ; Kato Panagia 270, 271; St George (St Theodora) 270, 271, 270; St Theodore 289, 309; Theotokos Paregoritissa 288, 288
Artaxata 347
ARTISANS architects 6, 54, 64, 67, 71, 89, 112, 155, 201, 202, 205, 260, 346, 347, 348; artist(s) 6, 36, 52, 104, 114, 127, 129, 160, 179, 182, 188, 190, 194, 224–6, 231, 252, 253, 254, 260, 261, 266, 269, 275, 313, 326, 329, 330, 333, 338–341, 346; bronzeworkers 245; craftsmen 6, 32, 73, 74, 96, 124, 128, 150, 153, 192, 208, 215, 227, 230, 231, 237, 244, 246, 260, 262, 265, 266, 271, 279, 287, 289, 297, 324, 325, 339, 341; see also scribes
 INDIVIDUALS architects: Anthemius of Tralles 67; Isidore of Miletus 67; bronze caster: Staurakios 45; painters: Eulalios 232, 260, 317; George, Demetrios and Theodore 275; Lazarus 128; Michael and Eutychios 313; Theodore Apseudes 226, 260; Theophanes, monk 254
Asinou, Panagia Phobiotissa 225
Athanasius, St 133, 141
Athens 11; National Library 2603 (gospels) 326, 327; Panagia Gorgoepikoos 211, 211; Panagia Lykodemou 204; St John Mangouti 146
Audenarde 242
automata 151, 355
Auxerre 177, 178
Avars 59, 115

Baldwin I 263, 264
Baldwin II 279
Balkans 215, 224, 226, 231, 261, 270, 272, 273, 275, 277, 291, 297, 298, 306, 307, 313, 339, 340
Baltimore, Walters Art Gallery: Hama Treasure, Kaper Koraon Hoard 96, 97–9
Bamberg, Diözesan Museum: textile 240, 240
Basil I 3, 132, 134, 143, 145, 148, 151, 153, 155, 157, 160, 164, 180, 192, 222, 347
Basil II 132, 134, 140, 170, 177, 187–90, 192–5, 234, 251, 260, 336
Basil of Caesarea 11
Bel, temple of 13
Bela III of Hungary 243
Belisarius, general 79
Berlin: Kupferstichkabinett, Ms 78.A.9 (Hamilton Psalter) 330, 331, 337; Staatliche Museen: ivory panels 93, 94, 96; sceptre-finial 171, 171, 175, 193, 234; Staatsbibliothek Cod. theol. lat. fol. 485 (Quedlinburg Itala) 52, 53
Beth Misona 97
Bethlehem, Church of the Nativity 20, 21, 21
Bible of Leo 184, 184, 185, 187, 193
Binbir Kilise 23, 23, 24
Bithynia 74, 137, 252
Black Sea 2, 16, 100, 111, 142, 263, 269, 291, 347
Bobbio 100, 101, 106, 114
BOOK DECORATION author portrait 52, 108, 109, 129, 188,

189, 247, 252, 253, 255, 269, 325, 331, 333, 335; Canon
tables 105, 108, 109, 247, 355; dedication page 104, 106,
114; frontispiece 109; headpiece 247, 252, 253, 256, 325;
initials, decorated 179, 259; marginal illumination 130,
179, 180, 181, 184, 190, 191, 250, 251, 331

BOOK TYPES Acts of the Apostles 179, 312; Akathistos hymn
336; Bible 52, 108, 179, 182, 184, 185, 187, 193, 248;
Gospels 51, 52, 99, 103–105, 108, 109, 111, 113, 114,
129, 130, 174, 179, 180, 182, 183, 188, 247, 248, 251,
252, 254, 255, 259, 260, 266, 325, 326, 329, 355, 357;
Gregory of Nazianzos, *Homilies* 164, 180, 181, *181*, 183,
184, 189–93, 252; Gregory of Nazianzos, Homilies 180,
252, 255; Herbal 104; Homilies 179–81, 247, 252, 255,
256; James of Kokkinobaphos, *Homilies* 252; Menologion
179, 183, 187–90, 192, 194, 247, 251, 252, 255, 260, 313,
325, 336, 358; Octateuch 248; Prophet Book 188; Psalter
130, 164, 179–81, 184, 185, 187–92, 193, 247, 248, 250,
251, 258, 325, 326, 329–33, 337, 338

Boris I 133
Bosphoros 16, 198
Bosra, cathedral 71
Bostanci, Palace of Bryas 122, *122*
Boyana, St Nicholas 273
Brescia, Museo Civico Cristiano: ivories 49, *49*; 51, *51*
Bristol Psalter 250
Brussels, Musées Royaux d'Art et d'Histoire, silk 125, *125*
Bryas *see* Bostanci
Budapest, Magyar Nemzeti Múzeum: crown 237, 238, *238*, *239*
BUILDING TECHNIQUES ashlar 23, 24, 60, 347, 355; brick
23, 62, 113, 135, 136, 140, 203, 281, 283, 290–2, 340;
brick, patterned 203, 271, 279, 281, 286, 292; brick,
recessed 200, 201, 202, 267; brick/stone 10, 18, 23, 137,
140, 204, 205, 268, 271, 279, 288, 290, 356; rock-cut 6,
140, 160, 207, 272
Bulgaria 8, 133, 150, 196, 263, 272, 278, 291, 350
Bulgars 132, 196, 276
Bursa 277
Byzantium 2, 8, 10, 16, 208, 263, 279, 345
Byzas, King 16

Caesarea, Anatolia 11, 196
Caesarea Philippi 33
Cairo 348
Cappadocia 6, 202, 215
 ROCK-CUT CHURCHES Ayvalı Kilise 157, *158*, 160; Çarıklı
 Kilise 222; Çavuşin, Pigeon House Church 162, 163, *163*,
 186; Elmalı Kilise 219, *220*, 222, *221*; Hallaç Monastery
 208; Karabaş Kilise 222; Karanlık Kilise 222; Karşı Kilise
 271, 272; Kılıçlar Kilise 140, *140*, 159, *159*; Şahinefendi,
 Forty Martyrs 271, 272, *272*; Tokalı Kilise 157
Carthage 46
catacombs 14, 15, *15*, 31, 35, 36, 38, 44–6, *45* 54, 55
Cefalù 208, 228
Çeltek, Çanlı Kilise 140, *141*
Ceremonies, book of 160, 213
Chalcedon, St Auxentios 116
Chalke Gate, *see* Constantinople, Imperial Palace
Charlemagne 52, 115, 125, 129, 132, 244
Charles of Anjou 276

Chios, Nea Mone 205, *205*, 215, *216*, 217, *217*, 218, 219, *220*,
 224, 262
Chludov Psalter 130, *130*, 164, 179, 180, 250
Chonae 241
Choricius of Gaza 88
chrysobull 335, 356
Chrysopolis 10, 16
Chrysotriklinos *see* Constantinople, Imperial Palace
Church Councils 10–12; Chalcedon 12, 347, 358;
 Constantinople (381) 11; Constantinople (754) 116;
 Constantinople (1166) 258; Constantinople (1351) 334;
 Ephesus 12, 39, 358; Florence 278; Iconoclast (815) 180;
 Nicaea (325) 10; Nicaea (787) 127
Church Fathers 155, 179, 247, 257, 325, 356
CHURCH FURNITURE altar 13, 20, 26, 27, 50, 79, 88, 173,
 245, 246, 262, 356; ambo 27, 355; *cathedra* 28, 355;
 Chair of Maximianus 96, *96*, 112, 333 ; ciborium 88, 265,
 356; iconostasis 145, 294, 296, 357; pulpit 27, 355;
 sanctuary screen 27, *28*, 47, 74, 79, 144, *144*, 145–7, *147*,
 149, 173, 210, 211, 243, 271, 357, 360; synthronon 20,
 360
church unity 276, 278
Cilicia 60, 66
classical tradition 7, 31, 45, 46, 55, 57, 58, 76, 104, 108, 111,
 112, 124, 131, 134, 176, 177, 184, 186, 187, 193, 194,
 197, 344
codex 52, 108, 356
coenobium 11, 356
collobium 100, 106, 114, 167, 356
Cologne, Erzbischöfliches Diözesan-Museum, textile 178, *178*; St
 Gereon 258
colophon 5, 6, 179, 183, 190, 247, 251–4, 259, 334, 337, 338,
 356
Constans II 124
Constantia 36, 37
Constantine I 2, 8, 10, 12, 13, 16–21, 24, 29, 30, 32, 51, 54,
 55, 59, 60, 65, 79, 161, 174
Constantine V 116, 118, 126, 127
Constantine VI 118
Constantine VII 134, 145, 150, 151, 157, 160, 161, 169, 171,
 171, 192, 193, 197, 213, 234, 236, 264
Constantine VIII 177, 195
Constantine IX 196, 198, 199, 204, 205, 231, 232, 237, 238,
 256; crown of 239, 240
Constantine X 256
Constantine XI 278
Constantine Asen, Tsar 273
Constantine Rhodios 153, 231
Constantinople: 5, 10, 11, 16, 19, 20, 32, 54, 55, 57–9, 62, 63,
 66, 74, 77, 80, 88–91, 94–6, 101, 103, 110–16, 122, 124,
 127, 133, 134, 143, 146, 150, 165, 176, 177, 190, 194–8,
 202, 204, 208, 210, 212, 215, 224, 237, 243, 244, 246,
 257–9, 261–6, 269, 271, 273, 275, 276, 278, 279, 281,
 286–8, 292, 294, 295, 297, 298, 303, 309, 313, 326, 337,
 339, 340, 341, 344–6, 348; fall of 3, 202; Latin occupation
 of 3, 132, 195, 197, 260, 263–5, 271, 275, 276, 297, 332,
 339, 340, 345; sack of 166, 197, 246
 CITY acropolis 16, 198; aqueduct of Valens 16, 65, 72, 78,
 135, 200, 284; arch of Theodosius 18; basilica cistern

62, 63; Bucoleon 150; column of Marcian 32; Golden Gate 18; Golden Horn 16, 19, 196, 198, 276; hippodrome 16, 17, 33, 48, 59, 67, 74, 90, 126, 127, 223, 265, 309, 358; obelisk base 30, 30, 74; Orphanage 198;
palaces: Blachernae 198, 264, 274, 279; Hormisdas 70; Imperial, 62, 67, 79, 80, 111, 112, 116, 121, 126, 127, 134, 145, 148, 152, 153, 160, 198, 222, 238, 267, 346, 355; – Chalke Gate 79, 116, 126, 129, 273; – Chrysotriklinos 152, 153, 198; – Kainourgion 145, 148, 160, 192, 193; – Milion 126; – Mouchroutas 198, 238; Mangana 145; Tekfur Sarayı 268, 279, 280, 283, 291; Topkapı 248
walls 16, 18, 18, 19, 198, 279; weather vane 33; Yediküle 18; Yerebatan Sarayı, see above basilica cistern
CHURCHES/MONASTERIES Anthony II Kauleus, Monastery of 153; Beyazit A 63, 74; Chora (Kariye Camii) 199, 201, 213, 214, 285–7, 286, 294, 295, 295, 296–8, 298–302, 303, 304, 306, 314; Constantine Lips 135–7, 136, 148, 148, 150, 284, 284, 294, 296, 296, 297; Gül Camii 120, 201, 267; Hodegon 332, 334, 337, 338, 357; Holy Apostles 17, 24, 36, 64, 78, 134, 153, 199, 205, 208, 231, 253, 259, 260, 264, 297, 317; Kalenderhane Camii 78, 78, 201, 265, 265, 349, 350; Myrelaion 135–137, 135, 145, 148, 150, 199, 200; Nea Ekklesia 134, 137, 143, 148, 157, 160, 192, 264; Pantepoptes 199, 200, 264; Pantocrator 200, 201, 201, 210, 211, 214, 215, 252, 259, 260, 264, 265; Philanthropos 200, 281; St Akakios 18; St Andrew in Krisei 283, 283, 294; St Eirene 17, 65, 72, 117, 117, 118, 119, 120, 128, 128; St Euphemia 309; St George of the Mangana 199, 213, 231, 264; St John in Hebdomon 71; St John in Trullo 201, 210; St John of Stoudios 19, 19, 22, 27, 42, 215, 248, 250, 264; St Martha 281; St Mokios 18, 19, 74, 74, 234; St Paul 198; St Polyeuktos 65, 72–4, 73–5, 79, 104, 111–113, 147, 192, 210, 349;
St Sophia 6, 62, 63, 66, 67, 67, 68, 69, 69, 71–3, 73, 76, 79, 111, 116, 117, 121, 126, 126, 127, 134, 143, 151, 151, 152, 153, 154, 155, 155, 156, 160, 161, 161, 162, 164, 171, 174, 193, 232, 232, 233, 234, 238, 259, 260, 264, 265, 297, 298, 298, 302, 348, 357; – Fossati drawings 155;
St Theodosia 201; Sts Peter and Paul 63; Sts Sergius and Bacchus 69–73, 70, 73, 78, 111, 212; Theotokos Chalkoprateia 264; Theotokos Gorgoepikoos 281; Theotokos of Blachernae 19, 43, 126, 127, 128, 153, 198, 264; Theotokos of the Pêge 127, 153; Theotokos of the Pharos 153; Theotokos Pammakaristos (Fetiye Camii) 202, 269, 281, 282, 291, 298, 303, 305; Theotokos Peribleptos 199, 289; True Hope 335; Vefa Kilise Camii 201, 284–286, 285, 292, 294, 298, 307
Constantius 8, 17, 67
consular diptych 49, 49, 89, 90, 90, 91, 92, 94, 103, 295, 356
Copts 103, 348, 349
Coronation Gospels 129, 129
Cortona, Cathedral Treasury, cross-reliquary 173, 173
Cosmas, Hymnographer 303
Cosmas Indicopleustes, Christian Topography 182, 183, 193
craftsmen see artisans

Cresconi 46
Crete 132
Crusades 166, 197, 263, 276
Čučer, St Niketas 313
Cuenca, Cathedral Treasury, reliquary-icon 317, 317
Cyprus 101, 124, 124, 127, 132, 215, 224, 225, 226, 231, 261, 344
Cyril of Alexandria 12

Dağ Pazarı, church 60
Damascus, Great Mosque 128, 129
Daphni 204, 211, 215, 216, 218, 218, 219, 220, 224, 228, 261
Dâr Kîtă, Paul and Moses 23, 24
Dara 67
Darmstadt, Hessiches Landesmuseum, ivory casket 176, 177, 193, 194
Dečani 293, 312, 312
Decius, emperor 10
Demre, St Nicholas 118, 119, 119
Dereağzı, church 118, 119, 119
Didascalia Apostolorum 13
Digenes Akrites 145
Diocletian 8, 10, 12, 13, 16, 18
Dionysios the Areopagite 335
Dioscurides of Anazarbos 104, 105, 111–13, 131, 187
Dragutin 274, 309–11
Dura Europos 13, 15, 34, 55

earthquakes 18, 34, 71, 79, 117, 134, 152, 183, 206, 297
Easter tables 330, 250, 258
Edessa 165
Egeria, pilgrim 55, 348
Egypt 11, 30, 39, 101, 103, 113, 115, 179, 247, 348, 349, 359
Eirene, empress of Alexios I 242
Eirene, empress of Constantine V 116
Eirene, empress of Constantine VI 118, 127
Eirene, empress of John II 200, 233
ekphrasis 6, 62, 79, 153, 201, 231, 343, 356
Eparch, Book of the 146
Ephesus, church of the Virgin 22; St John 65, 65, 121
Epiphanius of Salamis 53
Epiros 263, 264, 269, 270, 271, 276, 277, 288
Esztergom, Keresztény Múzeum, reliquary 242, 243
Euchaita, St Theodore 38
eucharist 47, 83, 98, 222, 356, 358
Eudokia, empress of Basil I 180
Eudokia, empress of Constantine X 256
Eudokia, empress of Romanos II 171, 234, 237
Euphemia, empress of Justin I 76, 77
Euripides 176, 194
Eusebius of Caesaria 12, 17, 19, 24, 33, 53, 55, 105, 108, 109, 247, 355
Euthymios, St 150
Euthymios Zygabenus, Panoplia Dogmatica 257

Felix IV, Pope 81
festival icons 153, 155, 157, 165, 175, 190, 217–19, 222, 225–9, 244, 246, 260, 269, 272–4, 298, 301, 305, 307, 309–12, 322, 357

filoque 133, 357
Florence, Biblioteca Laurenziana cod. Plut. I. 56 (Rabbula Gospels) 103, 104, *106*, *107*, 108, 109, 114, 130, 180; Museo Nationale del Bargello, ivory casket 236, *236*
Franks 3, 115, 132, 133, 197, 264, 266, 276, 277, 290, 340
funerary art 45, 54, 55, 57, 102, 112, 217, 274, 285, 295, 303, 347, 358

Gagik I of Armenia 348
Galen 104
Galerius, tetrarch 8, 24, 41
Gaza, St Sergius 88
Geneva, Musée d'Art et d'Histoire: cross 170, *170*
Genoese 196, 276
Geza I of Hungary 238
Gibbon, Edward 346
Gortyn 121
Goths 12, 58, 59, 80, 85
Gračanica, monastery 292, 293, 312, 313
Great Church *see* Constantinople, St Sophia
Greek Anthology 65, 79, 152, 153
Gregory of Nyssa 24, 38
Gregory, Pope 100
Grelot, G. 265
Grimaldi, J. 123
guilds 6, 103, 146
Gunther, bishop 240, 241

Hadrian 16
Hama Treasure 96, 97
Hamilton Psalter 330, 331, 337
Hannover, Kestner Museum, Crucifixion ivory 236, *236*
Harbaville triptych 235, *235*, 236
hegoumenos 87, 250, 338, 357
Helena, empress of Manuel II 317, 323, 335
Helena, mother of Constantine 48
Helena, wife of Uros I 274, 311
Henotikon 58, 278
Heraclius, emperor 59, 103, 115, 124
heraldry 324
Herculaneum 34, 44
hermit 11, 139, 160, 226
Hesychasm 334, 357
Heybeliada, Panagia Kamariotissa 204, 262
Hippocrates 333
hoard(s) 5, 46, 47, 56, 97–100, 124, 170
Holy Land 3, 20, 48, 54, 100, 114, 224, 263, 265
Honorius, Pope 122
Hungary, holy crown of 236, 237, 238, 239

Iconoclasm 3, 74, 79, 115, 116, 120–2, 125–33, 132, 152, 156, 163, 179, 180, 190–3, 250, 260, 273
ICONOGRAPHY
 GENERAL aniconic decoration 79, 88, 128, 262, 355; anti-iconoclast imagery 130; chi-rho monogram 46–8, 98, 100, 355; cross 39, 42, 75, 87, 88, 95, 98, 99, 100, 114, 120, 122, 126, 128, 148, 149, 152, 156, 166, 170, 172, 180, 210, 213, 244, 255, 350; donor imagery 107, 122, 124, 192, 222, 227, 244, 254, 255, 257, 260, 273, 297,

307, 310, 312, 317, 323, 331, 333, 339, 340; – with church model 81, 83, 88, 162, 204, 225, 273, 310; imperial imagery: 39, 56, 123, 152, 160, 161, 162, 163, 171, 176, 177, 192, 193, 213, 222, 234, 237, 240, 256, 260, 312, 335, 350, 351 (*see also* portrait, imperial); Mandylion 164, 165, 358; personification 34, 39, 92, 104, 112, 113, 131, 187, 188, 193, 204, 238, 256, 333, 358; portrait: – artist 231, 260, 317; – author 52, 108, 109, 129, 188, 189, 247, 252, 253, 255, 269, 325, 331, 333, 335; – donor 255, 273, 312, 331, 333, 340; – evangelist 129, 188, 247, 269, 325, 333; – imperial 71, 76, 127, 160, 171, 192, 213, 222, 268, 298, 333, 335; – secular 26, 32, 45, 46, 48, 76, 77, 102, 104, 112, 351
 HOLY HIERARCHY angel 42, 43, 50, 81, 83, 92–5, 100, 102, 122, 149, 152, 153, 155, 156, 161, 167–70, 173, 175, 180, 186, 189, 213, 215, 217, 218, 222, 226–8, 241, 242, 246, 256, 269, 271, 294, 300, 303, 312, 322; archangel 93, 95, 96, 102, 112, 113, 122, 126, 147, 153, 160, 163, 171, 212, 217, 225, 240, 293, 350; – Gabriel 137; – Michael 121, 189, 222, 241, 256, 271, 297, 332; cherubim 98, 155;
 Christ 74, 100, 102, 122, 126, 153, 155, 173, 189, 236, 294, 300, 333, 335, 336, 350, 351; – ancestors of of 299, 300, 301, 307, 310, 311, 339; – crowning 234, 238, 256; – *Deesis* 147, 168, 172, 173, 222, 236, 244, 297, 298, 302, 305; – Divine Liturgy 98, 222, 223, 225, 274, 307, 309, 356; – enthroned 39, 42, 44, 56, 83, 94, 100, 105, 106, 113, 156, 157, 159, 160, 168, 180, 222, 225, 231, 232, 256, 257, 273, 297, 305; – as Good Shepherd 13, 31, 35, 36, 40, 44, 56; – of the apocalypse 74, 79, 81, 157; – Pantocrator 102, 103, 107, 153, 155, 217, 222, 231, 240, 247, 314, 319, 332;
 evangelist symbols 39, 40, 42, 43, 51, 149, 357, 360; Prophets 24, 39, 41, 42, 53, 83, 86, 102, 105, 108, 109, 137, 152, 153, 155, 179, 180, 181, 182, 183, 185, 188, 217, 218, 227, 228, 244, 246, 251, 269, 307, 309, 310, 319, 357;
 saints: Anthony 165 ; Apollinarius 87; Constantine and Helena 236, 242, 243; Cosmas 171, 309; Damian 164, 171, 309; Demetrios 85, 309, 336; Eustace 180; Euthymios 309; Forty Martyrs of Sebaste 224, 272, 321 ; Francis of Assisi 265; George 176, 222, 312; Gereon 258, 259; John Chrysostom 321, 256, 321; John the Baptist 81–3, 96, 122, 147, 164, 168, 173, 217, 219, 224, 297, 305, 307, 323, 335; John the Evangelist 102, 122; John the Grammarian 180; Lawrence 40; Marina 243; Mark 246; Maurus 81; Neophytos 260; Nicholas 137, 164, 184, 273, 307, 311, 321; Panteleimon 227; Paul of Thebes 165; Peter and Paul 39, 45, 48, 81, 94, 95, 99, 124, 155, 171, 229, 238, 241; Stephen 173; Thaddeus 165; Theodora of Arta ; Theodore 38, 81, 350; Vitalis 83; Zosimos 164;
 seraphim 98, 153, 155, 169; tetramorph 149, 155, 360; Virgin 12, 19, 22, 39, 43, 85, 98, 113, 120–23, 126, 137, 147, 152, 156, 159–162, 166–8, 170, 171, 173–5, 184, 185, 193, 198–200, 213, 217, 223, 227, 228, 233, 234, 236, 241, 243, 252, 255, 256, 264, 272–4, 281, 294, 295, 297, 300–1, 303, 305, 309, 311, 319, 321,

331–3, 356, 337, 351, 355–7, 360; – and Child 74, 80–2, 88, 94, 95, 100–3, 105, 128, 151, 153, 155, 161, 164, 212, 231, 237, 242, 244, 254, 259, 307, 314, 315, 322, 323, 331, 335, 350; – Hodegetria 264, 289, 309, 313, 332, 357; – Maria Regina 123;

NARRATIVE SUBJECTS

New Testament: Adoration of the Magi 44, 101, 153, 301, 357; Anastasis 153, 157, 164, 175, 217, 219, 236, 252, 265, 269, 303, 307, 323, 332, 355, 357; Annunciation 39, 81–3, 88, 100, 153, 157, 217, 222, 242, 244, 301, 309, 314, 357; Ascension 51, 88, 100, 103, 105, 153, 156, 157, 159, 160, 175, 222, 224, 226, 227, 231, 253, 272, 273, 357; Baptism 31, 41, 55, 96, 100, 101, 153, 155, 164, 181, 217, 269, 301, 305, 307, 357; Betrayal 153; Crucifixion 100, 102, 105, 106, 114, 130, 153, 165, 169, 173, 175, 180, 181, 217, 236, 242, 259, 269, 301, 307, 314, 321–3, 356, 357; Deposition 175, 181, 236, 242, 306, 307; Disciples on Lake Galilee 231; Dormition of the Virgin (*Koimesis*) 174, 227, 274, 301, 307, 310, 356, 357; Doubting of Thomas 88, 217, 219, 317; Dream of Joseph 300; Entry into Jerusalem 95, 153, 175, 301, 307, 357; Feeding of the Multitude 41; Flight into Egypt 39, 247; Healing of the Paralytic 88; Joachim and Anna 300, 311–13, 322; Last Judgement 234, 269, 303, 309, 355; Last Supper 88; Matthias Joining the Apostles 105, 107; Ministry of Christ 12, 13, 39, 88, 95, 96, 231, 269, 298, 300, 309, 312; Nativity 20, 21, 39, 101, 153, 175, 217, 269, 307, 357; Passion cycle 88, 106, 109, 217, 218, 222, 225, 226, 269, 271, 273, 274, 298, 301, 309–11, 358; Paul on the Road to Damascus 181; Pentecost 105, 106, 153, 155, 217, 231, 307, 357; Presentation 78, 90, 93, 153, 217, 242, 252, 257, 259, 301, 309, 357; Presentation of the Virgin 300, 307; Raising of Lazarus 36, 153; Raising of the Daughter of Jairus 303; Raising of the Widow's Son 153; Resurrection 31, 36, 50, 55, 96, 100, 105, 181, 303, 355, 358; Transfiguration 86, 87, 114, 153, 301, 307, 321, 335, 357; Virgin Fed by an Angel 242; Virgin, life of 82, 218, 219, 222, 225, 231, 253, 269, 298, 299, 307, 310, 312, 336; Visitation 81–3, 100; Washing the Feet of the Disciples 217; Wedding at Cana 88; Woman with the Issue of Blood 33; Women at the Tomb 13, 88, 153, 231, 236, 357;

Old Testament: Adam and Eve 13, 33, 109, 219, 269, 303; Anointing of David 185; Ark of the Covenant 185, 303; Column of Fire 179; Creation 229; Crossing of the Red Sea 181, 185, 329, 330; Dance of Miriam 330; Daniel and the Lions 31, 48, 96; David cycle 124, 185, 189, 251, 330; David Playing the Harp 187; David with Wisdom and Prophecy 329; Death of Jacob 109; Elias Ascending to Heaven 181; Jacob's Ladder 224, 303; Jonah and the Whale 31, 35, 36, 38, 45; Manna from Heaven 179; Moses on Mount Sinai 185; Moses Receiving the Law 83, 187, 329, 330; Moses Striking the Rock 179; Pharaoh with Moses and Aaron 108; Rebecca at the Well 230; Sacrifice of Isaac 83, 179, 180, 224; Three Hebrews 31, 36, 48, 224; Tree of Jesse 310–312

other texts: Akathistos hymn, 309, 336, 337, 355; Baptism of Constantine 79; Church Councils 126, 309, 310; Consecration of Gregory of Nazianzos 181

ORNAMENT acanthus 26, 72–4, 128, 148, 150, 294, 295, 297, 348, 355, 356; animals and birds 34, 80, 88, 96, 98, 103, 104, 128, 146, 148, 150, 151, 210, 211, 238, 265; animals, fighting 80; cornucopia 90; crown, winged 125; foliage 27, 30, 34, 37, 48, 73, 79, 80, 90, 103, 146, 147, 210, 211, 213, 215, 238, 271, 355, 357; geometric 27, 30, 34, 35, 37, 79, 146, 147, 241, 271, 349, 355; gryphons 176, 357; masks 80; palm trees 75; peacock 37, 72–4, 98, 104, 113, 167, 346; *putti* 33, 35, 37, 104, 359; quadriga 125, 359; *senmurv* 150, 359; vine 33, 88, 98, 100, 148, 357

PAGAN SUBJECTS Helios 36, 56; Hercules, labours of 176; Rape of Europa 176; Sacrifice of Iphigeneia 176; Silenus 101

SECULAR SUBJECTS charioteers 45; circus 48, 90, 94; hunting scenes 34, 80, 127, 223; months, labours of 335; musicians 223, 323;

idolatry 12, 26, 34, 56
Ihlara, Karagedik Kilise 140
Innocent, Pope 38
Ioanina 315
Isaac II 196, 198, 213
Isauria 58
Islamic art 149, 177, 238, 349
Istanbul: Archaeological Museum: archivolt 296, *296*; capital 296, *296*; funerary stele 295, *295*; marble icons 212, *212*; marble relief of an emperor 213, *213*; Porphyrios statue base 74, *75*; sarcophagus front *74*, *75*; Fatih Camii 65, 137, 268; Topkapı Sarayı Ms.G.I.8 (octateuch) 248, *249*; (*see also* Constantinople)
Izmit 8

James of Kokkinobaphos (homilies) 252, *253*
Jerusalem 10, 95, 153, 175, 197, 254, 300, 301, 307, 357; Dome of the Rock 128; Holy Sepulchre 20, 21, 50, 51; Latin Kingdom of 266
Jews 14
John I Tzimisces 132, 134, 162, 169
John II Komnenos 200, 233, 234, 247, 260
John III Vatatzes 264, 267
John V Palaiologos 277, 278
John VI Kantakouzenos 277, 289, 333, 336, 338
John VII, Pope 122, 124
John VIII Palaiologos 278, 323
John of Damascus 303
John Skylitzes, *Chronicle* 128, 259
Joshua Roll 175, 184, 186–8, *186*, 193
Julian, emperor 11, 182
Junius Bassus, sarcophagus 32
Justin I 58, 76
Justin II 98
Justinian I 2, 17, 22, 32, 59, 60, 62–7, 69, 71, 74, 76, 79, 83, 85, 89, 93, 96, 100, 111–13, 115, 117, 153, 162, 192, 241; equestrian figure of 76
Justinian II 32

Kairouan, Great Mosque 150
Kalenić 293
Kaloyan of Bulgaria 263

Kaper Koraon hoard 96, 97–9
Kariye Camii, *see* Constantinople, Chora monastery
Kartmin, Sts Samuel, Symeon and Gabriel 88
Kastoria 270; Anargyroi 205, *206*; Panagia Mauriotissa 310
katchkars 347
Katsouri, St Demetrios 271
Kemalpaşa, *see* Nymphaion
Khakhouli triptych 238, *239*, 240, 243
Kiev 207, 238, 244; St Sophia 208, *208*, 222, 223, 224, 231, 261, 303, 307; Tithe Church 140
Kokkinobaphos, James, Homilies on the Virgin 252
Konya, Sultanate 264
Korykos 60
Kücükyalı, Palace of Bryas 122, *122*
kufic script 149, 150, 177, 204, 238, 349, 357
Kumluca 97, 99
Kurbinovo, St George 227, 244

Lactantius 12, 52
Lagoudera, Panagia 225, *225*
Lambousa 124
Leningrad, *see* St Petersburg
Leo I 19, 43, 58
Leo III 116
Leo IV 116
Leo V 116
Leo VI 134, 153, 160, 161, 166, 171, 178, 240
Leo IX, Pope 197
Lesbos 28
Licinius, tetrarch 10, 16, 46
Liège, Musée d'Art Religieux et d'Art Mosan, textiles 103, 178, 241, *241*
Limburg, Cathedral Treasury, reliquary 168, *168*, 169, 170, 192, 242
Lincoln Typikon 335, 336
liturgical calendar 42, 313, 358
liturgy 10, 98, 145, 222, 223, 225, 274, 307, 309, 344, 356
Liudprand of Cremona 150
Lombards 59, 100, 115
London: British Library Mss: Add. 19.352 (Theodore Psalter) 248, 250, *250*; Burney 20 (gospels) *324*, 325; British Museum: Archangel ivory 93, 96, *93*, 112; Crucifixion ivory 236, 237, *237*; Proiecta casket 46, *47*, 56; Water Newton treasure 47, *47*, 48; Victoria & Albert Museum: ivory figure 237, *238*; Joshua ivory 175, *175*; steatite medallion 213; Symmachi panel 49, *50*; Veroli Casket 176, *176*, 177, 194, 236
Louis the Pious 127
Lucca, Duomo, diptych of Areobindus 90, *90*
Lycia 119

Macedonian Renaissance 184, 193, 194, 260, 297, 344
Madinat al-Zahrah, Palace 150
Madrid, BN Vitr. 26-2 (Skylitzes) *258*, 259
Malaja Perescepina 99
Manuel I 196–8, 234, 243, 247, 258–60, 268
Manuel II 278, 317, 323, 335
Manuel Philes 283
Manzikert 196

mappa 48, 90, 358
Marcian 19
Marciana Job 183, *183*, 189
Marmara, Sea of 2, 16, 27, 74, 122, 135, 145, 204, 262
Martin I, Pope 124
MATERIALS bronze 26, 33, 74, 76, 121, 122, 151, 244, 245, 262, 265, 297, 350, 355; cameo 176, *177*; enamel 4, 140, 166, 167, 166–8, 170, 190, 191, 193, 238, 240, 243, 247, 321, 323, 325, 351, 356; encaustic 101, 102, 356; gems/pearls 39, 43, 100, 122, 126, 166, 167, 168, 169, 170, 190, 191, 240, 317, 321, 346, 355; glass 34, 45, 46, 55, 72, 74, 113, 147, 166, 167, 170, 177, 193, 243, 346, 356, 360; gold 43, 121, 166, 167, 170, 265, 321, 350; gold leaf 45, 55, 188, 190, 360; ivory 3–5, 45, 48, 49, 51, 52, 57, 76, 89, 91–6, 102, 111–13, 129, 171, 173–7, 191, 193, 235, 237, 256, 314, 323, 324, 325, 342, 351, 356, 359; marble 22, 26, 27, 34–6, 40, 65, 73, 74, 76, 77, 112, 114, 121, 143, 145, 146, 160, 199, 212, 213, 215, 217, 219, 237, 262, 265, 281, 285, 288, 294, 299, 359; mosaic 4, 5, 34–44, 52, 55, 57, 76–81, 85, 86, 88, 89, 96, 103, 111, 112, 114, 118, 120–2, 126–8, 151–3, 155, 156, 160, 161, 164, 190, 191, 193, 204, 205, 208, 215, 217, 219, 222, 224, 227, 228, 230–3, 254, 259, 261, 262, 294, 297, 298, 299, 301, 302, 303, 306, 307, 313, 314, 319, 321, 322, 325, 339, 340, 342, 346, 360; – floor 34, 35, 80, 89, 111, 112; – miniature 321, 339; *opus sectile* 215; papyrus 52; parchment, *see* vellum; porphyry 30, 37, 348, 359; pottery 46, 78, 150, 177, 201, 349, 350; sardonyx 170, 359; silk 103, 125, 177, 178, 183, 240, 241 ; silver 45–8, 56, 97, 98, 99, 111, 112, 124, 128, 144, 166, 170, 177, 241, 243, 265, 314, 317, 321–3, 325, 339, 343, 346, 350, 355, 359; silver-gilt 46, 166, 170, 177, 243, 343, 359; stained glass 265; stucco 41, 360; tempera 102, 360; tiles, glazed 350; vellum 52, 108–110, 129, 360; wood 3, 48, 150, 164, 243, 247, 356, 360
materials, re-used 4, 26, 27, 29, 75, 76, 100, 146, 148, 149, 202, 208, 210, 213, 269, 271, 285, 286, 288, 294, 296, 323, 339, 359
Maurice, emperor 101
Maxentius, tetrarch 10
Maximian's chair 95, 96, 112, 333
Mediterranean Sea 3, 10, 16, 55, 150, 170, 263, 348
Megara, St Meletios 211
Mehmet I 278
Mehmet II 3, 18
Melbourne, National Gallery of Victoria (gospels) 254, *254*, 260
Melitene 196
Menologion of Basil II 187, *187*, 188–90, 194, 260, 336
merchants 183, 195, 196, 213, 244, 263
Mereyemlik 60
Mesembria, St John Aleitourgetos 291, *291*
Meteora, Monastery (icons) 315, *316*, *318*
Michael II 116, 127
Michael II of Epiros 270, 288
Michael III 132, 134, 151, 152
Michael V 199
Michael VII Doukas 238, 240, 257
Michael VIII Palaiologos 264, 276, 288
Michael Keroularios, Patriarch 241

Michael Psellus 197, 231; *Chronographia* 197
Milan 8; Castello Sforzesca, ivory panel 50, *50*; San Lorenzo 24, 25, 71
Mileševo, Ascension 272, 273, 275
Milutin 274, 277, 292, 293, 310–13
Milvian Bridge 10
mint stamps 46, 97–9, 101, 124
minuscule 179, 183–7, 358
Mistra 277, 278, 289, 309, 339, 341; Brontocheion 289; Evangelistra 290; houses 290–1; palace complex 290, *290*; Pantanassa Church 289; St Demetrios (Metropolis) 289, *289*; St Sophia 289; St Theodore 289, *289*; Theotokos Hodegetria 289, *290*, 309
Mithras 13
monasteries 6, 24, 59, 99, 110, 129, 133, 141, 144, 174, 190, 192, 199, 206, 222, 233, 242, 259, 264, 279, 281, 338, 339, 341, 344, 346 *see also* under place-names
monasticism 11, 309, 348, 356, 357
Monemvasia 335
Mongols 264
monk(s) 103, 105–7, 133, 144, 150, 183, 184, 190, 204, 242, 252–4, 256, 257, 272, 273, 312, 332, 334–6, 348, 356
Monophysitism 12, 58, 88, 358
Monreale 208, 228–31, *230*, *231*, 261
Monza, Cathedral Treasury, ampullae 100, *100*, 101, 106, 114
Morea 277
Moscow: Museum of Fine Art, ivory, Christ and Constantine 171, *171*, 213, 234; State History Museum: Cod. gr. 382 (menologion of 1063) 251, 252; Cod. gr. 129 (Chludov psalter) 130, *130*, 164, 179, 180, 250; Synodal gr. 429 (Akathistos hymn) 336, *337*; Tretyakov Gallery, icon 332, *322*
Mount Athos, monasteries of 133, 141, 272, 341; Chilandar 293; Dionysiou, Ms. 61 (homilies of Gregory of Nazianzos) 255, *256*; Grand Komnenoi 335; Great Laura 141, 254, 341; icon 321, 323, *322*; Iviron 141, *142*; Kutlumusiu 255; Pantocrator, Ms. 61 (Pantocrator Psalter) 130, 164, 179, 180, *180*; Vatopedi, church 141; icon 321, *321*; Ms 938 (gospels) 325, *326*
Mount Sinai, Monastery of St Catherine 64, *64*, 72, 86, *86*, 88, 191, 206; icons 101, 102, *102*, 103, 107, 108, 111, 112, 114, 163, 164, *164*, *165*, 243, 244, *244*, 245, 252, 266, *266*; Ms gr. 61 (psalter) 329, 330; Ms gr. 364 (homilies of John Chrysostom) 256; Ms gr. 152 (gospels) 326; Ms gr. 339 (homilies of Gregory of Nazianzos) 252, 253, *253*
Munich, Bayer. Staatsbibliothek, cod. Lat. 4453 Cim. 58 (Gospels of Otto III) 174, *174*
Murano 96
Murat I, Sultan 277
Myra, St Nicholas *118*, 119, *119*, 120

Naissus 46
Nauplion 203
Nerezi, St Panteleimon 226, *227*
Nessebur *see* Mesembria
Nestorianism 12, 358
New York, Metropolitan Museum, Joshua ivory 175; marble bust 77, *77*; pectoral 101, *101*; silver dish *124*
Nicaea 3, 10, 196, 197, 263, 264, 272, 278, 281, 283, 339, 340; Koimesis (Dormition) church 120, *120*, 122, 126, 128, 155, 157, 191, 231, 267; St Anthony 267; St Demetrios 281; St Sophia 206, *207*; St Tryphon 267
Nicander, *Theriaca* 187
Nicetas, patriarch 127
Nicholas I, Pope 133, 197
Nicomedia 8, 12, 20, 46, 52
Nika riots 59, 65, 67, 117
Nike 92, 358
Nikephoros II Phokas 132–4, 144, 162, 169, 174, 186, 192
Nikephoros III Botaneiotes 213, 257
Nikephoros, patriarch 180
Niketas Choniates 198, 265
Nikolaos Mesarites 198, 231
Niphon, patriarch 286, 306, 307
Niš 46; Euphemia head 76, *77*
Normans 196, 197, 208, 234
Nymphaion, palace 267, *267*, 279

OBJECT TYPES ampulla 100, *100*, 101, 106, 114; book cover 4, 96, 99, 167, 170, 238; candlestick 45; casket 175, 176, *176*, *177*, 193, 194, 236, *236*; chalice 45, 85, 88, 96, 98, 99, 128, 166, 169, 170, *170*, 193; coin 101, 103, 171, 350, 351; cross 48, 98, 166, 170, *170*, 173, 174, 241, 242, *242*, 343; crown 4, 41, 125, 166, *166*, 167, 169–71, 177, 189, 234, 237, 238, 240, 243, 256, 324, 351; diptych 45, 48–50, 89–94, 96, 102, 103, 112, 166, 167, 172, 236, 295, 332, 356; dish 45, 46–8, 85, 100, 124, *124*; door 121, 244, 245, 262; ewer 100; fountain-front 213; glass bowl 45, *45*; icon 52, 53, 56, 101, 102, *102*, 103, 107, 108, 111–13, 116, 126, 127–30, 145, 153, 155, 157, 161, 163–7, 172, 175, 180, 190, 193, 212, *212*, 217–19, 222, 225–9, 237, 241, 243, 244, 245, 246, 252, 260, 264, 266, *266*, 269, 272–4, 294, 295, 298, 301, 305, 307, 309–12, 314, *314*, 315, *315*, 316, 317, 319, *319*, 320, 321, *321*, 322, *322*, 323, *323*, 325, 331, 332, 337–9, 342, 343, 350, 355–7, 359, 360; – double 166, 167, 314, 317; – monumental 212, 237, 242, 295; – mosaic 319, 321, 339; jewellery 101; lamp 48, 98, 99; marble panel 34, 212, 262; paten 98, *98*, 99, 99, 100, 113, 166, 169, 222, 358; pectoral 101, 170, 358; plaque, votive 47; pyxis 96, 97, 323, 324, 359; reliquary 4, 43, 48, 98, 100, 125, 127, 129, 166, 168–70, *168*, 169, 170, 173, *173*, 177, 192, 242, 243, *243*, 317, *317*, 346; sarcophagus 24, 26, 30–2, *31*, *32*, 36, 37, 54–7, 74, *74*, 75, *75*, 201, 219, 295, 332, 348, 355, 359; sceptre 48, 90, 102, 112, 171, *171*, 175, 193, 213, 234; seal 350, 351, 356; spoon 46, 48, 98; statue 11, 26, 32, *32*, 33, 56, 57, 74, 76, 92, 113, 122, 150, 151, 193, 245, 265, 297, 350, 355; statuette 237; textile 3, 45, 73, 103, 125, 150, 178, 240, 241, 349; triptych 102, 164, 171, 172, 175, 191, 192, 235, 236, 238, 240, 243, 360; trulla 100, 360; weather-vane 33
Ohrid 195, 196; St Clement, icons 313, 314, *314*, *315*, 341; St Sophia 223, 224, *224*, 229, 261, 292, *292*
Olympia *28*
Ordelafo Falier, Doge 246
orthodoxy, Byzantine 3, 10, 12, 58, 59, 85, 86, 88, 116, 133, 152, 170, 250, 257, 263, 278, 309, 310, 323

Otto II 171, 234
Otto III, Gospels of 174, *174*
Ottoman Turks 277, 278; architecture 18, 72, 136, 210;
 tile-making 350
Oxford: Bodleian Library gr. th. f. 1 (menologion) 335, *337*; Ms
 Clarke 10 (gospels) 247, *248*, 252; Christ Church gr. 61
 (psalter) *331*, 332; Lincoln College Ms. grec. 35 (typikon)
 335, *336*

pagan imagery 36–8, 45, 46, 50, 55, 57, 77, 100, 112
paganism 11, 14, 30, 31, 33, 34, 37, 47, 56, 58, 102, 182
painters *see* artisans
Pala d'Oro, San Marco 245, *246*, 323
Palermo; Martorana 209, *210*, 227, 228, *228*; Palace Chapel
 208, *209*, 228–30, *229*, 244
Palestine 10, 20, 21, 33, 34, 44, 59, 64, 88, 89, 100, 101, 103,
 115, 132
Pantocrator Psalter 130, 164, 179, 180, *180*
Paphos, Hermitage of St Neophytos 226, *226*
Parastaseis syntomoi chronikai 32, 150
Paris: Bibliothèque Nationale, *ivories*: diptych of Philoxenus 91,
 91; diptych Christ & Virgin 94, *95*, 95; Romanos &
 Eudokia, 171, *175*, 234, *234*, 235, 237; Crucifixion, 236,
 237; *Mss*: Coislin 79 (*Homilies*, Chrysostom) 256, *256*; gr.
 20 (psalter) 179; gr. 70 (gospels) 188, *188*; gr. 74 (gospels)
 249, *249*; gr. 139 (Paris Psalter) 184, 185, *185*, 187–90,
 193, 248, 250, 251, 326, 329, 330; gr. 247 (Theriaca)
 187; gr. 510 (Paris Gregory) 164, 180, 181, *181*, 183, 184,
 189–93, 252; gr. 580 & 1499 (menologion of 1056) 252;
 gr. 922 (Sacra Parallela) 256; gr. 1208 (*Homilies*,
 Kokkinobaphos) 252, 253, *253*; gr. 1242 (Kantakouzenos)
 333, 334; gr. 2144 (Hippokrates) 333, *332*; Syr. 341 (Syriac
 Bible) 108, *109*;
 Louvre, *ivories*: equestrian emperor 92, *92*; Harbaville triptych
 235, *235*, 236; marble head 76, *77*; *Ms*: MR 416
 (Dionysios Areopagite) *334*, 335;
 Musée de Cluny: capital 296; cross 242, *242*; diptych of
 Areobindus 90, *90*
Paris Gregory 164, 180, 181, *181*, 183, 184, 189–93, 252
Paris Psalter 184, 185, *185*, 187–90, 193, 248, 250, 251, 326,
 329, 330
Paros, Katapoliane 65, 66, 121
Paschal tables *see* Easter tables
Paternus paten 99, 100
Patleina 350
patronage 3, 5, 6, 24, 26, 54, 59, 60, 62, 80, 83, 85, 86, 88, 89,
 96, 104, 108, 112–14, 133, 134, 141, 144, 160, 166, 169,
 179, 190, 192, 193, 199, 201, 202, 204, 219, 234, 250,
 254, 256, 257, 259, 260, 262, 266, 271, 279, 287, 297,
 303, 313, 339–41, 344, 346, 356
PATRONS Alexios Apokaukos 291, 333; Alexios,
 protospatharios 142; Alexios, son of Constantine Angelos 226;
 Anastasius, consul 89; Andronikos, *sebastos* 234; Anicia
 Juliana 65, 72–4, 77, 104, 113, 192, 346; Anna Dalassena
 196, 197, 199; Anna Dandolo 274; Areobindus, consul 89,
 90; Basil, consul 89, 91; Basil, *proedros* 169, 192; Boethius,
 consul 49, *49*; Christopher, *protospatharios* 202; Claudius,
 archdeacon 81; Clementius, consul 89, *91*; Constantine
 Akropolites 323; Constantine Lips 135, 136, 192, 259, 284;
Constantine, *protospatharios* 184; Danilo II, archbishop 313;
 Demetrios Palaiologos 336; Ecclesius, bishop 83; Eirene
 Gabras 255; Eirene *sebastokratorissa* 197; Enrico Dandalo,
 Doge 263, 264; Euphrasius, bishop 81; Eustathios,
 archbishop 197; Eustathios, bishop 147; Eutychianos,
 bishop 99; Galla Placidia 22, 40, 44; George of Antioch
 209, 227, 254; Isaac Asen 196, 273, 326; Isaac Komnenos
 195, 201, 242, 248, 285, 303, 339; John Phrangopoulos,
 protostrator 289; John, *proedros* 255; John Stoudios,
 senator 19; John, *synkellos* 122; Julianus Argentarius 83;
 Kaloeidas 332; Kaloyan, Sebastocrator 273; Kosmas, monk
 242; Krinites, *strategos* 139, 192; Leo, archbishop 223; Leo,
 bishop of Argos 203; Leo, *domestikos* 170; Leo Grammatikos
 143; Leo, *protospatharios* 138; Leo, *sakellarios* 184;
 Leontios, Prefect 86; Makarios, Abbot 184 ; Manuel
 Chrysoloras 335 ; Manuel *disypatos*, bishop 322; Manuel
 Kantakouzenos, Despot 289; Maria (Martha) Glabas 281,
 287, 305; Maria Angelina 315; Maria, daughter of Eirene
 242; Maria Doukaina 199, 201, 202; Maria of Antioch
 258; Maria, wife of Constantine Akropolites 323; Maria, wife
 of Michael VIII 238; Maria, wife of Thomas Preljubovic 317;
 Maximian, bishop 83, 85, 96, 112; Melane the nun 303;
 Michael Angelos Komnenos Doukas 263, 270; Michael
 Glabas 281, 283, 287, 305, 309, 341; Michael Tornikes
 294, 303; Naukratios 156; Neon, bishop 40, 41; Nicholas
 of Sion 99; Nicomachi 50; Nikephoros Choumnos 281;
 Nikephoros, *magistros* 225; Nikephoros, son of the Despot
 Michael II 288; Orestes, consul 89, *91*; Pantaleon of Amalfi
 244; Paternus, bishop 100; Paul, archbishop 156;
 Philoxenus, consul 90, *91*; Pietro Oreolo, Doge 246; Sabas,
 monk 256; Simonis 277, 292, 311, 312; Stephen Dusan
 293; Stephen, governor of Palestine 88; Stephen Nemanja
 196, 263, 272, 273, 293, 309, 310, 312; Stephen
 Prvovenčani 263, 272–4, 311; Stephen, *skeuophylax* 174;
 Stylianos Zaoutzas 153; Symmachi 50; Theodora of Arta
 270, 271; Theodora Raoulina 283; Theodore Gabras 255;
 Theodore Metochites 279, 285, 294, 298, 301, 303, 339;
 Theodore Prodromos 197; Theodorus, bishop 34;
 Theophanes, monk 254; Thomas Preljubovic 315; Ursianus,
 bishop 40; Vladimir, of Russia 140, 207
 (*see also* Iconography, donor imagery)
Paul the Silentiary 79
Peć, monastery 313
Pechenegs 196, 197, 234
Peloponnese 277, 278
Perinthos 27
Peristerai, Theotokos 138, *139*, 146, 150
persecution of Christians 10, 12, 13, 18
Persia 59, 67, 115, 125, 359
Persian art 73, 125, 150, 178, 344, 350
Peter of Aragon 276
Phela 97
Phokis, Hosios Loukas 139, *140*, *141*, 144, *148*, *149*, 149, 150,
 177, 192, 204, *210*, 211, 215, *216*, 217, *217*, *218*, 219,
 220, 224, 261, 289, 303
Photios, patriarch 133, 134, 151, 192, 197; *Bibliotheca* 134
pilgrimage 86, 100, 101, 204
pilgrims 21, 48, 55, 86, 103, 114, 160, 348
Pisans 196

Pliny 44, 52
Poganovo (icon) 317, 319
Pompeii 34, 44, 187
Pontus 142, 143
Poreć, Euphrasian basilica 74, 78, 81, 82
Porphyrios, statue base 74, 75
porphyrogennetos 30, 359
portrait *see* Iconography
post-Byzantine 3, 77, 135, 141, 145, 149, 155, 199, 206, 237, 281, 307, 322, 323
Preslav, Round Church 149, 150
Princeton, Speer Library II.21.1900 (lectionary) 255
Prizren, monastery 292, 311
processions 85, 116, 314
Procopius of Caesarea 59, 62, 63, 65, 67, 71, 76, 78, 79, 103, 113
Proiecta casket 46, 47, 56
Prokonessos 27, 74
proskynesis 254, 359
Protevangelion of St James 253, 300
Psalter of Basil II 189, 189
Pulcheria, empress 19
purple codices 110, 111, 112, 129

Qalat Siman 60, 60, 72
Qasr'ibn Wardan 66, 66, 89
quarries 26, 27, 31, 74, 143, 348
Quedlinburg Itala 52, 53

Rabbula Gospels 103, 104, 106, 107, 108, 109, 114, 130, 180
Ravanica 293
Ravenna 22, 38, 43, 55, 58, 75, 77, 85, 103, 112, 114, 115; Arian Baptistry 41, 44; Basilica Ursiana 40, 41; Exarchate of 115, 357; Mausoleum of Galla Placidia 40, 40, 44, 75; Orthodox Baptistry 40, 41; San Apollinare in Classe 63, 87, 87, 88, 114; San Apollinare Nuovo 87, 87; San Vitale 71, 74, 83, 83, 84, 86, 96, 103; St John the Evangelist 22
relics 19, 24, 40, 48, 103, 122, 137, 161, 165, 168, 169, 173, 174, 188, 194, 226, 242, 243, 251, 317, 355, 358; – of the True Cross 48, 168, 169, 173
Resafa, Holy Cross 63, 89
restoration 4, 40, 44, 78, 152, 153, 156, 231, 267, 270, 276, 285, 297, 309, 313, 339, 340
Riha paten 97, 98, 98, 222
Roger II of Sicily 208, 227, 228, 228, 259
Roman empire 2, 8, 10, 16, 346, 347, 360
Romanesque 272, 293
Romanos I 135, 145, 165, 169, 178, 192, 199, 200
Romanos II 145, 169–71, 192, 193, 234
Romanos III 199
Romanos IV 171, 196, 234, 235
Romanos IV and Eudokia (ivory) 171, 175, 234, 234, 235, 237
Rome 2, 4, 8, 10, 13, 16, 20, 31, 40, 43, 48–50, 54, 55, 57, 58, 76, 89, 91, 115, 133, 171, 245, 276–8, 324, 358; Arch of Constantine 29, 29; catacombs 14, 15, 45, 45, 46; Esquiline Treasure 46, 47; Grotte Vaticane, sarcophagus 32; Lateran basilica 20, 21, 122; Museo dela Therme, sarcophagus 31, 31; Palazzo Venezia, ivory triptych 171, 172, 192, 236, 172; San Stefano Rotonda 122; St Paul

outside the Walls (bronze doors) 244, 245; St Peter 21, 36, 123, 123; Sta Agnese 122, 123; Sta Constanza 24, 36, 37; Sta Maria Antiqua 124; Sta Maria Maggiore 22, 39, 39, 44, 88; Sta Pudenziana 38, 38, 44; Sts Cosmas and Damian 81, 81; Via Latina catacomb 15, 36
Rossano Duomo, Gospels 108, 109, 109, 111, 113, 114, 188
Russia 6, 100, 133, 140, 196, 207, 215, 222, 227, 260, 278, 347
Russian Primary Chronicle 207

Sagmata, monastery 206, 207
Samarina, Messenia 203, 203
Sangarius river 62
Saqqara, St Jeremiah 348
Sardica 8
Sava, archbishop 312
schism 133, 197, 241
scholarly revival 190, 191
scholars 5, 52, 134, 150, 193, 194, 197, 342–4
scribe(s) 6, 105, 107, 108, 179, 186, 190, 253, 254, 256, 332, 334, 336–8, 356; Chariton 338; Ioasaph 332, 334, 336–8
secular work 6, 19, 26, 34, 45, 49, 56, 62, 77, 79, 80, 97, 98, 100, 101, 112, 121, 127, 131, 134, 145, 176, 187, 190, 198, 247, 333, 346, 349, 357
Selçikler, church 146, 147, 147, 150
Seljuk Turks 196, 264, 277; art 196, 198, 269
Selymbria *see* Silivri
Septimius Severus 16
Serbia 86, 272, 273, 277, 278, 292, 310
shrine churches 18, 21, 54, 55
Sicilian Vespers 276
Sicily 6, 208, 209, 215, 224, 227, 255, 259, 260, 262, 276, 298, 340; Norman Kingdom of 209, 224, 298
Side, church 138, 138
Siegburg 178
Silivri (Selymbria) St John the Baptist 291
Sinope Gospels 108, 109, 111, 114
Sion treasure 97
Sirmium 8, 86
Sixtus III, Pope 22, 39
Skripou, Dormition 138, 138, 144–6, 144, 148
Slavs 59, 115, 118
Smyrna 127, 267
Socrates 17
Sofia 8, 273, 317
Sopoćani, monastery 273, 274, 274, 275, 275, 293, 298, 309, 340
Spain 59, 150, 317
Spalato (Split) 8
spolia, see materials, re-used
St Petersburg: Hermitage: Paternus paten 99, 100; ivory 96; silver dishes 99, 100, 101, 124; Public Library gr. 291 (gospels) 255, 255
Stephen the Younger, St 116, 126–8
Staro Nagoričino, St George 292, 312, 313
Studenica, monastery 272, 273, 273, 311, 312, 313, 340
Stuma 97, 98, 222
Sylvester, Pope 241
Symeon the Stylite, St 11, 60

Symmachus, Pope 122
synagogue 13, 34
Syria 8, 11, 24, 34, 44, 59, 60, 63, 66, 71, 74, 89, 99, 101,
 103, 113–16, 165
Syriac Bible 108, 109

Tbilisi, Khakhouli triptych 238, 239, 240, 243
Tetrarchs 8, 10, 16, 24, 41, 46, 341, 360
Thasos 28
Thebes (Greece), St Gregory 146
theme system 115, 116, 132, 196
Theodelinda, Queen 100
Theodora, empress 205, 238, 252, 256
Theodora, empress of Justinian I 64, 71, 76, 79, 85, 103
Theodora, empress of Michael VIII 283
Theodora, empress of Theophilos 116
Theodora Palaiologina 335
Theodora, wife of Constantine Akropolites 226
Theodore I Laskaris 263, 264
Theodore II Laskaris 267, 273
Theodore Lector 43
Theodore, Pope 122
Theodore Psalter 248, 250, 250
Theodore the Stoudite 248, 250
Theodoric the Goth 41, 58, 88
Theodosius I 11, 22, 30, 30, 33, 40, 74
Theodosius II 18, 35, 67
Theodotos 180
Theophanes Continuatus 121, 128, 145, 150, 171
Theophano, empress of Nikephoros Phokas 162, 163
Theophano, wife of Otto II 171, 175, 234
Theophilos, emperor 116, 121, 127, 145, 151
Theotokos Hodegetria, icon of Constantinople 332
Theriaca of Nicander 187
Thessalonike 3, 8, 38, 55, 141, 197, 212, 264, 270, 271, 276–8,
 286, 287, 288, 290, 307, 313, 323, 339–41; Acheiropoietos
 22, 22, 42; Archaeological Museum, silver box 48, 48; Holy
 Apostles 286, 287, 287, 292, 306, 306, 307, 314; Hosios
 David 42, 43, 44, 127, 319; Panagia Chalkeon 202, 203,
 203, 222, 224; Rotunda of St George 24, 41, 42; St
 Catherine 287; St Demetrios 21, 85, 86, 85, 150, 287,
 309; St Nicholas Orphanos 287, 288, 288, 307, 308; St
 Panteleimon 164, 287, 287; St Sophia 118, 118, 120, 128,
 156, 156, 160
Thrace 58, 119, 291, 340
Timur (Tamburlane) 278
Tirilye 74; St John of Pelekete 137
tituli 13
torah 45
Torcello 231
Trdat 348
Trebizond 3, 263, 264, 278, 298, 340; Chrysokephalos 268,
 268; Kingdom of 263; St Anne 142, 142; St Eugenios
 335; St Sophia 268, 269
Trier 8, 20
Trnovo 196
Tur Abdin 88

Turks 3, 5, 196, 17, 234, 264, 276–8, 325, 350
typikon 200, 201, 335, 360

uncial script 108, 179, 180
Uroš I 273, 274, 293, 298, 311
Uroš II Milutin 292, 311
Uroš III Dečanski 293, 312
Utrecht, Rijksmuseum, ivory 237, 237

Valerian 10
Van, Lake 196, 347
Vatican Cosmas 183, 193
Vatican Library Mss: gr. 1 (Bible of Leo) 184, 184, 185, 187, 193; gr. 1291
 (Ptolemy) 131, 131; gr. 1613 (Menologion of Basil II) 187, 187,
 188–90, 194, 260, 336; gr. 431 (Joshua Roll) 175, 184, 186–8,
 186, 193; gr. 666 (Zygabenus, Panoplia Dogmatica) 257, 257; gr. 699
 (Cosmas Indicopleustes) 182, 183, 193; Palat. gr. 381 (psalter) 328,
 329
veil of the Virgin 19, 43, 198
Venetians 196, 263, 264, 276, 332
Venice 72, 111, 171, 172, 192, 194, 212, 213, 242, 263; Civico Museo
 Correr, reliquary 243, 243; Marciana Library Mss: gr. 17 (Psalter of
 Basil II) 189, 189; gr. 538 (Book of Job) 183, 183, 189; Lat. Cl. I,
 101 (book cover) 167, 167, 170; San Marco, 208, 209, 231; bronze
 horses 33, 265; chalice of Romanos 169, 170, 170; glass bowl
 177, 177, 193; Pala D'Oro 245, 246, 323; votive crown 166, 166,
 169
Veroli Casket 176, 176, 177, 194, 236
Veronica, St 165, 358
Vienna 93, 171, 172, 192; Öst. NB Mss: cod. Hist. gr. 6
 (menologion) 251, 252; Med. gr. 1 (Vienna Dioscurides)
 104, 105, 111, 113, 131, 187; Theol. gr. 31 (Vienna
 Genesis) 108–110, 110, 186; Theol. gr. 336 (psalter) 258;
 Weltlische Schatzkammer Ms. XIII/18 (Coronation Gospels)
 129, 129
Virgil, Aeneid 52
Vize, St Sophia 118, 119, 119
Vladimir, Our Lady of (icon) 244
Vladislav I 273

Washington DC, Dumbarton Oaks: crosses 170, 241, 242, 250;
 dish 101; icons 319, 320, 321, 321; ivory panel 175;
 marble panels 212, 213; psalter of 1084 251; pyxides 96,
 96, 324, 324; Riha paten 97, 98, 98, 222
Water Newton treasure 47, 47, 48
William II 229, 259
William III 208

Yaroslav of Kiev 196, 207, 222
Yerebatan Sarayı 62, 63
Yerevan, Armenia 95

Zagba, monastery 105, 107
Zeno, emperor 58, 60, 66, 76, 93, 113
Zeus 13, 56
Zica 313
Zoe, empress 195, 198, 199, 205, 232, 233, 238, 256, 281